Art in Focus

Third Edition

Gene A. Mittler, Ph. D.
Professor of Art
Texas Tech University

GLENCOE
McGraw-Hill

New York, New York Columbus, Ohio Mission Hills, California Peoria, Illinois

About the Author

Gene A. Mittler received an MFA in sculpture from Bowling Green State University and a Ph.D. in art education from Ohio State University. He has taught elementary and middle school art in Elyria, Ohio and middle school and senior art in Lorain, Ohio where he also served as supervisor of art and Director of School-Community Relations. He has authored grants and published numerous articles in professional journals, including *Studies in Art Education, Peabody Journal of Education, Art Education Journal, School Arts, Design for Arts in Education,* and *The Clearinghouse.* In addition to *Art in Focus,* he coauthored *Creating and Understanding Drawing.* His most recent books, in which he collaborated with Dr. Rosalind Ragans of Georgia Southern University, are junior high school textbooks entitled *Exploring Art* and *Understanding Art.*

Dr. Mittler has taught at Indiana University and is currently Professor of Art Education at Texas Tech University. He and his wife, Maria Luisa, live in Lubbock, Texas.

Editorial Consultants

Jean Morman Unsworth brings years of art education to her writing and consulting work. She has taught at the elementary and secondary levels and was Professor of Fine Arts at Loyola University of Chicago until 1987. She initiated and designed the Chicago Children's Museum and the Interdisciplinary Arts Masters program at Columbia College in Chicago and now gives full time to writing and consulting.

Nancy Miller
Art Teacher
Booker T. Washington High School
for the Performing and Visual Arts
Dallas, Texas

Nancy J. Blomberg
Associate Curator of Native Arts
The Denver Art Museum

Johanna Stout
South Park High School
Art Teacher
Fairplay, Colorado

Veronika Jenke
Assistant Curator of Education
National Museum of African Art
Smithsonian Institution

Cover Art: Mary Cassatt. *At the Opera.* 1879. Oil on canvas. 80 x 64.8 cm (31 1/2 x 25 1/2"). Museum of Fine Arts, Boston, Massachusetts. Hayden Collection.

Send all inquiries to:
GLENCOE/McGraw-Hill
15319 Chatsworth Street
P.O. Box 9609
Mission Hills, CA 91346-9609

ISBN 0-02-662312-9 (Student Text)

4 5 6 7 8 AGK 99 98 97 96 95

Studio Lesson Consultants

The author wishes to express his gratitude to the following art teachers who participated in field testing the studio lessons with their students:

Karen Anable-Nichols
Reseda High School
Reseda, CA

Karen J. Banim
Hunters Lane
High School
Nashville, TN

JoAnne Beck
Raleigh Egypt
High School
Memphis, TN

Pam Bergman
Hume-Fogg Academic
High School
Nashville, TN

Wendy Bull
Colonial Junior
High School
Memphis, TN

Carol A. Burris
East High School
Columbus, OH

Karen Butterfield
Coconino High School
Flagstaff, AZ

Marsha Conway
New Castle Chrysler
High School
New Castle, IN

Barbara Cox
Glencliff
Comprehensive
High School
Nashville, TN

Maggie Davis
Northwestern
High School
Miami, FL

Libby Devine
Roswell High School
Roswell, GA

Jean Carl Doherty
Riverwood High School
Atlanta, GA

Pat Drew
Chattahoochee
High School
Alpharetta, GA

Ricque Finucane
Pojoaque High School
Santa Fe, NM

Chris Greenway
Woodward Academy
College Park, GA

Marsha Hogue
Lake Highlands
High School
Dallas, TX

Dan Howell
North Central
High School
Indianapolis, IN

Denise E. Jennings
Milton High School
Alpharetta, GA

Quita McClintoc
Hewitt-Trussville
High School
Trussville, AL

Nancy Miller
Booker T. Washington
High School for the
Performing and Visual
Arts
Dallas, TX

Roberta Sajda
Klein Forest High School
Houston, TX

David Sebring
Dobson High School
Mesa, AZ

Kim Shipek
Buena Vista High School
Sierra Vista, AZ

Jerry Smith
Dobson High School
Mesa, AZ

Johanna Stout
South Park High School
Fairplay, CO

Student Contributors

The following students contributed exemplary work for the Studio Lesson and Student Portfolio pages:

Hewitt-Trussville High School, Trussville, AL: James Sransky; Buena High School, Sierra Vista, AZ: Milam L. Gill, Jr., Tess Heydorn, Camine White; Coconino High School, Flagstaff, AZ: Kelvin Derek Bizahaloni, Philissa Calamity; Dobson High School, Mesa, AZ: Thomas Alexander, Megan Cory, Clay Holley, Trinon Meyer; Reseda High School, Reseda, CA: Amiee Johnson, Johannah Muhs; South Park High School, Fairplay, CO: Jason Paprocki, Judy Sexton; Chattahoochee High School, Alpharetta, GA: Gloria Haynes, Debbie Malone; Milton High School, Alpharetta, GA: Dusty Kaylor, Malena Rivas; Roswell High School, Roswell, GA: Jonathan Edward Allen, Jill C. Stidham; Riverwood High School, Atlanta GA: Yuko Kurihara, Tere Tomlinson; Woodward Academy, College Park, GA: Jennifer Yancy; New Castle Chrysler High School, New Castle, IN: Holly Hines; North Central High School, Indianapolis, IN: MaryAnn Zent; Pojoaque High School, Santa Fe, NM: Amber Gauthier; East High School, Columbus, OH: Sarah Beck, Andy Smallwood; Colonial Junior High School, Memphis, TN: Josh Jennings; Raleigh Egypt High School, Memphis, TN: Michael Grant; Glencliff Comprehensive High School, Nashville, TN: Kenneth Woodruff; Hume-Fogg Academic High School, Nashville, TN: Stacy Kraft, Philip Sohn, Somboon Xayarath; Hunters Lane High School, Nashville, TN: Tina Pouder; Booker T. Washington High School for the Performing and Visual Arts, Dallas, TX: Elisa Lendvay; Lake Highlands High School, Dallas, TX: Yuki Negishi, Keith Williams; Klein Forest High School, Houston, TX: Megan Fraser, Chris Murray, Tuong Ngo, Kenneth R. Washington; New Caney High School, Houston, TX: Chris Ryan, Marty Weinzel.

CONTENTS

Unit One *Creating and Understanding Art*

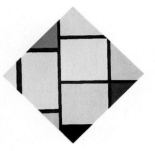

Unit Six Art of an Emerging Modern Europe

Features

Creating and Understanding Art

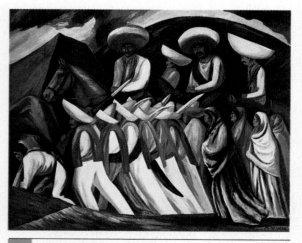

Zapatistas
1931 Page 7

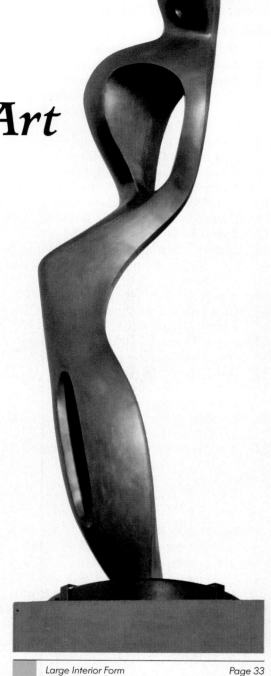

Large Interior Form
1953 Page 33

1100	1200	1300	1400

LEARNING A VISUAL VOCABULARY

2

The Kirifuri Waterfall
1832
Page 69

Diamond Painting in Red, Yellow, Blue
1921–25
Page 111

The Rumanian Blouse
1937
Page 110

3

Art and You

Objectives

After completing this chapter, you will be able to:

➤ Explain what aestheticians do.

➤ Identify three theories of art and explain how these theories differ from each other.

➤ Discuss how the three theories of art can help in arriving at a definition for art.

➤ Provide your own answer to the question, "What is an artist?"

➤ Identify some reasons why people study art.

Terms to Know

aesthetician
art patron
caricature
criteria
curator
docent
emotionalist
formalist
imitationalist
logo

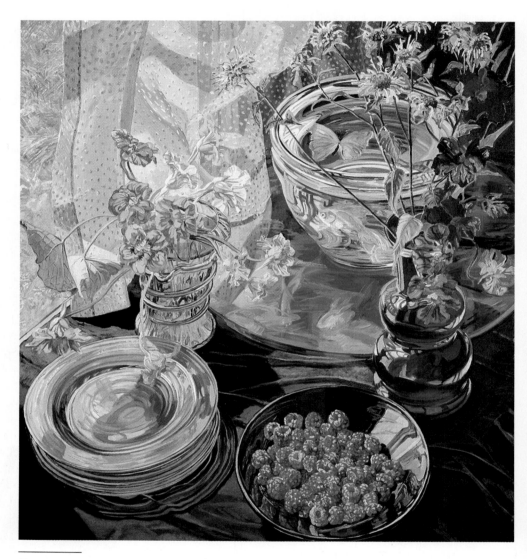

Figure 1.1 Janet I. Fish. *Raspberries and Goldfish*. 1981. Oil on canvas. 182.9 x 162.6 cm (72 x 64″). The Metropolitan Museum of Art, New York, New York. Purchase. The Cape Branch Foundation and Lila Acheson Wallace gifts, 1983.

"I like paintings of things that I can recognize. Why, the raspberries in that painting

we saw a moment ago looked so real I felt as if I could reach out and touch them."

"I don't see what this painting is supposed to mean."

"Artists today don't seem to take the time to paint like the artists of the past."

"I may not know anything about art, but I certainly know what I like."

SECTION ONE

Why Study Art?

Do the above comments sound familiar? Most people at one time or another have made or overheard statements like these about art. Sometimes they are heard over the hum of a projector in a darkened classroom as students view slides of artworks. Such statements are rather common in galleries and museums where they are whispered as if for the very first time. Often, such statements are met with smiles and outright laughter, or with furrowed brows and heads nodding in agreement.

The comments people make about art usually reflect the past experiences they have had with art. These experiences influence what they see in a work of art and how they will react to it. Like everyone else, you have inherited some parts of your cultural background, but your unique experience with that cultural heritage means that you will be prepared to see a work of art and react differently to it than will others from different backgrounds. Thus, a work you feel is outstanding may cause others to shake their heads disapprovingly. However, by openly discussing your point of view with others, you might see some things you missed before, or learn to interpret works from a completely different angle. When this happens, everyone benefits.

Fortunately, people always seem ready and willing to express their opinions about art. This is true whether they have a broad background in art or know nothing at all about it. Point to a work of art in a museum and make a statement about it to friends, and they will quickly respond with statements of their own. This is a good sign. After all, it shows that they are interested enough to make a statement or offer an opinion. However, merely stating an unsupported opinion about a work of art is not enough if that work is going to have more than passing interest. If a work of art is to be appreciated, opinions about it should be based upon knowledge and understanding.

Understanding Art

The purpose of this book is to help you acquire the knowledge and understanding you will need to make and support your own personal decisions about works of art. In order to do this, you must first learn the vocabulary of art and how to use it. Artists use many different colors, values, lines, textures, shapes, forms, and space relationships to create their works. These are called the *elements of art*, and they are used by artists in countless combinations. If you are to fully understand a painting, a sculpture, or a building, you will need to recognize the elements within each and find out for yourself how they are being used. In Chapter 2 you will learn how to do this. It will not only add to your understanding of how others create, it will also help you to express yourself through art. A visual vocabulary is essential when you are trying to do the following:

- Gain insights into the artworks produced by others.
- Create your own artworks with different media and techniques.

Once you have mastered a vocabulary of art, you will be ready to learn how art criticism and art history can be used to gather information from and about works of art. The following paragraphs will introduce you to these two different kinds of information-gathering operations.

Gaining Information from Works of Art: Art Criticism

Many people seem to think that art criticism is very complicated and difficult. This is simply not true. In fact, it can be quite uncomplicated, is easily learned, and will add a great deal of interest and excitement to your encounters with all kinds of art. You could say that art criticism is an orderly way of looking at and talking about art. It helps to direct you to information found within works of art.

To gain information from a work of art, you must know two things: what to look for and how to look for it. This will be covered in Chapter 5. You will be shown the qualities that you should look for when examining a work. Those qualities represent the **criteria**, or *standards for judgment*, you will need when making and supporting decisions about art. A search strategy, or way of looking, will make the task of looking for those qualities much easier. The search strategy will consist of four steps:

- **Description**: Through which you try to find out what is in the work.
- **Analysis**: Through which you discover how the work is organized or put together.
- **Interpretation**: Through which you try to determine the feelings, moods, or ideas communicated by the work.
- **Judgment**: Through which you make your own decisions about the artistic merit of the work.

Gaining Information about Works of Art: Art History

Artworks are not created in a vacuum. Your understanding of them cannot be complete until you determine who made them as well as when, where, how, and why they were made. You can add greatly to your knowledge and understanding of a work by learning something about the artist and what caused that artist to select and paint certain subjects in certain ways. Every great work of art reveals something seen plus the artist's insight into it.

Paul Cézanne painted a rather ordinary mountain in southern France over and over again (Figure 1.2). Mexican muralist José Clemente Orozco painted pictures that expressed his anger for all forms of tyr-

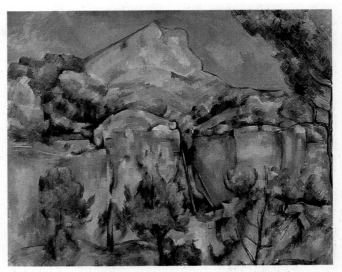

> Paul Cézanne painted more than sixty versions of the little mountain known as Sainte-Victoire. In each, he used blocks of color to build a solid form that is both monumental and durable.

Figure 1.2 Paul Cézanne. *Mont Sainte-Victoire as Seen from Bibemus Quarry.* c. 1897. Oil on canvas. 65.1 x 80 cm (25½ x 31½"). The Baltimore Museum of Art, Baltimore, Maryland. The Cone Collection, formed by Dr. Claribel Cone and Miss Etta Cone of Baltimore, Maryland.

anny (Figure 1.3, page 7). To understand and appreciate such works, you must know something about the environment that influenced the sight and the insight of the artists who created them.

Art history can add to the knowledge you have gained from artworks during criticism. It also enables you to check some of the decisions you made during art criticism. For example, during art criticism you will make some preliminary decisions about the meaning and merits of a certain work of art. After this you will be ready, perhaps even eager, to find out what meaning and merits others have found in the same work. Facts about the artist, the period, the country, the artistic style, and the subject matter will help you to check your decisions. How historians value a work could have an impact upon your final judgment. Thus, by referring to art history, you can confirm, change, or reject all or some of the decisions you made during art criticism.

A search strategy can be just as useful to you in art history as it is in art criticism. Furthermore, it can consist of the same four steps used in an art-criticism search strategy. However, you must remember that when it is applied to art history this search strategy operates from a different point of view. It is used to gain information *about* a work of art rather than gain information *from* the work. As used in art history, the search strategy would look like this:

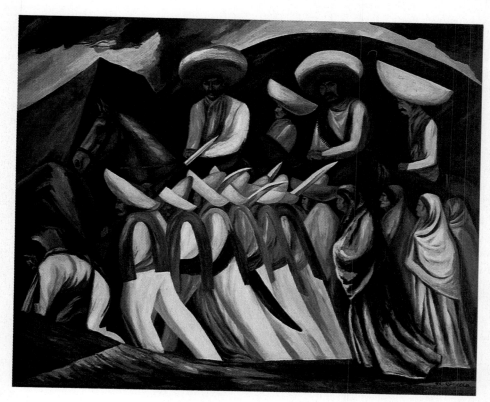

> Notice how the artist has used strong contrasts in value to give this work a feeling of power. How has he conveyed the mood of the people?

Figure 1.3 José Clemente Orozco. *Zapatistas*. 1931. Oil on canvas. 114.3 x 139.7 cm (45 x 55"). Collection, The Museum of Modern Art, New York, New York. Given anonymously.

- **Description**: Through which you try to find out when, where, and by whom the work was done.
- **Analysis**: Through which you discover the unique stylistic features of a work of art.
- **Interpretation**: Through which you try to determine how the artist was influenced by the world in which he or she lived and worked.
- **Judgment**: Through which you make a decision about the work's importance in the history of art.

Studying Art

There are many reasons why people choose to study art. Some find it enlightening and exciting to learn more about artists and artworks. Others, eager to develop their own skills as artists, recognize that past and present masters can be among their most valuable teachers. Still others, hoping to learn about past civilizations, regard works of art as windows to those past civilizations (Figure 1.4).

While people have many different reasons for wanting to study art, they often begin their study at the same place: trying to find a definition for art.

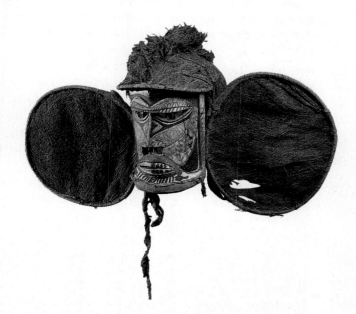

> Information about any previous civilization would be meager if it were not for that civilization's arts. This mask has been designed to convey a feeling of power. How has the artist made the facial features look menacing?

Figure 1.4 Mask. Late nineteenth century. Melanesia: New Ireland, Northwest Region. Wood, paint, obsidian chips, cane, plant fibers, bark cloth, shagged bark. 33 x 62 x 37.5 cm (13⅛ x 24½ x 14¾"). Dallas Museum of Art, Dallas, Texas. The Roberta Coke Camp Fund.

Maya Lin

Architect and sculptor Maya Lin (b. 1959) has successfully completed sculptural commissions that require her to understand the deep feelings and history of various groups of people. For example, Lin was only thirteen years old when the cease-fire between the United States and North Vietnam was declared in 1973, but later as an architecture student at Yale University, she was keenly aware of the sorrow of those involved in the war. She designed a memorial monument that powerfully reflected their depth of emotion (see Figure 24.27, page 577).

In 1989, Lin created a fountain to commemorate the civil rights movement (Figure 1.5). The work sensitively incorporates key events in the history of the African-American civil rights movement between 1955 and 1968, and the names of those who died in the struggle for justice. A biblical quotation spoken by civil rights leader Martin Luther King, Jr., in his first speech during the Montgomery bus boycott, is also inscribed on the wall.

Lin's parents are from Beijing and Shanghai, and although she identifies herself as a Chinese American, she states, "If I had to choose one thing over another, I would choose American. I was not born in China, I was not raised there, and the China my parents knew no longer exists." The Ohio-born artist feels that "a single national identity doesn't exist, especially for Americans. So much of this country is about being an individual and about being mixed." The varying aesthetic styles of different countries were not discussed when Lin was in college, but she insists that this must change. She calls it unforgivably self-indulgent to focus on western European art alone when "the world is getting so small, its peoples so intertwined."

Some viewers see an Asian influence in Lin's work, a sensibility that Lin acknowledges may unconsciously stem from her Asian-American upbringing. She notes, "Much of the Western architectural training I've had has left me cold, but when I walk into a Japanese garden, I respond immediately. I find its simplicity lets me think and come to my own conclusions; I find it more sympathetic than the didactic, assertive stance of most Western architecture."

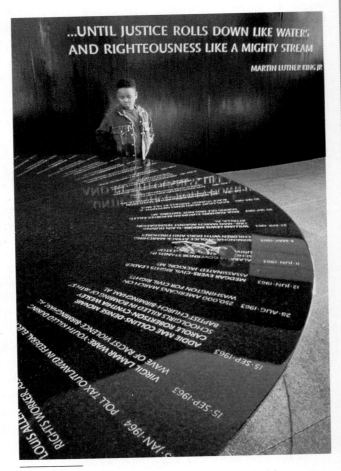

Figure 1.5 Maya Lin. *Civil Rights Memorial*, Montgomery, Alabama.

What Is Art?

Finding a definition for art may not sound too difficult at first—until you realize that this has proved to be a challenge for a long line of scholars stretching back in time to ancient Greece. Great philosophers, such as Plato and Aristotle, attempted to define the unique nature of art and understand its contribution to human life. The study of the nature of beauty and art was originally a branch of philosophy called aesthetics, and today *a scholar who specializes in the study of the nature of beauty and art* is called an **aesthetician**.

Throughout the ages, aestheticians have been concerned with identifying the criteria to be used in understanding, judging, and defending judgments about works of art. They have tried to define art by forming theories that focus on what they believe to be the most important criteria to use when judging art. You will learn about three of the most commonly held aesthetic viewpoints later in this book. There you will find one group of aestheticians, who we will call **imitationalists**, that *favor the realistic representation of subject matter in artworks.* A second aesthetic view is held by **formalists**, *who place importance on how well artists design their works.* They look to see if artists make good use of the building blocks of art: color, value, line, texture, shape, form, and space. The third aesthetic view is held by those we might call **emotionalists**, *who place most importance on the vivid communication of ideas, feelings, and moods.*

By drawing on all three theories of art—imitationalism, formalism, and emotionalism—we can arrive at a useful definition for art. It is the unique expression of an idea, experience, or feeling in a well-designed visual form.

What Are the Visual Arts?

Artworks are the product of human sensitivity, creativity, imagination, and skill. Few people would challenge the claim that many of these artworks take the form of paintings, sculptures, and architecture. However, the visual arts include much more, including a great many things we take for granted.

Even the most familiar and ordinary items we see and use every day can provide us with visual satisfaction and pleasure. A chair can be visually attractive as well as comfortable to sit in (Figure 1.6). Well-designed dishes do more than merely hold food.

When you think about it, a great many objects can be included in the visual arts. These range from carefully designed, useful products to those created for no

other reason than to give us enjoyment. While paintings and sculpture fall into what is called the *fine art* category, we should remember that artistic quality is not limited to those forms of expression. Chairs, dishes, and clothing can be designed to be visually pleasing as well as functionally practical.

What Is an Artist?

Of the thousands of questions people ask when studying art, none are more familiar than those asked about artists. Perhaps you have found yourself asking questions like: What sort of people become artists? Are they more introverted, extroverted; more temperamental, odd? Are they more practical or less practical than other people?

Actually, the major difference between an artist and a plumber, or a shoe salesman, or a waitress, or anyone else for that matter, is that on the whole the artist makes better art. Beyond that, they are pretty much like everyone else.

Why, then, do some people choose to become artists rather than plumbers, shoe salesmen, or

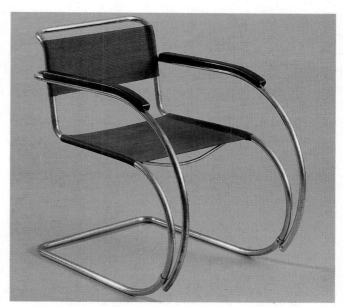

➤ In a series of chair designs from 1926 to 1927, van der Rohe sought to modify traditional chair forms and eliminate the need for rear legs. He felt the chair would then reflect more clearly a relationship to the seated human figure.

Figure 1.6 Ludwig Mies van der Rohe. Armchair, designed in 1927. Chrome-plated tubular steel, horsehair fabric, and ebonized wood. 77.4 x 55.15 x 79.9 cm (30½ x 21¾ x 31½"). The Saint Louis Art Museum, St. Louis, Missouri. Purchase, Museum Shop Funds.

waitresses? Are they attracted to art by the promise of great wealth? Indeed, this would seem to be the case with some very successful artists. One of these was the fifteenth-century Italian painter Titian (Figure 1.7). Titian's fame as a painter to kings and nobles enabled him to earn huge commissions and to live like a lord.

However, not all artists were as fortunate. Rembrandt spent the last years of his life bankrupt and living as a lonely hideaway. His countryman, Frans Hals, died in a poorhouse and was buried in a potter's grave. No one knows what Vermeer received for his paintings, but we do know that his widow was forced to trade his works for food for herself and her large family. Most people know that Vincent van Gogh depended upon his brother's generosity rather than the income received for his paintings. He sold only one painting in his lifetime.

If obtaining riches was their motive for becoming artists, a great many would have to be regarded as failures. Wealth, however, is not the measure used to determine success in art. This is determined by the quality of the art produced. That is why today Rembrandt, Hals, Vermeer, and van Gogh are among the most highly praised artists in history.

The Impulse to Create

Perhaps there is another reason why some people are attracted to art. Could it be that they seek recognition and glory?

The quest for personal recognition is relatively new in art. During the Middle Ages the names of artists were unknown. Artists directed their efforts to creating art that glorified God rather than themselves or the life going on around them. This changed during the Renaissance. At that time, artists hoped to gain fame through their art. Many succeeded in earning the respect and admiration of society. In fact, there were times when this respect and admiration was carried too far. When the painter Filippo Lippi died in Florence, there was a loud cry from the tiny city in which he had been born. The townspeople felt that the artist should be buried in their town since he was born there. Besides, they said, Florence had enough famous artists already buried in its cemeteries!

Another Renaissance artist, Correggio, may have died because people failed to recognize his skills as a painter. Commissioned to decorate the dome of a cathedral, Correggio was shocked to find that his finished work failed to meet the expectations of his patrons. An **art patron** is *an individual who sponsors and supports activities in the arts.* Apparently there was even some debate as to whether or not Correggio

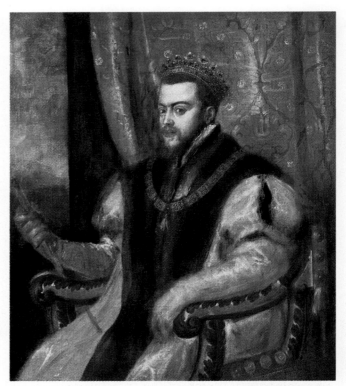

➤ Titian painted this full-scale oil sketch to serve as a model from which other official portraits of the Spanish king could be made. The face and a few other parts of the composition are finished, while the hands, the staff in Philip's right hand, and the details of the costume are only blocked in to suggest the pose.

Figure 1.7 Titian (Tiziano Vecellio). *Philip II.* c. 1549–51. Oil on canvas. 106.4 x 91.1 cm (42 x 35⅞"). Cincinnati Art Museum, Cincinnati, Ohio. Bequest of Mary M. Emery.

should be paid for his work. Eventually it was agreed that payment should be made—in the form of copper coins. According to legend, while attempting to carry the heavy sack of coins home, Correggio's heart failed and he died. Many claimed that the true cause of his death, however, was a broken heart.

It seems unlikely that artists create out of a desire for either wealth or glory. Most would say that they continue to create art because they have to and are not happy doing anything else (Figure 1.8, page 11).

Examples of this single-minded dedication to art are found throughout the pages of art history. The proud, restless, and irritable Japanese artist Katsushika Hokusai, for example, was so consumed with the need to create that he illustrated novels, poems, calendars, greeting cards, and even the Japanese equivalent of comic books. It has been estimated that he illustrated 437 different volumes and enriched the art of Japan with no less than thirty thousand pictures.

This same commitment to art is noted in the lives of many artists, including the sixteenth-century Italian painter Tintoretto. One of this artist's rivals once

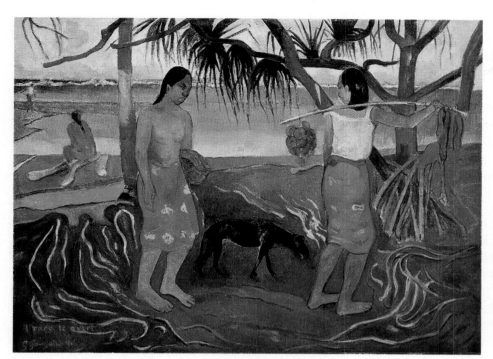

➤ Although Gauguin's work did not sell and his family was reduced to poverty, he would not abandon his painting. He felt that, in spite of the ridicule heaped upon him, he was destined to be a great artist.

Figure 1.8 Paul Gauguin. *I Raro te Oviri* (*Under the Pandanus*). 1891. Oil on canvas. 67.3 x 90.2 cm (26½ x 35½"). Dallas Museum of Art, Dallas, Texas. Foundation for the Arts. Collection, Adele R. Levy Fund.

complained that Tintoretto could paint more in two days than he himself could paint in a year. Tintoretto's drive to create was demonstrated in a competition for a painting to decorate the ceiling of a school in Venice. Five painters, including Tintoretto, were invited to submit their designs for the ceiling. After his competitors revealed their sketches Tintoretto pointed to his own entry—the completed painting in place on the ceiling, where it remains to the present day.

Clearly, for true artists like Hokusai and Tintoretto, art is not a means of livelihood or the path to personal recognition and glory. Rather, it is life itself—life dominated and often complicated by the overpowering impulse to create.

SECTION ONE

Review

1. Who are aestheticians and what do they do?
2. The realistic representation of the subject matter in a work of art is stressed by which aestheticians?
3. What is the primary concern of formalists?
4. What do emotionalists look for in works of art?
5. How can the different concerns of imitationalists, formalists, and emotionalists aid in the formation of a useful definition for art?
6. What is *your* definition of an artist?
7. At what time in European history did artists begin to gain individual fame for their works?

Creative Activity

Humanities. Today, much of the support for the arts comes from foundations. A foundation is a financial endowment set up by a person, a corporation, or a special-interest group to support the arts. The endowment money is invested and the interest from it, together with a portion of the principle, is dispensed in the form of financial grants to individuals, schools, or other groups that teach or perform an art.

Research the foundations that give support to artists, such as the Chicago-based MacArthur Foundation. Learn about the National Endowment for the Arts, the individual state arts councils, and not-for-profit organizations whose aim is to bring the arts to schools and neighborhoods.

Art-Related Careers

If you enjoy studying or creating art you may want to consider the many career opportunities in the art field. Every year challenging and rewarding positions are available in the visual arts.

Schools, museums, galleries, small businesses, and large corporations look for creative and knowledgeable persons for art and art-related jobs. An awareness of some of these opportunities may help you as you begin thinking about your own career plans. It may also prompt you to respond to the experiences offered in your art class with even greater interest and enthusiasm. For this reason, a brief discussion of some of the career opportunities involving the visual arts follows. For more detailed information concerning careers in art, consult your art teacher, guidance counselor, and librarian. You may be surprised to find that art and art-related career opportunities are plentiful and quite varied.

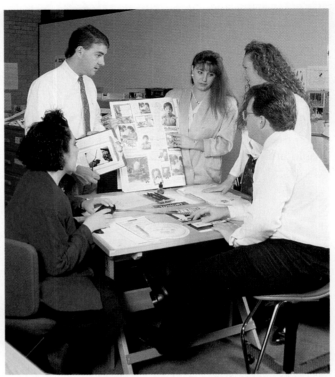

➤ The art director discusses advertising layouts and artwork with staff members.

Figure 1.9 Art Director.

Business and Industry

Today's world is filled with an endless array of products designed, produced, advertised, and sold by countless industries and businesses. Increasing numbers of people with knowledge and skill in the visual arts are needed to help meet the creative demands of these industries and businesses. Each year these creative demands become more diverse and sophisticated, requiring art specialists of different kinds who can explore new ideas, comprehend problems, and provide solutions.

Advertising Art

The advertising industry is concerned with selling products and services to people. The history of advertising can be traced far back into history. People with goods and services to sell or messages to deliver realized that they would be more successful if they could communicate to as many people as possible. It is not altogether surprising then that on a papyrus found among the ancient ruins of Egypt there is an advertisement offering a reward for runaway slaves. In Pompeii, there were political ads that advised readers to vote for certain candidates for public office and

not to vote for others. In the Middle Ages, the town crier often mixed his news announcements with "commercials" for various local business establishments.

Today, when a manufacturing company develops a new product, it faces the same task of trying to tell as many people as possible about it. The advantages of the new product are presented to potential buyers through a variety of media including television, radio, newspapers, magazines, and billboards. Imaginative, creative people are needed to produce the visual materials and write the messages delivered by these media.

For example, suppose that the Acme Company has created a revolutionary new product known as the Gadget. The success of the company and everyone associated with it may depend upon how well the Gadget is received in the marketplace. Thus, an advertising firm is contracted to coordinate a campaign aimed at introducing the Gadget to the buying public.

The art director (Figure 1.9) of the advertising firm works with a team of experts who gather information about the potential market and the consumer. After closely studying this information, a selling strategy is agreed upon and formally presented to Acme Company executives. If they approve it, specialists within

the advertising agency prepare newspaper and magazine advertisements, while others plan radio and television commercials. People with art skills, working closely with copywriters, design the illustrations and photographs to be used in newspaper and magazine ads. An important part of their assignment is to select and arrange the proper kind of typeface and images for those ads.

In the case of the Gadget, the artist and copywriter would probably discuss several different ways to showcase their product in ads. Some of these different ways might include the following:

- Showing the Gadget in such a way that its streamlined design would make it an attractive addition to any home.
- Showing the Gadget being used by someone who is obviously enjoying its efficiency and ease of operation.
- Showing the Gadget in elegant surroundings to suggest that it is used in the most fashionable households.
- Showing the Gadget in the hands of a well-known movie star or sports figure who urges readers to be the first in their neighborhood to own one.

It might help you gain a better understanding of the planning that goes into a magazine ad if you select an ad from a magazine and study it closely. You may be surprised to discover how the artist and copywriter who produced it succeeded in arousing your interest and directing your eye to the most important objects and copy. A layout is prepared that shows the size of all the written text and illustrations as well as where they are to be placed on the page. To do this, the layout artist has to have an understanding of the visual vocabulary — the elements and principles of art — which you will learn about and apply to your encounters with art throughout this book.

Television commercials require a host of people to create costumes, sets, and props. Even more people serve as filmmakers, interior designers, fashion designers, makeup specialists, and fine artists.

If an advertising campaign is effective, a product such as the Gadget could become a familiar item in thousands of households. As a result, the Acme Company and its employees would prosper. Further, the people associated with the advertising firm would be rewarded with new contracts from other companies hoping to have their products sold as effectively as the Gadget. As for consumers, they might well wonder how they ever managed to get along without the Gadget.

Graphic Design

The next time you watch television, pay attention to the symbols used by the networks to identify themselves. The people who design such *identifying symbols*, or **logos**, are known as graphic designers. Just think of the many different symbols that you have come to associate with various corporations and manufacturers — the CBS "eye," the Izod alligator, the golden arches of McDonald's. How many times have you purchased a pair of jeans because of the special symbol sewn onto a back pocket? Of course, graphic designers do more than create symbols for companies.

➤ A graphic designer prepares a page layout by planning illustrations and arranging type in a visually pleasing way.

Figure 1.10 Graphic Designer.

➤ A computer graphics specialist works with a mouse and software to create art that will be stored in the computer's memory.

Figure 1.11 Computer Graphics Artist.

Who do you think designed the colorful box that contains the indispensable Gadget?

Graphic designers (Figure 1.10, page 13) are also employed as magazine and book designers. Before a new magazine or book is published, an artist is often selected to design the layout. The designer of a magazine can make it look sophisticated, glamorous, humorous, folksy, homey, or informative to appeal to a particular type of reader. You can see how effectively they do this by comparing two different kinds of magazines, perhaps a newsmagazine with a fashion magazine. These magazines differ in more than just the kind of articles and advertisements they contain. The newsmagazine is designed to look as though it will cover timely and important information to readers in a fast, efficient manner. The fashion magazine typically has a more elegant, unhurried look about it.

Book designers are employed by publishing houses or independent agencies to plan the layouts for the books that are produced. They must carefully consider and integrate the ideas and requirements presented by representatives of the publishing house and the author. Then they may select the styles of type and create line drawings and color illustrations for the book. Further, they may decide how these items are to be arranged on each page. Included among the decisions they might make are how much white space to use, where color could be most effective, and what colors to choose to dramatically or subtly attract the reader's attention. Frequently, the designer submits a design for the cover and dust jacket of a book as well.

How important are book designers? They are very important. Their contribution to the success of a book is evident when you consider that an effective design will invite people to pick up a book, flip through the pages, and begin reading. An unsuccessful design, on the other hand, may cause potential readers to push the book aside after flipping through pages that lack visual appeal.

Computer Graphics

Instead of making marks on paper with drawing instruments, computer artists draw by using a mouse, joy stick, or track ball to move line and color around on a computer screen (Figure 1.11). They create images that can be moved, erased, duplicated, shrunk or enlarged, colored, textured, and changed immediately. Artists can also select and save one image from an entire group.

Once an image has been completed to the artist's satisfaction, it can be stored in the computer for future use. When it is needed, it can be printed on paper or some type of film, such as slide, video, or photographic. This printed image, or hard copy, can be used in various ways by artists and designers.

Artists today are using the computer to produce works of art unlike anything created in the past. The computer also helps them increase their creative output. It enables them to find more solutions to artistic problems and enhances the quality and originality of those solutions.

Computer designers can assemble text material, select type, create images, and plan the layout to produce full-color or black-and-white designs to serve a variety of purposes.

Photojournalism

Photography was unheard of until the mid-1800s. No sooner had photography emerged on the scene, however, than the field of photojournalism was born. Photojournalism is the taking of pictures for newspapers and magazines.

Photojournalists are expected to seek out and record newsworthy scenes. They must be able to take action pictures quickly and process them with equal speed.

Some photojournalists in recent decades have chosen specialties for themselves. Two of these areas are politics and sports.

Arts Administration

People who choose to become arts administrators assume administrative responsibilities in public and private museums, libraries, theaters, concert halls, and art centers. These administrators oversee the daily operations of their institutions, and this involves them in a variety of important tasks. They are in charge of securing operational funds, preparing budgets, organizing volunteers, arranging publicity, and working closely with various groups to make the institution a vital and active part of community life.

Corporate Art Advising

A few years ago only a handful of major corporations in the United States sought advice from critics and museum personnel when purchasing works of art. At that time art was acquired mainly for decorative purposes. Pictures and sculptures were used to add interest to executive offices and reception rooms. Recently, however, a growing number of corporations have exhibited a desire to develop their art collections. With this increased activity in corporate collecting, a new profession was born—the corporate art adviser.

The duties of corporate advisers include purchasing artworks, developing a unified collection, and advising the corporation on laws and taxation as they apply to art. They also speak to various groups about the collection and organize traveling exhibitions. Consultants are either full-time employees of corporations or work as freelance advisers for several companies at the same time.

Fashion Design

Fashion designers (Figure 1.12) learn to use fabrics of different colors, textures, and weights to create garments that people wear for different occasions. A designer creating a design for a winter jacket, for example, must make certain that the jacket is warm, comfortable, and attractive. This means selecting the most suitable fabric and fashioning a garment that meets these specifications. If one of these specifications is ignored, the jacket may be rejected by buyers. After all, no one wants a winter jacket that may look stunning but fails to protect the wearer from the cold. Every garment that the fashion designer creates has different specifications. These must be taken into account if the garments are to be favorably received by buyers.

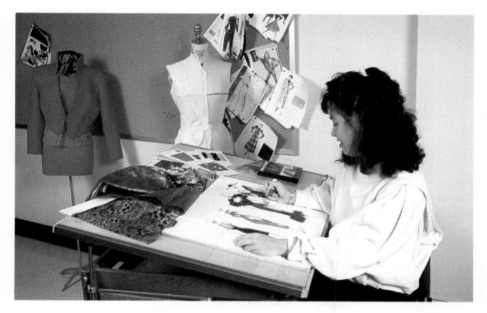

➤ Is a career in the fashion industry one that interests you? Here, a designer coordinates fabric colors and designs for an upcoming fashion season.

Figure 1.12 Fashion Designer.

Environment

The design of interior and exterior spaces is the task of specialists who serve as architects, landscape architects, and interior designers. When our earliest ancestors left their cave shelters and began to build crude huts of tree branches, they became the world's first architects. Over time, larger, more durable structures were designed and constructed to meet the demands of an increasingly complex way of life. As the concern grew to make these different structures more functional and attractive, attention was directed to the spaces surrounding them. This created a need for landscape designers, people with the ideas and know-how to design these spaces for maximum efficiency and beauty.

Architecture

Do you live in an apartment house or a private home? Whichever you live in, you are in a building designed by an architect. Architects are artists who design buildings of all kinds, including residences, office buildings, and museums.

The architect works with two major goals in mind. One is to make sure the building does what it was planned to do. The second goal is to make sure the building is pleasing to the eye. How a structure fits in with its surroundings is also a concern.

Architects must know a great deal about building materials. They must also understand how weather and other natural elements act on such materials. Architects are also trained in such matters as ventilation, heating and cooling, and plumbing.

Architects must have a strong background in mathematics and drafting. Most architects today specialize in a particular type of building.

Landscape Architecture

In recent years the role of the landscape architect has been increasingly recognized as very important in making the business and industrial areas of our cities environmentally healthy and aesthetically pleasing. Landscape architects design outdoor areas around buildings. They also create arrangements of shrubs, trees, and flowers for playgrounds, parks, and highways.

Landscape architects work closely with architects and city planners to improve the natural setting. Their goal is to make the setting both easy to maintain and beautiful to look at. Landscape architects work with a number of different materials and landforms. These include flowers, plants, trees, rivers, ponds, walks, benches, and signs.

Some landscape architects work independently. Others work for architectural firms, governmental agencies, or private companies.

Interior Design

Interior designers direct their talents to making our living, working, and playing areas more attractive and useful. They plan and supervise the design and arrangement of building interiors and furnishings. When planning the interior space for a home, they take into account the desires and needs of each family member as they go about selecting furniture, fabrics, floor coverings, lighting fixtures, and accessories. Interior designers also consider the various activities associated with each room in the house when designing attractive and functional areas for eating, sleeping, working, and playing and estimate what the work and furnishings will cost for each.

In order to help their clients visualize their plans, interior designers prepare floor plans and elevations, and make sketches or perspective drawings. After the client approves the plans and the costs, the designer may make arrangements for purchasing the furnishings and supervises the work of painters, carpetlayers, cabinetmakers, and other craftspersons.

No one would deny that people are happier and work more efficiently in surroundings that are pleasant and comfortable. For this reason, interior designers are being called upon in greater numbers than ever before to plan the work spaces for entire office buildings, hospitals, libraries, stores, and even factories. Businesspeople realize that when their employees are comfortable and content their efficiency increases. This in turn leads to lower production costs, which means that the items or services provided by the business will be more competitive. No wonder then that the drab, disagreeable interiors that characterized many of the work spaces of the past are being replaced today with colorful, pleasant places in which to work.

Industrial Design

What do toys, tools, furniture, home appliances, light fixtures, and automobiles have in common? All those items and just about anything else with which you come into contact every day of your life have been carefully designed to function easily and look appealing. Specialists whose job it is to create those designs

are known as industrial designers. These specialists are called upon by manufacturers to work on things as simple as a tamper-proof cap for an aspirin bottle, or as complex as an information-processing system.

The Gadget, for example, owes its modern, streamlined appearance to the efforts of industrial designers who worked closely with the engineers who developed it. Those designers were not satisfied that the Gadget was easy to use and did the job that it was supposed to do. They wanted it to have an eye-catching appearance as well.

To be successful, industrial designers must know about various production processes as well as the characteristics of the different materials used in those processes. Moreover, they must understand completely the function of each product with which they are working. The most successful and profitable products are those in which design and function complement each other.

Education and Research

People with interests in education, scholarship, and the visual arts have discovered that they can combine these interests to prepare for meaningful and exciting careers in a variety of different settings. These settings range from the classroom to hospitals to museums to the mysterious ruins of past civilizations.

Art Education

Many people with an interest in art and a desire to work with children and young people decide to become art teachers (Figure 1.13). These people realize that there can be as much creativity and excitement involved in planning and presenting stimulating art lessons as there is in designing and executing a painting or a sculpture.

A teaching career in art requires a college education that combines a broad background in art materials and techniques with instruction pertaining to child development, learning theory, teaching techniques, and curriculum planning. Effective art teachers are prepared to provide their students with a wide variety of art experiences. Consequently, they offer students opportunities to create their own art forms and to respond to the art forms created by others.

An art teacher's responsibilities are not limited to helping talented students develop their artistic skills. They also include preparing as many students as possible to be intelligent consumers of art. In order to do all of this, art teachers design their programs to include educational experiences in studio, history, aesthetics, and criticism.

Today art teachers can be found working in a variety of settings. While it is true that most teachers continue to be employed in elementary and secondary schools as well as colleges and universities, others work in museums, hospitals, retirement centers, nursery schools, and child-care centers.

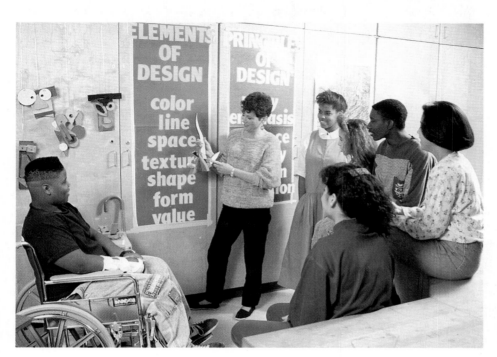

➤ Art students analyze a three-dimensional project to see which elements and principles of art were used.

Figure 1.13 Art Teacher.

Archaeology

Archaeologists study the material remains of past human life. Tombs, sculpture, pottery, tools, weapons, and the foundations of buildings are unearthed to learn how ancient peoples lived (Figure 1.14). These are the clues needed to determine how civilizations began, developed, reached maturity, and disappeared. By enlarging our knowledge of the past, archaeologists give us a better understanding of the present.

Archaeology combines the excitement of a treasure hunt with the painstaking methodical work of the detective. However, only rarely are treasures of gold, jewels, or great works of art found. Most often pot shards, broken fragments of sculpture, or the remains of tools are all that are recoverable. Archaeologists patiently fit together complicated assortments of clues that often offer little more than a glimpse into the distant past. With each new glimpse, however, we gain a better understanding of how people lived in the past.

Art Therapy

Art therapy is a profession that combines interests in the visual arts and mental health. A career in art therapy is especially rewarding for people with the personality and patience needed to work with individuals who have emotional disorders. The therapist uses art as a means of opening the lines of communication with patients. This is done by encouraging patients to discuss freely the meaning or meanings of the images that they create with various art media. Thus art can serve as a way for patients to express their pent-up feelings and emotions. Moreover, patients who project these repressed emotions into images are often able to interpret the meanings of these images for themselves, thereby aiding the efforts of the therapist.

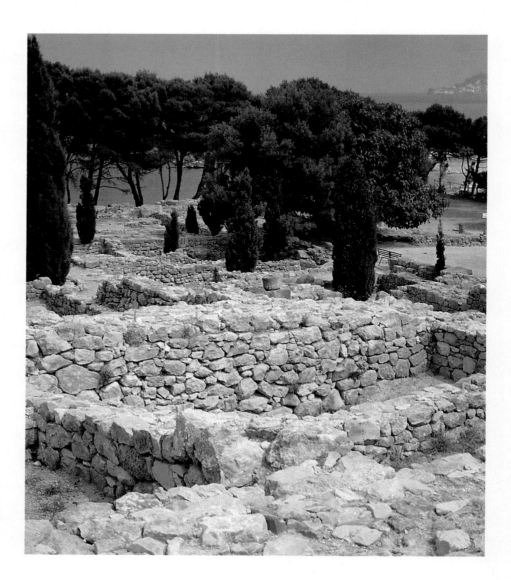

➤ Excavations by archaeologists at Ampurias, Spain, revealed the foundations of two ancient settlements. The first, established by the Greeks, dates back to 600 B.C.

Figure 1.14 Archaeology.

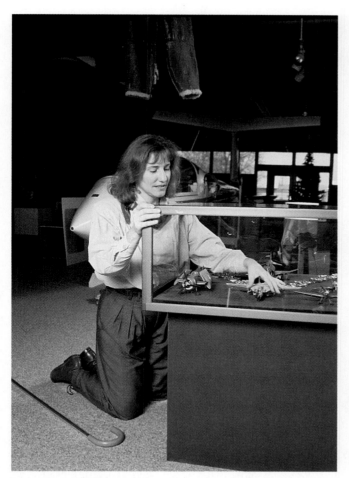

➤ A museum employee draws on a number of skills when arranging displays for public viewing.

Figure 1.15 Museum Science.

Some art therapists work as members of therapeutic teams in psychiatric wards of large hospitals, in clinics, in community health centers, and in prisons. Others are employed at institutions and special schools for students who have emotional disorders or learning disabilities. Therapists also work with individuals who are blind, hearing impaired, or are in some other way physically handicapped.

Museum Science

The basic and traditional tasks of a museum are to acquire, conserve, display, and study art. By doing these things, the museum, like the university and the library, performs the valuable service of passing on to each new generation the rich cultural heritage of the past. Individuals with advanced degrees in art history and museum science, called **curators**, are *responsible for securing and exhibiting artworks* for the general public and scholars to view (Figure 1.15).

Drawing upon their knowledge of human attention, perception, and learning, curators seek to impart specific knowledge as well as teach general ideas. To do this, carefully selected objects are labeled and exhibited in such a way that they teach and inform viewers. Thus, each visitor undergoes an educational experience while walking through the halls of a museum.

However, museum curators are also scholars. As such they carry on research into their own specialized areas of interest. Eventually they report their findings in books, lectures, and papers prepared for publication in scholarly journals.

Of course, modern museums must not limit themselves to the needs of scholars alone. They must also devote themselves to the spread of knowledge to an ever-increasing and interested general public. For this reason, major museums in the United States have set up education departments. Educators within these departments teach *volunteer guides*, known as **docents**, to take groups of adults and children through the museum's exhibitions. These educators are also responsible for preparing various publications, providing lectures, producing radio and television programs, and planning special educational displays and exhibitions. Frequently, too, they are in charge of after-school or Saturday art programs for people of different ages and levels of ability. However, the art programs offered in museums are designed to supplement rather than duplicate the art programs provided in the schools.

Entertainment

The entertainment industry offers a great deal to challenge the imagination and skill of young artists. Highly competitive careers linking the visual arts and entertainment are varied, and the list of these careers is constantly expanding.

Cartooning

The origins of cartooning are unknown, although it is recognized as an ancient art form. Rock-painting examples have been estimated to have been done thousands of years ago. Today, the word "cartoon" is used to identify animated cartoons, comic strips, caricatures, and editorial cartoons.

The animated cartoons that you see in movie theaters and on television are examples of cartoons produced by a team of specialists. Writers, artists, animators, and inkers work together to produce a

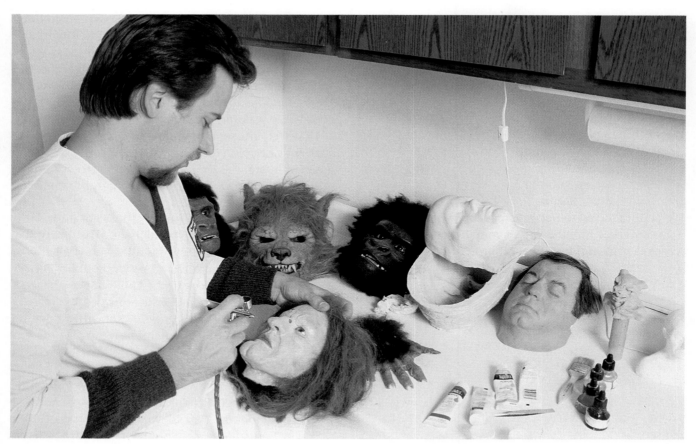

➤ Special effects are created by designers who use many tools and techniques.

Figure 1.16 Special Effects Designer.

series of drawings on sections of clear acetate. These acetate sections are then photographed singly on frames of movie film. When the film is run rapidly through a projector or video machine and projected on a screen, motion is realized.

Comic-strip artists must not only know how to draw, they must be good storytellers as well. Some draw stories for comic books while others illustrate the humorous and adventurous comic strips you read each day in your newspaper.

Caricatures and humorous drawings appear in magazines as illustrations for articles, decorative filler material in various publications, and as advertisements on television and in newspapers. A **caricature** is a *humorous drawing of a person in which a familiar characteristic has been exaggerated.*

Cartoons that humorously express opinions on politics and social issues are known as editorial cartoons. Many of these focus attention on political figures, often depicting them in amusing and sometimes unflattering ways. Not surprisingly, editorial cartoonists are typically experts in the art of caricature.

Special Effects Designer

Are you the sort of person whose imagination works overtime? Then maybe the field of special effects design is for you (Figure 1.16).

Like people in other art careers, special effects designers may need to attend a school with an art department and a film production course as well. Many people who have created film and television magic to date have come up through the ranks. They may have started by building sets for plays or designing film backgrounds. Today, many universities have cinema departments that offer classes in all aspects of film production.

Special effects artists are one part painter, one part sculptor, and one part engineer. They have the ability to imagine, and then create, fantasy scenes or creatures. They are masters of make-believe.

There is no limit to the tools used by special effects designers. Depending on the needs of a project, they might use papier-mâché, plaster, plastic molds, or paint. Makeup, trick photography, and computers are just a few of the other media they use.

Career Directions for the Future

Careers in the fine arts—involving drawing, painting, sculpture, and printmaking—are irresistible to unique kinds of people. These are people willing to ignore the security offered by salaried positions with established businesses and corporations. Financial security is sacrificed in order to devote time and energy to the task of developing and refining the knowledge and skill required to become a successful artist.

The market for fine art in many media and processes is growing, but it is still limited. People do not become fine artists because of the financial rewards. Many find it necessary to take on an additional career to pay the bills. Some choose to teach while others accept commercial assignments. At the same time they continue to focus attention on their own art and search for outlets for their work.

Art galleries accept the work of a limited number of artists for exhibition and sale. Most galleries willingly examine the creative efforts of artists but are only able to accept a few for actual exhibition. In exchange for exhibiting an artist's work, galleries receive a commission on all sales.

There is no guarantee of success in the fine arts, but some of the barriers can be overcome by a genuine commitment to developing your artistic talent to the fullest. Make this commitment as early as possible. Keep a sketchbook to capture the sights you see. The practice of drawing daily will sharpen your skills. Develop a portfolio of ideas, work-in-progress, and finished pieces. You will observe the improvement in the quality of your work over time. Study the artworks of the masters for inspiration as well as to see how they have used various media and expressed their ideas.

The list of art-related careers in this chapter is by no means complete. Furthermore, it is unlikely that any such list could remain complete for very long. Even now, new demands prompted by new technology offer unique career opportunities for people with interests and talent in art. Many of these careers were unheard of just a few years ago. One need look no further than the rapid development and widespread use of computers to see an example of new career opportunities. In the next few years, more and more artist-technicians will be needed to create increasingly sophisticated graphics and animation with computers for a wide range of uses. Their unique creations will go beyond the wildest dreams of even the most imaginative of yesterday's artists.

SECTION TWO

Review

1. Give three examples of advertising that occurred in ancient times.
2. Describe two logos that have been created by graphic designers and are readily recognizable.
3. Name two advantages of using the computer to produce works of art.
4. What are two specialty areas that photojournalists can pursue?
5. List two major goals of an architect.
6. What educational requirements are needed to become an art teacher?
7. Explain the responsibilities of a museum curator.
8. Explain how animated cartoons are produced.
9. Name three media that special effects designers use.

Creative Activities

Studio. Design a poster on careers in the arts using press-on type. Find interesting alphabets and use a variety of type styles for the different careers you include. Plan the arrangement before you start. Try pressing the type for some of your careers on a strip of a different color paper to give interest and variety to your design. Add letter styles of your own design.

Studio. Interview an artist who works in one of the art-related careers mentioned in this chapter. Find out the qualifications and requirements of the job. What advice does the artist give aspiring young artists who are interested in the career field?

Review

Reviewing the Facts

SECTION ONE

1. Define the word *criteria*.
2. What aspect of a work of art is of interest to imitationalists?
3. The design qualities of a work of art are stressed by which aestheticians?
4. What determines success in art?
5. What is the role of an art patron?

SECTION TWO

6. List five art careers to be found in an advertising agency.
7. Describe five responsibilities of a book designer.
8. On what two design aspects would an industrial designer focus attention?
9. Explain how an archaeologist participates in art-related activities.
10. Select a celebrity and tell how you would caricaturize that individual if you were drawing a cartoon.

Thinking Critically

1. ***Compare and contrast.*** You probably know what it means to be literate. Now consider the term *visual literacy*. In a world that is becoming more and more oriented toward computer technology, why do you think becoming visually literate might be to your advantage?

2. ***Extend.*** In this chapter you read that Rembrandt and Vincent van Gogh are among the most highly praised artists in history. Do you have any idea what these artists may have looked like? Do you think that their appearances would have enabled you to identify them as artists if you had been able to meet them?

Find self-portraits of both of these artists. Select one of them and use it to write a *detailed* description of the artist. Then compare your description with those of the same artist written by other members of the class. Which adjectives were used most frequently to describe the artist? Do these adjectives differ from those used by students who chose to describe the other artist?

Using the Time Line

Compare the two artworks identified on either end of the time line. Which of these would you favor if you were an Imitationalist? Which would you prefer if you were a Formalist? Is there another work specified on the time line that would be pleasing to an Emotionalist? Which one? Does this examination of the time line suggest that styles of art tend to change from one period to another?

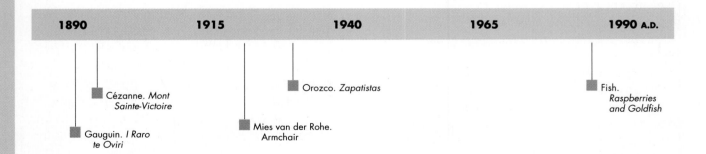

1890	1915	1940	1965	1990 A.D.

Cézanne. *Mont Sainte-Victoire*

Gauguin. *I Raro te Oviri*

Mies van der Rohe. *Armchair*

Orozco. *Zapatistas*

Fish. *Raspberries and Goldfish*

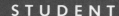

Portfolio

Jennifer Yancy, Age 18
Woodward Academy
College Park, Georgia

Seeing and creatively presenting the unique aspects of an everyday scene is one of the skills every artist works to develop.

Jennifer chose fire escapes as the subject of her photograph. "The linear pattern found on this wall was rich with geometrical qualities. It attracted the eye immediately, so I wanted to share it with others. I had to figure out how to frame and capture the image while effectively bringing out the contrasts."

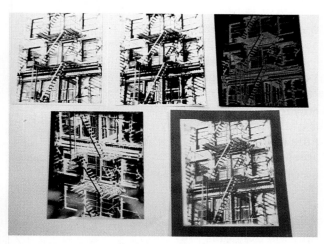

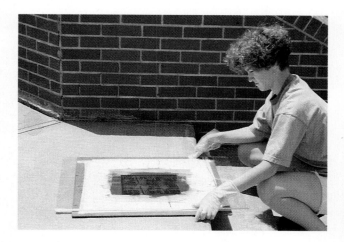

"There are many different possibilities for this photograph. I can do straight black-and-white, high-contrast, or an experimental print." First Jennifer had to develop the film. The next step was to expose the film to the photography paper with the use of the enlarger. "The time the image must be exposed is hard to predict. Therefore it takes a lot of experimenting to get the right exposure."

"I decided to try an experimental, salted print, which creates a totally different picture than the original image. It came out very well. During this project I learned how to take an idea and expand on it, not only in the darkroom but in other art media as well."

Jennifer's advice to other students is, "Don't stick to the traditional processes. Take risks and experiment; try alternative methods of printing."

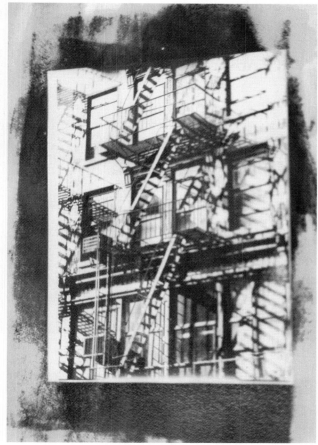

➤ *Fire Escapes.* Photography. 30 x 25 cm (12 x 10").

Learning a Visual Vocabulary

Objectives

After completing this chapter, you will be able to:

➤ Identify the elements of art.

➤ Explain how the principles of art are used to organize the elements of art.

➤ Analyze how successful works of art achieve unity by using the elements and principles of art.

➤ Demonstrate how a Design Chart can be used to identify the elements and principles in a work of art.

➤ Apply the elements and principles of art in a Studio Lesson.

Terms to Know

axis line
balance
color
design
elements of art
emphasis
form
gradation
harmony
intensity
line

movement
principles of art
proportion
rhythm
shape
space
texture
unity
value
variety

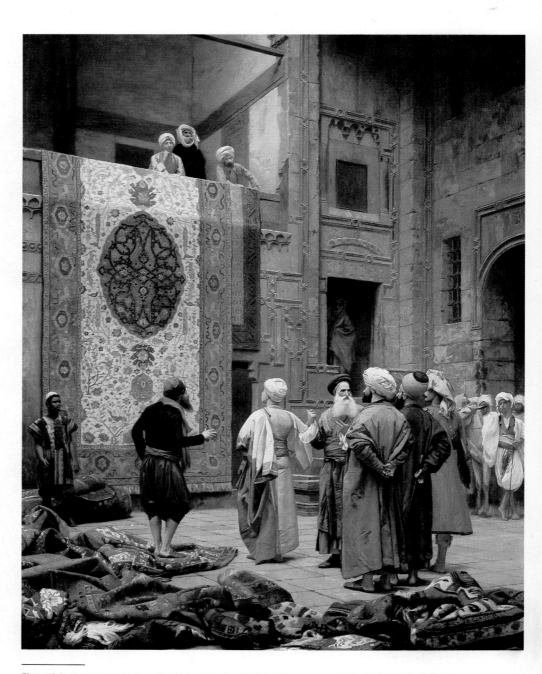

Figure 2.1 Jean-Léon Gérôme. *The Carpet Merchant.* 1887. Oil on canvas. 83.8 x 64.8 cm (33 x 25½"). Minneapolis Institute of Arts, Minneapolis, Minnesota. The William Hood Dunwoody Fund.

When looking at works of art, you see different colors, values, lines,

textures, and shapes. You see countless ways that artists combine and organize these

elements so their ideas and feelings can be communicated and understood by viewers. Looking

at works of art, however, doesn't mean you "see" them. To fully understand a painting, a

sculpture, or a building, you need to understand a visual vocabulary and recognize how

it is used to produce successful works of art.

The Language of Design

Works of art are unique arrangements of the obvious and the not-so-obvious. In order to understand any art object, you must be willing to go beyond the obvious and examine the not-so-obvious as well. To do this, you need to know what to look for. You must understand the language of art. Art uses a language of its own; words that refer to the visual elements (or basic parts) and the principles (the guidelines for putting the parts together).

One of the most important things to look for in works of art is the way those works have been designed, or planned. To do this means you must know what the elements and principles of art are and how they are used to create art objects.

The **elements of art** are *the basic components, or building blocks. They consist of color, value, line, texture, shape, form, and space.* Artists use the elements of art to express their ideas. We are not referring to the media the artist uses, such as paint or clay or stone, but to the *visual vocabulary* used by the artist.

If the elements of art are what artists use to express their ideas, what are the principles of art? The **principles of art** are *the different ways the elements can be used in a work of art. The principles of art consist of balance, emphasis, harmony, variety, gradation, movement, rhythm, and proportion.*

We can make a comparison with writers who must do more than just select words if they are to communicate their ideas to others. The words are similar to the elements of art. How writers organize those words is similar to using the principles of art. Writers form phrases, sentences, and paragraphs. Then they must carefully arrange these into meaningful sequences. After all, a book composed of words haphazardly placed on each page would be of little value to anyone. The words must be organized so that the reader will be able to understand the writer's ideas. Like books, works of art are also organized so that artists' ideas and feelings can be understood by viewers.

Unity in Artworks

When organizing their works of art, artists make use of the principles of balance, emphasis, harmony, variety, gradation, movement, rhythm, and proportion. They select and use these art principles to arrange the elements. In this way, they are able to achieve unity in their works. **Unity** refers to *the look and feel of wholeness or oneness in a work of art.* In works where unity is evident, the elements and principles work together to show harmony and completeness (Figure 2.1). Where unity is lacking, the works may look disorganized, incomplete, or confusing.

You may find it useful to think of unity in terms of a basketball team. When there is team unity, each player works toward a common goal. That goal is to score as many points as possible while preventing the opposing team from scoring. This goal may not be realized if the players act more like individuals than a team. If they are more concerned with their own performances than with the team's performance, their game will suffer. Try to picture such a team playing in your school gym. The players would be running wildly up and down the floor, calling for the ball, shooting at every opportunity, and ignoring their defensive responsibilities. Their confused play would make it easy for a well-organized team to beat them.

Of course, artists have goals too. If a color, a shape, or some other element does not contribute to unity, they will eliminate it or change it in some way. Disorganized basketball teams need to adjust or change their strategy to work well together. Otherwise, they might find themselves playing before a great many empty seats. Likewise, few people are willing to view and respond favorably to disorganized works of art.

Artworks owe much of their uniqueness to the ways artists have used the elements and principles. No doubt you have heard people talk about an artist's "style." More often than not, they are referring to the special way an artist uses the elements and principles to organize a work. Just as there are different styles in writing, there are different ways to achieve unity in painting, sculpture, or architecture.

Some artists place great importance on the use of the elements and principles while creating their art products. They deliberately try out different principles, or ways to use each element. These artists are not satisfied until a certain combination of elements and principles looks right to them. Other artists choose to use the elements of art in a more spontaneous or intuitive manner. They do not make deliberate decisions regarding the principles of art. Rather, these artists instinctively select and organize the art elements in their works. They are satisfied with the unity of the work if it feels right to them. In order to understand what is involved in this process, we will begin by examining the elements of art.

The Elements of Art

Often people looking at works of art stop looking once they have examined the subject matter. They recognize the people, objects, and events shown but pay little attention to the elements of art used in the works. They overlook the fact that a painting is made up of colors, values, lines, textures, shapes, and spaces (Figure 2.2).

In a realistic landscape painting, for example, the art elements are combined to look like trees and hills and fields and sky. While you may admire the realistic scene, you should not limit your attention to the subject matter alone. If you do, you might miss seeing other important and interesting things in the work. For instance, you might miss seeing the elements of art used to create that realistic scene. If the subject matter in a painting is not apparent, you should be prepared to examine what is shown in terms of color, value, line, texture, shape, and space.

Actually, you are already familiar with the elements of art even if you have never taken an art course or read a book about art. Pick up any object and study it for a minute or two. Now, imagine yourself trying to describe the object to a friend over the telephone without naming it. What things would you include in your description? No doubt you would find yourself talking about the object in terms of color, value, line, texture, shape, form, and space. If your comments about these

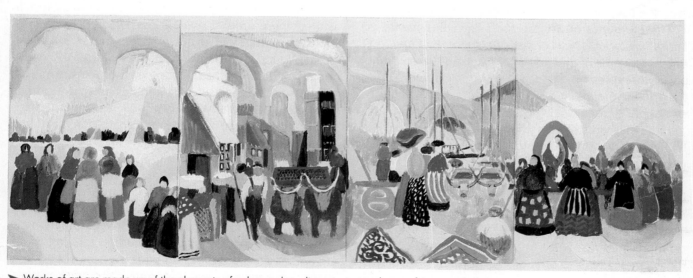

➤ Works of art are made up of the elements of colors, values, lines, textures, shapes, forms, and spaces. Notice how the artist has used the element of color to create shapes in this scene.

Figure 2.2 Sonia Terk Delaunay. *Study for Portugal.* 1937. Gouache on paper. 36.2 x 94 cm (14¼ x 37"). National Museum of Women in the Arts, Washington, D.C. Gift of Wallace and Wilhelmina Holladay.

art elements are clear and detailed, your friend would have a good chance of identifying the object.

Suppose for a moment that you are listening to a description of an object over the telephone. Could you guess what that object is after hearing a description that includes the following list of art elements?

- It has height, width, and depth and occupies actual *space*.
- Abrupt changes in light and dark *values* indicate that it is made up of flat planes at right angles to each other.
- It is a flat, three-dimensional *form* with six sides.
- It is rectangular in *shape* when viewed directly from any side or from the top or bottom.
- Three sides are a rich, leather-brown *color*; the remaining three sides are white.
- Three sides are hard and smooth in *texture*; this contrasts with the fine ridged texture of the remaining three sides.
- The three sides with the ridged texture are made up of a series of thin, parallel *lines*.

Did you correctly identify the object as a book? It is unlikely that you guessed that it was an umbrella, or a shoe, or a tennis racquet even though those items also contain the art elements of color, value, line, texture, shape, form, and space. However, those items are distinguished by having *different* colors, values, lines, textures, shapes, forms, and spaces.

There is always a problem of interpretation with any language, and this seems to be especially true with regard to a visual language. When you use the term *line*, for example, you will want to be sure that the person to whom you are talking has the same understanding of the term as you do. If this bond of understanding is missing, confusion will occur. In order to avoid this, each of the elements of art will be examined and defined in this chapter.

Color

Color is *an element which is made up of three distinct qualities: hue, intensity, and value.* When talking about a color or the differences between two or more colors, you can refer to any one or all of these qualities.

Hue

Hue refers to the name of a color. The term is used to point out the difference between a blue and a

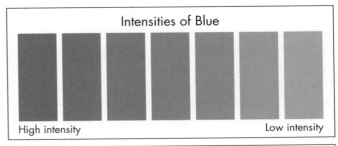

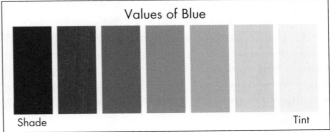

Figure 2.3 *Value and Intensity Scales*

green, or a red and a yellow. Imagine that you have gone into a department store and have asked to see a selection of blue sweaters. You would not expect the salesperson to return with several yellow sweaters. The name "blue" should be enough of a color description for the salesperson to know what color you have in mind. Examples of twelve different hues are shown in the Color Wheel on page 28.

Intensity

Now assume for a moment that while checking the store's stock of sweaters, the salesperson discovers that there is a variety of blue sweaters in your size. Some seem to be brighter, purer blues than others. These could be described as the "bluest blues." This is called a color's **intensity**, or *quality of brightness and purity*. When a hue is strong and bright, it is said to be high in intensity. When that same color is faint and dull, it is said to be low in intensity. Perhaps the salesperson brings a selection of blue sweaters out for you to see. Unsure which you like best, you arrange them on the counter in a row, from the brightest to the dullest. Your arrangement would reveal the differences in color intensity. All the sweaters on the counter would be blue, but some would appear to be more blue, or higher in intensity. Others would be less vivid. In fact, it might even be difficult to call them blue because they would be nearly neutral. These would be referred to as being low in intensity. The differences in color intensity of these sweaters might resemble the range of intensities shown in Figure 2.3.

Value in Color

The salesperson now brings out more blue sweaters. Some of these sweaters are darker and some are lighter than those you have just seen. You arrange this second group of sweaters in a row from darkest to lightest. Your awareness of the lightness and darkness of the blues would mean that you have recognized the differences in their values. When describing a hue, the term **value** refers to *that hue's lightness or darkness*. Value changes are often obtained by adding black or white to a particular hue. The *value* chart on page 27 shows the range of dark and light values created when various amounts of black and white were added to blue. The differences in color value that you found in the sweaters might resemble the range of color values shown in this chart.

The Color Wheel

An understanding of color is aided by the use of a Color Wheel (Figure 2.4). Notice, first of all, the three *primary colors:* red, yellow, and blue. These are called primary colors because they can be mixed to make all the other colors, but they cannot be made by mixing other colors.

The *secondary colors* are orange, green, and violet and are located midway between the primary colors on the wheel. Each of the secondary colors is made by mixing two primary colors. Orange is made by mixing red and yellow; green, by mixing blue and yellow; and violet, by mixing blue and red. Adding more red to the combination of red and yellow will produce a red-orange. Adding more yellow will produce a yellow-orange. Red-orange and yellow-orange

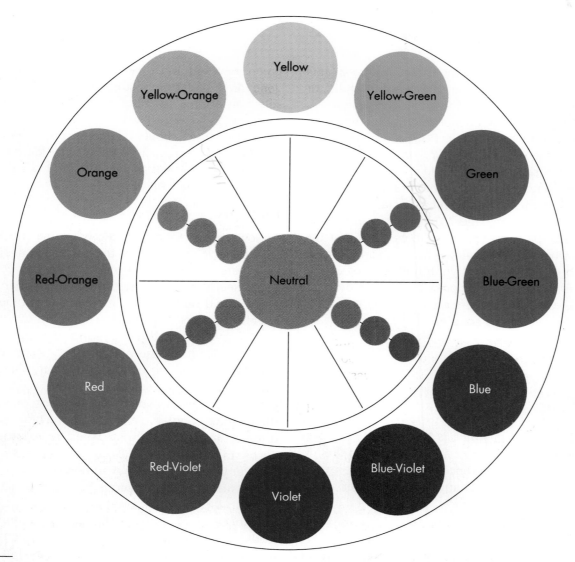

Figure 2.4 Color Wheel

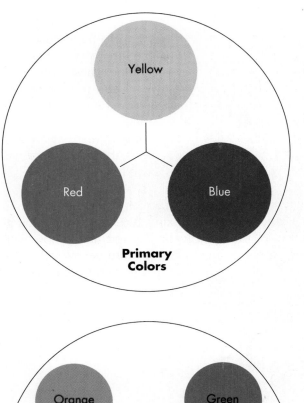

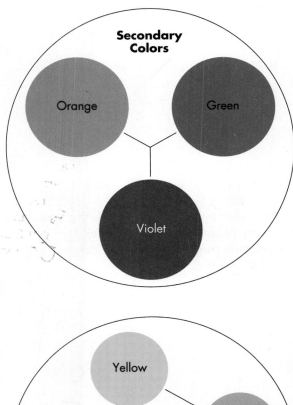

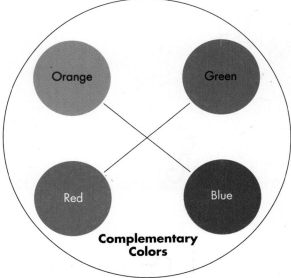

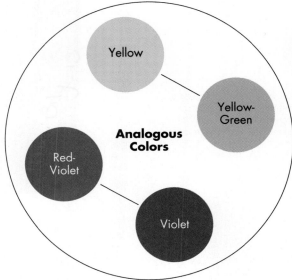

are examples of *intermediate colors.* By varying the amounts of the two primary colors used, it is possible to create a number of these intermediate hues, or *tertiary colors*. Both terms, *intermediate* and *tertiary*, refer to the colors found between the primary and secondary colors.

Colors that are opposite each other on the color wheel are called *complementary colors*. Thus, red and green are complementary colors. However, these hues are opposites in a more fundamental way: there is no green hue at all in red and no red in green. You can say then that no other color in the wheel is as different from green as red.

When two complements are mixed in equal portions, they will cancel each other out to form a neutral gray tone. The addition of only a small amount of a hue's complement will lower its intensity. In other words, a green can be made to look less green—and move by degrees closer and closer to a neutral tone—by the addition of its complement, red.

Colors that are next to each other on the color wheel and are closely related are called *analogous colors*. Examples of analogous colors are blue, blue-green, and green.

The terms *warm* and *cool* are applied to certain colors on the color wheel. *Cool colors* are those often associated with water and sky and suggest coolness. These are the colors that contain blue and green and appear on one side of the color wheel opposite the warm colors. *Warm colors* are often associated with

➤ Notice how the lines of color in this painting create a surface that seems to have a life of its own. It reaches out to stimulate and perhaps even disturb you.

Figure 2.5 Bridget Riley. *Entice 2.* 1974. Acrylic on canvas. 154.3 x 137.5 cm (60¾ x 54⅛"). Sidney Janis Gallery, New York, New York.

fire and sun and suggest warmth. These are colors that contain red and yellow and appear on one side of the color wheel opposite the cool colors. Cool colors appear to recede into the background, while warm colors seem to advance.

Over the centuries, artists have used color in many different ways. Some have tried to reproduce exactly the colors of the objects they have painted. Others have freely changed colors in order to emphasize a certain feeling or mood. Bridget Riley, a contemporary British artist, creates works that are composed of completely unexpected changes in color (Figure 2.5). Sometimes these color changes are sudden, sometimes gradual, but they are found everywhere in her paintings. If you look into one of her pictures long enough, you will find that your eye begins to wander over the waving lines of color. Eventually the surface seems to rise and fall, and you find it difficult to think of the painting as flat and still.

Value

There are times when *value* is found to be an important element in works of art even though color appears to be absent. This is certainly the case with drawings, woodcuts, lithographs, and photographs. It is just as true with most sculpture and architecture. Abrupt or gradual changes in value can add greatly to the visual effect of these art forms. Abrupt value changes can suggest planes at various angles to each other. Gradual value changes can indicate concave or convex surfaces. However, they can do more than this. Changes in value can also be used to help the artist express an idea. Imogen Cunningham, who specialized in portraits of famous celebrities, also took photographs of her plants and flowers. Notice how she used gentle changes in value to capture the personality of a flower (Figure 2.6).

➤ Notice how the photographer captured the essence of a blossom's form by using strong value contrast.

Figure 2.6 Imogen Cunningham. *Magnolia Flower.* 1925. Photograph. 25.1 x 32.5 cm (9⅘ x 12¾"). Denver Art Museum, Denver, Colorado.

SECTION ONE

Review

1. List the seven elements of art.
2. What are the principles of art?
3. Name the three qualities that make up color.
4. What adjectives could be used to describe a hue that is high in intensity? Which ones describe a hue that is low in intensity?
5. How can value changes in color be obtained?
6. List the three primary colors.
7. Explain how intermediate colors are produced.
8. What are colors called that are opposite each other on a color wheel?
9. Give an example of an analogous color scheme.

Creative Activity

Humanities. Colors can be described as warm, cool, intense, quiet, or harsh, depending on the color qualities of *hue, value,* and *intensity.* Likewise, sounds produced by musical instruments can be described by qualities of:

- pitch — the height or depth of a sound;
- timbre — the tone color or resonance of the sound; and
- volume — loudness or softness of the sound.

Working with a partner, listen to musical instruments and try to find sound qualities that compare to cool blue, intense red, dark brown.

The Elements of Line, Texture, Shape, Form, and Space

Line, texture, shape, form, and space join color and value (apart from color) to make up the list of art elements artists draw upon when creating works of art. In many works, and especially in painting, color is the most obvious and dramatic of these art elements, but this does not in any way minimize the importance of any of the others. All are important, and their prominence or lack of prominence in a particular work of art is dependent upon the objectives of the artist.

Line

Line is an element that is difficult to describe. However, most people know what it is and can easily think of several ways to make it. Perhaps the simplest way to describe **line** is to say that it is *a continuous mark made on some surface by a moving point*. The marks made by a ballpoint pen moving across a sheet of paper are lines. So are the marks made on canvas by a moving paintbrush, or the marks made by the sculptor's finger moving across a clay surface.

Using Line

Artists use several different types of line in their works to identify and describe objects and their movements and directions. Different effects are created through use of these different types of line.

Emphasizing line. One type of line shows the edges or contours of an object. This is called a *contour line*. Such a line is familiar to anyone who has tried to draw. It is, in fact, one of the most common forms of line used by children. When children pick up pencils or crayons to make their first marks on paper, they use line to show figures, houses, trees, and flowers. Usually, children draw these objects in outline form. That is to say, they draw the edges of the objects.

Artists often use contour lines in much the same way to identify and describe different objects in their drawings and paintings. They do this even though they know that these outlines are not actually a part of the

real object. However, the contour line helps to identify the object in a work. The contour line separates the object from the background and from other objects in the same work.

You will find that some artists place great importance on contours or outlines. They use them as a way of adding interest or unity to their paintings. The works created by such artists are frequently called *linear*. Notice, for example, how the French artist Marie Laurencin (law-rahn-**san**) used black outlines to add clarity and interest to her portrait of the woman wearing a hat (Figure 2.7). Because of these outlines, every area is clearly defined and stands out on its own. More important, the black outlines add a decorative accent that increases the picture's appeal.

De-emphasizing line. Of course, not all artists emphasize line in their work. Some even try to eliminate or hide the outline of objects in their pictures. The term *painterly* is used when describing works by these artists. Claude Monet (kload moh-**nay**) was such an artist, and you can see why when you look at his painting of haystacks (Figure 21.17, page 497).

▶ Do the black outlines help define the shapes in this portrait? Would the painting have had the same impact without the use of these lines?

Figure 2.7 Marie Laurencin. *Woman with Hat (Femme au Chapeau)*. 1911. Oil on canvas. 35 x 26 cm (13¾ x 10¼"). The Museum of Fine Arts, Houston, Texas. The John A. Jones and Audrey Jones Beck Collection.

Monet was interested in recording the fleeting effect of light playing on the various surfaces of objects. In order to do this, he used short brushstrokes to create a shimmering effect in which the contour lines seem to disappear.

Lines used in sculpture. *Linear* and *painterly* are not terms reserved only for discussions about paintings. They are also applied to sculptures. Henry Moore was interested in using a continuous flowing contour line in his sculpture of a standing figure (Figure 2.8).

It is usually inappropriate to attach labels to artists and their works. However, terms like *linear* and *painterly* can help you see more clearly a quality found in works of art. Thus, when told that a painting or sculpture is linear, you know immediately that the element of line has been stressed. The word *linear* produces a mental image that is quite different from the image that comes to mind when a work of art is described as painterly.

Lines suggesting movement. In addition to defining and describing objects in works of art, line can also serve to suggest movement in some direction. This movement could be horizontal, vertical, diagonal, or curved. Certain feelings or sensations are associated with each of these movements. *Vertical*, or straight up and down, suggests strength and stability. *Horizontal*, or from side to side, suggests calmness. *Diagonal* suggests tension. *Curved* suggests flowing movement. Sometimes the feelings suggested by the lines in a picture can influence your reactions to it. The lines in one picture may help you feel calm and relaxed (Figure 21.11, page 491), while the lines in another may create a tense and uneasy feeling (Figure 19.9, page 437).

An **axis line,** *an imaginary line that is traced through an object or several objects in a picture*, can be helpful when you are trying to determine movement and the direction of movement in a work of art. It can show you if the object or objects have been organized in a particular direction. For example, examine the painting by Jacob Lawrence in Figure 2.9, page 34. Use your finger to trace the movement and direction of the three sailors trudging up the gang-

➤ Describe the movement of your finger if you could trace around this sculpture. Would it change direction suddenly, or travel in a smooth, flowing manner?

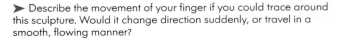

Figure 2.8 Henry Moore. *Large Interior Form.* 1953, cast 1981. Bronze. 5 x 1.4 x 1.4 m (195 x 56¼ x 56¼"). Nelson-Atkins Museum, Kansas City, Missouri. On long-term loan from the Hall Family Foundations.

plank of their ship. Notice how your finger moves upward in a diagonal direction from the lower left-hand corner to the upper right-hand corner of this painting. The axis line is the line that would have been made if your finger had left a mark on the picture as it moved along this strong diagonal. You should remember that the axis line is not a real line that can actually be seen in a work of art. Rather, it is an imaginary line that you invent and use visually to trace the direction of movement in a work.

Some artworks make use of a single axis line; others make use of several. When more than one is found, you should determine how these relate to one another. For example, in Sandro Botticelli's (**sand**-roh-**bought**-ee-**chel**-lee) painting of *The Adoration of the Magi* (Figure 2.10), four axis lines are combined to

➤ How do the contour lines help to emphasize the strong diagonal movement of these figures?

Figure 2.9 Jacob Lawrence. *War Series: Another Patrol.* 1946. Egg tempera on composition board. 40.6 x 50.8 cm (16 x 20"). Collection of Whitney Museum of American Art, New York, New York. Gift of Mr. and Mrs. Roy R. Neuberger.

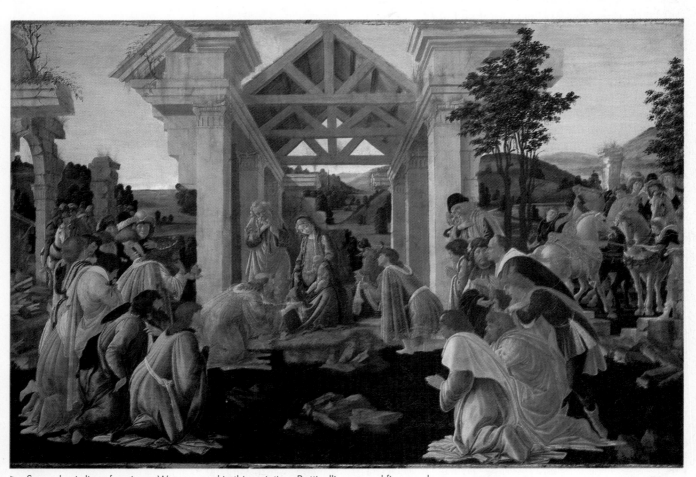

➤ Several axis lines forming a W were used in this painting. Botticelli arranged figures along these lines and placed the most important figures in the center of the W.

Figure 2.10 Sandro Botticelli. *The Adoration of the Magi.* c. 1481–82. Tempera on wood. Approx. 70.1 x 104.1 cm (27⅝ x 41"). National Gallery of Art, Washington, D.C. Andrew W. Mellon Collection.

form a large W. Can you find it? Why do you suppose the artist arranged his composition in this manner? The answer becomes obvious when you find that the most important figures in this painting are placed at the point in the center of this W. It is at that point that the Christ Child and his mother, the Madonna, are located. Even though they are not the largest figures in the picture, they are the most important. Botticelli has skillfully arranged his lines to guide your eye.

Axis lines can be just as important in sculpture and architecture as they are in painting. They can help you recognize the rigid, vertical pose of one sculpture (Figure 8.17, page 175) or the active, twisting pose of another (Figure 8.18, page 176). Axis lines can also help you define the vertical emphasis of one building or the horizontal emphasis of another.

Texture

Whenever you talk about the surface quality or "feel" of an object, you are referring to its texture. **Texture** is *the element of art that refers to the way things feel, or look as if they might feel if touched*. In painting, some works have an overall smooth surface in which even the marks of the paintbrush have been carefully concealed by the artist. There are no textural "barriers" or "distractions" to get in the way as your eyes sweep over the smooth, glossy surface. Other paintings have a more uneven surface. This occurs where a heavy application of paint has been used to produce a rough texture that you sense with your eyes and could feel with your fingers. Both types of

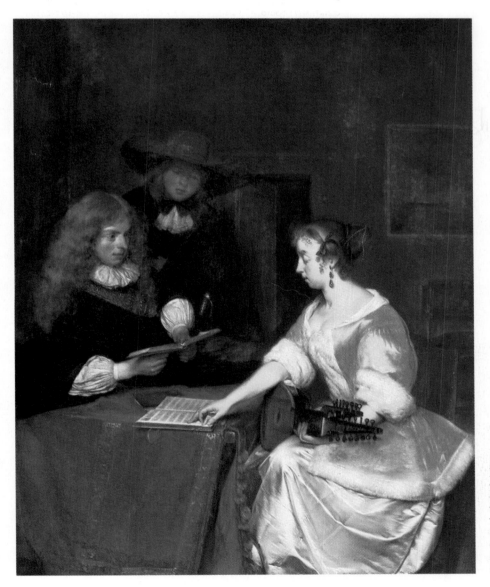

➤ How many different textures has the artist used in this painting? What other elements of art have been used to give variety to the many surfaces?

Figure 2.11 Gerard Ter Borch. *A Music Party.* c. 1675. Oil on wood panel. 58.1 x 47.6 cm (23 x 19"). Cincinnati Art Museum, Cincinnati, Ohio. Bequest of Mary E. Emery.

painting are examples of actual texture because you could actually feel the smooth or rough surfaces.

However, there are many paintings where the surface is smooth to the touch but the sensation of different textures is suggested by the way the artist painted some areas. In a painting entitled *A Music Party* (Figure 2.11, page 35), the artist, Gerard Ter Borch, obviously delighted in painting as accurately as possible a range of different textures. There is a distinctive "feel" to the smooth silk of the women's dresses. Still other textures are shown in the crimped hair and rough plaster of the walls. Yet if you were to pass your fingers lightly over this painting, you would find that it is smooth all over. When artists try to make different objects in their pictures appear rough or smooth, they are using simulated texture.

Because three-dimensional forms seem to invite touch, texture is especially important to sculptors. They recognize the urge to touch a sculptured surface and often encourage this by providing rich textural effects. José de Creeft creates obvious contrasts in rough and smooth textures in his sculpture of *The Cloud* (Figure 2.12). These different textures are emphasized by the effect of light playing across the surface of the work. In this way, de Creeft has added variety as well as increased textural interest.

Sculptors must not overlook the natural textural qualities of the materials they choose to work with. They know that wood, marble, and bronze all have unique textural qualities of their own. It is necessary to keep this textural quality in mind when they choose the material for a particular work.

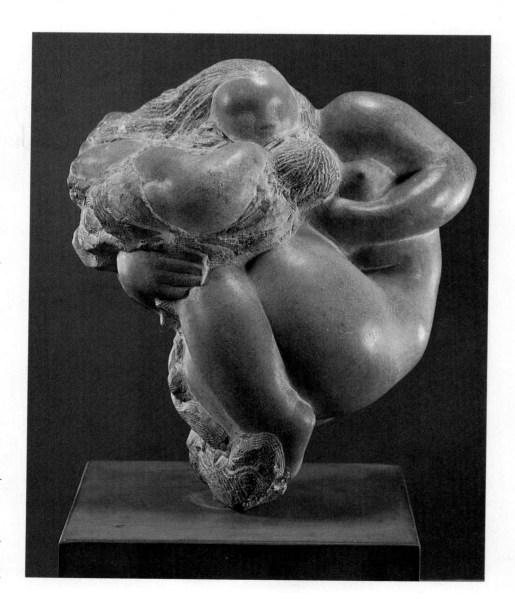

➤ Notice how light emphasizes the textures in this three-dimensional piece. What other element of art has been used to provide variety?

Figure 2.12 José de Creeft. *The Cloud.* 1939. Greenstone. 42.5 x 31.4 x 25.4 cm (16¾ x 12⅜ x 10"). Collection of Whitney Museum of American Art, New York, New York. Purchase.

Shape and Form

The term **shape** refers to *an area clearly set off by one or more of the other visual elements such as color, value, line, texture, and space*. Shapes are flat. They are limited to only two dimensions: height and width. This two-dimensional character of shape distinguishes it from form, which has depth as well as height and width. Thus, a **form** is *an object with three dimensions*.

Shapes can be created deliberately in drawing and painting by joining a single continuous line or several lines to enclose an area. For example, when two parallel horizontal lines are joined to two parallel vertical lines, a square or rectangular shape is made.

Usually, when trying to visualize a shape, the first thing that comes to mind is an area surrounded by lines. Yet line is not always needed to create shapes. Many shapes are formed in a more indirect manner without the aid of lines. When an artist paints an area of a picture with a particular color, a shape is created. When an area is isolated by making it texturally different from its surroundings, a shape is also created.

Many painters have tried to create the illusion of solid, three-dimensional objects in their works. Frequently, the look of solidity and depth is achieved by painting shapes with light and dark values. For example, a circular shape can be made to look three-dimensional by gradually changing its value from light to dark. This technique can be used to reproduce the effect of light on the surface of a round object. When combined with a dark shadow cast by the round object, the desired three-dimensional effect is realized (Figure 2.13).

A form can be thought of as a shape in three dimensions since it possesses the added dimension of depth. You cannot actually feel around a shape in a painting, but you are able to do so with the forms found in sculpture and architecture.

Two important features of form are *mass* and *volume*. Mass refers to the outside size and bulk of a form, while volume refers to the space within a form.

When discussing the *mass* of a sculpture or building, the vocabulary of solid geometry is used. This allows you to describe more clearly a three-dimensional work as resembling a cube, a sphere, a pyramid, a cylinder, or a cone. However, this does not mean that a sculpture or a building must be solid. You can also describe a contemporary sculpture made of transparent plastic and wire as having mass and resembling a sphere, cylinder, or cone.

The term *volume* is used during discussions of interior space. In architecture, volume refers to the space within a building. This inside space is determined by the exterior mass of the building. You should not limit your concern for volume, however, to buildings alone. You can also refer to the volumes that are created between and within sculptural masses.

Occasionally it is convenient to describe a sculpture or a building in terms of its shape as well as its form. This is done when you are concerned with the two-dimensional outline or silhouette of a sculpture or building seen from a fixed position. In this way, a sculpture may be found to offer several interesting shapes as you walk around it and view it from different angles. Similarly, a building that looks small and square when viewed directly from the front might prove to be very large and rectangular when viewed from one side.

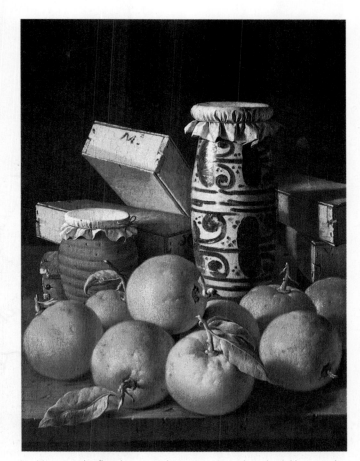

➤ How are the flat shapes in this painting made to look like round, three-dimensional forms?

Figure 2.13 Luis Meléndez. *Still Life with Oranges, Jars, and Boxes of Sweets.* c. 1760–65. Oil on canvas. 48.2 x 35.3 cm (19 x 13⅞"). Kimbell Art Museum, Fort Worth, Texas.

Space

Space can be thought of as *the distance or area between, around, above, below, or within things*. In art, space is an element that can be described as being either three-dimensional or two-dimensional.

Space that is three-dimensional is recognized as having height, width, and depth. Three-dimensional space is known as *actual* space. It is the type of space found in art forms that are themselves three-dimensional. This would include, for instance, sculpture, ceramics, and architecture. For example, when studying José de

Creeft's sculpture of *The Cloud* (Figure 2.12) in its museum setting, the viewer can move about freely in the space that surrounds the sculpture. Only then can the viewer see the way this work changes when viewed from different positions. It offers not only different shapes, but different images and meanings as well. From one angle the sculpture resembles a cloud. From another, it changes to look like a woman, and from a third, it appears to be a mother and child. Certainly an understanding of this sculpture would be incomplete if a viewer insisted on examining it from a single point of view rather than walking completely around it.

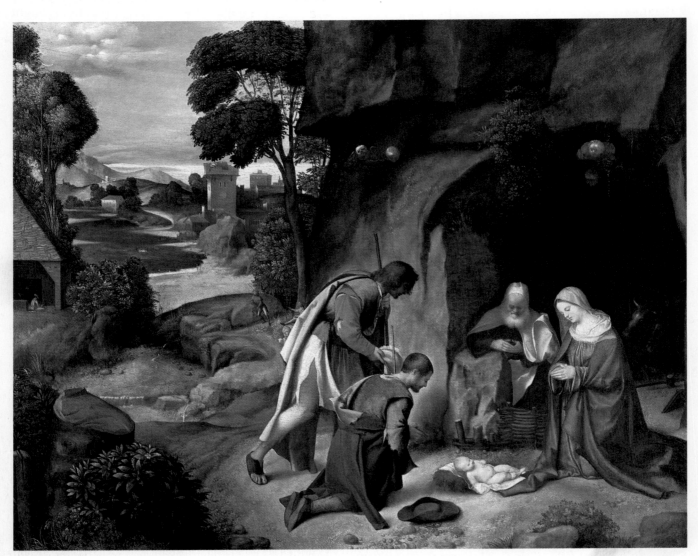

➤ Of course this painting is flat, but does it look flat? How is the illusion of space created? What has the artist used to carry your eye back to the distant hills? How are the hills made to look as if they are far off in the distance?

Figure 2.14 Giorgione. *The Adoration of the Shepherds*. c. 1505–10. Oil on wood. Approx. 0.9 x 1.1 m (35¾ x 43½"). National Gallery of Art, Washington, D.C. Samuel H. Kress Collection.

As noted earlier during the discussion on volume, architecture too is concerned with three-dimensional space. In fact, architecture is an art form devoted to the enclosure of space. To truly appreciate this art form, you must carefully consider the way in which space is treated in different structures.

Unlike three-dimensional works of art, the space in flat, two-dimensional works is limited to height and width. There is no actual depth or distance in such works. However, artists have devised several techniques to create the illusion of depth or distance on flat or nearly flat surfaces. These include the following:

- Overlapping the shapes in a work.
- Making distant shapes smaller and closer shapes larger.
- Placing distant shapes higher and closer shapes lower in the picture.
- Using less detail on distant shapes and greater detail on closer shapes.
- Using duller, less intense hues for shapes in the distance.
- Coloring distant shapes with hues that appear more blue to suggest the layers of atmosphere between the viewer and those shapes.
- Slanting the horizontal lines of shapes (buildings and other objects) to make them appear to extend back into space.

Many of these techniques were used by Giorgione (jor-**joh**-nay) when he painted his *Adoration of the Shepherds* (Figure 2.14). With these techniques, the flatness of the picture plane seems to be destroyed. The viewer is transported into what appears to be a world of actual space, atmosphere, and three-dimensional forms. Giorgione's picture may be an illusion, but it is a very convincing illusion.

Working with the Elements

Typically, artists are faced with the challenge of considering several elements with each step taken in creating a work of art. They cannot, for example, work effectively with color without considering other elements. They must realize that the selection and application of one hue in one part of a painting will have an impact upon the hues, shapes, lines, and textures used in other parts of the work. Some artists respond to this challenge in a deliberate, thoughtful manner, while others are more spontaneous and intuitive. It will be important for you to understand and appreciate the different ways in which different artists respond to this challenge. To do this, you will need to be familiar with the elements of art and understand how the principles of art are used.

SECTION TWO

Review

1. Define line.
2. Name the type of line used to show the edges of an object.
3. How can line be used to suggest movement in a work of art?
4. What is the benefit of identifying the axis line in a work of art?
5. What element of art refers to the surface quality or "feel" of an object?
6. What is the difference between shape and form?
7. Tell how mass and volume are used to describe form.
8. Name four ways that artists can use to create the illusion of depth in a two-dimensional work of art.

Creative Activity

Studio. Pen and ink, brush, charcoal, pencil, and crayon are just a few of the drawing media and tools that can be used to create a wide range of line possibilities. Experiment with a variety of media and tools including cardboard edges, twigs, pipe cleaners, and so forth. Divide into small groups, and discuss the line qualities and potential for expression of each of your resulting lines. Look at *War Series: Another Patrol* (Figure 2.9, page 34) to see how Jacob Lawrence used line to emphasize the movement of the figures.

The Principles of Art

Artists "design" their works by controlling and ordering in some way the elements of art. When trying to combine these different elements into an organized whole, they use certain principles or guidelines. These principles of art are balance, emphasis, harmony, variety, gradation, movement, rhythm, and proportion. *A skillful blend of elements and principles results in a unified* **design**, a design in which all the parts hold together to produce the best possible effect. Without this overall principle of unity, the work would "fall apart," or appear less successful to the viewer.

The principles of art then describe the different ways artists can use each element. When artists add the element of shape to their paintings, for example, they deliberately or instinctively decide how this element will be used. The placement of certain shapes in the right places might help balance the picture, or a combination of large and small, light and dark shapes could be used to add variety to a composition. Some shapes might also be repeated in a way that suggests movement or rhythm in the picture. A decision might be made to include a series of shapes that change gradually, or in a gradation from round to angular. An angular shape might be placed in the midst of many round shapes, a contrast which would create emphasis. The difference in proportion between a large, important shape and smaller, less important shapes helps to highlight that importance. When working with shape, or any other element, artists seek variety without chaos, harmony without monotony.

The elements must fit together and work together to make a complete and unified whole.

In order to understand works of art, you will need to know how the principles of art are used. You will use this knowledge whether you are examining works created by artists who deliberately use a variety of art principles, or by artists who create by instinct. Learning the principles will help you recognize and enjoy one of the most fascinating things about works of art: how they are put together.

The following principles should help you determine how the elements of art can be used to produce art. Remember, each of these principles describes a unique way of combining or joining elements to achieve different effects.

Balance

Balance refers to *a way of combining elements to add a feeling of equilibrium or stability* to a work of art. Balance can be of three kinds: symmetrical, asymmetrical, or radial.

Symmetrical balance means a formal balance in which two halves of a work are identical; one half mirrors exactly the other half (Figure 2.15). This is the simplest kind of balance.

Asymmetrical balance is more informal and takes into account such qualities as hue, intensity, and value in addition to size and shape. All these qualities have an effect on the apparent weight of objects in a work of art. It is possible to balance a large white shape at one side of a picture with a similar large white shape at the other side. However, a smaller dark

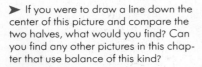

➤ If you were to draw a line down the center of this picture and compare the two halves, what would you find? Can you find any other pictures in this chapter that use balance of this kind?

Figure 2.15 Ad Reinhardt. *Red Painting.* 1952. Oil on canvas. 198.1 x 365.8 cm (78 x 144"). The Metropolitan Museum of Art, New York, New York. Arthur Hoppock Hearn Fund, 1968.

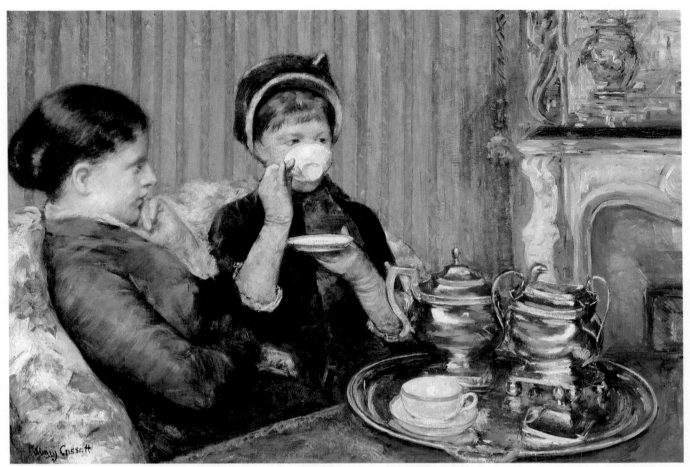

➤ What is used to balance the weight of the woman at the far left of this picture? Do you think the "felt" balance found here is more, or less, interesting than the symmetrical balance noted in *Red Painting* by Ad Reinhardt?

Figure 2.16 Mary Cassatt. *Five O'Clock Tea.* c. 1880. Oil on canvas. 64.8 x 92.7 cm (25½ x 36½"). Museum of Fine Arts, Boston, Massachusetts. M. Theresa B. Hopkins Fund.

shape may accomplish the same result. The result is a "felt" balance. The dark value of the smaller shape makes it appear heavier and equal to the task of balancing the larger white shape (Figure 2.16).

Radial balance occurs when objects are positioned around a central point. The petals of a daisy radiating from the center of the flower is a good example. Notice how the stained-glass window (Figure 2.17) was designed using radial balance.

Emphasis

Emphasis, *or contrast,* is *a way of combining elements to stress the differences between those elements.* Often, contrasting elements are used to direct and focus the viewer's attention on the most important

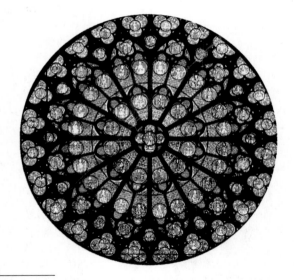

Figure 2.17 Stained-glass window. Notre Dame Cathedral, Paris, France. 1153–1260.

> ➤ In what ways do the shapes contrast in this painting? Can you find contrasts of hue and line as well?

Figure 2.18 Georgia Mills Jessup. *Downtown.* 1967. Oil on canvas. 111.8 x 120 cm (44 x 48"). The National Museum of Women in the Arts, Washington, D.C. Gift of Savanna M. Clark.

parts of a design. Artists try to avoid making works of art in which the same colors, values, lines, shapes, forms, textures, and space relationships are used over and over again. They know that such works may be monotonous and uninteresting. To avoid this, they introduce obvious contrasts that establish centers of interest in their works. In *Downtown* (Figure 2.18), Georgia Mills Jessup creates a center of interest by painting a compact collection of vertical, abstract shapes to represent the crowds of people found in a busy downtown area at night. Around the edges she uses larger shapes that are brighter and more loosely defined. The contrast between both the colors and the shapes gives the scene vitality. Try to imagine how this picture would look without these contrasts. If they were missing, the picture would lack a great deal of visual interest and it is unlikely that it would hold your attention very long.

Harmony

Harmony refers to *a way of combining similar elements in an artwork to accent their similarities.* It is accomplished through the use of repetitions and subtle, gradual changes. Complex, intricate relationships are avoided in favor of a more uncomplicated, uni-

form appearance. Often, a limited number of like elements is used in an effort to tie the picture parts together into a harmonious whole. This is certainly evident in Fritz Glarner's work entitled *Relational Painting* (Figure 2.19). Notice how similar colors, shapes, and values are repeated throughout the painting in an effort to emphasize the overall unity of the picture surface.

Variety

Variety is *a way of combining elements in involved ways to create intricate and complicated relationships. It is achieved through diversity and change.* Artists turn to this principle when they want to increase the visual interest of their works. A picture made up of many different hues, values, lines, textures, and shapes would be described as complex (Figure 2.20).

A carefully determined blend of harmony and variety is essential to the success of almost any work of

> ➤ Can you find any shapes in this work that are *not* rectangular? Name the hues. What is this group of three hues called?

Figure 2.19 Fritz Glarner. *Relational Painting.* 1949–51. Oil on canvas. 165.1 x 132.1 cm (65 x 52"). Collection of Whitney Museum of American Art, New York, New York. Purchase.

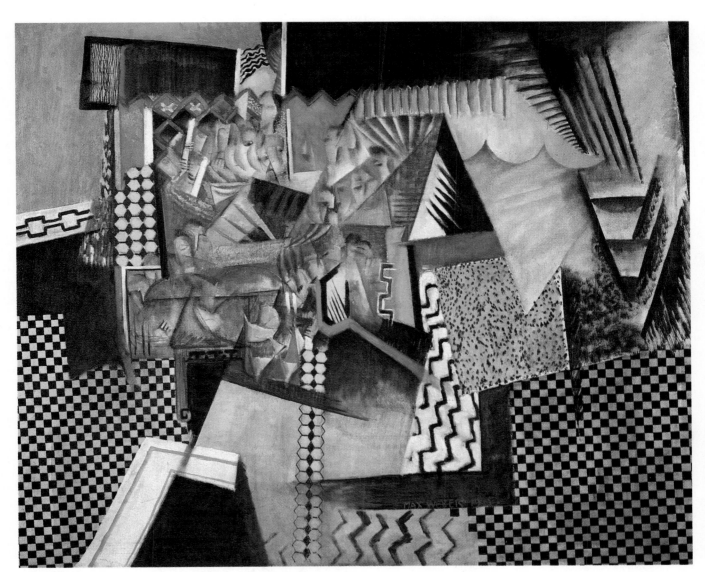

➤ Describe the shapes in this work. Are they rounded, angular, or a combination of both? Do the hues differ in value and intensity? How many different textures can you count?

Figure 2.20 Max Weber. *Chinese Restaurant.* 1915. Oil on canvas. 101.6 x 121.9 cm (40 x 48"). Collection of Whitney Museum of American Art, New York, New York. Purchase.

art. Artists who concentrate on harmony but ignore variety may find it easier to achieve balance, but do so at the expense of interest. Their finished works may look static and lifeless. On the other hand, artists who overlook harmony in their quest for variety may find that their works are too complex and confusing to viewers.

Both harmony and variety must be taken into account during the creative process. Harmony aids efforts to blend the picture parts together to form a unified whole, and variety enables the artist to add visual interest to this unified whole. It is this visual interest which attracts and holds the attention of viewers.

Gradation

Gradation refers to *a way of combining elements by using a series of gradual changes in those elements.* For example, a gradual change from small shapes to large shapes, or from a dark hue to a light hue, would be gradation. A common sight is a series of telephone poles lining a country road, each successive pole looking slightly smaller than the one preceding it. Unlike emphasis, which often stresses sudden and abrupt changes in elements, gradation refers to an ordered, step-by-step change (Figure 2.21, page 44).

➤ Notice the step-by-step change from large to smaller shapes. Can you find any other examples of gradation in this painting?

Figure 2.21 Fred Kabotie. *Hopi Ceremonial Dance.* c. 1945. Watercolor on paper. 14.7 x 55.8 cm. (18 x 22").
The Philbrook Museum of Art, Tulsa, Oklahoma.

Movement and Rhythm

Movement is *the principle of art used to create the look and feeling of action and to guide the viewer's eye throughout the work of art.* Of course, in a two-dimensional artwork, any look or sensation of action or motion is only an illusion: a horse pictured at full gallop gives only the impression of motion. However, some three-dimensional artworks actually do move. They allow the viewer to study the constantly changing relationships of colors, shapes, forms, lines, and textures found in the artworks. Movement is also used to direct the viewer's attention to a center of interest

(emphasis), or to make certain that the main parts of the work are noted. This movement is achieved through placement of elements so that the eye follows a certain path, as the curve of a line, the contours of a shape, or the repetition of certain colors, textures, or shapes. Closely related to movement is the principle of rhythm.

Rhythm is created by *the careful placement of repeated elements in a work of art to cause a visual tempo or beat.* These repeated elements invite the viewer's eye to jump rapidly or glide smoothly from one to the next. For example, the same shape may be repeated several times and arranged across the picture to create the sensation of movement in a certain

direction. As the viewer's eye sweeps from one shape to the next, this sensation is heightened, as seen in Marcel Duchamp's *Nude Descending a Staircase #2* (Figure 2.22). Sometimes visual contrasts set up a rhythm when elements are repeated and combined with contrasting colors, values, shapes, lines, or textures. For instance, a certain color may rush forward, then backward, or light values may clash with darker values, all the while moving the viewer's eye through the work.

➤ Describe the shapes used here. Do these shapes appear to be moving? If so, do they look as if they are moving slowly or rapidly?

Figure 2.22 Marcel Duchamp. *Nude Descending a Staircase #2.* 1912. Oil on canvas. 147.3 x 89 cm. (58 x 35"). Philadelphia Museum of Art, Philadelphia, Pennsylvania. Louise and Walter Arensberg Collection.

Proportion

Proportion is *the principle of art concerned with the relationship of certain elements to the whole and to each other.* Often proportion is closely allied to emphasis. If there are more intense hues than dull hues, or more rough textures than smooth, emphasis is suggested. In a similar manner, the large size of one shape compared to the smaller sizes of other shapes would create a visual emphasis. The viewer's eye would automatically be attracted to the larger, dominant shape.

In the past and in other cultures, artists often relied on the principle of proportion to point out the most important figures or objects in their works. The more important figures were made to look larger than the other, less important figures. This was the case in the bronze sculpture (Figure 2.23) by artists of the Benin Empire in Africa. This relief was made to decorate the wooden pillars of the palace in the Court of Benin. The powerful king of the tribe is shown on horseback. Two servants hold shields over his head to protect him from the sun. Two other figures support his hands, while another supports the king's feet with his head. The sculptor has made the king the largest figure, emphasizing his importance. Each pair of servants is shown proportionately smaller to indicate their lesser importance. The size of the main character in relation to the others is as effective as a spotlight in emphasizing his importance.

➤ What principles of art have been used, in addition to proportion, to give this bronze sculpture a unified look?

Figure 2.23 Court of Benin, Benin Tribe. *Mounted King and Attendants.* c. 1550–1680. Bronze. 49.5 x 41.9 x 11.3 cm (19½ x 16½ x 4½"). The Metropolitan Museum of Art, New York, New York. The Michael C. Rockefeller Memorial Collection. Gift of Nelson A. Rockefeller, 1965.

Joyce Scott

Jewelry artist and sculptor Joyce Scott (b. 1948) creates beaded works that lure viewers with dazzling intricacy and then confronts them with difficult social issues: "I want to coyly initiate a tête-à-tête and then Bam!—grab and surround the viewer in the mysteries of my . . . creations." Scott says that without the beauty of her materials and technique, people might not be willing to listen to her messages about racism and sexual inequality. In fact, the complexity of her themes and images is reflected in the highly detailed beadwork itself.

Scott was born in Baltimore, where she studied at Maryland Institute College of Art and now maintains her studio. Scott has studied the craft traditions of Mexico, Central America, and Africa. She once "toyed with the idea of painting, but alas it was too much like cooking and cleaning. Always waiting for things to cool off or dry. Not immediate enough to the touch." She enjoys weaving and working with handmade paper, fabrics, and ceramics, but only glass and plastic beads provide the quality of light and translucence that Scott desires for her work. She imaginatively combines beads with materials ranging from plastic sheeting and photographs to diffraction grating and leather.

Beads are the medium through which Scott relates her thoughts about sociopolitical issues and, even more so, her dreams and nightmares. She is inspired both by the African-influenced quilts made by her mother and grandmother and the silk-screened fabrics made in West Africa that include pictures of pop stars and political leaders. She also credits mysterious, dreamlike voices for the shape of her art.

Among the issues that Scott has explored through her art are apartheid and the fear that comes from living in an unsafe world. Scott hopes that her neck-pieces and other art address "the constant fight to be balanced in an existence where your skin tone, weight, or ethnicity validates your impact. Not your kindness, your need to love and give love in return."

Figure 2.24 Joyce Scott. *What You Mean Jungle Music?* 1988. Beaded necklace, mixed media. 28 x 35.5 x 5 cm (11 x 14 x 2").

Achieving Unity in a Work of Art

Although unity was discussed earlier, its importance demands additional comment here. Unity may be thought of as an overall concept—or principle. It describes the total effect of a work of art. All artists draw from the same reservoir of elements and principles, but few are able to take those elements and principles and fashion works of art that are unique, exciting, and complete. Those who do, achieve what is referred to as unity. Any of the works illustrated in this book can be studied in relation to this overall principle.

Discovering Design Relationships in Art

A Design Chart (Figure 2.25) can help you identify the many possible relationships between elements and principles in works of art. The first step in determining how a work is put together is to ask the right questions about it. The Design Chart helps identify these questions. For example, begin with any element and then, referring to the chart, ask yourself how this element is used in a work. The questions you come up with will link the element with each principle. You might begin an examination of a painting with hue. Then, referring to each principle in order, you would

	PRINCIPLES OF ART						
	Balance	Emphasis	Harmony	Variety	Gradation	Movement/Rhythm	Proportion
Color: Hue							
Intensity							
Value							
Value (Non-Color)							
Line							
Texture							
Shape/Form							
Space							

ELEMENTS OF ART — UNITY

Note: Do not write on this chart.

Figure 2.25 Design Chart

ask and then answer such questions as these about the work of art:

- Are the hues in the picture *balanced* formally or informally?
- Are contrasting hues used to direct the eye to areas of *emphasis*?
- Is *harmony* achieved through the use of similar hues that are repeated throughout the picture?
- Are different hues employed to add *variety* to the composition?
- Do any of the hues change gradually, or in a *gradation* from one to another?
- Are the hues arranged to create a feeling of *movement* or *rhythm*?
- Is the presence of any one hue out of *proportion* to the other hues used in the picture?

Once you have completed an examination of hue, you would turn to the next quality of color, which is intensity, and repeat the procedure with all the principles. An analysis carried on in this manner would help you gain the knowledge and understanding needed to determine how the parts of a picture have been put together to achieve *unity*. In Chapter 5, you will find that a Design Chart can be a very helpful aid when you are trying to learn as much as you can from a work of art.

A work of art is made up of many different colors, values, lines, textures, shapes, forms, and space relationships. The artist who creates it must combine these elements into an organized whole, and this takes a great deal of knowledge and skill. When viewing a work of art, you must determine how the artist has done this, and that too takes a great deal of knowledge and skill. Without this knowledge and skill, you merely *look* at art, you do not *see* it, and you may never learn to fully appreciate it.

SECTION THREE

Review

1. How are the principles of art used in creating works of art?
2. Name and define the three types of balance.
3. What principle of art is used to show contrast or stress the differences between elements?
4. How can harmony be achieved in creating a work of art?
5. What principle of art is used to increase the visual interest in a work of art?
6. Gradual, step-by-step changes refer to what principle of art?
7. What principle of art leads a viewer to sense action in a work?
8. The repeating of an element again and again to make the work seem active refers to what principle of art?
9. What principle of art refers to the way parts of art relate to each other?
10. How can a Design Chart identify the ways the elements and principles are used in a work of art?

Creative Activities

Humanities. Listen to a piece of classical music to hear the same elements and principles of art in the musical sounds. You will find *emphasis* in crescendo and decrescendo, *line* in melodic line, *color, harmony,* and *contrast* in a combination of instrumental sounds. Of course, *rhythm* and *movement* are the essence of music.

Then watch a contemporary music video and identify the elements and principles in both the sound and the visual images. For an extra challenge, work in small groups and create your own music video incorporating the elements and principles of art. Share the video with your classmates and see if they can identify the elements and principles you have used.

Studio. Design a complete outfit for yourself for a particular occasion: applying for a job, prom, or sports event. Then list the art principles of harmony and variety and show how you have used each through choice of color, texture, and shape.

STILL LIFE USING LINE

Supplies
- Pencils and sketch paper
- White drawing paper or mat board, 15 x 22 inches (38 x 56 cm)
- Ruler
- Colored pencils

Using colored pencils, complete a drawing of a close-up view of a still life. Include all or parts of four or more objects. Draw these objects in outline and overlap the shapes. Use four different types of line:
- Even weight
- Light to dark
- Thick to thin
- Broken

Two or more "negative shapes" in the composition will be filled in completely with hues that are low in intensity. Identify one "positive shape" as the focal point of your composition, and emphasize it by filling it in with a high-intensity hue.

Focusing

Examine the paintings and drawings in *Art in Focus*, noting the different kinds of lines used in each. Can you find a work in which the lines:
- Are of an even weight or thickness throughout?
- Change from light to dark?
- Change from thick to thin?
- Appear to be interrupted or broken in places?

Figure 2.26 Student Work

The areas representing the figures and other objects in a composition are known as "positive shapes." Can you identify the positive shapes in Figure 5.3? The areas that remain after the positive shapes have been created are known as "negative shapes." Can you point out these negative shapes in the same work?

Concentrating on the paintings in the text, is there one in particular (other than Figure 5.3) that demonstrates how a contrast of intensities can be used to emphasize an important part of the composition?

Creating

Complete several pencil sketches of a still life arrangement consisting of four or more interesting objects. The objects in your drawing should overlap.

Study your drawings carefully and, with a ruler, draw a box around the most interesting sections of each. On white drawing paper, complete a line drawing of the area represented in the best of your boxed sections. The lines in this drawing should be of four types: even weight; light to dark; thick to thin; and broken.

Select at least two negative shapes in your composition and, with colored pencil, carefully fill these in with hues of low intensity. Identify a single positive shape in your composition that you wish to emphasize. Color this in with a hue of high intensity.

CRITIQUING

• **Describe.** Can you point out and name the four or more still life objects in your drawing? Are others able to correctly identify these objects?

• **Analyze.** Does your drawing include four different kinds of line? Can you show where each is used? Did you color two or more negative shapes with dull or low-intensity hues? Did you also emphasize one positive shape by coloring it with a bright or high-intensity hue?

• **Interpret.** Do you think you solved the artistic problems pertaining to line, shape, and emphasis called for in this studio exercise? Do you think viewers will be able to recognize these artistic problems by studying your finished composition?

• **Judge.** Do you think your composition is successful? What is its most appealing feature? If you were to do it again, what would you change?

Figure 2.27 Student Work

Review

Reviewing the Facts

SECTION ONE

1. What is the relationship between the elements and principles of art?
2. Which of the three qualities of color refers to a color's name and its location on the color wheel?

SECTION TWO

3. How do works of art described as *linear* differ from those that are described as *painterly*?
4. Describe the way each of the four kinds of line causes a viewer of an artwork to feel.
5. How does actual texture differ from simulated texture?
6. How can painters create the illusion of solid, three-dimensional objects?

SECTION THREE

7. What kind of balance is shown in a work where one half mirrors the other?
8. What can happen to a work when an artist overuses harmony?
9. How is unity achieved?

Thinking Critically

1. ***Analyze.*** What would you do if you were interested in changing a color's intensity? How would you change a color's value?

2. ***Apply.*** To test your understanding of the elements and principles, select a familiar object and try to describe it to a classmate in terms of its elements and principles alone. Then have a classmate do the same. This time you try to identify the object that he or she has selected. Explain how your use and understanding of a visual vocabulary can help when you are discussing works of art.

3. ***Compare and contrast.*** Look at Figure 2.10 on page 34 and Figure 2.14 on page 38. Make a list of the techniques that both artists use to create the illusion of depth or distance.

4. ***Synthesize.*** Imagine an artist who is planning to paint a picture using only the elements of color and line. The artist has identified an analogous color scheme and curving lines to be the prominent elements in a work. What could be the risk in this plan? What advice would you give to the artist?

Using the Time Line

Which of the works specified on the time line do you find to be especially pleasing or unusual? Note the date when this work was completed. Visit your school or community library and research that date to discover an important event that occurred within five years of the time this work was created. Report your finding to the class.

| 1500 | 1600 | 1700 | 1800 | 1900 A.D. |

Giorgioni. *Adoration of the Shepherds*

Botticelli. *Adoration of the Magi*

Ter Borch. *A Music Party*

Meléndez. *Still Life with Oranges, Jars, and Boxes of Sweets*

Duchamp. *Nude Descending a Staircase #2*

Cassatt. *Five O'Clock Tea*

Michael Grant, Age 17
Raleigh-Egypt High School
Memphis, Tennessee

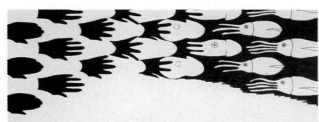

After reading about the elements of art, Michael selected the elements of shape and space as a focus for his project. "At the time, I was particularly interested in the works of M. C. Escher." Michael decided to create a transformation design that produced positive and negative space. He began by sketching his hand to see what would happen with a repeated pattern. "I put four hand shapes together in a diamond pattern and discovered a squid shape within the negative space.

"I found it was difficult to keep track of what was positive and what was negative space during the middle stage." Michael decided that the best way to keep track of the black-and-white areas was to work in rows across the surface of his design.

When asked what he was most satisfied with, Michael replied, "the impact of the positive-negative space and the movement created by it."

➤ *Hands and Squid.* Mixed media. 25 x 42 cm (10 x 16½").

Making Art: Two-Dimensional Media and Processes

Objectives

After completing this chapter, you will be able to:

➤ Name and define several two-dimensional processes and identify the media used in each.

➤ Explain where artists find ideas for their artworks.

➤ Name and describe the three basic ingredients in paint.

➤ Discuss the origins and historical development of printmaking.

➤ Describe the four basic printmaking methods.

➤ Experiment with drawing and printing media.

Terms to Know

binder
burin
dry media
intaglio
lithography
photography
pigment
relief
 printing
screen
 printing
serigraph
solvent
still life
wet media

Figure 3.1 John Frederick Peto. *The Old Violin*. c. 1890. Oil on canvas. 77.2 x 58.1 cm (30⅜ x 22⅞"). National Gallery of Art, Washington, D.C. Gift of the Avalon Foundation.

Artists who create two-dimensional works of art produce a wide variety of visual images upon flat surfaces. Depending on the materials and processes they use, we refer to the artworks they create as drawings, paintings, prints, and photographs.

SECTION ONE

Drawing and Painting

Drawing and painting are two important ways by which artists give visible form to the ideas and feelings suggested by their daily experiences and observations. A knowledge of the media and processes used to create drawings and paintings will prepare you to recognize and respond to those ideas and feelings. It will also aid you during efforts to give form to your own ideas and feelings.

Drawing

Drawing is a process of portraying an object, scene, or form of decorative or symbolic meaning through lines, shapes, values, and textures in one or more colors. This process involves moving a pointed instrument such as a pencil, crayon, or stick of chalk over a smooth surface, leaving behind the marks of its passage. The generally accepted name for a mark of this kind is *line.*

Of all the art processes, drawing has always been thought of as the most fundamental. It is practiced by everyone, from the small child making marks with a crayon to the busy executive idly doodling on a note pad. No doubt our earliest ancestors also engaged in similar activities—prompting some interesting theories on how the art of drawing originated.

Beginning in prehistoric times and continuing to the present day, artists have experimented with different drawing processes and media. The results of their experiments can be found on museum walls as finished drawings or as the paintings that evolved from drawings. Although their styles will differ, all drawings have a common purpose; to give form to an idea and express the artist's feelings about it.

The seventeenth-century Italian artist Guercino (guair-**chee**-noh) used his drawing skills to capture the strong religious feelings that dominated his time and place (Figure 3.2). With a style featuring spontaneous and vigorous lines he gives visual form to his idea of Saint Jerome listening intently to an angel.

In this work the rapidly drawn lines add excitement and action to the scene. Compare these to the carefully placed fine lines found in a portrait created by a French artist almost two hundred years later (Figure 3.3, page 56). Jean-Auguste-Dominique Ingres (zjahn oh-**gust** doh-min-**eek ahn**-gr) used the lines in his drawing to capture the exact appearance and scholarly dignity of a wealthy English gentleman.

➤ Would you be able to recognize the subject matter in this drawing if the title were unknown?

Figure 3.2 Guercino. *Saint Jerome and the Angel.* c. 1640. Brown ink on paper. 24 x 21.6 cm (9⁷⁄₁₆ x 8½"). University Purchase, University of Iowa Museum of Art, Iowa City, Iowa.

➤ Which part of this drawing is emphasized? How is this emphasis achieved? Would you guess this person to be a man of action, or a scholar? What clues in the work helped you make this decision?

Figure 3.3 Jean-Auguste-Dominique Ingres. *John Russell, Sixth Duke of Bedford.* 1815. Graphite. 38.6 x 28.9 cm (15¼ x 11⅜"). The Saint Louis Art Museum, St. Louis, Missouri. Purchase.

➤ Do you find the empty areas in this drawing disturbing? Why do you think they were left empty? The writing on this drawing is poetry expressing the feelings inspired by the drawing. The poems were added by several poets at different times after the drawing was completed.

Figure 3.4 Chang Yen-fu. *Thorns, Bamboo and Quiet Birds.* 1343. Hanging scroll, ink on paper. 76.2 x 63.5 cm (30 x 25"). The Nelson-Atkins Museum of Art, Kansas City, Missouri. Nelson Fund.

Unlike Western artists, Oriental artists were less interested in expressing strong emotional feelings or capturing the exact appearances of their subjects in their drawings. A work from the early fourteenth century demonstrates the Chinese artist's concern for recording the visual impressions of a scene following a long period of meditation (Figure 3.4). The drawing includes only enough information to suggest an image of birds, thorns, and bamboo. By concentrating upon the drawing and mentally filling in the details, viewers join with the artist in creating a picture of great beauty. In this way, artist and viewers share in the pleasure that comes from recognizing and responding to a scene.

Clearly, the artist's purpose is important in determining the style of a drawing. However, the choice of a drawing medium, often based upon the artist's purpose, can also contribute to style.

Drawing Media

The media for drawing can be divided into two types: dry and wet. **Dry media** are *those media that are applied dry* and include pencil, charcoal, crayon, and chalk or pastel. An example of a drawing created with a dry medium is Mary Cassatt's (cuh-**sat**) pastel in Figure 3.5. Here the artist makes use of a subject to which she returned over and over during her career — mothers and their children. She also employs a favorite medium — pastels. In this instance, she abandons her more familiar smooth, even surface in favor of one composed of swiftly applied strokes of color. The finished drawing looks as if it were done quickly, suggesting that the artist wanted to capture a fleeting moment shared by a mother and her children.

Wet media are *those media in which the coloring agent is suspended in a liquid and include ink and paints.* The wet medium most commonly used in

▶ This is one of the largest pastels ever drawn by Cassatt. The year after it was completed, her eyesight, which had been failing for years, was completely lost. She never painted again and spent the last dozen years of her life in darkness.

Figure 3.5 Mary Cassatt. *Young Mother, Daughter, and Son.* 1913. Pastel on Paper. 110 x 84.5 cm (43¼ x 33¼"). Memorial Art Gallery of the University of Rochester, Rochester, New York. Marion Stratton Gould.

drawing is ink in various colors, applied with pen or brush. Paints can also be used as a drawing medium. The drawing of fishing boats (Figure 3.6, page 58) by Vincent van Gogh (**vin**-sent van **goh**) demonstrates the skill with which that artist worked with a wet medium. The drawing is based on an earlier oil painting composed of brush strokes of bright color. Using a reed

pen and brown ink, van Gogh completed a drawing that features a variety of different lines. These lines give an exaggerated sense of movement to an otherwise simple scene.

Recognizing the advantages offered by both dry and wet media, many artists have combined them in their drawings.

➤ How is the principle of variety demonstrated in this work? What gives the drawing its spontaneous appearance?

Figure 3.6 Vincent van Gogh. *Fishing Boats at Saintes-Maries-de-la-Mer.* 1888. Ink and graphite on paper. 24.3 x 31.9 cm (9½ x 12½"). The Saint Louis Art Museum, St. Louis, Missouri. Gift of Mr. and Mrs. Joseph Pulitzer, Jr.

Drawing as a Major Art Form

Only in recent times have drawings been thought of as a major art form. Earlier artists used drawings mainly as a way of developing the ideas they wished to express in their paintings and sculptures. More recently artists have used drawings in both ways: as finished works of art and as preliminary studies to develop ideas. Certainly Canaletto's (can-uh-**let**-toh) *View of Venice* is quite capable of standing on its own as a serious work of art (Figure 3.7), but what of Thomas Gainsborough's study done in preparation for a painting (Figure 3.8)? Is such a work worthy of consideration as serious art? Each viewer must answer that question for himself or herself, but a valid answer must follow a careful, critical examination in which the viewer describes, analyzes, and interprets the drawing.

Interestingly, Gainsborough had no difficulty determining the worth of his work. He regarded the draw-

➤ This artist's drawings range from those that are as accurate as photographs to those that are highly imaginative. In his more imaginative works, he did not hesitate to alter the scene—often combining buildings from several different locations.

Figure 3.7 Giovanni Antonio Canal (called Canaletto). *View on the Lagoon.* No known date. Oil on canvas. 124.5 x 204.5 cm (49 x 80½"). Museum of Fine Arts, Boston, Massachusetts. Abbott Lawrence Fund, Seth K. Sweetser Fund, and Charles Edward French Fund.

Figure 3.8 Thomas Gainsborough. *Preliminary Study for "Repose."* No date. Charcoal and white chalk on blue paper. 25.4 x 32 cm (10 x 12⅝"). The Nelson-Atkins Museum of Art, Kansas City, Missouri. Gift of Thomas Agnew & Sons.

ing and the painting that came from it (Figure 3.9) as among his best. When the painting was completed he set it aside as a wedding gift for his daughter.

Drawings in Sketchbooks

Artists have long recognized the value of maintaining sketchbooks in which to record the ideas suggested by daily observations and experiences. Leonardo da Vinci (lay-oh-**nar**-doh da **vin**-chee) included everything from the movement of water and the mechanics of flight to the study of light in countless drawings, diagrams, and notes in the five thousand pages of his notebooks. The English landscape painter John Constable sketched outdoors during the warmer months and during the winter developed the ideas in his sketchbooks into paintings. For a two-year period beginning in 1832, the French artist Eugène Delacroix (oo-**zhen** del-lah-**kwah**) observed and recorded the people and events he encountered while

➤ Many artists prepare preliminary sketches for their paintings, using them to plan and test out ideas beforehand. Can you find details in the painting that were not included in the drawing?

Figure 3.9 Thomas Gainsborough. *Repose.* c. 1777–78. Oil on canvas. 122.3 x 149.6 cm (48⅛ x 58⅞"). The Nelson-Atkins Museum of Art, Kansas City, Missouri. Nelson Fund.

➤ Do you think the artist was trying to capture the exact appearance of his young model, or was he more interested in recording details of the youth's costume? What purpose could be served by doing drawings like these?

Figure 3.10 Eugène Delacroix. *Two Views of a Young Arab.* c. 1832. Watercolor over pencil. 34.5 x 29.7 cm (13⁹⁄₁₆ x 11¹¹⁄₁₆"). The Baltimore Museum of Art, Baltimore, Maryland. The Nelson and Juanita Greif Gutman Collection.

visiting Morocco. He filled sketchbooks with pencil and watercolor drawings, often adding descriptive notes that helped him preserve his impressions and provided a permanent record for future reference.

Some of Delacroix's sketchbooks remain intact, but others have been dismantled and the individual sheets sold. *Two Views of a Young Arab* (Figure 3.10) was probably a sheet in one of those sketchbooks. Drawings like this one were a source of inspiration for the artist throughout the rest of his life.

Painting

Painting is one of the oldest and most important of the visual arts. An artist creates a painting by arranging the art elements on a flat surface in ways that are sometimes visually appealing, sometimes shocking or thought-provoking. By presenting us with unique design relationships, offering new ideas, and giving form to the deepest feelings, the painter awakens us to as-

pects of life that we might otherwise overlook or ignore.

The subjects which artists select for their paintings often depend upon the time and place in which they live. For a painter living in western Europe during the Middle Ages, a religious subject would have been the most likely choice. That was the only kind of art in demand by the Church, which was the most powerful patron of the arts at that time. However, changes in religious practices in seventeenth-century Holland brought an end to the Church's influence, and artists were required to find new subjects for their paintings. Their choices were portraits, landscapes, and pictures of the ordinary events and objects that they found around them. At the same time, on the other side of the world, Japanese artists were perfecting an art style that catered to the demands of a growing number of wealthy landowners. It was the age of decorative screen painting, when artists created dreamlike landscapes set before glowing gold backdrops (Figure 3.11).

Where Artists Find Ideas for Their Paintings

Have you ever sat before a blank sheet of paper or stood behind a canvas trying to arrive at an idea for a painting? Perhaps on those occasions you wondered where artists find the ideas they use in their works. An examination of art history reveals that artists have discovered subjects for their paintings in the real world of people, places, and events around them, and the imaginary world within them.

It would be difficult to find a subject that is more fascinating for painters than people. Peering out at us from the pages of history are the countless smiling, frowning, crying faces of people painted in many different ways. Some are famous and easily recognized, but a great many more are long forgotten (Figures 3.12 and 3.13, page 62).

Did you know that the oldest known paintings in the world are not of people, but animals? Created tens of thousands of years ago, they can be found lining the walls and ceilings of caves throughout the world.

➤ Several copies of the design of this bridge are known, suggesting that it was a popular subject for artists. What do you think made it so popular? How do the principles of harmony and variety add to the success of this design?

Figure 3.11 Unknown. *Uji River Bridge.* Momoyama Period, 1568–1614. Ink, colors, and gold on paper. 171.5 x 338.5 cm (67½ x 133¼"). The Nelson-Atkins Museum of Art, Kansas City, Missouri. Nelson Fund.

➤ The president posed for this portrait the year before he was assassinated. What does the portrait tell you about Kennedy?

Figure 3.12 Elaine de Kooning. *Portrait of John F. Kennedy.* 1962. Pastels. 155 x 124.5 cm (61 x 49"). John F. Kennedy Library and Museum, Boston, Massachusetts. Willem de Kooning Estate.

➤ Although the identity of this woman is unknown, the artist offers clues to her personality and status in life. Using those clues, how would you describe this woman to a friend?

Figure 3.13 Élisabeth Vigée-Lebrun. *Portrait of a Lady.* 1789. Oil on wood. 107 x 83 cm (42⅛ x 32¾"). National Gallery of Art, Washington, D.C. Samuel H. Kress Collection.

➤ This painting became one of the most reproduced works of the nineteenth century. To what do you attribute its popularity? What do you think was of greater concern to the artist when painting this picture, the people or the animals?

Figure 3.14 Rosa Bonheur. *Plowing in Nivernais.* 1850. Oil on canvas. 133.3 x 259 cm (52½ x 102″). The John and Mable Ringling Museum of Art, Sarasota, Florida.

However, this interest in animals as a subject for art is not limited to prehistoric times. Over the centuries artists have continued the practice of including animals in their paintings—sometimes as interesting details, and sometimes as the main subject. Rosa Bonheur (roh-zah bah-**nur**), the most famous woman artist of her time, was regarded as an outstanding painter of animals (Figure 3.14). Bonheur defied the customs of her time to visit stockyards and animal auctions in order to make detailed and accurate animal studies.

Landscape paintings without figures were rare in Europe before the seventeenth century. Although artists used landscapes as backgrounds for their figures they rejected the idea of using natural scenes as the main subject for their paintings. This certainly was not true in the East where landscape painting enjoyed a long and glorious tradition. However, this changed in the seventeenth century when Dutch painters recognized that nature could serve as a beautiful and often dramatic subject for their art. Jacob van Ruisdael's (van **ris**-dahl) paintings, for example, are more than realistic—they also convey the artist's emotional reaction to the scene (Figure 3.15, page 64).

Some artists prefer to paint **still life**, *an arrangement of such things as food, plants, pots, pans, and other inanimate objects*. One of these, the American John Frederick Peto (**pee**-toh), delighted in presenting authentic-looking objects arranged in shallow spaces. The violin was a favorite subject because he admired the beauty of its shape, and because it gave him an opportunity to pay homage to another art form that he admired and practiced—music (Figure 3.1, page 54). Peto's paintings remind us of the beauty to be found in the simple things in life, things that we might otherwise consider commonplace or outdated and useless.

At one time historical pictures were thought of as the highest form of painting. Often they take the form of dynamic, colorful pictures depicting dashing military leaders engaged in epic battles. While it may lack the dynamic force of other historical pictures, John Trumbull's painting *The Declaration of Independence* (Figure 3.16, page 65) is no less important or stirring. Of the forty-eight figures included in the work, thirty-six were painted from real life. Shown in a momentary lull, the face of each figure reveals the significance of their meeting.

➤ In what way is this Western landscape similar to the Chinese painting in Figure 3.4? Does this picture communicate a certain mood or feeling? If so, how is this done?

Figure 3.15 Jacob van Ruisdael. *Forest Scene.* c. 1660–65. Oil on canvas. 105.5 x 131 cm (41½ x 51½"). National Gallery of Art, Washington, D.C. Widener Collection.

In addition to finding subjects in the people, places, and events around them, painters have also been inspired by the dreams and visions created by their fertile imaginations. Henri Rousseau (ahn-**ree** roo-**soh**), a self-taught French artist, never visited far-off jungles or deserts, except in his dreams. His paintings allowed him to share with others the exotic places he came to know in his make-believe world (Figure 3.17). He often showed exotic plants and trees towering unnaturally over the people and animals in his paintings. At first, people laughed at his pictures. His native town even refused to accept a work Rousseau wished to donate to the local museum. Accustomed to paintings showing images from the real world, people failed to appreciate the simple forms, pure colors, and precise, but inaccurate, details that sprang from the artist's mind to his canvas. His work was not taken seriously until other artists, recognizing his unique talent, befriended and honored him.

The Media and Tools of Painting

Clearly there are a great many sources to which artists can and have turned for ideas. They also have a variety of media and tools from which to choose in order to express those ideas in visual form. Several kinds of paint can be used to achieve different results. All are composed of three basic ingredients: pigment, binder, and solvent.

➤ How has the artist captured the seriousness of this event? When you "listen" to this picture, what sounds do you hear? Can you find other examples of history paintings in this book?

Figure 3.16 John Trumbull. *The Declaration of Independence.* 1786–97. Oil on canvas. 53.6 x 79 cm (21⅛ x 31⅛"). Yale University Art Gallery, New Haven, Connecticut.

➤ Did you notice something missing in this work? There are no footprints in the sand around the gypsy. Do you think this was merely an oversight? Or, are the footprints unnecessary because this is an imaginary scene representing the gypsy's dream?

Figure 3.17 Henri Rousseau. *The Sleeping Gypsy.* 1897. Oil on canvas. 129.5 x 200.7 cm (51 x 79"). Collection, The Museum of Modern Art, New York, New York. Gift of Mrs. Simon Guggenheim.

Joyce Kozloff

and decorative heritage and incorporates this information into her design. She wants each mural to be site specific not only in the sense of relating to its physical surroundings, but also in communicating the local character and values. For example, the Harvard Square subway station in Cambridge, Massachusetts, includes motifs that are reminiscent of the stenciled wall decorations used by colonial New Englanders. Viewers can also find colonial weathervanes, gravestones, quilts, and sailing ships incorporated in the artwork.

Although she accepts the risk of graffiti as a part of making public art, she notes that graffiti is usually a problem only in blank spaces, not in decorated ones. Kozloff enjoys creating art that can be enjoyed by the everyday public. She says, "I wanted to give them something different to look at on different days. They won't exhaust the piece the first time they see it. I can't affect the people who are running by at rush hour, but sometimes they may get there a little early, notice something new, and then see the piece from a different perspective."

The colorful tile murals of ceramicist Joyce Kozloff (b. 1942) challenge the twentieth-century notion that the decorative arts have a lower status than the so-called fine arts. Bored with the minimalist aesthetic viewpoint favored by the art world in the 1960s, Kozloff believes that art should be "additive, subjective, romantic, imaginative, personal, autobiographical, whimsical, narrative, decorative, [and] lyrical." She expresses her philosophy of art in the form of enormous tile and mosaic murals that enrich such otherwise mundane spaces as a subway station, an airport, and a train station.

Kozloff was born in Somerville, New Jersey. Despite growing up in a small country town, she has spent her entire adult life in New York City and has a great love and understanding of urban settings. Early in her career Kozloff painted very formal, geometric works but gradually began to include patterned motifs influenced by Mexican stonework, Moroccan tiles, and North African Berber textiles. Having immersed herself in the folk traditions of other cultures, it was natural for her to experiment with craft materials, especially clay.

Before Kozloff starts work on a public art commission, she researches the community's history

Figure 3.18 Joyce Kozloff. Mural at Harvard Square Subway Station, Cambridge, Massachusetts. 1985. Hand-painted, glazed ceramic tiles. 2.4 x 25.3 m (8' x 83').

The **pigment** is *finely ground powder that gives every paint its color*. Pigments are produced by a chemical process or by grinding up some kind of earth, stone, or mineral. The **binder** is *a liquid that holds together the grains of pigment* in a form that can be spread over some surface, where it is allowed to dry. Some tempera paints use the white of eggs as a binder (Figure 3.19); encaustic uses melted wax; oil paint, linseed oil; and watercolor, a mixture of water and gum arabic. A relatively new painting medium, known popularly as acrylics, makes use of acrylic polymer as a binder. The **solvent** is *the material used to thin the binder*.

Brushes are by far the preferred tools for painters. These come in a variety of shapes and sizes: pointed or flat, short and stiff, or long and flexible. Some artists also use a palette knife to spread their paint. This painting method results in rough, heavy strokes that can add to the textural richness of their paintings (Figure 3.20, page 68).

The best tools and most highly recommended techniques seldom aid the mediocre artist, but great artists manage to produce great works of art even when they use the poorest tools and abandon accepted practices. Francisco Goya (frahn-**seese**-koh **goh**-yah) always worked in a frenzy, disregarding patience and processes. He used whatever odd objects came to hand—a crayon or piece of burnt cork, charcoal or pen. Dipping his brush into ink mixed in tobacco, or applying his colors with sponges and spoons, he delighted in the accidental blots and splotches he created.

Your Use of Two-Dimensional Media and Processes

Your own efforts in creating two-dimensional art forms will depend in large measure upon what you learn about the media and processes introduced in this chapter. However, as important as it is to *know* about media and processes, it is even more important to know *what to do* with what you know. One of the most fascinating things about art is the fact that it offers you the opportunity—and the challenge—of making personal choices at every stage of the creative process. Of course, many of these choices involve the media and the processes you use. In order to best

➤ Is it surprising to you that egg white is used as a binder for paint? Egg adds strength to pigment as it dries.

Figure 3.19 Andrew Wyeth. *Soaring.* 1950. Tempera on masonite. 130 x 221 cm (48 x 87"). Shelburne Museum, Shelburne, Vermont.

express your thoughts, feelings, and ideas it will be necessary for you to make these choices carefully and thoughtfully. You can improve upon the care and thought with which you make these decisions if you take the time to experiment with art media and processes whenever you can. Doing so will enable you to use them most effectively to express your ideas in unique and stimulating ways.

➤ Is emphasis demonstrated in this painting? How is texture used to help create this emphasis? What type of texture is realized by using a palette knife to apply the pigment in this painting?

Figure 3.20 Lee Ables. *Untitled.* 1978. Private Collection.

SECTION ONE

Review

1. Describe the drawing process.
2. Name at least three dry media used in drawing.
3. Name the most common wet medium used in drawing and suggest one other that could be used.
4. Where do artists find ideas for their work?
5. Explain the attitude held by European artists up to the seventeenth century on the subject of using landscapes in their paintings.
6. What is meant by the term *still life*?
7. What are the three basic ingredients in paint?

Creative Activity

Humanities. As you begin to keep a sketchbook, start also to keep a "visual log"—a notebook in which you put into words the impressions, images, feelings, and moods that you experience in your everyday path. The artist must be open to everything in the world: the sights, the sounds, the small details, the tensions, excitements, even boredom of ordinary situations. Observe people, patterns of movement in rush hour, the relaxation of lunch time, the pressures of a game or other competition. All this is grist for the mill of the creative mind.

Avoid evaluating your impressions and deciding they are not of any value. Often the observation you thought was ridiculous will trigger a great idea. Read your log frequently; mull over its contents and see where it leads you.

Printmaking and Photography

Although different in terms of the media and processes involved, printmaking and photography are similar in one respect. Both offer an artist the opportunity to create multiple images. In printmaking, the artist does this by repeatedly transferring an original design from one prepared surface to other surfaces. In photography, black-and-white or color images are first obtained with the use of light rather than pencil, pen, or brush. These images can then be reproduced to serve specific purposes. One of these purposes is to accurately portray people, objects, and events in newspapers, books, and magazines. Another purpose—the one you will learn about in this chapter—is the use of photography as an art form.

Printmaking

Printing was discovered long ago, perhaps when someone discovered that by pressing the inked surface of a raised design against another surface, a copy was made. Of course, there is no way of knowing if this actually happened, but it is known that Chinese artists were printing with carved wooden blocks over one thousand years ago. At first the process may have been used to create repeat designs on textiles. Later it was applied to paper as well. Some scholars believe that one of the earliest uses for block printing was in the manufacture of paper money.

Printmaking did not develop in Europe until the fifteenth century, in time to meet the growing demand for inexpensive religious pictures and playing cards. Later it was used to provide illustrations for the books produced with movable type. This printing process, invented by a German printer named Johannes Gutenberg, made it possible to print different pages of a book by using the same metal type over and over again.

Eventually artists began to recognize the value of printmaking applied to the production of fine art. This led to a variety of printmaking processes ranging from those that are relatively simple to others that are more complicated. The four basic printmaking methods are relief, intaglio, lithography, and screen printing.

Relief Printing

In **relief printing** *the image to be printed is raised from the background*. This method requires that the artist cut away the sections of a surface not meant to hold ink. The remaining raised portion is then covered with ink and becomes the printing surface. Paper is laid upon it, pressure is applied, and the ink is transferred to the paper.

Printing with carved wooden blocks originated in China and spread to Japan where, in the seventeenth century, it became a highly developed art form. At first, oriental prints consisted of inked outlines that were later filled in with color by hand. Eventually separate blocks were created for each color in a design. Each block was inked, aligned, and printed to produce a design with multiple, rich colors (Figure 3.21).

➤ How does line variety add to the visual appeal in this print?

Figure 3.21 Katsushika Hokusai. *The Kirifuri Waterfall at Mt. Kurokami, Shimozuke Province.* c. 1832. Polychrome woodblock print. 37.2 x 24.5 cm (14⅝ x 9⅝"). The Nelson-Atkins Museum of Art, Kansas City, Missouri. Nelson Fund.

➤ What makes this composition so unusual? What do you think the person shown in this work is feeling? What would cause those feelings?

Figure 3.22 Edward Hopper. *Night Shadows.* 1921. Etching. 17.6 x 21 cm (6¹⁵⁄₁₆ x 8¼"). McNay Art Museum, San Antonio, Texas. Gift of the Friends of the McNay.

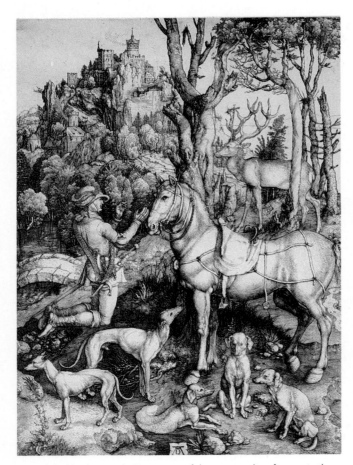

➤ Works like this made Dürer one of the outstanding figures in the history of German art.

Figure 3.23 Albrecht Dürer. *St. Eustace.* c. 1501. Engraving. 35.6 x 26.6 cm (13⅞ x 10⅜"). The Saint Louis Art Museum, St. Louis, Missouri. Purchase.

Intaglio

A printing process that is exactly the reverse of relief printing is intaglio. The name comes from the Italian word meaning "to cut into." **Intaglio** is *a process in which ink is forced to fill lines cut into a metal surface.* The lines of a design are created by one of two methods: etching or engraving.

In *etching*, a copper or zinc plate is first covered with a coating made of a mixture of beeswax, asphalt, and resin known as a ground. The artist uses a fine needle to draw an image through this protective coating. When the plate is placed in acid, it bites or etches the lines into the metal where the ground has been removed. The remaining ground is then removed, the plate inked, the unetched surface is cleaned, and damp paper is pressed onto the plate with a press. This forces the paper into the inked grooves, transferring the image (Figure 3.22).

In an *engraving* the lines are cut directly into the metal plate with a **burin**, or *engraving tool*. The lines made in this way are more pronounced and clear (Figure 3.23) than the fine lines produced by the etching process. When the prints have been made, you can actually feel the lines of raised ink on etchings and engravings.

Lithography

There is a printing process based on the principle that grease and water do not mix. **Lithography** is *a printmaking method in which the image to be printed*

is drawn on limestone, zinc, or aluminum with a special greasy crayon. When the drawing is completed, it is chemically treated with a nitric-acid solution. This makes the sections that have not been drawn on resistant to the printing ink. The surface is dampened with water and then inked. The greasy printing ink sticks to the equally greasy crayoned areas but is repelled by the wet, blank areas. Finally, the surface is covered with paper and run through a press to transfer the image.

Among the many artists attracted to the direct drawing methods of lithography was the Mexican painter, José Clemente Orozco (hoh-**say** cleh-**men**-tay oh-**ross**-coh). He used this printing method to create the powerful image of a monk attending a starving Indian seen in Figure 3.24.

Screen Printing

Screen printing is a more recent printmaking process. In **screen printing**, *paint is forced through a screen onto paper or fabric.* This technique makes use of a stencil that is placed on a silk or synthetic fabric screen stretched across a frame. The screen is placed on the printing surface, and a squeegee is used to force the ink through the porous fabric in areas not covered by the stencil. If more than one color is needed, a separate screen is made for each color (Figure 3.25). *A screen print that has been handmade by an artist is called* a **serigraph**.

➤ Do you think this is a successful design? What has the artist done to make his figures fit comfortably within the overall arched shape of his composition?

Figure 3.24 José Clemente Orozco. *The Franciscan and the Indian.* 1926. Lithograph. 31.4 x 26.3 cm (12⅜ x 10⅜″). McNay Art Museum, San Antonio, Texas. Margaret B. Pace Fund.

➤ How does gradation help create the feeling of deep space in this work? Why was the screen printing process ideal for producing a print like this? Do you think another printing process would have been as effective? Why or why not?

Figure 3.25 Edward Ruscha. *Standard Station.* 1966. Color serigraph. 48.4 x 94 cm (19⁹⁄₁₆ x 37″). McNay Art Museum, San Antonio, Texas. Gift of the Friends of the McNay.

➤ Does this photograph suggest a particular time of day? Is that an important consideration when attempting to interpret the picture? What sounds do you associate with this scene? How does this work succeed in pulling the viewer's eye into it?

Figure 3.26 Alfred Stieglitz. *A Bit of Venice.* 1894. Platinum Photograph. National Gallery of Art, Washington, D.C. Alfred Stieglitz Collection.

Photography

Photographs appear everywhere—in newspapers, magazines, and books. In fact, their popularity may be one of the main reasons why photography has had difficulty being accepted as a serious art form. After all, anyone can point a camera, trip the shutter, and obtain a fairly accurate image. However, this simple description ignores the many other concerns of the serious photographer. These include the decisions that must be made regarding the subject, light conditions,

and point of view, and creative work done in the darkroom. Other decisions concern the type of camera, film, and lens to be used.

Photography is *a technique of capturing optical images on light-sensitive surfaces.* The best photographers use this technique to create an art form powerful enough to teach others how to see, feel, and remember. Alfred Stieglitz (**steeg**-litz) used his talent and his camera to place viewers on a bridge spanning a canal in Venice. There they share with the artist a brief, magical moment in time (Figure 3.26). Works

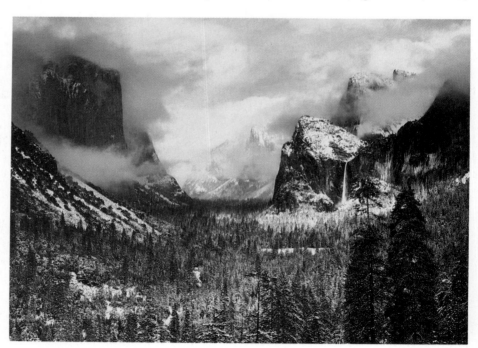

➤ Adams is perhaps the best-known photographer of the twentieth century. Trained as a concert pianist, he turned to photography full-time in 1930.

Figure 3.27 Ansel Adams. *Clearing Winter Storm, Yosemite Valley.* 1944. Silver print. 26.5 x 33.7 cm (10½ x 13¼"). The Saint Louis Art Museum, St. Louis, Missouri. Purchase.

like this inspired other artists, including Ansel Adams. Stieglitz, old and in poor health, urged Adams to continue where he was forced to leave off. Adams responded with thousands of photographs that marked a career covering nearly half a century. He photographed everything from the unsettling stillness of a New Mexico moonrise to the majesty of a Yosemite winter storm (Figure 3.27).

Imogen Cunningham's work combines a sensitivity for simple forms and a straightforward photographic technique. By working closely to her subject, the artist was able to create an image that seems to pull viewers into it (see Figure 2.6, page 31).

By placing objects directly on light-sensitive paper and exposing them to light, Man Ray created immediate photographic images (Figure 3.28). This process owed a great deal to chance and produced results unlike anything seen in the real world. Innovations like this could be expected from an artist who once dressed a crowd of people in white, set them dancing on a white dance floor, and projected movies on them.

A great many more two-dimensional media and processes could have been discussed in this chapter. However, even this relatively brief examination should serve to demonstrate that two-dimensional art forms are as different as the artists who create them. These works, whether produced with pencil, brush, printing press, or camera, offer the artists who create them and the viewers who see them the opportunity to venture freely into areas of experience that were formerly unknown.

➤ How is the principle of harmony evidenced in this work? Can you point to areas where value gradation is used?

Figure 3.28 Man Ray. *Untitled.* 1943. Rayograph. 35.6 x 28 cm (14 x 11"). Denver Art Museum, Denver, Colorado.

SECTION TWO

Review

1. Printing with carved wooden blocks is a form of what method of printmaking?
2. When did printmaking first appear in Europe and for what was it used?
3. Explain the difference between the two intaglio processes—etching and engraving.
4. Which printing process is based on the principle that grease and water do not mix?
5. Name and explain the printing process that uses stencils, fabric stretched across a frame, and a squeegee.
6. What is a serigraph?
7. List five concerns of a serious photographer.

Creative Activity

Humanities. Techniques for printing on fabric are similar to those used on paper. Silkscreen and block printing are most widely used. Designs for fabric must be planned as a continuous repeat pattern. Often the designs interlock so that a break is not apparent. Study pieces of printed fabric to see if you can find the design unit.

Tie-dye and batik are versatile techniques for fabric design. A rich heritage of design in batik and tie-dye comes from the many cultures of the Far East as well as Africa. A kind of wood block, called Adinkra, comes from the African Ashanti tribe of Ghana. Try making your own tie-dye or batik prints.

KEEPING A SKETCHBOOK

Supplies

- Pencils
- Felt-tip markers
- Sketchbook filled with a moderately good grade of drawing paper. Select a size that is convenient for you to carry. The size could range from 4 x 5 inches (10 x 13 cm) to 9 x 12 inches (23 x 30 cm).

CRITIQUING

Develop the habit of regularly showing your sketchbook to your art teacher. Ask for comments and suggestions.

Maintain a sketchbook in which you regularly record the ideas suggested to you by observation and experience.

Focusing

Examine the drawings by Thomas Gainsborough and Eugène Delacroix (Figures 3.8 and 3.10). Why did these artists make these kinds of drawings? Can you think of any reasons why it might be beneficial for you to keep a sketchbook? What kinds of things would you include?

Creating

Form the habit of carrying a sketchbook in which you keep a visual record of the people, places, objects, and events with which you come into daily contact. The sketches you do should range from those that are done quickly on the spot to others that are more deliberate and detailed. Some drawings will fill an entire page and others will be "thumbnail" sketches so small that several can be included on a single sheet.

Use a pencil and felt-tip pen for your sketchbook drawings. Some will take the form of line drawings while others serve as value studies. Date each page of the sketchbook so comparisons can be made between earlier drawings and those done later.

Think of your sketchbook as serving several purposes. These include:

- A way of developing your powers of observation.
- An opportunity to sharpen your drawing skills.
- A ready source for ideas to be used when creating more finished two-dimensional artworks.

Figure 3.29 Student Work

Figure 3.30 Student Work

WHIMSICAL SANDWICH PAINTING

Using tempera or acrylic, paint a picture of a large, whimsical sandwich seen from the side.

Focusing

Examine the two-dimensional works illustrated in this chapter and throughout the book. Notice that the subjects in these works range from those that are realistically represented to others that are based upon images drawn from the artist's imagination.

Creating

Discuss in class the possibilities of creating a unique, whimsical sandwich, unlike any sandwich seen in real life. Compile a list of "ingredients" for such a sandwich on the chalkboard. Avoid familiar items in favor of such highly unlikely ingredients as: an entire pig with an apple in its mouth; an assortment of candy bars, or items not normally associated with food and eating, such as books, articles of clothing, or tools.

Prepare several sketches of a whimsical sandwich. These should show the sandwich from the side in order that five or more items can be more easily shown between two slices of bread or the top and bottom half of a bun. You may wish to develop a theme for your sandwich, such as "food for thought" (Figure 3.31), or a "club sandwich" (Figure 3.32).

Transfer your most successful sketch to the mat board, making certain to fill the entire sheet with your drawing. Use acrylic or tempera to paint your composition. Light, bright colors should be used for the sandwich and a contrasting dark, dull color for the background.

Supplies
- Pencil and sketch paper
- Large sheet of white mat board, 12 x 18 inches (30 x 46 cm)
- Tempera or acrylic paint
- Brushes, mixing tray, and paint cloth
- Water container

CRITIQUING

- **Describe.** Is your painting easily recognized as a sandwich? Is it seen from the side? Does it contain five or more ingredients? Can these be readily identified?
- **Analyze.** Does your sandwich fill the space on which it is painted? Did you use light, bright hues for the sandwich? Do these contrast with the dark, dull background to emphasize the sandwich?
- **Interpret.** Does your painting present a highly imaginative version of a sandwich? Are others able to recognize the whimsical nature of your creation?
- **Judge.** Do you feel that your painting is successful? Is it successful because it is painted in a realistic style, or because it uses the elements and principles of art to achieve an overall sense of unity? Is it successful because it represents a familiar object from real life in a unique and highly imaginative way?

Figure 3.31 Student Work

Figure 3.32 Student Work

Reviewing the Facts

SECTION ONE

1. Name the two ways that artists use their drawings.
2. Who was the most powerful patron of the arts in western Europe during the Middle Ages?
3. During the Middle Ages what subjects were artists in Japan painting?
4. What is the subject of the oldest known paintings and where are they located?
5. What do some tempera paints use as a binder?

SECTION TWO

6. Although the Chinese developed a printing process over one thousand years ago, Europe did not develop it until what century?
7. What contribution to the printing process was made by Johannes Gutenberg?
8. Name the four basic printmaking methods.
9. What two methods are used to cut into a metal surface in the intaglio process?

Thinking Critically

1. **Extend.** From time to time the expression "painting is dead" is heard. Examine the possible meanings of this statement. Then organize your thoughts in an outline form to argue for or against the statement.
2. **Compare and contrast.** Refer to Figures 3.4, page 56 and 3.6, page 58. Create a Design Chart for each work to help you focus on how the artists use the art elements according to each principle. Then make a list of the similarities and differences of the two works.
3. **Analyze.** Identify the artworks in this chapter that most clearly illustrate the word clues provided below. When finished, compare your choices with those made by other members of the class. (a) Transparent layers of color; (b) empty spaces; (c) historical event; (d) close-up view; (e) blended colors; (f) deliberate, carefully placed lines; (g) dry drawing medium; (h) slow drying time; (i) make-believe world; (j) preliminary sketch; (k) wet drawing medium; (l) rapid drying time; (m) palette knife; (n) everyday scene; (o) wet and dry drawing media; (p) decorative screen painting; (q) created with carved wooden blocks.

Using the Time Line

What important historical event took place in the United States the year before Gainsborough painted *Repose*? Which war of independence ended the year after Delacroix produced *Two Views of a Young Arab* and Hokusai painted *The Kirifuri Waterfall*? Can you identify the influential invention made in the same year that Orozco painted *The Franciscan and the Indian*? (Hint: You were probably entertained by it yesterday evening.)

1750	1800	1850	1900	1950 A.D.

Bonheur. *Plowing in Nivernais*

Orozco. *The Franciscan and the Indian*

Vigée-Lebrun. *Portrait of a Lady*

• Delacroix. *Two Views of a Young Arab*
• Hokusai. *The Kirifuri Waterfall*

Rousseau. *The Sleeping Gypsy*

Gainsborough. *Repose*

Stieglitz. *A Bit of Venice*

Peto. *The Old Violin*

van Gogh. *Fishing Boats*

MaryAnn Zent, Age 18
North Central High School
Indianapolis, Indiana

MaryAnn enjoys painting flowers and decided to reproduce one of her paintings using the silk-screen process. "I began by making stencils for each of the twelve colors that I separated from my original watercolor painting." Regarding the complexity of the project and materials, MaryAnn said, "I had to decide the best order in which to print each separate color to get the effect I wanted with overlapping and registration. I learned about different types of inks, making stencils by exposing the film to light, and the developing process—something I had never done before."

"Once I printed all twelve colors, I had to look at each print separately to see if it 'qualified,' regarding registration, to be in the series. I discovered that I can take on a medium I know very little about and learn as I create. I have gained confidence in my work as well as myself."

➤ MaryAnn's serigraph won a Gold Key First Place award in the Scholastic Art Regional and a First Place in the Congressional Art Competition, 6th District.
➤ *Iris.* Serigraph. 36 x 42 cm (14 x 16½").

Making Art: Three-Dimensional Media and Processes

Objectives

After completing this chapter, you will be able to:

➤ Name several three-dimensional processes and identify the media used in each.

➤ Explain how relief sculpture differs from sculpture in the round.

➤ Specify why the choice of materials is important for both sculptor and viewer.

➤ Describe the sculpture processes of modeling, carving, casting, and assembling.

➤ Create a three-dimensional work of art.

Terms to Know

armature
assembly
bas relief
carving
casting
high relief
investment
kinetic art
modeling
sculpture in
 the round

Figure 4.1 Duane Hanson. *Janitor.* 1973. Polyester, fiberglass, mixed media. 166.3 x 71.1 x 55.8 cm (65½ x 28 x 22"). Milwaukee Art Museum, Milwaukee, Wisconsin. Gift of Friends of Art.

Throughout history artists in every culture and society have created sculpture of some

kind. The works created come in various sizes and shapes, are made with all kinds of materials

and processes, and satisfy many different purposes.

➤ If you did not know the name of this work, would you still be able to identify the emotion or feeling it expresses? How is exaggeration used in this work? Would you describe the forms used as simple or complex? How does this use of form add to the work's impact?

Figure 4.2 Hugo Robus. *Despair.* 1927. Bronze. 34.9 x 34.9 x 24.8 cm (13¾ x 13¾ x 9¾"). Collection of Whitney Museum of American Art, New York, New York. Purchase.

SECTION ONE

Types of Sculpture

As an art form, sculpture differs from painting in that it exists in space. It can be seen, touched, and even walked around. Painting may hope to suggest on flat surfaces the *illusion* of space, but it is *actual* space that is of concern to the sculptor. Such an artist sets out to fill space creatively with three-dimensional forms. At times these forms may record actual appearances (Figure 4.1) or express emotions (Figure 4.2) or ideas (Figure 4.3).

➤ Can you think of any reason why this man and this woman look so much alike? What relationship do you think these two figures have with one another? Do you think this is a warm, enduring relationship, or one that is casual and temporary? What clues did you use to make that decision?

Figure 4.3 *Seated Man and Woman.* Jalisco, Mexico. 100 B.C.–A.D. 250. Ceramic, slip. 40.8 x 47.3 x 28.7 cm (16 x 8⅝ x 11⅓"). The Dallas Museum of Art, Dallas, Texas. Gift of Mr. and Mrs. Eugene McDermott, the McDermott Foundation, and Mr. and Mrs. Algur H. Meadows and the Meadows Foundation, Inc.

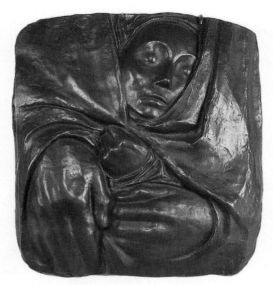

➤ Do any of the forms in this sculpture extend outward into space?

Figure 4.4 Käthe Kollwitz. *In God's Hands*. 1935–36. Bronze. 35.5 x 31.8 x 9.2 cm (14 x 12½ x 3⅝"). National Gallery of Art, Washington, D.C. Gift of Mr. and Mrs. Hans W. Weigert in memory of Lili B. Weigert.

➤ Notice how the figures in the foreground project out into space.

Figure 4.5 Lorenzo Ghiberti. *Biblical Stories of Joseph*. Detail of the east doors, Baptistry. 1425–52. Gilt bronze. Florence Cathedral, Florence, Italy.

Relief Sculpture

Not all sculptures can be viewed from all sides. Relief sculptures are similar in some ways to painting in that their three-dimensional forms are attached to a flat surface. Like paintings, these works are designed to be viewed only from the front. In low relief, or **bas relief**, the *forms project only slightly from the background* (Figure 4.4). In **high relief** *the sculptured forms extend boldly out into space* (Figure 4.5).

Sculptures in the Round

Sculpture in the round is *freestanding sculpture surrounded on all sides by space*. However, not all free-standing sculptures are meant to be seen from all sides. Many are designed to be examined only from the front in much the same way one would look at a painting or a relief sculpture. An example of such a work is the ancient Egyptian statue of the Lady Sennuwy in Figure 4.6. Imagine for a moment that you have come upon this statue in a darkened tomb. You would notice almost immediately that the figure stares straight ahead as if she knew for certain that you would take a position directly in front of her. This confidence is well founded. There is no reason for you

to walk around this sculpture. Everything of importance can be seen easily from a stationary position facing the seated figure. There, as the artist intended, you experience the full impact of its steady gaze and welcoming smile.

Figure 4.6 *Lady Sennuwy*. Kerma, Sudan. Dynasty XII. c. 1950 B.C. Black granite. Over life-size. Museum Expedition. Courtesy of Museum of Fine Arts, Boston, Massachusetts.

Luis Jimenez

as the threesome work their way through river grasses to a new life in the United States. Although there is no direct reference to border guards or immigration officials, the difficulty and danger of the group's journey is nevertheless apparent. Jimenez carefully modeled bulging veins and taut sinews in the man's already exaggerated physique to express fortitude and determination. The sheer mass of the sculpture suggests the power of the desire to seek a better life.

Not surprisingly, Jimenez feels a strong affinity for Baroque art (Chapter 19), which has the same love of expressive anatomy embodied in Jimenez's art: "When I was in school, Baroque art was hardly mentioned. It was viewed as a corruption of the Renaissance. When I first went to Italy, it was a revelation to really *see* Baroque art; Bernini, Rubens — it all felt great."

Jimenez's style has also been likened to that of regionalist American painter Thomas Hart Benton and Mexican muralist José Clemente Orozco. Like Benton and Orozco, Jimenez selects stereotypical characters, but he transforms them into muscularly three-dimensional forms that are both pop and high-tech.

The enormous resin and fiberglass sculptures by Luis Jimenez (b. 1940) not only tell stories of the West and his native Southwest background, but also elevate the characters to an almost mythical status. His robust monumental sculptures are often displayed in galleries but look more at home in an outdoor public setting.

Jimenez has perfected his technique of airbrushing cast-fiberglass. He learned to airbrush as an apprentice in his father's neon shop in El Paso, Texas, where he worked as a sign painter. However, his skill in working with fiberglass originated from his early passion for customizing cars. His sculptures are intensely colored with metal flake and topped with several layers of a high-gloss epoxy finish that creates a candied, light-filled surface.

Jimenez has a strong commitment to creating public art that is easily understood by ordinary people, whose lives he wishes to honor. Among his subjects are a Mexican cowboy, or *vaquero*, roping a massive longhorn, a Native American killing a buffalo, and a North Dakota farmer plowing a field with a team of oxen. *Cruzando el Rio Bravo/Border Crossing* dramatizes the plight of a Mexican man who hefts a stout woman and her baby on his shoulders

Figure 4.7 Luis Jimenez. *Cruzando el Rio Bravo/Border Crossing.*

Unlike the statue of the Lady Sennuwy, the delicately poised bronze head in Figure 4.8 invites viewers to examine it from all sides. Highly polished simplified forms flow into each other, spiraling completely around the figure, tempting viewers to follow along.

Materials and Tools for Sculpture

Place yourself in the position of an artist about to transform an idea into three-dimensional form. A number of important questions must be answered before you can begin. For example, what material will you use—clay, wood, stone, metal? Then, what tools and process are best used with the material selected?

➤ The spiral of this composition may have come from the artist's study of a dancer's pose. Does this spiral give the sculpture a sense of movement?

Figure 4.8 Constantin Brancusi. *Mlle Pogany* (Margin Pogany). 1913. Bronze. 43.8 x 21.6 x 31.7 cm (17¼ x 8½ x 12½"). Collection, The Museum of Modern Art, New York, New York. Acquired through the Lillie P. Bliss Bequest.

➤ How does the surface of this marble version of the same subject differ from the earlier bronze work seen in Figure 4.8?

Figure 4.9 Constantin Brancusi. *Mlle Pogany*. 1913. White Marble. 44.5 x 15.2 cm (17½ x 6"). Philadelphia Museum of Art, Philadelphia, Pennsylvania. Given by Mrs. Rodolphe Meyer de Schauensee.

Answers to these questions will determine in large measure what your finished sculpture will look like.

Look again at the sculpture illustrated in Figure 4.8. Try to imagine how this work would look if it were made of clay, or wood, or marble rather than bronze. Instead of a slick, shiny surface, picture this sculpture as a clay piece bearing the signs of the sculptor's fingers, or a rough-hewn wood carving. Would its appearance—and its impact upon the viewer—be different if it had been carved in a light colored marble?

As a matter of fact, the artist, Constantin Brancusi, created three marble and nine bronze versions of this sculpture over a nineteen-year period. Take a moment to compare one carved in marble (Figure 4.9) with the

version cast in bronze. Did you react to both works in the same way? If not, what prompted the different reactions?

Clearly, the choice of materials is an important one for both the sculptor and the viewer. Sculptors choose a certain material because of what they can do with it and what it can contribute to the finished work. Sometimes a material is favored because of the ease with which the artist can form it. An artist may choose to work with clay because it is easy to manipulate and offers a great deal of spontaneity. In the skilled hands of Auguste Rodin (oh-**gust** roh-**dan**), this spontaneity can add freshness and vitality to a portrait of a young woman (Figure 4.10). Other materials may be more

➤ Describe this woman's appearance. Can you identify differences in the actual textures on this sculpture? Do those differences in texture add to its visual appeal? What mood or feeling do you think this woman expresses?

Figure 4.10 Auguste Rodin. *Bust of a Woman.* 1865. Terra cotta and tinted plaster. 48.9 x 35.6 x 33.6 cm (19¼ x 14⅛ x 10⅝"). National Gallery of Art, Washington, D.C. Gift of Mrs. John W. Simpson.

difficult to work with but make up for this by providing other advantages. Marble proved to be an excellent choice for Jean-Antoine Houdon (zjahn ahn-**twahn** oo-**dahn**), who carved, smoothed, and polished it to capture the warm, soft, silky look and feel of a child's face (Figure 4.11).

Observe how the play of light across their surfaces affects both these sculptures and contributes to the different interpretations of each. Sudden contrasts of light and shadow add life to Rodin's portrait. These value changes accent the movement of the woman's head and the warm, friendly expression on her face. On the other hand, light flows more evenly over Houdon's portrait, resulting in changes of light and shadow that are more even and softer. This helps make the child's face appear more still, relaxed, and innocent.

Take time to examine the sculptures illustrated in this book, concentrating on the materials with which they are made. You may find that much of what you enjoy about sculpture is due to the artist's choice of materials.

Notice the character of each medium as you examine sculpture. The smooth surface of marble, the varied textures of wood, clay, and metal provide endless surface variety.

➤ How is the principle of gradation noted in this work? Does the subject appear to be moving, or is it calm and still?

Figure 4.11 Jean-Antoine Houdon. *Louise Brongniart.* Date unknown. Marble. 37.7 x 25.3 x 19.5 cm (14⅛ x 9⅞ x 7⅝"). National Gallery of Art, Washington, D.C. Widener Collection.

SECTION ONE

Review

1. What are the two types of relief sculpture and how do they differ from each other?
2. How do relief sculptures differ from sculptures in the round?
3. Explain the difference between the two kinds of sculpture in the round.
4. Name four media used to create sculpture.
5. What enters into an artist's decision concerning his or her choice of a material for a sculpture?
6. How do sculptors decide what medium to use for a specific sculpture?
7. Tell what medium you would select if you wanted to sculpt a portrait figure of an old man, and explain why you would select that particular medium.

Creative Activity

Studio. Make a sand-casting relief sculpture. You will need sand and a cardboard gift box about 2 inches (5 cm) deep. Beach sand works well, but foundry sand is best. This is sand saturated with carbon for use in foundry casting.

Start with a 1-inch (2-cm) layer of sand moistened enough to take and hold a shape. Use your fingers, a table knife, or a popsicle stick to press and cut a design into the sand. Remember: The result will be in reverse—both positive and negative and mirror reverse.

Add small objects such as shells, beads, or stones to your design if you wish. While the sand is still moist, mix plaster of paris and pour it gently into the box with the sand mold you have created. When the plaster has set, remove the plaster relief and wash the sand away. Some of it will cling to the casting, giving an interesting texture and color to the design.

Processes of Sculpture

Artists use a variety of different processes or techniques to create sculptures from the materials they choose. These processes include modeling, carving, casting, and assembling.

Modeling

Modeling is *a process in which a soft, pliable material is built up and shaped*. The artist uses a material such as clay, wax, or plaster. Because the sculptor gradually adds more and more material to build a three-dimensional form, modeling is referred to as an additive process.

With most modeled sculpture the artist finds it necessary to begin by constructing an **armature** or *support system* of some kind. Usually made of metal, the armature provides the support needed as the artist builds the sculpture around it.

Over two hundred years ago the Italian sculptor Gianlorenzo Bernini (jee-ahn-low-**ren**-zoh bair-**nee**-nee) made brilliant use of the modeling process to create the clay figure of an angel in Figure 4.12. This was one of several created as models for ten life-size marble statues that would then be carved to decorate an ancient bridge in Rome. Working in clay, Bernini formed the figure quickly, trying to give it a sense of movement. Notice how the body turns in space, causing its garments to swirl about. This creates a rich pattern of light and shadow that seems to energize the figure.

➤ Observe how details are ignored in favor of creating a figure that appears to be moving in space. Why do you think clay was a good choice of material for a work like this?

Figure 4.12 Gianlorenzo Bernini. *Angel with the Superscription.* 1667–69. Terra cotta with traces of gilding. 30.2 cm (11⅞"). Kimbell Art Museum, Fort Worth, Texas.

Carving

Carving is *cutting or chipping a form from a given mass of material to create a sculpture.* Unlike modeling, which is an additive technique, carving is subtractive. Material is removed until the sculpture is completely exposed.

Stone carving is a process that has changed little over the centuries. In fact, even the tools remain essentially the same today as in ancient times. First a pointed metal instrument, much like a large, heavy pencil, is used to cut the general outline of the sculpture to about an inch from the desired surface. A variety of flat-tooth chisels are then selected to cut away more stone, gradually revealing the finished form.

Finally, flat chisels are used to cut to the final surface of the work. If a highly polished surface is desired, the sculptor will rub several abrasive stones over its surface. These stones become finer and finer, smoothing the surface and giving it a warm lustre.

Modern stonecarvers follow this same process but make use of power tools to cut away excess material and to polish finished works. This makes the carving process faster, but in no way minimizes its challenges. Despite its hardness, stone can be broken, leaving the artist with little more than the shattered pieces of a dream to show for hours of hard work.

Every kind of stone has its own unique character, and the artist must take this into consideration when deciding upon the right one for his sculpture. Marble is often selected because it offers a variety of colors and interesting vein patterns. It can also be polished

➤ Pan, the mythological god of woodlands and pastures, is often shown with a human torso and goat's legs and horns. This work was carved from an older sculpture, and traces of drapery and a fringe from the original carving are still visible on the back. What does the figure hold in its right hand? Why is this a fitting instrument for a sculpture representing this particular character?

Figure 4.13 Giovanni Angelo Montorsoli. *Reclining Pan.* c. 1535. Marble. 134.5 cm (53"). The Saint Louis Art Museum, St. Louis, Missouri. Purchase.

➤ Sculptures are said to invite viewers to touch them. In your opinion, does this work extend such an invitation?

Figure 4.14 Hans Tilman Riemenschneider. *Three Holy Men.* c. 1494. Lindenwood. 53.3 x 33 cm (21 x 13″). Würzburg, Germany. The Metropolitan Museum of Art, New York, New York. The Cloisters Collection, 1961.

➤ Are you able to identify either of these figures as male or female? Since literal qualities are lacking here, on what aesthetic qualities should viewers focus their attention?

Figure 4.15 Barbara Hepworth. *Two Figures.* 1947–48. Elmwood with white paint. 96.5 x 68.6 x 58.4 cm (38 x 27 x 23″). University Art Museum, University of Minnesota, Minneapolis, Minnesota. John Rood Sculpture Collection.

to a glasslike surface, or left rough and heavily textured. A mythological figure carved in marble by a student of Michelangelo illustrates the range of different textures possible with this material (Figure 4.13).

Different textured surfaces can also be realized in another favorite material of sculptors—wood. For thousands of years woodcarvers have turned to this medium because of its warmth, color, and grain. A work from the fifteenth century shows what a skilled carver can accomplish with this versatile material (Figure 4.14). Although it was customary to paint wooden sculptures at that time, the artist responsible

for this work preferred to leave it uncolored. In this way the warm, natural color and fine grain of the wood could add to the visual appeal of a carving of three holy men.

The realistic figures in this five-hundred-year-old carving certainly contrast with the two wooden figures carved in 1947–48 by the British sculptor Barbara Hepworth (Figure 4.15). Hepworth's abstract sculpture forsakes realism in favor of an interesting combination of solid form, concave areas, and negative shapes or holes. Like the earlier carving, it too makes the most of the material from which it is carved.

Casting

In **casting**, *a melted-down metal or other liquid substance is poured into a mold to harden*. This method allows the artist to duplicate an original sculpture done in wax, clay, plaster, or some other material. The technique is practiced today much as it has been for hundreds of years. Known as the *cire-perdue*, or "lost wax" process, it was used to re-create in bronze a clay portrait of a woman (Figure 4.16) by Alberto Giacometti (**jah**-cuh-**met**-ee). The complex procedure involved the following operations:

- Giacometti first completed a clay model.
- Plaster (or gelatine) was applied to the model in sections. This made it easy to remove each section once it had hardened.
- A layer of melted wax was brushed onto the inside surface of each plaster section. The thickness of this wax layer determined the thickness of the bronze walls of the finished, hollow sculpture. The size of a sculpture usually determines the thickness of its walls. A large work requires thicker walls than a small one.
- The wax-lined plaster sections were then reassembled and filled with a solid core of fireproof material. This is usually a mixture of plaster and silica, or silica and brick dust.
- Once the core was dry, the plaster sections were removed, leaving the wax surface exposed. Several long metal pins were pushed through the wax into the core, holding it in place.
- Wax rods were attached to the wax layer around the core. These served later as air vents and conduits, or channels, for the molten metal.
- The wax model, along with rods and core, was placed upside down in a container and a mixture of plaster and silica was poured around it. This was allowed to be hardened into a *fireproof mold* called an **investment**.
- The investment was heated in a kiln and the melted wax allowed to run out. It is for this reason that the process is called *cire-perdue*, or lost wax. The metal pins inserted earlier maintain the gap between the core and the investment as the wax that previously separated them melted and ran out.
- Molten bronze was poured into the empty space between the inner core and the investment. In this way metal replaced areas that were previously filled with wax.

- The sculpture was taken from the kiln and the inner core and investment removed. The pins, air vents, and conduits were cut off and the surface of the sculpture cleaned and finished.

Casting offers several advantages to the sculptor, not the least of which is the opportunity to work with a soft, pliable medium to create the original sculpture. By casting his clay portrait in bronze, Giacometti maintained the richly textured surface of the clay, producing a work that is a joy to look upon and tempting to touch. Moreover, he was able to make six versions of it.

➤ Would you describe this as a realistic portrait? Realistic or not, does it have some lifelike qualities? If so, to what do you attribute those lifelike qualities?

Figure 4.16 Alberto Giacometti. *Bust of Annette IV.* 1962. Bronze. 58.2 cm (22⅞"). McNay Art Institute, San Antonio, Texas. The Mary and Sylvan Lang Collection.

➤ Explain how this work makes use of both sculpture and painting. Do you think this is a successful work of art? What aesthetic qualities would you use to defend your judgment?

Figure 4.17 Marisol. *The Generals.* 1961–62. Wood and mixed media. 221 x 72.4 x 193 cm (87 x 28½ x 76"). Albright-Knox Art Gallery, Buffalo, New York. Gift of Seymour H. Knox, 1962.

Assembly

In the process of **assembly**, *the artist gathers and joins together a variety of different materials to construct a three-dimensional work of art.* Unlike the other sculpture processes, assembly is a modern technique. Marisol chose to use wood, plaster, and other common materials to construct an amusing sculpture that pokes fun at military heroes (Figure 4.17). Her work is a far cry from the statues of the past in which grand military leaders were shown boldly advancing into battle astride mighty steeds. Marisol paints the serious and dignified faces of her "heroes" on wooden blocks that serve as their heads. Their mighty steed is nothing more than a barrel mounted on legs that were once part of an ordinary table. Presented in this manner the heroes appear ridiculous, and subjects for jeers rather than cheers. Identify other ways Marisol has introduced humor in this sculpture.

While Marisol made some use of "found objects" in her work—the table legs—James Love used nothing else in his whimsical sculpture of a choir director (Figure 4.18). However, the pose is so familiar that it often takes a second, closer look before viewers discover that it is made from items found in almost any tool shed.

Another form of assembly is represented by Seymour Lipton's welded metal sculpture entitled *Sorcerer* (Figure 4.19, page 90). Lipton's technique involved cutting sheet metal into pieces, bending them into shape, and welding them together edge to edge. Different colors and textures were obtained by melting small amounts of metal onto the surfaces of his works.

Although abstract, *Sorcerer* can be recognized as a figure with arms outstretched as if performing a ritual of some kind. A strange form rises upward from a

➤ Are you able to identify the objects from which this sculpture is made? Did you recognize these objects immediately—or did this recognition come later?

Figure 4.18 James Love. *Choir Director.* 1959. Iron. 35.9 cm (14⅛"). McNay Art Institute, San Antonio, Texas. The Mary and Sylvan Lang Collection.

➤ How is the principle of harmony demonstrated here? What do you find most appealing about this work, its visual qualities or its expressive qualities?

Figure 4.19 Seymour Lipton. *Sorcerer.* 1957. Nickel silver on metal. 154.3 cm (60¾″). Whitney Museum of American Art, New York, New York. Purchase, with funds from the Friends of the Whitney Museum of American Art.

container in front of the figure. Perhaps it is a spirit or a genie. Awakened by the magical incantations of the sorcerer it comes forth to do his bidding.

Kinetic art is *a sculptural form that actually moves in space.* This movement continually changes the relationships of the shapes and forms that have been assembled to make up the sculpture. Movement can be caused by such forces as the wind, jets of water, electric motors, or the actions of the viewer. For example, the long stainless-steel strips in George Rickey's sculpture are so delicately balanced that they are set in motion by the slightest current of air (Figure 4.20). As they move, they continually create new relationships to each other and to the constantly changing background of sky, clouds, and trees.

Movement in sculpture is no longer limited to the gyrations of actual shapes and forms in space. The

Greek-born American sculptor Chryssa shaped and assembled neon light tubes inside a transparent box to create a sculpture of moving lights (Figure 4.21). A flip of a switch and she sets in motion a constantly changing pattern of brightly colored lights that come on and go off in a predetermined sequence. This is an art form clearly rooted in the twentieth century. Her unique and colorful works are said to have been inspired by the illuminated lights of New York's famous Times Square.

Today's sculptors, given the advantage of new materials and processes, are creating artworks that go beyond the wildest dreams of artists of just a generation ago. No one can predict what the sculptures of the future will look like. In one important way, however, they will be like those of the past and present: They will continue to record the full range of human experience in ways that are sometimes shocking, sometimes touching, but always exciting to see, to touch, and to experience.

➤ What gives this work a sense of weightlessness? Do you think this sculpture's movement is fast and jerky, or slow and smooth? If slow and smooth, how do you think it would make you feel while watching it?

Figure 4.20 George Rickey. *Two Lines Oblique Down, Variation III.* 1970. Stainless steel. 6.4 x 4.6 m (21 x 15′). Denver Art Museum, Denver, Colorado. Acquisition 1972.66.

➤ What elements and principles would you be certain to mention if asked to describe this work? What kinds of feelings or moods do you associate with this sculpture? What makes it difficult to respond to a picture of this work?

Figure 4.21 Chryssa. *Fragments for the Gates to Times Square.* (Detail.) 1966. Neon and plexiglass. 205.7 x 87.6 x 69.9 cm (81 x 34½ x 27½"). Whitney Museum of American Art, New York, New York. Purchase, with funds from Howard and Jean Lipman.

SECTION TWO

Review

1. Name four sculpture processes.
2. Which sculpture process can be described as additive, and which is subtractive?
3. Why is marble favored by many carvers?
4. In which sculpture process is a mold used and what is the mold called?
5. Describe the assembly process and list five materials suitable for use in an assemblage.
6. What is kinetic art and how does it differ from sculpture in the round?
7. Select a freestanding sculpture shown in this chapter and describe the steps in the process used by the sculptor to create the piece.

Creative Activity

Humanities. Architecture sometimes takes on a sculptural quality. Contemporary California architect Frank Gehry gets his ideas from everything he sees. "I'm like a vacuum cleaner," he says. "I look at everything and I have a good memory for space and form. I fantasize in 3-D." Gehry will often sketch an idea on a restaurant napkin and then develop it in three dimensions as a paper sculpture before drawing floor plans.

Learn more about Frank Gehry and other current architects who are breaking away from the ordinary.

RELIEF SCULPTURE

Using pieces of plastic foam covered with plaster, create a relief sculpture. This sculpture can be done in either high or low relief and can be abstract or make use of recognizable subject matter. The finished sculpture should exhibit an interesting pattern of contrasting light and dark values created by forms extending outward from the background. The marks of the spatula used to apply the plaster will provide an overall actual texture that will add harmony to the work. This surface should be both appealing to the eye and inviting to the touch.

Focusing

Examine the low-relief and high-relief sculptures illustrated in this chapter (Figures 4.4 and 4.5). What are the advantages of this particular form of sculpture? What are its disadvantages? Which of the two relief sculptures appeals to you? Why?

Creating

Complete several sketches for a relief sculpture. This sculpture can be either abstract or realistic. As you work out your design in pencil, determine if you wish to create a work in low or high relief.

Use the large sheet of plastic foam for the background of your relief. Then cut out the various forms for your relief from other pieces of foam. These can be cut easily with a hacksaw blade. Safety Tip: Saws should be handled carefully. Cut away from the face, keep the other hand away from the cutting area. Brace the piece to be placed in the vise before cutting. Use a mask and protective eye goggles.

Arrange the pieces of your relief on the large foam sheet. You can try out various arrangements by fastening the pieces in place with toothpicks. When you are satisfied with the design, glue the sections together with white glue.

Mix plaster in a large bowl and apply it quickly to the surface of your relief with a spatula. Safety Tip: Use a dust mask when mixing powdered plaster. Think of this process as similar to applying frosting on a cake. Keep the surface smooth, but recognize that the spatula marks add an interesting texture. Cover the entire sculpture, including the background, with plaster.

If two or more sessions are needed to finish the plastering, remember to dampen all the previously plastered surfaces before beginning anew. This will prevent separation and cracking.

Use fine sandpaper to lightly smooth the surface of the finished sculpture. Safety Tip: Use a dust mask when sanding plaster surfaces. Sand only in a well ventilated area. After sanding, examine your sculpture and determine if a bronze finish, or patina, would add to its visual appeal. *Patina* is defined as a film that can form naturally on bronze and copper (by long exposure to air) or artificially (by the application of acid, paint, etc.) to a

Figure 4.22 Student Work

- *Describe.* Is your work best described as abstract or realistic? If realistic, is the subject matter easily recognized? Is your sculpture done in high or low relief?
- *Analyze.* Does your work exhibit an interesting pattern of contrasting light and dark values? Is there an actual texture created by the marks of the spatula?
- *Interpret.* Does your sculpture appeal to the viewer's sense of touch?
- *Judge.* Do you consider your relief sculpture a success? Is this judgment based upon a consideration of its literal, design, or expressive qualities?

surface. A simulated bronze patina can be achieved by using shellac (white or orange) and powdered tempera paint in the following manner.

1. Generous portions of black, green, and blue-green powdered tempera paint are poured from their containers onto sheets of newspaper spread over a tabletop in a large, well-ventilated room.
2. A *small* amount of shellac is poured into a flat container. The amount is kept small since the unused shellac will be too contaminated for future use.
3. A stiff brush is dipped into the shellac and then into the black powdered tempera paint. This mixture is brushed thoroughly over the entire relief, including the edges.
4. When the entire surface of the relief is blackened and while it is still tacky, a light application of green or blue-green powdered tempera is lightly brushed over the entire surface. In this way, the raised portions of the relief will be highlighted.
5. The "patina" process can be repeated on any section of the relief that fails to look bronzelike.

Safety Tip

Dust masks and rubber gloves should be worn when mixing and handling shellac and powdered tempera. Use a mask when applying mixture with a stiff brush.

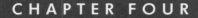

Review

Reviewing the Facts

SECTION ONE

1. A critic holding which aesthetic view would favor Duane Hanson's sculpture *Janitor* (Figure 4.1, page 78). Explain why.
2. What is a relief sculpture?
3. List two works in this chapter that are made out of clay.
4. Name a sculpture shown in this chapter that would be considered successful by a critic favoring the emotionalist view.

SECTION TWO

5. Name the sculpture process in which the artist builds up and shapes the piece with a pliable material.
6. Which sculpture process is a subtractive process?
7. Which sculpture process is a method of duplicating by using a mold?
8. Name and describe the sculpture process used by Marisol in Figure 4.17.
9. What are "found objects"? Identify two works illustrated in this chapter that make use of found objects.
10. What is the unique aspect of kinetic art?
11. Why would Chryssa's neon light sculpture (Figure 4.21, page 91) not have been made in the nineteenth century?

Thinking Critically

1. **Analyze.** Imagine that you are on a committee considering the purchase of a sculpture for a nearby museum. Your qualifications to serve on this committee are based upon your professional experiences as (select one of the following): an aesthetician, an art critic, or an art historian.

Assume that the list of potential purchases has been narrowed to include the sculptures illustrated in this chapter. Drawing on your professional background, which work would you identify as your first choice? Prepare a written justification for your choice.

2. **Evaluate.** On the board, prepare three columns labeled "aestheticians," "art critics," and "art historians." In each column, list the sculptures selected by students playing each of these roles. Discuss the results. Were there any sculptures identified by students in all three groups? Which work or works were preferred by the aestheticians? Which were preferred by the art critics? Which works did the art historians select? Defend your personal choice by referring to your written justification. Listen closely while other members of the class do the same. Then take a poll to determine which work should be "purchased" by the museum.

Using the Time Line

Select one of the three-dimensional works identified on the time line and note when it was completed. Look through the book to find a two-dimensional work that was created within twenty-five years of the sculpture you selected. Do these two works have anything in common? If they differ, can you think of reasons why?

1800 1850 1900 1950 2000 A.D.

- Giacometti. *Bust of Annette IV*
- Marisol. *The Generals*
- Love. *Choir Director*

Hepworth. *Two Figures*

Robus. *Despair*

Rodin. *Bust of a Woman*

Brancusi. *Mlle Pogany*

Portfolio

Clay Holley, Age 16
Dobson High School
Mesa, Arizona

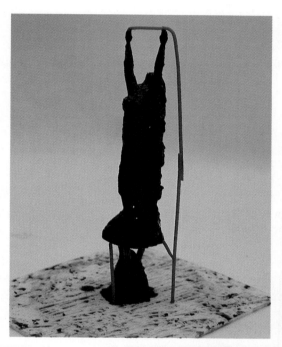

Clay created a bronze sculpture using the casting process. He began by soldering a framework for the wax he would use to build up the form for the sculpture.

"I chose to do a sculpture of the human body because of its beauty. I learned that wax is a flexible medium to work with but that it is also difficult to control." During the casting process, Clay pours molten bronze into the mold.

Clay's main goal for the project was to learn the techniques involved. When evaluating the finished work, he said, "I liked the way the hair turned out. I was least satisfied with the hands and feet; I would have liked to add more detail. My advice to other students is to take your projects step by step."

➤ *Figure of a Woman.* Bronze. 18 x 8 cm (7 x 3").

Using Art History, Art Criticism, and Aesthetics

Objectives

After completing this chapter, you will be able to:

➤ Describe the steps art historians and art critics use to evaluate works of art.

➤ Explain the relationship between the aesthetic qualities and theories of art.

➤ Point out the value of the literal, design, and expressive qualities in works of art.

➤ Explain how the use of the art-criticism operations, followed by the art-history operations, enables a viewer to gain the understanding and knowledge needed to make and defend personal judgments about works of art.

Terms to Know

design qualities
expressive qualities
literal qualities
style

Figure 5.1 Jean-Baptiste Siméon Chardin. *Young Student Drawing.* c. 1738. Oil on wood. 21 x 17.1 cm (8¼ x 6¾"). Kimbell Art Museum, Fort Worth, Texas.

People have always shown a great deal of interest in art, although

in recent years this interest has increased dramatically. Signs of this increased interest

are everywhere. Bookstores display attractive new books on art and artists. Motion picture

studios produce major films on such artists as Michelangelo, Vincent van Gogh, and

Paul Gauguin. Television networks present prime-time specials on art. Meanwhile,

museum officials report that attendance continues to rise every year.

SECTION ONE

Art History: Learning about Works of Art

Discussions about art are no longer confined to whispered comments in quiet museum corridors or lively exchanges of opinion at noisy gallery openings. People talk about art every day in homes, schools, and shopping malls—wherever pictures are hung to be seen. For example, a group of students strolling through a mall notice a large art print in the window of a bookstore. A passerby might hear such statements as these: "Now that's something I wouldn't mind hanging in my room." "Not me; I think it's a mess!" "Well, I think there are some good things to say about it." "There are? Name one!" "I don't care what you say, I like it." "That's fine—you can have it."

Viewing Works of Art

You may have noticed that all these statements have something in common. Look again and you will see that they all deal with likes and dislikes. This is a common feature of many conversations about art. As long as the discussion centers on what people like or dislike, everyone participates. However, the talk trails off quickly after everyone voices an opinion.

People with little experience in art usually have no special way of looking at paintings or sculptures.

➤ What is your first impression of this painting? Why do you think you respond to it in that way? Do you think you could learn enough about this work during a brief examination, or would you like to study it carefully?

Figure 5.2 Meindert Hobbema. *A Pond in the Forest.* 1668. Oil on oak panel. 60 x 84.5 cm (23⅝ x 33¼"). Allen Memorial Art Museum, Oberlin College, Oberlin, Ohio. Prentiss Bequest, 1944.

Often they do not know what to look for in a work of art. They may glance at the work and decide at once if they like it or not. If they do, they may take time to look at it more closely. On the other hand, if their first impression is not favorable, they probably will not take time to examine the work of art further. A realistic landscape by Meindert Hobbema (**mine**-dirt **hob**-uh-muh) (Figure 5.2, page 97) might cause a group of museum visitors to stop and express their admiration with such a statement as "Everything looks so peaceful and realistic, you wish you were really there in the picture." On the other hand, a quick glance and a whispered "What's that supposed to be?" may be enough as they hurry past an abstract work by Stuart Davis (Figure 5.3).

Unfortunately, people who do this miss out on a great deal. For one thing, they fail to experience the joy of discovering how these two artists responded to different situations in different ways. Hobbema succeeded in giving us a glimpse of a Dutch landscape just as it must have looked over three hundred years ago. Davis, however, did not try to make his painting look real. Instead, he combined abstract images in a composition that suggests the sights one might see from the windows of an elevated train in a twentieth-century American city. His black-and-white work is certainly very different from Hobbema's, but this does not mean that Davis's work is less successful or that it cannot be appreciated. As you will begin to understand, both works can be appreciated but for different reasons.

Many people seem willing to point to artworks that they think are good or successful. However, they often have trouble when it comes to offering good reasons for their decisions. Some might say that a work of art is good if it looks real; others, because it was painted by a famous artist. These reasons are neither convincing nor valid. After all, not all successful artworks are realistic, nor were they always done by well-known artists.

In order to make and support intelligent judgments about a work of art, you must first learn as much about the artwork as you can. Learning leads to understanding. Only when you understand a work of art is it possible to make a decision about it and to defend that decision with good reasons. How, exactly, do you learn about the work of art? Where do you turn to find information about it?

Two ways of looking and learning in art are art history and art criticism. You can use an art-history approach when you want to learn *about* a work of art. An art-criticism approach will help when you want to learn *from* a work of art. When both of these approaches are used, they can help you understand and appreciate many different kinds of art. Before you can do this, however, you should become familiar with the differences between these two ways of looking and learning in art. For this purpose, you will be introduced to two imaginary characters. One will be someone who has worked in the field of art history. We will call her Helen. The other will be an art critic named Robert.

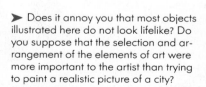

➤ Does it annoy you that most objects illustrated here do not look lifelike? Do you suppose that the selection and arrangement of the elements of art were more important to the artist than trying to paint a realistic picture of a city?

Figure 5.3 Stuart Davis. *Sixth Avenue El.* 1931. Lithograph. 30.4 x 45.6 cm (11¹⁵⁄₁₆ x 17¹⁵⁄₁₆"). McNay Art Museum, San Antonio, Texas. Gift of the Friends of the McNay.

The Art-History Approach

As an art historian, Helen is mainly interested in identifying and learning about works of art. She tries to place them within a framework of time and place. When studying a work of art, she tries to find out such things as these:

- When was it done?
- Where was it done?
- What style of art does it represent?
- What artists or works of art influenced the artist?
- What impact did the artist or the work have upon artists and works that followed?

To learn all these things, Helen realizes that it is helpful to have a plan of action. Helen's plan makes use of four steps, or operations, which she calls *Description, Analysis, Interpretation,* and *Judgment.*

In Helen's plan

- *Description* means discovering when, where, and by whom the work was done.
- *Analysis* means discovering the unique features of a work of art.
- *Interpretation* means discovering how artists are influenced by the world around them.
- *Judgment* means making a decision about a work's importance in the history of art.

Because Helen will apply these steps from the art historian's point of view (discovering facts *about* a work of art), she will call them *art-history operations.* Later, you will see that these steps, applied in a different way, can be used for art criticism (or learning facts *from* a work of art).

Observe how an art historian works as you follow Helen's use of these four operations. She is examining a painting of a young girl with a watering can (Figure 5.4).

Description: Discovering When, Where, and by Whom the Work Was Done

During this first operation, Helen tries to find out who painted the work as well as to learn when and where it was done. In this instance, her knowledge of art history enables her to immediately identify the artist. Helen does not even have to refer to the signature in the lower right-hand corner of the picture to know that it was painted by the well-known French artist Pierre Auguste Renoir (pee-**air** oh-**gust** ren-**wahr**). A date next to the signature reveals that the painting was done in 1876. Since Renoir was born in

> Look at the information given in the credits below. Make a note of the artist's name. The date given is the year he painted this picture. What other information is provided?

Figure 5.4 Pierre Auguste Renoir. *A Girl with a Watering Can.* 1876. Oil on canvas. 100.3 x 73 cm (39½ x 28¾"). National Gallery of Art, Washington, D.C. Chester Dale Collection, 1962.

1841, Helen realizes that this picture was painted when the artist was thirty-five years old.

At other times Helen might not recognize the artist so easily. Then she would carefully examine the work to see if the artist had signed it. Usually a signature would be found, although it might be the name of an artist unknown to Helen. This would require her to do research on the artist. She would examine books, magazine articles, newspaper clippings, and letters to learn as much as possible about the artist. In most cases, the needed information is found in readily available sources. However, sometimes a great deal of additional time and effort must be put into research before all the important facts are uncovered.

There are times, of course, when no signature is found on a work of art. Even after a long investigation, it might be impossible to say for certain who created the artwork. Then Helen would make a well-informed

guess. She would base her guess upon the information gathered during her investigation. You may have noticed on your trips to museums that some identification labels state that the works are "attributed to" or are "from the school of" this or that artist. These are instances where historians have not yet been able to identify the artist with certainty.

Analysis: Discovering the Unique Features of a Work of Art

Great artists have special ways of seeing and, with their art, they develop their own ways of showing us what they see. Historians call this the artist's individual **style**, or *personal way of using the elements and principles of art to express feelings and ideas*. For Georges Rouault (zjorzj roo-**oh**) this individual style consists of using a bold, dark outline around brightly colored shapes (Figure 5.5). Paintings by this artist look like stained-glass windows. In this case, the art-

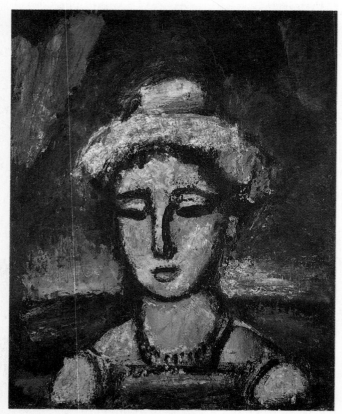

➤ Rouault's unique style involved the use of a heavy, dark outline enclosing brightly colored shapes. As a result, his pictures look like stained-glass windows.

Figure 5.5 Georges Rouault. *The Italian Woman*. 1938. Oil on panel. 79.4 x 63 cm (31¼ x 24¹³⁄₁₆"). Dallas Museum of Art, Dallas, Texas. Gift of Mr. and Mrs. Vladimir Horowitz.

ist's painting style is as personal and unique as a signature (see also Figure 23.4, page 535).

Following many years of study, historians are able to recognize the main features of an artist's style. They also learn that this style often develops gradually as the artist's special way of seeing matures and as his or her artistic skills are perfected. A historian who has studied the development of an artist's style can usually tell if a work of art was done early or late in the career of that artist.

During analysis, the historian tries to learn about the style of an artwork by examining its features. When Helen examines the painting of the girl with a watering can, she sees certain features that she has learned to associate with Renoir's individual style. For example, she notes that strong, pure colors are used in the painting. Also, the edges and details seem to be blurred. Only the child's face is painted in sharp detail. Everything else seems fuzzy, as if slightly out of focus. Helen knows that this was the artist's way of showing what the eye sees at first glance. The viewer's eye is attracted to the girl's face, and so this is painted with the most detail. With its rosy cheeks and blue eyes, the face is the center of attention. In contrast, the rest of the picture gives only a general impression. The child's body and the flowers in the garden seem to blur together in the bright sunlight. Renoir's picture shows what you might expect to see if you glanced up a garden path and suddenly spied a girl standing alone in the dazzling afternoon sun.

During analysis, Helen also tries to group Renoir's painting with other pictures having the same features but painted by other artists. She knows that many works of art have a "family resemblance," which allows historians to group them in the same category. Such works are said to have a group style.

A group style is evident to Helen as she continues to study the painting by Renoir. She observes that the picture is made of bright-colored paint applied in small dabs and dashes. She also notes that some colors are carefully placed next to their complementary colors. This technique makes the bright colors seem even brighter. For example, the red flowers at the top of the picture seem more brilliant because they are surrounded by green, the complementary color to red.

Helen knows Renoir's reason for using dabs of paint and carefully selecting and placing the hues in his picture. He was trying to show the flickering effect of sunlight on the child, the grass, and the flowers. She is convinced that light is an important part of this picture, perhaps even the most important part. This

decision enables her to group the painting with other works in which the effect of light on subject matter is a major feature. Paintings of this kind were first done in the nineteenth century by a group of French artists. Helen and other art historians now refer to the group style developed by those artists as *Impressionism.* One of the most famous artists in this group was Pierre Auguste Renoir.

Interpretation: Discovering How Artists Are Influenced by the World around Them

When *interpreting* a work of art, historians consider the influence of time and place upon the artist. They know that pictures of the same subjects painted at the same time but in different countries often reflect different traditions and values. As a result, these pictures may look quite different. A picture of the *Madonna and Child* painted in Italy during the fifteenth century (Figure 5.6) may be quite different from a picture of the same subject painted in Germany at about the same time (Figure 5.7). Moreover, historians know that pictures of the Madonna and Child painted in the same country but at different times may also have little in common. Works of art are created in real-world settings, which have a strong influence on artists. The setting contributes to the ideas formed by artists and the techniques they choose to interpret those ideas. It even influences the tools and materials artists use to put their ideas into visual form.

In an effort to discover how time and place influenced Renoir, Helen turns to sources of several types. She uses history books, biographies, magazine articles, and published interviews with the artist or people who knew him. From these sources, she learns that when he was thirteen Renoir was already earning a living by working in a porcelain factory painting

➤ Observe how these figures are modeled in light and dark values so they appear solid, round, and lifelike. Except for the halos, they look and act like real people.

Figure 5.6 Giovanni Bellini. *Madonna and Child.* c. 1470–75. Tempera and oil on wood panel. 82 x 58 cm (32⅜ x 22¾"). Kimbell Art Museum, Fort Worth, Texas.

➤ Do these look like real people in a real-world setting? Of course not. The figures may be detailed and very charming, but you certainly would not say that they are lifelike.

Figure 5.7 Stephen Lochner. *The Madonna in the Rose Garden.* c. 1430–35. Tempera on wood. Approx. 50 x 40.6 cm (20 x 16"). Wallraf-Richartz Museum, Cologne, Germany.

scenes on china. He used the money earned in this way to pay for his studies at a famous art school in Paris. It was there that he met two other young artists, Claude Monet (kload moh-**nay**) and Alfred Sisley (**sis**-lee), and the three became friends. Monet and Sisley convinced Renoir that he should leave his studio and paint outdoors in natural sunlight. Soon Renoir was painting alongside his friends trying, as they were, to capture in his pictures the fleeting, shimmering effects of sunlight on subject matter. In 1874, these three painters were among a group of artists who held a famous exhibition of their work. However, the critics scorned and laughed at their paintings. It was these critics who first called the artists *Impressionists* because their works showed a general impression of subject matter. The name was meant to belittle them, although time has changed that. Today, paintings by the Impressionists are among the most admired in the history of art.

The Impressionists were influenced by many things in their world. These influences included new scientific theories about light, the relationship of colors, and the way people see. The recently discovered camera also had an impact on them. They began to paint what seemed to be unstudied, candid views that looked like snapshots. Many of their pictures look as if the artist had come upon an interesting scene and was able to sketch it in a few minutes.

No subject was too small or unimportant for the Impressionists. They left their dark studios and ventured out into the sunlight to record all aspects of life around them. They painted simple scenes of common people going about their daily routines. Of little interest to them were the rousing battle scenes, famous national heroes, and solemn religious events favored by more traditional artists. Some of the Impressionists even found beauty in railway stations and the factory smoke that filled the sky over a nation that was becoming more and more industrialized. Renoir, however, preferred to paint the world at its happiest and most beautiful. He refused to include ugliness or evil or sickness in his pictures. It is not surprising then that he decided to paint a simple but happy scene of a little girl holding some flowers and a watering can.

Judgment: Making a Decision about a Work's Importance in the History of Art

Helen's examination of Renoir's painting concludes with her decision about its historical importance. She realizes that some paintings are more important than others because they were the first examples of new ideas or techniques that inspired artists who followed. She also knows that some works are valued because they are excellent examples of a great artist's fully developed individual style.

The date of Renoir's painting, 1876, tells Helen that it was done when the artist was most interested in the goals of Impressionism. She remembers that Renoir later moved away from Impressionism and painted pictures with more solid forms and clear outlines, but this painting has all the features of the mature Impressionistic style. Perhaps the most important of these features is the use of many colors applied in dabs and dashes to show the effect of sunlight flooding a casual, everyday scene. For this reason, Helen decides that the painting is an excellent example of Renoir's fully developed Impressionistic style. She places great historical importance on it.

Learning from External Cues

At this point you may be wondering why historians devote so much effort to the study of artworks. Perhaps Helen is on the staff of a museum where Renoir's picture is on display. Her research may be the first step leading to a publication on Renoir that museum officials want to have ready for a major exhibition of his work, or the results of her study might be presented in the form of gallery notes which are made available to museum visitors. These notes are found in many museums. They can be very enlightening to people who know little about Renoir, his style of painting, or his historical importance.

Of course, Helen may not work in a museum at all. She might be a professor of art history at a college or university. Her study of Renoir's painting may have been done as part of her preparation for a lecture on Impressionism, or perhaps she is planning to write an article on the artist for an art-history journal. In the article, she would share with other scholars what she has learned.

There are many reasons why historians do what they do. They also do it in many different settings. The important thing to remember, however, is that their knowledge and skill will be a help to you in your appreciation of art. They provide the facts and information about art that contribute so much to others' understanding and enjoyment of it.

As you can see, it is possible to learn a great deal about a work of art if you use the four art-history

Marilyn Richardson

Marilyn Richardson is a persistent and creative art historian whose investigations have led to the rediscovery of a long-lost work by nineteenth-century artist Edmonia Lewis. Lewis was the first African-American to win international acclaim as a sculptor in the nineteenth century.

Richardson (b. 1942) specializes in the history of African-American women. She first learned of Lewis while researching the history of nineteenth-century black women's intellectual and cultural history. Richardson discovered that Lewis's statue *The Death of Cleopatra* was first exhibited at the Philadelphia Centennial in 1876, where it received a great deal of interest. However, there was virtually no documentation of the statue's fate after the exhibition closed. According to Richardson, there are very few references to Lewis after late neoclassical sculpture lost its popularity in the 1880s.

Richardson eventually discovered that the white marble sculpture had been placed on the infield of Harlem Race Track in Forest Park, Illinois, marking the spot where the racetrack owner's favorite horse, Cleopatra, was buried. The racetrack closed during the 1920s, however, and was replaced by a golf course. Richardson notes, "The infield was flooded to create a water hazard," but the statue remained on an island.

The Death of Cleopatra was removed from the site, according to Richardson, when the golf course went out of business. The statue's whereabouts for the next few decades is a mystery, but Richardson has been able to document the statue's location in 1985, when it caught the eye of a fire chief who was inspecting a junkyard in nearby Berwyn. Richardson states, "The fire chief was a Scoutmaster, and he decided rescuing the statue was a good project for his troop." After several months of periodic digging, the Scouts dislodged the work. To the chagrin of preservationists, the troop also painted it.

Local news media attention of the Scouts' efforts alerted the Forest Park Historical Society to the statue's existence. The society gained possession of Lewis's historic work and planned to display it at the shopping center that had been built on the former site of the golf course. Before this plan was carried out, however, the ownership of the shopping center changed hands and the new mall owners did not wish to display the statue. Richardson says that *The*

Figure 5.8 Edmonia Lewis. *The Death of Cleopatra*. Exhibited at the World's Columbian Exposition, 1893. Chicago Historical Society, Chicago, Illinois.

Death of Cleopatra remains in storage at the shopping center. The statue's condition reflects the wear and tear of its travels, but a recently discovered 1893 photograph of the work will provide information to guide restoration efforts.

Richardson continues to research Lewis's life and is also conducting research on the extraordinary history of black people on the island of Nantucket. She finds historical investigation fascinating and states, "It's a particularly exciting moment to look into the study of African-American art and art history, especially studies in the eighteenth and nineteenth centuries, because there are wonderful discoveries to be made. A young scholar can make discoveries that will change the way we think of American art history."

	ART-HISTORY OPERATIONS			
	Description	**Analysis**	**Interpretation**	**Judgment**
External Cues	Determine **when, where,** and **by whom** the work was done.	Identify **unique features** to determine artistic style.	Learn how **time and place** influenced the artist.	Use information to **make a decision** about the work's importance in the history of art.

Figure 5.9 Art-History Operations

operations. During each of these operations, you can gather facts and information about the work and the artist who created it. Facts and information of this kind can be called *external*, or "outside," cues. (*Cue* is another word for "key" or "clue.") Figure 5.9 shows the external cues you should look for in each of the art-history operations.

Applying the Steps of Art History

Perhaps you are still not quite certain that facts and information about an artist or a work of art can have an effect upon your reaction to that work. If so, examine the painting by Arshile Gorky (are-**sheel gore**-key) showing a boy standing beside a seated woman (Figure 5.10). How do you react to this painting? If you were to see it in a museum, would you stop to look at it closely or quickly move on to something more interesting? What relationship do these two figures have with one another? How do you think *they* feel and how do *you* feel after looking at them? A brief look into the life of the artist and the circumstances leading up to his painting this picture might well change some of your answers to questions of this kind.

Gorky was born in the mountain forests of Turkish Armenia in 1905. When he was four years old, his father emigrated to the United States to avoid service

in the Turkish army. He left Gorky and his sisters in the care of their young mother. Four years later, Gorky and his mother posed for a photograph that was sent to his father in Providence, Rhode Island. Not long after that, in 1915, a bloody conflict between Turks and Armenians living within Turkish borders caused Gorky and his mother to flee Turkey. They marched 150 miles (241 km) to reach safety in Russian Armenia. That difficult trek and the hardships they endured in Russia were too much for Gorky's mother to bear. In 1919, just four years after their arrival, she died of starvation in her son's arms. She was only thirty-nine years old; he, a mere fourteen years old.

Not long after his mother's death, Gorky managed to emigrate to the United States. There, using the photograph taken years before as his inspiration, he painted a haunting double portrait of himself and his mother.

Look at Gorky's painting again. Has your reaction to it changed because of what you have learned about it? Do you think you might still casually pass it by if you came across it on a museum visit, or would you now stop and look deeply into those haunting eyes to share some of the sorrow the artist must have felt as he painted it?

Of course, this does not mean that every work of art will have a story behind it that will affect your reactions to the work. However, if you fail to look for such a story, you may be missing important information. In your quest for knowledge and understanding, this may not be a risk you wish to take.

➤ Look at the people in this painting. Do you find a haunting quality in the faces? What kind of relationship do you suppose exists between the two? How do you feel when you look at this painting?

Figure 5.10 Arshile Gorky. *The Artist and His Mother.* c. 1926–36. Oil on canvas. 152.4 x 127 cm (60 x 50"). Collection of Whitney Museum of American Art, New York, New York. Gift of Julien Levy for Maro and Natasha Gorky in memory of their father.

SECTION ONE

Review

1. When an art historian *describes* a work of art, what information is given?
2. What is meant by the term *style*?
3. Describe the primary characteristic of Georges Rouault's style.
4. What does an art historian do during the operation of *analysis*?
5. When *interpreting* a work of art, what factors are examined by the art historian?
6. Look at Renoir's *A Girl with a Watering Can* (Figure 5.4, page 99) and explain what an art historian would consider while *judging* it.
7. Select one of the four art-history operations and apply it to Arshile Gorky's *The Artist and His Mother* (Figure 5.10, page 105).

Creative Activity

Humanities. Just as the conditions of a time in history affect the visual artist, so do they affect music, literature, drama, and all the other arts. The 1930s in this country felt the impact of the stock market crash in 1929 and the Great Depression that followed. Two themes—the anguish of want and the patriotic hope for a future—color all the arts of the 1930s.

Read about the Works Progress Administration (WPA), a government program that paid artists to paint, write poetry, and compose music. Research more about this era, and report to your class what effect the times had on the subject matter of the art produced in the 1930s.

Art Criticism: Learning from Works of Art

Art critics, like art historians, have their own methods of studying works of art. They use these to learn as much as possible from all kinds of artwork. They carefully study works of art, searching for information that will increase their understanding of them. They gather facts found in works that will enable them to make and defend intelligent judgments about them. Often, the methods used by art critics make use of the same four operations used by art historians: Description, Analysis, Interpretation, and Judgment. However, critics work from a different point of view.

The Art-Criticism Approach

Art critics use the operations of description, analysis, interpretation, and judgment to gain information from the artwork itself rather than gathering facts about the work and the artist from books, articles, letters, and other external sources. Used by a critic, these operations direct attention to *internal cues*, that is, cues found *in* the work itself. When examining a painting, critics try to answer such questions as these:

- What is in the artwork?
- How is the artwork designed or put together?
- What does it mean?
- Is it a successful work of art?

To understand more clearly how the critical and historical approaches differ, follow along as the art critic named Robert examines a painting. The work in question is a landscape featuring a windmill silhouetted against a golden sky (Figure 5.11). You will be studying the way the art critic, Robert, uses the operations of description, analysis, interpretation, and judgment to examine this painting. In this way you will learn *how to look at works of art*.

Description: Discovering What Is in the Work

The first thing that Robert does is to make a complete list of all the people and objects he sees in the painting. In other words, he takes inventory of the literal qualities, or *realistic qualities*, he sees in the work. He makes sure to include everything on his list no matter how small and unimportant it might seem. In this way, he notices the solitary dark windmill and the way it stands out against the sky. Houses and stone barns surround the mill, which is perched on a curved rampart overlooking a quiet river. A glowing sunset is reflected in the still water of the river below.

Describing the Details

Looking closer, Robert begins to identify details in the picture. Almost lost in the deepening shadows of dusk are the dim figures of a woman and a child at the lower left. They have crossed a small bridge and walk slowly in the direction of two figures at the river's edge. One of these figures seems to be a woman who may be washing clothes carried to the river in the basket resting on the ground behind her. A boat glides silently into the picture at the far right. Its sail is furled and a man tends the oars. In the lower half of the picture, shadows creep over the scene. Overhead, the approaching night descends to extinguish the golden glow of the setting sun.

Describing the Elements

Satisfied that he has found all the important details in the picture, Robert turns his attention to listing the *elements of art* used. As he studies the painting, he makes note of the different hues, values, lines, shapes, textures, and space relationships in it. He is surprised to find that there are few hues in the work. In fact, the picture has just three main hues—brown, yellow, and blue. There are, however, different values of these hues. They are dark in some places and light in others. Robert also notices that the large brown shapes in the lower half of the picture have strong outlines, which help to separate them from the sky behind. The glow in that sky is a deep glow created with a heavy application of paint. This also adds to the painting's rich textural surface.

Having found all the objects, important details, and elements of art, Robert has now completed his description of the painting. He is now ready to move on to the analysis, the second step of the art-criticism process.

Analysis: Discovering How the Work Is Organized or Put Together

During analysis, Robert tries to learn how the elements of art found in the picture are organized. To do this, he concentrates on the *principles of art*. When he

➤ Look carefully at this painting. How many people and objects are you able to see?

Figure 5.11 Rembrandt van Rijn. *The Mill.* c. 1650. Oil on canvas. 87.6 x 105.6 cm (34½ x 41⅝"). National Gallery of Art, Washington, D.C.

has determined how well the elements have been organized, Robert will have an understanding of the painting's **design qualities**, *or how well the work is organized, or put together.*

Using the Design Chart

Robert decides to complete a *Design Chart*, which will help him analyze this picture and act as a check sheet. He can use it to identify the relationships between elements and principles found in the work. If you were to look over Robert's shoulder, you might see him working on a chart like the one in Figure 5.12, page 108.

Robert's Design Chart records the most important relationships between the elements and principles of art observed in the picture. Notice, for example, that

the first mark (#1) is placed at the intersection of hue and harmony. This reflects his decision that an uncomplicated, uniform appearance is due mainly to the fact that the yellow and brown hues in particular are distributed throughout the entire composition. Gradation in both hue (#2) and value (#3) is noted in the sky, where pale yellow and pale blue toward the center change gradually to dark brown at the left and top.

Robert's chart also indicates that the dark values in the sky are repeated in the lower half of the work, adding harmony to the painting (#4). Texture is accounted for by a mark under variety (#5). Variety in texture has been achieved by a difference in the way the sky and the shadow area have been painted. The

	PRINCIPLES OF ART						
	Balance	Emphasis	Harmony	Variety	Gradation	Movement/ Rhythm	Proportion
Color: Hue			X (#1)		X (#2)		
Intensity							
Value			X (#4)		X (#3)		
Value (Non-Color)							
Line							
Texture				X (#5)			
Shape/Form		X (#6)	X (#7)				
Space						X (#8)	

ELEMENTS OF ART

UNITY

Note: Do not write in this book.

Figure 5.12 Design Chart

sky reveals a thick application of paint, while the shadow area is more thinly painted. This change in texture helps to increase the visual and tactile interest of the work.

The dark shape of the solitary windmill is clearly the center of interest in this painting. This emphasis is achieved by the contrast between the windmill and the lighter value of the sky behind. For this reason, Robert placed a mark at the intersection of shape and emphasis (#6). He also decided that shape and harmony are related (#7). The principal shapes in the work are unified by their similarity in value.

Observing that overlapping shapes were used to lure the viewer's eye deeper and deeper into the work, Robert placed a final mark at the intersection of space and movement (#8). As he did so, he saw that this illusion of space is accented by the differences in values noted earlier (#3). The darker parts of the sky appear to be much closer, while the lighter parts seem to extend far back into the picture.

Of course, Robert could have gone on to identify additional design relationships in the picture had he chosen to do so. Many other, more subtle relationships could have been uncovered with further analysis. Having done this many times before, Robert had de-

veloped fully his skills at analysis. (Although he remembers how difficult it had seemed when he was learning how to analyze works of art.) However, on this occasion, he is satisfied with his identification of the most important and obvious design relationships. Now, having done this, he is ready to move on to the third step of art criticism, interpretation.

Interpretation: Discovering the Meaning, Mood, or Idea in the Work

Robert is eager to interpret the picture because he knows that this is the most exciting and the most personal of the art-criticism operations. Here he takes everything he learned about the work during the processes of description and analysis and tries to determine what it means. His concern centers on identifying the **expressive qualities**, or *the feelings, moods, and ideas communicated to the viewer*. However, Robert realizes that a work of art is often complicated. It can be interpreted in different ways by different people. For this reason he does not believe that his interpretation will be the only one possible. He knows that his interpretation will be a personal one, based upon information he has gathered from the picture.

Interpreting the Work

For a time, Robert viewed the painting as a possible symbol or idea. Perhaps, he thought, the windmill, steadfastly silhouetted against the sky, was meant to represent and honor the patriotism of a brave people or nation. The longer he viewed the picture, however, the more Robert began to feel that it represented peacefulness and stillness. It is evening and the day's work is done. The only sounds are the occasional creaking of the old mill, the gentle splash of boat oars, the muffled voice of a mother talking to her child. Darkness has started to settle over a drowsy world. In the shadows, half-hidden figures can be seen moving slowly as though weary after a long day's activity. In addition to peacefulness, there is a feeling of solitude and loneliness in the picture. This feeling can be traced to the single idle windmill outlined dramatically against the fading sunset. The great sweep of the sky seems to overwhelm the windmill and adds to its isolation. Robert finally decides that the picture presents a mood of peaceful silence. This mood, he feels, is tempered by a strain of loneliness and melancholy. It is a mood that he finds both comforting and restful. His examination of the painting's literal, design, and expressive qualities is complete. Now he is ready to make a judgment about the success of the artwork.

Judgment: Making a Decision about Works of Art

Judgment is the final step of the art-criticism process. The critic attempts to answer the question, "Is this a successful work of art?"

How the critic answers this question depends upon the particular aesthetic theory or theories he or she favors. These theories take into account different aesthetic qualities found in the artwork. These aesthetic qualities—the literal, the design, and the expressive—play important roles in the final art-criticism operation.

Aesthetic Qualities and Theories of Art

You may wonder why the literal, design, and expressive qualities have been singled out for discussion here. It is because these three seem to be the aesthetic qualities often referred to by critics during discussions about art.

➤ Imitationalism requires that a work of art look real, or lifelike, in order to be considered successful. Do you think that this painting would be appreciated by someone using that theory of art?

Figure 5.13 Élisabeth Vigée-Lebrun. *Self-Portrait.* 1781. Oil on canvas. 64.8 x 54 cm (25½ x 21¼"). Kimbell Art Museum, Fort Worth, Texas.

Imitationalism and Literal Qualities

Some critics feel that the most important thing about a work of art is the realistic presentation of subject matter. It is their feeling that a work is successful if it looks like, and reminds the viewer of, what he or she sees in the real world. People with this view feel an artwork should *imitate* life, that it should look lifelike before it can be considered successful (Figure 5.13). Their theory is called *imitationalism*.

Formalism and Design Qualities

Other critics feel that the design qualities, or the way the work is organized or put together, must be dominant for an artwork to be successful. They contend that the most important aspect of a work of art is the effective arrangement of the elements of art according to the principles of art. They believe that an effective organization depends upon how well the artist has arranged the colors, values, lines, textures, shapes, forms, and space relationships used in the

➤ Look at this painting closely. What elements of art did Matisse use in order to focus attention on the blouse the woman is wearing? What elements did he use to balance the composition? What principles of art did he use to arrange the elements? Do you think this painting has unity? Do you consider this a successful work of art? Why or why not?

Figure 5.14 Henri Matisse. *The Rumanian Blouse.* 1937. Oil on canvas. 73.3 x 60.6 cm (29 x 24"). Cincinnati Art Museum, Cincinnati, Ohio. Bequest of Mary E. Johnson.

work (Figure 5.14). Works of art that use these elements successfully are said to have an overall unity. This theory is known as *formalism*.

Emotionalism and Expressive Qualities

Other critics deny the importance of the literal qualities favored by imitationalism and the design qualities preferred by formalism. These critics claim that no object can be considered art if it fails to effectively communicate with the viewer. The expressive quality is most important to them. Their theory, called *emotionalism*, places greatest importance on the feelings, moods, and emotions communicated, or expressed, to the viewer by the work of art (Figure 5.15).

These three theories of art, summarized in Figure 5.16, can be useful when you look for different aesthetic qualities in works of art. Keep in mind, though, that each of these theories stresses some aesthetic qualities and rejects others.

Importance of Trying More than One Theory

It is during judgment, the last art-criticism operation, that Robert must make a decision about the merits of the painting entitled *The Mill* (Figure 5.11, page 107). He knows that some art critics might consider this painting successful because of its outstanding literal, or realistic, qualities. Others would do so because of the painting's superb design, or compositional qualities. Still others would do so because of its fine expressive qualities. Robert knows, however, that if he always uses the same theory with its emphasis only on certain qualities, he may be doing the artwork an injustice. He would be in danger of overlooking other important qualities stressed by the other theories.

This will also be true if you rely on a single art theory. It will cause you to limit your search for information to just those qualities favored by the theory you are using. This will place you at a disadvantage, especially when you examine different works of art. Imitationalism, for example, may be very helpful when examining works that are realistically painted.

➤ This work seems to ignore the literal and design qualities in an attempt to communicate a powerful message. Concentrate on the expressive qualities. Can you identify that message?

Figure 5.15 Louis Guglielmi. *Terror in Brooklyn.* 1941. Oil on canvas mounted on composition board. 86.4 x 76.2 cm (34 x 30"). Collection, Whitney Museum of American Art, New York, New York.

	THEORIES OF ART		
	Imitationalism	Formalism	Emotionalism
Aesthetic Qualities	Literal Qualities: **Realistic presentation** of subject matter.	Design Qualities: **Effective organization** of the elements of art through the use of the principles of art.	Expressive Qualities: **Vivid communication** of moods, feelings, and ideas.

Figure 5.16 Theories of Art and Aesthetic Qualities

However, it would be useless when examining paintings in which there is no realistic subject matter. In such cases, it would be wise to turn to one or both of the remaining theories.

Using More Than One Aesthetic Theory

To illustrate this last point, examine the painting by the Dutch artist Piet Mondrian (peet **mohn**-dree-**ahn**) (Figure 5.17). There is no recognizable subject matter in this painting. It is a work in which colors, lines, and

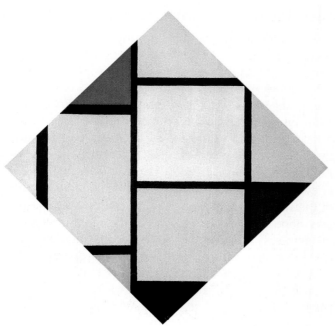

➤ Formalism, which stresses the importance of the elements and principles of art, would be helpful when you are trying to understand this painting.

Figure 5.17 Piet Mondrian. *Diamond Painting in Red, Yellow, Blue.* c. 1921–25. Canvas on hardboard. 142.8 x 142.3 cm (56¼ x 56″). National Gallery of Art, Washington, D.C. Gift of Herbert and Nannette Rothschild.

shapes have been used to create simple vertical and horizontal units. These units have been arranged in a precise and formal order. Since there is no subject matter, imitationalism, which emphasizes literal qualities, would not be useful here. Insisting on using this theory would result in rejecting Mondrian's painting as a successful work of art. In order to avoid this and gain an understanding of this painting, you would have to turn to another theory for help. Of the two remaining theories discussed, formalism and emotionalism, which do you think would be the most useful in helping you to understand this painting?

Formalism, with its emphasis on the elements and principles of art, would be the most helpful here. Why? Because the painting ignores both realistic subject matter and the expression of a mood or feeling. Instead, it makes use of carefully selected colors, shapes, and lines arranged to achieve an overall sense of unity or wholeness.

However, consider the painting by Matthias Grünewald (muh-**tee**-uhs **groon**-eh-vahlt) in Figure 5.18 on page 112. Although the subject is recognizable, it is hardly true-to-life and so it might be dismissed if imitationalism is used to determine its success. At the same time, it seems to ignore the rules of good design stressed by formalism. However, it would still be regarded as an outstanding work of art if another theory were used. This painting succeeds in communicating a powerful message to the viewer. By using emotionalism as a guide, the viewer is able to "read" this message of violence and suffering.

Always remember to take into account all the three theories of art during each and every encounter with an artwork. A single theory of art can point out some qualities in some works of art, but it will fail to point out all the qualities in the work.

➤ Using emotionalism as a guide helps you focus attention on the powerful feelings and emotions contained in this painting. Look at how the principles of art have been used to organize the elements. In what ways does Grünewald ignore the rules of good design stressed by formalism?

Figure 5.18 Matthias Grünewald. *The Small Crucifixion*. c. 1511–20. Oil on wood. 61.6 x 46 cm (24¼ x 18⅛"). National Gallery of Art, Washington, D.C. Samuel H. Kress Collection.

An Art Critic's Judgment

When Robert decides to judge the artwork *The Mill*, he refers to these various aesthetic viewpoints and decides that *The Mill* is a successful work of art. He feels he can defend that decision by referring to everything he learned about it during the earlier criticism operations.

During the descriptive step, Robert was impressed by the literal qualities of the work. He was impressed with the authentic look of the ancient windmill, the surrounding houses and barns, the small figures, and the golden sunset. He also liked the way light and shadow were used to lure his eye deeper and deeper into the work.

When he analyzed it, Robert saw how well the painting was organized. Among the things he observed during analysis was the way hues, values, and shapes were used to add harmony to the picture. This harmony was balanced with variety in the form of different rough- and smooth-textured surfaces that added visual and tactile interest to the work. Robert was especially impressed with the way the windmill stood out boldly against the glowing sky. Clearly, the windmill was meant to be the center of interest in this painting. The result was a painting that to Robert seemed direct, monumental, and majestic. At the same time, he felt it was a composition in which all the art elements contributed to an overall sense of wholeness, or unity.

However, Robert was most pleased by the expressive qualities. He was struck by a feeling of calmness he found in the picture, a calmness that seemed to creep silently across a weary world. It seemed to emerge in the same quiet way that the lengthening shadows of night advanced softly to wrap all things in darkness. To Robert, the work clearly showed that moods and feelings can be communicated by a painting in which human subjects play a minor role.

Clearly, Robert made certain that he considered all three theories of art: imitationalism, formalism, and emotionalism as he judged the work of art. By doing so, he felt confident that he had attended to a range of different aesthetic qualities found in the painting.

Learning from External Cues

His examination of the painting finished, Robert might now wish to look at what others have had to say about it. No doubt he would want to know what historians like Helen had written about the work. It is at this point that Robert concerns himself with certain external cues. These would include the name of the artist, when and where the picture was painted, and the artistic style it represents. Of course, as an experienced critic with a broad education in art, Robert knew many of these things before he began his study of the work. He had realized at once that the painting was done by Rembrandt, one of the most famous of all painters. However, he made a conscious effort to disregard these cues during his critical examination. He knew that if he took these external cues into consideration too soon they might influence his study of the internal cues and color his judgment.

Keep in mind that the critic's main objective is to gain an understanding of the work of art. In order to do this, the four-step, systematic approach of description, analysis, interpretation, and judgment is used. The outline in Figure 5.19 summarizes the four operations used in such a systematic approach.

	ART-CRITICISM OPERATIONS			
	Description	Analysis	Interpretation	Judgment
Internal Cues	Focus: **Subject matter and/or elements of art** noted in the work.	Focus: **Organization**—how principles of art have been used to arrange the elements of art.	Focus: **Moods, feelings, and ideas** communicated by the work.	Focus: **Decision-making** about the work's artistic merit.

Figure 5.19 Art-Criticism Operations

Why Critics Study Art

Earlier in this chapter, some of the reasons why historians study art were briefly discussed. Having observed a critic examine a painting, you might be curious about the purpose of such efforts. Robert, for example, might be on the staff of a newspaper or magazine, where he writes a column about art. Perhaps he was assigned to write an article on *The Mill* because it was included in a major exhibition of Rembrandt's work held at the local art museum.

Perhaps Robert is an art consultant rather than a newspaper critic. As such he would be called upon to offer advice to clients who want to buy or sell works of art. His list of clients would include individuals who are interested in collecting. It could also include small businesses and large corporations that maintain their own collections. By doing this, businesses and corporations not only encourage the arts, but also provide a more attractive setting for their employees. In whatever situation he finds himself, Robert, like all critics, realizes that his primary goal is to aid others in their search for meaning and pleasure in art.

SECTION TWO

Review

1. Where does an art critic look for cues in order to understand a work of art?
2. What is examined by an art critic during the *description* operation?
3. On what does a critic focus attention when *analyzing* a work of art?
4. Describe what a critic searches for while *interpreting* a work of art.
5. List the three aesthetic qualities a critic takes into consideration when examining a work.
6. What qualities would be considered most important by a critic who favors the formalism theory of art?
7. What is the art critic's main goal?

Creative Activities

Humanities. All the arts really connect. Poets often write about the visual arts, and they paint pictures with words. Read Robert Frost's descriptions, and those of e.e. cummings, William Carlos Williams, and others. Apply the same kind of careful analysis to your reading as you apply to your study of visual art forms. Listen for sounds of words, watch for metaphor, simile, personification, and many other figures of speech that color poetry and prose. Gather a collection of metaphors and draw the imagery you gain from them.

Studio. Separate into small groups. Find a reproduction of a work of art that you can cut up. Cut apart all the shapes you find in the work. Then try rearranging them into a new composition. You will find it difficult to reorganize a good work, because the original parts work together so well. Discuss your efforts and your results.

Aesthetics: Evaluating Works of Art

The art critic, then, combines a way of looking with a knowledge of what to look for. The critic uses the four art-criticism operations as an aid in looking for cues to the work's aesthetic qualities. These, in turn, are keys to judging the work's success. Now consider using this process to your own advantage in judging a work of art.

How the Process Can Work for You

Imagine yourself standing before a painting. You know that you should try to find as many aesthetic qualities in that painting as you can. Because you are now familiar with literal, design, and expressive qualities, you are interested in seeing if these qualities are in the work. What is the best way of finding them? You remember the four art-criticism operations: description, analysis, interpretation, and judgment. These steps form a search strategy that will help you find those aesthetic qualities. The first three operations are used to find the different aesthetic qualities stressed by imitationalism, formalism, and emotionalism. Make sure that you take into account the aesthetic qualities favored by each of these theories when you examine the painting before you. Using this method will help you to make wise judgments about the work and support them with sound reasons.

During description, you should list the literal, or realistic, qualities. You should also list the elements of art. If the painting does not have recognizable subject matter (as in Mondrian's painting, Figure 5.17, page 111), then you would list only the elements of art used. Later, during analysis, your attention would shift to the principles of art. When interpreting the work, concern would center on the expressive qualities. Judgment, the fourth and final criticism operation, would require a personal decision on your part. You would have to decide if the various aesthetic qualities in the work are used effectively.

In this way, you might decide that the painting is successful because of the skillful handling of realistic subject matter (literal qualities), or you might decide the painting is a success because it provides an effec-

➤ Examine this painting carefully and then make a judgment about it. To which aesthetic qualities — literal, design, or expressive — did you refer when making your decision? Did you turn to more than one of these qualities?

Figure 5.20 John Constable. *A View of Salisbury Cathedral.* c. 1825. Oil on canvas. 73 x 91 cm (28¾ x 36"). National Gallery of Art, Washington, D.C. Andrew W. Mellon Collection.

tive and pleasing arrangement of art elements (design qualities). Alternatively, you might feel it is successful because it offers a clear and powerful idea in visual form (expressive qualities). The painting might be considered successful for *one or more* of these reasons.

Using the Process on Specific Artworks

For example, assume that the painting you have been studying is *A View of Salisbury Cathedral* by John Constable (Figure 5.20). You might decide that this painting is successful because it offers a well-done, realistic treatment of the subject matter. After all, the picture captures the fleeting effects of sky, light, and atmosphere. It makes you feel almost as if you are actually there looking at the real thing.

However, you might also praise the picture because of the way the artist has arranged the elements of art to produce a unified design. Constable's combination of light and dark values could be a major reason why you thought this work was successful. Also, you may have noticed that he did not paint his trees and meadows in one uniform green. Instead, he used a rich pattern of light and dark green values that helps bind the picture parts together into a unified composition. The light area of the sky and cathedral is joined visually with the light green areas of the foreground, but the combination of light and dark values contributes even more than this to the picture's effectiveness. The dark green values, which contrast with the lighter area of the sky and cathedral, also serve to frame the center of interest. Thus, the viewer's attention is drawn to the distant spire of a great cathedral.

Finally, you might feel this painting is successful because it communicates a feeling of peacefulness or calmness. You can almost feel the pleasant warmth of the summer sun, the inviting coolness of the shaded areas beneath the trees, the gentle breeze which stirs the leaves and grass. It is a casual, no-rush world that Constable paints. His picture allows you to experience that world and feel relaxed and refreshed as a result of that experience.

As you can see, a work such as Constable's *A View of Salisbury Cathedral* can be judged in terms of its literal qualities, its design qualities, or its expressive qualities. Moreover, it can be judged with *all* these aesthetic qualities in mind. You might decide that it is successful (or unsuccessful) because of the way it deals with only one, with two, or with all three of these qualities.

The same procedure would be followed when you critically examine architecture. During description,

you should concentrate on identifying the principal features of a building—doors, windows, towers, and building materials. You could then list the elements of art used. When analyzing a building, you would note how the principles of art have been used to organize the elements. The meaning or purpose of the building would be probed during interpretation. At this point, you would discover that some buildings, like paintings and sculptures, can communicate unmistakable moods and feelings (Figure 5.21).

As in judging other forms of visual art, your judgments about any kind of architecture should be based upon how well the various aesthetic qualities have been used and integrated.

➤ Following description and analysis, try to interpret the feeling or mood you receive from this building. Is it serious and forbidding, or gay and inviting? What impression does the design of this building convey about its purpose?

Figure 5.21 John Nash. *The Royal Pavilion.* Brighton, England. c. 1816–22.

When to Use Art History and Art Criticism

Earlier it was stated that when you use both art history and art criticism, you are more likely to learn as much as possible about and from a work of art. However, when you are standing before a painting or looking at a reproduction of one in a book, where do you start? Do you first use art history or art criticism? Should you begin by determining who painted it, where and when it was painted, and what style it represents; or should you first identify the aesthetic qualities used and then decide for yourself if these qualities have been used to create a successful work of art?

If a work of art is going to mean anything special to you, then you must become personally involved with it. You should avoid depending entirely upon others to tell you whether it is successful or unsuccessful. Rather, you should be prepared to make your own decisions about it. Only after you have made these personal decisions will you want to turn to what others have said about the work. You may recall that Robert did not consider what others had to say about the painting of *The Mill* until after he had finished his own examination of it.

It is suggested then that when you study a work of art, you should begin with the art-criticism operations. Concentrate on finding the internal cues that will enable you to learn as much as you can from the work. When this has been done, you will be ready for the art-history operations. They will help you to discover the external cues about the work and the artist who created it. During the art-history process, you will have a chance to make additional decisions about the work. This time, those decisions will relate to its historical importance. After you have done this, you can compare your decisions to those expressed by others. Remember, however, that the final decision is *yours* to make and defend. If you forget this, it is doubtful that your experience with the work of art will be personally rewarding.

In your reading about art and during visits to museums, you will encounter many works that you will want to examine closely. These examinations will be more valuable to you if you follow the sequence of art-criticism and art-history operations outlined in Figure 5.22.

		A SEQUENCE OF ART-CRITICISM AND ART-HISTORY OPERATIONS			
		Description	Analysis	Interpretation	Judgment
1.	Art Criticism	Subject matter and/or elements of art noted in the work.	Organization: how principles of art have been used to arrange the elements of art.	Moods, feelings, and ideas communicated by the work.	Personal decision about the degree of artistic merit.
2.	Art History	Determine when, where, and by whom the work was done.	Identify unique features to determine artistic style.	Learn how time and place influenced the artist.	Make decision about work's importance in the history of art.

Figure 5.22 A Sequence of Art-Criticism and Art-History Operations

Using the Steps of Art History and Art Criticism

The sequence of steps you will be using in your study can be summarized briefly as follows. Describing the work from the art critic's point of view, you will discover what is in the work of art. You will look for the literal qualities (stressed by imitationalism) and the elements of art (stressed by formalism). As you analyze the work, you will discover how it is organized. You will look for the principles of art, which, along with the art elements, constitute the design qualities (stressed by formalism). The Design Chart shown in Figures 2.25 and 5.12 can be of help to you during analysis. Using it as described on pages 48–49 and 107–108 will aid you in checking the relationships between elements and principles in a work of art. As you interpret the work, you will discover its meaning, mood, and underlying idea. You will look for the expressive qualities (stressed by emotionalism). As you judge the work, you will make a decision about the work's success or lack of success.

Describing the work from the art historian's point of view, you will discover when, where, and by whom the work was done. As you analyze the work, you will discover its unique features. As you interpret the work, you will learn how the artist was influenced by the world around him or her. As you judge the work, you will make a decision about its importance in the history of art.

The first time you attempt this process it may seem difficult and time consuming. However, each time after that will be easier and faster. You may be surprised to discover how much you can learn from and about a work of art by doing this. You may also be pleased to find how much meaning, pleasure, and excitement you can receive from that work once you understand it.

SECTION THREE

Review

1. How do you go about discovering the different aesthetic qualities in a work of art?
2. Which three operations are used to find the different aesthetic qualities stressed by imitationalism, formalism, and emotionalism?
3. Why is it preferable to use the art critic's approach first in evaluating a work of art?
4. Using the emotionalism theory of aesthetics, tell which place you would prefer to visit: *A View of Salisbury Cathedral* as painted by John Constable (Figure 5.20, page 114), or *A Pond in the Forest* by Meindert Hobbema (Figure 5.2, page 97).
5. Select a work of art from this chapter and apply the art historian's *description* operation by listing when, where, and by whom the work of art was completed.

Creative Activities

Humanities. Musicians compose "sound pictures." Claude Debussy's *La Mer* (The Sea) uses sound to create the visualization of the sun rising over the ocean, the waves, a storm at sea. In Ferde Grofé's *Grand Canyon Suite* you can "hear" the sun rising over the canyon and also the clop of donkeys' hooves as they descend the canyon carrying visitors into its depths. Other music also creates images. Listen to the background music composed for films. As you listen, use the art critic's step of interpretation to discover the mood, meaning, or idea the composer has conveyed with the "sound picture."

Studio. Paint a musical composition. Select a pleasing piece of music, and before you begin painting, listen to the work you selected. Think of colors, shapes, and movement that the music suggests. Music is a time art. You can hear it in a flow of sound. Painting is a space art. You see it all at once. Try to capture the essence of the sound quality in your painting.

PAINTING A REPRESENTATIONAL STILL LIFE

Supplies

- Pencil and sketch paper
- Sheet of white drawing paper, 9 x 12 inches (23 x 30 cm)
- Tempera or acrylic paint
- Brushes, mixing tray, and paint cloth
- Water container

CRITIQUING

- **Describe.** Can you point out and name the five objects in your still-life composition? Are these objects realistically represented? Were other students able to accurately identify them?
- **Judge.** Do you think that your painting would be favorably received by a critic focusing exclusively on the literal qualities?

Complete a still-life painting consisting of no less than five familiar objects. Draw and paint these items as realistically and accurately as possible. Your finished painting will exhibit a concern for the literal qualities of the objects favored by imitationalism.

Focusing

Look through *Art in Focus* for illustrations of artworks that effectively emphasize literal qualities. Select one that you find especially appealing. Compare your selection to those made by other members of your class. Was one work mentioned more often than any other? If so, discuss the reasons for its popularity.

Creating

Working with other members of your class, arrange a still life made up of at least five familiar objects. Select objects that have different forms, textures, and colors. Arrange the items so the display is interesting from all sides. Draw this still life as accurately as possible on the sheet of paper.

Use tempera or acrylics to paint your still life. Mix your colors to match those of the still-life objects. Paint carefully, trying to reproduce the shapes, forms, and textures of each object.

Figure 5.23 Student Work

PAINTING AN ABSTRACT STILL LIFE

Complete a still-life painting composed of three or more objects in which attention is focused upon the design qualities rather than upon realistic representation. Your painting will illustrate a concern for harmony of line, variety of shapes, and emphasis realized by the use of contrasting complimentary hues.

Focusing

Look through *Art in Focus* for illustrations of artworks that make effective use of the design qualities. Select one of these works and examine it closely. What elements of art are used? How are the principles of art used to organize these elements? Do you feel that the overall effect realized by the use of these elements and principles is unified?

Creating

Arrange a still life made up of no less than three familiar objects. Draw this still life lightly with pencil on the sheet of white paper. To create harmony of line, use a ruler to straighten every line in your drawing. (If you prefer, make all the lines in your composition curved rather than straight.) Extend these lines to divide the background and the still-life objects into a variety of large and small angular shapes.

Select two complementary hues. All the shapes in the picture must be painted with hues obtained by mixing these two colors. Different values of these hues can be obtained by adding white or black.

Emphasize the most important shapes by painting them with hues and values that contrast with surrounding shapes.

Supplies
- Pencil and sketch paper
- Sheet of white drawing paper, 9 x 12 inches (23 x 30 cm)
- Tempera or acrylic paint
- Brushes, mixing tray, and paint cloth
- Water container

CRITIQUING

- **Analyze.** Are all lines in your composition straight (or curved)? How does the use of the same type of line throughout add harmony to your painting? Does your picture exhibit a variety of large and small shapes? Are these shapes painted with hues obtained by mixing two complementary colors? Did you use these contrasting hues to emphasize certain important shapes in your composition? Were other students able to identify these important shapes?
- **Judge.** Do you think that your painting would be favorably received by a critic relying exclusively on the design qualities?

Figure 5.24 Student Work

CREATING AN EXPRESSIVE COLLAGE

Supplies

- Mat board or poster board, 12 x 18 inches (30 x 46 cm) or larger
- White glue
- Pictures and print material torn from magazines and newspapers
- Colored tissue paper
- Watercolor paints
- Brushes, mixing tray, and paint cloth
- Water container

Complete a nonobjective *papier collé*, or "collage," that communicates a one-word idea such as lonely, lost, joyful, afraid, excited. Your finished composition will exhibit a concern for the expressive qualities favored by emotionalism.

Focusing

Look through *Art in Focus* for illustrations of artworks that stress the communication of ideas, moods, and feelings. Identify one of these that is highly abstract or nonobjective. How does this work succeed in communicating an idea, mood, or feeling without the use of realistic subject matter?

Figure 5.25 Student Work

• *Interpret.* Does your collage succeed in communicating a one-word idea? Are other students able to correctly identify this idea?

• *Judge.* Do you think that your collage would be favorably received by a critic focusing exclusively on the expressive qualities?

Figure 5.26 Student Work

Creating

Identify a one-word idea and use this as the theme for your collage. From magazines and newspapers, tear out pages that contain images, words, colors, and textures that you associate with this idea. Tear these pages into a variety of large and small irregular shapes and arrange them on the mat board. Establish a focal point or center of interest for your composition. To do this, contrast the hues, intensities, and values of the shapes placed at this center of interest with the hues, intensities, and values of the surrounding shapes. When you are satisfied with your composition, glue the shapes in place. Use white glue thinned with water and applied with a brush.

Use colored tissue paper and applications of opaque and transparent watercolor paint to tone down some areas or highlight other areas. The center of interest can be accented even more with the tissue paper or paint. Choose colors that you associate with the idea, mood, or feeling you are trying to communicate.

Several layers of paper and paint may be needed before you are completely satisfied with the overall effect of your collage.

Display your finished collage along with those completed by other members of the class. Try to determine the one-word idea each collage attempts to communicate.

Review

Reviewing the Facts

SECTION ONE

1. Name the four steps that both art historians and art critics use when studying a work of art.
2. What do art historians do?
3. Noticing the intensity of the colors in a painting would be considered part of which step in the art historian's approach?
4. Name the artist whose unique style involved using heavy, dark outlines around his figures.

SECTION TWO

5. What do art critics do?
6. What aesthetic quality does a critic who stresses the importance of the theory of imitationalism believe is most important?
7. Focusing on the elements and principles of art would be to stress which art theory?

SECTION THREE

8. What is the difference between art history and art criticism?
9. Why is a sequence of art-criticism operations followed by art-history operations beneficial to viewers of art?
10. List the three aesthetic theories of art mentioned in the chapter.

Thinking Critically

1. **Extend.** One day, in a secondhand store, you discover a painting that seems to be just blobs of paint, but it is very pleasing to you. After a while you notice that you have been holding the painting sideways and that it really is a picture of a fruit basket. Held correctly, the picture doesn't seem well done or interesting. You buy it and hang it on your wall sideways. Explain which aesthetic qualities you found most interesting in the work and which qualities you found unsuccessful.

2. **Compare and contrast.** Refer to *Sixth Avenue El* by Stuart Davis (Figure 5.3, page 98) and to *A Girl with a Watering Can* by Pierre Auguste Renoir (Figure 5.4, page 99). Make a separate list of adjectives for each painting that describes the artist's style.

3. **Extend.** Every artist has a unique style that becomes more consistent as the artist gains more experience. Brainstorm to make a list of other things that can be identified by a particular style. Examples might include: typefaces (or fonts), clothing styles, or singing styles.

Using the Time Line

Visit the library and identify a key event that took place during one of the centuries indicated on the time line. On the chalkboard, reproduce the time line to include the names of the artists and their works. Use a different color chalk to list, in its proper place, the event you identified. Other students should do the same. Discuss why it is important to learn about the key events that were taking place in the world at the same time a work of art was being created.

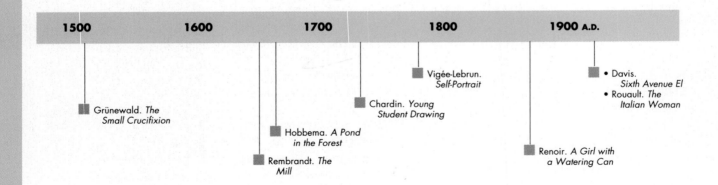

1500	1600	1700	1800	1900 A.D.

Grünewald. *The Small Crucifixion*

Rembrandt. *The Mill*

Hobbema. *A Pond in the Forest*

Chardin. *Young Student Drawing*

Vigée-Lebrun. *Self-Portrait*

Renoir. *A Girl with a Watering Can*

• Davis. *Sixth Avenue El*
• Rouault. *The Italian Woman*

Amber Gauthier, Age 17
Pojoaque High School
Santa Fe, New Mexico

Amber chose a historical focus for her project after she read this chapter. "My roots are Native American, and my goal was to create a visually pleasing and united piece with a message: This is a tired warrior — Chief Joseph — and his decision is to escape war and bloodshed." Some research was required in order to accurately portray the chief. The next step involved decisions about where to place the portrait and what else to include. A loose pencil sketch shows the first layout.

Amber chose to add borders at the top and bottom to balance the portrait. "During war and when Indians were in prison, they were given ledger paper to draw on to recapture battle scenes." Amber decided to use a replica of ledger art as an added historical reference.

When asked what she had learned about herself as an artist, Amber replied, "I need to loosen up my style a bit, try different techniques, and to experiment." Her advice to other students is, "Stay in touch with your culture and be free with your artwork — there are no limitations."

➤ *Warrior No More: A Portrait of Chief Joseph.* Mixed media. 46 x 38 cm (18 x 15").

Unit Two

Art of Early Civilizations

Head of King Sesostris
1887–49 B.C.

Page 150

Second Chinese Horse
15,000–10,000 B.C.

Page 131

15,000	12,000	9000

PREHISTORIC ART IN WESTERN EUROPE

Bison with Turned Head Page 137
11,000–9,000 B.C.

Khafre Page 149
c. 2600 B.C.

Temple of Amon-Re Page 148
c. 1280 B.C.

6000 3000 1000 B.C.

THE ART OF ANCIENT EGYPT

The Magic Picture: Prehistoric Art in Western Europe

Objectives

After completing this chapter, you will be able to:

➤ Use the art-criticism operations to examine an example of a prehistoric cave painting.

➤ Explain how prehistoric cave paintings may have originated.

➤ Explain how prehistoric paintings survived.

➤ Describe the manner in which prehistoric paintings were created.

➤ Make a contour drawing of an animal in motion.

Terms to Know

megalith
Old Stone Age
Paleolithic period
post and lintel

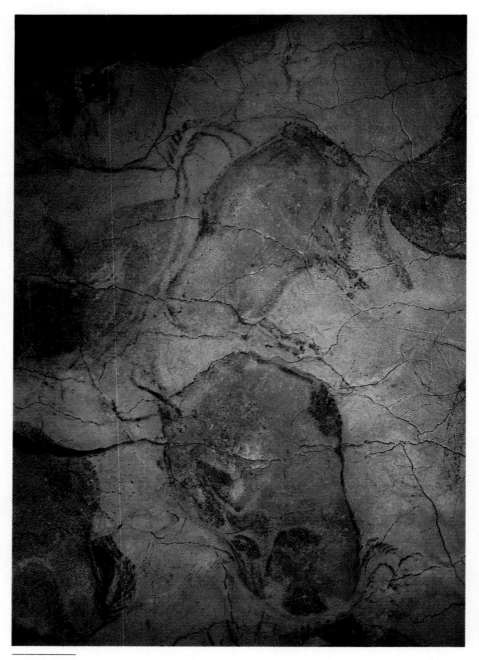

Figure 6.1 Group of Bison. Cave painting. Hall of the Bisons. Altamira, Spain. c. 15,000–10,000 B.C.

Imagine you are inside the cave of Altamira in northern Spain

walking down a wide passageway carved by an ancient underground

river. Having seen pictures of prehistoric cave paintings, you think you are prepared

for what you are about to experience, but no picture could have prepared

you for what you see. You are struck by the visual impact of huge, powerful

animals parading silently across the rough ceiling of the cavern . . .

SECTION ONE
Life in Prehistoric Times

One of humanity's earliest achievements was art. Long before they could write or fashion utensils and weapons from metal, early humans were painting and scratching pictures of animals on the uneven walls of their caves and rock shelters. This was a remarkable achievement when you consider what it must have been like to live in a world where each person fought a daily battle for survival. The lives of prehistoric people were filled with danger, hunger, and fear. Winter found them searching for shelter from the cold and snow, and in the summer they suffered from the heat and sudden rains that flooded their cave dwellings. Those who were fortunate enough to survive were old in their early forties, and few lived beyond their fiftieth year.

It is difficult then to understand why these people took time to produce art. Certainly it would be reasonable to expect that the artworks they did create would be primitive and crude, but are they? This is a question you should answer for yourself. However, before you do this, it is necessary to examine thoroughly an example of prehistoric art. Such an example is a painting of a bison from the ceiling in Altamira (Figure 6.2). Notice the proportion of the animal. Examine how the artist used color and line to give definition to the form. Look for any expressive qualities that may be present.

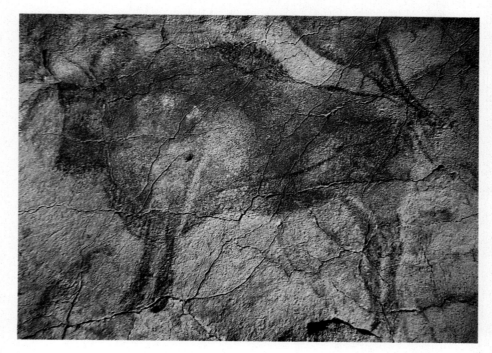

➤ Examine this painting carefully. Does the animal look lifelike? Can you identify its main features? Does this animal seem timid or fierce, slow or swift, helpless or powerful?

Figure 6.2 Standing Bison. Cave painting. Altamira. Near Santillana, Spain. c. 15,000–10,000 B.C.

Cave Painting: The Bison from Altamira

To help you in your examination of this painting it is suggested that you use the art-criticism operations to describe, analyze, interpret, and judge it. You will recall that these operations were discussed in Chapter 5. In that chapter it was suggested that you gather as much information as possible from a work by looking for the answers to certain questions about it ("The Art-Criticism Approach," pages 106–109). Finding the answers to these questions will add to your understanding and enjoyment of the work of art.

Describing the Work

As you examine the bison from Altamira, try to describe the animal to yourself. You can do this by asking and answering questions about the various features of the animal. For example, where is the head and what position is it in? Are the legs clearly defined? Does the animal seem to be motionless, or is movement suggested? As you scan the picture further, you might notice that just a few details were used to highlight the most important features of the bison.

Did you notice that the animal is not placed in a setting? Indeed, there is no hint of the ground beneath its hooves, nor are there signs of trees or hills or sky behind the bison. What effect does this have upon the animal's apparent size and its position in space?

Before moving on to analysis, you should ask yourself about the elements of art found in this painting. What hues are noted? What kinds of values and lines are employed? How would you describe the shapes that are used—are they rounded, angular, or both? Do you think that the rough texture of the stone surface on which the bison was painted adds to the overall effect of the animal? Does it look flat or does it seem to extend out from the ceiling into space?

After you have asked and answered description questions, you might be inclined to say that this painting of a bison is surprisingly lifelike. How was this lifelike quality achieved? To find the answer, you'll need to consider how the principles of art are used in arranging the art elements to achieve a realistic appearance.

Analyzing the Work

Using a copy of the Design Chart illustrated in Chapters 2 and 5, pages 48 and 108, will help you determine how the art elements were used to create this painting of a bison. Refer to the painting as you consider each relationship of element and principle indicated on the Design Chart. For example, notice how the rich reddish hue is applied in such a way that the three-dimensional mass, or volume, of the animal is suggested. Gradual value changes in the body of the bison add to the illusion of a fully rounded form projecting outward in space. On the Design Chart, this discovery is indicated with a checkmark at the intersection of "color: value" and "gradation." Did you also observe how a dark outline, which varies from thick in some places to thin in others, defines the simple, compact shape of the animal? If you did, you would place a checkmark for "line" under "variety" and another for "shape" under "harmony," but your analysis is not yet complete. Do you see how smaller shapes of contrasting values are used to call attention to such vital details as the head, legs, and hump? How would this be indicated on the Design Chart? Since this discovery points out how value and shape have been used to emphasize the most important parts of the animal, the answer is obvious.

Of course, not *all* the relationships of elements and principles found in this bison have been discussed. Only the more obvious relationships have been touched upon. You can, and should, go on to determine other, more subtle, relationships for yourself to complete your understanding of this painting. However, you should be warned. This kind of detective work can be habit-forming. Each new discovery will add to your eagerness to learn even more about the work of art.

Interpreting the Work

You are now ready to interpret this painting. You will recall that this means discovering the meaning, mood, or idea of the work. Even though this work was made in prehistoric times, it will still be possible to interpret it.

At first glance you might have thought it would be difficult to guess the size and character of this animal. After all, only the bison is shown here; it is not placed in a scene with other animals or objects with which to compare it. However, by the time you have reached this point in your study, you should have little difficulty choosing from such interpretation statements as "large and powerful," "small and helpless," or "slender and frail."

Having observed that the head of the bison is held erect and the legs are supporting the body in a standing position, your curiosity might be aroused. What is

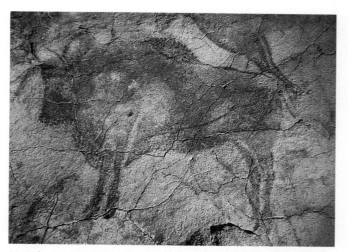

➤ Refer again to this painting as you describe, analyze, interpret, and judge the work. What conclusions did you reach regarding the work's aesthetic merit?

Figure 6.2 *Standing Bison. Cave painting. Altamira. Near Santillana, Spain. c. 15,000–10,000* B.C.

the animal doing? Obviously it is not fleeing, and so you might be tempted to say that the animal is alone and unthreatened. Another possibility is that it had been in motion, perhaps charging at full speed toward some unseen enemy, and come to a sudden stop. The wide-open eyes and standing position seem to support the idea that the bison is alert rather than weary and inactive. Nevertheless, after examining all the evidence, you alone must decide which interpretation seems best based on your observations.

Judging the Work

You should now be prepared to make an intelligent judgment about this painting. Would you say that it is crude and primitive, or do you think it was painted by a skilled artist who succeeded in producing a lifelike image of a bison? Does the painting call to mind the bison's untamed nature and its unique attributes? Has a thorough examination of it uncovered signs of the animal's fierceness, strength, and speed? Remember, this painting can only become personally meaningful to you if you supply answers to questions of this kind.

You have now provided answers to some questions by critically examining this painting of a bison, but you have not covered all the important questions concerning this work. You have yet to consider questions *about* the work, questions such as "Who painted this picture?" "How and when was it done?" "Was it painted to serve some special purpose and, if so, what was that purpose?" For answers to questions of this kind, it is necessary for you to turn to art history.

SECTION ONE

Review

1. Describe the primary daily concerns of the prehistoric people who made the cave paintings.
2. Describe how the artists used the rock surfaces of the caves to give their drawings a three-dimensional look.
3. How did prehistoric artists use media to give their paintings a three-dimensional look?
4. How was the *shape* of the animals in the cave paintings shown by the artists?
5. Tell how it is possible to *interpret* a painting of an animal from prehistoric times.
6. What does the bison (Figure 6.2, page 127) appear to be doing?

Creative Activity

Humanities. Collect sticklike objects that can be used for rhythm instruments. Use a utility knife to notch 1/2 inch (1 cm) dowel rods to use as rasps. Make drum surfaces by stretching circles cut from wide inner tubes over the open end of a coffee can. Find objects at home that can be used as sound and rhythm instruments.

Then compose rhythm patterns that can be played on the instruments. Listen to the sound that each of your found or made instruments makes. You will hear different *timbres*, or tone qualities. Play the sounds together to hear orchestration. Then add vocal sounds such as scat singing. Imagine prehistoric peoples inventing their music and celebrating their lives.

History of the Cave Paintings: Lascaux and Altamira

As you know, the art-history operations can be used to describe, analyze, interpret, and judge a work of art. Some of these operations will be more helpful in discovering facts about the cave paintings than others. However, you should try out all the operations to see which ones are most helpful and to be sure your study of the cave paintings is complete. The art-history operations were discussed in Chapter 5, pages 97–104, "The Art-History Approach."

Origins of the Paintings

There is much uncertainty among historians and archaeologists about the early dates of human development. However, some experts believe that it was during an age that began some thirty thousand years ago that the earliest known works of human achievement were made. This book relies on the early dates determined by these experts because they are the best dates available.

The age of cave paintings and artifacts produced thousands of years ago can be determined by several means. One way is to date the artifact according to the age of the surrounding earth layer. Another way is radiocarbon-dating of once-living objects found near the artifact. In general, all living organisms maintain a known amount of radioactive carbon 14. After the organism's death, the carbon 14 loses its radioactivity at a known rate. By measuring how much radioactivity is left in charcoal or carbonized bones, for instance, it is possible to discover their age. When these objects are found in caves where prehistoric paintings are located, scholars are able to arrive at the approximate date the paintings were produced. However, dating methods are constantly being improved, and this may mean that scholars will eventually have to revise some of their estimates.

Since a study of the history of art must start somewhere, this book will go back in time to a period known as the Old Stone Age. The **Old Stone Age**, or the **Paleolithic period**, *is the historical period believed*

to have lasted from 30,000 B.C. until about 10,000 B.C. There you will find these earliest works—the vivid, lifelike pictures of animals painted on the rough ceilings and walls of caves.

In caves found in southern France and northern Spain are numerous paintings, so well preserved and skillfully done that they caused great controversy among scholars when they were discovered. The reason for this controversy becomes clear if you look closely at one of the animal paintings found at the cave of Lascaux in the Dordogne region of southern France (Figure 6.3). Is it possible that cave people working with the most primitive instruments could have produced such splendid works of art, or are these the work of skilled artists from a more recent time? Perhaps, as some have suggested, they are the work of tramps or shepherds who took shelter in the caves. On the other hand, if they are truly the creations of prehistoric artists, why were they done and how did they survive?

Today scholars agree that the paintings discovered at Lascaux and at Altamira are the work of prehistoric artists. However, it is unlikely that they are the first works of art ever created. They are too sophisticated for that. No doubt they were preceded by hundreds, perhaps thousands, of years of slow development about which nothing is known still. Of course, this does not keep people from speculating about how art may have started . . .

Deep inside the cave, the man sat down for a moment to rest. After several minutes, he raised his torch high above his head to examine his surroundings. Curiosity had driven him to explore deeper into the cave than he had ever ventured before, even though he and his family had lived at the mouth of the cave for many weeks. The light of his torch cast long shadows on the rough stone walls of the cave, and the man noticed that some of the shadows looked like the animals he hunted daily in the fields. Idly, he bent down and picked up a piece of soft stone and walked to a place on the wall where the surface seemed to swell outward like the round body of an animal. With a few awkward strokes of stone, he added legs and then a head to the body. Finished, he stepped back to admire his work. It was crude, but it did look something like a bison. The man, standing alone in the dark, silent cave, suddenly became frightened by the strange image he had created on the wall. He turned and made his way back to the mouth of the cave. It would be many days before he gathered enough courage to return to the mysterious drawing on the wall, and he would take others with

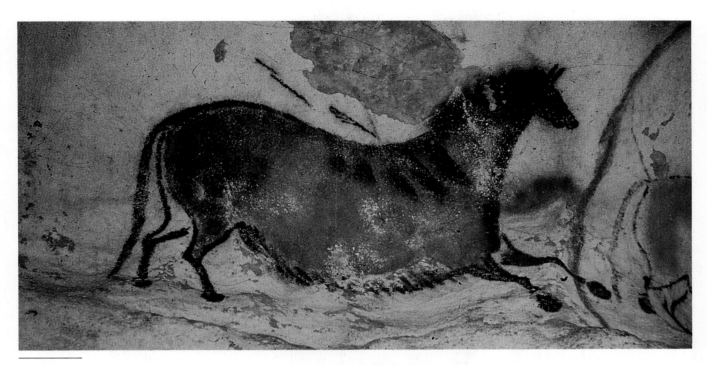

Figure 6.3 Second Chinese Horse. Cave painting. Lascaux. Dordogne, France. c. 15,000–10,000 B.C.

*him to see it. They would all agree that what he had
done on the wall of the cave was magic . . .*

While this story is imaginary, it is quite possible
that prehistoric cave painting started this way. Be-
cause these paintings of animals were done deep in-
side caves, far from the living quarters near the
entrance, scholars now feel that they must have had
something to do with magic rituals.

Use of the Paintings in Hunting Rituals

During prehistoric times, art was almost entirely
limited to the drawings of animals. This was probably
due to the prehistoric people's dependence on animals
for food. The painting of animals almost certainly
played a part in some kind of magic ritual that would
help them in the hunt.

Of course, hunting in prehistoric times was quite
different from what it is today. Primitive spears and
clubs were the only weapons known, and these had to
be used at close range. This made the hunting of large
game very dangerous. Often hunters were seriously
injured or killed. When this happened, the rest of the
family was in danger of starving.

Before taking up their clubs and spears, prehistoric
hunters may have turned to magic to place a spell
over their quarry. This was intended to weaken it and
make it easier to hunt. The magic may have involved
a ceremony in which an image of the animal was
painted on the wall or ceiling of the cave. They prob-
ably believed that by drawing a lifelike picture of an
animal they were capturing some of that animal's
strength and spirit. This would make it easier for them
to find and overcome the real animal in the fields.

These prehistoric people may have thought that the
animal could be weakened even more if, during the
magic ceremony, they frightened it or struck the
painted image with their spears and clubs. The pres-
ence of spears shown penetrating the bodies of some
of the animals suggests that efforts were made to
weaken the animals before the hunt took place.

These prehistoric hunting rituals may sound un-
usual and even amusing to you at first, but they were
probably very effective. No doubt they bolstered the
confidence and the courage of the hunters, who were
convinced that their quarry would be weaker and eas-
ier to kill. In some ways, these prehistoric rituals were
not unlike some of the rituals we practice today. A
school pep rally with its rousing cheers and inspiring
music serves the same purpose. It builds confidence
and courage in team members just as the hunting
ritual did for prehistoric hunters.

Art · P A S T A N D P R E S E N T ·

Psyching-Up

It is fascinating to realize that prehistoric people, who lived a primitive life ten thousand years ago, may have used a psychological process that many athletes use today. Anthropologists believe the cave dwellers used their cave paintings in hunting rituals for two purposes: to weaken an animal by capturing its spirit, and to build courage and skill in the hunter. The cave paintings probably served the purpose of allowing the hunters to visualize and rehearse for their physical contests, thus building confidence and skill.

Figure 6.4 Coach giving a chalk-talk.

While prehistoric hunters thought their ritual gave them an advantage because it was "magic," we know today that visualizing a complicated physical process serves as useful mental and physical preparation.

Coaches use chalk-talks to diagram plays for team members; choreographers use computer software to demonstrate complicated dance routines for their dancers; and performers such as singers and actors mentally rehearse their physical performances. This mental process has a sound basis in modern psychology; some psychologists even recommend such preparation for any difficult task, whether it be physical, mental, or emotional. "Psyching-up" for a contest has been around for a long time.

How the Paintings at Lascaux and Altamira Survived and Were Discovered

Utensils, bones, and charcoal from numerous campfires found at the mouths of caves suggest that the Stone-Age occupants lived there to take advantage of the daylight and ventilation. A special place farther back in the cave was set aside for their magic rituals, and this was where the paintings were done. There they were protected from the wind and rain, and for this reason many paintings have survived to the present day. Unfortunately, many others were washed away by underground rivers. Only a few stone tools and utensils have been found, and scholars now look sadly at the barren walls and try to imagine what wonders might have once been painted there.

The discoveries of prehistoric paintings at both the caves of Lascaux in 1941 and Altamira in 1879 were quite accidental. The Lascaux caves were found by two boys playing in a field with their dog. A ball was thrown to the dog, and, in his eagerness to retrieve it, the dog failed to notice a small hole in the ground. The boys were startled to see the dog disappear and rushed to investigate. They quickly found the hole and saw that the dog was trapped within a cave. Frantically the boys searched for a way to reach the dog and finally discovered another, larger hole nearby. Cautiously they crawled down into it. Imagine how their hands must have trembled as they lit matches and illuminated the magnificent paintings of animals on the cavern surfaces.

It is a curious fact that another dog played a similar key role in the finding of the caves of Altamira some seventy years before the discovery at Lascaux. One morning in 1869 a man living in northern Spain took his gun, called for his dog, and set out to hunt in the

Figure 6.5 View of countryside around the Altamira Cave. Near Santillana and Picos, Spain.

made in prehistoric times. These discoveries kept drawing him back to the cave where he hoped to make a more important find.

One day de Sautuola's five-year-old daughter went along with him to the cave. They entered and made their way to a low-roofed chamber which the archaeologist had examined many times before. The father had to bend over as he went into the chamber, but the little girl was able to walk upright. The light from the candle in her father's hand made strange shadows on the walls of the cave and these amused the child. Then she glanced up at the ceiling and screamed for joy as she saw something more than shadows. Her father turned and saw her looking upward and, with some difficulty, raised his own gaze to the ceiling just a few inches (several centimeters) above his head. There he saw for the first time the painted images of bison, boar, wild horses, and deer. He held his candle closer, and the light revealed the sleeping, galloping, crouching animals that had been hidden for centuries in the dark chamber (Figure 6.6). De Sautuola knew at once that this was the great discovery he had been hoping for.

De Sautuola knew that the cave had only been visited by a few hunters since its discovery. He was convinced from the outset that the paintings dated from the Stone Age. He believed they were the work of the same prehistoric people who had made the tools found earlier in the cave. However, when he reported his discovery, it was greeted with widespread disbelief. Most people felt that the paintings were too

green, open countryside near the quaint village of Santillana in the northern province of Santander (Figure 6.5). There was little about the day to stir much interest, although the hunter later reported that his dog had fallen into a hole. The hole proved to be the blocked entrance to an unknown cave. Fortunately, he had been able to find the dog and pull him free. The incident was soon almost completely forgotten.

Several years later, an amateur archaeologist named Marcelino de Sautuola heard the hunter's story and decided to explore the cave. For four years he excavated inside the cavern, uncovering a number of flint and stone tools, which he recognized had been

➤ In what part of the cave were pictures like this done? How have they survived up to the present day? Why was it so difficult for scholars to accept paintings like these as the work of prehistoric artists?

Figure 6.6 Two Bison. Hall of the Bison. Altamira, Spain.

sophisticated to be the work of Stone-Age artists. Only after similar paintings were uncovered in southern France in 1896 was de Sautuola's amazing discovery recognized as authentic.

Skills of the Prehistoric Artists

If you could visit Altamira today, you would see a low ceiling covered with animals painted in shades of red, brown, and black. Looking carefully, you would be able to count at least sixteen bison grouped in the center of the ceiling. Surrounding them are two boars and a deer. A smaller deer painted over a horse is located nearby. It was not uncommon for Stone-Age artists to paint on top of earlier paintings when space ran out.

The way in which many of the animals have been painted on the uneven rock surfaces seems to accent the swelling muscles and hollows of their bodies. Perhaps the most surprising thing about the paintings is their size. A deer at the far end of the chamber is almost 6.5 feet (2 m) long, while most of the other animals average around 5 feet (1.5 m).

Should you look closely at any animal on this ceiling, you would be impressed by its fresh, vivid color. This makes it seem as if the animal had just been painted. The pigments, or coloring mixture, were made from lumps of clay and soft stone that were ground into fine powder. They were then mixed with animal fat, blood, or some other medium. In some caves, this pigment was applied to the smoothest walls with the fingers, although at Altamira the technique was more advanced. There the artist first scratched in the outline of the animal on the stone and then filled in the lines with black or dark brown pigment to give it a strong edge. The animal was then filled in with different shades of reddish-brown hue. This shading technique added to the impression of a three-dimensional form projecting outward from the ceiling. Finally, realistic details were added. These details suggest that the artist made a careful study of the animals before painting them. Such a study would explain why they seem so lifelike.

The painting technique may have made use of some kind of reed or bristle brush. Perhaps the animal was colored in by wiping the paint on with a piece of fur or a moss pad. Even with these crude instruments, prehistoric artists were able to demonstrate a knowledge and an affection for the animals they hunted. What they knew and felt was combined with a sensitive artistic instinct. This enabled them to capture in paint the power of a bison, the fleetness of a horse, the gentleness of deer (Figure 6.7). Such is the impression that would linger long after you left the darkness of the prehistoric Altamira cave and returned to the surface and the bright sunshine of the Spanish countryside.

➤ Can you identify these animals? What clues enabled you to make this identification? How has line been used to create the animals? How would you answer someone who criticized this painting as the work of an unskilled artist?

Figure 6.7 *Frieze of Stags.* Cave painting. Lascaux. Dordogne, France. c. 15,000– 10,000 B.C.

Nancy Holt

Sculptor and video artist Nancy Holt (b. 1938) is a leader among artists who have turned to the art of prehistory for inspiration. Many of these artists dislike the modern notion of the artist as a lone genius or "art-world star" and wish to create art that is not merely a commodity for sale to the wealthy. Prehistoric art, fashioned at a time when art and life were inseparable, provides a model for an art that is connected to the very rhythms of the earth itself.

Holt was born in Worcester, Massachusetts, and studied at Tufts University. During a 1968 visit to the Southwest she felt the lure of desert landscapes: "As soon as I got to the desert, I connected with the place."

Since then Holt has made many sculptures that are placed both in urban places and in bare deserts.

Holt's *Sun Tunnels* is among her best known works. The work, set in Utah's Great Basin Desert, consists of four massive concrete pipes that are oriented according to the summer and winter solstices. The gray cylinders are punctured with holes exactly positioned to reflect the configurations of the constellations Draco, Perseus, Columba, and Capricorn. Holt states, "The sizes of the holes vary relative to the magnitude of the stars to which they correspond. During the day, the sun shines through the holes, casting a changing pattern of pointed ellipses and circles of light on the bottom half of each tunnel. On nights when the moon is more than a quarter full, moonlight shines through the holes, casting its own paler pattern." Visitors can sit inside the twenty-two-ton pipes and observe an ever-changing artwork that intensifies their experience of the natural world.

The creation of Holt's sculptures requires a great deal of collaboration. Architects, landscape designers, contractors, city planners, and municipal authorities are among the people that Holt must consult in the course of erecting one of her pieces. It is a very different process than a prehistoric artist would have undertaken, but there is still a strong similarity between prehistoric art and works such as Holt's *Sun Tunnels*.

Figure 6.8 Nancy Holt. *Sun Tunnels.* 1973–76. Concrete. 2.9 x 5.5 x 26.2 m (9½ x 18 x 86'). Great Basin Desert, Utah.

Prehistoric Builders

Eventually prehistoric peoples ventured out of their caves to begin building more comfortable shelters. Small communities developed and hunters replaced their weapons with crude farming tools and shepherds' staffs. In time, communities grew into organized villages surrounded by cornfields and grazing animals.

Rock Carvings and Standing Stones

Abstract symbols were carved into stone by prehistoric people during the Paleolithic period. Spirals and concentric arcs appear etched in standing stones as well as on flat rock surfaces. Simple line carvings and ornamental designs have been discovered throughout England, Spain, France, and Germany, as well as Malta, the Canary Islands, and beyond.

Today ancient **megaliths**, or *large monuments created from huge stone slabs*, lie scattered across Europe, India, Asia, and even America. Remnants of primitive stone art have been discovered all across the globe. Archaeologists once thought that the skills in building and design demonstrated by the megalith builders had originated from more advanced civilizations in the Near East. As more accurate research becomes available, it appears that the architectural methods of prehistoric peoples developed independently in several geographical areas, perhaps earlier than previously believed.

As early as 4000 B.C. unusual circular arrangements of huge, rough-hewn stones were being created

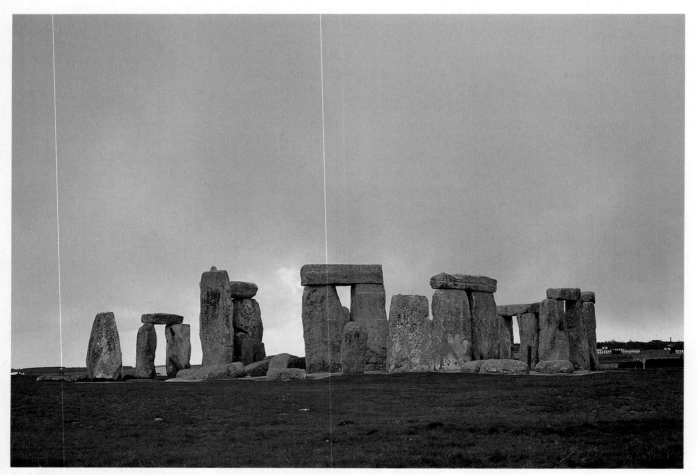

➤ How would you describe this monument to someone who had never seen a picture of it? What would you say about the forms used to construct it? How is it balanced? How is rhythm suggested? What feelings does it stir in you? Does the word *mysterious* seem appropriate when applied to this structure? Why do you think many people regard this as an impressive monument? Do you share their opinion? Why or why not?

Figure 6.9 Stonehenge. Salisbury Plain, Wiltshire, England. c. 2000 B.C.

in western Europe. The most famous of these is at Stonehenge in England (Figure 6.9). Built in several stages around 2000 B.C., Stonehenge consists of a large ring of stones with three progressively smaller rings within. The outermost ring is nearly 100 feet (30 m) in diameter. Of the thirty original upright stones, more than half are still standing. The tallest of these is about 17 feet (5 m) and weighs over 50 tons (45 t). *Massive posts supporting crossbeams, or lintels,* is called **post-and-lintel** construction.

Questions concerning Stonehenge have baffled scholars for centuries. What purpose did this prehistoric monument serve? How did people working with the most primitive tools quarry, transport across many miles, and raise these huge stone blocks into position? In the past, Stonehenge was thought to have been the work of a great magician or a race of giants with superhuman strength. Today it is thought that it served as a kind of astronomical observatory enabling prehistoric people to accurately predict the different seasons of the year.

Whatever its purpose, the impact of Stonehenge is undeniable. Mysterious, massive, and silent, it is a durable testament to the emerging ingenuity of our prehistoric ancestors.

➤ This relief sculpture, executed on a piece of horn, shows skill in sculpting and incising to show form and value.

Figure 6.10 *Bison with Turned Head,* La Madeleine. c. 11,000–9,000 B.C. Reindeer horn. 10.5 cm (4⅛"). From Dordogne, France. Musée des Antiquités Nationales, St. Germain-en-Laye.

SECTION TWO

Review

1. By what two names is the period called that lasted from about 30,000 B.C. to 10,000 B.C.?
2. Why do scholars believe that the cave paintings shown in this chapter were not the earliest works of art created by prehistoric artists?
3. Where in the caves were the prehistoric paintings located?
4. What did the prehistoric artists use for pigment and binder?
5. Name three materials that could have been used to apply the paint used by prehistoric artists.
6. Define the meaning of the word *megalith*.
7. Give an example of post-and-lintel construction.

Creative Activity

Humanities. The skill of the prehistoric artists is readily seen in cave paintings, but their imaginative powers are also demonstrated in carvings done in antlers (Figure 6.10) and chunks of stone. Perhaps a prehistoric artist looking at an antler may have seen the beginnings of a bison head. The image could have been completed by cutting the head, legs, and body with improvised carving tools.

This same inventiveness is seen today in the carvings of the Inuit people of North America. Their soapstone carvings begin with a chunk of stone. The carver studies it until he or she "sees" an image. Then the artist simply cuts away what is unnecessary to release the image from the stone. Can you identify pictures of carvings made from chunks of stone or other natural materials illustrated in this book? Do any of those sculptures suggest the shape of the stone from which they were carved?

CONTOUR DRAWING OF AN ANIMAL IN MOTION

Supplies

- Pencil and sketch paper
- Sheet of gray construction paper, 18 x 24 inches (46 x 61 cm)
- Single stick of dark-colored chalk

CRITIQUING

- **Describe.** Is your animal easily recognized? What features were most helpful to others in identifying it?
- **Analyze.** Does your animal completely fill the paper on which it is drawn? Is it colored with a single hue? Did you use gradations of value to make the animal seem three-dimensional?
- **Interpret.** What is your animal doing? Are other students able to correctly identify its actions? What clues were most helpful to them in doing this?
- **Judge.** Using the literal qualities as the basis for judgment, do you think that your chalk drawing of an animal is successful? Does it look lifelike? If so, what contributes the most to its realistic appearance?

Complete a large, simple contour drawing of a familiar animal in motion to fill completely a sheet of gray construction paper. Color your drawing using a single stick of dark chalk. Create light and dark values of this single hue by varying the pressure used when applying the chalk to your paper. Gradual changes of value will serve to make your animal appear three-dimensional rather than flat.

Focusing

Look at the paintings of bison (Figures 6.1 and 6.2, pages 126–127). What have the prehistoric artists done to make these animals look three-dimensional? Was it necessary for them to include a great many details to make them seem lifelike?

Creating

Complete several pencil sketches of a familiar animal in motion (rearing up, running, jumping). Keep these drawings simple by eliminating all but the most important details of the animals.

Reproduce your best drawing to completely fill the sheet of gray construction paper. Select a single dark color of chalk. Press down hard on the chalk when coloring the outer edges of the animal. Gradually lessen the pressure as you color further into the animal form. Using this procedure will make the animal appear three-dimensional. (You may wish to practice this procedure using the side and the point of the chalk stick.)

Emphasize the necessary details in your drawing by using the tip of your chalk stick.

Figure 6.11 Student Work

MODELING AN ANIMAL IN CLAY

Using the modeling process described in Chapter 4, create a compact clay sculpture of an animal based on one of the basic geometric forms (sphere, cylinder, cone). This animal must exhibit a trait commonly associated with it such as power, grace, gentleness, or fierceness. Use contrasting rough and smooth textures to add interest to the surface of the animal.

Focusing

Look again at the examples of prehistoric animal paintings in Figures 6.2 and 6.6. Notice how the artists have avoided the use of unnecessary details. What has been done to show the animals' power, grace, or gentleness?

Creating

Along with the other students in your class compile a list of different animals on the chalkboard. Select an animal listed on the chalkboard and complete several pencil sketches of it in a compact reclining or sitting position. Each sketch should attempt to show the trait associated with the animal.

Select the best of your sketches and model the animal in clay, using the following steps as a guide:

1. Identify and fashion in clay a geometric form that resembles the body of the animal in your sketch.
2. Attach the head, legs, tail, and other large features to the basic form.
3. Keep turning the sculpture as you continue to work on it. Once the larger features have been joined to the basic body form, use the modeling tools to refine the features.
4. Finish your sculpture with a clay modeling tool. Add details and textures.
5. When the sculpture is firm but not dry, hollow it out with a clay tool. Allow it to dry thoroughly, and fire it in a kiln.

Supplies

- Pencils and sketch paper
- Clay (a ball about the size of a grapefruit)
- Piece of canvas, muslin, or cloth, about 14 x 14 inches, (36 x 36 cm) for each student to cover tabletops
- Clay modeling tools ("modeling tools" defined in Glossary)
- Slip (a liquid mixture of clay and water)

CRITIQUING

- **Describe.** Is your sculpture easily identified as an animal? What features are most useful in helping others identify the particular animal it represents?
- **Analyze.** What geometric form did you use as the starting point for your animal sculpture? Can you point to areas of contrasting rough and smooth textures?
- **Interpret.** Does your animal exhibit a trait commonly associated with it? Are other students in your class able to recognize this trait?
- **Judge.** What aesthetic qualities would you refer to when making and defending a judgment about your sculpture? Which of these aesthetic qualities is most appropriate in this case? If you were to make another sculpture of an animal, how would it differ from this one?

Figure 6.12 Student Work

Review

Reviewing the Facts

SECTION ONE

1. When describing the painting of a bison from Altamira, what did you discover about the setting in which the animal is placed?
2. Are the shapes used in the bison paintings rounded or angular? Explain your answer.
3. How has the bison been made to look three-dimensional?
4. How is line used in this prehistoric painting?
5. What does the bison in Figure 6.2, page 127 appear to be doing, and what clues point to this?

SECTION TWO

6. Why were these prehistoric paintings done?
7. Where were prehistoric paintings done, and how did this contribute to their survival?
8. Why was the discovery of prehistoric paintings at Altamira first greeted with disbelief?
9. What is there about prehistoric paintings that suggests the artists made a careful study of the animals they painted?
10. List several unusual aspects of the megalith construction at Stonehenge.

Thinking Critically

1. ***Compare and contrast.*** Look at the bison (Figure 6.2, page 127) and the horse (Figure 10.15, page 224). Describe the gradation of value in each and tell how they differ. Tell how the media used contribute to the difference.

2. ***Extend.*** In this chapter you have read that scholars believe prehistoric people may have used the animals in their cave paintings in magic rituals. Explain the purpose these rituals served and describe a similar practice observed today.

3. ***Analyze.*** As a noted art critic you disagree with another scholar who insists that prehistoric cave paintings are simple and childlike. A friendly debate is scheduled and you must now prepare for it. List all the arguments you will use to demonstrate that prehistoric cave paintings were expressive and skillfully done.

Using the Time Line

What is the most important thing that you learned from an examination of the time line? Compare your answer to those of other students in your class. Was one answer mentioned more frequently than others? Were you surprised by the length of time represented by the era *before* recorded history? How does that length of time compare to the time period in which history has been written or recorded?

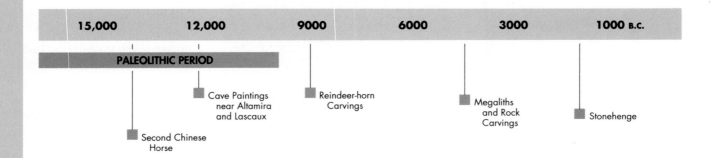

15,000	12,000	9000	6000	3000	1000 B.C.

PALEOLITHIC PERIOD

Cave Paintings near Altamira and Lascaux

Reindeer-horn Carvings

Megaliths and Rock Carvings

Stonehenge

Second Chinese Horse

Christopher H. Ryan, Age 17
New Caney High School
New Caney, Texas

After reading the chapter on prehistoric art, Chris chose to draw an animal that lived during the time the cave art was produced in France and Spain. In order to draw from a model rather than using research materials, the class brought in stuffed animals. Chris selected a mammoth as his subject.

First he used a soft pencil to rough in its shape. He felt the pencil gave him the most freedom to sketch quickly. Chris liked the way the lines flowed, but he was not entirely satisfied with the proportions of the animal.

In the middle stage, Chris began to work with charcoal, using the stick to give both the shape of the animal and to provide texture. He still felt the proportion of the mammoth was the most difficult aspect to capture.

His advice to other students: "Study the project first; get the proportions fixed in your mind, and then let the right side of your brain take over."

➤ Woolly Mammoth. Pencil and charcoal. 30 × 30 cm (12 × 12").

Art for Eternity:
The Art of Ancient Egypt

Objectives

After completing this chapter, you will be able to:

➤ Name the three major historical periods of ancient Egypt.

➤ Explain the relationship of religion to the development of the pyramids.

➤ Evaluate Egyptian art and describe the strict set of rules imposed on Egyptian artists.

➤ Design and paint a sarcophagus cover in the Egyptian style.

Terms to Know

dynasty
hieroglyphics
mastaba
obelisks
pharaoh
sarcophagus

Figure 7.1 The throne of Tutankhamen (ruled 1361–52 B.C.) Wood overlaid with gold, silver, semiprecious stones, and glass paste. Egyptian Museum, Cairo, Egypt.

Traveling up the Nile River in Egypt today, you would be amazed by the mighty monuments seen at almost every bend in this great river. Most of these huge stone structures are tombs and temples, reminders of a once-powerful ancient Egyptian civilization. Who were these Egyptians who were able to build such impressive monuments? Where did they come from? What were they like? Your search for answers to these questions will lead you back in time to prehistoric periods when people first came to inhabit the lands bordering the Nile.

SECTION ONE

The Growth of Egyptian Civilization

Sometime around 5000 B.C., perhaps seeking the animals they depended upon for food, prehistoric hunters and their families came upon and settled in the fertile valley of the Nile River (see Figure 7.2). As far as experts can tell, these people came from western Asia. Since there is no evidence that they moved on or were somehow destroyed, they are regarded as the direct ancestors of most Egyptian peoples. The Nile River valley in which they settled was about 750 miles (1207 km) long, but measured no more than about 31 miles (50 km) at its widest point. In some places, it was not much more than 10 miles (16 km) wide. It was lined on both sides by cliffs ranging in height from around 300 to 1000 feet (100 to 300 m). Beyond these cliffs was nothing but desert.

Early Inhabitants Along the Nile

Each summer the Nile River would flood its banks and deposit layers of fertile soil. This soil had been carried for thousands of miles (kilometers) from the African interior. In some places, these rich soil deposits reached a depth of more than 30 feet (9 m). In this fertile environment, people gradually changed from food gatherers to food producers. Discovering that the

wild vegetables and grains they gathered grew from seeds, they began to gather these seeds and plant them in the fertile soil of the valley. This soil was so productive that as many as three crops could be raised in a single year on the same land.

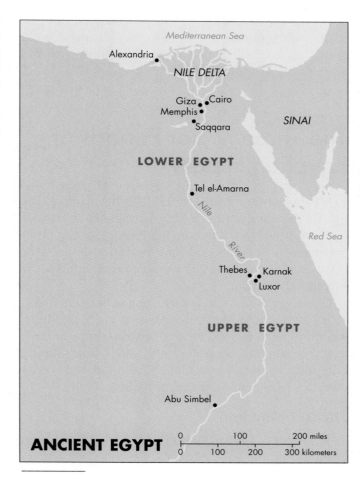

Figure 7.2 Ancient Egypt

The people continued to hunt animals for food, but came to rely more and more on the animals they raised themselves. This gave them a decided advantage over their ancestors. They were no longer entirely dependent upon the game they hunted for survival. Because they no longer had to move from one location to another in search of game, they could give up the practice of living temporarily in caves. Instead, they began to build more permanent houses of mud, wood, and reeds.

This settled existence brought about an increase in population and led to the growth of villages and towns. Some towns grew so strong that they took control of neighboring villages and, in this way, formed kingdoms. As the prehistoric period came to a close, there were only two large kingdoms in Egypt. One of these was Lower Egypt, which included the fan-shaped delta region at the mouth of the Nile. The other was Upper Egypt, which was the valley carved in the desert by the river (see Figure 7.2).

Thus, an Egyptian civilization grew up along the banks of the Nile more than three thousand years before the birth of Christ. It continued in existence for nearly three thousand years. During that period, Egypt became a thriving nation in which a **pharaoh**, or *king*, ruled with complete authority. Agriculture and trade grew; art flourished; and majestic monuments and temples were constructed.

The Three Major Periods of Egyptian History

It is customary to divide the long history of Egypt into three periods: the Old Kingdom, the Middle Kingdom, and the New Kingdom, or Empire. These kingdoms are further divided into dynasties. A **dynasty** was *a period during which a single family provided a succession of rulers.*

One reign ended and another began with the death of a pharaoh and the crowning of a successor from the same royal family. For this reason, every precaution was taken to keep the blood of the royal family pure. One of these precautions was to forbid the pharaoh to marry outside of the immediate family.

The Old Kingdom

The earliest dynastic period began around 3100 B.C. when Upper and Lower Egypt were united by a powerful pharaoh named Menes. Menes established his capital at Memphis and founded the first of the thirty-one Egyptian dynasties. The Old Kingdom dates from the start of the third of these dynasties, in about 2686 B.C. It ended about five hundred years later. The end came when the strong centralized government established by the pharaohs was weakened by the rise of a group of independent nobles. These nobles split the country into small states. Soon civil war and disorder broke out between these states, and the authority of the reigning pharaoh collapsed.

After a long period of turmoil, the nobles in Thebes, a city on the upper Nile, were able to gain control of the country. They managed to unify Egypt once again into a single state, and order was restored to their troubled land. The success of these nobles marked the beginning of the Middle Kingdom, an approximately 250-year period from around 2050 to 1800 B.C.

The Middle Kingdom

The Middle Kingdom was a time of law and order and prosperity in Egypt. This was true even though the pharaoh, while still the supreme head, was not as powerful as pharaohs had been during the Old Kingdom. Then, around 1800 B.C., Egypt was overrun for the first time by foreign invaders. The Hyksos from western Asia, using horses and chariots, swept across the country. They easily defeated the Egyptians, who were fighting on foot. The Hyksos inhabited Lower Egypt and for two hundred years forced the Egyptian people to pay them tribute. Finally, the Egyptians, having learned how to use horses and chariots from the Hyksos, drove the invaders from their country and restored independence.

The New Kingdom

The third and most brilliant period of Egyptian history is known as the New Kingdom, or Empire, and began in 1570 B.C. Warrior pharaohs used their knowledge of horses and chariots to extend Egypt's rule over neighboring nations. The greatest of these warrior pharaohs was Thutmose III. He reigned for fifty-four years and was such a great military leader that he is often referred to as the Napoleon of Egypt.

Under a later pharaoh, Amenhotep III, the New Kingdom reached the peak of its power and influence. Thebes, the royal capital, became the most magnificent city in the world. But Amenhotep's son and heir, Amenhotep IV, broke suddenly with tradition. He tried to bring about changes in Egyptian religion, which for centuries had recognized many different gods. Amenhotep IV moved the capital from Thebes to Tell el-

Amarna where he established Aton, symbolized by the sun disk, as the one supreme god. In honor of his god, Amenhotep changed his name to Ikhnaton (also spelled Akhenaton), which meant "It is well with Aton." Unfortunately, while Ikhnaton was absorbed in his new religion, Egypt's enemies began to whittle away pieces of the once-mighty nation.

Ikhnaton's new religion did not survive after his death. Tell el-Amarna was destroyed, the capital was returned to Thebes, and the old religion was restored. Other pharaohs after Ikhnaton tried to recapture the glories of the past. However, Egypt's long chapter in history was coming to an end. In 332 B.C. Egypt was conquered by Alexander the Great of Macedonia, bringing the New Kingdom to a close. There followed several centuries of Hellenistic rule. Finally, in 30 B.C., Egypt was made a province of Rome.

The greatness of ancient Egypt has not been forgotten over the centuries. Works of art of all kinds remain. They range from huge pyramids and tombs to skillfully formed stone statues, carved and painted reliefs, and wall paintings. These and other treasures remain as fascinating reminders of the magnificent civilization that flourished on the banks of the Nile some four thousand years ago.

The Pyramids

It is clear to anyone visiting the great pyramids at Giza or the Temple of Amon-Re at Karnak that these ancient people were master planners and builders with great resources at their command.

People are so accustomed to seeing pictures of the pyramids that they are no longer impressed by them. Try, however, to picture them as they once were: covered with a smooth layer of polished white limestone, they were massive, pure-white monuments standing solidly before a backdrop of constantly shifting brown sand and blue sky. Photographs can only hint at the tremendous effort that must have gone into the pyramids' construction. What purpose did they serve? How were they built? What is inside?

Before considering these questions, however, an effort should be made to bring your mental picture of these pyramids into sharper focus. When viewing the Pyramid of Khufu (often called "Cheops," its Greek name) (Figure 7.3), you may be attracted first by its great size. Rigid, straight contour lines clearly define and accent the simple triangular shape of this monu-

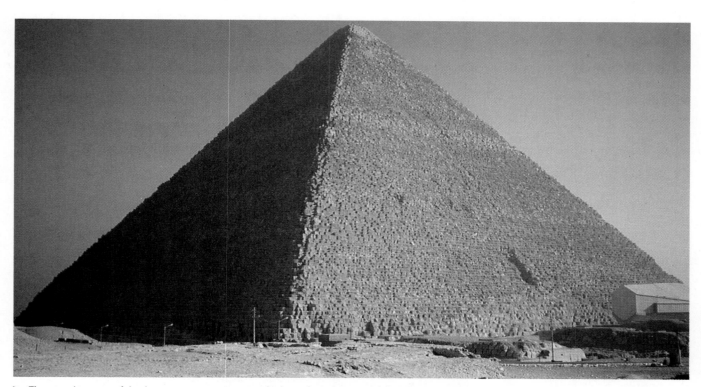

➤ The visual impact of this huge structure conveys a feeling of permanent solidity. Does it look as if it served its purpose well?

Figure 7.3 Pyramid of Khufu, Giza, Egypt. c. 2650 B.C.

mental structure. To begin to appreciate its massive size, consider the fact that the Pyramid of Khufu covers an area of almost 13 acres (5.3 ha). This may not seem very impressive at first. However, it means that the five largest cathedrals in the world could be placed within its base with room to spare. It was made by piling 2.3 million blocks of stone to a height of 480 feet (146.3 m). This makes the pyramid about as high as a 48-story building.

The pyramid was built on an almost perfectly square ground plan. The base, which measures more than 750 feet (229 m) on each side, is much greater than the height. Because the pyramid is wider than it is tall, it lacks an upward movement. Rather than a vertical, soaring quality, the shape and proportions of the pyramid suggest solidity and permanence.

Looking at it from the outside, you might expect the inside of the pyramid to be spacious. This is not the case. Except for passageways and a few small rooms called galleries, the pyramid is made of solid limestone. Perhaps your curiosity is aroused. Why build such a massive building and then provide such little space inside for rooms? To answer this question you must first learn something about the religious beliefs of the ancient Egyptians. As you will see, religion influenced every phase of Egyptian life.

The Influence of Religion

Egyptian religion placed great importance on the resurrection of the soul and eternal life in a spirit world after death. The Egyptians believed that the soul, or *ka*, as it was called, came into being with the body and remained in the body until death. At death, the ka would leave the body for a time. However, eventually it would return and unite with the body again for the journey to the next world and immortality. If the body were lost or destroyed, the ka would be forced to spend eternity in aimless wandering. For this reason, the Egyptians went to great lengths to preserve and protect the body after death. Following a complicated embalming process, the body was wrapped in strips of cloth and placed in a fortresslike tomb where it would be safe until the ka's return. Thus, a strong tomb was a kind of insurance against final death.

The most impressive tomb was built for the most important person in Egyptian society, the pharaoh. The pharaoh was not only a king, but, in the eyes of the people, he was also a god. When he died, the pharaoh was expected to join other gods, including Re, the sun god; Osiris, the god of the Nile and ruler of the underworld; and Isis, the great mother god. The

pyramid was built to house and protect the body of the pharaoh and the treasures he would take with him from this world to the next. His body was sealed in a **sarcophagus**, *a stone coffin*. It was then placed in a burial chamber located in the very center of the pyramid. Dead-end passages and false burial chambers were added to the building. These were meant to confuse tomb robbers and enemies who might try to destroy the pharaoh's body. For an Egyptian, the destruction of the body was the most horrible form of vengeance.

Evolution of the Pyramid Shape

Probably the now-familiar pyramid shape developed gradually over a long period of time. Originally, the Egyptians buried their dead in hidden pits and piled sand and stone over the top. Later this practice changed, and they began to use sun-dried bricks to build mastabas. A **mastaba** is *a low, flat tomb*. These rectangular tombs had sloping sides and contained a chapel and a false burial chamber in addition to the true one hidden deep inside. In time, several mastabas of diminishing size were stacked on top of each other to form a step pyramid (Figure 7.4). Finally, they were built without steps, and a point was added to the top. With this, the true pyramid form was completed.

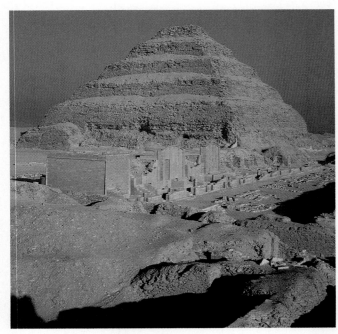

➤ Structures of this kind were one step in a long tradition of Egyptian tomb building. Why were tombs such an important concern for the Egyptians?

Figure 7.4 Step Pyramid of King Zoser. Saqqara, Egypt. c. 2750 B.C.

Art · PAST AND PRESENT ·

High-Tech Pyramid

Chinese-American architect, I. M. Pei (b. 1917), brought the past into the present by designing and building an ancient Egyptian pyramid using new high-tech materials and processes. Pei's recently completed pyramid is the new main entrance to the Louvre museum in Paris, France.

Pei used pioneering techniques in the development of the glass curtain wall. The pyramid is made of the special high-strength optical-quality glass that makes such walls possible. The glass walls give the structure a sense of transparency and lightness. Many other elements of the pyramid are technologically advanced.

Pei's glass pyramid is the first modern addition to the Louvre, which was originally a palace for the kings of France and now houses one of the world's largest and most important art collections.

The pyramid has been criticized by people who are puzzled by the combination of this high-tech pyr-

Figure 7.5 Pei's Entrance to the Louvre. Paris, France. 1989.

amid and the surrounding nineteenth-century buildings. However, Pei felt the project was a chance to integrate artistic design with his commitment to urban renewal. The new addition to the Louvre is not merely an entrance; it is also a vast below-ground network of services and passages. Pei hoped to revitalize the Louvre by making it accessible and integral to modern Paris.

Thousands and thousands of paid workers and slaves toiled for decades to build a single pyramid. Limestone was quarried and dragged to the construction site and then carefully fitted into place. How the Egyptians managed to lift and fit these huge blocks of stone, each averaging 2.5 tons (2.3 metric tons), into place remains unclear. Some scholars believe that the stones may have been dragged up ramps of earth and sand that were raised with each level of the structure. They believe that when finished, the pyramid was almost completely covered with sand. The final task, then, was to remove this sand, exposing the finished structure for the first time.

By the time of the Middle Kingdom, the weakened position of the pharaohs and the threat of invasion made large-scale structures such as the pyramid impractical. Many small pyramids and mastabas may have been built during this period. However, these were probably made of mud bricks which soon crumbled and disappeared. More permanent tombs prepared for the pharaoh were cut into the rock cliffs of a valley across the Nile from the capital city of Thebes.

The Temples

If the pyramids are evidence of the skill of Old Kingdom builders, then the architects of the New Kingdom could point to the great temples they constructed as proof of their own genius. The practice of burying pharaohs and nobles in tombs hidden in the cliffs west of the Nile continued throughout the New Kingdom. Meanwhile, architects took on more important tasks. Temples were erected along the eastern banks of the river near Thebes, and these became more and more elaborate. Each of these temples was built by command of a pharaoh and was dedicated to

the pharaoh's favorite god or gods. When the pharaoh died, the temple became a funeral chapel where people could bring offerings for the pharaoh's ka. Often, a temple built to honor a particular god was enlarged by several pharaohs until it reached tremendous proportions. The ruins of the Temple of Amon-Re at Karnak (Figure 7.6), dedicated to the all-powerful chief god of Thebes, will give you an idea of what these gigantic structures must have looked like.

The approach to the Temple of Amon-Re was a wide avenue which led directly up to the massive sloping front of the structure. A great doorway flanked by **obelisks**, *tall, four-sided, pointed stone shafts*, statues of the pharaoh, and huge banners opened onto an uncovered courtyard. Directly across from this courtyard was the entry to the great hall, perhaps the largest ever built. This hall was filled with massive stone columns, the tallest reaching a height of nearly 70 feet (21 m). Beyond this hall was the sanctuary, the small, dark, and mysterious chamber where only the pharaoh and certain priests were allowed to enter.

Walking from the courtyard to the sanctuary at Karnak, you would move gradually from spacious, bright, warm areas to those that were smaller, darker, and cooler. No doubt this created the impression that you were leaving the real world behind and, with each step, were moving nearer and nearer to another, spiritual world beyond.

➤ Can you determine how this huge temple was constructed? Posts and lintels were used to support the heavy stone slabs of the ceiling and to form the openings for windows and doors.

Figure 7.6 Hypostyle Hall, Temple of Amon-Re. Karnak, Egypt. c. 1280 B.C.

SECTION ONE

Review

1. How did the fertile soil of the Nile River influence the ancient people of Egypt?
2. When did an Egyptian civilization grow up along the banks of the Nile and how long did it continue in existence?
3. What are the three major historical periods of ancient Egypt?
4. What was so unusual about the religious beliefs of the pharaoh Amenhotep IV, or Ikhnaton?
5. What was the ka and how did the Egyptian belief in the ka contribute to efforts to preserve the body after death?
6. Why and for whom were the pyramids built?
7. Whose body was sealed in a stone coffin, called a sarcophagus, and placed in the center of a pyramid?
8. What were mastabas?

Creative Activity

Humanities. Pyramids have a mystery, a mysticism about them. Even today, pyramids are thought to have mysterious powers related to health and good fortune. For the Egyptians, who placed great importance on the afterlife, pyramids were tombs for pharaohs. For the Aztecs of ancient Mexico, the peak of the pyramid was the sacrificial altar to their gods, particularly the sun god. In Figure 7.5 on page 147, you can see the immense glass pyramid I. M. Pei designed for the Napoleon Court of the Louvre in Paris. Pei explained his choice of the pyramid as the "simplest geometric shape, the best." Working in teams and using directions supplied by your teacher, make large, inflatable plastic pyramids that you can enter.

Egyptian Sculpture and Painting

It is readily apparent that ancient Egypt's most impressive achievements in the field of art were the publicly visible pyramids and temples. Within the pyramids, however, were treasures in the areas of sculpture and painting, many of which have survived over the centuries.

Sculpture

Despite every precaution, the fortresslike pyramids and tombs of the pharaohs were soon broken into and robbed of their treasures. Frequently the mummified bodies of the pharaohs were mutilated or destroyed in the process. To make certain that the ka would have a body to live in even if this happened, sculptors were commanded to carve the pharaoh's portrait out of hard stone. These sculptures were then placed in the tomb near the sarcophagus where they acted as substitutes for the body inside. The Egyptians believed that even if the real body were destroyed, the ka would still have the stone substitute to enter for the journey to the next world. In fact, one of the Egyptian words for sculptor translates to read, "He who keeps alive."

Portrait of Khafre

The strength and dignity that were a trademark of the pyramids also characterized the sculptures produced during the Old Kingdom. In the seated portrait of the Fourth-Dynasty pharaoh Khafre (the Greek "Chephren" [Figure 7.7]), the figure keeps the solid, blocklike form of the hard diorite stone from which it was carved. The pharaoh is shown sitting erect and attentive on a throne inscribed with symbols proclaiming him the king of Upper and Lower Egypt. He

Figure 7.7 Khafre, (side and front). c. 2600 B.C. Diorite. 1.7 m (66") high. Egyptian Museum, Cairo, Egypt.

wears a simple, pleated garment that fastens at the waist. A cloth headdress covers his forehead and falls over his wide shoulders. His left hand rests on his knee, while the right hand forms a fist, which must have once gripped some symbol of his high office.

Khafre is more than just a powerful king. He is also a god, the descendent of Re, the sun god. To show the pharaoh's divinity, the sculptor has added a falcon representing Horus, god of the sky. Can you find it? It is placed at the back of the pharaoh's head, where its wings partly encircle and protect his head.

The head of Khafre is not as stiff or rigid as the body. Even though it is simplified, the head has a more lifelike appearance. Khafre looks straight ahead and seems to be completely motionless, although the eyes seem alive to events taking place around him. In studying Khafre's portrait, you may have the feeling that the pharaoh is aware of, but above, the concerns of ordinary mortals. It is this quiet aloofness that makes this portrait a symbol of eternal strength and power—befitting a king and a god.

Perhaps the most familiar and impressive example of Old-Kingdom sculpture is the Great Sphinx (Figure 7.8). Carved from rock at the site, the Sphinx presents the head of the pharaoh, probably Khafre, placed on the body of a reclining lion. It towers to a height of almost 65 feet (20 m). Its massive size was no doubt

intended to demonstrate the power of the pharaoh, but why was the pharaoh's head placed on the body of a lion? Perhaps it was done to show that the pharaoh possessed the courage and strength of a lion.

Portrait of a Middle-Kingdom Ruler

You may recall that the Middle Kingdom was a time of law and order that followed a long period of internal strife and civil war. It lasted only about 250 years, from around 2050 to 1800 B.C. when Egypt was invaded by the Hyksos.

Much of the sculpture produced during the Middle Kingdom was destroyed by the invading Hyksos as well as the New Kingdom rulers who followed. The works that have survived range in quality from those that are quite crude to others that were skillfully done. A fragment of a portrait of King Sesostris III is an example of the skill and sensitivity demonstrated by the best of these Middle-Kingdom carvers (Figure 7.9).

Figure 7.9 *Fragment of Head of King Sesostris III.* 1887—49 B.C. Red quartzite. 16.5 cm (6½") high. The Metropolitan Museum of Art, New York, New York. Gift of Edward S. Harkness, 1926.

The expression on this surprisingly realistic face suggests none of the confidence and aloofness noted in the portrait of Khafre. In this work, the firmly set mouth and the "worry" lines above the eyes convey a look that is troubled and weary. The great pharaoh Khafre would never have been portrayed with such an expression, but Khafre ruled during the Old Kingdom—a time when no one dared question the pharaoh's divine power or authority. Conditions had changed by the Middle Kingdom when this pharaoh's portrait was carved. The sculptor captured a look of

▶ In what ways does the Great Sphinx resemble the pharaoh Khafre?

Figure 7.8 Great Sphinx, Giza, Egypt. c. 2600 B.C.

concern and resignation on the face of this ruler, whose power had been taken away and whose authority depended largely upon his personality, strength, and cleverness.

Portraits of Ikhnaton

By about 1570 B.C., all of the conquering Hyksos who had not been destroyed or enslaved had been driven out of the country. Egypt then entered into a period of expansion and prosperity known as the New Kingdom. Apparently the Egyptians' military success against the Hyksos resulted in a desire for more victories. The powerful army created to defeat the invaders was already in place, and it must have seemed appropriate for the Egyptians to make use of it. A series of successful raids into Palestine and Syria followed. Eventually all opposition in Syria was eliminated. Egypt then found itself in control of a vast territory.

Figure 7.10 *Ikhnaton (Amenhotep IV).* c. 1360 B.C. Ägyptisches Museum, Berlin, Germany.

The expansion of the Empire, which now extended from the upper Nile to the Euphrates River, brought new wealth to the country, and this encouraged artistic activity. During the New Kingdom, sculptors were commissioned to complete a variety of works. These ranged from huge tomb sculptures carved in the native rock to smaller pieces used to decorate temples. Statues of pharaohs were often gigantic, reaching heights of 90 feet (27.4 m). Sometimes these were painted and the eyes made with rock crystal to add to their realistic appearance.

It was during the New Kingdom that an unusual man appeared and briefly challenged the centuries-old traditions of Egyptian life. This was the pharaoh Amenhotep IV, or Ikhnaton, mentioned earlier. You will remember that he was the rebel who refused to follow the religious customs of his ancestors. Many of Ikhnaton's portraits show him with an elongated head, pointed chin, heavy lips, and a long, slender neck (Figure 7.10). Of course, as pharaoh he could have demanded that his artists portray him in a more flattering manner. Perhaps he did not object to these portraits because they showed him as he really looked. Indeed, much of the art that was done during Ikhnaton's reign took on a more realistic look. Instead of the solemn, stiff likenesses favored by earlier pharaohs, Ikhnaton's portraits are more natural and lifelike. They often show him in common, everyday scenes in which he is playing with his daughters or strolling with his wife, Nefertiti (Figure 7.11).

Ikhnaton's revolutionary religious ideas died with him. However, much of the art produced after Ikhnaton continued to exhibit the realistic, relaxed poses favored during the reign of this unusual king.

➤ What similarities do you notice in the expressions shown on the faces of Ikhnaton (Figure 7.10) and his wife Queen Nefertiti? How did the sculptors convey a feeling of authority?

Figure 7.11 *Queen Nefertiti.* c. 1360 B.C. Limestone. Approx. 51 cm (20″) high. Ägyptisches Museum, Berlin, Germany.

Lorraine O'Grady

Lorraine O'Grady (b. 1940) describes her art as "obsessed with the reconciliation of opposites: past and present, conscious and unconscious, black and white, you and me." Her four-part *Sisters* series began when she studied history in school and wondered why portraits of Egyptians resembled herself and other African-Americans. History books traditionally have discussed Egypt as part of the Middle East, not Africa, and O'Grady wanted to "reclaim Egyptian imagery" for African-Americans. Struck by the physical resemblance between the Egyptian queen Nefertiti and Nefertiti's daughter and members of her own family, O'Grady developed *Nefertiti/ Devonia Evangeline*, the performance art piece from which *Sisters*, a quadriptych of paired images, was later taken.

O'Grady entered the visual arts by an indirect path. Born in Boston, she studied economics at Wellesley College and then worked as a research economist for the United States government. Eventually deciding to become a writer, O'Grady earned an M.F.A. in creative writing at the prestigious Iowa Writers' Workshop.

In 1980 a show of African-American art inspired her to begin working as a performance and visual artist: "It was the first time I'd seen a show of African-American abstract art and a gallery opening filled with black people. Reflecting on this show afterward, I felt that it was accomplished but not aggressive enough." To protest the timidity of middle-class black artists, O'Grady fashioned a cape and gown out of many white gloves and wore it with a ribbon emblazoned "Mlle. Bourgeoise Noire" (Miss Black Bourgeoise). O'Grady appeared in this costume at a number of art openings in New York City, distributed flowers to the people gathered there, and shouted, "Black artists must take more risks!" The director of the legendary and now defunct black avant-garde gallery, Just Above Midtown, was greatly impressed by O'Grady's wit and message and invited her to represent the gallery. O'Grady states, "I was in the art world from then on."

Figure 7.12 *Sisters 4: Devonia's sister, Lorraine and Nefertiti's sister, Mutnedjmet.* 1988. Cibachrome diptych. 68.6 x 96.5 cm (27 x 38"). Courtesy of Lorraine O'Grady.

Relief Sculpture and Painting

Just as much can be learned about the ancient Egyptians from their freestanding sculpture, so a great deal can also be learned from their relief sculpture and painting.

Relief Sculpture

About forty-five hundred years ago, a relief panel was carved showing Methethy, a man of that period, and two children (Figure 7.13). This panel illustrates an artistic style that was practiced without change throughout the long history of Egyptian art.

Have you noticed that something seems unusual about the way this man's figure is shown? Perhaps you have observed that the head, arms, legs, and feet are in profile, but the shoulders and eye are shown as if seen from the front. It even appears as though the man has two left feet, since there is a big toe on the outside of each foot. Furthermore, the figure looks as if it has been twisted in some way, making it look flat; notice how all parts of the body seem to be at the same distance from your eye.

Do you think the artist who carved this panel simply lacked the skill needed to make his portrait more lifelike? This argument is not very convincing after examining the figure more closely. The head, for instance, is skillfully modeled and looks realistic. Also, the body is correctly proportioned and details on the other parts of the panel show that the sculptor could carve realistically when he chose to. He was also aware of how to achieve effective design relationships. The detailed areas at the top and left edge of the panel offer a pleasing contrast to the large area occupied by the figure of the man.

Rules of Egyptian Art

The skill of the Egyptian artist in handling realistic detail and design relationships makes one thing clear: the carving's unusual features are not due to a lack of ability. Instead, they are the result of a strict set of rules followed by all Egyptian artists. These rules required that every part of the body must be shown from the most familiar point of view. For this reason, the head, arms, legs, and feet were always shown in profile, while the eyes and shoulders were presented as if seen from the front. Following these rules meant that paintings and relief sculptures of the body looked distorted and unnatural. However, it is a credit to the skill of Egyptian artists that this distortion was kept to

a minimum and did not take away from the appealing appearance of their works.

You may be wondering why these rules were established. It is necessary to refer again to the Egyptian concern for life after death for an answer. Like sculptures, paintings and relief sculptures of the dead were meant to act as substitutes for the body. When artists created images of the pharaoh, they wanted to make sure that all parts of the body were clearly shown. This was more important to them than making the image beautiful or accurate. A complete image was vital. After all, if an arm were hidden behind the body in a

➤ What rules of Egyptian art are shown in this limestone relief?

Figure 7.13 *Methethy with his Daughter and a Son.* c. 2450 B.C. Polychromed limestone relief. 143 x 76 cm (56¼ x 30"). Nelson-Atkins Museum of Art, Kansas City, Missouri.

relief sculpture or painting, it would mean that the ka would enter a body without an arm. It would then be forced to spend eternity in a deformed body. Thus, over the years a strict set of rules was formed to make sure that all parts of the body were shown, and shown correctly, in sculptured and painted images. As you can see, the artist who carved the portrait of Methethy followed those rules carefully.

At one time, it was customary for a pharaoh to have his wife, servants, and slaves sealed in the tomb with him when he died. Then, when he arrived in the next world, he would have his loved ones and servants with him for eternity. They would make sure that his new life would be just as pleasant as the old one. In time, this practice of burying others with the pharaoh was discontinued. Instead, painted relief sculptures or sculptures in the round were substituted for real people and placed in the tomb with the dead king.

Painting

Eventually the tomb of every important or wealthy person was enriched with painted relief sculptures. When it became difficult and costly to carve reliefs on the rough, hard walls of cliff tombs during the Middle Kingdom, however, painting came into its own as a separate art form. The rough walls of the cliff tombs were first smoothed over with a coating of plaster.

When this was done, the artist went to work by drawing a series of horizontal straight lines on the plastered wall. Figures and animals were carefully arranged along these lines to tell a story, usually an event from the life of the deceased. The pictures were then colored in with rich red and yellow hues, with black and blue-green added for contrast. Typically, little shading was used, and so the figures look flat. This method of arranging pictures in horizontal bands and using bright colors with little shading resulted in a style that looks very much like comic-strip art.

A look inside a New-Kingdom tomb prepared for a priest named Nakht will add to your understanding of Egyptian painting.

Portraits of Nakht and his wife are found on one wall of this tomb (Figure 7.14). They are surrounded by busy servants engaged in different hunting and fishing activities on the priest's land.

The way in which the figures have been painted should look familiar to you. The style used to paint them is much like the style used in the relief portrait of Hesire. The artists who did both these works were bound by the same set of rules.

The figures of the priest and his wife are much larger than the other figures to show that Nakht and his wife are more important. They are also stiff and solemn because the Egyptians believed that such a

Figure 7.14 *Nakht and His Wife.* Copy of wall painting from Tomb of Nakht. c. 1425 B.C. Thebes, Egypt. The Metropolitan Museum of Art, New York, New York.

pose was fitting for people of high rank. In contrast, the smaller servants are shown in more natural positions as they hunt and fish.

Under the border at the top of the painting you can see rows and columns of small birds and other shapes. These are Egyptian **hieroglyphics,** *an early form of picture writing.* These symbols, some of which represented objects, communicated information and were included in wall paintings and other art forms to help tell the story. The signs were generally spaced to form attractive patterns, frequently in square or rectangular clusters.

Painted on another wall of the small chapel within this tomb is a false door (Figure 7.15). The priest's ka was expected to pass through this door in search of offerings. Arranged in bands on either side of the door are painted substitutes for servants bearing offerings of food and drink for the ka. An assortment of offerings is painted in the section directly below the door where the ka would be sure to find them when it entered.

Egyptian artists were content to echo the art of the past until influenced by new ideas from places such as Greece and Rome. As the impact of these new ideas grew, Egyptian art lost much of its unique character—and the art of the pharaohs perished.

➤ The ka was expected to pass through the door painted on the wall of this tomb. What was the ka?

Figure 7.15 *False Door Stela.* Copy of a wall painting from the Tomb of Nakht. Thebes, Egypt. c. 1425 B.C. 1.69 x 1.54 m (5.5 x 5'). 1:1 scale with original. Egyptian Expedition of the Metropolitan Museum of Art, New York, New York. Rogers Fund, 1915.

SECTION TWO

Review

1. Why were sculptures of the pharaoh created?
2. What is the Great Sphinx and who does it represent?
3. How are the portraits of Ikhnaton different from portraits of earlier pharaohs?
4. Who was Nefertiti?
5. Describe the rules that Egyptian artists were required to follow when painting or sculpting a figure.
6. Why were these rules imposed on Egyptian artists?
7. What are hieroglyphics and what function did they perform in Egyptian art?
8. What is the purpose of a false door being painted on the wall of an Egyptian's tomb?

Creative Activity

Studio. Many walls of Egyptian temples and tombs are covered with figures raised only slightly from the background. This is called bas relief, or low relief. Make a bas relief design by carving into the surface of a cast plaster tube. Mix plaster and pour it into a cardboard paper-towel tube. When the plaster is set, remove the cardboard paper-towel tube and carve the surface. Try inventing your own hieroglyphic symbols. You may want to divide the surface geometrically, as the Egyptians did. When the carving is complete, roll a slab of clay the width of the tube. Roll the carved shape along the slab, pressing to make the impression. Your negative shapes will become raised forms on the clay. You may want to add color with underglaze stains. To avoid warping, allow the slab to dry slowly and then fire it in a kiln.

DESIGNING AND PAINTING A SARCOPHAGUS COVER

Supplies
- Pencil
- White drawing paper, 9 x 24 inches (23 x 61 cm)
- Ruler
- The sarcophagus drawing
- Mat board, 9 x 24 inches (23 x 61 cm)
- Tempera or acrylic paint
- Brushes, mixing tray, and paint cloth
- Water container

Complete a pencil drawing of a fictional deceased king or queen designed to fit within a specified shape representing the lid of a sarcophagus. Use only the element of line in your drawing. Include the following in your drawing:

1. the head, arms, legs, and feet of the ruler in profile and the eyes and shoulders as if seen from the front view;
2. clues about the ruler's appearance, personality, and major accomplishments.

Use tempera or acrylic to paint your sarcophagus design. Paint the king or queen with intense hues such as bright red, yellow, orange, and blue. Use duller hues for the background to emphasize the figure and to provide contrast. Avoid gradation of value to make the shapes in your painting appear two-dimensional.

Focusing

Why were the Egyptians so concerned with preserving and protecting the bodies of the deceased? Study the relief sculpture of Methethy (Figure 7.13, page 153) and the wall painting from the tomb of Nakht (Figure 7.14, page 154). How did Egyptian rules for painting and sculpture contribute to the way the figures were painted and carved? Identify the intense hues employed. What did the Egyptian artists do to emphasize the most important parts of their paintings? Do their shapes look flat or three-dimensional?

Creating

Imagine that you are living in a culture similar to that of ancient Egypt. This culture requires that its deceased kings or queens be buried in sarcophagi with highly decorated covers. These cover decorations include a likeness of the deceased and provide clues to his or her personality and accomplishments. Like Egyptian sculptures and paintings of the human figure, these portraits must show the head, arms, legs, and feet as if seen from the side and the eyes and shoulders as if seen from the front.

Working with several other students, identify a fictional departed king as being a scholar, a spiritual leader, a military hero, or a vicious tyrant. Discuss his appearance, personality, and accomplishments. Make a list of the visual clues pertaining to each of these features.

On the sheet of white paper complete an outline for a sarcophagus lid conforming to the measurements shown below.

(A) 4 inches (10 cm)

(B) 5 inches (12.7 cm)

(C) 8 inches (20.3 cm)

(D) 14 inches (35.6 cm)

(E) 4 inches (10 cm)

Figure 7.16 Student Work

CRITIQUING

• **Describe.** Does your painting follow the Egyptian rules requiring that all parts of the body be shown clearly? Are the head, arms, legs, and feet shown in profile? Are the eyes and shoulders presented as if seen from the front? Is it possible to determine if the person depicted is a scholar, a spiritual leader, a military hero, or a tyrant?

• **Analyze.** Can you point out areas in your painting where intense colors are used? Where are dull hues employed? Does the contrast of these intense and dull hues help emphasize portions of the painting? Do the shapes appear flat and two-dimensional?

• **Interpret.** Are other students able to read the visual clues in your painting and correctly identify the personality of your king or queen? What clues helped them recognize the ruler's accomplishments?

• **Judge.** Do you think this is a successful painting? What aesthetic qualities did you refer to when determining whether or not it was successful?

With pencil, draw your version of the king to fit in this space. Use the same rules for drawing figures imposed upon ancient Egyptian artists. Your drawing should tell others how the king looked and provide clues to his personality and accomplishments.

Transfer your drawing to the mat board. Paint your design with tempera or acrylic. Use intense reds, yellows, oranges, blues, and other hues to contrast with the duller hues to achieve emphasis. Shapes should be painted without gradation to reproduce the same flat quality noted in Egyptian painting. Place your finished painting on display with those of other students.

CHAPTER SEVEN

Review

Reviewing the Facts

SECTION ONE

1. How long did each of the three major historical periods of ancient Egypt last?
2. How did the Egyptians view the pharaoh?
3. Name three other gods that the Egyptians believed the pharaoh would join when he died.
4. Why were dead-end passages and false burial chambers added to pyramids?
5. Describe the development of the true pyramid form.
6. Why and when were temples built?

SECTION TWO

7. How did the expansion and prosperity of the New Kingdom affect artistic activity?
8. Explain why Egyptian paintings show the head, arms, legs, and feet in profile, but the eyes and shoulders are presented as seen from the front.
9. Why were sculptures or painted relief sculptures buried in the tomb with the dead king?

Thinking Critically

1. *Explain.* What change occurred in the life style of the nomadic hunter-gatherers as a result of the annual flooding along the Nile River valley?

2. *Compare and contrast.* Compare the reigns of Menes, Thutmose III, and Amenhotep IV. Which reign do you think contributed the most to the development of Egyptian arts? Support your opinion.

3. *Analyze.* What clues do sculptures such as the *Portrait of Khafre* (Figure 7.7, page 149) provide about the Egyptians' beliefs concerning the afterlife and the pharaoh's divinity?

4. *Evaluate.* A great deal of information about ancient Egypt is available because the culture was highly concerned with eternal life and building monuments that would last. What factors helped to contribute to the preservation of Egyptian works of art?

Using the Time Line

Identify on the time line what you regard to be the most fascinating period of Egyptian history. What do you find most interesting about that period? If you could be transported back in time to live in that period, what would be the most difficult thing for you to adjust to? How does your answer to these questions differ from those made by other students?

2800	2100	1400	700	1 B.C.

OLD KINGDOM MIDDLE KINGDOM NEW KINGDOM

- Great Sphinx
- Pyramid of Khufu
- Portrait Sculpture of Khafre

Step Pyramid of King Zoser

Portrait Sculpture of King Sesostris

Temple of Amon-Re

Sculpture Portraits of Ikhnaton and Nefertiti

Nakht Tomb Paintings

Tom Alexander, Age 18
Dobson High School
Mesa, Arizona

Since the falcon and pyramid are symbolic of the Egyptian culture, Tom selected them as design motifs. He decided to make a silver pendant. "I began by finding a piece of quartz that resembled a pyramid. My goals were for the falcon to hold the stone and to make the falcon look realistic."

Tom made an armature and used wax to sculpt the bird. "I discovered it was not easy to look at a picture of a falcon and then sculpt it so it looked realistic."

The next step was to cast the bird in silver using the lost-wax method.

In evaluating the finished piece, Tom was most satisfied with the texture of the wings; he felt the head could have been improved. His advice to other students: "Re-creating animals requires time and precision. Take your time and be patient but persistent."

➤ Pendant. Silver and quartz. 8 x 8 x 2.5 cm (3 x 3 x 1").

Art of Rising Civilizations

Panathenaic Amphora Page 162
c. 340 B.C.

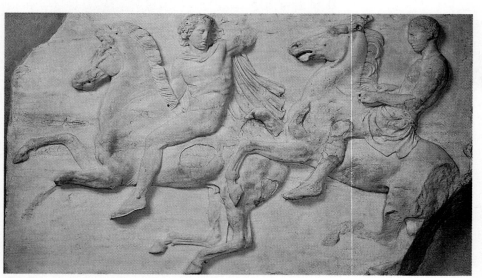

Procession of Horsemen Page 178
c. 440 B.C.

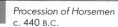

900	700	500
		GREEK ART

Roman Baths, Bath, England
First century A.D.

Page 198

Colosseum, Rome, Italy
A.D. 72–80

Page 201

Nike of Samothrace
c. 190 B.C.

Page 182

100	B.C.	A.D.	100	300

ROMAN ART

161

The Age of Beauty: Greek Art

Objectives

After completing this chapter, you will be able to:

➤ Identify the contributions of the ancient Greeks to the history of art.

➤ Describe the three orders of decorative style that originated in Greece.

➤ Explain how Greek sculpture changed over time from the early Kouros and Hera figures to those created later by Myron and Polyclitus.

➤ Recognize features of Greek architecture in your own city.

Terms to Know

capital
colonnade
column
Corinthian
 order
cornice
Doric order
entablature
frieze
Ionic order
lintel
pediment
stylobate

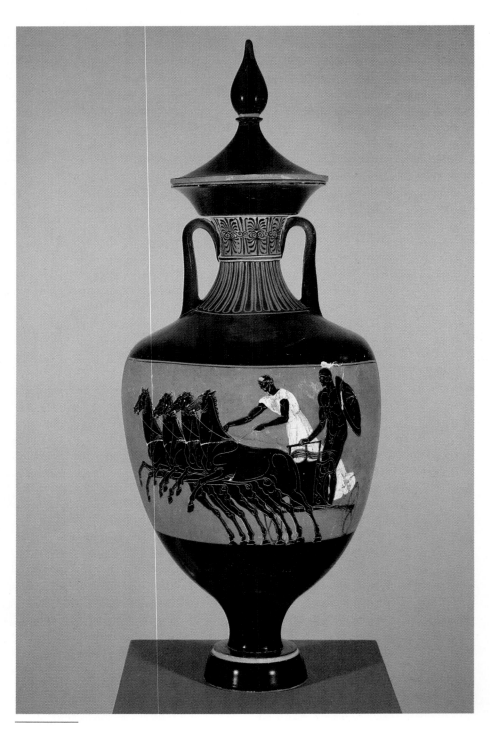

Figure 8.1 *Panathenaic Amphora.* c. 340 B.C. Terra cotta. 101 x 39.2 cm (39¾ x 15⁷⁄₁₆"). J. Paul Getty Museum, Malibu, California.

Why do historians place so much importance on events that

happened over thirty centuries ago in a country not much larger than the state of

Arizona? Why are the names of such artists as Myron, Phidias, and Polyclitus still held in esteem

even though none of their works are known for certain to exist today? The answer is simply that the

country — Greece — was the birthplace of Western civilization. Furthermore, its contributions

to art have had a profound effect upon artists up to the present day.

The Birthplace of Western Civilization

The long story of ancient Greece begins around 2000 B.C. At that time it is believed the earliest Greek tribes entered the land. The descendants of these primitive peoples remained there, and in about five hundred years a strong culture known as the Mycenaean had formed. However, the power of the Mycenaeans eventually gave way to that of a stronger people. After a series of invasions, the warlike Dorians took over the land in about 1100 B.C. This meant a changed way of life in many areas as the conquerors mingled with the native populations. Towns eventually grew into small independent city-states. Many other civilizations began as a collection of city-states which then joined together to form kingdoms and empires. This did not happen in Greece. Instead, the city-states remained fiercely independent. One reason for this may have had to do with geography. Greece is a country cut into pieces by mountains, valleys, and the sea, and this made communication difficult. In addition to these natural barriers were the social barriers of local pride and jealousy. These factors combined to keep the Greek city-states from uniting to form a nation. (See map, Figure 8.2.)

The Delian League

Although there was a great rivalry among the city-states, not one of them was able to grow strong enough to conquer the others. Their rivalry was so intense that they could never agree about anything or work toward a common goal. It was even difficult for them to join together for mutual defense. Fear alone finally united them long enough to fight off invaders from Persia during the fifth century B.C. Then, suspecting still further invasions by the Persians, several city-states joined together to form a defensive alliance. This alliance came to be known as the Delian League. It was so called because its treasury was kept

Figure 8.2 Ancient Greece

on the island of Delos. The larger cities contributed ships and men to this alliance, while the smaller cities gave money.

Because it was the most powerful member of the Delian League, Athens was made its permanent head. Athenian representatives were put in charge of the fleet and were authorized to collect money for the treasury. Pericles, the Athenian leader, decided to move the treasury from Delos to Athens when the threat of invasion lessened. No doubt this angered the other city-states, but Pericles insisted that the treasury would be safer in Athens. However, he soon began to use the money to rebuild and beautify Athens, which had been badly ruined by the Persian invaders.

Athenian greatness was not destined to last long. The actions of Pericles were bitterly resented by the other members of the Delian League, especially Sparta and Corinth. Finally, in 431 B.C., this resentment led to the Peloponnesian War. At first, Pericles successfully withstood the challenge of Sparta and the other city-states, but in 430 a terrible plague struck which killed a third of the Athenian population. A year later, Pericles himself was a victim of this great plague. With the death of its leader, Athens was doomed.

Unfortunately, the Greeks never learned a lesson of unity which enabled them to defeat the Persians. After Athens was defeated, a century of bickering and conflict followed. First one, then another city-state gained the upper hand. This conflict so weakened the country that it was helpless before foreign invaders. Finally, in 338 B.C., Greece was conquered by Macedonia.

Despite a history of rivalry, wars, and invasions, the Greek people managed to make many important contributions to art. Their accomplishments in architecture, particularly temple architecture, were among their most enduring legacies to Western civilization.

The Greek Contribution to Architecture

The Greeks thought of their temples as dwelling places for gods and believed that these gods looked and often acted like humans. The gods controlled the universe and the destiny of every person on earth. For

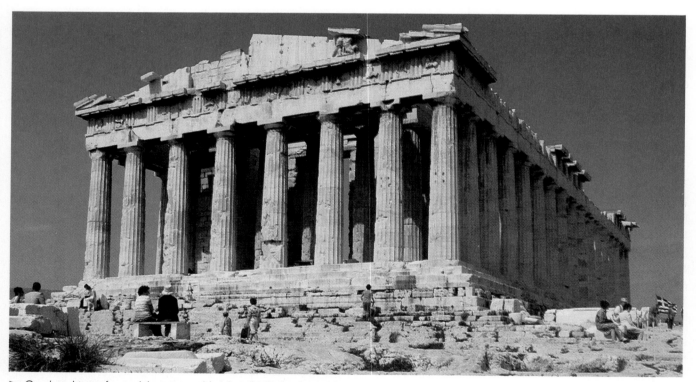

➤ Greek architects favored the post-and-lintel method of construction. Can you find the posts and lintels? What is the overall effect of this building — unbalanced and awkward, or balanced and graceful?

Figure 8.3 Parthenon, Acropolis, Athens, Greece. c. 447 B.C.

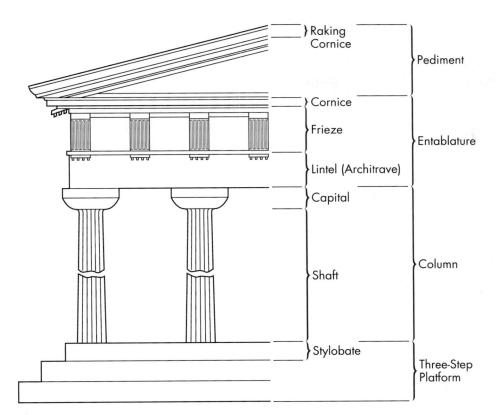

Figure 8.4 Features of Temple Construction.

the Greeks, a perfect life was the highest goal, and a perfect life meant doing what the gods wanted them to do. As a result, fortune tellers and omens were very important in the Greek religion because they helped people discover the will of the gods.

The earliest Greek temples were made of wood or brick, and these have disappeared. As the economy prospered with the growth of trade, stone was used. Limestone and finally marble became the favorite building materials. Even though changes were made in building materials, the basic design of Greek temples did not change over the centuries. Unlike the Egyptian pyramid, which evolved from mastaba to step pyramid to true pyramid, the design of the Greek temple remained the same. Greek builders chose not to alter a design that served their needs and was also pleasing to the eye. Instead, they made small improvements upon the basic design in order to achieve perfection. Proof that they realized this perfection is found in temples such as the Parthenon (Figure 8.3). It was built as a house for Athena, the goddess of wisdom and guardian of the city named in her honor.

The Parthenon

In 447 B.C., using funds from the treasury of the Delian League, Pericles ordered work to begin on the Parthenon. Ten years later the building was basically finished, although work on outside carvings continued until 432 B.C. The construction of such a building in just a decade is itself a wonder. Still, it was finished none too soon. The last stone was hardly in place before the Peloponnesian War started.

Like most Greek temples, the Parthenon is a simple rectangular building placed on a three-step platform (Figure 8.4). The top step of this platform is called the *stylobate*. From the stylobate rose *columns*, or posts, the tops of which were called *capitals*. The columns supported crossbeams, or *lintels*, and these held up a series of members which culminated in a sloping roof. The lintel, also referred to as the architrave, was part of the upper portion of the building called the *entablature*. Another component of the entablature was the **frieze**, *a decorative band running across the upper part of a wall*. Also included in the entablature was a horizontal member called a *cornice*, which was positioned across the top of the frieze. The cornice, along with a sloping member called a raking cornice, framed a triangular section called the *pediment*. A covered **colonnade**, or *line of columns*, surrounded the entire porch. Thus the Parthenon made use of the most familiar features of Greek architecture: post-and-lintel construction; a sloping, or gabled, roof; and a colonnade. Like all Greek buildings, the parts of the Parthenon were carefully planned to be balanced, harmonious, and beautiful.

The Parthenon had just two rooms (Figure 8.5). The smallest held the treasury of the Delian League, while the other housed a colossal gold-and-ivory statue of Athena. (See Figure 8.19, page 177.) However, few citizens ever saw this splendid statue. Only priests and a few attendants were allowed inside the sacred temple. Religious ceremonies attended by the citizens of Athens were held outdoors in front of the building.

Of course, the details of these religious ceremonies are not known. Perhaps the people gathered before the temple to sing hymns of praise or hymns which asked for help from the goddess. At some point in the ceremony, a procession may have formed to carry offerings up to an altar. Food, pottery, and other gifts would be placed before the altar, and, on special occasions, animals may have been brought forward to be sacrificed.

Since few people were allowed inside the temple, there was no need for windows or interior decorations. Instead, attention centered on making the outside of the building as attractive as possible. It is hard to see with the naked eye, but there are few, if any, perfectly straight lines on the entire structure. The three-step platform and the entablature around the building *look*

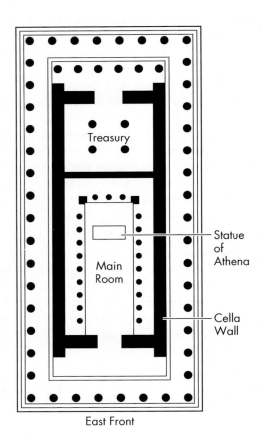

Treasury

Statue of Athena

Main Room

Cella Wall

East Front

Figure 8.5 Plan of the Parthenon.

straight but actually bend upward in a gradual arc, so that the center is slightly higher than the ends. This means that the entire floor and ceiling is a low dome slightly higher in the middle than at the edges. The columns also curve outward slightly near their centers. Like muscles, they bulge a bit as they hold up the great weight of the roof. In addition, each column slants inward toward the center of the building. The columns were slanted in this way to prevent a feeling of top-heaviness and to add a sense of stability to the building. The slant is so slight that if the lines of the column were extended they would meet about 1 mile (1.8 km) above the center of the Parthenon.

The Greeks did not like the cold whiteness of their marble buildings. For this reason, they painted large areas with bright colors. Blue, red, green, and yellow were used most often, although some details were coated with a thin layer of gold. Today little of this color remains since the painted surfaces were exposed to the weather and have been worn away. If you look closely at the more protected places of these ancient buildings, however, you might still find a few faint traces of blue paint.

The Parthenon has been put to a variety of uses over its long history. It was a Christian church in the fifth century and a mosque in the fifteenth century. Its present ruined state is due to an explosion that took place in the seventeenth century. The structure was being used as an ammunition storehouse by the Turks when an artillery shell fired by a Venetian ship landed in the center of it. The ruins have now been restored as far as possible with the original remains. Although only parts of the Parthenon remain standing on the Acropolis in Athens, a full-scale replica of the building can be seen in Nashville, Tennessee. (See "Art Past and Present," page 167.)

The Parthenon was only one of several buildings erected on the sacred hill, or *Acropolis*, of Athens (Figure 8.7). The Acropolis is a mass of rock that rises abruptly 500 feet (152 m) above the city. Like a huge pedestal, it was crowned with a group of magnificent buildings that symbolized the glory of Athens. Covering less than 8 acres (3.2 ha), it was filled with temples, statues, and great flights of steps. On the western edge was a huge statue of Athena that was so tall that the tip of her gleaming spear served as a beacon to ships at sea. The statue was created by the legendary sculptor Phidias, and it was said to have been made from the bronze shields of the defeated Persians. Today, the crumbling but still impressive ruins of the Acropolis are a reminder of a great civilization and the achievements of the original and inspired artists it produced.

Art · PAST AND PRESENT ·

The Parthenon at Nashville

It is possible to see a full-scale replica of the Parthenon by visiting Nashville, Tennessee. Originally built as the centerpiece for the Tennessee Centennial Exposition in 1896, the building was constructed using plans and architectural and archeological studies of the ruins in Athens. Experts who had studied the ruins of the Parthenon provided measurements accurate to one-thousandth of an inch. The Greek government cooperated by providing the necessary information and reports. The British government cooperated by making plaster casts of the Elgin marbles (now in the British Museum) to assist in the recreation of the friezes.

In the early 1920s, because of public demand, the Parthenon in Nashville was made permanent. Ornamentation that had deteriorated was replaced. The structure was reinforced and in some places rebuilt with concrete. In the late 1980s, the building was renovated to provide greater accessibility and to meet changing demands. Today, it serves as the only full-scale replica of the Parthenon in the world, and each year hundreds of thousands of people visit this monument in Nashville, "The Athens of the South."

Figure 8.6 The Parthenon in Nashville, Tennessee. 1896.

➤ The sacred hill, or Acropolis, was crowned with a group of buildings symbolizing the glory of Athens.

Figure 8.7 View of the Acropolis today. Athens, Greece.

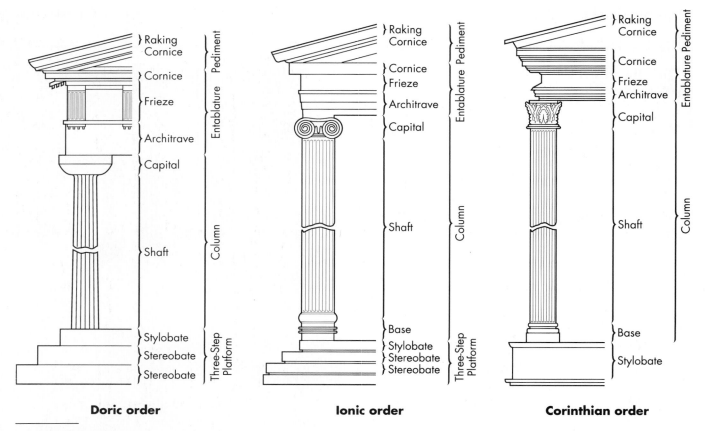

Doric order — Raking Cornice, Cornice, Frieze (Pediment, Entablature), Architrave, Capital, Shaft (Column), Stylobate, Stereobate, Stereobate (Three-Step Platform)

Ionic order — Raking Cornice, Cornice, Frieze, Architrave (Pediment, Entablature), Capital, Shaft (Column), Base, Stylobate, Stereobate, Stereobate (Three-Step Platform)

Corinthian order — Raking Cornice, Cornice, Frieze, Architrave (Pediment, Entablature), Capital, Shaft (Column), Base, Stylobate

Figure 8.8 Three Orders of Decorative Style

The Three Orders of Decorative Style

The Parthenon was built according to a particular order, or decorative style, known as the Doric order. This was the earliest of three orders developed by the Greeks (Figure 8.8). In the **Doric order** *the principal feature is a simple, heavy column without a base, topped by a broad, plain capital.*

Later the Greeks began making use of another order called the *Ionic*. This order used columns that were more slender and higher than those in the Doric. In the **Ionic order**, *columns had an elaborate base and a capital carved into double scrolls that looked like the horns of a ram.* This was a more elegant order than the Doric, and for a time architects felt that it was only suitable for small temples. Such a temple was the little shrine to Athena Nike built on the Acropolis between 427 and 424 B.C. (Figure 8.9). The more they looked at the new Ionic order, the more the Greeks began to appreciate it. Soon they began making use of it on larger structures such as the Erechtheum, a temple located directly opposite the Parthenon. This building was named after Erechtheus, a legendary king of Athens who was said to have been a foster son of Athena.

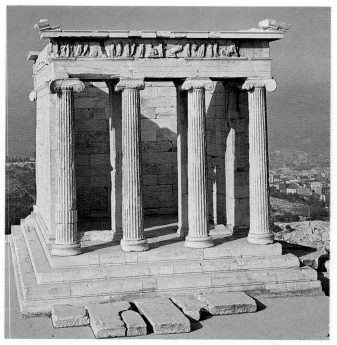

➤ Compare this temple with the Parthenon (Figure 8.3). How do the columns on these two temples differ?

Figure 8.9 Temple of Athena Nike, Acropolis, Athens, Greece. 427–24 B.C.

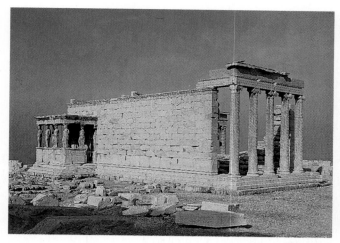

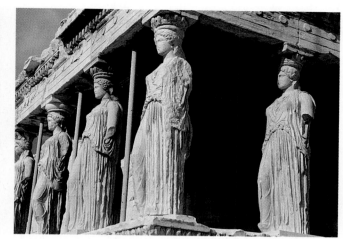

➤ Notice the two types of columns on this building. What order of columns is found on the stylobate? What is unusual about the columns found on the porch?

Figure 8.10 Erechtheum with the Porch of Maidens, Acropolis, Athens, Greece. 421–05 B.C.

An unusual feature of the Erechtheum is the smaller of two porches added to its sides. Called the "Porch of the Maidens," the roof of this porch is supported by six caryatids, or columns carved to look like female figures (Figure 8.10).

The most elaborate order was the *Corinthian*, developed late in the fifth century B.C. In the **Corinthian order**, *the capital is elongated and decorated with leaves*. It was believed that this order was suggested by a wicker basket overgrown with large acanthus leaves found on the grave of a young Greek maiden. At first, Corinthian columns were used only on the inside of buildings. Later, they replaced Ionic columns on the outside. A monument to Lysicrates (Figure 8.11) built in Athens about three hundred years before the birth of Christ is the first known use of this order on the outside of a building. The Corinthian columns surround a hollow cylinder which once supported a trophy won by Lysicrates in a choral contest.

Painting and the Greek Love for Color

The Greeks had a great affection for color. In fact, they liked color so much that they painted their statues as well as their buildings. Some sculptures have been found with their colors still preserved. Unfortunately, none of the great paintings have survived. They are known only through written descriptions.

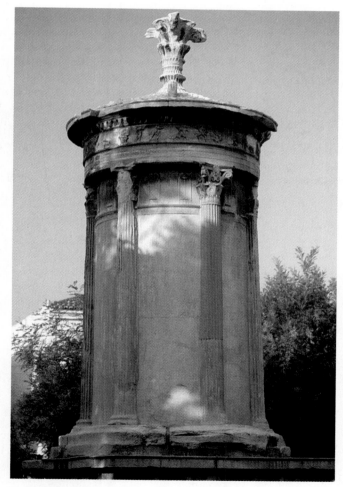

➤ Describe the form of this structure. How does it differ from the form used for the Temple of Athena Nike (Figure 8.9)?

Figure 8.11 Monument to Lysicrates, Athens, Greece. c. 334 B.C.

Concern for Realism

It is likely that Greek painters had a concern for realism as did the Greek sculptors. The Roman historian Pliny the Elder supports this notion. He tells of a great competition that took place in the fifth century B.C. The purpose of this competition was to determine which of two famous painters was more skilled in producing lifelike paintings. The painters, Zeuxis and Parrhasius, faced each other with their works covered by curtains. Zeuxis confidently removed his curtain to reveal a painting of grapes so natural that birds were tricked into pecking at it. Certain that no one could outdo this feat, he asked Parrhasius to reveal his work. Parrhasius answered by inviting Zeuxis to remove the curtain from his painting. When Zeuxis tried, he found he could not—the curtain was the painting.

Of course, Pliny's story is probably more fiction than fact. A more accurate idea of what Greek painting was like may be found on ancient Greek vases.

Greek Vase Decoration

The earliest Greek vases were decorated with bands of simple geometric patterns covering most of the vessel. Eventually the entire vase was decorated in this way (Figure 8.12). It was for this reason that the label *Geometric* was given to the period of years between 900 and 700 B.C. when this form of pattern was being used. Early in the eighth century B.C., artists began to add figures to the geometric designs on their vases (Figure 8.13). Some of the best of these figures were painted on large funeral vases. These vases were used in much the same way as tombstones are used today, as grave markers. The figures on these vases are made of triangles and lines, and look like simple stick figures. Often they are placed on either side of a figure representing the deceased as though they were paying their last respects. Their hands are raised upward, pulling on their hair in a gesture of grief and despair.

➤ During the Geometric period, patterns of this kind were found on Greek vases and jugs. Does this look like an early, or a well-developed, form of decoration?

Figure 8.12 *Geometric Jug.* Seventh century B.C. Terra cotta. 41 cm (16"). Indiana University Art Museum, Bloomington, Indiana.

Realism in Vase Decoration

In time, vase figures became more lifelike and were placed in storytelling scenes. An excellent example of this kind of painting is provided by a vase showing two figures engrossed in a game (Figure 8.14). It was created by an artist named Exekias (ex-**ee**-kee-us).

Have you ever become so caught up in a game that you failed to hear someone calling you? It happens to everyone, no matter how important the person being called or how urgent the summons. Exekias painted such an event on a vase over twenty-five hundred years ago. Two Greek generals are seen playing a board game, probably one in which a roll of the dice determines the number of moves around the board. The names of the generals are written on the vase. They are two great heroes from Greek literature, Ajax and Achilles. The words being spoken by these warriors are shown coming from their mouths just as they appear in modern cartoon strips. Ajax has just said "tria," or "three," and Achilles is responding by saying

➤ How are the figures depicted on this vase?

Figure 8.13 Geometric vase, dipylon, colossal. Side A: Funerary scene. Athens, Greece. Eighth century B.C. Terra cotta. 108.2 cm (42⅝"). The Metropolitan Museum of Art, New York, New York. Rogers Fund, 1914.

➤ Notice how the artist has arranged this scene to complement the shape of the vase. What makes this an effective design? What kinds of changes in vase decoration had taken place between the time of the vase shown in Figure 8.13 and the one by Exekias?

Figure 8.14 Exekias. *Vase with Ajax and Achilles Playing Morra (dice).* c. 540 B.C. Vatican Museums, Rome, Italy.

Edward Allington

British sculptor and draftsman Edward Allington (b. 1951) recycles the ideas and forms of ancient Greek art and invests them with new meanings. Far from simply taking an affectionate or nostalgic view of the ancient world and its culture, he explores the importance that classical works and fragments have for people living today.

Allington was born at Troutbeck Bridge in Cumbria, England. His father was a craftsman, and Allington initially decided to pursue a career in pottery. In the middle of his training in ceramics, however, he became frustrated with the direction of contemporary pottery. Questioning the relationship between art, craft, and culture, Allington stopped working in pottery and became a sculptor. Sculpture permitted him the freedom to articulate the complicated role of historical objects in modern society.

Even as a child, Allington was intrigued by ancient Greece, and as an adult his art gives expression to his highly ambivalent feelings about a historical culture that prized both the rational, ethical philosophy of Plato and the wildly celebratory cult of the god Dionysus, which Plato opposed. The geometric forms in Allington's sculptures reflect his respect for Plato's orderly universe, yet Allington finds it impossible to accept that there can be any one absolute standard or description of "truth" or "reality," such as Plato offered.

Allington's art is complex and critics differ in their interpretation of it. Some critics say his sculptures rooted in classical antiquity refer to the pathos of ancient fragments that rest in glass cases in museums. Some say his art compares the chaotic atmosphere of the present day with a well-ordered past. Others find in Allington's art a plea for a cyclical view of history wherein ideas from the past are constantly recycled and given new life as they become relevant.

Allington himself states that his guiding principle is "remembering where your feet are," a reference to the importance of realizing and accepting one's own position in time and history. We may never fully understand what an object meant to a person who lived many centuries ago, but we can at least explore what it means to us today.

Figure 8.15 *An Apollo Admiring Two Vases/in Black.* 1987–88. Painted wood, resin cast, and plastic. 176.5 x 152 x 183 cm (70 x 60 x 72"). Lisson Gallery, London, England.

"tessera," or "four." Legend says that these two great heroes were so involved in this game that their enemy was able to mount a surprise attack.

Exekias has tried to show the informality of this simple scene. Shields have been set aside, and Achilles, at the left, has casually pushed his war helmet to the back of his head. Ajax, forgetting for a moment that they are at war, has removed his helmet and placed it out of the way on top of his shield. For a few moments, the Greek heroes are just two ordinary people lost in friendly competition.

Exekias has also made an effort to add details to his scene to make it seem as realistic as possible. An intricate design decorates the garments of the two generals. Also, the facial features, hands, and feet are carefully drawn, although the eyes are shown from the front as they were in Egyptian art. However, Exekias was not so concerned with realism that he ignored good design. The scene is carefully arranged to complement the vase on which it is painted. The figures lean forward, and the curve of their backs repeats the curve of the vase. Also, notice how the lines of the spears continue the lines of the two handles and lead your eye to the game, which is the center of interest in the composition.

At this stage in Greek vase design, decorative patterns became a less important element, appearing near the rim or on the handles. Signed vases also began to appear for the first time in the early sixth century B.C., indicating that the potters and artists who made and decorated them were proud of their works and wished to be identified with them.

SECTION ONE

Review

1. Name two factors that contributed to keeping the Greek city-states from uniting to form a nation.
2. What was the Parthenon?
3. Define *frieze*.
4. What three features of Greek architecture were used in the construction of the Parthenon?
5. How many rooms are in the Parthenon? What were these rooms used for?
6. Name the sacred hill where the Parthenon is found.
7. What was the earliest of the Greek decorative orders? Describe its principal feature.
8. What decorative style is used on the Erechtheum?
9. Name and describe the most elaborate of the Greek decorative orders.
10. How did the ancient Greek people use the large funeral vases?

Creative Activities

Humanities. One of the greatest contributions of ancient Greek society to the world's culture is Greek theater—both the architecture and the rich resource of plays. Form teams to research and construct a model of one of the most significant forms of theater design throughout history. Research the Greek amphitheater and trace its evolution to the enclosed box stage of the early twentieth century. Then look at the many new and inventive solutions to contemporary theater design.

Studio. Architects throughout history have turned to nature as a source of inspiration for column design and capitals. The Egyptian temple at Luxor has a lotus blossom theme, the flower becoming a graceful shape tapering out from the capital, and columns designed to look like bundles of papyrus reeds. Greeks used the human figure in their caryatid columns. Design a contemporary column using some object from nature. Think about cauliflower capitals and celery columns.

The Evolution of Greek Sculpture

The buildings on the Acropolis were constructed during the fifth and fourth centuries B.C. This was a time in Greek history known as the Classical period. Like architecture, Greek sculpture also reached its peak during this Classical period. To understand and appreciate Greek accomplishments in sculpture it is necessary to turn the pages of history back to an earlier time known as the Archaic period.

Sculpture in the Archaic Period

From around 600–480 B.C., Greek sculptors were busy carving large, freestanding figures known as *Kouroi* and *Korai*. Kouroi is the plural form of Kouros, meaning "youth," and Korai is the plural of Kore, or "maiden."

The *Kouros*

A Kouros was a male youth who may have been a god or an athlete (Figure 8.16). In some ways, the stiffness and frontal pose of this figure brings to mind Egyptian statues. The only suggestion of movement is noted in the left foot, which is placed slightly in front of the right.

You may have noticed that even though the figure is stepping forward, both feet are flat on the ground. Of course, this is impossible unless the left leg is longer than the right one. This problem could have been corrected if the right leg had been bent slightly, but it is perfectly straight. Later, Greek artists learned how to bend and twist their figures to make them appear more relaxed and natural.

Except for the advancing left foot, the Kouros is symmetrically balanced. Details of hair, eyes, mouth, and chest are exactly alike on both sides of the figure just as they are on Egyptian statues. Unlike Egyptian figures, the arms of the Kouros are separated slightly from the body and there is an open space between the legs. These openings help to break up the solid block of the stone from which it was carved.

No one knows for certain what the Kouros was meant to be. Some say he represents the sun god

➤ What is unusual about the position of this figure?

Figure 8.16 *Kouros.* 615–600 B.C. Island marble. 193 cm (6'4"). The Metropolitan Museum of Art, New York, New York. Fletcher Fund, 1932.

Apollo, while others insist that he is an athlete. If he is an athlete, he may be stepping forward to receive an award for a victorious performance in the games that were such an important part of Greek life. The wide shoulders, long legs, flat stomach, and narrow hips support the claim that he is an athlete.

The face of the Kouros is interesting because it has a number of unusual features which were used over and over again on early Greek sculptures. Among these are the bulging eyes, square chin, and a mouth with slightly upturned corners. This same mouth with its curious smile can be found on scores of early Greek sculptures. You may find it strange and even amusing, but this smile may have been a first step in the direction of greater realism. Greek sculptors wanted their figures to look more natural, and what could be more natural than a warm, welcoming smile? However, it took them a while to learn how to make that smile look more natural.

The *Hera of Samos*

Korai were clothed women, often goddesses, which were also carved during the Archaic period. One of these goddesses, the *Hera of Samos* (Figure 8.17), looks a great deal like a stone cylinder. It has the same frontal pose as the *Kouros*, but its right arm is held lightly against the body and the feet are placed tightly together. The missing left arm was bent and may once have held some symbol of authority. There is no deep carving here and no open spaces. Perhaps the artist was afraid to cut too deeply into the stone for fear of breaking it. Instead, a surface pattern of lines is used to suggest the garments and add textural interest to the simple form. Straight vertical lines are repeated to suggest a light lower garment. These contrast with the more widely spaced and deeper lines of a heavier garment draped over her shoulders. The folds of the garments gently follow the subtle curves of the figure. There is little to suggest action or movement; the figure stands perfectly upright and still. Over 6 feet (1.8 m) tall, it must have been an impressive symbol of authority and dignity to all who saw it.

➤ Which element of art seems most important here? Can you find any deep carving or open spaces on this sculpture?

Figure 8.17 *Hera of Samos.* c. 570–60 B.C. 1.8 m (6′) tall. The Louvre, Paris, France.

Sculpture in the Classical Period

With each new generation, Greek artists became bolder and more skillful. During the Classical period, they abandoned the stiff frontal pose and made their figures appear to move in space.

Myron's *Discus Thrower*

You can see how successful they were by examining a life-size statue of a discus thrower, or *Discobolus*, by a sculptor named Myron (**my**-run) (Figure 8.18). Gone is the blocky, rigid pose of the earlier Kouroi and Korai. Myron has skillfully captured one of the rapidly changing positions required of an athlete throwing a discus. The athlete's weight is placed on his right leg, and the other is poised and ready to swing forward. He is frozen for a split second at the farthest point of the backswing.

Have you noticed something unusual about the face of Myron's figure? You would think that at this instant, just before vigorously hurling the discus, the athlete's face would be tense and strained. He is about to put all his strength into a mighty throw, and yet his face is completely calm and relaxed. In this respect, the figure is more idealistic than real.

Few facts about Myron the man are known, but his work says a great deal about Myron the artist. It reveals that he had a thorough understanding of anatomy (how the body is structured) and that he delighted in the expression of motion. Myron's work also reveals that he must have spent many hours studying athletes in action and that he had complete confidence in his skills as an artist. Today he is regarded as one of the most important of the ancient Greek sculptors.

Myron's chief material was bronze, although it was said that he also created huge figures of gold and ivory. As far as is known, he did not work in marble. However, knowledge of his sculptures comes from marble copies produced in Roman times. A dependence on Roman copies for information about Greek sculptures is not unusual. Today there no longer exists a single certified original work by the great sculptors of Greece. Bronze works, which once numbered in the thousands, were melted down long ago. Even marble sculptures were mutilated, lost, or ruined by neglect. What is known of those ancient works comes from copies made by Romans who used them to decorate their public buildings, villas, and gardens.

➤ Trace the axis line that begins at the tip of the right hand. Where does this line lead? Does this figure look realistic or idealistic to you?

Figure 8.18 Myron. *Discobolus (Discus Thrower)*. Roman copy of a bronze original. c. 450 B.C. Life-size. Palazzo Vecchio, Florence, Italy.

Sculptures for the Parthenon

It is through Roman copies and descriptions by ancient writers that the works of Phidias (**fid**-ee-us) are known. He was one of the greatest of all Greek sculptors and the creator of the gigantic statue of Athena in the Parthenon. Use your imagination to appreciate the full impact of this work. Walking into the darkened room of the Parthenon, you would face this colossal goddess, towering over you to a height of 42 feet (13 m). Her skin was of the whitest ivory, and over 1 ton (0.9 t) of gold was used to fashion her armor and garments. Precious stones were used for her eyes and as decorations for her helmet. A slight smile softened a face that looked as if it could turn cruel and angry at any moment. You might fear her or admire her, but it is unlikely that you would ever forget this powerful vision of Athena fashioned by Phidias.

Today a full-scale re-creation of this statue stands in the Nashville Parthenon (Figure 8.19). Sculptor Alan LeQuire worked for eight years with an international team of scholars to insure that his work would accurately represent the original. You no longer have to use your imagination to see this colossal Athena Parthenos, goddess of the Athenians. She can be viewed in a re-creation of the temple originally built for her in 447 B.C.

Other Sculptures by Phidias

In addition to creating the original statue of Athena, Phidias also supervised the decorations on the outside of the Parthenon. One of these decorations was a large relief sculpture made up of 350 people and 125 horses taking part in a religious parade.

A parade today is an exciting and colorful event whether you are participating in it or watching as it passes by. It must have been just as exciting and colorful in ancient Athens. On a 525-foot (160-m) band, or frieze, Greek sculptors directed by Phidias show you how a parade looked to them over twenty-four hundred years ago.

Every four years, the citizens of Athens held a great celebration in honor of Athena. As part of this celebration, a procession was held. The people in this procession carried new garments and other offerings to Athena in the Parthenon. These were the city's gifts thanking the goddess for her divine protection. The procession was formed in the city below the Acropolis and moved slowly up a winding road through a huge gateway, the entrance to the sacred hill. Then it wound between temples dedicated to various gods and goddesses and past the huge bronze statue of Athena. The procession finally stopped at the entrance to the Parthenon where, during a solemn ceremony, the presentations were made.

The processional frieze is no longer on the Parthenon. In fact, it is not even in one piece. Badly damaged parts of it are housed in museums in London, Paris, and Athens. This is unfortunate since they were intended to go together to form a single work of art. Since you cannot see it in one piece, try to picture it as it must have looked when it was completed.

To see the frieze you would have had to climb the three steps and pass through the row of outside columns surrounding the Parthenon. Inside are the walls of the temple. The frieze, which was over 3 feet (1 m) high, ran around the top of these walls like a giant stone cartoon strip. It must have been difficult to see

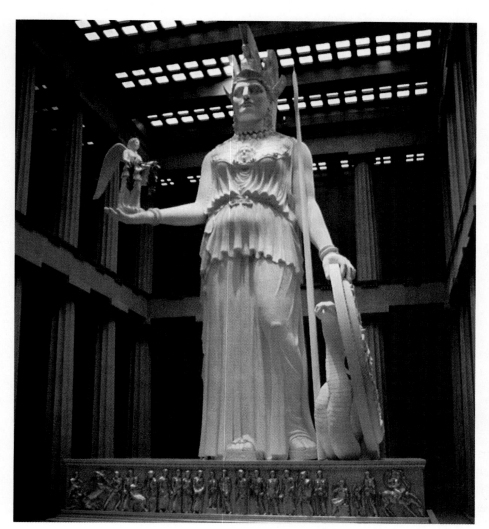

➤ To prevent the head of this colossal Athena from appearing tiny when viewed from floor level, the proportions have been expanded from the waist up. In her right hand there is a statue of Nike, the Winged Victory.

Figure 8.19 Alan LeQuire. *Athena Parthenos.* 1990. Fiberglass and gypsum cement, marble, paint, and gold leaf. 13 m (42') high. The Parthenon, Nashville, Tennessee.

because it was so high and, placed just below the ceiling, poorly lit.

The scene begins on the western side of the Parthenon. There the procession is seen taking shape in the city. A feeling of anticipation is in the air as riders prepare to mount their prancing horses. Others, preparing to march on foot, are seen standing about impatiently, lacing their sandals or adjusting their garments. Further on, mounted and unmounted youths, charioteers, city officials, and sacred animals are moving forward—the parade is under way. As they move, the figures bunch up in some places and spread out in others as paraders often do. At one point, an irritated horseman turns and raises his hand in warning to the horseman behind him, who has come up too quickly and jostled his mount. The rider behind responds to the warning by reining in his rearing horse (Figure 8.20). All along the parade, there is a strong sense of movement. It is evident in the spirited prancing of the horses and the lighthearted pace of the figures on foot. This pace seems to quicken as the

procession draws nearer to its destination. Perhaps movement is best suggested by the pattern of light and shadow in the carved drapery. This pattern of alternating light and dark value contrasts creates a flickering quality that becomes even more obvious when contrasted with the empty spaces between the figures.

Finally, the procession slows down and becomes more serious as it approaches a group of seated gods and goddesses watching the scene. They may be guests enjoying the parade at the invitation of Athena. Nearby, a number of standing figures stop the parade at a point just over the main door of the temple (Figure 8.21). You will recall that, in reality, it was here at the main entrance to the Parthenon that the gifts and offerings were made to Athena.

There are many legends about Phidias, but few reliable facts about his life. One story says that he was accused of stealing gold that was to be used for the statue of Athena. This charge apparently was not proved, but it was followed by another—that he had

➤ Find two axis lines in this relief sculpture. Does the use of these repeated diagonals suggest a movement or rhythm? What other elements and principles of art has the sculptor used to give this work a sense of unity?

Figure 8.20 *Procession of Horsemen,* from the west frieze of the Parthenon. c. 440 B.C. Marble. Approx. 109 cm (43″) high. British Museum, London, England.

➤ Notice how value has been used to create variety between the drapery and the empty spaces between the figures. How has line been used? Would you say the rhythm or movement shown here is swift or slow?

Figure 8.21 *Head of the Procession*, from the east frieze of the Parthenon. c. 440 B.C. Marble. The Louvre, Paris, France.

included his portrait and that of Pericles in the design on Athena's shield. For this act of blasphemy, he was thrown into prison. Recent excavations show that he was working on a statue of Zeus at Olympia after he left Athens and that he died in exile.

Sculpture from the Temple of Athena Nike

Another relief sculpture, this one from the Temple of Athena Nike, may remind you of Myron's discus thrower since it also shows a figure frozen in action (Figure 8.22). The unknown sculptor has carved the goddess of victory bending over to fasten her sandal. A graceful movement is suggested by the thin drapery which clings to and defines the body of the goddess. As you analyze this work, you will see how the flowing folds of the drapery and the line of the shoulder and arms create a series of oval lines that unifies the work. If you compare the handling of the drapery here with that of the *Hera of Samos*, you can appreciate more fully the great strides made by Greek sculptors over a 150-year period.

Polyclitus' *Spear Bearer*

The second most famous Classical Greek sculptor after Phidias was Polyclitus (pol-ee-**kly**-tus). His specialty was creating statues of youthful athletes such as

➤ In what way is this carving similar to the *Discus Thrower* (Figure 8.18)? How has the sculptor created the impression that a real body exists beneath the drapery?

Figure 8.22 *Nike Fastening Her Sandal*, from the Temple of Athena Nike. c. 410 B.C. Marble. 107 cm (42″) high. Acropolis Museum, Athens, Greece.

his *Doryphorus* (or *Spear Bearer)* (Figure 8.23). Often his figures are shown in a pose that has come to be known as "contrapposto." In such a pose, the weight of the body is balanced on one leg, while the other is free and relaxed. In the *Doryphorus*, the left leg is bent and the toes lightly touch the ground. The body turns slightly in a momentary movement that gives the figure a freer, more lifelike look. The right hip and left shoulder are raised; the head tips forward and turns to the right. The result is a spiral axis line, or line of movement, that begins at the toes of the left foot and curves gently upward through the body to the head. Action is kept to a minimum, but there is an unmistakable feeling of athletic strength and prowess here. The figure seems to be doing little more than just standing around at the moment. Perhaps he is waiting his turn to test his skill in the spear-throwing competition. If so, he certainly does not look nervous or tense. On the contrary, he looks not only completely relaxed but also confident that he will be victorious in competition.

Sculpture in the Hellenistic Period

The Peloponnesian War left the Greek city-states weakened by conflict. To the North lay Macedonia ruled by Philip II, a military genius who had received a Greek education. Having united his own country, Philip turned his attention to the disunited and bickering Greek city-states. Their disunity was too great a temptation to resist, and in 338 B.C. Philip defeated them to realize his dream of controlling the Greek world. Before Philip could extend his empire further, he was assassinated while attending the wedding of his daughter. His successor was his twenty-one-year-old son, Alexander the Great, who soon launched his amazing career of conquest.

Alexander, whose teacher had been the famous Greek philosopher Aristotle, inherited his father's admiration for Greek culture. Alexander's admiration was so great that he was determined to spread this culture throughout the world. As he marched through one country after another, the Greek culture that he brought with him blended with other non-Greek cultures. The period in which this occurred is known as the Hellenistic age. It lasted about two centuries, ending in 146 B.C. when Greece was again conquered, this time by Roman legions.

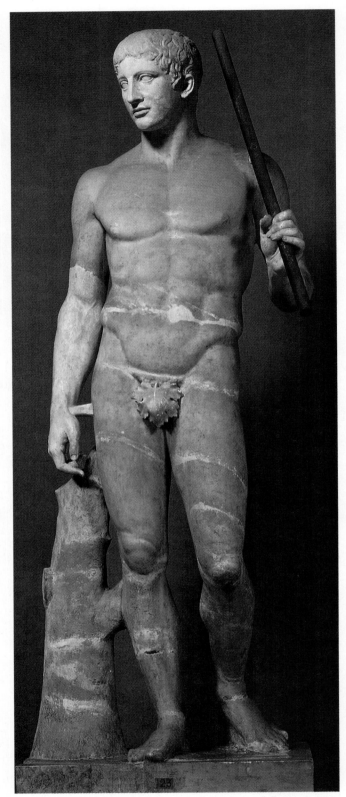

➤ Draw an imaginary axis line down the center of this figure. Is this axis line straight, or does it curve? What makes this figure so lifelike? Is this a successful work of art? Why or why not?

Figure 8.23 Polyclitus. *Doryphorus (Spear Bearer)*. Roman copy after Polyclitus. c. 450–40 B.C. Life-size. Museo Nazionale, Naples, Italy.

Sculptors working during the Hellenistic period were extremely skillful and confident. They showed off their skills by creating dramatic and often violent images in bronze and marble. The face was especially interesting to them because they felt that the face was a mirror of inner emotions. Beauty was less important to them than the expression of these inner emotions. Their works left little to the imagination, and often lacked the precise balance and the harmony of Classical sculptures.

The *Dying Gaul*

Many of the features of the Hellenistic style can be observed in a life-size sculpture known as the *Dying Gaul* (Figure 8.24). A Roman copy shows a figure that was once part of a large monument erected in the ancient Greek city of Pergamon. The monument was built to celebrate a victory over the Gauls, fierce war-riors from the North. In this sculpture, you witness the final moments of a Gaul who was fatally wounded in battle. The fighting has swept by and in the stillness that follows, a once-feared warrior gallantly fights one final battle, one he cannot win. Blood flows freely from the wound in his side. Life seems to have already left the legs crumpled beneath him, and he uses what little strength he has remaining to support himself with his right arm. He has difficulty supporting the weight of his head and it tilts downward. Pain and the certain knowledge that he is dying distorts the features of his face. In a few moments, no longer able to hold himself up, he will sink slowly to the ground.

Works like the *Dying Gaul* were intended to touch the emotions of the viewer. You are meant to become involved in this drama of a dying warrior, to share and feel his pain and loneliness and marvel at his quiet dignity at the moment of death.

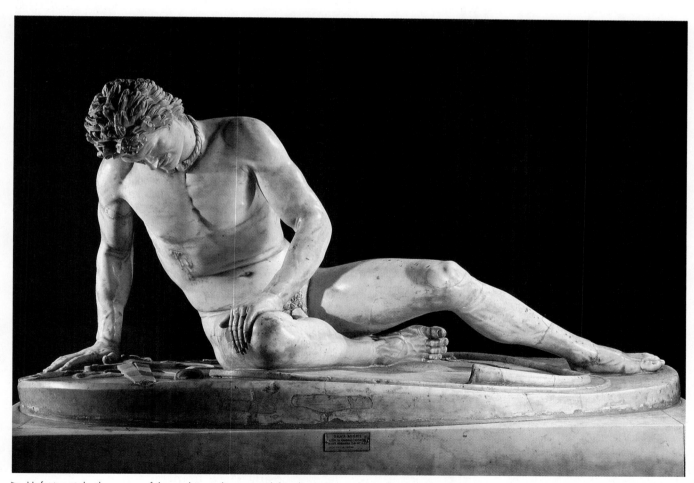

➤ Unfortunately, the name of the sculptor who created this dramatic work is unknown. How does this sculpture make you feel? What aesthetic theory of art seems especially appropriate to use in judging this piece?

Figure 8.24 *Dying Gaul.* Roman copy of a bronze original from Pergamum. c. 240 B.C. Life-size. Museo Capitolino, Rome, Italy.

The *Nike of Samothrace*

About twenty-one hundred years ago, an unknown sculptor completed a larger-than-life marble sculpture to celebrate a naval victory (Figure 8.25). The finished sculpture of a winged Nike (goddess of victory) stood on a pedestal made to look like the prow of a war ship. She may have held a trumpet to her lips with her right hand while waving a banner with her left. Loudly trumpeting victory, her wings outstretched, she lands lightly on the ship. Clearly the vessel is under way, speeding to meet and defeat some enemy. A brisk ocean breeze whips Nike's garments into ripples and folds, adding to a feeling of forward movement. Her weight is supported by both legs but the body twists in space, creating an overall sense of movement.

It is not known for certain what great victory this sculpture was meant to celebrate. Likewise uncertain is its original location. It was found in 1875 on a lonely hillside of Samothrace, headless, without arms, and in 118 pieces. Pieced together, it is now known as the *Nike* (or *Victory*) *of Samothrace*. It stands proudly once more, welcoming visitors to the Louvre, the great art museum in Paris.

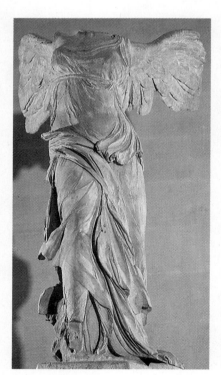

➤ What has the artist done to create a feeling of forward movement here? Does this work suggest excitement and action, or calmness and dignity?

Figure 8.25 *Nike of Samothrace.* c. 190 B.C. Marble. Approx. 2.4 m (8'). The Louvre, Paris, France.

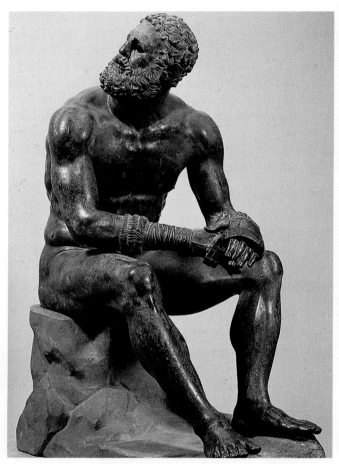

➤ What are your feelings about this figure? Is emotionalism an appropriate theory to use in judging this work?

Figure 8.26 *Seated Boxer.* c. 50 B.C. Bronze. Museo Nazional Romano, Rome, Italy.

The *Seated Boxer*

Ten years after the *Nike of Samothrace* was found, a bronze sculpture of a seated boxer (Figure 8.26) was unearthed in Rome. It is not as dramatic as the *Dying Gaul* nor as spirited as the "Winged Victory," but it has an impact on the emotions of anyone pausing to look at it carefully. The unknown artist does not present you with a victorious young athlete, but a mature, professional boxer seen resting after what must have been a brutal match. Few details are spared in telling you about the boxer's violent occupation. The swollen ears (a boxer's trademark), scratches, and perspiration are signs of the punishment he has received. He turns his head to one side as he prepares to remove the leather boxing glove from his left hand. The near-profile view of his face reveals his broken nose and battered cheeks. What is he looking at? Of course, it is impossible to know for certain, but there is no mistaking the joyless expression on his face.

Stylistic Changes in Sculpture

The development of Greek sculpture can be traced through an examination of the cavalcade of gods, goddesses, and athletes created from the Archaic period to the Hellenistic period. Sculptured figures produced during the Archaic period were solid and stiff, but by the Classical period they had achieved near perfection in balance, proportion, and sense of movement. During Hellenistic times, sculptures emphasized even greater movement in space and added an emotional appeal intended to actively involve the viewer.

Perhaps this development can be illustrated best by looking again at several sculptures that made use of the same subject matter. The *Kouros*, the *Discus Thrower*, the *Spear Bearer*, and the *Seated Boxer* are all sculptures of male athletes, but each reflects different objectives stressed at different periods in Greek art history. The *Kouros* was created at a time when artists were seeking greater control of their materials in order to make their statues look more real. The *Discus Thrower* shows that they eventually gained the knowledge and skill to do this. From there, they went on to improve upon their works, striving for the balance, harmony, and beauty noted in works such as the *Spear Bearer*. Finally, their interest shifted to more dramatic and emotional subjects, such as the *Seated Boxer*.

The Demand for Greek Artists

In 197 B.C., the Romans defeated Macedonia and gave the Greek city-states their freedom as allies, but the troublesome Greeks caused Rome so much difficulty that their freedom was taken away and Corinth burned. Athens alone continued to be held in respect and was allowed a certain amount of freedom. Although the great creative age had passed its peak, Greek artists were sought in other lands where they spread the genius of their masters.

SECTION TWO

Review

1. Early Greek sculptors carved large, freestanding male figures. What were these figures called and who did they represent?
2. What features are characteristic of early Greek sculptures?
3. How did Greek sculpture change during the Classical period?
4. Who was Myron?
5. What famous artist oversaw the work on the Parthenon's frieze? What other contribution to the Parthenon did he make?
6. Name the Greek sculptor who created the *Spear Bearer*.
7. Describe the sculpture of the Hellenistic period.
8. Identify the differences between Hellenistic sculptures and those created earlier during the Classical period.

Creative Activity

Humanities. Greek classical architecture lives today. Its columns, pediments, and proportions were revived in the Renaissance on a grand scale. They were then combined with the Roman dome to create the grandeur of St. Peter's in Rome and St. Paul's Cathedral in London. As American buildings were constructed in the eighteenth century, classical forms became the symbol of democracy, recalling Plato's *Republic* and Greek democratic ideals. You will find this influence in the elegant columns and pediments in the mansions of the pre–Civil War South and, usually in smaller scale, in white-frame spired churches all across the country. Do a photograph or video documentation of your own neighborhood, looking for pedimented doorways, corniced eaves, columns, and Doric, Ionic, and Corinthian capitals. Does classicism live in your community?

DRAWING FEATURES OF GREEK ARCHITECTURE

Supplies
- Pencil and sketch paper
- A sheet of white drawing paper, 12 x 18 inches (30 x 46 cm) or larger

CRITIQUING

- *Describe.* Does your drawing clearly illustrate the different features of Greek architecture found on buildings in your community? Can you name these features? Can other students in your class identify these architectural features?
- *Analyze.* Did you fill the entire picture surface with your drawing? Do the lines in the drawing define a variety of large and small shapes?
- *Interpret.* Does your drawing communicate the same dignified look observed in Greek buildings? Do the details illustrated in your drawing bear a resemblance to details noted in a particular Greek building? If so, which building is it?
- *Judge.* Explain how your drawing achieves an overall sense of unity. If you were to do it again, how would you improve upon this unity?

Complete a detail drawing in pencil of a section of a building in your community that exhibits features of Greek architecture. Fill the entire sheet of sketch paper on which it is made. Make your drawing entirely of lines that define a variety of large and small shapes. The drawing will also seek to communicate the same unified, dignified appearance associated with such Greek buildings as the Parthenon.

Focusing

Review the features of the Greek orders illustrated and discussed on page 168. Examine pictures of Greek buildings in this and other books available in your school or community. Discuss the different features and details observed on these buildings with other members of your class.

Creating

Search your community for buildings that exhibit some of the architectural features found on Greek structures. Complete sketches of the parts of those buildings that best demonstrate these architectural features.

Select your best sketch and reproduce it as a line drawing on the large sheet of paper. Add as many details as possible to make an identification of the Greek architectural features as easily as possible. Fill the entire sheet of paper with your drawing. Option for advanced students: Use shading to give your drawing a three-dimensional look.

Figure 8.27 Student Work

Studio Lesson

PAINTING USING ANALOGOUS COLORS

Use tempera or acrylic to paint the line drawings of the features of Greek architecture. Select an analogous color scheme consisting of three or more hues placed next to each other on the color wheel. Mix white and black with these hues to produce a variety of light and dark values. Contrasts of value will help to emphasize those parts of your painting that you feel are especially interesting or important. The hues that you choose should give your painting a definite mood or feeling such as gay and inviting, somber and forbidding, or dark and frightening.

Focusing

Examine Figures 8.3, 8.10, and 8.11. Use your imagination to picture how these Greek buildings might have looked when they were painted with bright colors. How would those colors have contributed to the mood or feeling associated with those buildings?

Creating

Identify three or more neighboring hues on the color wheel (see Figure 2.4, page 28) to make up your analogous color scheme. Select hues that you associate with a particular mood or feeling.

Use the colors selected to paint your detail drawing of a building exhibiting Greek architectural features. Add white and black to your hues to obtain a variety of light and dark values. Use contrasting values to emphasize the portions of your drawing that you feel are most important or interesting.

Figure 8.28 Student Work

Supplies

- The drawing you completed in the previous studio lesson
- Tempera or acrylic paint
- Brushes, mixing tray, and paint cloth
- Water container

CRITIQUING

- **Describe.** Can you point out and name the three or more hues that you selected for your analogous color scheme? Are the shapes in your composition painted precisely?
- **Analyze.** Does your painting include a variety of light and dark values? Did you use contrasts of value to emphasize the most interesting or important parts of your composition? Can you explain how the use of light and dark values adds to the visual interest of your painting?
- **Interpret.** Does your painting communicate a mood or feeling? If so, what did you do to achieve this? Are other students in your class able to correctly identify the mood you were trying to communicate?
- **Judge.** Do you think your painting is successful? What aesthetic quality or qualities did you turn to when making your judgment?

185

Reviewing the Facts

SECTION ONE

1. How did Athens rise to greatness? What caused it to lose power?
2. Describe how the following features are used in Greek temples: stylobate, capitals, lintels, frieze, and cornice.
3. Name and describe the three orders of decorative style that originated in Greece.
4. What types of designs were painted on early Greek vases?
5. What features characterize the figures found in later Greek vase painting produced by artists like Exekias?

SECTION TWO

6. Explain why Myron's *Discus Thrower* would be described as being more idealistic rather than realistic.
7. If the works of ancient Greek sculptors no longer exist, how do we know what they look like?
8. What does the frieze on the Parthenon represent?
9. Describe a pose that is considered to be "contrapposto."
10. How did Alexander the Great influence the spread of Greek culture to neighboring countries?

Thinking Critically

1. *Analyze.* List the similarities and differences between the way the Greeks and Egyptians thought about their temples. How did the worship of the Greek gods influence architecture and art?

2. *Interpret.* Look again at the sculpture in Figure 8.24 on page 181. What do you think this figure is doing? Decide what word you would use to describe his feelings at this moment. Explain your answer.

3. *Extend.* As you learned in this chapter, the processional frieze from the Parthenon and other ancient artworks are no longer in Greece. Instead, they can be found in various museums throughout the world. Acting as a reporter for a noted art publication, prepare a written argument supporting the return of these artworks to their place of origin. Present your argument in class for discussion. This discussion should take into account the pros and the cons of your case.

Using the Time Line

As an archaeologist, you unearth a Greek sculpture of a striding athlete. Viewed from the front, it is symmetrically balanced and has bulging eyes, a square chin, and a mouth exhibiting a curious smile. Examine the time line and identify the period in which you think the sculpture was created. Explain why it is unlikely that it could have been produced in any other period of Greek history.

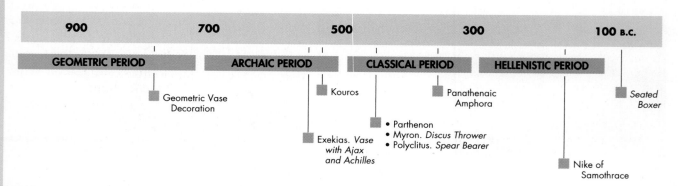

900	700	500	300	100 B.C.
GEOMETRIC PERIOD	ARCHAIC PERIOD	CLASSICAL PERIOD	HELLENISTIC PERIOD	

Geometric Vase Decoration

Kouros

Exekias. *Vase with Ajax and Achilles*

• Parthenon
• Myron. *Discus Thrower*
• Polyclitus. *Spear Bearer*

Panathenaic Amphora

Seated Boxer

Nike of Samothrace

Philip Sohn, Age 18
Hume-Fogg Academic High School
Nashville, Tennessee

Reading about the Greek gods and Greek sculpture that focused on the ideal human form served as inspiration for Philip's choice. He decided to do a head sculpture of the god Dionysus. "I began by building a framework out of scrap wood and pipe cleaners to hold the clay."

After building the basic support structure, Philip added clay and began to shape the head. When asked about what he had discovered during the actual sculpting process, Philip said, "I found that the clay is best for carving and detail work when it is medium hard."

In evaluating the finished piece, Philip said he was most satisfied with the facial expression and the texture of the hair.

▶ *Dionysus.* Clay. 25 x 15 x 25 cm (10 x 6½ x 10").

The Age of the Conquerors: Roman Art

Objectives

After completing this chapter, you will be able to:

➤ Identify the inspiration for much of Roman art and architecture.

➤ Name the ways Roman artists improved on earlier building processes.

➤ Describe the characteristics of Roman public buildings.

➤ Describe a Roman bath and indicate why structures like this were so important to the Romans.

➤ Identify the quality Romans favored in their sculptures and their paintings.

➤ Design the exterior of a Roman structure.

Terms to Know

apse
aqueduct
barrel vault
basilica
baths
coffers
groin vault
keystone
mural
nave
niche
pilaster
triumphal
 arch

Figure 9.1 Arch of Constantine, Rome, Italy. A.D. 312–15.

Long before the Roman Empire rose to greatness, Italy was

the home of a mysterious ancient people called the Etruscans. No one is sure

where these dark, sturdy people came from. Some claim they were a seafaring

people from Asia Minor, while others believe that Italy was their native land. One thing is

certain; of all the peoples in Italy they were the most civilized and the most powerful.

In time, they conquered much of Italy north of the Tiber River. Among their

conquests was the hill town of Rome (Figure 9.2).

SECTION ONE
The Rising Power of Rome

Under the rule of Etruscan kings, Rome grew in size and importance. By the end of the sixth century B.C., it had become the largest and richest city in Italy. However, the Romans were never happy under Etruscan rule, and in 509 B.C. they drove the Etruscans from the city and established a republic.

Ridding themselves of the Etruscans did not end Rome's problem. Finding itself surrounded by enemies, it was forced to fight for survival. As nearby enemies were defeated, more distant foes tried to conquer the young republic. Rome managed to defend itself against these threats, however, and extended its power until all of Italy was under its control.

An early victory over Carthage, its chief rival, won Rome its first overseas province, Sicily, but that was just the beginning. Eventually, Rome controlled territory from Britain in the west to Mesopotamia in the east. So extensive was its rule that Romans proudly referred to the Mediterranean as "*mare nostrum* — our sea."

Figure 9.2 Ancient Rome

The Greek Influence

It is difficult to talk about "Roman art" because so much of it was copied from the Greeks. From the very beginning, well-born and cultured Romans exhibited a great admiration for Greek art forms of every period and style. They imported Greek works by the shipload and even brought Greek artists to Rome to work for them. Generally, the Romans were content with being heirs of Greek art. Except for architecture, they made few original contributions of their own in art.

Roman Sculpture and Painting

In sculpture and painting, the Romans aimed for realism like the Greeks before them. This is especially true in the case of sculptured portraits.

Portrait Sculpture

A desire for lifelike portraits can be traced back to the earliest periods of Rome's history. At that time, wax masks of deceased family members were made to be carried in funeral processions. These masks were then displayed in small shrines in the home. Masks made of wax were not permanent, and a more durable material was sought. Stone and marble were found to be perfect. Soon artists who could carve portraits from these materials were in great demand.

Many of the sculptors who worked in Rome came from Greece. These artists worked in the Greek tradition, but adapted that tradition to meet Roman demands. The Greeks preferred idealistic portraits. However, the Romans wanted theirs to look real. Perhaps this was because Greek portraits were almost always designed for public monuments, while Roman portraits were meant to serve private needs. Romans wanted their sculptures to look and remind them of specific people. This explains why most of their portraits seem so natural and lifelike. They felt that the character of a person could best be shown by facial features and expressions. Therefore, they often commissioned portrait heads rather than sculptures of the entire figure. The Greeks, on the other hand, rarely made sculptures of parts of the body. For them, a sculpture of a head or bust (head and shoulders) was not complete.

A Roman portrait sculpture (Figure 9.3) gives the feeling that you are looking at a real person. The fig-

➤ Would you say this portrait is lifelike or idealistic? Point out details that support your decision.

Figure 9.3 *Man of the Republic.* Artist unknown. Late first century B.C. Terra cotta. 35.7 cm (14"). Museum of Fine Arts, Boston, Massachusetts. Contribution, purchase of E.P. Warren.

ure may even look familiar. He may remind you of someone you met somewhere, although it is difficult to remember exactly where or when. He could be a high-school football coach, a teacher, or a fast-food restaurant manager. Like all Roman portrait sculptures, this example is an exact duplicate of a real person with all the wrinkles and imperfections intact and an expression suggesting a definite personality and character.

Mural Painting

Wealthy Roman families lived in luxurious homes with courts, gardens with elaborate fountains, rooms with marble walls and mosaics on the floors (Figures 9.4 and 9.5), and numerous works of art. They did not like to hang paintings on the walls of their homes. Perhaps they felt that this ruined the design of the

➤ The murals on these walls survived the eruption of the volcano Vesuvius.

Figure 9.5 *Bedroom from the villa of P. Fannius Synistor.* Pompeian, Boscoreale. First century B.C. Fresco on lime plaster. Mosaic floor, couch and footstool come from Roman villas of later date. 2.6 x 5.8 x 3.3 m (8'6" x 19'1⅞" x 10' 11½"). The Metropolitan Museum of Art, New York, New York. Rogers Fund, 1903.

➤ Notice the variety of shapes used by the designer of these mosaic floors. Can you see the arrangement of the individual tiles?

Figure 9.4 Mosaic floor from a Roman villa. Ampurias, Spain. c. First century B.C.

interior. Instead, they hired artists to paint murals. A **mural** is *a large picture painted directly on the wall.* The artists who painted these murals tried to reproduce as accurately as possible the world around them. They painted landscapes and pictures of buildings that suggested a world beyond the walls of the room. Often these scenes create the impression that you are gazing out a window overlooking a city (Figure 9.5).

Of course, not all Roman paintings were noteworthy. This is evident in many paintings found in houses in Pompeii and neighboring cities which were covered by ashes when the volcano Vesuvius erupted in A.D. 79. When the well-preserved ruins of these cities were discovered and excavations began, it was found that almost every house had paintings on its walls. Many are quite ordinary and were done by painters of limited ability, but a surprising number of fine works were also found. Among these is a painting of a maiden pausing in mid-stride to pluck a flower to add to her bouquet (Figure 9.6). A breeze stirs her garments as she turns her head and daintily removes a blossom from the tip of a tall bush. Charming and beautiful, this work hints at the level of skill and sensitivity that must have been reached by many Roman painters. Unfortunately, the paintings they produced no longer exist for viewers to admire.

➤ What gives this figure a graceful look? Name the elements and principles of art used by the artist to accomplish this effect.

Figure 9.6 *Maiden Gathering Flowers.* Wall painting from Stabiae, a Roman resort on the Bay of Naples, Italy. First century A.D.

Richard Haas

Born in the small town of Spring Green, Wisconsin, Richard Haas (b. 1936) paints architectural murals that have a dual mission: to delight people passing by and to remind architects of the beauty and inventiveness in architecture. On both accounts he succeeds.

Haas uses a technique called *trompe l'oeil*, which is designed to fool the viewer's eye by creating the illusion of tactile and spatial qualities on a flat surface. His murals are widely popular with the general public, and once again contemporary architects are turning to history for sources of inspiration.

As a child Haas accompanied his stonemason uncle, who worked for the world-famous architect Frank Lloyd Wright. This gave Haas many opportunities to view Wright's extensive collection of Asian art. In high school Haas developed an interest in architecture and often returned to Wright's architectural studio to make sketches of the surrounding buildings.

After completing formal training as an artist, Haas painted in a variety of abstract styles and taught college students. However, he was not completely satisfied until he realized that making prints of the buildings he could see from his loft window in New York City was what excited him the most. "I rolled up all my paintings, put them away, and never painted again." He then began to create architectural studies, which were favorably received by art critics. The publicity that followed led to Haas's first opportunity to paint a wall mural.

Haas plans each mural commission in great detail before it is painted. Working with three assistants, he carefully studies the site to be painted and notes its history, condition, and the details of the setting. Haas then makes numerous sketches and drawings and has them translated into full-scale paintings. Under Haas's supervision, the wall painting is carried out by a team of painters. In the case of the Brotherhood Building in Cincinnati, Haas utilized an imaginary cutaway view to illustrate the ancient Roman temple of Vesta (based on a drawing by the eighteenth-century architect and painter Giovanni Battista Piranesi).

Haas's *trompe l'oeil* paintings point out the value of ancient architecture. He says of his murals, "I see them as reinventions of things that didn't deserve to die . . . of concepts and traditions that answer very definite needs today." When buildings are torn down or remodeled, Haas's paintings are destroyed. In the meantime, Haas's art enjoys a degree of visibility that few artists can hope to equal.

Figure 9.7 Mural on the Exterior of the Brotherhood Building, the Kroger Company, Cincinnati, Ohio. Architectural Projects. 1974–88.

➤ Do all the columns on this temple act as structural supports? If not, what purpose do they serve? Have you seen buildings before that looked something like this? Where?

Figure 9.8 Maison Carree, Nimes, France. First century B.C.

Roman Architecture

Whereas few Roman paintings or murals remain for viewers to see, many examples of Roman architecture, bridges, and monuments have survived. Rome ruled an area that extended from present-day Great Britain to the Near East. The Romans built roads, sea routes, and harbors to link their far-flung cities. They designed and constructed city services such as aqueducts and sewer systems, and they erected public buildings for business and leisure-time activities. Because they were excellent planners and engineers, the Romans were destined to make their mark as the first great builders of the world.

The Temples

Many early Roman temples made use of features developed earlier by others, especially the Greeks.

These features, however, were used by Romans to satisfy their own needs and tastes. For example, while the Greeks used columns as structural supports, the Romans added columns to their buildings as decoration without structural purpose.

The Greek influence can be seen in the Maison Carree, a temple built in France during the first century B.C. (Figure 9.8). At first, the rectangular shape and Corinthian columns make this building look like a Greek temple. When you look closer, however, you will see that freestanding columns do not surround the entire building as they do in Greek temples such as the Parthenon. Instead, they are used only for the porch at the front. Along the sides and back of the building, half-columns are attached to the solid walls to create a decorative pattern.

The Romans did not limit themselves to borrowing solely from the Greeks. The Roman temple is placed on a podium or platform which raises it above eye

level. This was a feature the Romans borrowed from the Etruscans, who built their temples in this way.

Another early Roman temple that made use of Greek features is found in the foothills of the Apennines, a short distance from Rome. The route to this temple is along an ancient Roman road called the Appian Way. This road was once lined with the grand villas and tombs of wealthy Roman citizens. Many chose to be buried here since a law prohibited burials within the city. A two-hour trip over this historic road will take you to the site of the ancient town of Praeneste (now the modern city of Palestrina). This town was said to have originated when a peasant found a mysterious tablet in the woods nearby. It was reported that on this tablet was recorded the history of the town, even though it had not yet been built. The people were so impressed that they erected a temple (Figure 9.9) to hold a statue of Fortuna, the goddess of good fortune, and the mysterious tablet was placed within this statue. Eventually the temple became the home of a famous oracle, and people came from great distances to have their futures revealed to them.

People wishing to consult with the oracle at the Temple of Fortuna Primigenia had to climb a series of ramps and terraces until they reached a great courtyard. From there, a flight of stairs led to the semicircular colonnade of the main temple. The entire complex was made up of many circular and semicircular temples, terraces, colonnades, arches, and staircases. To span openings, the builders made use of the arch. To roof large areas, they placed *a series of arches from front to back to form a tunnel*, or **barrel vault** (Figure 9.10). This made it possible for them to cover huge rooms and halls with half-round stone ceilings. Because these ceilings were so heavy, thick windowless walls were needed to support them.

Innovations in Structure and Materials

If you look closely at the round arch (Figure 9.10), you will see how it improved upon the post-and-lintel system favored by the Greeks. The post and lintel limited builders in terms of the space it could bridge. A stone lintel could not be used to span a wide space because it would break. Under pressure, stone does not bend; it snaps. Unlike a lintel, an arch is made of a number of bricks or cut stones. These are held in

➤ Here Roman builders constructed staircases leading to a series of seven terraces built into a hillside. How does this differ from the way Greek builders used a hill site for the Acropolis?

Figure 9.9. Palestrina. View of the Archeological Museum. Museo Archeologico Nazionale, Palestrina, Italy. c. 120–80 B.C.

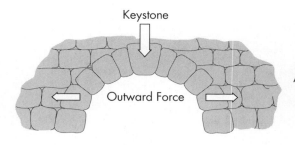

Keystone

Outward Force

The Round Arch
A wall or another arch is needed to counter the outward force of the arch.

The Barrel Vault
A half-round stone ceiling is made by placing a series of round arches from front to back.

The Groin Vault
A groin vault is formed when two barrel vaults meet at right angles.

Figure 9.10 Features of Roman Architecture

place by a wooden form until the **keystone**, or *top stone of the arch*, is fit into place. The space that can be spanned in this manner is much greater than the space bridged by a lintel. However, an arch needs the support of another arch or a wall. If this support is not provided, the outward force of the arch will cause it to collapse. For this reason, the Romans created a series of smaller arches to replace the single large arch (Figure 9.15, page 197).

Concrete, one of the most versatile of building materials, was used in the Temple of Fortuna Primigenia. Although it had been used in the Near East for some time, the Romans were the first to make extensive use of this material. Coupled with their knowledge of the arch, concrete enabled the Romans to construct buildings on a large scale.

After Rome became Christianized, the oracle at Praeneste was banished and the temple destroyed. Eventually it was forgotten and, after the fall of Rome, a town was built on the site. It was not until a bombing raid in World War II destroyed most of the houses that the ruins of the huge temple were discovered.

Wherever the Roman legions went, they introduced the arch and the use of concrete in architecture. With

these they constructed great domes and vaults over their buildings and covered these with marble slabs or ornamental bricks. Even today, the remains of baths, amphitheaters, theaters, triumphal arches, and bridges (Figures 9.11, Figures 9.12–9.14, page 196) are found throughout countries once part of the Roman Empire.

Figure 9.11 Roman Amphitheater, Arles, France. End of first century A.D.

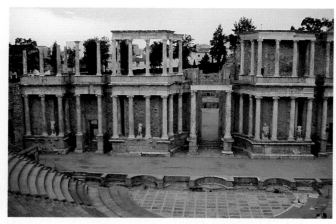

➤ This theater provided seating and entertainment for many during the time Rome ruled over its vast empire. It was built by Agrippa in 24 B.C.

Figure 9.12 Roman theater, Merida, Spain. 24 B.C.

➤ Note the construction of the rounded archways. Each contains a keystone and is supported on the sides to counter the outward thrust of the arch.

Figure 9.13 Triumphal Arch, Medinaceli, Spain. c. A.D. 100–200.

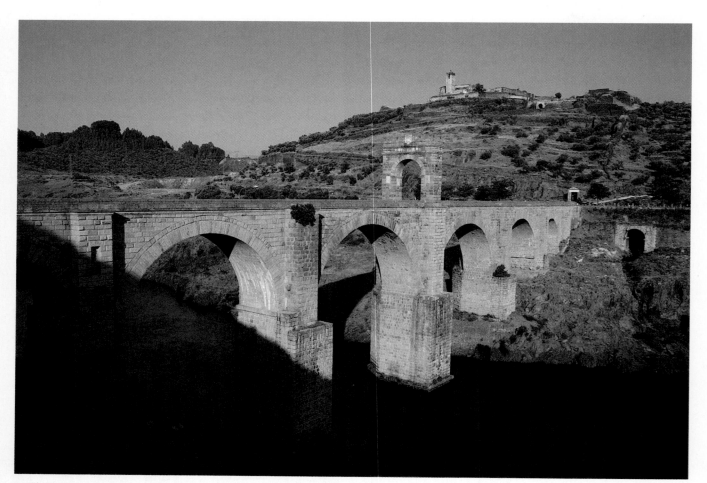

➤ This bridge near Alcantara, in Spain, was built about A.D. 105. It stands today, providing a way for traffic to cross the river, in the same way it stood over eighteen hundred years ago. The Roman introduction of the arch and the use of concrete in their structures has stood the test of time.

Figure 9.14 Roman Bridge, Alcantara, Spain. A.D. 105–06.

The Aqueducts

Their aqueducts demonstrate how the Romans were able to combine engineering skills with a knowledge of architectural form. An **aqueduct**, *a system that carried water from mountain streams into cities by using gravitational flow*, was constructed by placing a series of arches next to each other so they would support each other and carry the weight to the ground. While attractive, these aqueducts were designed for efficiency rather than beauty. Eleven were built in and around Rome alone. These ranged from 10 miles (16 km) to 60 miles (96.6 km) in length and carried about 270 million gallons (1 billion liters) of water into the city every day.

One of the best-known aqueducts is found in Segovia, Spain (Figure 9.15). It brought water to the city from a stream 10 miles (16 km) away. Constructed of granite blocks laid without mortar or cement, the aqueduct made use of many angles to break the force of the rushing water. Many regard this as the most important Roman construction in Spain.

Figure 9.15 Roman Aqueduct (two views), Segovia, Spain. First century A.D.

SECTION ONE

Review

1. What ancient city was Rome's chief rival?
2. How did the defeat of this rival extend Rome's power?
3. From whom did the Romans copy much of their art and architecture?
4. What quality did Romans prefer in their sculptures and paintings?
5. What did wealthy Romans use to decorate the walls of their homes?
6. How did the Roman temples adapt Ionic columns?
7. What two innovations enabled Roman architects to improve upon earlier building techniques?
8. Describe a Roman aqueduct and the purpose it served.

Creative Activity

Studio. Although the Romans brought in Greek artists to carve their statues, they preferred exact realism to the Greek idealistic form, especially in their own portraits. Use pencil to draw a portrait of a friend or your own self-portrait. Keep your eyes focused on the edge you are drawing. First draw the jawline and general contour of the head. Note that the eyes are located in the center of the skull. Feel and then draw the eyebrows, relating the eye cavity to the bridge of the nose. Look carefully at the lines of the eyes — the eyelid and the iris. (Note that in normal position, only about two-thirds of the iris shows.) Position the ears in relation to the eyes. Draw the mouth allowing space for the chin. Add the neck and shoulders to complete the portrait. Then consider whether your portrait resembles the Roman realistic style.

Roman Buildings and Monuments

Roman emperors were constantly building and rebuilding the cities of their empire. The emperor Augustus boasted that he had found Rome a city of brick and stone and left it a city of marble. His boast was justified. As long as there was money to do so, baths, circuses, forums, and amphitheaters were constructed for the enjoyment of the people. Of course, there was a reason for such generosity. By providing beautiful monuments and places for public recreation, the emperors hoped to maintain their popularity with the people.

Buildings for Recreation

Roman monuments and public buildings were numerous and impressive. An ancient guidebook to Rome, published in the middle of the fourth century A.D., claims that there were 424 temples, 304 shrines, 80 statues of gods made from precious metals, 65 made of ivory, and over 3,700 bronze statues scattered throughout the city.

The Baths

Among the most popular of the Roman public buildings were the baths. These were much more than just municipal swimming pools. **Baths** were *vast enclosed structures that contained libraries, lecture rooms, gymnasiums, shops, restaurants, and pleasant walkways*. These made the baths a social and cultural center as well as a place for hygiene. In many ways, they were like the shopping malls of today.

Every large Roman city had its baths. Although they differed in ground plan and details, these baths had certain features in common. They all contained a series of rooms that contained progressively cooler water (Figure 9.16). The "calidarium" with its hot water pool was entered first. From there one walked to the "tepidarium," where a warm bath awaited. The last room was called the "frigidarium," and there a cool bath was provided. The different water and room temperatures were made possible by furnaces placed in rooms beneath the building. These were tended by scores of workers and slaves.

One of the most famous baths was built by the Emperor Caracalla in the early part of the third century A.D. It sprawled out over 30 acres (12 ha) and had a bathhouse which measured 750 feet (228.6 m) by 380 feet (116 m). A huge central hall over 180 feet (55 m) long and 77 feet (23.5 m) wide was spanned with concrete groin vaults (Figure 9.17). A **groin vault** is formed *when two barrel vaults meet at right angles* (Figure 9.10, page 195). In this structure, a barrel vault

> The Roman baths at Bath, England, provided recreation and a choice of water temperatures in their pools. This picture shows one of the pools and some of the architecture as it looks today.

Figure 9.16 Roman Baths. Bath, England.

➤ A long barrel vault was intersected by three shorter barrel vaults to make groin vaults.

Figure 9.17 Central hall of the Baths of Caracalla (restoration drawing). Rome, Italy.

that ran the length of the hall was intersected at right angles by three shorter barrel vaults, producing the groin vaults. The use of these groin vaults allowed the builders to cover a very large area. It also permitted the use of windows, which was not possible with barrel vaults requiring thick, solid walls.

Buildings for Sports Events

Although the Romans enjoyed many different athletic events, the chariot races were easily their favorite spectator sport. As many as one hundred fifty thousand Romans would gather at the Circus Maximus to cheer on their favorite teams. These races became so popular that eventually they were scheduled sixty-four days a year.

Almost as popular as the chariot races were the armed contests. These were held in large arenas or amphitheaters such as the Colosseum (Figure 9.18). The Colosseum was built in the second half of the first

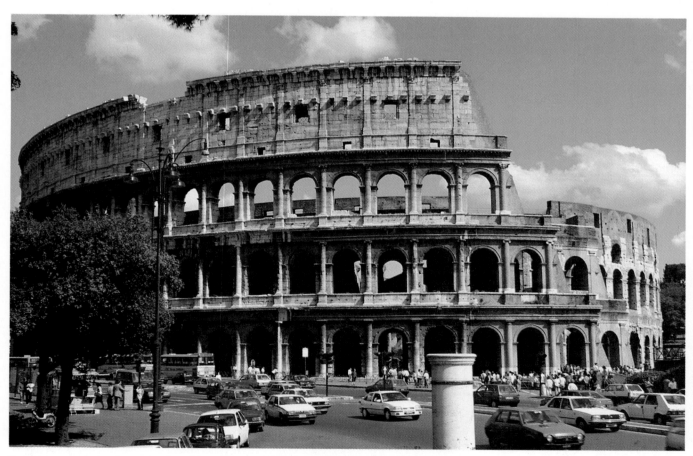

➤ How many stories do you see here? Repetition is an important aid to harmony. What shapes are repeated on the outside of this building? What do you think was the purpose of this structure?

Figure 9.18 Colosseum, Rome, Italy. A.D. 72–80.

$\mathcal{A}rt$ · PAST AND PRESENT ·

The West Edmonton Mall

Just as Roman baths contained everything from libraries to restaurants and served as social and cultural centers, so too do contemporary malls provide recreation, social, and cultural activities. One shopping mall in particular vies with the Roman baths in grandeur. The West Edmonton Mall is located in the city of Edmonton in Alberta, Canada. It covers an area the equivalent of 115 American football fields and holds the *Guinness Book of Records* title for "largest shopping mall in the world." Among its many attractions are an ice arena, a water park, and an amusement park—all indoors. The mall also features a deep-sea park with dolphin shows, sealife caverns, and the largest indoor lake in the world—400 feet (122 m) long and 20 feet (6 m) deep.

Other features of interest include two themed streets. One is modeled after the famous Bourbon Street in New Orleans and the other is fashioned after European boulevards. Among these streets and others, shoppers find over 800 stores and services,

Figure 9.19 The West Edmonton Mall

22 rides and attractions, 19 movie theaters, and over 100 eating establishments.

To entertain the eye, there is a stunning collection of Chung dynasty vases, a Ming dynasty ivory pagoda that stands 7 feet (2 m) tall, and replicas of the crown jewels of England and Scotland. There is also an aviary featuring peacocks and cranes, and an aquarium containing many varieties of fresh- and saltwater fish. In fact, one doesn't ever have to leave—the mall also houses a 355-room hotel!

century A.D. It owes its name to a colossal statue of the Roman emperor Nero that once stood nearby. The huge structure covers 6 acres (2.4 ha). It forms a complete oval measuring 615 feet (187 m) by 510 feet (155 m). The structure is so large that during the Middle Ages people moved within its protective walls and erected a small city.

Over the centuries, rulers, popes, and nobility carried off large masses of stone from the Colosseum to construct new buildings. Only after many of the stones had been removed did Pope Benedict XIV put a stop to this destruction, but it was too late. Today the great amphitheater is little more than a broken shell.

The outside of the Colosseum consists of four stories constructed of stone, brick, and concrete. Each

story makes use of a different column type borrowed from the Greeks. The lower level uses the Doric, which is the heaviest and sturdiest of the columns. The Ionic is used on the second story and the Corinthian on the third. At the fourth level, Corinthian columns flat on one side are attached to the wall between a row of small holes. Poles were placed in these holes to support a canvas awning which was used to protect the spectators from the sun and rain.

At the ground level, eighty arched openings enabled spectators to enter and leave the Colosseum so efficiently that it could be emptied in minutes. Seventy-six of these openings were used by the general public. One was reserved for the emperor, and another was used by priestesses. Another door, named the "Door of Life," was reserved for victorious gladiators.

The bodies of the slain gladiators were carried through the final door, which was called the "Door of Death."

From inside the Colosseum, you can see clearly how it was built (Figure 9.20). The arches are the openings of barrel vaults that ring the amphitheater at each level. These vaults supported the sloped tiers of seats. These seats are gone now, but once there were enough to accommodate fifty thousand people.

Securing a seat for a particular event at the Colosseum must have been much like buying tickets for a football game today. The more you were willing to pay, the better your seat. The best seats were in the first tier and were reserved for the emperor and state officials. The upper classes sat in the second tier, while the general public crowded into the upper tiers. A high stone wall separated the spectators from the gladiators and the wild animals fighting in the arena. As further protection, archers, nets, and a second wall made sure that no energetic animal would leap up among the onlookers.

Beneath the floor of the Colosseum (Figure 9.21) were compartments and passages serving a number of purposes. There were places to hold caged animals, barracks for gladiators, and rooms to hold the machinery needed to raise and lower stage sets and performers.

In the third century B.C., the Romans revived an Etruscan spectacle in which slaves were pitted against each other in battles to the death. In 264 B.C., the first contest between armed gladiators was held in the forum, the public square, or marketplace of the city. The purpose was to celebrate the funeral of an important nobleman. It was a modest contest between three pairs of battlers. However, it was so popular that soon contests between hundreds of gladiators were being staged before thousands of spectators.

Not all Romans approved of these brutal contests, but they were so popular with the masses that most objectors were afraid to express their feelings. For instance, when Cicero, the famous orator and statesman, had to attend, he took his secretary and notebooks with him and refused to watch. He was an exception, however. The amphitheater was always filled to capacity for events in which as many as five thousand pairs of gladiators fought to the death and eleven thousand animals were killed in a single day.

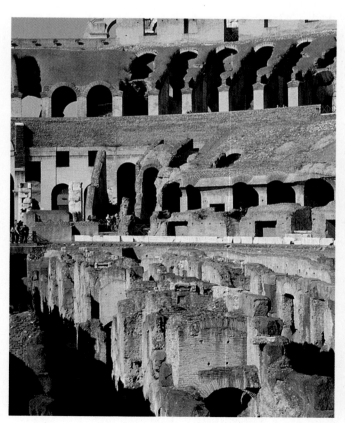

➤ What was used to support the tiers of seats — posts and lintels, barrel vaults, or groin vaults?

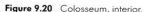

Figure 9.20 Colosseum, interior.

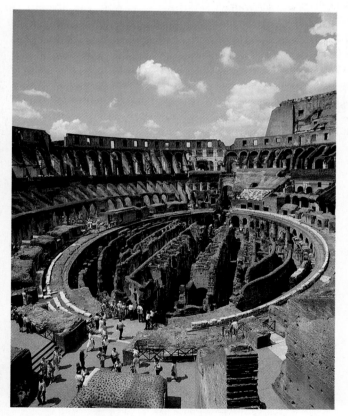

➤ The floor is gone now, but you can still see the passageways and rooms. For what were these rooms used?

Figure 9.21 Colosseum, interior.

Public Buildings and Structures

The Roman emperors had great civic pride, and in addition to the buildings provided for public entertainment, they commissioned public squares and civic centers. Magnificent structures were built: meeting halls, temples to Roman gods, markets, and basilicas. Architects and engineers combined their talents to erect huge buildings that were not only structurally sound but also beautifully designed to be pleasing to the eye.

The Pantheon

One of the marvels of Roman architecture is the Pantheon (Figure 9.22). Designed as a temple dedicated to all the Roman gods, it was later converted into a Christian church. This explains why it is in such excellent condition today.

From the outside, the Pantheon looks like a low, gently curving dome resting on a cylinder. However, from street level the building can no longer be viewed as it was intended. The level of the surrounding streets is much higher now, and the steps that once led up to the entry porch are gone. The building loses much of its original impact today because you are forced to look straight at it rather than lifting your eyes up to it.

It may not be as impressive as it once was from the outside. However, the interior of the Pantheon is certain to have an impact on you. Passing through the entrance hall, you step suddenly into the great domed space of the interior (Figure 9.23). Raising your eyes upward, you discover that the dome that looked so shallow from the outside is actually a true hemisphere. Made of brick and concrete, this huge dome soars to a height of 144 feet (44 m). This is exactly the same measurement as the diameter.

The inside of the Pantheon is divided into three zones. The lower zone has seven **niches**, *recesses in the wall*. These may have contained statues or altars dedicated to the Roman gods of the heavens: Sol (sun), Luna (moon), and gods of the five known planets. Above this, another zone contains the twelve signs of the zodiac. Finally, rising above all, is the magnificent dome representing the heavens. The surface of the dome is covered with **coffers**, or *indented panels*. These coffers are more than just a decorative touch. They also lessen the weight of the dome.

You may be surprised to find that the interior of the Pantheon is well illuminated, although there are no windows. Walls up to 20 feet (6 m) thick were needed to support the dome, and windows would have weakened these walls. In addition to the door, the only source of light is a round opening at the top of the dome. Although it may look small from floor level, this opening is almost 30 feet (9 m) across. It fills the interior with a bright, clear light and enables you to see a section of sky at the top of the dome. What

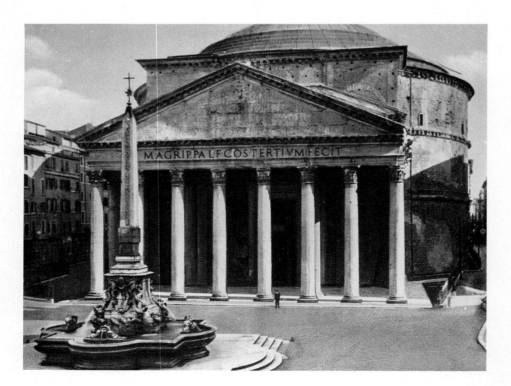

➤ Does the exterior of this building give the impression of heavy solidity, or light gracefulness? Notice the proportion of the large cylinder capped by a low dome.

Figure 9.22 Pantheon, Rome, Italy. A.D. 118–25.

happens when it rains? Surely rainwater would come through the opening. It does, of course, but the Romans anticipated this problem. They built the floor so that it was raised slightly in the center, formed a shallow depression directly under the opening, and created a drainage system to carry away the water.

Basilicas

The Romans also constructed spacious rectangular buildings called basilicas. The **basilica** was *a functional building made to hold large numbers of people.* Designed as a court of law and public meeting hall, it was often a part of the forum, or public square. Basilicas are important because they combined in one structure many of the architectural advances made by the Romans, but they are important for another reason. They were to serve as models for generations of Christian church builders.

On the inside, rows of slender columns divided the space into what was later called the **nave**, *a long, wide center aisle*, and two or more narrower side aisles (Figure 9.24). The roof over the center aisle was usually higher than the roofs over the side aisles. This allowed the builders to install windows to let sunlight in. The Roman basilica had a side entrance and one or more *semicircular areas at the end of the nave*, later called the **apse**.

Wooden roofs were used for most basilicas. The roof over the center aisle was peaked, while those over the side aisles sloped gently downward. An exception

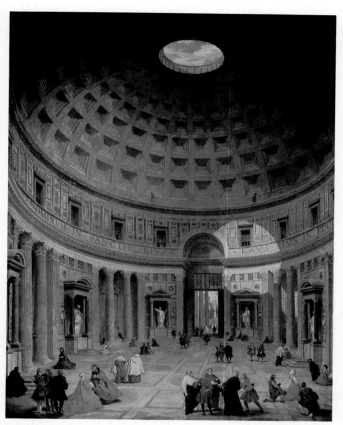

➤ Does the interior proportion of the cylindrical, domed room give the same impression as the exterior proportions did? Why, or why not?

Figure 9.23 Giovanni Paolo Panini. *Interior of the Pantheon.* c. 1740. Oil on canvas. 1.3 x .99 m (50½ x 39″). National Gallery of Art, Washington, D.C. Samuel H. Kress Collection.

Figure 9.24 Plan of a Roman Basilica.

Figure 9.25 Reconstruction of the Basilica of Constantine.

was the Basilica of Constantine (Figure 9.25, page 203), where stone was used to construct barrel and groin vaults. These replaced the wooden crossbeams and peaked timber roofs used in other basilicas.

Triumphal Arches

The Romans loved celebrations and often marked their successful military campaigns by building a monument to the victory: a triumphal arch. After such a victory, the general and his troops would pass through the **triumphal arch**, *a heavily decorated arch*, to the cheers of thousands. These arches often consisted of a large central opening and two smaller openings on each side. The general and his officers rode chariots and horses through the central opening, while unmounted troops marched through the smaller ones. It was not unusual for the troops to carry banners showing the major events of the campaign.

The Arch of Constantine (Figure 9.1, page 188) was the largest and most elaborate of these triumphal arches. It was decorated for the most part with sculptures and reliefs taken from earlier monuments dedicated to other emperors (Figure 9.26). Of course, this meant that the sculptures showing the emperor had to be changed to look more like Constantine.

The Romans built triumphal arches throughout their empire. The Arch of Bara in Tarragona, Spain, (Figure 9.27) differed from most because it was not meant to glorify a military campaign. It was built with funds left in the will of a Roman general and advisor to the emperor Trajan, and its purpose is not known. It has only one large passageway and does not make use of sculptured reliefs. The decoration is limited to two grooved **pilasters**, *flat, rectangular columns attached to a wall*, on either side of the passageway. The Arch of Bara owes its beauty to its simplicity, the excellence of its workmanship, and its fine proportions. This and other monuments attest to a Roman presence in Spain.

The Declining Power of Rome

It is difficult to pinpoint exactly what brought about the decline of the great Roman Empire. No doubt, an important factor was the transfer of the capital of the Roman Empire from Rome in the west to the site of the ancient Greek city of Byzantium in the eastern provinces. In A.D. 330 the Emperor Constantine I dedicated his new capital, which was renamed "Constantinople," in the eastern Roman Empire. This move marked the beginning of the long history of what would eventually be known as the Byzantine Empire, but from that time on the western section of the Roman Empire was marked by weakness and decline. Eventually, invaders from the north came down to overrun the once-powerful western Roman Empire. In 410, Alaric, king of the Visigoths, took Rome, and after that followed wave after wave of barbarian invasions. By the last of the fifth century A.D., the Roman Empire in the west had come to an end, and the barbarian kingdoms of the Middle Ages took its place.

➤ Notice the relief sculptures on this detail from the Arch of Constantine. Have you seen similar reliefs on Greek structures?

Figure 9.26 Arch of Constantine, Rome, Italy. (Detail). A.D. 312–15.

➤ In what ways does the construction of this arch differ from that of the Arch of Constantine (Figure 9.1, page 188)? How do the decorative elements differ?

Figure 9.27 Arch of Bara, Tarragona, Spain. Second century A.D.

SECTION TWO

Review

1. Describe a Roman bath. Why were these structures so popular?
2. What was the Colosseum and what was it used for?
3. What was the Pantheon?
4. What does the Pantheon look like from the outside?
5. What functions did the coffers perform?
6. Identify the name given to the spacious rectangular buildings that Romans used as public meeting halls.
7. What type of structure was built to celebrate a successful Roman military campaign?
8. Name one important factor that contributed to the decline of the Roman Empire.

Creative Activity

Humanities. As the Roman troops moved across Europe, they established towns in the places they conquered. The town of Bath in southern England is a fascinating example. Two thousand years ago, discovering hot springs, the Romans built public baths (see Figure 9.16, page 198). Today hot water continues to flow into these baths. Research the rich history of this city, which is, like Rome, built on seven hills.

RELIEF OF A ROMAN STRUCTURE

Complete a mat board or poster board relief showing the exterior of a temple, aqueduct, colosseum, or arch based upon a Roman example. Include the same architectural features as the structure that inspired it. A three-dimensional look will result from layering increasingly smaller shapes on top of larger shapes. This will also provide contrasts of value (light and dark) that will add visual interest to the relief.

Focusing

Examine the Roman temples, aqueducts, colosseums, and arches illustrated in this chapter. Select one of these for detailed study. What are the most interesting and characteristic features of this structure? If seen directly from the front (or side) would it seem flat or three-dimensional? How many different kinds of shapes can you point out? Which shapes project outward into space? Do the shadows created by the different projections and recessions give the structure a more interesting appearance?

Creating

Complete several line drawings of the Roman structure you chose to study. These drawings should show the different shapes you see in this structure. However, do not try to draw these as three-dimensional forms, but as simple flat shapes such as triangles, circles, half-circles, squares, and rectangles. *Optional:* More advanced students can use perspective to create a building seen from an angle.

Using your best drawing as a model, use scissors or utility knife to cut out the various shapes identified from mat board or foam-core board. Carefully arrange these shapes on the sheet of poster board to create a relief of the structure. Make certain that this structure fills the board. Stack increasingly smaller mat board shapes on top of each other to give your relief a three-dimensional look. This will also add shadows, creating dark values that will contrast with light areas to add interest.

Safety Tip

Place a sheet of heavy, protective cardboard on your work surface. Hold your mat board down with the metal ruler, keeping fingers away from the cutting line. Draw the knife blade over your pencil line with firm, downward pressure, but do not try to cut through the board with one stroke. By the third or fourth stroke, you should be able to cut through the board easily. Be sure to use a sharp blade; dull blades can slip.

➤ Maison Carree, Figure 9.8, page 193.

• *Describe.* Is your relief easily recognized as a particular type of Roman architecture? What features of your relief contributed the most to making this identification possible?

• *Analyze.* Did you use a variety of large and small shapes on your relief? Are these shapes stacked in such a way that a three-dimensional appearance is realized? Does your relief exhibit an interesting pattern of light and dark values? What do these value contrasts contribute to the overall effectiveness of your relief?

• *Interpret.* Do you think viewers could determine the purpose for which your structure might have been built?

• *Judge.* Evaluate your work in terms of the visual qualities. Do you think it demonstrates an overall unity? Which art elements and principles contributed the most in achieving that unity?

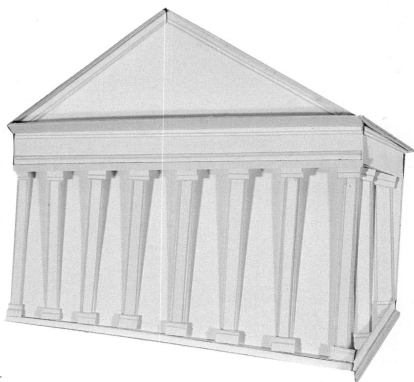

Figure 9.28 Student Work

CHAPTER NINE

Review

Reviewing the Facts

SECTION ONE

1. What people lived in Italy before 509 B.C.?
2. How did Roman sculpture and painting differ from the style of Greek sculpture and painting?
3. How did the Roman arch improve upon the post-and-lintel system favored by the Greeks?
4. In what art form did the Romans make their greatest contribution?
5. What did the Romans build to provide water to their cities and how did they work?

SECTION TWO

6. What motivated emperors to construct baths, circuses, forums, and amphitheaters for the enjoyment of the people?
7. What features did all the Roman baths have in common?
8. Name an advantage of the groin vault construction over the barrel vault.
9. Which column types, borrowed from the Greeks, were used in the construction of the Colosseum in Rome?
10. Name two unusual aspects of the Pantheon's dome.

Thinking Critically

1. *Compare and contrast.* Using the Parthenon (Figure 8.3, page 164) and the Pantheon (Figure 9.22, page 202) as models, list the similarities and differences between Greek and Roman temples.
2. *Evaluate.* The Romans, as you have read, were influenced by Greek ideas about art and used them in their own works. In which area of art do you find this influence to be most evident? Support your answer with facts and examples of specific works from the chapter.
3. *Analyze.* Look closely at the scenes shown in the wall painting from the villa at Boscoreale (Figure 9.5, page 191). Then refer to the list of techniques that artists have devised to create the illusion of depth on page 39 in Chapter 2. Which techniques did the Roman artist know how to use?

Using the Time Line

Examine the time line closely, noting the works of art and architecture identified. Are all the important artworks discussed in this chapter accounted for? Name one that is not and determine where a reference to it would be made on the time line.

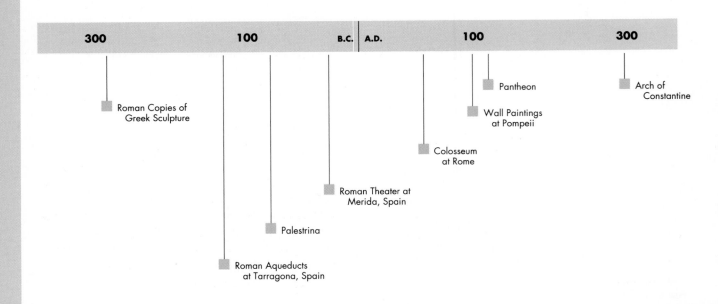

| 300 | 100 | B.C. | A.D. | 100 | 300 |

Roman Copies of Greek Sculpture

Pantheon

Arch of Constantine

Wall Paintings at Pompeii

Colosseum at Rome

Roman Theater at Merida, Spain

Palestrina

Roman Aqueducts at Tarragona, Spain

Megan Cory, Age 18
Dobson High School
Mesa, Arizona

Megan selected a Roman-style portrait bust as the subject for her artwork. She began by using the potter's wheel to throw a cylinder for the neck and an egg-shaped form for the head of her sculpture.

Keeping in mind that the Romans wanted their portraits to look realistic, rather than idealistic, Megan included facial characteristics that gave her subject a distinct identity.

➤ Roman-style Bust. Clay. 46 x 38 x 25 cm (18 x 15 x 10").

With regard to the medium, Megan advises: "Clay takes special care. Students should work hard to keep the clay in the proper working condition throughout the process." She felt that pre-thrown forms were easy to manipulate and that combining the techniques of throwing and sculpting gave her good results.

Art of Regional Civilizations

Standing Buddha Page 222
A.D. 477

Relief from the Bharhut Stupa Page 217
Early second century B.C.

2500	2000	1500	1000	500

THE ART OF INDIA, CHINA, AND JAPAN

Kwakiutl Dance Mask
1938
Page 247

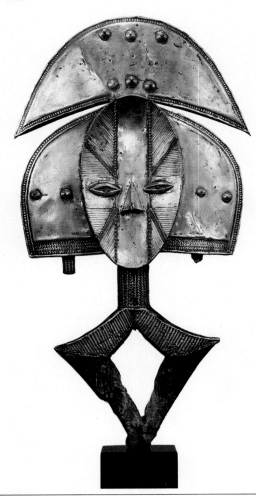

Kota Reliquary Figure
Nineteenth to twentieth centuries
Page 276

Mayan Man and Woman
c. A.D. 700
Page 244

B.C.	A.D.	500	1000	1500	2000

THE NATIVE ARTS OF THE AMERICAS

THE ARTS OF AFRICA

Centuries of Tradition in the East: The Art of India, China, and Japan

Objectives

After completing this chapter, you will be able to:

➤ Explain how the religions of Hinduism and Buddhism influenced the architecture and sculpture of the art of India.

➤ Analyze the impact of meditation on Chinese art.

➤ Trace the influences on Japanese art and identify specific Japanese art styles.

➤ Create a work of art using visual symbols.

➤ Use negative and positive space in a painting.

Terms to Know

Bodhisattva
meditation
pagoda
porcelain
scroll
stupa
Ukiyo-e
vanishing
 point
woodblock
 printing
Yamato-e

Figure 10.1 Tamil Nadu. *Shiva, King of the Dancers* (*Nataraja*). Chola Dynasty. Tenth century. Bronze. 76.2 x 57 x 22½ x 7″). Los Angeles County Museum of Art, Los Angeles, California.

The ten centuries ending in the fifth century A.D. can be thought of as a formative period in both the West and the East. During this long period the seeds for both halves of our modern world civilization were sown. The Greco-Roman culture you learned about in the previous two chapters resulted in the formation of contemporary culture in the West. In this chapter, you will learn about the religious, intellectual, and artistic achievements that took place in India, China, and Japan—achievements that combined to form the basis for contemporary culture in the East.

The Art of India

The long history of India is also the history of two great and enduring religions. For centuries Hinduism and Buddhism have influenced all aspects of Indian life. Nowhere is this more evident than in the art of India, the birthplace of both.

At times these two religions vied with one another, each producing its own unique art style in architecture and sculpture. At other times the two have existed side by side, resulting in artworks that are both Hindu and Buddhist in character. When and how did these religions originate? How did they influence the art of India? A search for answers to these questions involves a journey far back into time, to the same period, approximately 4,500 years ago, when the period called the Old Kingdom occurred in the long history of Egypt.

The Indus Valley Civilization

Shaped like an upside-down triangle, the subcontinent of India is as large as all Europe without Russia. The modern nations of India, Pakistan, and Bangladesh trace their cultural beginnings to the early Indian civilizations. However, it was only recently that historians began to realize how far back in time those beginnings were rooted. (See Figure 10.2.)

Not so many years ago no one realized that there was once a flourishing civilization located on the banks of the Indus River in northwest India. In recent

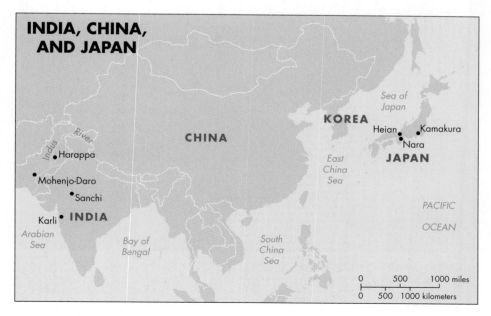

Figure 10.2 India, China, and Japan

years two important sites have been discovered, one at Mohenjo-Daro (Figure 10.3) and the other at Harappa. Many more are known to exist. Excavations reveal that about 4,500 years ago a civilization rose along the 400 mile (644 km) route separating these two cities.

More than seventy cities, towns, and villages have been discovered, and the remnants of these civilizations are believed to have been part of an organized kingdom with a central government.

The Harappans

The Harappans, or people of the Indus Valley, gradually developed a way of life that was as far advanced as that of Egypt. They made use of bronze and copper technology, erected multistoried buildings made of fired bricks along streets as wide as 40 feet (12 m), built an efficient drainage system, and developed a written language based on pictograms, or picture symbols.

While most Harappans raised grain and vegetables in the fields surrounding their cities and towns, others engaged in a lively commerce. Among the items they made and traded were small clay pottery, bronze and stone figures, and cotton cloth. The production of these items made the Indus Valley an important trading center.

A great many Harappan clay works have been found, but these were apparently made for trading purposes and have little artistic value. Only a handful of small stone and bronze sculptures from Mohenjo-Daro have survived to the present day. These hint at a fully developed artistic style and provide insights into the religious beliefs of the mysterious Harappan people. They indicate that the Harappans worshiped a great many spirits who, they thought, were to be found in water, trees, animals, and humans. (See Figure 10.4.)

About 2000 B.C. the Harappan civilization began to decline and by 1500 B.C. it vanished completely. Today most historians believe that invaders from the northwest, known as Aryans, were largely responsible for bringing an end to the sprawling and developed Indus Valley civilization.

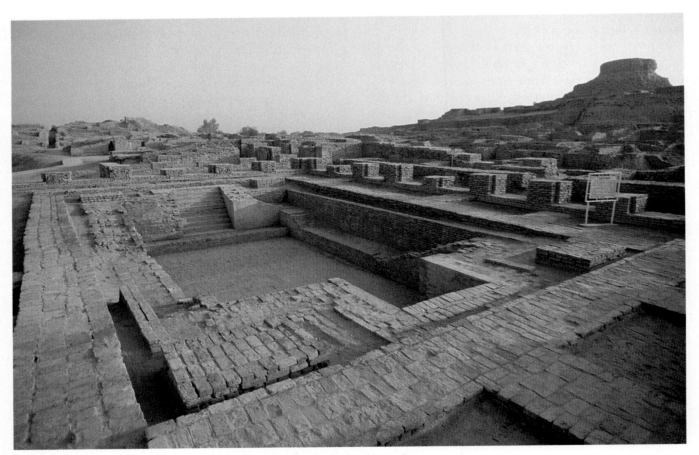

➤ What do the ruins of this ancient city tell you about the people who lived here? Do you see evidence of city planning?

Figure 10.3 Mohenjo-Daro, India. c. 2500 B.C.

➤ What elements and principles of art would you discuss when analyzing this work?

Figure 10.4 Painted Jar with Birds. Pakistan, Chanhu-daro. 2400–2000 B.C. Terra cotta. 25 x 49.5 cm (9¾ x 19½"). Joint expedition of the Museum of Fine Arts and the American School of Indian and Iranian Studies. Courtesy of the Museum of Fine Arts, Boston, Massachusetts.

The Ganges Civilization and the Rise of the Hindu Religion

The Aryans controlled India during the thousand-year period that is now commonly known as the Ganges civilization. They were warrior-shepherds who relied upon their cattle and sheep for livelihood. There is no evidence to suggest that the Aryans were as well organized as the Harappans. Instead of a central government, they were loosely organized into tribes. Each tribe was ruled by a Raja, or chief, who was assisted by a council of warriors.

Over time the Aryan religion, which recognized many gods and goddesses, blended with the beliefs of the Harappans to form what was to become the national religion of India: Hinduism.

Hinduism was not founded on the teachings of a single person. Instead, it was a blend of several different beliefs and practices that developed over a long period of time. To the Hindu, there are three primary processes in life and in the universe: creation, preservation, and destruction. The three main Hindu gods reflect this belief. They are Brahma, the Creator; Vishnu, the Preserver; and Shiva (or Siva), the Destroyer. In addition to these great gods, Hindus recognize and worship a multitude of other gods that include good and evil spirits, heavenly bodies such as the sun, and even birds and animals. To the devout Hindu there is no distinction between humans and animals. Both have souls, or spirits, that continuously pass from one to the other through reincarnation, or rebirth. Reincarnation is a purification process in which the soul lives in many bodies over many lifetimes. Every action performed in one life influences how a person will be born in the next life. To move to a higher, purer state a person must follow a set of rules governing moral conduct. The ultimate hope of the Hindu is to escape the cycle of reincarnation. When that happens the soul becomes one with Brahma, the great soul or Force of the World.

The Birth of Buddhism

By 500 B.C. northern India was little more than an on-again, off-again battlefield for a number of feuding kingdoms. It was during this troubled period that another important religion known as Buddhism emerged. The founder of this new religion was a prince named Siddhartha Gautama, whose holiness and love for all creatures earned him widespread fame throughout India. In time he came to be called the Buddha, which means "the Enlightened One."

Buddha did not claim to be of divine origin, nor did he claim to receive inspiration from gods. He **meditated**, or *focused his thoughts, on a single object or idea*, but did not pray to a Higher Being. After his death in 483 B.C., temples were built in his honor and his beliefs eventually spread throughout Asia. Fundamental to those beliefs is reincarnation. Like Hinduism, Buddhism holds that after death a soul will return in other forms of life. The two religions differ primarily in terms of the rules that must be followed if the cycle of reincarnation is to be completed successfully. If completed successfully, the spirit would experience nirvana, a blissful state free of all desires.

Buddhist Architecture

The importance attached to meditation moved many of Buddha's followers to withdraw from society to live in monasteries, called *vihāras*. At first these monasteries

➤ What makes this monastery so unusual?

Figure 10.5 Entrance, Lomas Rishi Cave. Barabar Hills, India. Third century B.C.

were simple wooden structures or natural caves. Around the third century B.C., more elaborate chambers and meeting halls were carved out of the rock of hillsides and cliffs. One of these was the Lomas Rishi Cave in the Barabar Hills in northeastern India (Figure 10.5). The exterior of this cave is carved to duplicate the look of the wooden structures of that time. This particular feature continued in evidence on monasteries of this kind for a thousand years.

By the end of the second century B.C. another important architectural form appeared known as the **stupa**, *a small, round burial shrine erected over a grave site to hold relics of the Buddha*. Shrines like these offered opportunities for the faithful to engage in private meditation, an important element in the Buddhist religion.

The most impressive of these stupas was erected, enlarged, and finally completed in the first century A.D. at Sanchi (Figure 10.6). Buddhists showed their devotion by walking clockwise along a railed path at the base of the dome. This walkway symbolized the path of life that circled the world. As they strolled slowly, contemplating the holy relic within the shrine, they were transported from the real world and its distractions to the comfort of the spiritual world. In this way they approached the enlightened state sought as a means of moving ever closer to nirvana.

The complex carvings and sculptures that adorned the shrine were intended to remind worshipers of Buddha's teaching and aid them in meditation. However, the figure of Buddha never appears. His presence is implied by such symbols as an empty throne, a tree under which he sat when meditating, and his footprints. The use of symbols to represent the Buddha reflects a belief in a teacher who had attained nirvana. There was, for the Buddhist, nothing to which such a person could be compared. Still, the religion required images to aid in teaching and to inspire meditation.

➤ What was the purpose of this structure? How did Buddhists practice their faith at sites like this?

Figure 10.6 The Great Stupa. Sanchi, India. c. A.D. 1.

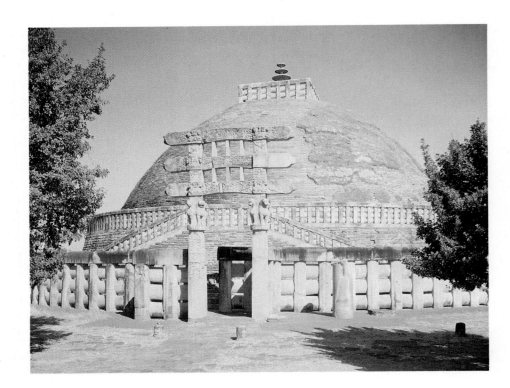

➤ How is the principle of harmony shown here?

Figure 10.7 *Interior of the Chaitya Hall. Karli, India. c. A.D. 50.*

The stupa at Sanchi is recognized as the greatest of the early Buddhist shrines, while the cave at Karli is thought to be the finest of cave temples. By the second and first centuries B.C., cave structures had progressed far beyond the earlier efforts at the Lomas Rishi Cave. At Karli an elaborate exterior was carefully carved to look exactly like a wooden building. While breathtaking, it hardly prepares the visitor for what awaits inside, where a hall nearly 45 feet (13 m) high and 125 feet (38 m) long was carved out of a stone cliff (Figure 10.7). This hall is divided into three aisles by rows of closely spaced columns crowned with male and female riders astride elephants. These columns lead up to and around a stupa forming the pathway Buddhists follow when meditating. A large window above the main entrance allows light to filter in, dramatically illuminating the interior of the stupa. Walking along the central aisle toward the sunlit stupa, worshipers experience the sensation that they are moving away from the harsh realities of the real world and, with each step, closer to spiritual enlightenment.

Buddhist Sculpture

Early Buddhist relief sculptures depicted various events in the life of the Buddha. An example from a stupa erected in the second century B.C. (Figure 10.8) shows the Buddha being visited by a king. As in all early Buddhist art, the Buddha is represented only by a symbol—here by a wheel placed on an otherwise empty throne. To the faithful the wheel had several

meanings. One of these encompassed the circle of life, maturity, and death associated with each reincarnation leading to nirvana.

A close examination of this relief reveals a curious blend of fact and fantasy. At the right a pair of oxen is pulling a chariot bearing two figures outward, directly toward the viewer. The two standing figures in the center flanking the wheel seem too large for the building in which they are placed. The building, like everything else in the relief, is shown in great detail. This enables the viewer to see, understand, and share in the homage being shown to the Buddha, while at the same time smile at the efforts of the man in the upper left corner vainly trying to prevent his elephant from pulling down a branch of a tree.

By the end of the first century A.D., a number of reforms took place in the Buddhist religion. As a consequence of those reforms artists began to represent the Buddha in human form.

Buddhist sculpture reached its peak during a period known as the Gupta era, which lasted from A.D. 320 to A.D. 600. Sculptures and relief carvings produced during this time combine an appearance of great power with a feeling of inner peace. The standing Buddha image and the Buddha seated cross-legged in meditation were perfected at this time. These became the models sculptors used to portray the Buddha throughout Asia.

➤ How is space suggested in this relief?

Figure 10.8 *King Prasenajit Visits the Buddha.* Detail of a relief from the Bharhut Stupa. Early second century B.C. Hard, reddish sandstone. 48 x 52.7 x 9 cm (19 x 20¾ x 3½"). Freer Gallery of Art, Smithsonian Institution, Washington, D.C.

Anish Kapoor

The sculptures of Anish Kapoor (b. 1954) are inspired by the Hindu myths of his native India. The goddess of the earth and of fertility, Kali, has especially captured Kapoor's imagination, and he hopes to combine in his art the coexistence of fertility and violent ecstasy that are Kali's attributes. Describing his understanding of Kali, Kapoor says, "My sense of her is that she is completely benign, yet full of destruction. She is the great mother, the creator, the place of all creation, yet potentially the destroyer of everything."

Kapoor was born in Bombay but has lived most of his life in England, where he attended art school. In 1979, after he returned to India, the land of his birth, he devoted himself to making sculptures that re-create the sensual ecstasy of the Hindu faith and world view.

Kapoor is also intimately familiar with the work of British artists Henry Moore, who made sensuous biomorphic sculptures, and Richard Long, noted for his ritualistic stone art. An observer and participant in British culture as well as Indian culture, Kapoor has been described as both an insider and outsider of the two cultures, and he is as much a presence on the British art scene as he is linked with Indian society.

Kapoor's works are first carved out of polystyrene, then coated with earth and cement. Finally he applies a layer of the powdered pigment that gives each piece its optically intense and deep coloration. Occasionally Kapoor even pours some of the pigment directly onto the floor where a work is installed, making it appear as though the form itself is dissolving. The result is sculptures of vibrant intensity, and viewers are frequently tempted to touch Kapoor's art.

Now living in London, Kapoor is less interested in making art that explores form for its own sake than he is in communicating the spirit of Hindu religion in a manner that is as compelling as the ancient Indian temple carvings. He states, "I wish to make sculpture about belief, or about passion, about experience that is outside of material concerns." Kapoor's art appears both weighty and weightless, solid and dissolving. It is this tension that conveys the sense of cyclical transformation that is central to the Hindu cosmology.

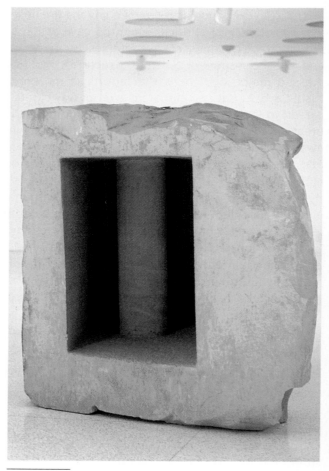

Figure 10.9 *Pillar of Light.* 1991. Sandstone. 152 x 153 x 143 cm (59¾ x 60 x 56⅛"). Lisson Gallery, London, England.

Revival of Hinduism

Although Buddhism was for many centuries the leading religion in India, Hinduism was never completely forgotten. Beginning around the fifth century A.D. it experienced a revival that ended with its return to prominence in the two centuries that followed. Reasons for this revival vary, but it may have been due to the fact that Hinduism offered more, as well as less demanding avenues to spiritual perfection. These included the simple performance of one's daily duties.

Hindu Architecture

Nothing remains of monumental Hindu architecture before the fourth century A.D. At that time some Hindu architects began to follow the example of Buddhist builders by carving their temples in caves. Meanwhile, others began erecting temples of stone. One of the earliest of these is a sixth-century temple in north central India constructed during the Gupta era (Figure 10.10). Since many of the features found in this building were used in subsequent structures, it warrants a closer look.

Like all Hindu temples, this building was never intended to accommodate large numbers of worshipers. Its primary purpose was to serve as a residence for a god. In this case the god was Vishnu, the Preserver. Inside, the building contained a sanctuary lined with thick, solid walls and a heavy ceiling that housed and protected a statue or relic. Like earlier Greek temples, it was meant to be seen from the outside and appreciated in the same way one would appreciate a fine sculpture. However, in this early example, the "sculpture" is relatively simple. The overall form is little more than a cube once crowned with a tower. Some exterior walls contain relief panels but these only hint at the ornate carving that characterized Hindu temples that were built later.

Hindu Sculpture

In addition to carving stone sculptures and reliefs to decorate their temples, Hindu sculptors produced bronze works of high quality. A bronze figure of Shiva from the kingdom of Chola demonstrates their skill and sensitivity (Figure 10.11, page 220).

Shiva is recognized as one of the most important of the Hindu gods. He is shown in various forms in Hindu sculpture, but one of the most fascinating is his portrayal as the Lord of the Dance. Here he is seen performing a ritualistic dance, which symbolizes the destruction of the universe that is then reborn. This work echoes the Hindu belief that the human spirit too is born again after death, taking on a new form reflecting the state of perfection achieved in previous

➤ In what ways does this Hindu temple differ from churches you have seen? Why is this temple more like sculpture than architecture?

Figure 10.10 Vishnu Temple. Deogarh, India. Early sixth century A.D.

➤ What is the most unusual feature of this sculpture?

Figure 10.11 *Shiva Nataraja, the Dancing Lord.* Madras. Late Chola. Thirteenth century A.D. Bronze. 87 x 70 x 33 cm (34¼ x 27½ x 13"). The Nelson-Atkins Museum of Art, Kansas City, Missouri. The Nelson Fund.

lives. The multiple arms serve a dual purpose. They not only emphasize the god's graceful movements but also permit him to hold several symbolic objects. In one hand he grasps a drum symbolizing creation. In another he holds the flame of destruction. A third hand is raised to protect the faithful. The fourth points gracefully to his upraised left foot which symbolizes escape from ignorance represented by the small figure he crushes beneath his right foot.

The Spread of Indian Art

The great achievements of Indian art were not confined to India alone. Its ties to Indian religious beliefs assured the spread of Indian art as these religious beliefs swept across Asia. Buddhism, in particular, contributed to the spread of Indian art. While this religion experienced a decline in the country of its birth, it found new, fertile ground for growth in other countries. Among the most important of these countries were China and Japan.

SECTION ONE

Review

1. What two religions have, over the centuries, influenced all aspects of life in India?
2. Name three technologies used by the Harappans of the Indus Valley.
3. How was the Hindu religion founded? Is it based on the teachings of a single person?
4. What is so unusual about the number of gods recognized and worshiped by the Hindus?
5. Buddhism places great importance on meditation. What does meditation involve?
6. What is a Buddhist stupa?
7. Since Hindu temples were not intended to hold large numbers of worshipers, what was their primary purpose?

Creative Activity

Humanities. Dance in India is an art of incredible discipline. Body movements are slow and sensual. Girls begin at a very early age to learn the intricate movements, particularly of the arms, hands, and fingers. Stories are told through the dance with each delicate, graceful movement being part of the visual language. Dance, music, and drama are inseparable and usually have a deep spiritual meaning. Often the dance is begun with a prayer. Indian music is *monadic* (single tone) and based on a system of *ragas*, each raga having ethical and emotional properties associated with the seasons and even with the times of the day. Drums of many types and tone qualities are most common, with bagpipes, lutes, fiddles, oboes, cymbals, and gongs adding richness to the sound. Locate an example of Indian music and share it with your classmates.

The Art of China

The history of India is marked by the rise and fall of dynasties and kingdoms, and the Gupta era was no exception. Its decline was followed by a period of internal disorder and conflict that preceded the country's invasion by powerful outside forces. Recorded in the long history of China is a similar succession of dynasties, each with its own unique problems and contributions to art.

The Beginnings of Chinese Civilization

Chinese civilization, which began some two thousand years before the birth of Christ, can lay claim to being the oldest continuous culture in the world. (See Figure 10.2, page 213.) As this civilization grew, its people gained skill and knowledge in many different fields. The Chinese are credited for such accomplishments as inventing the compass, paper, porcelain, and printing with carved wood blocks.

Skill in bronze casting was developed at an early date in Chinese history. Bronze vessels found in ancient graves reveal that Chinese artisans were exercising this skill by the first dynasty. This period was known as the Shang dynasty and was founded in 1766 B.C. Many of the early bronze vessels show extraordinary technical mastery and hint at centuries of development (Figure 10.12).

The art of painting is mentioned in Chinese literature several centuries before the birth of Christ. According to tradition, the first Chinese painter was a woman named Lei (lah-**ee**). She was the sister of the emperor Shun (2255 to 2205 B.C.), who numbered among his accomplishments an improved calendar and a standardized system of weights and measures.

Unfortunately, no paintings have survived from these early periods of Chinese history. However, written reports tell us that paintings of great skill and beauty were created and were appreciated.

The Chow dynasty, which followed the Shang dynasty in 1030 B.C., apparently produced few artistic changes. This dynasty eventually disintegrated into warring states and continued to be fragmented until the powerful Han dynasty was founded in 206 B.C.

➤ What sculptural techniques were used to produce this vessel?

Figure 10.12 Ritual Lobed Tripod Cauldron. Chinese, Shang dynasty. Eleventh century B.C. Bronze inlaid with black pigment. 21.3 x 18 cm (8⅜ x 7⅟₁₆"). The Metropolitan Museum of Art, New York, New York. Gift of Ernest Erickson Foundation, Inc. 1985.

The Arrival of Buddhism during the Han Dynasty

It was near the end of the Han dynasty that the religion of Buddhism, which originated in India, came to China. This religion had a great impact on the way artists approached their work. It also helped raise artists to a position of respect and admiration in Chinese society. The Chinese people were the first to consider the painting of pictures as an important and honorable task and placed the artist on the same level as that of poets, who were very highly regarded.

Buddhism offered comfort to the weary and hope for an eternity of peace in the next world. It recognized the existence of people who had attained a state of enlightenment. It also recognized those who had either postponed death or made the decision to return to the world for the purpose of bringing comfort and offering guidance to the living.

Such a person was known as a **Bodhisattva** (boh-dee-**saht**-vah) or *Buddha-to-be*. Figure 10.13 on page 222 shows a type of Bodhisattva, a gilt bronze statue called a *Maitreya*, the "Buddha of the Future." It is also one of the largest of its kind to survive to the present day. With a serene smile he extends his open hands

in a sign of welcome and a promise of peace that must have been calming to those who saw him.

Unlike ancient Greek sculptors, who recognized the beauty of the human body and tried to capture that beauty in their sculptures, Chinese sculptors did not regard the body as a thing of beauty. This, combined with the fact that they did not regard sculpture as one of the important arts, caused them to limit their

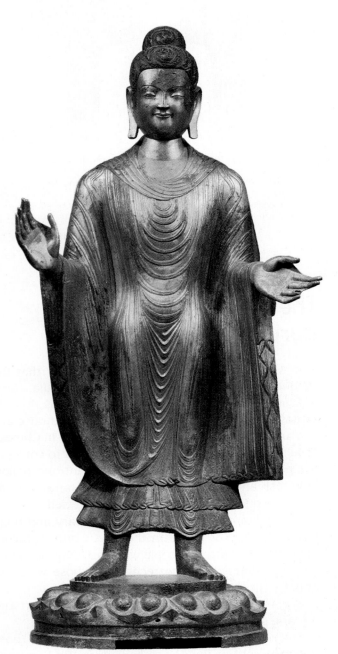

▶ What aesthetic qualities are most appropriate when making a judgment about this work?

Figure 10.13 *Standing Buddha.* Chinese, Wei dynasty. A.D. 477. Gilt bronze. 140.3 x 48.9 cm (55¼ x 19½"). The Metropolitan Museum of Art, New York, New York. John Stewart Kennedy Fund, 1926.

sculpture production to religious portraits like the Bodhisattva in Figure 10.13.

The Importance of Meditation

Buddhism, like other Eastern religions, places great emphasis on meditation. It is important to be aware of this emphasis because it had great impact on Chinese art.

Meditation is the process of focusing one's thoughts on a single object or idea. In this way the inherent beauty or meaning of that object or idea can be completely experienced. Thus, it is not unusual for Buddhist monks to remain motionless in meditation for hours, or even entire days. They may contemplate a leaf sagging from the weight of raindrops, or the possible meanings of a single word. Influenced by these monks, Chinese artists found that long periods of time spent in meditation enabled them to recognize the beauty of a leaf, a tree, a rock, or a mountain. They were then better prepared to capture that beauty in their painting.

Increased Concern for Landscape Painting

For over a thousand years, beginning with the Han dynasty in 206 B.C., the human figure dominated in Chinese painting, just as it did in the West. By the ninth century A.D. however, Chinese artists were beginning to exhibit a greater appreciation for nature. By the eleventh century this trend was complete. While Western artists continued to focus their attention on people, artists in China preferred to concentrate on nature.

The landscape was the primary interest and the major accomplishment of Chinese painting. Artists, like poets, sought out places in which they could meditate and be inspired to create. They valued every opportunity to do this, taking long, leisurely walks across the countryside.

When an artist named Tsung Ping found himself to be too old for such activity, he must have been heartbroken. In a short essay, however, he explained how he was able to overcome this loss. He re-experienced his earlier travels by painting the landscapes that lived in his memories on the walls of his room. Looking at those paintings, he wrote, aroused the same feelings he had experienced when viewing the real scenes.

To gain the knowledge and skills needed to continue in the tradition of painting landscapes, Chinese artists spent years copying the paintings of earlier artists. Although it was common to base a painting on the work of an earlier artist, the painter was expected to add some personal touches as well.

Scroll Painting

In addition to a few murals on the walls of burial chambers, the earliest Chinese paintings that have survived to the present are of two kinds: hanging scrolls and horizontal handscrolls.

A **scroll** is *a long roll of illustrated parchment or silk*. Scrolls were designed to be rolled and carefully stored away. When their owners were in the mood for quiet reflection, the scrolls were taken from the shelf just as we might choose a book to read. Unrolling the scrolls section by section, the viewer gazed at no more than 24 inches (61 cm) or so at a time. In this way it was possible to journey slowly from scene to scene through the entire painting.

The End of the Han Dynasty

The Han dynasty produced a culture that rivaled that of the Roman Empire, which was flourishing at this same time in history. The Han dynasty extended over a four-hundred-year period, the second longest in Chinese history.

Due to a series of weak emperors, the Han empire ended. It was followed by a period, beginning at the close of the third century A.D., in which China was divided into a number of smaller states. None of these states became strong enough to conquer the others in order to restore a unified empire. After a period of chaos, a new dynasty, the T'ang dynasty, assumed control in 618 and held control for nearly three hundred years.

The Powerful T'ang Dynasty

During the T'ang dynasty the people enjoyed prosperity, military campaigns extended the boundaries of the empire, foreign trade increased, and Buddhism grew in strength. It was a period in which China reached the peak of its power and influence.

Sculpture during the T'ang Dynasty

Most of the sculptures produced during the T'ang period were religious. Believers in Buddhism, looking forward to a peaceful life in the next world, commissioned thousands of sculptures of Buddha. Tomb sculptures, chiefly in clay, were also created to honor the dead. Many of these sculptures were of animals. An excellent example is the earthenware and polychrome-glazed horse illustrated in Figure 10.14.

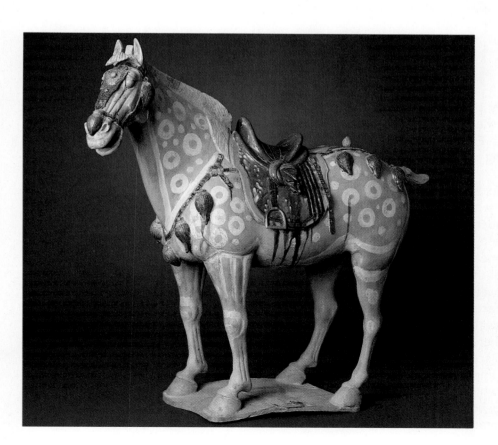

➤ Many clay sculptures like this were found in ancient Chinese tombs. Why do you think they were placed there? Do you think this is a successful work of art? Explain your answer.

Figure 10.14 Saddled Piebald Horse. Chinese, T'ang dynasty. 618–907. Earthenware with polychrome glaze. 74.9 cm (29½"). The Nelson-Atkins Museum of Art, Kansas City, Missouri. Acquired through the Joyce C. Hall Funds of the Community Foundation, the Joyce C. Hall Estate, the Donald J. Hall Designated Fund of the Community Foundation, the Barbara Hall Marshall Designated Fund, and the Elizabeth Ann Reid Donor Advisory Fund.

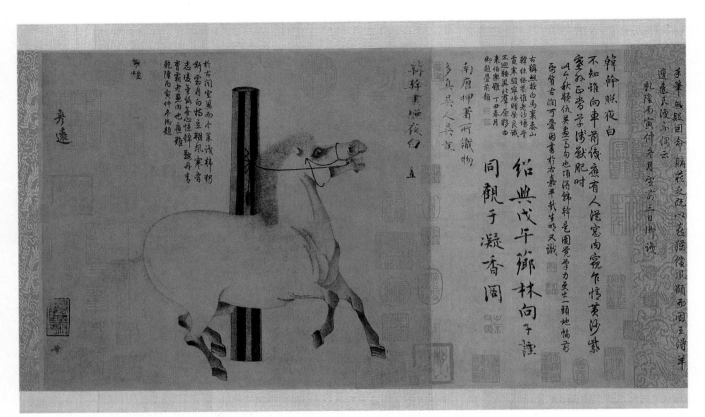

➤ Would you describe the lines used here as delicate or bold? How has gradation been used in this work? Does this work make good use of the literal qualities?

Figure 10.15 Han Kan. Handscroll: *Night-Shining White*. Chinese, T'ang dynasty. c. A.D. 742–56. Ink on paper. 30.8 x 34 cm (12⅛ x 13⅜"). The Metropolitan Museum of Art, New York, New York. Purchase, the Dillon Fund Gift, 1977.

T'ang Handscroll

Apparently horses were highly prized by the Chinese. The emperor Ming Huang was said to own over forty thousand. The handscroll in Figure 10.15 shows one of his favorite horses rearing against the tether that binds it to a post.

One of the chief measures of excellence in Chinese painting throughout its long history is the quality of the brushline, which is certainly evident in Figure 10.15. A delicate use of line is combined with subtle value gradations to give a realistic appearance to the animal. The work demonstrates that the artist, Han Kan (**hahn kahn**), knew his subject well and could apply this knowledge effectively to his art.

The many inscriptions and seals placed on Han Kan's painting indicate that others appreciated his knowledge and skill. They were placed there by collectors who wished to express their approval of the work. These inscriptions and seals, which are found on many Chinese paintings, have become a part of the work and add their own ornamentation and meaning.

Wu Tao-tze

Perhaps the greatest painter of the T'ang period was Wu Tao-tze (woo **tow**-tzeh). He is said to have created three hundred beautiful fresco paintings on the walls of Buddhist temples throughout China. One of these included over one hundred figures and became as famous in China as Michelangelo's Sistine Ceiling or Leonardo's *Last Supper* in Europe. This famous painting by Wu Tao-tze, like all his other works, has not survived. The loss is an important one if we attach any significance to the legends told about this artist's abilities.

According to one of these legends, Wu Tao-tze was sent by the emperor to draw the scenery along a certain river. When the artist returned, however, he did not have a single drawing to show the emperor. When asked to explain himself, the artist claimed that he had the scenes stored in his head and in his heart. Then, isolating himself in a room in the palace, he painted pictures showing a hundred miles of landscape.

None of the legends about this remarkable artist is as fascinating as the one concerning his death. When he felt he had lived long enough, he painted a grand landscape. Then, having put his affairs in order, the artist stepped into the mouth of a cave pictured in the painting. He was never seen again.

A Period of Stability and Great Art

Following the collapse of the T'ang dynasty in 906, China experienced a period of confusion. Finally, re-unification was realized in 960 under the Sung dynasty. The rule of this dynasty proved to be a period of great stability that produced a series of artists who created works of art that were admired the world over for centuries.

The Production of Porcelain

During the Sung period, the production of porcelain ware perfected earlier was carried to new heights. **Porcelain**, *a fine-grained, high-quality form of china*, is made primarily from a white clay known as kaolin. This clay is relatively rare and can be found in only a few locations in China, Europe, England, and North America. After a vessel is made from this clay and others that give it a more workable quality, it is fired in a kiln to a high temperature. It is then coated with

a glaze containing feldspar and fired again. The result is a vessel with a hard, translucent surface of great beauty.

An excellent example of Sung porcelain is illustrated in Figure 10.16. Bowls like this were the first of the classic pieces that were widely imitated but seldom equaled by later artists. The bowl's delicate shape and beautiful translucent surface are enhanced with a subtle pattern of lines.

Sculpture during the Sung Dynasty

Sung sculpture remained strongly tied to Buddhism, although the figures that were created were more informal and natural than those created earlier. A painted and glazed ceramic sculpture of a follower of Buddha (Figure 10.17) is an example of this more relaxed and natural figure style.

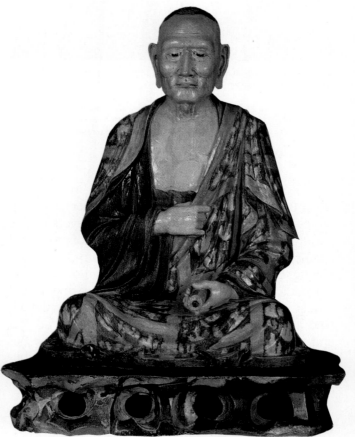

➤ This seated figure is shown in a pose similar to that of many Buddha sculptures. What mood does this work convey to you?

Figure 10.17 *Seated Lohan.* Chinese, Late T'ang or Early Sung dynasty. Tenth century. Pottery. 76.2 cm (30"). The Metropolitan Museum of Art, New York, New York. Frederick C. Hewitt Fund, 1921.

Figure 10.16 Bowl. Ting ware. Chinese, Sung dynasty. Eleventh to twelfth century A.D. Incised and glazed porcelain. 15.7 cm (6½") high; diam. 33 cm (13"). Asian Art Museum of San Francisco, San Francisco, California. B73 P10. The Avery Brundage Collection. Gift of Elise S. Haas in memory of her mother, Rosalie M. Stern.

➤ What feature does this work have in common with the one illustrated in Figure 10.17?

Figure 10.18 The Bodhisattva, Kuan-yin. Chinese, Liao dynasty. Eleventh to early-twelfth century. Polychromed wood. 241.3 x 165.1 cm (95 x 65"). The Nelson-Atkins Museum of Art, Kansas City, Missouri. The Nelson Fund.

This same relaxed attitude is noted in a carved wood Bodhisattva figure traditionally associated with mercy and compassion (Figure 10.18). Prayers to this Buddha-to-be were answered in the form of protection against any possible misfortune. The image is seen resting comfortably on a weathered, moss-covered ledge. Calm and gentle despite splendid garments and jewels, the figure represents no threat to the devout who approach with their petitions. Its gaze is direct and unwavering, causing viewers to feel that the Bodhisattva is concerned exclusively with them. The beginning of a soft smile serves as a clue to his willingness to respond to any request.

Landscape Painting during the Sung Dynasty

The Sung dynasty was noted for its great landscape artists. Painters like Kuo Hsi (**koo**-oh **see**) claimed that the value of landscape painting lay in its capacity to make viewers feel as if they were really in the place pictured. In a handscroll entitled *Clearing Autumn Skies Over Mountains and Valleys* (Figure 10.19), the artist invites you to join a group of scholars who are traveling beneath the trees of an enchanted mountain landscape. Such an invitation is difficult to ignore and so . . .

Imagine that you are seated comfortably with this handscroll in your hands. What will you experience as you slowly unroll it? If you allowed yourself to meditate on each scene as it appeared, you could expect to be carried off on a magical journey alongside gently flowing streams, past quaint cottages and magnificent temples. Perhaps you would choose to pause briefly to spend time with some fishermen before striding through a bamboo grove and into an area of towering pine trees. Another scholar is encountered trudging homeward, and you greet each other with mutual respect. Continuing on, you enter a clearing at the foot of tall mountains, the tips of which disappear into the fine mist. The mountains are breathtaking even though dimmed by haze and great distance. Across the clearing, a rustic restaurant and tea shop offers a perfect place to rest, to experience, to think. Your pace quickens even though you are weary from your long journey . . .

Unlike Western paintings, Chinese art makes use of different vanishing points. In perspective drawing, a **vanishing point** is *the point at which receding parallel lines seem to converge.* Thus, as you unroll a handscroll, you may find that the perspective shifts. This makes you feel as though you are looking at the scene from different vantage points. The result is a strong sensation that you are indeed traveling through the work—journeying over worn paths, under stately trees, in front of distant mountains, and across quaint bridges placed there for your convenience by the thoughtful artist. Every opportunity is provided for you to stop and to examine a flower heavy with dew or notice a butterfly perched on a blossom. There is nothing to distract you from your quiet contemplation. Even shadows are eliminated from the picture because they might interfere with your efforts to experience and enjoy the painting.

The End of the Sung Dynasty

In 1224 Genghis Khan and his powerful Mongol army swept into northwest China, bringing the Sung dynasty to an end. Following a period of strife, the Mongols, under Kublai Khan, a grandson of Genghis

Khan, took control of the country and established the Yüan dynasty. The work of two artists is notable.

Ch'ien Hsüan. The career of the painter Ch'ien Hsüan (chee-**en** shoo-**ahn**) covers the period from the fall of the Sung and the establishment of the Yüan dynasty. Like many other Chinese artists, he chose to retire rather than to serve the new leaders of his country. Living in seclusion, he turned to the past for inspiration and continued to paint. His handscroll of a scholar watching geese on a lake (Figure 10.20) re-

peats a familiar Chinese theme—the quiet contemplation of nature.

Chao Meng-fu. The contemplation of nature is also the theme of a painting by Chao Meng-fu (**chow** meeng-**foo**), a pupil of Ch'ien Hsüan's (Figure 10.21, page 228). This artist was greatly admired even though he chose to cooperate with the Mongol ruler Kublai Khan. His picture of pine trees, rocks, and distant mountains was done only after the artist had meditated upon the subject at great length. Because

➤ Why are handscrolls intended to be examined slowly, quietly, and in private? What kinds of subjects were typically painted on these handscrolls? Study this view of the mountains and valleys and decide if a mood or feeling is conveyed. If so, how does it make you feel?

Figure 10.19 Kuo Hsi. *Clearing Autumn Skies Over Mountains and Valleys.* Chinese. Date unknown. Section of handscroll, ink and colors on silk. 26 cm (10¼") high. Freer Gallery, The Smithsonian Institution, Washington, D.C.

➤ Describe the literal qualities in this work. Identify the most important elements of art used. What appears to be more important in this work—the figures or the setting? Why is it sometimes difficult for Western viewers to appreciate Eastern paintings like this one?

Figure 10.20 Ch'ien Hsüan. *Wang Hsi-chih Watching Geese.* Chinese, late southern Sung to early Yuan dynasty. Handscroll, ink, color, and gold on paper. 23.2 x 92.7 cm (9⅛ x 36½"). The Metropolitan Museum of Art, New York, New York. Gift of the Dillon Fund. 1973.

➤ *Why is it important for the viewer to learn what not to look for in a painting like this? How does the treatment of space in this work differ from the treatment of space in Western paintings?*

Figure 10.21 Chao Meng-fu. *Twin Pines, Level Distance.* Early fourteenth century. Handscroll, ink on paper. 25.4 x 127.3 cm (10 x 42½"). The Metropolitan Museum of Art, New York, New York. Gift of the Dillon Fund, 1973.

he had to be properly prepared to produce on paper the mental images that resulted from such meditation, he practiced his skills at representing trees, rocks, mountains, and clouds in a precise style for years before actually painting the picture. He did this in the traditional way—by carefully studying the paintings of earlier masters rather than by studying nature. Only when his skills were perfected did he attempt to create a painting based on his own response to the natural world.

To fully understand and appreciate a painting like this scroll, you must learn to see more than is there—you must also learn to look for what is *not* in the picture. Observe the carefully studied understatement in this work. Most of the painting is simply left blank. The landscape has been reduced to its barest essentials. Concentrating on each brushstroke, the artist applied the ink to paper with confident strokes. There was no room for error, no opportunity to erase a misplaced mark. Yet the artist had to work quickly to capture the mental impressions he received when meditating about the scene. Years of practice enabled him to work swiftly and flawlessly. Further, he knew exactly when it was time to stop and set his brush aside. He painted no more than was absolutely necessary to portray the subject and convey the mood.

It is important to remember that works like this were not done to tell a dramatic story, teach a profound lesson, or decorate a wall of a house. They were intended to inspire the same deep thoughts in the viewer that passed through the mind of the artist while the work was created. A work like this would only be unrolled and savored when the viewer was in the proper state of mind and was certain not to be disturbed.

The Art of the Ming Dynasty

The Ming dynasty, which followed the collapse of the Yüan dynasty in 1368, signified the end of foreign rule and the beginning of another Chinese dynasty. Thus, it was a time in which artists sought to restore the glories of the past. In painting, nature scenes of great beauty were done on silk and paper. Mainly these were done in a manner that continued the traditions of the past.

A range of different styles and techniques is noted in the ceramics produced during the Ming dynasty. The use of a stunning cobalt blue glaze at this time is regarded as one of the major accomplishments in the development of Chinese porcelain. An early example of a matched pair of vases (Figure 10.22) is admired for the intricate design that complements their forms.

Tribes from Manchuria conquered China in 1644. This brought the Ming dynasty to an end and ushered in the Ch'ing dynasty, which continued until 1912. Like other conquerors before them, Manchu rulers were determined to make the Chinese culture part of their own. However, despite the work done by several well-known and talented artists and the encouragement of Manchu emperors, Chinese painting experienced a decline during this period.

Porcelain production fared somewhat better than painting. During this last great age of Chinese porcelain, large quantities of fine works were produced. Unfortunately, rebellion and subsequent warfare in the middle of the nineteenth century resulted in the destruction or closing of most kilns and the flight of craftspeople into a disordered world.

➤ What important innovation is evident on these vases? What adjectives would you use when describing the decoration and the form of these vases?

Figure 10.22 Pair of Vases. Mei-p'ing. Reign of Xuande, Ming dynasty. 1426–35. Porcelain with underglaze blue decoration. 55.3 x 29.2 cm (21¾ x 11½"). The Nelson-Atkins Museum of Art, Kansas City, Missouri. The Nelson Fund.

SECTION TWO

Review

1. Name three inventions credited to the Chinese.
2. State the difference between the way Chinese and Greek sculptors viewed the human body.
3. How did Chinese artists make use of meditation?
4. What was considered the primary interest and major accomplishment of Chinese painting?
5. What is a scroll painting and how is it used?
6. Name the element of art that was considered one of the chief measures of excellence in Chinese painting.
7. How does a landscape painted on a Chinese scroll differ from a painting of the same subject done in the West?

Creative Activity

Humanities. According to Chinese historical records, masks were first used in China for singing and dancing in religious rites as early as the fifth century B.C. The use of masks in theater has a military origin. According to legend, fifth-century warriors, wanting to cause fear in their enemies, began wearing masks with horrifying expressions in battle. Actors adapted this idea and began donning masks to exaggerate their theatrical expressions. Masks continue to be used today in the famous Peking opera, a multifaceted performance including dance and remarkable acrobatic feats. Each mask design has a meaning derived from the relationship of colors and shapes. Each mask represents a mood, age, and temperament of the character. Enjoy mask designs made in another ancient Chinese art—paper cutting. Try creating your own designs in this medium.

The Art of Japan

Japan owed a debt of gratitude to China for its initial artistic development. However, it eventually produced an abundance of painting, sculpture, and architecture that was uniquely its own. The accomplishments of its artists added the luster to this island empire's ancient and proud history. (See map, Figure 10.2, page 213)

Early Development of Japanese Art

The first traces of Japanese art date to about 3000 B.C. and a culture known as Jomon. The earliest artworks consist mainly of simple, undecorated vessels, figures, and animals made of red clay (Figure 10.23). Curiously, many clay pieces in the form of figures and animals have been discovered in the areas surrounding burial mounds. This has caused some experts to suggest that they were placed there to ward off evil spirits and protect the dead.

Until the end of the ninth century, the art of Japan was largely modeled on that of China and other ori-ental cultures. After that time, however, foreign influences became less pronounced and Japanese artists began to develop their own styles. In the centuries that followed, various subjects grew in favor, faded, and were replaced by new ones. At certain times, scenes of life at court, witty caricatures, and portraits were popular. Other favorite subjects included battle scenes, genre scenes, and landscapes.

Our examination of the development of Japanese art begins in A.D. 552, when the ruler of a kingdom in Korea sent a gilt bronze figure of the Buddha to the emperor of Japan. Along with the sculpture came Buddhist writings and missionaries. This is how Buddhism was introduced to Japan.

At first there was resistance to the new religion, particularly by those who chose to remain faithful to Shinto, the indigenous religion of Japan. Eventually Buddhism became firmly established and came to affect every aspect of Japanese culture.

Temple Construction

In the year 594, the empress Shiko ordered that Buddhist temples be built throughout her kingdom. Prince Shotoku was charged with the responsibility of seeing that this edict was carried out. He brought architects, wood carvers, bronze workers, weavers, and other skilled artisans from Korea to build and decorate the temples that soon filled the countryside.

In many respects these temples were similar to those in China. They were, however, more richly dec-

▶ Would you describe this falcon as realistic? Does this work communicate any feeling or emotions? If not, does this lessen its appeal? What do you find most interesting about this work?

Figure 10.23 Haniwa Falcon. Japanese, late Kofun period. Sixth century. Earthenware. 11.1 x 17.8 cm (4⅜ x 7"). Asian Art Museum of San Francisco, San Francisco, California. B80 S3. The Avery Brundage Collection. Bequest of Mr. Joseph M. Branston.

orated and more delicately assembled. Since the Japanese islands were formed from volcanic rock, there was little hard stone suitable for building these temples. Consequently, these and other structures were made of wood. Japanese builders raised the art of constructing wooden buildings to a sophisticated art form. Their temples and palaces were built on a stone base with wooden posts and rafters that were carefully fitted together in beautifully crafted joints. These buildings had to be especially well designed and constructed to survive the frequent earthquakes and violent storms that plagued the island nation.

The Temple at Horyuji

Among the greatest architectural achievements in Japan was the temple complex at Horyuji built near Nara in about the year 616. The temple was built on a square plan surrounded by a double wall. Inside were a number of buildings: the main hall containing a sculpture of the Buddha, a lecture hall, a library, and a bell tower. In addition there were two pagodas. A **pagoda** is *a tower several stories high with roofs slightly curved upward at the edges*. These structures contained sacred relics, and although it is something of a miracle, one of these ancient wooden pagodas has survived countless earthquakes and outlasted thousands of stone edifices. It still stands today as the oldest wooden structure in the world (Figure 10.24). However, its fame does not rest on age alone. Few buildings in history have surpassed its simple majesty.

The Temple and Treasures at Todaiji

Perhaps as beautiful, and only slightly younger, is the temple of Todaiji in Nara, which was erected by

➤ What makes this particular structure so important in art history? Point to the features on this building that are found on all pagodas.

Figure 10.24 Pagoda from the Temple Complex at Horyuji, near Nara, Japan. c. A.D. 616.

➤ Identify the most important figure in this composition. What has been done to emphasize this figure? Who do you think this person represents: an important king, a powerful military leader, or a great religious teacher?

Figure 10.25 *Historical Buddha Preaching on Vulture Peak (Hokkedo Kompon Mandata).* Japanese, c. eighth century. Artist unknown. Ink, color and gold on hemp. 107 x 143.5 cm (42 x 56½"). Museum of Fine Arts, Boston, Massachusetts. William Sturgis Bigelow Collection.

the emperor Shomu in 752. Four years after the temple was completed the emperor died. Not long after his death, his widow, the empress Komoyo, presented the treasures of his court to the Great Buddha enshrined at Todaiji. Other gifts were later added to these treasures and were housed and protected in the temple. As a result, no less than ten thousand works of eighth-century Japanese art were preserved.

Among the artworks preserved at Todaiji is a painting on hemp, regarded as one of the temple's greatest treasures (Figure 10.25). It portrays the Buddha, surrounded by Bodhisattvas, preaching in the mountains. Although retouched in the twelfth century, this painting still testifies to the high quality of eighth-century Buddhist painting.

The Japanese took pleasure and pride in building huge sculptures. Examples are plentiful, but certainly one of the most impressive is the Great Buddha at Todaiji. In the year 747, when an epidemic of small-pox broke out in Japan, the emperor ordered a gigantic bronze Buddha to be created to pacify the gods. The sculptor used 437 tons (396 metric tons) of bronze, 228 pounds (103.4 kg) of gold, 165 pounds (75 kg) of mercury, 7 tons (6.4 metric tons) of wax, and several tons of charcoal. Two years and seven attempts were required to successfully complete the casting. The head was cast in a single mold, but the body was formed of several metal plates that were soldered together and then coated with gold.

The Heian Period

In 784, Heian (the modern city of Kyoto) was made the capital of Japan. The name Heian has since been used to identify a period regarded as a golden age for Japanese art. During the four hundred years of this period, numerous new temples and monasteries were built and founded. Also during this period, members of the royal court and the heads of great families commissioned painters to create works of art.

Contacts with China continued until the year 898, when ties were broken as a consequence of internal strife in Japan. No longer able to draw inspiration from China, Japanese artists developed their own unique style of painting, which was known as **Yamato-e**, or *painting in the Japanese manner.*

Paintings done in this style were the first true examples of pure Japanese art. Yamato is an area near Kyoto and Nara considered to be the center of Japanese culture. Artists using the Yamato-e style created decorative wall paintings showing travelers on the road, nobles admiring cherry blossoms or hunting, peasants working in the fields, and other scenes from everyday life. These spirited scenes included clear references to particular seasons of the year. Unfortunately, only a handful of works dating to this period have survived to be enjoyed and appreciated.

The Kamakura Period

A series of civil wars prompted by corrupt provincial governments brought an end to the Heian period in 1185. Clan leaders waged war with one another until one leader, Minamoto Yoritomo, was able to establish a military government at Kamakura. As in previous periods, the name of the capital city proved to be a convenient label for the period. A succession of military rulers assumed control over various parts of the country for the next 148 years. These rulers recognized the emperor as little more than a powerless figurehead.

A painting from the Late Heian–Early Kamakura period (Figure 10.26) shows the elegantly dressed Benzai-Ten, Japanese goddess of language, music, and eloquent speech. This work was probably painted to grace the interior of a Buddhist shrine. Seated on the bank of a stream, gently strumming a musical instrument, the goddess reflects on the grace and dignity associated with a life of quiet contemplation.

The Great Buddha at Kamakura

The tradition of creating colossal sculptures continued during this period with such works as the Great Buddha at Kamakura, which was cast in bronze in 1252 (Figure 10.27). Today it sits outdoors on a rise surrounded by a pleasant grove of trees. This seems to be an especially appropriate setting for the gigantic Buddha seated in quiet contemplation.

The Burning of the Sanjō Palace

Painting is the most interesting visual art form from the Kamakura period due to the advances made in the Yamato-e style. These advances reflected the artistic

➤ How does this work differ from religious paintings with which you are familiar?

Figure 10.26 *Benzai-Ten.* Late Heian-Early Kamakura. Late twelfth century. Colors on silk. 120.7 x 68.5 cm (47½ x 27"). The Nelson-Atkins Museum of Art, Kansas City, Missouri. The Nelson Fund.

➤ What material was used to make this sculpture? Is there a reason why it is located outdoors rather than within a temple?

Figure 10.27 Great Buddha. Kamakura, Japan. c. 1252.

➤ Describe what you see in this painting. What seems to be happening here? What emotions does the painting evoke in *you?* Is this a successful work of art? What aesthetic qualities would you identify to support your judgment?

Figure 10.28 *The Burning of the Sanjō Palace.* Japanese, Kamakura period. Second half of thirteenth century. Handscroll, eighth view of twelve. Ink and colors on paper. 41.3 x 699.7 cm (16⅓ x 144"). Museum of Fine Arts, Boston, Massachusetts. Fenollosa-Weld Collection.

tastes of the new military leaders, who preferred paintings that stressed realism and action. Nowhere is this realism and action more apparent than in a handscroll, *The Burning of the Sanjō Palace* (Figure 10.28).

This scroll illustrates with shocking realism a revolt that took place on the night of December 9, 1159. On that tragic night the Sanjō Palace was attacked and the emperor taken prisoner. Unrolling the scroll from right to left, the viewer is immediately swept up in the frantic scene. Noblemen and their servants are seen arriving at the palace after hearing of the attack. They are too late. The palace, already ablaze, is surrounded by warriors, some of whom are forcing the emperor into a cart to carry him away. Within the palace itself the horrors of war are presented in graphic and frightening detail: palace guards are beheaded, loyal attendants are hunted down and killed, and ladies-in-waiting are trampled beneath the hoofs of the rearing, frantic horses.

As the scroll is unrolled further, the viewer is led at a less hectic pace through swarms of soldiers, horses, and carts. Finally, at the very end of the scroll — nearly 23 feet (7 m) long — a warrior astride a rearing horse is seen following a single archer (Figure 10.29). The lone figure of the archer brings the powerful narrative to a quiet end, like the final period at the end of a story. However, the manner in which this story is told is not likely to be quickly forgotten.

➤ Compare this scene with the scene from the same handscroll illustrated in Figure 10.28. Why does the handscroll format seem especially suitable for telling a story of this kind? What emotions are communicated by this final scene in the long narrative? Describe your overall impressions of the two scenes from this handscroll.

Figure 10.29 *The Burning at the Sanjō Palace.* Detail: *Rider and Warriors.* Handscroll, twelfth view of twelve. Ink and colors on paper. 41.3 x 699.7 cm (16⅓ x 144"). Museum of Fine Arts, Boston, Massachusetts. Fenollosa-Weld Collection.

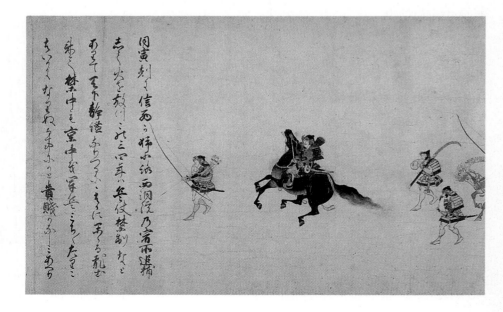

$\mathcal{A}rt$ · PAST AND PRESENT ·

Japanese Zen Garden, Water Reclamation Plant

Japanese gardens are not only found in Japan — one also exists in Los Angeles, California. This garden is, remarkably, part of a water reclamation plant. The Japanese garden at the Donald C. Tillman Water Reclamation Plant provides visitors the opportunity to experience the beauty and serenity of Japanese art while learning about water treatment and reuse.

The main purpose of the garden is to show the public how reclaimed water can be used. Thus, water is depicted in three states: a lake shows its calm state; streams show its horizontal movement; and waterfalls show its vertical movement.

Figure 10.30 Japanese Zen Garden.

The garden was designed by Dr. Koichi Kawana, a designer of architecture and landscape at large-scale gardens. Dr. Kawana's design covers six and one-half acres and is authentic in every detail, from the hand-set stones to the bonsai-style Japanese black pines. The garden, dubbed *Suiho-en*, or "garden of water and fragrance," contains three distinct areas. One enters at the dry Zen garden area. In this section, stone arrangements are the main design feature. As a symbol of longevity, a large turf-covered mound represents Tortoise Island. A group of upright stones is arranged in the "three Buddha" style, symbolizing the island of the immortals and everlasting happiness. An arbor nestled nearby is an ideal place to rest and contemplate the Zen stone arrangements.

The next section is the wet strolling garden, complete with waterfalls, streams, and a lake. Overlooking the lake and adjoining a teahouse is the Shoin building, a residential dwelling that is used here to provide a meeting place. The authentic tea garden is informal and represents a mountain path with a waiting bench.

This peaceful and tranquil Japanese garden allows visitors to focus on simplicity and beauty, leaving behind traffic, pressures and deadlines.

The Rise of Zen Buddhism and the Fall of the Kamakura Rulers

During the Kamakura period new Buddhist sects were formed. One of these, the Zen sect, was introduced from China. As you will discover, this sect was to have an impact on later Japanese art.

The power of the Kamakura military rulers ended in 1333. To their great shame this loss of power did not occur on the battlefield. Like their predecessors, they too became corrupted by power. This corruption is evident in the actions of Takatoki, the last in the line of the military rulers. He developed such a passionate fondness for dogs that he neglected the affairs of state. He eagerly accepted dogs as tax payments, and in time he collected over four thousand dogs, which he kept in kennels decorated with gold and silver. He fed the dogs fish and fowl and ordered that they be

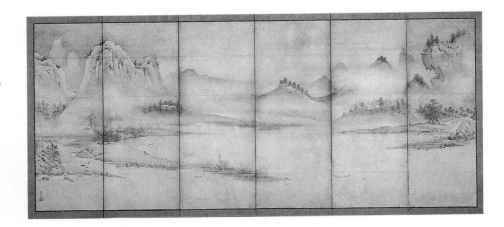

➤ What does this Japanese landscape have in common with the Chinese landscapes you have seen in this chapter? What differences do you see? How does this painting make you feel?

Figure 10.31 Sōami Kangaku Shinsō. *Landscape of the Four Seasons: Fall and Winter.* Japanese, early sixteenth century. Ink on paper. 173.4 x 371 cm (68¼ x 146"). The Metropolitan Museum of Art, New York, New York. Gift of John D. Rockefeller, Jr., 1941.

carried about in covered litters by his servants. The emperor, who was powerless at the time, saw in this unusual behavior a sign of weakness and an opportunity to regain control, and following a series of defeats, the emperor was ultimately able to claim victory. As for Takatoki, he fled to a temple and together with 870 of his generals and servants committed suicide.

Unfortunately, political unrest did not end with Takatoki's death. Civil war again broke out and continued until 1573. Somehow the arts managed to flourish during this period of almost continuous unrest and conflict.

The growing appeal of Zen Buddhism resulted in the popularity of art forms associated with that religion. Zen's appeal may have been due to the fact that it offered people an escape from the chaos that marked daily life. A desire to escape reality may have motivated artists as well. For example, when a painter named Sōami Kangaku Shinsō (soo-ah-mee kahn-gah-koo sheen-soh) took up ink and paper to create a design for a screen, he chose as his subject a quiet and peaceful landscape rather than an event marked by conflict and horror (Figure 10.31). His finished paintings were mounted on two screens illustrating the four seasons. Reading from right to left in the same manner as a handscroll, the paintings were intended to gently draw viewers into an imaginary world of beauty and peace in which they could forget the real world of unrest and fear.

This same quest for beauty and peace was undertaken by architects. The result can be seen in carefully proportioned pavilions set in the midst of splendid gardens. One such structure, the Golden Pavilion at Kyoto, was erected in 1397.

A period known as the *Momoyama* marked a time in which a succession of three dictators, or *shoguns*,

finally restored unity and brought peace to the troubled land. During this era, huge palaces were built (Figure 10.32). These palaces served two purposes—they were both protective fortresses and symbols of power. Inside these structures, sliding doors and large screens were decorated with gold leaf and painted with a range of different subjects.

➤ What two purposes were served by Japanese castles such as this one?

Figure 10.32 Hiroshima Castle. Lake Biwa, Japan. Rebuilt after World War II.

A Rich Era of Japanese Art

In 1615, Iyeyasu Tokugawa overwhelmed the forces of rival military leaders in a battle that left forty thousand dead. Victory enabled him to build a new capital at Edo (Tokyo) and establish the Edo rule, which continued until 1867. This period represents one of the longest periods of peace and one of the richest eras for art in Japanese history.

Peace brought about a prosperous middle class even as the once-powerful warrior class declined in importance and number. This new middle class demanded artworks that showed the life of the people rendered in new techniques. Demands such as these led to the development of the **Ukiyo-e** style, which means *pictures of the passing world*.

Woodblock Printing

Since painting produced only one picture at a time, artists searched for other ways to satisfy the increased demand for art. A solution, which had been introduced from China in the eighth century, was found in **woodblock printing**. This process involved *transferring and cutting pictures into wood blocks, inking the surfaces of these blocks, and printing*. Using this technique, an artist could produce as many inexpensive prints as needed.

Originally prints were made with black ink on white paper. If color was desired, it was necessary to add it by hand. However, in the eighteenth century a process for producing multicolored prints was developed. This process required the talents of a painter, a wood carver, and a printer. The artist first prepared a design in ink, adding color notations to guide the printer. The lines of the design were then transferred to a wood block, and a specialist in wood cutting carved away the wood between the lines. A separate block was prepared for each color. Finally, the printer inked each block and pressed each one against the paper, being careful to align the blocks exactly. Since hundreds of copies could be made from one set of blocks, the prints produced were relatively inexpensive.

Hishikawa Moronobu

Around the middle of the seventeenth century, a designer of dress patterns named Hishikawa Moro-

nobu (hee-shee-kah-wah moh-roh-noh-boo) produced the first woodblock prints. At first these were used as illustrations for books, but later they were sold separately. Moronobu's work was appealing due to the artist's charming style. With clear and precise lines he was able to record the grace of a female figure. At the same time he skillfully organized the interplay of black lines against white paper to achieve a striking effect.

➤ Describe this work in terms of its literal qualities and the elements of art used. Which of the elements — value, line, or texture — seems to be especially important in this work?

Figure 10.33 Torii Kiyonobu I. *A Woman Dancer.* Japanese. c. 1708. Woodblock print. 55.2 x 29.2 cm (21¾ x 11½"). The Metropolitan Museum of Art, New York, New York. Harris Brisbane Dick Fund, 1949.

Torii Kiyonobu I

Moronobu paved the way for other artists who soon began producing individual prints with a similar style and technique. Included among these artists is Torii Kiyonobu I (toh-ree kyoh-noh-boo), an actor's son who often selected as his subjects actors from the Kabuki theater. His picture of a woman dancer (Figure 10.33, page 237) uses a characteristic bold line that flows across the paper to create a complex yet graceful rhythm of curved lines and patterns.

Suzuki Harunobu

The first multicolored prints were probably done by Suzuki Harunobu (soo-zoo-kee hah-roo-noh-boo). Examining his prints (see Figure 21.21, page 500) reveals that he endowed his female figures with an almost supernatural grace. They appear to have weightless bodies with slender waists and tiny hands and feet. Rarely do their faces betray any signs of emotion or stress.

Harunobu, along with Katsushika Hokusai (kah-tsoo-shee-kah hok-sigh) and Andō Hiroshige (ahn-doh hee-roh-shee-gay) produced many of the works that were to inspire the French Impressionists in the nineteenth century.

Katsushika Hokusai

Hokusai was fond of saying that he "was born at the age of fifty." By this he meant that long years of diffi-

cult preparation were required before he was able to produce works of art that he considered worthy of merit.

From about 1825 to 1831 Hokusai published his brilliant Mount Fuji series of prints. In spite of its title, "Thirty-six Views of Mount Fuji," there are actually forty-six scenes included in the series. In this group of prints he adopted a long angle of vision to increase the dramatic impact. One of these prints, *The Great Wave off Kanagawa* (Figure 10.34), shows Mount Fuji in the distance, beyond a huge wave that threatens to destroy the fishing boats that are almost lost in the violently churning sea.

Hokusai was a humble man destined to be ranked among the great artists of history. Shortly before he died at the age of eighty-nine, Hokusai is quoted as having said, "If the gods had given me only ten more years I could have become a truly great painter."

Andō Hiroshige

Although he greatly admired Hokusai and was greatly influenced by him, the younger Hiroshige did not adopt his predecessor's spirited style. Instead, he used delicate lines and a harmonious color scheme to give nature a more subdued atmosphere. He often unified a scene by giving it an overall darkness of tone that captures the sadness of a rainy scene (Figure 10.35). Much of the beauty of his work comes from his sensitive response to variations in the weather and changing seasons.

➤ Discuss the way line variety adds to the visual interest of this composition. Discuss the different ways value is used. In what way does the addition of the fishing boats enhance this picture? What is the only thing in the picture that does *not* seem to be in motion? Could you justify a positive judgment of this work in terms of its expressive qualities? Explain.

Figure 10.34 Katsushika Hokusai. *Under the Wave off Kanagawa.* c. 1823–29. Woodblock print. 25 x 37.8 cm (9⅞ x 14⅞"). The Metropolitan Museum of Art, New York, New York. The Henry L. Phillips Collection, Bequest of Henry L. Phillips, 1939.

Figure 10.35 Andō Hiroshige. *Evening Rain on the Karasaki Pine* from the series Eight Views of Omi Province. Japanese. Nineteenth century. Woodblock print. 26 x 38 cm (10¼ x 15"). The Metropolitan Museum of Art, New York, New York. Bequest of Mrs. H.O. Havemeyer, 1929. The H.O. Havemeyer Collection.

SECTION THREE

Review

1. Explain how the Buddhist religion reached Japan.
2. What did a Japanese temple look like? From what material was it made and why?
3. What period in Japanese art was considered the golden age and why?
4. What led to the development of the Ukiyo-e style of art?
5. What prompted the development of woodblock printing in Japan?
6. What type of art requires the talents of a painter, a wood carver, and a printer?
7. Nineteenth-century French Impressionists were inspired by the work of two Japanese artists. Identify these artists and tell why you would be inspired by their work.

Creative Activity

Humanities. Japanese kimonos, once worn daily by both men and women, are now the ceremonial dress of Japanese women. The fabrics and the techniques used to decorate them make kimono design a most specialized art form. Appliqué, often with gold or silver foil worked into the design, is widely used. Fine embroidery adds details to the appliqué, or it is used for the entire fabric. Fine detailing done in tie-dye is another technique. Rows of tiny dots are achieved by tying thread around points of fabric only 1/8 inch (3 mm) in diameter. When the fabric is dyed, the thread prevents these spots from taking dye. Call museums in your area to see if they have a display of kimonos.

CREATING VISUAL SYMBOLS

Supplies
- Pencil
- White drawing paper, 9 x 12 inches (23 x 30 cm) or larger

CRITIQUING

- **Describe.** Are the different symbols in your drawing drawn accurately? Are they easily identified by viewers?
- **Analyze.** Is your drawing a complex composition made up of a variety of lines, shapes, simulated textures, and values? Can you point to and describe these different art elements in your work?
- **Interpret.** Is it possible for others to read the symbols in your composition to accurately determine the person represented? Was there one symbol in particular that viewers found useful in identifying the subject?
- **Judge.** What is most successful about your drawing? Overall, do you think it demonstrates unity? If you were to redo this drawing, what would you do to make it more unified?

Complete a complex, highly detailed pencil drawing composed of symbols representing a specific person. Use a variety of lines, shapes, simulated textures, and values to add to the complexity of your design and completely fill the paper on which it is made.

Focusing
Examine the relief carving from the Bharhut Stupa (Figure 10.8, page 217). How is the Buddha represented in this work? What other images were used by Buddhist artists to symbolize the founder of their religion?

Creating
Choose a well-known person to serve as the subject for this drawing. However, *do not reveal your choice to any other member of the class*. On a sheet of paper list as many visual symbols associated with your subject as you can. For a baseball star, you might compile such symbols as a bat, baseball, glove, spiked shoes, and the player's number.

On the white drawing paper complete a composition made up of the detailed drawings of each of the symbols on your list. These should be drawn in a variety of sizes and should overlap each other to create a complex composition. Use a variety of lines, simulated textures, and add shading.

Exhibit your drawing with those completed by other members of the class. Try to identify the subject of each drawing by "reading" and interpreting the symbols in each.

Figure 10.36 Student Work

NEGATIVE SHAPE PAINTING

Following a period of intense contemplation or study, draw a large branch as accurately as possible. The lines of this branch will run off the paper on which it is drawn. This will create a variety of negative shapes. These will then be painted with hues obtained by mixing two complementary colors, which will provide a range of intensities.

Focusing

Examine the paintings by Ch'ien Hsüan (Figure 10.20, page 227) and Chao Meng-fu (Figure 10.21, page 228). What did these artists do before beginning work on a painting? Do you feel that doing the same thing could have a positive effect on your own work?

Creating

Bring a large branch to class and remove most, but not all, of its leaves. Silently study this branch, noting the way it bends, twists, and divides.

Slowly draw the outline of the branch with pencil as accurately as possible. Make the drawing large enough so that it runs off the paper on all sides, creating a variety of negative shapes. (The shapes between the branches are negative shapes. The branch itself is a positive shape.)

Use tempera or acrylic to paint *the negative shapes only*. These shapes should be painted with a variety of intensities obtained by mixing two complementary hues. To do this, first number each negative shape lightly in pencil. Shape number one is then painted with the first complementary color selected. Shape number two is painted with the same color to which a small amount of its complement is added. The final shape is painted with the second complementary color. Following this procedure enables you to complete a type of intensity scale.

Figure 10.37 Student Work

Supplies
- A large branch with a few leaves intact
- Pencil
- White drawing paper, 9 x 12 inches (23 x 30 cm) or larger
- Tempera or acrylic paint (two complementary colors only)
- Brushes, mixing tray, and paint cloth
- Water container

CRITIQUING

- *Describe.* Does your drawing of a branch look accurate? Do the lines of this branch run off the paper at the top, bottom, and sides?
- *Analyze.* How were the negative shapes in your picture created? How many different intensities did you obtain by mixing the two complementary colors?
- *Interpret.* Does your finished work offer hints to the intense contemplation you practiced before beginning your painting? What effect do you think that contemplation had on your work?
- *Judge.* How would you respond to someone who says your picture is "nothing more than a painting of a common, ordinary branch?" What aesthetic qualities would you want such a person to consider when judging your work?

Review

Reviewing the Facts

SECTION ONE

1. What are the two great religions that have endured for centuries in India?
2. Name the three main Hindu gods and tell what primary process each represents.
3. Explain what the wheel symbolized in Buddhist art.
4. During what years did Buddhist sculpture reach its peak in India?

SECTION TWO

5. Who was the first Chinese painter?
6. Which Chinese dynasty was flourishing at the same time as the Roman Empire?
7. During which dynasty did China reach its peak of power and influence?

SECTION THREE

8. Would Yamato-e painting, during the Kamakura period, be considered a more symbolic or more realistic style of painting?
9. How might *The Great Wave off Kanagawa* (Figure 10.34, page 238) have differed had it been a painting?
10. What aspect of nature was Hiroshige particularly interested in capturing in his prints?

Thinking Critically

1. *Compare and contrast.* Refer to Figure 10.13 (*Standing Buddha*) on page 222, and to Figure 8.22 (*Nike Fastening Her Sandal*) on page 179 in Chapter 8. Discuss the similarities and differences between the figures. Do you have a feeling that a real person exists beneath the drapery of each figure?
2. *Analyze.* Look closely at the artist's line in Figure 10.15 on page 224. Make a list of adjectives to describe the quality of this line. Then look through the book to find another artist whose lines could be described in much the same way. Finally, find another work showing lines that are very different in quality.
3. *Analyze.* Refer to Figure 10.22 on page 229. Describe how the artist has used line, shape, and color to create harmonious designs. Then tell what the artist has done to keep the designs from being boring.

Using the Time Line

The time line highlights some of the artworks associated with the three great countries discussed in this chapter. Explain how religion, and the Buddhist religion in particular, can be thought of as the thread linking the artists of these countries. Do you think it is unusual for religion to have an impact on art over such a long period of time? Are you aware of any other period in which the religious impact on art was so strong?

100 400 800 1200 1600

Han Kan. *Knight Shining White*

Pair of Vases, Ming Dynasty

Great Stupa at Sanchi, India

Haniwa Falcon

• Great Buddha at Kamakura, Japan
• Tamil Nadu. *Shiva, King of the Dancers*
• The Bodhisattva, Kuan-yin

Standing Buddha

Ting Bowl, Sung Dynasty

Yuki Negishi, Age 18
Lake Highlands High School
Dallas, Texas

➤ *Figure and Portrait in Abstraction.* Mixed media. 71 x 56 cm (28 x 22").

Yuki chose Torii Kiyonobu's *A Woman Dancer* as her inspiration. "The traditional curves in Japanese art have influenced my own work. I chose to combine the figure and the portrait, because these two subjects represent the ultimate natural forms with soft curves. My goal was to combine the two forms so the lines of one moved into the other in a subtle and abstract way.

I want to encourage other students to improve their basic drawing skills. Then they can be imaginative with their subject matter."

Civilizations Lost and Found:
The Native Arts of the Americas

Objectives

After completing this chapter, you will be able to:

➤ Identify the contributions to art made by different Native American cultures.

➤ Explain what is meant by the term *pre-Columbian*.

➤ Identify the first great civilization in Mexico and describe the artworks by which this civilization is best known.

➤ Create an abstract ink drawing.

Terms to Know

adobe
Inuit
kiva
potlatch
pre-Columbian
shaman
sipapu
totem poles

Figure 11.1 Mayan Man and Woman. Mexico. c. A.D. 700. Buff clay with traces of color. 26.7 x 14.6 x 9.8 cm (10½ x 5¾ x 3⅞"). Honolulu Academy of Arts, Honolulu, Hawaii. Purchase.

While art flourished in India, China, and Japan, it also developed

in North and South America. Anthropologists estimate that by the time Europeans

arrived on these continents around A.D. *1500, there may already have been as many as*

twenty million people inhabiting the Americas. Up to two thousand groups had settled

in different areas across the land, and each had its own way of celebrating with

a variety of ceremonies, songs, dances, prayers, sacrifices, and art.

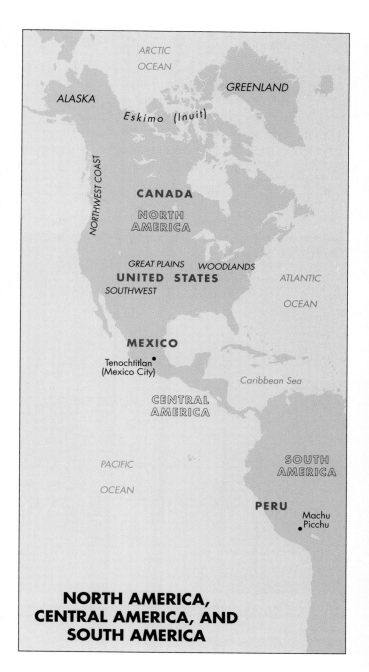

SECTION ONE

Native American Art

Archaeologists believe that the first visitors to North America were groups of Asian hunters who crossed an ancient land bridge across the Bering Strait. They began to arrive in what is now Alaska between twenty thousand and forty thousand years ago. Gradually these people spread out to cover all parts of North and South America. Some groups continued to be hunters while others turned to growing crops as a way to survive. Artifacts found in these regions show that all of them created art of some kind, and that these works have given us insight into the cultures of these peoples.

Arctic Region

The arctic region, covering the vast coastal area between northeast Siberia and eastern Greenland, was the homeland of the **Inuit**, or *Eskimos*. (See map, Figure 11.2.) Compared to hunters and boat builders, artists played a minor role in Inuit life until recent times. Their daily lives were no different from the lives of nonartists. They fished and hunted along with other members of their villages and turned to their art only when the opportunity presented itself. Artists did not imitate each other or criticize each other's work and did not consider themselves as belonging to any special group. However, they took their art seriously and were proud of their accomplishments.

Figure 11.2 North America, Central America, and South America

NORTH AMERICA, CENTRAL AMERICA, AND SOUTH AMERICA

➤ Can you identify the activities illustrated in this engraving? In what ways is this art similar to the Egyptian tomb paintings? How would you describe this style of art?

Figure 11.3 Eskimo. Engraved Tobacco Pipestem. Norton Sound, Alaska. Nineteenth century. Walrus ivory. 27.3 cm (10¾") long. Smithsonian Institution, Washington, D.C.

Inuit Art

The images created by Inuit artists reveal the importance attached to the animals they relied on for food—seal, walrus, fish, whale, and caribou. Other animals such as the fox, wolf, and bear were also represented in their art. The human figure was shown in the masks and dolls they created.

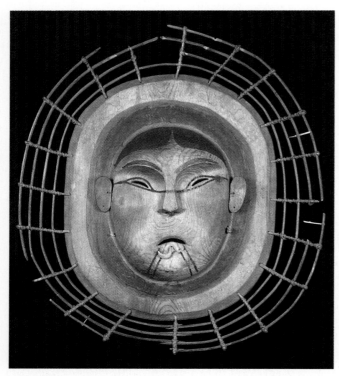

➤ For what purpose were masks like this created? Who wore such masks?

Figure 11.4 Eskimo. Mask of Moon Goddess. Lower Yukon or Northwest Bering Sea. Before 1900. 63.5 cm (25¼") high. Hearst Museum of Anthropology, The University of California at Berkeley, Berkeley, California.

Figures are also found on the engravings done on walrus ivory. In these engravings, Inuit artists used a kind of pictorial writing that described various activities and events associated with everyday life. In one such engraving on an ivory pipestem (Figure 11.3), a series of lively drawings record the activities associated with the daily quest for food. Since the surfaces of this pipestem are less than 1 inch (2.5 cm) wide, the engraving takes the form of tiny, decorative circles and miniature figures. Despite their small size, the artist still managed to present an easy-to-read account of the hunt. To accent the engraved lines used in works like this, artists filled them in with color or made them dark with soot.

Frequently, Inuit art was created to serve the religious needs of the people. This was the case of a mask carved to represent a moon goddess (Figure 11.4). An Inuit **shaman**, or *medicine man*, wore such a mask during ceremonial dances. While dancing, he would go into a trance and act as a messenger between the world of the living and the mysterious world of spirits.

Northwest Coast Region

Today it is customary to divide the vast North American territories below the arctic into a number of different regions when discussing the original inhabitants of the land. These regions are determined by similarities in culture and language of the Indians, or Native Americans, who settled there.

The Native Americans of the Northwest Coast depended upon a plentiful supply of fish for their food. Vast forests provided the timber used to construct their fishing boats and their houses. These forests also offered abundant game and a rich variety of food

plants. The prosperity and leisure realized by having such a plentiful food supply contributed to the rise of elaborate rituals and ceremonies designed to celebrate and demonstrate rank and status.

The Kwakiutls, one of the tribes inhabiting this Northwest region, identified people of differing rank and wealth according to their affiliation with one of several secret societies. The most distinguished of these societies is one in which only shamans are allowed membership. Within this society, the most important members form a subgroup known as the Hamatsa.

Ritual Masks

Like other societies, the Hamatsa held annual rituals to initiate new members, reinforce the status of old members, and demonstrate to nonmembers the extent of their magical powers. During these rituals, new members performed by screaming and leaping wildly about as rites were conducted to pacify the spirits, performed by other members of the society wearing fantastic costumes and masks. The Hamatsa mask illustrated in Figure 11.5 is composed of several hinged pieces that could be made to move. This movement was intended to add surprise and drama to the ritual. Each of the several beaks on this mask could be manipulated to open and close to enhance its threatening appearance. The eye areas have been painted white to reflect the firelight.

Hamatsa rituals are carefully staged for dramatic impact. Subdued lighting permits the use of elaborate props to add mystery and suspense. For example, a woman member might suddenly claim to have supernatural powers and, to prove it, ask another to inflict some injury on her or even behead her. The ritual was carried out and, indeed, the woman's detached head was prominently displayed in the dim light. It was, of course, not the woman's head at all but a replica carved in wood. This replica had been so realistically crafted that the audience, caught up in the excitement of the moment, was tempted to believe that they had actually witnessed the beheading. Thus, when the woman appeared with her head still firmly in place, the audience was convinced of her power.

Often after a Hamatsa ceremony, or to celebrate some other important event, members of a tribe celebrated with *an elaborate ceremony known as a* **potlatch**. This was a clan event, enabling the members of one clan to honor those of another while adding to their own prestige. It involved the giving and receiving of gifts and was meant to reveal rank and status. The host clan was able to exhibit its wealth and confirm its status by offering enormous quantities of food and valuable gifts to the members of the guest clan.

The potlatch was so important a ceremony that it often took years to prepare for one. Once under way, it could involve several hundred guests and would continue for ten or more days. The task of providing

➤ Each of the beaks on this mask is movable. What other design elements has the artist used to add drama to the mask?

Figure 11.5 Kwakiutl. Dance Mask. Blunden Harbour, British Columbia. 1938. Cedar, cedar bark, commercial paint, and cord. 1.2 m (4') long. Denver Art Museum, Denver, Colorado.

food and shelter for that many people was in itself a great strain on the hosts, although their responsibilities did not end there. They also had to provide gifts for each and every guest, and these had to be selected with great care in order to match the recipient's rank. Sometimes the hosts destroyed leftover gifts, thereby gaining increased prestige. The guests were expected to consume as much food as humanly possible as a sign of honor to their hosts.

Totem Poles

No discussion of the art of the Northwest would be complete without some mention of the totem poles created by artists of this region. **Totem poles** *are tall posts carved and painted with a series of animal symbols associated with a particular family or clan.* They can be thought of as similar to a European family's coat of arms and were erected in front of a dwelling as a means of identification and a sign of prestige.

Totem poles like the one in Figure 11.6 rank among the world's largest wood carvings and are considered by many to be the equal in visual appeal to anything produced by wood carvers anywhere in the world. According to some authorities, it took a team of male carvers as long as an entire year to carve a single totem pole. The amount of effort spent creating these poles can be more fully appreciated when you discover that in one village every house had a totem pole, each measuring from 30 to 50 feet (9 to 15 m) high. Exceptional examples have been measured to stand as high as 80 feet (24 m) above the ground.

Each totem pole is composed of a design that is often so complex that it becomes bewildering to the viewer. Every foot from bottom to top is given equal importance. Thus, the viewer's eye is offered no opportunity to rest as it sweeps upward from one animal symbol to the next. This complexity increases in the case of totem poles that are completely painted, often with contrasting colors. However, this method of painting the poles is a modern innovation. Early artists painted only the eyes, ears, and a few other details using mainly black, red, blue-green, and occasionally white.

In the nineteenth century, as the wealth and prestige of some families grew, it was necessary to add more symbols to their totem poles. The more symbols on a pole, the greater the prestige. In the case of some families, this meant that the poles had to be made higher and higher. Eventually it was found that a single pole often proved to be inadequate, and additional ones had to be carved to accommodate all the symbols associated with a family.

➤ What purpose did poles like this serve? Can you think of anything in European history that served the same purpose?

Figure 11.6 Haida Totem Pole. Prince of Wales Island. c. 1870. Originally 16.2 m (53′) high. Colorado Springs Fine Art Center, Colorado Springs, Colorado.

Denise Wallace

Metalworker Denise Wallace (b. 1957) creates engaging and highly inventive jewelry that reaches out to people and tells them about Native American culture: "The designs for my jewelry represent native Alaskan culture, in particular my Aleut heritage and the peoples' connection to the land and animals. It's my way of being a storyteller."

Wallace was born and raised in Seattle. Her mother is an Aleut from the Prince William Sound region of Alaska, and her father is a German cabinetmaker. Although Wallace did not learn from her father how to use tools, in retrospect she believes that he conveyed the importance of the technical precision and patience that is as important in metalwork as it is in fine woodworking.

After Wallace graduated from high school she went to live with her grandmother in Alaska. She notes, "It was there that I began to desire to represent my native people." When Wallace returned to Seattle she heard of the Institute of American Indian Arts in Santa Fe, New Mexico, a school run by the Bureau of Indian Affairs. The Institute offered courses in cultural studies, art history, and both traditional Native American techniques, such as beadworking, and contemporary approaches to the fine arts. She earned an Associate of Fine Arts degree in 1981 and set up a jewelry studio in Santa Fe, where she has worked ever since.

Wallace employs about half a dozen assistants to help produce the jewelry that she sells in galleries across the United States. She designs each piece and does all of the actual metalwork on the first piece of a particular design.

The basic shape for each design is initially cut out of a sheet metal such as sterling silver. Wallace then uses thin strips of sheet metal to form the bezel, or rim, that holds the stonework. She draws up a pattern in the shape of the bezel so that fossilized walrus tusk or semiprecious stones can be fashioned in exactly the same size and shape. The bezels are soldered and Wallace's husband, Samuel, completes the lapidary work. Then Wallace adds detail work in silver or gold and uses tubing and pin stems to make the tiny hinges that are a feature of much of her jewelry: "Hinges and removable parts create a sense of movement that I find exciting."

Wallace's silver dancer ring is based on a mask made by the Yupik, a native group of people from southwestern Alaska. In depicting the dancer, Wallace is making a statement about the strength of native cultures as well as the responsibility of each generation to take care of the environment that they hand down to the next. She states, "Native culture is very strong. People think that we are dying out but we are not. Although some Native Americans make traditional art and some make art in a contemporary style, we all want to reach out, tell our stories, and carry on our culture. The dancers are a very important part of carrying on native traditions. Through dance, the past is brought forward, and that dance or song will be passed on to each generation."

Figure 11.7 Denise Wallace. Dancer ring and mask bracelets. Sterling silver with lapis lazuli and fossil walrus tusks. Ring is approx. 3.8 x 2.5 cm (1½ x 1").

Southwest Region

Another cultural region extends from the northern area of Mexico to the southern foothills of the Rocky Mountains. Many Native American groups lived in this territory although it is most often associated with the Pueblo people.

The Pueblo

Early Spanish explorers used the term *pueblo*, meaning village, to describe groups of people living in large, highly organized settlements. Ancient Pueblo dwellings were built with **adobe**, or *sun-dried clay*, walls. Remains of villages (Figure 11.8) reveal that the buildings consisted of a series of rooms arranged in several stories. Each of the stories was set back farther than the one below to form large terraces.

One of the most important parts of a pueblo was the **kiva**, a *circular underground structure*. Sometimes sunk deep into the ground, kivas served as spiritual and social centers (Figure 11.9). Here meetings were held and ceremonies performed. The main features of a kiva included a flat roof with one entry, a raised fire pit, and a small hole in the floor. The kivas symbolized the World Below, from where the Pueblos believed the spirits came that inhabited all things living or inanimate. The hole, called a **sipapu**, symbolized *the place through which the people originally emerged into this world*.

The Pueblos were especially skillful in creating painted pottery. Each community developed its own distinctive shapes and painted designs. In the Rio Grande Valley of New Mexico, for example, Pueblo potters used black outlines and geometric shapes to create bold designs over a cream-colored base (Figure 11.10).

➤ Describe this building. Can you identify the material used to construct it? What function do you think this structure served? What features helped you determine its function? Why is each story set back from the one below?

Figure 11.8 Taos Pueblo Adobe Huts. Taos, New Mexico. c. 1300.

➤ Identify the features of this kiva.

Figure 11.9 Kiva. Pecos Pueblo, Pecos National Monument, New Mexico.

The Navajo

Another Southwestern tribe, the Navajos, learned the art of weaving from the Pueblos. From male Pueblo weavers, the Navajo weavers, who were women, began making cloth with looms at the beginning of the eighteenth century. As Spanish and Mexican settlers moved into the Southwest, they introduced new designs and patterns that the Navajos adopted. By the first half of the nineteenth century, the Navajos were using European dyes and Spanish wool to create weavings that matched the work produced by the best looms in Europe. A saddle blanket (Figure 11.11) exhibits many of the qualities associated with the finest Navajo weavings. These include the closeness of the weave, rich, vibrant colors, and bold design. This kind of design was called an eye-dazzler, because it created the illusion of motion with its brilliant colors and repeated pattern of jagged-edged squares within squares.

➤ How are the principles of harmony and variety used in this design?

Figure 11.11 Saddle Blanket. Navajo weaving. c. 1890. Wool. 127 x 88.9 cm (50 x 35½″). Denver Art Museum, Denver, Colorado. Gift of Alfred Barton.

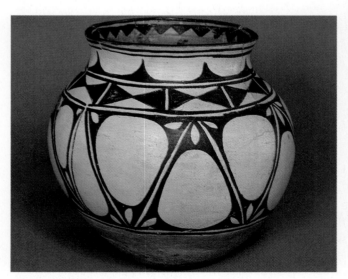

➤ What elements of art can you identify in this design?

Figure 11.10 Water Jar. Santo Domingo Pueblo, New Mexico. 1910. Ceramic. 24 cm (9½″) high x 24 cm (9½″) diameter. Denver Art Museum, Denver, Colorado.

Great Plains Region

Our most familiar image of the Native American comes from the Great Plains. This area between the Mississippi River and the Rocky Mountains stretches from the Gulf of Mexico into Canada. Because their lands were generally not suited to farming, people living here became hunters. Continually on the move, they followed the great herds of bison that once covered this territory, hunting the great animals for food and for skins with which to make leather garments. This movement from place to place made the production of pottery, basketware, or weaving impractical.

Work in wood or stone was limited mainly to the fashioning of bows and flint-tipped arrows for hunting.

The different tribes of the Plains — including Blackfeet, Crow, Cheyenne, and Sioux — were highly skilled in the preparation of skins used for clothing, footwear, shields, and various kinds of containers. These were then painted or embroidered with porcupine quills and, later, glass beads. The men of the tribe usually painted the skins used for tepees, shields, and robes for the chief. Often the events painted on a robe were meant to illustrate the bravery of the chief who wore it, reminding everyone of his prowess in war (Figure 11.12). A robe of this kind was highly prized, and it was not unusual for the person wearing it to believe that it would protect him from harm.

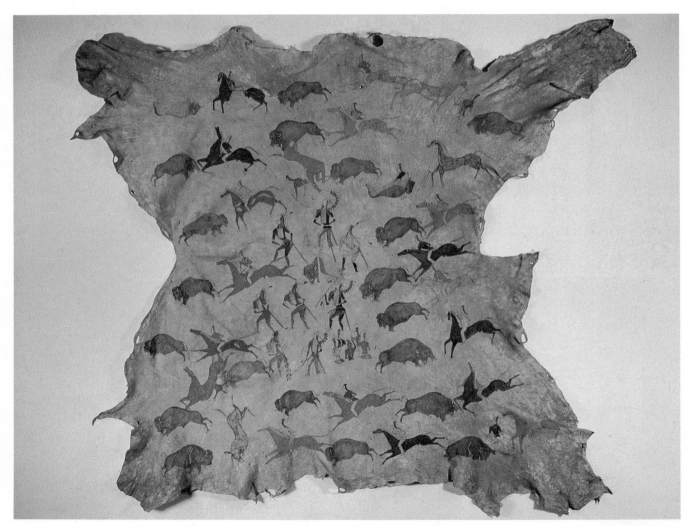

➤ Can you identify any of the events shown on this skin? What were the images supposed to tell others about the person wearing such a skin?

Figure 11.12 George Washakie. Elkhide painted with design of *Sun Dance Ceremony*. Shoshoni, Wyoming. Purchased from artist about 1900. 175.3 x 152.4 cm (69 x 60"). Courtesy of the National Museum of the American Indian/Smithsonian Institution, New York, New York.

Art · P A S T A N D P R E S E N T ·

Horse Dance Sticks

Horse dance sticks were traditionally used by Plains Indians in recounting events that happened to a warrior and his horse. These carvings were used during the Horse Dance and other celebrations. Upon the death of a horse, a horse stick would be carved to commemorate it. The bond between a warrior and his horse was a powerful one, and the warrior would look forward to being reunited with a favorite horse.

Figure 11.13 Horse Dance Stick.

Native American artist Anthony Gauthier is re-creating this tradition by making contemporary horse dance sticks in Santa Fe, New Mexico. His early work consisted of simple horse sticks carved from axe handles, resembling the traditional carvings. Later he began adding legs and then riders to his horse sticks to capture the romance of the connection between the rider and the horse.

Gauthier makes the figures small in comparison to the horse to symbolize the power of the horse. The horses also have symbols on them that correspond to the symbols the Plains Indians put on their horses. For example, a circle around the eye means that the horse can see danger and is a protector of its rider. Gauthier feels that by making the horse more realistic looking and by adding riders he is capturing the idealistic relationship that exists between a horse and its owner.

Woodlands Region

The Woodlands included the area between the Mississippi River and the Atlantic Coast, and from the Great Lakes to the Gulf of Mexico. The geographic variety of this region resulted in many different cultures.

The Mound Builders

In prehistoric times, small villages were often clustered around monuments constructed in the form of large earthworks or mounds. Some took the form of high, narrow ridges of earth that encircled large fields. Smaller burial mounds, some conical and others domed, were placed within these large earthworks.

The purpose of these mounds remains a subject for debate among archaeologists. Some contend that they were built to create a visually impressive setting for spiritual ceremonies, but conclusive evidence to support this point of view has not yet been found.

Among the first of the mound-building peoples were the Adena, who lived chiefly in the Ohio Valley. Carbon 14 tests reveal that their culture originated over twenty-five hundred years ago and flourished for about seven hundred years. Like many other primitive people, the Adena attached great importance to honoring their dead. Early in their history they built low mounds over burial pits, but over time, these funeral mounds became larger and larger. Many artifacts that have come from burial mounds are thought to be gifts given to the dead to accompany them on their journey to the land of spirits. Other objects include artifacts made from mica and embossed copper.

The Great Serpent Mound in Ohio is the most impressive of these later mounds. Formed to look like a huge serpent in the act of uncoiling, it measures

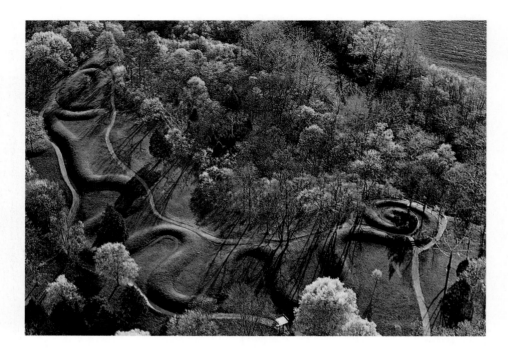

➤ Notice the shape of this mound. Were all mounds of this kind uniform in size and shape? What was usually clustered around earthworks of this kind? What does this tell you about the importance attached to them by the people?

Figure 11.14 Serpent Mound State Memorial. Adams County, Peebles, Ohio. c. 1000 B.C.–A.D. 300.

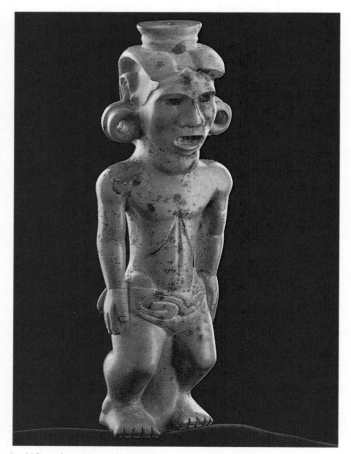

➤ What elements and principles of art would you be certain to identify during an analysis of this work?

Figure 11.15 Stone Pipe. Adena Mound. Southern Ohio. c. 1000–300 B.C. Pipestone. 20.3 cm (8") high. Ohio Historical Society, Columbus, Ohio.

about a quarter of a mile (.4 km) in length (Figure 11.14). The great size of this mound and other monuments like it indicates that a great many workers must have been involved in its creation, and this would have required both organization and leadership.

Some of the Adena mounds were built in several layers and, in addition to the dead, contained a rich assortment of artifacts. Many tools, weapons, ornaments, and pottery pieces have been unearthed, but the most impressive art is the carvings. An excellent example (Figure 11.15) is a pipe in the form of a figure, discovered in a mound in southern Ohio. The mouthpiece for the pipe is above the head, and the bowl is placed between the legs. The pipe is carved of pipestone, a fine-grained, hard clay that has been smoothed, polished, and hardened by heat. Iron in the clay produced the spotty effect over its surface. Observe how the fully rounded form and rigid posture give this work a solid, sturdy appearance. A muscular build with powerful shoulders and arms suggests great physical strength even though the figure is no more than 8 inches (20 cm) high. A work like this demonstrates that early Native American artists were able to overcome the handicap imposed by primitive tools to create works that were expressive as well as visually appealing.

The Iroquois

One of the largest tribes living in the northeast area of the Woodlands Region was the Iroquois. Expert

wood carvers, the Iroquois created wooden masks that were usually painted and decorated with horse hair. The best known were created for a society of healers known as the False Faces because of the masks they wore. These masks were thought to be sacred and represented the spirits who gave healers the magic they needed to treat illnesses. Because they were considered to be so powerful, these masks were hidden away when not in use so they would not cause accidental injuries.

Most False Face masks exhibit features that were used over and over again (Figure 11.16). These included repeating arching curves that were used to emphasize the staring eyes and the open, distorted mouth. Metal rings of various shapes were used to set off the eyes, and hair was fashioned from a horse's tail. Imagine for a moment the impact made by the sudden appearance of figures wearing masks like this at a healing ritual. Emerging without warning from the surrounding darkness, they were illuminated by the glare of a ceremonial fire. This appearance was so striking that the Iroquois never doubted that they had the power to treat both physical and mental illnesses.

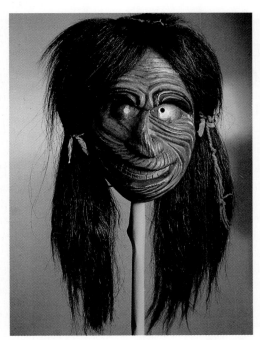

➤ What is most successful about this work: its literal, design, or expressive qualities? Explain.

Figure 11.16 Iroquois. False Face Mask. Western New York, Grand River Reservation. c. 1900. Wood, paint, horsehair, brass, and ribbon. 26.7 cm (10½") high. Milwaukee Public Museum, Milwaukee, Wisconsin.

SECTION ONE

Review

1. Who were the very first visitors to North America and how did they get here?
2. Who used a mask such as the one representing a moon goddess (Figure 11.4, page 246), and for what purpose?
3. Describe a potlatch ceremony celebrated by the Native Americans of the Northwest Coast.
4. What was a kiva used for and what are its main features?
5. Explain why the Native American tribes from the Great Plains region did not create such items as pottery or basketware and tell what they did create.
6. Explain the purpose of the Serpent Mound built by prehistoric mound builders in what is now Ohio.
7. Name one of the largest tribes that lived in the eastern section of the Woodlands region and tell the purpose of the masks they were known for creating.

Creative Activity

Humanities. For the Native American, music and dance is not entertainment; rather, it is ritual expressing a oneness with the universe. Music is a part of the life process, valued for its magical powers, not for its "beauty."

The Navajo Night Chant, a ceremony of healing lasting eight and one-half days, consists of almost continuous singing and dancing. These words from part of the Night Chant ritual give a sense of the deep spiritual connection to nature:

Happily with abundant dark clouds may I walk.
Happily with abundant showers may I walk.
Happily with abundant plants may I walk.
Happily on a trail of pollen may I walk.
Happily may I walk.

Discuss the attitude expressed in this ritual—a focused sense of wonder—and compare it to the thoughts about nature you might have. Keep a log for a week and record your efforts to focus on this kind of direct contact with nature.

Art in Mexico and in Central and South America

The term **pre-Columbian** is used when referring to *the various cultures and civilizations found throughout North and South America before the arrival of Christopher Columbus in 1492.* Many of these civilizations created works of art that give insights into their cultures and ways of life. Discovery and study of these works have helped to unravel some of the mysteries of these ancient people.

The Olmec

The first great civilization in Mexico was the Olmec, which dates from as early as 1200 B.C. to A.D. 500. These people lived on the great coastal plain of the Gulf of Mexico. They settled mainly in the areas that are now Veracruz and Tabasco. The Olmec are thought by many to have made the first Mexican sculptures. They left the earliest remains of carved altars, pillars, sarcophagi, and statues in Mexico. Their most surprising works were gigantic heads carved in volcanic rock (Figure 11.17). Eighteen have been discovered thus far. It is thought that they may represent the severed heads of losers in an ancient game known as pelota. These sculptures measured 8 feet (2.4 m) high and weighed up to 40 tons (36 metric tons). Some of the same features found on those heads can be seen in a realistic jadeite mask that may have once graced the tomb of an Olmec ruler (Figure 11.18). The huge heads and this striking mask have the same mouth that droops at the corners. The face on this mask is certainly not warm or welcoming. Eyes peer out at you from beneath heavy eyelids, and the open mouth suggests a snarl rather than speech. These features were intended to convey power, for the king not only ruled over the people but was thought to have a link to the supernatural world.

Although it is reasonable to assume that the Olmec produced architecture of the same high quality as their sculpture, no examples have been discovered.

➤ Describe the mood of this face. How does it make you feel? What aesthetic qualities seem most appropriate when making and defending a judgment about this work?

Figure 11.17 Olmec. Colossal Head. 1200 B.C.–A.D. 500. Basalt. 243.8 cm (8') high. La Venta Archeology Museum, La Venta, Mexico.

➤ Do you think that knowing when, where, why, and by whom this mask was created would affect your judgment of it? What does your answer to this question tell you about the value of art history?

Figure 11.18 Olmec. Mask. Tabasco, Mexico. 800–400 B.C. Jadeite. 18.1 x 16.5 x 10.1 cm (7⅛ x 6⁹⁄₁₆ x 4"). Dallas Museum of Art, Dallas, Texas. Gift of Mr. and Mrs. Eugene McDermott, the McDermott Foundation, and Mr. and Mrs. Algur H. Meadows and the Meadows Foundation, Inc.

The Maya

The most elegant and appealing of the pre-Columbian cultures was the Mayan. The Maya controlled vast lands that included what are now Yucatan, Guatemala, and Honduras. They never advanced technically beyond the Stone Age but possessed highly developed skills in a number of other areas. They became great builders, devised an elaborate system of mathematics, and invented the most precise calendar in history.

In order to understand the chilling rituals that were an important part of Mayan culture it is necessary to learn about their religious beliefs. The Maya believed that the gods created human beings through self-sacrifice and that the first people were formed by mixing maize, or corn, with water. They were then brought to life with the blood of the gods. To repay this debt, human beings were required to continuously return blood to the gods. This was needed to make certain that the gods would maintain their strength and nourishment. Thus, the most sacred rituals in the Mayan religion were characterized by efforts to secure blood for the gods. Public ceremonies typically included rituals in which the Mayan ruler and his wife drew their own blood and captives taken in war were sacrificed.

Mayan cities were constructed with vast central plazas to accommodate the masses of people who gathered to witness these ceremonies. Rich reliefs covered the buildings, monuments, and temples placed around and within these plazas. At first, these carvings were simple and realistic, but later they became more elaborate and complex. Figures were carved with so many ornaments that it is often difficult to separate them from backgrounds filled with symbols and inscriptions referring to various important events.

Mayan architecture and sculpture were painted, and in some cases, there are examples where traces of pigment still cling to the limestone surface. The carved surfaces were painted in contrasting colors, and this may have helped separate the figure from the background. Usually, red was used for the skin areas, blue and green for ornaments, green for feathers, and blue for garments.

One of these reliefs (Figure 11.19, page 258) shows a royal priestess dressed in a rich costume and wearing an elaborate plumed headdress. She is shown with her face in profile. Observe how the forehead slants back, the large nose dominates, and the chin recedes. All these are features found in most Mayan heads and are easily observed in a detail from a Mayan relief illustrated in Figure 11.20, page 258.

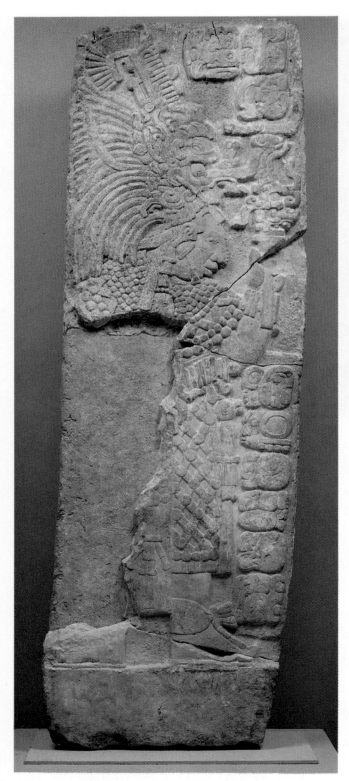

> How is this carving typical of those produced by the Mayas? What was originally done to separate this intricately carved figure from its elaborate background?

Figure 11.19 *Female Dignitary.* Relief carving. Chiapas or Tabasco, Mexico. A.D. 650–750. Limestone, stucco, paint. 220.3 x 76.8 x 15.2 cm (86¾ x 30¼ x 6"). Dallas Museum of Art, Dallas, Texas. Foundation for the Arts Collection, gift of Mr. and Mrs. James H. Clark.

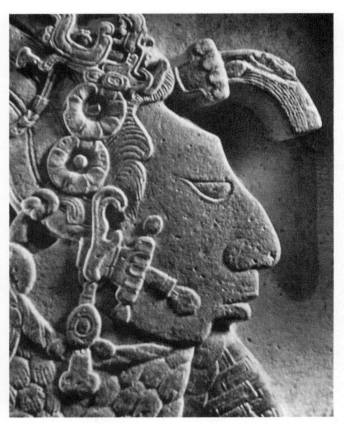

> Is this a successful work of art? On what aesthetic qualities did you base your decision?

Figure 11.20 *Mayan Relief* (detail). Yaxchilan, Mexico.

The Maya built their first cities by A.D. 320. Their civilization reached a peak, declined, revived, and declined again before the arrival of Hernando Cortés in 1519. The Spanish conquest completed the downfall of the Mayan culture.

The Aztecs

When Cortés waded ashore at Veracruz in 1519, a people called the Aztecs had nearly succeeded in conquering Mexico from the Atlantic Ocean to the Pacific Ocean and as far south as Guatemala. By 1521 the Aztec conquest was complete. It was an effort that took less than two hundred years (1324–1521). Following a legendary prophecy that they would build a city where an eagle perched on a cactus with a serpent in its mouth, the Aztecs settled in the marshes on the west shore of the great "Lake of the Moon," Lake Texcoco.

Their settlement grew into the splendid city of Te-nochtitlán on the site of the present-day Mexico City. Built on an island in the lake, it contained huge white palaces, temples, gardens, schools, arsenals, work-shops, and a sophisticated system of irrigation canals and aqueducts. City streets and palace walls were scrubbed clean by thousands of slaves. Bridges carried the streets over a network of canals that criss-crossed the city. Raised highways led from the mainland toward a spacious temple complex at the city's heart.

The Aztecs were a warlike people driven to continuous combat by their religious beliefs. They believed that human sacrifices were necessary to keep the universe running smoothly. Against a backdrop of brilliantly painted architecture and sculpture, these human sacrifices were made to ensure that the gods remained in good spirits. To remain in good spirits the gods demanded human hearts. At the dedication of the great temple at Tenochtitlán, twenty thousand captives were sacrificed. They were led up the steps of the high pyramid-temple to an altar where chiefs and priests awaited to slit them open and remove their hearts.

Art was closely linked to these rituals. Statues to the gods were carved and placed in the temples atop stepped pyramids. There were even statues of priests and celebrants dressed in the skins of flayed victims who had been sacrificed. Figure 11.21 depicts a man dressed in this way, and the artist has even shown stylized flay marks and the slash in the skin where the victim's heart was removed.

In addition to their carvings, the Aztecs also used a system of picture writing. This writing was done on sheets of parchment that were then joined together and accordion-folded to form a book. This kind of painted book, later called a codex by the Europeans, was produced by the most highly respected artists in Aztec society. Although all Aztec artists enjoyed the respect of the people, those known as "painters in red and black" were thought to be the most important. Their increased importance was due to the fact that their task involved the mysterious use of signs and symbols.

A look at a page from one of these codices (Figure 11.22) reveals a taste for fantastic images created with clear, bright colors and flat shapes. There is no shading or modeling to suggest three-dimensional forms. Heads are large and torsos and limbs short, indicating that the artist was not the least concerned with creating lifelike figures. These paintings were never meant to illustrate people or events associated with the real

➤ Notice what this figure is wearing. Why were figures like this one produced? Do you think such sculptures are useful in helping us understand the Aztecs? Explain.

Figure 11.21 Aztec. *Xipe Impersonator.* 1450–1521. Volcanic stone, shell, and paint. 69.8 x 28 x 22.2 cm (27½ x 11 x 8¾"). Dallas Museum of Art, Dallas, Texas. Gift of Mr. and Mrs. Eugene McDermott, the McDermott Foundation, and Mr. and Mrs. Algur H. Meadows and the Meadows Foundation, Inc.

➤ Do the two large figures in this work appear to be lifelike? What is each doing? What is there about these two figures that suggests their importance? Do you think they represent real people or supernatural beings?

Figure 11.22 Aztec. *Codex Borbonicus.* Painting of Tezcalipoca and Quetzalcóatl. Early 1500s.

world. The figures, most with humanlike heads, torsos, and limbs, do not represent human beings. Their poses and gestures are intended to communicate ideas and combinations of ideas, making these paintings as much like writing as pictures.

The painting illustrated in Figure 11.22 is from a codex known as *The Book of Days*, from which personal destinies were predicted. The page shows the Aztec deities Tezcalipoca, the war god and god of the night winds, and Quetzalcóatl, the life god. Tezcalipoca wears his necklace of seashells and the flayed skin of a sacrificial victim. The hands of the victim dangle uselessly at the god's wrists.

Quetzalcóatl, seen here as a feathered serpent, was a nature deity transformed into a national god. He was considered the cultural deity, and as such, the revealer of all learning. The Aztecs believed that Quetzalcóatl was originally an old priest who set himself on fire in order to purify his people. He was returned to life in the form of the planet Venus, promising to return from the East to redeem his people. This proved to be a deadly prophecy. When Cortés, a powerful stranger from the East, arrived in November of 1519, he received a friendly welcome from the Aztecs, who believed him to be their legendary redeemer, Quetzalcóatl. His arrival heralded the beginning of the end for the Aztec empire.

Art in Peru: The Incas

The Incas are the best known of all the ancient peoples who inhabited Peru. They were a small tribe who established their rule in the Valley of Cuzco, with the city of Cuzco as their capital. Between the thirteenth and fifteenth centuries, Inca power grew until their empire stretched from Quito in Ecuador to central Chile—a distance of more than 3000 miles (4827 km). Administering this vast area required great organizational skill. The Incas demonstrated this skill and managed to control their far-flung empire even though they had no written language. Their only method of calculating and keeping records made use of knotted strings of different colors known as *quipu.* These were kept in a secure place at Cuzco.

Skillful engineers, the Inca joined all parts of their empire together with a network of roads and bridges. They also established an efficient system of relay runners who used these roads to carry messages to every corner of the empire. Each community along a road had to provide runners for this relay system. They were expected to wait for any royal dispatch and, when it arrived, to race with it to the next village where another runner waited. This system was so efficient that when members of the royal family at

Cuzco wanted fresh fish from the Pacific, runners carried it over hundreds of miles through the Andes Mountains in two days. Running in short spurts at breakneck speed, a series of couriers could cover 250 miles (402 km) a day—faster than the speed of messengers on horseback galloping over the famous roads of Rome.

The capital at Cuzco and other Inca cities featured solid structures of stone built on a large scale. Skilled in the art of forming and fitting stone, Inca builders erected buildings that proved to be durable enough to survive to the present day. The durability of their buildings was due to the precision with which each block of stone was fit into place. It is thought that each of these blocks may have been placed in a sling of some kind and then swung against those that were to be placed below and beside it. Swinging continued until the surfaces were ground to a perfect fit. Buildings constructed in this manner followed the same basic design throughout the Inca empire. None was decorated with sculpture or relief carvings. Interior walls were bare, although they were often covered with tapestries decorated with geometric patterns.

Machu Picchu (Figure 11.23) was an Inca city built to protect the people from attacks from hostile tribes living in the jungle to the east. One of the world's most magnificent sites, the city is dramatically perched on a ridge between two rugged mountain peaks, 8000 feet (2438 m) above sea level. These buildings were

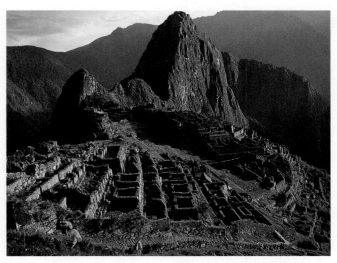

➤ Describe this city and its setting. What advantages does such a site provide? What are its disadvantages? What does this city tell you about the people who built it? Would you enjoy living in such a city? Why or why not?

Figure 11.23 Inca. Aerial view of Machu Picchu. Peru. c. 1500.

also constructed of huge stone blocks that were cut and locked into place with such skill that they have withstood wars and earthquakes for centuries.

By the time the Spaniards under Francisco Pizarro reached Peru in 1532, the Inca empire had been weakened by civil war. It fell easily to Pizarro and his handful of men.

SECTION TWO

Review

1. What was the first great civilization in Mexico, and when did it exist?
2. Describe the artworks for which the Olmec were best known.
3. List three accomplishments of the Mayans.
4. Why were Mayan cities constructed with large central plazas?
5. What did the Aztecs believe was required of them to keep their universe running smoothly?
6. How was art linked to sacrificial rituals in the Aztec culture?
7. What was Machu Picchu? Where and why was it built?

Creative Activity

Humanities. Even in the sixteenth century A.D., after more than a thousand years of civilization, the Aztecs and the Incas had no wheeled vehicles. Their roads were marvels of engineering, paved to make smooth passage for their runners to carry messages and materials with incredible speed. However, having no beasts of burden, they did not invent wheeled carts or carriages. They had no potter's wheels, no pulleys to lift heavy objects.

Remarkably, however, they did make toys with wheels. Trace the wheel in other cultures, from prehistory, to Egypt, to the Orient. Do sketches of its many uses and plan a display.

ABSTRACT INK DRAWING OF AN ANIMAL, INSECT, OR FISH

Supplies
- Pencil and sketch paper
- Ruler and compass
- A section of mat board measuring 10 x 12 inches (25 x 30 cm) or larger
- India ink
- Pen and small, pointed brush

Using india ink, complete a design in which you combine four identical images of an abstract drawing of an animal, insect, or fish. This drawing should exhibit a pattern consisting of repetitious, flat geometric shapes and contrasting light and dark values. The four images of this drawing should be combined to suggest a sense of movement associated with the animal, insect, or fish represented.

Focusing

Examine the totem pole illustrated in Figure 11.6, page 248. What kinds of images are included in this design? Are these images carved to look lifelike, or are they simplified? What term is used to describe works in which artists focus attention on the elements and principles of art and on simplified forms? Can you identify any other artworks in this book that are created in this same manner?

Creating

Select an animal, insect, or fish to use as your subject. Complete a series of pencil sketches in which you first eliminate all unnecessary details and then transform the image into a simplified pattern of flat, geometric shapes.

Complete a final line drawing of your simplified animal, insect, or fish measuring about 8 inches (20 cm) in length. Cut this out and, with the flat

Figure 11.24 Student Work (detail)

side of a pencil, darken the back of it. Place and trace four copies of this drawing on a section of mat board. Be certain to suggest a sense of movement in the placement of these drawings. This movement should be characteristic of the animal, insect, or fish depicted—running, hopping, swimming. You may find that this movement can be enhanced by overlapping the four drawings.

Use india ink to add light and dark value contrasts to the geometric shapes in your design.

Figure 11.25 Student Work

Reviewing the Facts

SECTION ONE

1. What kind of images were created by the Inuit artists of the arctic region? Why was so much importance attached to those images?
2. What ceremony was responsible for the high quality of art created by the Native Americans living in the Northwest Coast region?
3. In what North American region did the Pueblo people live? What kind of art were they noted for?
4. List at least three features common to False Face masks.

SECTION TWO

5. What is meant by the term *pre-Columbian*?
6. What group was thought to have made the first Mexican sculptures and what evidence led to this belief?
7. What made Mayan relief sculpture of figures so elaborate and complex?
8. What debt were the Mayans continuously trying to repay by their sacrificial rituals?
9. Explain how the ancient Incas of Peru, who had no written language, were able to get messages to every corner of their far-flung empire.

Thinking Critically

1. *Analyze.* Working with another student, select an artwork illustrated in Section One of this chapter and prepare a list of ten *single-word* clues to describe it. These clues should focus on

- The subject matter (if appropriate)
- The elements and principles of art
- The idea, mood, or feeling expressed

Present your word clues one at a time in class. How many clues were necessary before the artwork was correctly identified? Try to identify the artworks described by the word clues provided by other members of the class.

2. *Analyze.* Look at the sculpture, *Xipe Impersonator* (Figure 11.21, page 259). Describe the art elements that are found in the work. Then discuss how the artist uses these elements according to the principles of harmony, variety, and balance.

3. *Compare and contrast.* Look at *Female Dignitary* (Figure 11.19, page 258) and *Capital Carving* (Figure 14.26, page 328). Identify the similarities and differences you find.

Using the Time Line

Choose any artwork specified on the time line and determine when it was done. Examine other chapters in the book and find another artwork that was produced within fifty years of the work you selected. On the chalkboard, reproduce a large version of the time line and include the references to specific artworks. Along with other students in your class, identify the various artworks found and indicate where references to these should be made on the time line. Discuss what you learned from this activity.

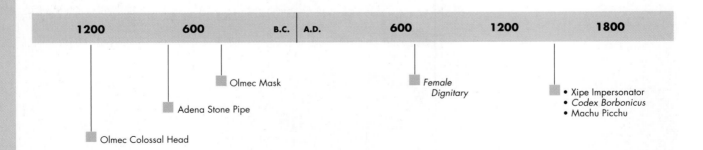

| 1200 | 600 | B.C. | A.D. | 600 | 1200 | 1800 |

Olmec Mask

Adena Stone Pipe

Olmec Colossal Head

Female Dignitary

- Xipe Impersonator
- *Codex Borbonicus*
- Machu Picchu

Portfolio

Kelvin Derek Bizahaloni, Age 18
Coconino High School
Flagstaff, Arizona

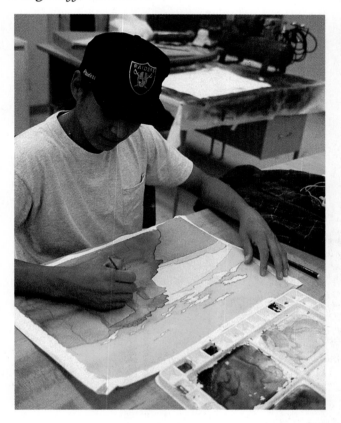

When Kelvin read the chapter on the arts of the Native Americans, he was especially interested in the Pueblos. Living in the Southwest, where examples of their communities can still be seen, he decided to do a project that focused on the homes they constructed.

In doing research, Kelvin discovered that the Pueblos built many of their structures to blend in with the environment and that some were on high cliffs. He began by sketching various ideas for a landscape that included large areas of land and sky as well as some dwellings. After deciding on the layout, he experimented with various media to see what would give the best results.

"First I tried chalk, but that was not working for me, so I decided to work with watercolors. I found that they worked best on mat board; I got better values and texture that way." Kelvin painted clear washes of contrasting colors for the sky and land areas. Then he added hues in darker values to give increased emphasis to the cliffs and the pueblo itself.

Kelvin's advice to other students is: "Do a lot of research on the subject you select before beginning."

➤ *Pueblo.* Watercolor. 34.3 x 49.5 cm (13½ x 19½").

The Arts of Africa

Objectives

After completing this chapter, you will be able to:

➤ Name the material used by Benin artists in the creation of their art.

➤ Identify the medium and the technique used in the production of most African sculptures.

➤ Name and describe the different types of figures created by African artists.

➤ Explain how ancestral figures served as a link between the living and the dead.

➤ Discuss the purposes for which African ritual masks were created.

Terms to Know

adz
concave
convex
funerary
Oba
raffia
scarification
secular

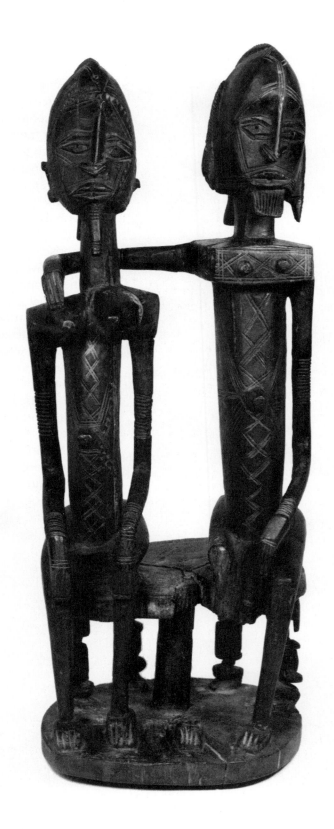

Figure 12.1 *Seated Man and Woman.* Dogon people, Mali. Wood. 76.2 cm (30″). Photograph © 1993 by the Barnes Foundation, Merion Station, Pennsylvania.

The enormous continent of Africa is the second largest continent

in the world and accounts for about one-fifth of the earth's land area.

It is more than three times the size of the contiguous United States including Alaska.

If you were to board a plane at the northernmost point and fly to the southern

tip of Africa, you would cover the same distance as a flight between

New York and San Francisco — and most of the way back again.

SECTION ONE
African Works in Metal

Within the vast continent of Africa (see map, Figure 12.2), an impressive array of art forms have originated. Typically, these art forms differ in appearance and intent from those produced in the West. As you will discover in this chapter, some artworks are centuries old; others have been produced in the recent past.

Western Europeans had little knowledge of the lands and peoples south of the Sahara until the end of the fifteenth century. At that time, Portuguese explorers and traders arrived in West Africa and established trade relations that lasted until the middle of the seventeenth century. Exploration into the interior of the continent did not occur until after the beginning of the European Industrial Revolution, around 1760. Before that time, there was little evidence enabling Europeans to know that the people of Africa produced objects of artistic merit.

In fact, the peoples of Africa could boast of long-established, highly developed cultures that had been producing sophisticated art forms for hundreds of years. The court of Ife, located in what is now southern Nigeria, flourished one thousand years ago. At that same time, Europe was still feeling its way cautiously through the Middle Ages. Other highly advanced African kingdoms and empires even predate Ife. You learned about one of these in Chapter Seven, the ancient Egyptian empire. Another was the kingdom of Cush, which conquered Egypt around 700 B.C.

In the many nations, kingdoms, and culture groups of the African continent, the arts were interwoven with all facets of everyday life. Sculpture, music, dance, drama, and other forms of art played an important role in the daily lives of the people and contributed to a rich cultural heritage that continues to grow today.

Many of the similarities observed in African art forms are due to the fact that artists select communal activities, rituals, and ceremonies as the focus of their

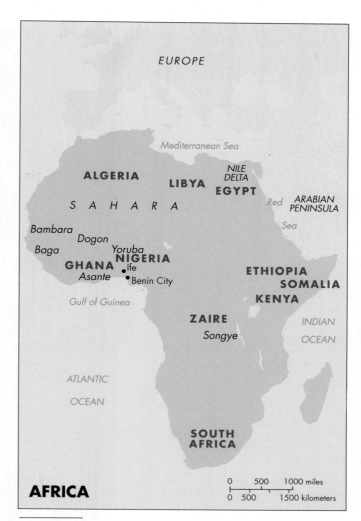

Figure 12.2 Africa

works. A great deal of African art emphasizes the important events of life and the forces in nature that influence the lives of individuals and communities. Dominant themes include: birth and death; the roles of men, women, and children; coming of age; sickness and healing; and the importance attached to food, water, and the human relationship with nature. Artworks are often linked to a variety of celebrations and rituals, both **secular**, or *nonsacred*, and sacred. Each work is usually more symbolically significant than it appears to a non-African. To understand any single piece, it is necessary to gain an understanding of the particular culture from which it came.

Sculpture is universally regarded as one of Africa's greatest contributions to the world's cultural heritage. Wood carving is the most common form of sculpture and will be discussed later in this chapter. For the moment, attention will center upon works created in copper alloy, iron, gold, and silver.

Copper Alloy Reliefs

The Benin kingdom, situated in what is now southern Nigeria, is a highly developed society with an oral tradition that goes back seven or eight centuries. The kingdom reached the peak of its power in the sixteenth century. Like earlier artists in nearby Ife, Benin artists excelled in creating sculptures made with metal, specifically a copper alloy with many of the same qualities associated with bronze.

For centuries in the West, bronze had been reserved for the most important works by European masters. Imagine, then, the excitement created in 1897, when a huge shipment of African metal castings arrived in England. These cast pieces were brought back to England by the leaders of a British expedition that had captured Benin City earlier that same year. Scholars and artists alike were amazed to discover

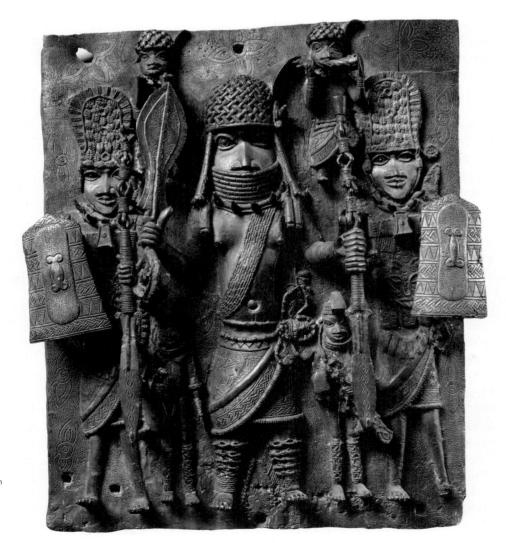

➤ Why was it so unusual for Benin artists to use copper alloy for their art? What do you find most interesting about this particular work? Do you think it is a successful work of art?

Figure 12.3 *Oba and Two Attendants.* Benin people, southern Nigeria. c. Sixteenth century. Copper alloy. 38.7 x 47.6 cm (15¼ x 18¾"). The University Museum, University of Pennsylvania, Philadelphia, Pennsylvania.

that the Benin sculptures were the equal of the best European work in terms of their technical proficiency and their aesthetic quality.

The most ambitious of the Benin castings are the high-relief sculptures that once covered the walls and pillars of the royal palace. One of these (Figure 12.3) contains the figure of the **Oba**, or *king*, flanked by two chiefs bearing shields. Four smaller attendants are located in the vertical spaces between these major figures. One of the two figures at the top blows a horn, signaling the arrival of the powerful Oba. At the bottom, one of the small figures carries a ceremonial sword and the other carries a fan. The Oba wears a patterned wrapper, an eight-ringed coral necklace, and a coral-net helmet that served as a royal crown. He holds a staff in his right hand and a spear in his left. The Oba's central position, size, weapons, and helmet indicate clearly that he is the most important figure in this group. It appears as if he has just arrived and is about to preside over a ceremonial event.

Without question, the Benin artist who created this relief was in complete command of metal-casting techniques. Notice how the arms and weapons are thrust forward in space, completely free of the background. This not only adds to the three-dimensional appearance of the figures but also creates an interesting pattern of light and dark values. A variety of contrasting textures and a symmetrically balanced design help tie all parts of this complex composition together to form a unified whole. Works of this complexity required not only a high degree of artistic skill but also an advanced knowledge of metalwork and the casting process.

Works in Iron

Africa, with its great wealth of minerals, has utilized iron from earliest times. With it, skilled artisans were able to produce a variety of tools and weapons. Many of these have, in addition to their utilitarian purpose, a symbolic meaning or are made to be used in various rituals. A handsome throwing knife from Gabon in west-central Africa, for example, is more than a remarkably efficient weapon capable of injuring an enemy or an animal at a distance of 50 yards (45.7 m) (Figure 12.4). Its shape is not only attractive and functional but also symbolic. It resembles a bird in flight. Knives like this were so prized that they often served as royal symbols of authority as well as weapons.

► Without the descriptive credit, could you have identified this object or determined its purpose? Would you say that this knife is both functional and aesthetically appealing?

Figure 12.4 *Throwing Knife.* Zande people, Zaire. c. 1850. Iron/brass. 40 cm (15¾"). National Museum of African Art, Smithsonian Institution, Washington, D.C. Eliot Elisofon Bequest.

Works in Gold

The Akan people lived in complex political societies in central and coastal Ghana. In the first half of the eighteenth century, these people joined together to form a powerful confederation of states, which included many cultural groups. The largest of these groups was the Asante. Gold was the measure of wealth for the Akan, and its use was tightly controlled by kings, whose power was thought to come from God the Creator. Items fashioned from the precious metal were made to be worn by these kings as a sign of their divine authority and absolute power. The skill demonstrated by goldsmiths in creating these items is remarkable. They often used chevrons, stars, circles, and other shapes placed on delicate backgrounds of gold threads to create a range of attractive jewelry designs. Pendants in the form of faces or animals, however, are not always mounted on such a background and are, in fact, miniature masks (Figure 12.5, page 270).

Asante necklaces, bracelets, and anklets were crafted by stringing cast-gold beads with gold nuggets,

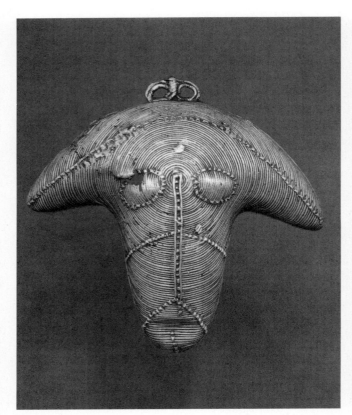

➤ Would you agree with someone who said this pendant mask is unsuccessful because it lacks realism? What would you say to convince such a person that this is in fact a successful work of art?

Figure 12.5 *Pendant Mask.* Baulé Nation, Côte d'Ivoire. Gold. Metropolitan Museum of Art, New York, New York.

➤ Why was this material important to the Akan peoples and their kings?

Figure 12.6 *Necklace.* Akan people, Asante group, Ghana. Nineteenth century. Cast gold. 2.5 x 40 cm (1 x 15¾"). Virginia Museum of Fine Arts, Richmond, Virginia. The Adolph D. and Wilkins C. Williams Fund.

glass and stone beads, and other items. In one example (Figure 12.6), a pendant in the form of a land crab is used instead of a miniature face. This necklace was probably designed for a queen mother, because the land crab was widely recognized by the Asante as a symbol for a person of this rank.

As the name implies, the goldweights of the Asante and other peoples of the same region were used for weighing gold. Gold was the currency used by the Asante; both chunks and dust were exchanged. Consequently, the weights were made according to a carefully calculated scale. They were cast from brass in the form of small, symbolic or representational figures and geometric forms (Figure 12.7). According to some accounts, if the casting of a particular piece resulted in an inaccurate weight, a limb or section might be broken off or a piece added to correct the error. This was done even though it might alter the appearance of the finished piece. At one time, Akan traders all had a set of scales and weights, and the very wealthy may have had as many as several hundred weights.

➤ These goldweights are abstract, geometric forms. What kind of person was most likely to have a large collection of these objects?

Figure 12.7 *Goldweights.* Akan people, Late period. Cast brass. Largest goldweight: 8 cm (3⅛"). UCLA Museum of Cultural History, Los Angeles, California.

John Tarrell Scott

The brightly painted, kinetic sculptures by John Tarrell Scott (b. 1940) combine the artist's interests in early African culture, New Orleans jazz, and contemporary physics. The use of bronze is a link to the copper-alloy casting done by the Ife and Benin people in western Africa. It is an unusual set of topics to integrate through art, and Scott states, "The more I realize that everything is connected, the more I have to learn."

Scott was born in New Orleans, where he continues to live, teach, and work. His career and artistic concerns have evolved through three different phases. As a young artist in the early 1970s, Scott made paintings to express his anger about a variety of social and political issues. By the end of that decade, he was making paintings, sculptures, and prints that were autobiographical in nature and celebrated events in his life. Scott's new wood, brass, steel, and bronze sculptures represent yet another shift in his current artistic and aesthetic development.

Scott's work in the mid- to late 1980s is based on a discovery that he made while he was researching his design for the 1984 Louisiana World Exposition's African-American pavilion. It was then that Scott learned of the diddlie bow, a single-stringed African instrument thought to have been inspired by the practices of early African hunters. According to Scott, after an animal was killed, these hunters turned their bows around and plucked or stroked them to express their sorrow over the death of their prey. By ritualistically changing their weapons into musical instruments, the hunters intended to bring peace to the dead animal's spirit.

In making art based on the diddlie bow, Scott also hopes to preserve a cultural tradition that African slaves brought to New Orleans. He points out that African-Americans in Louisiana made diddlie bows with vertically strung wires, and they used gourds or bottles for the sound box. Jazz music developed, in part, from these early forms of stringed instruments.

Contemporary technology is the third element in Scott's toylike works. Scott notes that he is fascinated by the physics principle that "any line between two points has all the properties of a wave on an oscilloscope." The carefully arranged air rods in *Akhnaten's Rowboat* flutter when moved by wind or hands, and they thereby make rhythm visible as motion. Scott hopes that people who view his sculptures will respond to them and derive pleasure from them as they might to their soundmaking kin, New Orleans jazz.

Figure 12.8 *Akhnaten's Rowboat.* 1983. Painted brass and wood. 43 x 89 x 30.5 cm (17 x 35 x 12"). Galerie Simonne Stern.

Works in Silver

In the fourth century, as Christianity was beginning to make its way into western Europe, the ancient kingdom of Ethiopia, then known as Aksum, was a center of Christianity. In fact, Ethiopia is the oldest Christian nation in the world. However, a Moorish invasion in the seventh century drove the Ethiopian Christians to mountain strongholds in search of safety. They remained there for eight hundred years, forgotten by the world. When Portuguese explorers arrived in the fifteenth century, they thought that they had discovered the kingdom of Prester John, a legendary Christian king of fabulous wealth.

In the fifteenth century, an Ethiopian king decreed that all his Christian subjects wear a cross around their necks. Early examples were made from iron or bronze, but since the nineteenth century, silver has been used to create a variety of delicately crafted crosses (Figure 12.9).

The art of Christian Ethiopia included large ceremonial crosses as well. These were made of wood, bronze, or silver in a variety of decorative styles and were used in religious processions. In addition, a great deal of silver jewelry dating from ancient to recent times constitutes an important part of the Ethiopian art heritage.

➤ Why are so many crosses found in Ethiopia? Name the different materials from which these crosses were made.

Figure 12.9 *Neck Crosses.* Ethiopia. Silver. 3–8.9 cm (1¹³⁄₁₆–3½″). National Museum of African Art, Smithsonian Institution, Washington, D.C. Gift of Mr. and Mrs. Donald F. Miller.

SECTION ONE

Review

1. When did Europeans make their first contact with the lands and people of Africa?
2. Why are there many similarities in African art forms?
3. What features about Benin metal castings most amazed Western viewers?
4. What were the most ambitious of the Benin castings and where were they originally placed?
5. What was the measure of wealth for the Akan people and who controlled its use?
6. Asante goldweights came in two forms. What were they?
7. What is the oldest Christian nation in the world?

Creative Activity

Humanities. In Africa, the visual arts, music, dance, poetry, and storytelling are all a natural part of daily life. There is rhythmic repetition in the music, in the movements of the dance, in the patterns of woven fabric, as well as in the geometry of mask design.

Rhythmic repetition appears in many art forms. It is the essence of improvisational jazz — the spontaneous quality that comes from a rhythm not mechanically produced. Rhythmic patterns occur in all song forms, in poetry, and in the visual arts. Find examples of all of these art forms and study their rhythmic patterns. Look for those with an irregularity that gives the design a dynamic quality.

SECTION TWO
African Works in Wood

Much of Africa's contribution to world art is in the form of wood carvings (Figure 12.1, page 266). These carvings include powerfully expressive figures, highly stylized masks, objects of regalia, and household furniture.

In the nineteenth century, these objects were regarded as novelties by Western travelers and were collected as souvenirs. Works of this kind have been admired by artists outside Africa since 1905 when Maurice de Vlaminck, a Fauve painter, saw and was impressed by three African figures displayed in a French cafe. Other artists, including Matisse, Picasso, and Kirchner, were subsequently intrigued and incorporated features of African art in their own work. In this way, the art of Africa has had an impact on the course of modern art in the West.

Creating Carved Objects

In addition to new artworks, which were created to serve new purposes, some African carved objects owe much of their fresh look and recent heritage to a wood-eating white ant and a damp climate. Both contributed to the destruction of wood carvings. This meant that each new generation of artists had to produce new carvings to replace those that had been damaged or destroyed. Although the lack of early examples makes comparison to more recent works impossible, it can be assumed that artists profited from the efforts of their predecessors. It is difficult to believe that they would be satisfied to merely copy earlier models. Instead, they most probably tried to improve upon them. In this way they continuously revitalized the images and forms used in traditional rituals and ceremonies and invented new forms of design for new celebrations or other purposes as the need arose.

African wood carvings include figures, masks, ceremonial items, and household objects such as furniture. However, it is the figures and masks that are most familiar to Western viewers. These vary in style from one ethnic group to another, and since there are approximately one thousand cultural groups distributed throughout the vast continent, there is a large variety of styles.

Figures

The carved-wood sculptures of Africa take on many different forms, although the most common are based on the human figure. To carve them the carver relies on the **adz**, *an axlike tool with an arched blade at right angles to the handle.* Often two or three of slightly differing sizes and shapes are used. Many figures are carved from a single section of wood and, when finished, reflect the shape of the log from which they are made. The adz is used to fashion the basic form, and a chisel or knife is used for details or to separate small parts, such as legs. A smooth finish is obtained by rubbing the completed work with rough leaves or oil, which is applied in ritual contexts or to give the piece color. Carvers typically complete this work while seated on the ground, often holding the block of wood in place with their feet.

African figure carvings can be classified into several different types. Included among these are ancestral figures, power figures, and **funerary**, or *funeral*, figures. These exhibit certain common characteristics that are noted in figures carved in different parts of Africa. These characteristics are:

- proportions that reflect cultural concepts rather than natural proportions;
- a frontal pose;
- an enlarged head to signify its importance as the center of reason and wisdom; and
- static poses, or a lack of movement.

Ancestral Figures

Most African ancestral figures were carved for two reasons: respect for the deceased, and fear of angry spirits of the dead. Many Africans believed that, at death, the soul was separated from the body and that the soul might remain in the village to influence the present. They thought that since these spirits were still about, they could affect the living. They also believed that not all spirits would be pleased with their fate and might even seek revenge against those still living. Therefore, people thought it was wise to do everything they could to please these spirits and make their existence as comfortable as possible. Ancestral figures were created as pleasant resting places for spirits. These sculptures were not created to symbolize a spirit; they were created to *contain* the spirit of the deceased person.

These ancestral figures were not necessarily realistic portraits of the deceased. The character of the work

is culturally determined and bears the style of the particular artist (Figure 12.10). To assure that the spirit inhabited the figure, sacrifices were offered in a ritual ceremony. The spirit would remain there until it decided to leave or was summoned to the hereafter. Since the spirit dwelled in the figure, members of the family were accustomed to talking to it. In this way, the carved figure served as an effective link between the past and the present, the living and the dead.

Many ancestral figures have been found to project a powerful presence. This is especially true of a figure from northeastern Angola illustrated in Figure 12.11. This carving represents a real historical figure named Ilunga Katele, who became the idealized ancestor of the god-kings of the Lunda. These were an agricultural and hunting people who lived in parts of Angola and Zaire.

Ilunga Katele was, through his mother, the bearer of the sacred blood of the Luba royal line. As a younger son, he was so skilled as a hunter and warrior that he represented a threat to his father, the ruler. To avoid conflict, Ilunga Katele fled, seeking his fortune elsewhere. Eventually, around 1600, he married the heiress to a powerful tribal chief, and from this union

➤ How did these figures act as links between the living and the dead?

Figure 12.10 Master of Ogol. *Standing Female Figure*. Dogon culture, Mali. Ogol Village. Late nineteenth century. Wood, metal, beads, patination. 58.1 x 11.5 x 14.2 cm (23 x 4½ x 5½"). Dallas Museum of Art, Dallas, Texas. The Gustave and Franyo Schindler Collection of African Sculpture, gift of the McDermott Foundation in honor of Eugene McDermott.

➤ What aesthetic qualities would you refer to when making and defending a judgment about this work?

Figure 12.11 *Chibinda (The Hunter), Ilunga Katele*. Chokwe, Northeastern Angola. Mid-nineteenth century. 40.6 x 15.2 x 15.2 cm (16 x 6 x 6"). Wood, hair, hide. Kimbell Art Museum, Fort Worth, Texas.

came the rulers of Lunda. Ilunga Katele became a culture hero to his people and to the nearby Chokwe, who furnished many of the sculptors who created carvings for the Lunda royal court.

If you study the carving of Ilunga Katele closely, you will note a mature, sturdy figure that seems to command attention. The powerful torso and limbs lack the detail that might divert attention away from their strength. This lack of detail is not observed in the treatment of the face, however. Each feature is carved with great care. The wide-open eyes suggest the vigilance of the hunter-warrior, and the mouth is firmly fixed to show determination. A beard made of animal hair adds an air of wisdom, suggesting that this person's strength is tempered by good judgment. The royal headdress and an animal horn held in the left hand are carved with exacting precision. The right hand bears a staff to aid Ilunga Katele in his journeys. The most impressive of these may be the journey spanning more than three centuries—the length of time this idealized ruler's reputation and influence was felt by the Lunda and Chokwe peoples.

Power Figures

The artists of several social groups produced power figures like the one from Zaire seen in Figure 12.12. These were regarded as a kind of magical charm used for positive or negative purposes. The figure is activated by a spiritualist who seals secret, magical substances in a cavity somewhere in the figure. Often, as in the example illustrated, this cavity projects from the abdomen. When the cavity is sealed with a mirror, it shows that the spiritualist has the magical power to see beyond the reflective surfaces of river or sea, where the spirit world lies. With this power the spiritualist is able to read the secrets of the dead.

Once activated, the power figure draws upon forces for good or evil to assist the person purchasing it from the spiritualist. Forces for good may be called upon to protect family members from disease or some other misfortune, natural or supernatural. Evil forces might be summoned to bring annoyance or harm to enemies.

Sometimes metal pieces or nails are driven into a power figure to inflict pain or to protect the user against some evil (Figure 12.13). These figures of

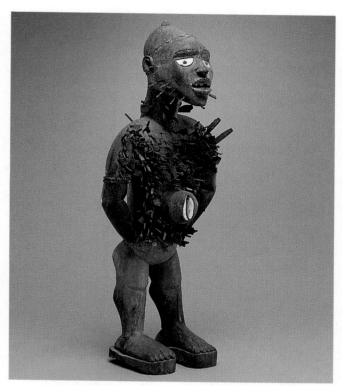

➤ What art element would you be certain to mention if asked to describe this work to a friend who had never seen it?

Figure 12.13 *Nkonde Nail Figure.* Nkonde people. 1875–1900. Wood with screws, nails, blades, and cowrie skills. 117 cm (46"). Detroit Institute of Arts, Detroit, Michigan. Founders Society Purchase, Eleanor Clay Ford Fund for African Art.

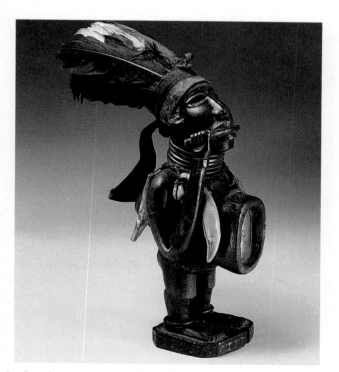

➤ For what purpose were figures like this carved?

Figure 12.12 *Magical Figure.* Kongo people, Zaire, Southern Savannah. Twentieth century. Wood, feathers, glass, metal, animal teeth, shell, cloth. 29.2 cm (11½"). University of Iowa Museum of Art, Iowa City, Iowa. The Stanley Collection.

men or beasts may become so covered with knife blades and nails that the wood is almost completely obscured.

Funerary Figures

Another type of African carving is the funerary figure that was produced to protect the relics of the dead. Among the best-known funerary figures are the wood and metal sculptures created by the Kota of central Africa (Figure 12.14, page 276). These abstract figures have large oval heads, and bodies that are reduced to open diamond shapes. They are made of wood and partially covered with thin sheets and strips of copper and brass. This metallic trim serves to emphasize portions of the face, neck, and body. The use of copper and brass indicates the importance attached to these figures, since metal is scarce in central Africa.

Note, in Figure 12.14, that the head is flanked by large near-rectangular shapes. No one knows for certain what these shapes are meant to represent. Some experts have suggested that they are intended to represent elaborate hairstyles. Others think they were

originally meant to be wings. If they were indeed meant to be wings, the first figures of this kind may have been gods of the dead rather than mere guardians of the dead.

Kota figures with **convex**, or *outwardly rounded*, faces represent males. Those with **concave**, or *inwardly curved*, faces indicate females. The large head is joined to what appears to be a neck, and this is attached to what some think are legs with flexed

knees. The figure is symmetrically balanced in terms of its surface decoration and overall form.

The exact purpose of these unusual, abstract figures is not entirely certain. It is known, however, that they were placed in, or on top of, baskets containing the relics of ancestors. This fact suggests that the purpose of the figures was to protect the dead. Indeed, they appear to embrace the funeral basket in a protective way when placed on top of it.

Masks and Headdresses

African masks are made to be seen in motion at important ceremonies and rituals. A wooden Nimba shoulder mask of the Baga culture (Figure 12.15) is part of a complete costume worn by a dancer in a farming ceremony. This type of mask is made to rest on the wearer's shoulders. Strips of palm fiber are used to conceal the rest of the body. With the mask in place, the dancer is an imposing figure, standing over 8 feet (2.4 m) tall. Witnesses at ceremonies in which masks of this kind are used have claimed that they have a strange, hypnotic effect.

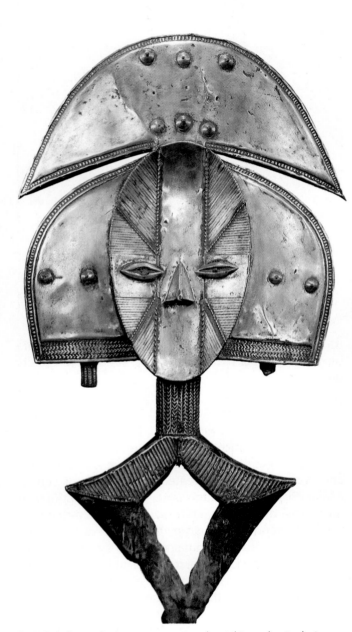

➤ What do you find more impressive about this work — its design qualities or its expressive qualities? Explain.

Figure 12.14 *Reliquary Figure.* Kota people, Gabon. Nineteenth to twentieth centuries. Wood, brass, copper, iron. 73.3 cm (28⅞"). The Metropolitan Museum of Art, New York, New York. Purchase 1983.

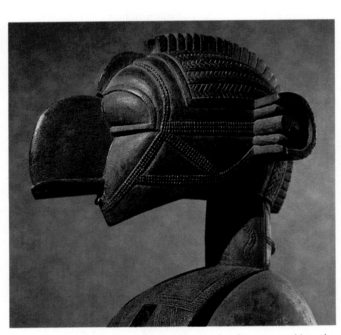

➤ Explain how exaggeration has been used in this carving. How do you think this contributes to the effectiveness of this work?

Figure 12.15 *Headdress.* Nimba people, Baga culture, Guinea. Nineteenth to twentieth centuries. Wood. 122.6 x 41 x 70.3 cm (48¼ x 16⅛ x 27⅝"). Dallas Museum of Art, Dallas, Texas. The Gustave and Franyo Schindler Collection of African Sculpture. Gift of the McDermott Foundation in honor of Eugene McDermott.

Art · PAST AND PRESENT ·

Handcrafted Objects

Today, as distances shrink and diverse cultures are striving to learn more about one another, ethnic art is of greater interest than ever before.

One of the most varied selections of handcrafted art is to be found at Textures, a shop in Palos Verdes, California, that specializes in "earth-connected" objects. Some are functional, such as wooden bowls, baskets, and clothing. Others, like the dolls shown in Figure 12.16, are primarily decorative.

The two taller figures are examples of ceremonial initiation dolls made by an Ndebele mother to give to her daughter when the girl comes of age. The dolls are formed over a cone of reeds, and their clothing is made from scraps of cotton material and natural fibers. Brass rings adorn the neck of the tallest doll, a custom followed by Ndebele women.

The two smaller figures are made by Zulu women and are not ceremonial in nature. During the winter months, when there is no work to do outside, the women make these dolls from fabric, discarded clothing, and decorative items that they have collected all year.

One doll has an elaborate necklace of European glass beads. Its blouse is a striped knit fabric, and its hair comes from the head of the woman who made it. The doll on the right wears a hat like some worn by Zulus. The hat itself is woven right into the hair and is worn until the hair grows too long. At that time, more rows of hat material are added close to the head and are secured by the new hair. Fabric,

Figure 12.16 Ndebele and Zulu Dolls.

yarn, beads, and bits of leather were used to make the clothing for this doll.

Ethnic accessories such as these and others are available today in shops and galleries across the country. Crafted by members of distant cultures and communities, these handmade works of art give insight into the creative spirit of the individuals who create them and help to bring a better understanding of diverse cultural backgrounds.

Although they are sometimes used in secular dances, ritual masks are intended to aid efforts to communicate with a world of spirits. These masks are also thought to have supernatural powers. When members of masking societies don such masks, they believe they cease being themselves. Instead, they either become, or act as, a kind of medium with the power to communicate directly with the god or force. For this reason, these masks are regarded by many Africans as very powerful and are to be treated with great respect.

In addition to the shoulder mask represented by the Nimba carving, a number of other types of masks have been produced, particularly the face mask and the headdress.

As the name implies, the face mask is designed to be worn over the face. One example is a Songye face mask from central Zaire (Figure 12.17, page 278). Observe how the facial features are indicated in simplified forms, which maintain the overall simplicity of the entire mask. A rich pattern of closely spaced lines accents the geometric planes that divide the face. These lines, which are actually carved into the wood with a sharp instrument, create a textured surface that contrasts and emphasizes the smooth surfaces of the eyes, nose, and mouth. Form, line, texture, and value contrasts are combined in this mask to create a unified design that is subtle and dramatic at the same time. A costume was attached to the holes at the bottom of the mask. This costume was made of long

strips of **raffia**, *a fiber made from the leaves of an African palm tree*. It was made to drape over and completely cover the body of the wearer. Masks like this were originally designed to be worn at the funeral of a chief.

Among the Lwalwa of Zaire, four types of masks are used by members of a secret society. These are worn during ceremonies in which young men are initiated into the society. Representing both males and females, the masks are worn by men in dances intended to calm the spirit of human victims once required for membership. Each dancer selects one of the four mask types available and makes his choice known to the carver, often the village chief who organizes the initiation dance.

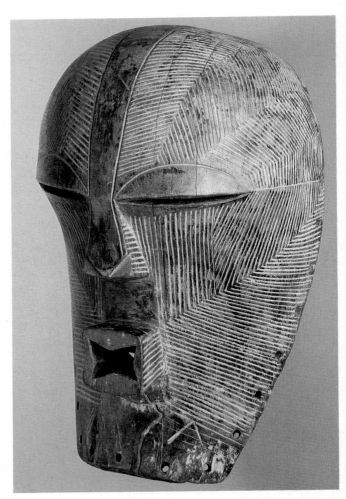

➤ Discuss the manner in which the elements of line, texture, shape, and form are used in this mask. Discuss the ways in which the principles of balance, emphasis, harmony, and variety are used. Do you think these elements and principles have been used effectively in achieving an overall sense of unity? Explain your answer.

Figure 12.17 *Face Mask.* Songye people, Zaire. Nineteenth to twentieth centuries. Wood, paint. 44.5 cm (17½"). The Metropolitan Museum of Art, New York, New York. The Michael C. Rockefeller Memorial Collection. Bequest of Nelson A. Rockefeller, 1979.

➤ Identify the features that you noticed first when examining this work. Explain how the principle of variety is used.

Figure 12.18 *Bundu Society Mask.* Mende, Sierra Leone. Late nineteenth century. Bombax wood, dye. 42 cm (16½"). Denver Art Museum, Denver, Colorado.

The Mende are one of several Guinea Coast people with a separate, secret society that assumes responsibility for educating and initiating young women into adult society. At ceremonies marking the end of the initiation process, prominent women in the society wear helmet masks that cover the entire head (Figure 12.18). Features of this mask, particularly the elaborate hairstyle and rolls of flesh at the neck, represent the wealth, beauty, and social status desired for the initiates. The ornate hairstyle, tiny, delicate face, and high forehead are characteristics found in most masks of this type. To date, this is the only example that is known of women wearing masks in Africa. All other masks are worn by men.

African Interior Furnishings

In addition to figures and masks made in metal and wood, African art includes stools, headrests, bowls and other containers, baskets, fabrics, and blankets made of various materials. Typically the interior furnishings of African dwellings are minimal. An elaborate example is a Luba chief's stool, carved to look like a kneeling female figure (Figure 12.19). The woman, as the source of life and principal support for the community, holds the seat aloft to demonstrate that the people must support its ruler. She is carved in smooth, solid forms with a large head and a short, stout torso. Her legs circle outward to provide additional support. The real beads she wears around her neck repeat, with only slight variation, the pattern of the design around the seat, the braided hair, and the **scarification**, or *ornamental scars* on her body. The care with which this work was created indicates that it was more than something to sit on — it was also an important symbol of power for the owner.

Today, African art has taken its rightful place among the art traditions of the world. Once dismissed for its consistent departure from realism, in recent times, African art has come to be understood and appreciated on its own terms.

➤ Why is this stool made to look like a kneeling female figure? Does this stool have more than a functional purpose?

Figure 12.19 *Stool Supported by Kneeling Female Figure.* Luba people, Zaire. Nineteenth to twentieth centuries. Wood, beads, metal. 41.7 x 29.4 x 26.8 cm (16½ x 11½ x 10½"). Dallas Museum of Art, Dallas, Texas. The Clark and Frances Stillman Collection of Congo Sculpture, gift of Eugene and Margaret McDermott.

SECTION TWO

Review

1. What tool did African artists rely upon when creating their wood carvings?
2. Why were ancestral figures created?
3. What is a power figure?
4. How did Kota funerary figures distinguish between those meant to represent males and those meant to represent females?
5. Where were Kota funerary figures placed and what does this placement suggest concerning their purpose?
6. What three types of masks were created by African artists?
7. Describe the helmet masks worn by the Mende women and tell what was unusual about their use.

Creative Activity

Studio. Fiber arts — weaving, stitchery, appliqué, batik, Adinkra block printing, tie-dye, and painting on woven fabric — are exciting aspects of the arts of Africa.

Learn about the Ndebele people of South Africa, whose women decorate the mud walls of their homes with vibrant, abstract designs. These patterns are repeated in their beaded neckpieces and the woven fabric of their robes.

Plan an abstract design for a wall of your school, or your own room, or for an article of clothing. Use lines and abstract shapes that symbolize one of your special interests or hobbies. Add this design plan to your sketchbook for future reference.

CREATING A PAPIER-MÂCHÉ CEREMONIAL MASK

Supplies

- Pencil and sketch paper
- Aluminum foil
- Masking tape
- Newspaper
- A sheet of poster board, approximately 10 x 12 inches (25 x 30 cm)
- Scissors
- Paper toweling
- Cellulose wallpaper paste, thinned to the consistency of cream
- Plastic mixing bowl
- Sheet of fine-grade sandpaper
- Tempera or acrylic paint
- Water container
- Materials for decorating (pieces of colored cloth or felt, buttons, bottle caps, yarn, cotton)
- White glue

You will create a three-dimensional, papier-mâché mask for an imaginary African ceremony. Craftsmanship will be observed in the use of this medium at every stage of production. Use pronounced facial features and place them correctly. These features, combined with the expression on the face, should communicate a sense of dignity and power. Paint the mask with a variety of hues mixed from the primary colors. Use black for details. Attach various materials to the mask to provide decoration and actual texture.

Focusing

Examine the Nimba *Headdress* (Figure 12.15, page 276) and the Songye *Face Mask* (Figure 12.17, page 278). What purposes did masks like these serve in ceremonies? In what ways are the designs of these masks similar? How do they differ? Where is actual texture noted on each? Which mask originally had a costume attached to it? Observe the ways the eyes, nose, and mouth are made and where they are placed.

Creating

Sketch your ideas for a mask to be used in a fictional African ceremony. Make certain that this mask communicates a sense of dignity and power.

Fold a sheet of aluminum foil into several layers, forming a rectangle large enough to cover the entire face. Place this over the face and, with your fingers, gently form it around the eyes, nose, mouth, and chin. Remove the aluminum-foil mask and place it on a sheet of poster board. Wad small pieces of newspaper and tuck these under the mask to support it and prevent it from collapsing. Tape the mask to the poster board.

Cut newspapers into 1/2-inch (1.3-cm) strips about 2 to 3 inches (5 to 7.6 cm) long. Soak these strips in the paste mixture and apply them carefully to the aluminum foil. Do not become alarmed if the facial features lose some of their sharpness at this point. Smooth the surface after each paper strip is added to remove all wrinkles. At least four layers of newspaper are recommended.

Allow the mask to dry, cut around it with scissors to free it from the poster-board backing, and remove the wads of newspaper inside. If desired, cut holes for the eyes and mouth. Cut and assemble various facial features from the poster-board scraps. Use masking tape to assemble and attach these features to the mask. It will be easy to locate these on the mask even though the original features may have lost some of their distinctive shapes when the paper strips were applied. Consider the possibility of exaggerating all or some of these facial features. When these features are in place, add a final layer of paper-toweling strips over the entire face.

When dry, lightly sandpaper the entire mask and paint it with hues mixed from the three primary colors. Add details with black paint and decorate by attaching various materials to the mask.

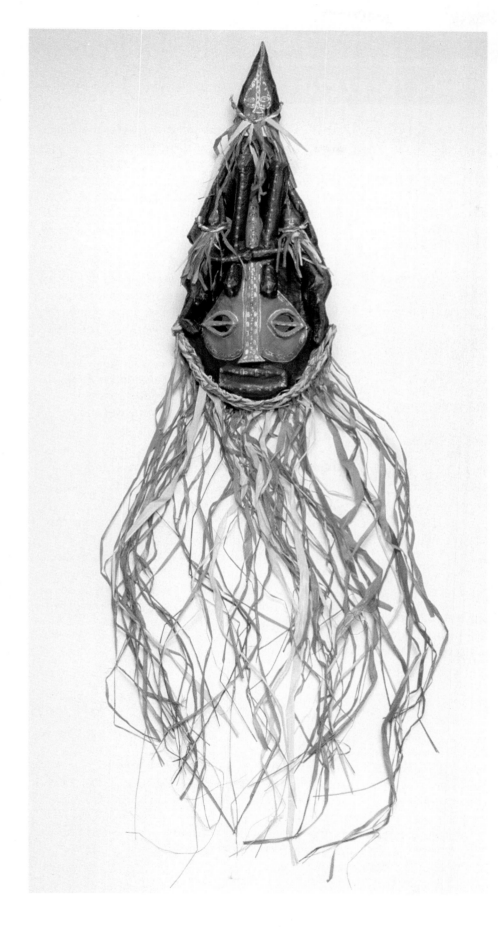

• **Describe.** Are the various facial features of your mask pronounced and accurately placed? Does the mask exhibit any lifelike qualities?

• **Analyze.** Does your mask exhibit good craftsmanship in the use of the papier-mâché medium? Did you use a variety of hues mixed from the primary colors? Was black used to indicate details? Were various materials attached to the mask to add decoration and actual texture?

• **Interpret.** Examine your mask through the eyes of a participant at your imaginary African ceremony. Would you consider it suitable for use at such an important ceremony? Why or why not? Does the mask suggest the dignity and power associated with such a ceremony? If so, how does it accomplish this?

• **Judge.** Do you think that your mask is successful? Can you explain why it is successful? What qualities does it share with the masks illustrated in Figures 12.15 and 12.17?

Figure 12.20 Student Work

Reviewing the Facts

SECTION ONE

1. In what two ways does African art differ from Western art?
2. Why was there little evidence before the middle of the eighteenth century to show Europeans that African artists had produced works of quality?
3. List at least three of the dominant themes of African art.
4. What material was used in the production of Benin relief sculpture?
5. Describe two ways that goldweights were designed by the artists of Africa.

SECTION TWO

6. What are the two most common forms of African wood carving?
7. What are three different types of figures created by African wood carvers?
8. Why is it not unusual for members of a family to talk to an ancestral figure?
9. Why are nails or other pieces of metal driven into power figures?
10. Identify one symbol shown by the figure in the Luba chief's stool.

Thinking Critically

1. *Analyze.* Look at the Songye *Face Mask* (Figure 12.17, page 278). Describe the art elements that are found in the work. Then discuss how the artist used these elements according to the principles of harmony, variety, and balance.

2. *Compare and contrast.* Look at *Seated Man and Woman* (Figure 4.3, page 79) and *Seated Man and Woman* (Figure 12.1, page 266). Identify the similarities and differences you find. What human relationship is portrayed in both works? How is this relationship revealed?

3. *Extend.* Imagine that you are a noted aesthetician preparing a newspaper article. In this article, you hope to teach readers with little art background how to interpret and appreciate art created in Africa. Identify one work illustrated in this chapter that you feel will prove your point. What would you say about this work to show that it has artistic merit? What arguments could you expect to hear in letters from readers who disagree with you? How would you answer those arguments?

Using the Time Line

Locate the earliest artwork noted on the time line. When was it created? How do you explain the absence of African artworks before this time? Select one of the works on the time line and find a sculpture illustrated in this book that was created in another part of the world at about the same time. If you did not know where either of these works was done, how would you be able to distinguish the African work from the other?

1750	1800	1850	1900	1950

Magical Figure

Ogol Standing Female Figure

Kota Reliquary Figure

Nkonde Nail Figure

Ilunga Katele

Amiee Johnson, Age 17
Reseda High School
Reseda, California

After reading the chapter on the arts of Africa, Amiee found it interesting that each new generation of African artists revitalized the images and forms used in traditional ceremonial rituals. She saw a parallel in what is occurring in African-American culture today: the incorporation of ancient images and traditions into the culture through music and, especially, through art. Seeing an exhibit of Romare Bearden's artwork, she was impressed with how expressive his collages were of all aspects of African-American culture. She decided to produce a collage, her goal being to demonstrate an obvious relationship between the past and the present.

Amiee began by collecting images she felt vividly expressed aspects of modern African-American culture and African tribal culture. She had previously created a batik fabric piece that she wanted to incorporate into the collage. Her first step was to arrange some of the objects loosely and then do a sketch of what she thought she wanted to include.

As she began to cut and arrange the various elements in her collage, Amiee said, "I discovered that a collage is a great deal more than just throwing together a bunch of materials and pictures that I like. A collage should have content as well as be aesthetically pleasing, and it must be simple to have impact. That proved to be the most difficult part for me, because I had collected so many images that I wanted to use."

In addition to using the batik, Amiee included two photographs of her own face. When the project neared completion, Amiee decided it needed some lines to tie it all together. In evaluating the finished project she said, "I am most satisfied with the theme of linking past and present and the images through which the theme is projected. I recommend that all students have the experience of doing a collage, because it demands a great deal of critical thinking and organization."

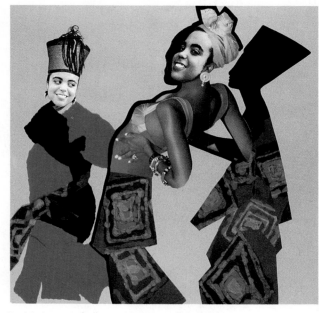

➤ *My Legacy.* Collage. 46 x 46 cm (18 x 18″).

283

Art in Quest of Salvation

Carved Ivory Cup
Tenth century

Page 286

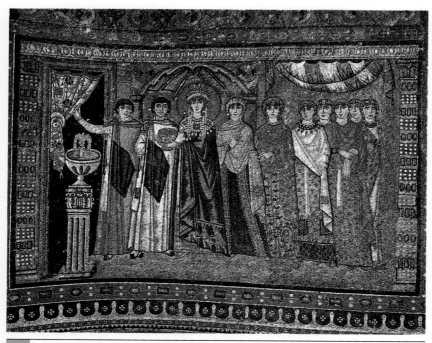

Mosaic from Church of San Vitale, Ravenna, Italy
c. A.D. 547

Page 296

300	500	700	900

EARLY CHRISTIAN, BYZANTINE, AND ISLAMIC ART

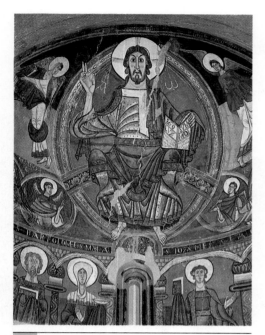

Church Wall Painting *Page 330*
Twelfth century

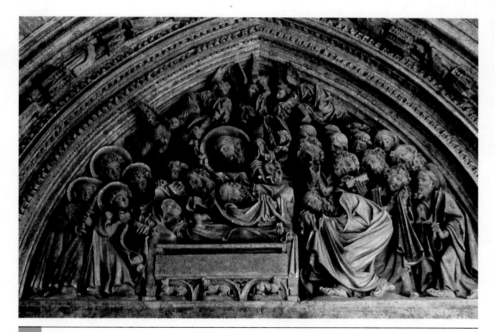

Capital Carvings *Page 328*
Twelfth to thirteenth centuries

Tympanum from Cathedral of Pamplona, Spain *Page 346*
Fourteenth century

| 1100 | 1300 | 1500 | 1700 |

EARLY MEDIEVAL AND ROMANESQUE ART

GOTHIC ART

In Quest of Salvation: Early Christian, Byzantine, and Islamic Art

Objectives

After completing this chapter, you will be able to:

➤ Explain how early Christians used art to express their religious beliefs.

➤ Describe the events that brought about the fall of Rome.

➤ Identify the rich and brilliant Byzantine art.

➤ Describe the Alhambra and explain its purpose.

➤ Create a self-portrait in the Byzantine style.

Terms to Know

alcazar
campanile
catacombs
Koran
mihrab
minaret
mosaic
mosque
muezzin
piers

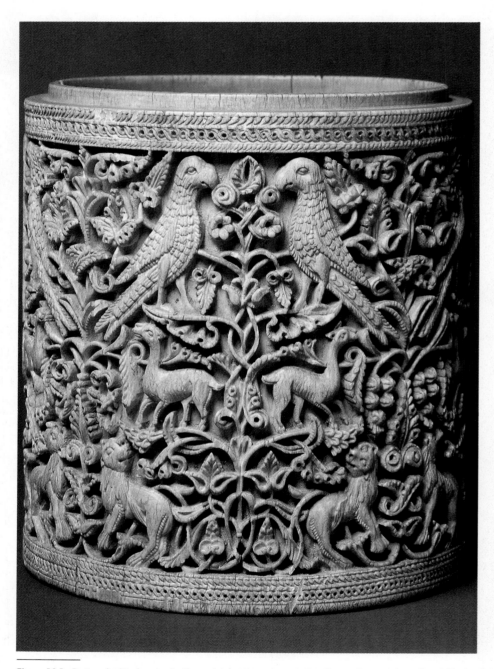

Figure 13.1 Pyxis, cylindrical, carved with candelabre trees, parrots, gazelles, and rearing lions. Spain. Tenth century. Ivory. 11.8 x 10.5 cm (4⅝ x 4³⁄₃₂"). The Metropolitan Museum of Art, New York, New York. The Cloisters Collection, 1970.

The latter part of the second century marked the beginning of a period

of rapid decline in the Eastern Roman Empire. In spite of capable rulers like Diocletian and

Constantine, the downward spiral continued, fueled by a variety of internal ills and

external threats and invasions. The devastating invasions of the fifth century

finally brought the collapse of Rome's political structure in the East.

SECTION ONE

Early Christian and Byzantine Art

In the vacuum left by the empire's decline, a new source of power was born — the Christian Church. The place of the Roman emperors was taken by popes and, in the East, the Church was to play the dominant role in the five hundred years following the waning of the Classical period. The Church's influence eventually spread to touch upon every aspect of life. Nowhere was this more evident than in the visual arts.

➤ What purpose did this painting serve?

Figure 13.2 Painted ceiling from the Catacomb of Saints Pietro and Marcellino. Rome. Fourth century A.D.

Early Christian Art

The Christian religion was not legal for many years throughout the Roman Empire. This meant much hardship and persecution for its many followers. Finally, in A.D. 313, it was made legal by the emperor Constantine with the Edict of Milan. However, pictures with hidden Christian meanings were being painted long before that time. Many of those early paintings were made on the stone walls of narrow underground passageways. When persecuted by Roman emperors, the Christians dug **catacombs**, or *underground passageways*, mainly outside the city as places to bury their dead and hold occasional religious services. In time, the catacombs grew into a vast maze of tunnels. These tunnels were lighted and ventilated by skillfully constructed air shafts.

Over 1,650 years ago, an unknown Christian artist completed a painting on the rough ceiling of a gallery in one of those catacombs. The painter was not greatly skilled and worked with the crudest of instruments.

The flickering light of a flame torch and a constant fear of being found by Roman authorities no doubt made the task more difficult. The finished painting (Figure 13.2) can tell you a great deal about the early Christians' outlook on life and offers insights into the characteristics and purpose of their art.

Early Christians viewed life in a way that was quite different from views held by believers in the Roman religion. The Christians believed Christ to be the Savior of all people and hoped to join him in heaven after death as a reward for following his teachings. They had little interest in gaining fame and fortune in the world. Instead, they sought an eternal reward in the form of a life after death. For this reason, early Christian paintings of people showed little interest in the beauty, grace, and strength of the human body, which were so important to Greek and Roman artists. Christian art was intended to illustrate the power and the glory of Christ. It was also meant to tell, as clearly as

possible, the story of his life on earth. Christ's life story was very important because it was the model for people to follow as the surest way to attain salvation.

Symbolism in Early Christian Art

The early Christians' view of life on earth as a preparation for the hereafter is reflected in the artworks they produced. These works may have *looked* Roman, but the beliefs and ideas they passed on to other Christians were not Roman beliefs and ideas — they were Christian. For example, a picture or sculpture of a shepherd was a popular subject for both Roman and Christian artists. When a Christian artist painted a shepherd, however, it was a symbol for Christ as the Good Shepherd.

Christian artists used symbols as a kind of code. Familiar figures or signs were used to represent something else. Catacomb paintings are filled with images of animals, birds, and plants, which are also found in Roman art. When Romans looked at one of these, perhaps a painting of a goldfinch, they saw only the goldfinch. Christians looking at the same painting saw a great deal more. They remembered that the goldfinch was fond of eating thistles and thorns, and plants of that kind reminded them of Christ's crown of thorns. Thus, the goldfinch was a symbol of Christ's death.

Over time, birds, animals, and plants came to symbolize different Christian ideas. The peacock became the symbol for immortality because it was believed that the flesh of that bird never decayed. A dog was used as a symbol of faithfulness because of its watchfulness and loyalty. Ivy, because it is always green, was associated with eternal life.

The artist who painted on that rough catacomb wall borrowed heavily from art forms seen all over Rome, but these forms were given new Christian meanings. A great circle was painted to represent heaven. Within this circle is a cross, the most important symbol of the Christian religion. The shepherd in the center circle represents Christ. The sheep around him symbolize his faithful followers. Christians believed that Christ, also called the Good Shepherd, was willing to lay down his life for them, his flock. The lamb on Christ's shoulders symbolizes those people who need additional help on the difficult road to salvation.

The arms of the cross end in half-circles in which the biblical story of Jonah and the whale is told. This was another favorite subject in early Christian art because, like the Good Shepherd, it illustrated God's power to protect the faithful from danger. Beginning at the left, Jonah is seen being thrown from his ship to be swallowed by the whale. On the right, he is

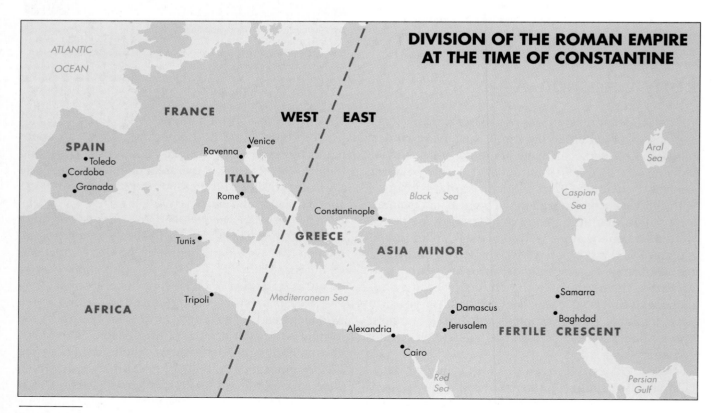

Figure 13.3 Division of the Roman Empire at the time of Constantine

being released by the whale at God's command. In the final scene at the bottom, he is shown recalling his adventures and thanking God for his mercy.

Between these scenes are standing figures with their hands raised in prayer. They represent all the members of the Church pleading for God's assistance and mercy in their own struggles for salvation.

You probably noticed that this picture contains only enough detail for you to understand the story. The figures are sketchy and there is little to suggest depth or the world in which the figures lived. The artist was clearly not interested in painting a realistic picture. Instead, interest was centered on illustrating the Christian story so that followers could read it easily and meditate upon its meaning.

Basilicas

Not long after this painting was completed, things began to improve for the new Christian religion. Christianity had spread rapidly across the entire Roman Empire, and the emperor Constantine had granted Christians the freedom to practice their faith openly. (See Figure 13.3.) This meant that they had to decide upon the kind of building to use as a church. In this matter, the Christians again borrowed from the Romans. Christian builders selected as their model the basilica. This was the long, spacious building that the Romans had used for their public meeting halls. It was a practical choice since such a building could accommodate the large numbers of people crowding into it to worship.

Early Christian church builders made no attempt to imitate the grandeur of Roman temples. Christian churches were intended as retreats from the real world where worshipers could go to take part in a deeply spiritual event. The outside of these churches was quite plain (Figure 13.4), especially when compared to classical temples. The addition of a **campanile**, or *bell tower*, later did little to change the outer simplicity of these early churches.

On Sundays and holy days the people gathered for services in the church (Figure 13.5). No doubt they looked forward to leaving their humble dwellings for

➤ The exteriors of Christian churches were quite plain.

Figure 13.4 *Sant' Apollinare in Classe. Ravenna, Italy.* A.D. 533–49.

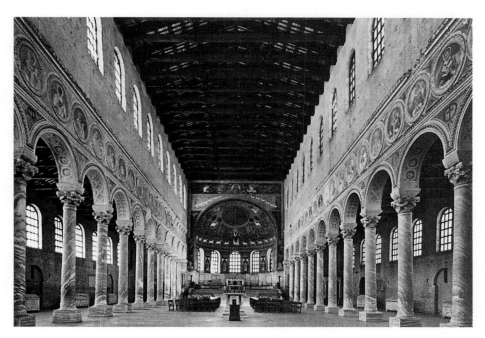

➤ How does the decoration inside this church differ from the decoration of the exterior? What is used to divide the space in this building? Do you think the design of this church was suited to its purpose?

Figure 13.5 *Sant' Apollinare in Classe* (interior, looking toward the apse).

what must have seemed like a brief visit to heaven itself. In contrast to the plain exterior, the inside of the church was designed for dramatic effect. As in the Roman basilica, rows of columns divided the huge space into a main corridor, or nave, and narrower aisles on either side. Also, as with the earlier model, windows were inserted in the space between the wooden roofs over the side aisles and the higher roof over the nave. However, unlike the Roman basilica, the main entrance was at one end of the nave, and at the other was a single apse. The light from the windows streamed into the nave and illuminated the aisle leading from the main entrance to the apse, where the main altar was placed. At this altar the priest solemnly celebrated the Mass, while the faithful silently followed each movement with their eyes.

When eyes strayed from the altar, they rose to view walls richly decorated with mosaics (Figure 13.6). **Mosaics** were *decorations made with small pieces of glass and stone set in cement*. This ancient medium had been very popular in Rome. There it had been used to decorate the floors of Roman villas rather than walls (see Figure 9.4, page 191). Christian artists saw the potential of the medium and placed mosaics on walls where the light from windows and candles caused them to flicker and glow mysteriously. This may be one of the reasons why early Christian churches came to be known as "Houses of Mystery."

Most of the early Christian churches are gone now, victims of a variety of misfortunes over the centuries.

From the few churches that have survived, it is clear that they served as the basic model for church architecture in western Europe for centuries.

Decline of the Classical World

After the dedication of Constantinople in A.D. 330, with some exceptions during the fourth century, the Roman Empire functioned as two separate sections, East and West (see map, page 288). There was an emperor in each section, although the emperor in the East was much more powerful.

In the West, the emperors gradually lost their influence and prestige. At the same time, the Church, governed by the popes, grew in power. Eventually, the Church replaced the emperor in the West as the central authority. This did not happen in the East, where the emperors were recognized as heads of both the Church and the State.

In theory, the Roman Empire was still united. However, as time passed, the two sections drifted further and further apart, separated by differences in language, politics, and religion. The western half finally fell to barbarian invaders from the North during the fifth century A.D. During the long struggle with these northern invaders, cities in the West were abandoned by frightened inhabitants who sought refuge in the countryside. The population of Rome dwindled from

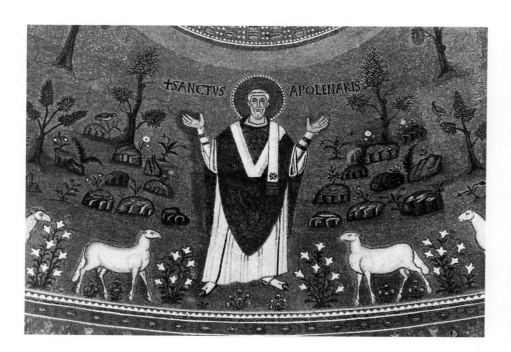

➤ Mosaics were used to decorate this apse. Why do you think this technique was so effective on the walls of a church?

Figure 13.6 Apse decorations from Sant' Apollinare in Classe.

Stathis Trahanatzis

Patience and dedication are hallmarks of Stathis Trahanatzis's life as a painter. His most recent project, the interior decoration of The Assumption Greek Orthodox Church in Long Beach, California, is expected to take some six years to complete. Trahanatzis (b. 1938), is one of only a very few American artists who specialize in painting Greek Orthodox religious icons in the manner of Byzantine art. He believes his specialty is time well spent, saying, "My hope is that people who see these icons will temporarily be transported from this world. . . ."

Trahanatzis was born in Greece. He recalls feeling frustrated in kindergarten because he was eager to mix paints and impatient with learning the alpha-bet. It was his childhood dream to paint the neighborhood church. Eventually Trahanatzis studied art in Paris and sold portraits and landscapes to make a living. At the age of twenty-two, however, he returned to Greece to study the Byzantine painting tradition. Trahanatzis augmented those studies with numerous trips to see the work of anonymous artists in churches throughout the world. It was a lengthy apprenticeship but one that enabled him to work skillfully in the exacting Byzantine tradition.

It isn't always prudent for Trahanatzis to follow every Byzantine technique exactly. To lessen the risk of earthquake damage to his work, for example, Trahanatzis paints his images onto a canvas that is later pasted onto the plastered ceiling and walls. In the event of a temblor, the canvas will be much easier to repair than if he had painted directly onto the plaster surfaces. Nevertheless, Trahanatzis spends a great deal of time atop wooden scaffolding 60 feet (18 m) in the air to carry out such tasks as applying the underlying layers of plaster and attaching the gold leaf that serves as a background.

Trahanatzis's work is physically demanding, but he views it primarily as a spiritual labor. Before Trahanatzis began, he spent several days praying and fasting to clear his mind of everyday, worldly concerns: "It takes a lot of concentration and spiritual preparation. When I am working I forget everything."

Figure 13.7 Stathis Trahanatzis. Dome ceiling painting in The Assumption Greek Orthodox Church, Long Beach, California.

1.5 million to about three hundred thousand. Magnificent temples, palaces, and amphitheaters were torn down, and the stone was used to erect fortifications to keep out the invaders. The effort was useless. Once-proud cities were overrun and their art treasures destroyed or carried off.

Growth of the Byzantine Culture

The classical world came to an end with the fall of the Western Roman Empire in the fifth century. However, the eastern half of the empire, now called the Byzantine Empire, continued to thrive for another thousand years. The city of Constantinople soon surpassed Rome in both size and wealth. It became the largest city in the medieval world and was a great cultural center with grand public buildings and fabulous art treasures.

In Constantinople, Roman, Greek, and Oriental influences were blended to produce a rich and brilliant art. Above all, this art glorified the Christian religion and served the needs of the Church. It set the standard for artistic excellence in western Europe until the twelfth century.

Byzantine Architecture and Mosaics

The best examples of the Byzantine style were great churches like the domed Hagia Sophia (Figure 13.8). Western architects favored the hall-like basilica plan for their churches, but those in the East preferred a central plan (Figure 13.9). Hagia Sophia, built in the sixth century A.D. by the emperor Justinian, was the greatest of these centrally planned churches. It replaced another church that had been ruined during political rioting some years before. Rebuilding it gave Justinian a chance to outdo Constantine, who had arranged for the original building.

Justinian hired two Greek math experts to design Hagia Sophia. The finished church beautifully blends the engineering skills of the Romans with a Greek sensibility for carefully balanced proportions. Its most impressive feature is the huge dome. Almost 200 feet (61 m) across, it is 31 feet (9.4 m) higher than the one used for the Pantheon. It differs from the Pantheon dome in other ways as well. The dome over the Pantheon is placed on a massive concrete drum made with thick concrete walls. Hagia Sophia's dome rests on four huge **piers**, *massive vertical pillars*, that support arches made of cut stone (Figure 13.10).

➤ How does this church differ from the basilica plan used in the Western Empire? Of which Roman building are you reminded when looking at this structure?

Figure 13.8 Hagia Sophia. Constantinople. A.D. 532–37.

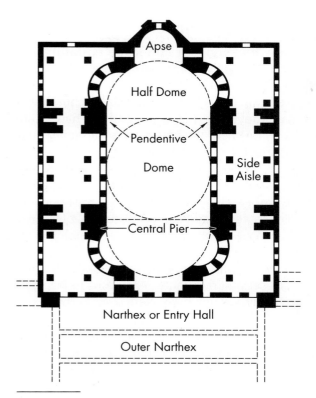

Figure 13.9 Ground Plan of Hagia Sophia

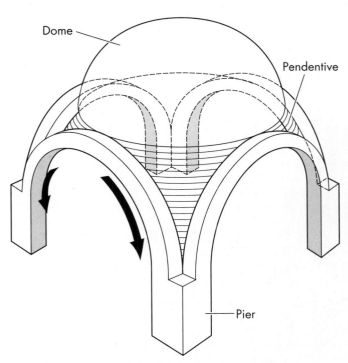

➤ The use of piers and arches in the construction of Hagia Sophia's dome allows more light to enter the building. Supporting the dome's great weight are four pendentives, the triangular portions at the corners of each arch. The arches are in turn supported by four piers.

Figure 13.10 Plan of Hagia Sophia Dome

By using this method of construction, the builders were free to erect thinner walls and add more windows to light the interior of the church. This method also creates the appearance of lighter weight. The great dome seems to soar over a row of windows placed around its base. As you look up at it, it is easy to understand how an astonished observer once said that it seemed as if the dome hung from heaven on a golden chain.

The Mosaics of Hagia Sophia

Inside, Hagia Sophia's dim lighting and richly shimmering surfaces combine to produce a dreamlike setting (Figure 13.11). Walls of stone and marble brought from Egypt and Italy are decorated with gold, silver, ivory, and gems. Worshipers are treated to a dazzling display of red and green marble piers, polished marble slabs, brilliant murals, and gleaming mosaics. Light filters into the church through rows of windows placed at several levels. Light from these windows illuminates the different colors of stone and marble, creating a spectacular effect.

Churches as large as Hagia Sophia required special decoration on the inside. Works of art had to be brightly colored and large enough to be seen from great distances. Mosaics were found to be the best way of meeting these needs. These brightly colored mosaics became a trademark of Byzantine churches. They were created to tell in glowing colors the familiar stories from the Bible. Often these stories made use

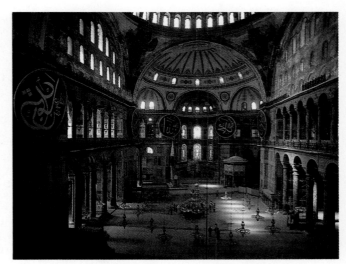

➤ Describe in detail the interior of this building. What principles of art help in unifying the interior? What do you think are its most impressive features?

Figure 13.11 Interior of Hagia Sophia

➤ The mosaics in this church are large and brilliantly colored. Why were they made that way?

Figure 13.12 *The Virgin and Child with the Emperors Justinian and Constantine.* A.D. 986–94. Mosaics from Hagia Sophia.

of symbols that were readily understood by the faithful. In Hagia Sophia, for example, a mosaic shows the Virgin and Christ Child between two figures (Figure 13.12). The figure on the left is the emperor Justinian carrying a small church, while the figure on the right is the emperor Constantine bearing a small city. The meaning of the mosaic is clear. The emperors are proclaiming the loyalty and dedication of Church and State to the Virgin and Child.

Refuge at Ravenna

The Byzantine style was not limited to just the eastern half of the empire. Contacts between East and West were not wholly broken off when Constantine moved his capital to Constantinople. They were maintained until the middle of the fourth century A.D. Also, trade between Constantinople, Venice, and other Italian towns lasted through the Middle Ages. Nowhere in Italy is the Byzantine style more obvious than in the city of Ravenna.

Ravenna had become the capital of the Western Roman Empire early in the fifth century A.D. The Roman emperor had moved to Ravenna because it was isolated and seemed to be a safe refuge from barbarian invaders. He was mistaken. Ravenna was captured in A.D. 476. With this, the last emperor of the West was forced to surrender his authority to the barbarian conquerors. Later, in A.D. 540, Justinian, the Eastern emperor, recaptured the city. It remained under Byzantine control for the next two centuries.

The Mosaics of San Vitale

Justinian had long dreamed of equaling the achievements of early Roman emperors. He saw his chance with the capture of Ravenna. He was determined to erect a great church in the city, a church that would rival anything his predecessors had built. When it was finished, the church was named San Vitale. It became the most famous church of that time.

Inside San Vitale, artisans created two mosaics on opposite sides of the apse (Figure 13.13). One of these shows the emperor Justinian with the archbishop, deacons, soldiers, and attendants (Figure 13.14). You should have no difficulty finding the emperor. His elegant attire, crown, and halo clearly set him apart from the others. The figures are tall and slender and have small feet and oval faces. They turn to face you and stare boldly through huge, dark eyes. Perhaps you find it odd that all the figures seem to float before a gold background. The gold color was used to add a supernatural glow to the scene. The gold makes it seem heavenly rather than worldly. A feeling of weightlessness is heightened by the lack of shadows and the position of the feet, which hang downward.

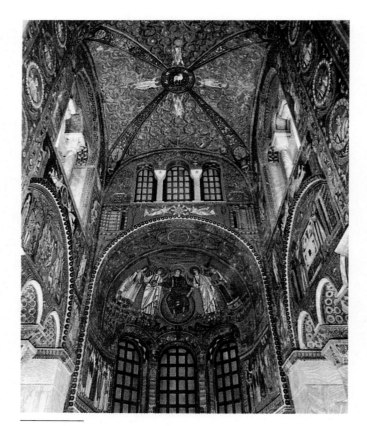

Figure 13.13 San Vitale. Ravenna, Italy. A.D. 526–47.

Some of the figures are even stepping on the toes of their companions, but, since they are floating, there is no sign of pain or annoyance by any of the injured parties. The bodies of the most important people overlap those of the lesser ones. However, the archbishop beside Justinian places his leg in front of the emperor's cloak. Perhaps this was meant to show that in spiritual matters the archbishop was the leader of all the people, including the emperor.

On the opposite wall facing the emperor and his party is his wife, the empress Theodora, and her attendants (Figure 13.15, page 296). Like Justinian, she is dressed in magnificent robes and wears the imperial crown. Observing her, you would never guess that this powerful woman was the daughter of a bear-keeper and was once a popular actress. Writers of her day agreed that she was charming, intelligent, and beautiful. However, on the wall of San Vitale, Theodora is shown as the equal of any saint in heaven. The great halo around her head is similar to her husband's. It is a symbol of their virtue and innocence and tells you that they are marked for future sainthood.

The emperor and empress are part of a solemn religious procession leading to the altar. They bear items used in the celebration of the Mass.

You would probably not describe the figures on the walls of San Vitale and other Byzantine churches as realistic or natural. They are flat and stiff and more

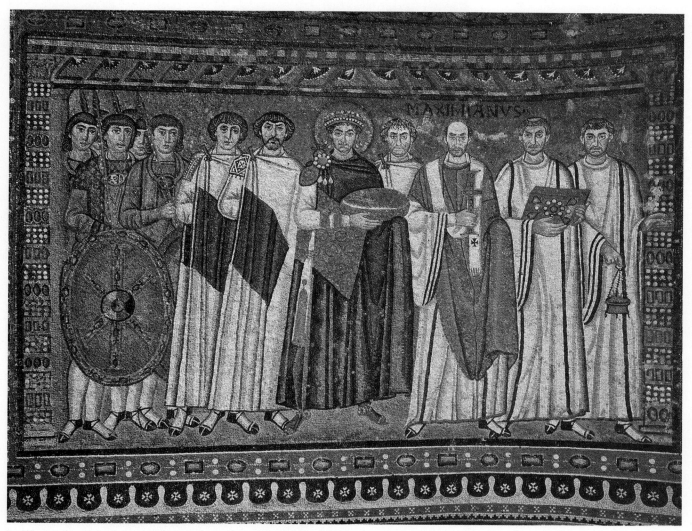

➤ What makes these figures appear to float? They seem to be engaged in some kind of ceremony. Would you say it was a civic, social, or religious ceremony? What clues did you use to make your decision?

Figure 13.14 *Justinian and Attendants.* c. A.D. 547. Mosaics from San Vitale.

abstract and formal than early Christian art. The figures give little suggestion of three-dimensional forms moving about in real space. Certainly they lack the beauty, grace, and lifelike qualities you observed in Greek and Roman figures, but these qualities were not sought by Byzantine artists. Their pictures were intended to be religious lessons presented as simply and clearly as possible. Thus, the lesson presented on the walls of San Vitale could be easily learned by anyone looking at the mosaics. Important to this lesson were the people shown in the mosaic. There was a reason for including important court dignitaries. It was necessary to show that people of their position were paying homage to God in order to gain salvation, and if they had to do so, then people of lesser status could do no less.

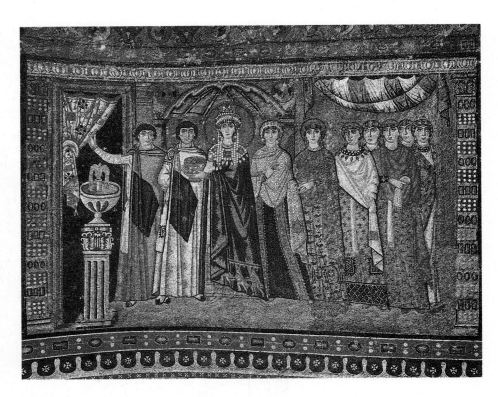

➤ Would you describe these figures as flat and stiff, or graceful and natural? What does their clothing tell you about these people? What do you think is more important in this work — its literal qualities or its expressive qualities?

Figure 13.15 *Theodora and Attendants.* c. A.D. 547. Mosaics from San Vitale.

SECTION ONE

Review

1. What part did symbolism play in early Christian art?
2. What form of art was used on the walls of basilicas? Why?
3. Tell why early Christian churches were often referred to as "Houses of Mystery".
4. What brought about the fall of Rome? When did this happen?
5. What name was given to the eastern half of the Roman Empire after the fall of Rome in Italy?
6. Which of the Byzantine Empire's cities replaced Rome in both size and wealth?

Creative Activity

Studio. The Byzantine church form is based on a cluster of domes. The large central dome is squared off at its base, forming *pendentives* — triangular wedges. Half domes are placed at the ends of the center dome.

Use a compass and ruler to create a geometric abstraction based on the principles of cluster-dome construction. Try cutting shapes from construction paper: circles, squares, half circles. Study the cross section and ground plan of Hagia Sophia in Constantinople (Figures 13.9 and 13.10, page 293). Try combining arch shapes from the section with top-view full-circle forms to enrich your design. Add ink lines.

Islamic Art

In the seventh century a religion known as Islam (which means "followers of God's will") emerged in the Middle East. The prophet of Islam was an Arab merchant named Muhammad who was born in Mecca around A.D. 570. Following the death of his parents, Muhammad was raised by an uncle. While a hardworking young trader, Muhammad learned the habits and languages of the wandering Arabs with whom he came in contact. His fortunes improved following his marriage to a wealthy widow, whose business he tended. In these years, Muhammad believed that he received personal revelations that forced him to challenge the current religion of the Arabs who worshiped many different idols.

The Teachings of Muhammad

Following years of meditation, Muhammad heard a divine call to be the last of the prophets and a teacher for all. He taught that there is only one god, Allah (in Arabic, "the God"), whose will should be followed in order for people to live just and responsible lives. At first Muhammad taught in secret, converting his wife, cousin, and adopted son. In 613, when he began to teach openly, Muhammad was opposed by those who wished to preserve established tribal and religious customs. He persisted, however, and today more than 925 million followers, called Muslims, honor him as the last and greatest of the prophets and their guide, the Messenger of God.

After Muhammad's death, messages that he received from God were assembled into the **Koran**, or Qur'an, *the holy scripture of Islam*. For Muslims, the Koran is the final authority in matters of faith. It also offers rules to guide the daily lives of Muslims.

A page from a Koran of the ninth century illustrates the skill with which Muslim artists used a decorative script to record Muhammad's revelations, laws, and moral stories (Figure 13.16). The top line of this page is a single word written in Arabic to be read from right to left. Observe how this line is designed to fit with the others on the page to form a visually pleasing, unified whole. Although you may find it impossible to read its message, you can still appreciate the design.

➤ What is the Koran? What religious leader was responsible for the messages contained in this book?

Figure 13.16 Leaf from Koran (Qur'an), in Maghribi Script. Islamic. North African. c. 1300. Ink, colors, and gold on parchment. 53.3 x 55.8 cm (21 x 22"). The Metropolitan Museum of Art, New York, New York. Rogers Fund, 1942.

Islamic Art in the Fertile Crescent

During the early centuries of Islamic history the center of the Muslim world was an area known as the Fertile Crescent, composed of parts of present-day Iraq, Syria, and Palestine (see map, Figure 13.3, page 288). This was an area where the constant blending of Eastern and Western cultures had left a stunning array of magnificent ruins. To these ruins, Muslim builders soon added their own impressive structures including the **mosque**, or *Muslim place of worship*.

In the ninth century, the largest mosque in the world was built at Samarra in Iraq. Measuring 384 by 512 feet (117 x 156 m), it covered ten acres and could accommodate 100,000 worshipers. Today little remains of this huge prayer hall. Only traces of the 464 brick columns that once supported the flat, wooden roof can be seen. On the north side of the ruins, however, a **minaret**, or *spiral tower*, still stands (Figure 13.17, page 298). From a lofty perch on top of this minaret, a **muezzin**, or *prayer caller*, once summoned the people to group worship each Friday.

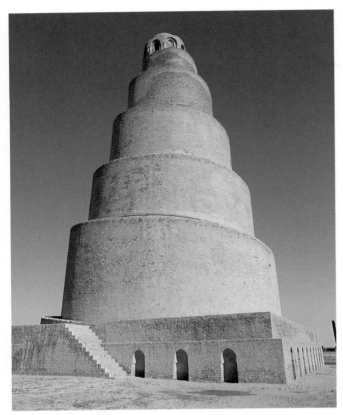

➤ From the outside, this building looked like a fortress. Name the tall tower at the corner of the mosque. Why was it built and what purpose did it serve?

Figure 13.17 Spiral Minaret of Al-Jami Mosque. Samarra, Iraq. A.D. 848–52.

Islamic Art in Spain

By 710, the religion of Islam had spread throughout North Africa, at times by persuasion and at times by force. In 711, Muslims crossed the Strait of Gibraltar and entered Spain.

The Muslim army advanced swiftly through Spain, encountering little resistance on the part of the disorganized Christian Visigoths who inhabited the peninsula. The Muslims then advanced into France where an army under the command of Charles Martel, the grandfather of Charlemagne, finally stopped them at Poitiers in 732.

Following this battle, the Muslims did not attempt additional invasions, choosing rather to consolidate their control of Spain and some other parts of southern Europe. The Muslims, known as Moors in Spain, remained on the peninsula for a period of almost eight hundred years.

Cordoba

At the height of Moorish power in Spain, Cordoba was one of Islam's most impressive capitals. In the ninth and tenth centuries it was reported to have over 800,000 inhabitants, 300 mosques, and 600 inns. People from all over Europe came for enlightenment and knowledge. There they gained the continent's first knowledge of algebra, paper, and glass. At a time when the rest of Europe was groping through the Medieval period, Cordoba was a splendid center of learning and art. All that survives today, however, are the remnants of a fortress—and the great mosque known as the Mezquita.

The first view of the Mezquita is not a memorable one. Its ancient brown walls marked by sealed, arched entries offer little hint of the pleasures that await inside its shadowy interior. Perhaps one of the most surprising features of this building is its lack of a façade.

Passing through an arch, the visitor enters a courtyard known as the Patio of the Orange Trees (Figure 13.18). Originally there were no walls separating this courtyard and the interior of the mosque. The court-

Figure 13.18 Patio of Orange Trees. Mezquita, the Mosque at Cordoba, Spain. A.D. 784–988.

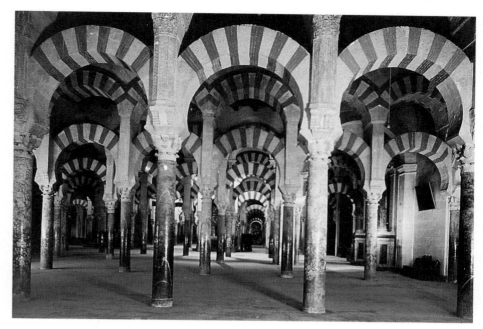

➤ Identify the capitals of these columns. Are they Doric, Ionic, or Corinthian? When and where did columns of this type originate? How does the interior of a mosque differ from the interiors of Christian churches you have studied?

Figure 13.19 The Mezquita Mosque at Cordoba (interior).

yard and the mosque were linked by the lines of orange trees outside and the rows of columns inside. Today, however, a wall separates them and trees grow at random.

Muslims worship five times a day—at sunrise, noon, afternoon, sunset, and evening. Private prayers can be offered anywhere, but group prayer takes place in the mosque at noon on Fridays. In Moorish times preparing for group worship involved ceremonial bathing. The fountains placed in the Patio of the Orange Trees were used for this bathing.

Stepping into the dark mosque from the bright Spanish sunshine is a shock to your vision. Once your eyes adjust to the dim light, you find yourself standing in an enchanting world, surrounded by a forest of polished marble columns that extend back into the darkness (Figure 13.19). Each pair of columns supports horseshoe-shaped arches decorated with yellow and red bands. These columns also support stone piers that carry a second tier of arches three feet above the first.

As you walk down one of the endless rows of columns, you cannot help but be impressed by the size of the mosque. The direction of the aisles guides you to the side of the building facing Mecca, the birthplace of Islam. (This is the direction Muslims face when praying.) Eventually, you notice a change in the arches over your head. They are now more ornate, and their colors have changed to creamy white and dark brown (Figure 13.20). You are nearing the most important part of the mosque, the mihrab.

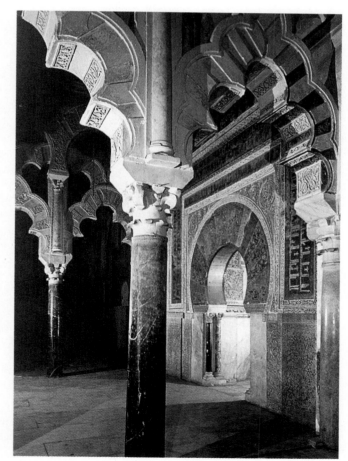

➤ What name is used to identify the most important part of a mosque? Why is this part of a mosque considered to be something of a mystery?

Figure 13.20 Mihrab. The Mezquita Mosque at Cordoba.

The **mihrab** is *a niche in the wall, which indicates the direction of Mecca and is large enough to accommodate a single standing figure*. It is richly decorated with a delicate stucco relief, incorporating passages from the Koran.

The interiors of Islamic mosques are unlike the interiors of Christian churches. Christian artists created religious images as a way of teaching the religion to people who could not read. Islamic artists, on the other hand, avoided portraying living creatures in mosques and other religious buildings, because they did not want in any way to diminish the greatness of God's creative power by portraying such forms. Instead, these artists decorated mosques and other religious structures with ornate calligraphy, geometric patterns, and stylized plants and flowers. Their skill in doing this is evident in the rich and varied visual effects concentrated around the mihrab.

The mihrab, a feature found in all later mosques, is something of a mystery. Its origins and purpose are still debated among scholars. Some think it may symbolize the place where Muhammad stood when teaching in his house. Others challenge this theory.

Whatever the mihrab's origins and purpose, the viewer does not forget its beauty. It is difficult to take your eyes from it, but eventually your eyes drift upward. There, in the dome that covers the area in front of the mihrab, you see how Moorish artists applied their decorative skills to perfection (Figure 13.21).

Madinat az-Zahra

Not far from Cordoba a tenth-century Moorish ruler, or *caliph*, decided to erect a palace — although when it was completed it was like no other palace in the world. It was more like an entire self-contained city extending upward in three levels — a mosque below,

➤ What single adjective best summarizes your reaction to this dome? Movies and novels have often depicted the Moors as barbaric and crude. Do you feel this dome looks like the product of a barbaric and crude people?

Figure 13.21 Dome before the Mihrab. The Mezquita Mosque at Cordoba.

> What made this Moorish palace so unusual? How many people were reported to work here? Why is this challenged today? If accounts of this palace are true, what do they tell you about the power and wealth of Moorish rulers?

Figure 13.22 The Palace at Madinat az-Zahra. Tenth century. Near Cordoba, Spain.

gardens at the center, and an **alcazar**, or *fortified palace*, at the top. Today only ruins remain, but if the legends associated with this building are true, it may have been the most luxurious palace ever built in Spain or anywhere else (Figure 13.22).

The palace at Madinat az-Zahra covered an entire hillside. According to contemporary accounts, the caliph's rooms numbered four hundred. Over four thousand marble columns supported the massive roof and there were so many fountains that it required eight hundred loaves of bread daily to feed the fish swimming in them.

Today the ruins at Madinat az-Zahra are the subject of controversy. Many feel that they are not large enough to support the ancient claim that twenty-five thousand people once worked here. However, descriptions of the palace at its height were written long ago by people who had actually seen it. Could this palace have been as vast and as magnificent as they described it? If so, it has crumbled away.

Occasionally, objects are found among the ruins at Madinat az-Zahra that rekindle the legends of its former greatness. One of these is a small ivory container only 4.5 inches (11 cm) high (Figure 13.23). Deeply carved into its tiny surface are pairs of lions, gazelles, and parrots placed within an elaborate vine scroll.

Granada

Granada, which resisted capture by the Christians until 1492, was the last great Moorish city in Spain. In the fourteenth century, while the rest of Europe was

> What makes the craftsmanship evident here so noteworthy? What design relationships would you be certain to take into account when making a judgment about this work?

Figure 13.23 Pyxis (detail). Spain. Tenth century. Ivory. 11.8 x 10.5 cm (4⅝ x 4³⁄₃₂"). The Metropolitan Museum of Art, New York, New York. The Cloisters Collection, 1970.

still struggling through a long period of turmoil, Granada realized the peak of an artistic period that had flourished for five hundred years.

Cordoba and Granada are both known for their impressive examples of Islamic architecture. However, Granada's remarkable Moorish fortress-palace, the Alhambra, or "red house," is more than a match for Cordoba's great mosque, the Mezquita.

The Alhambra is protected by an outer wall that can be entered at several well-fortified gates. The massive Justice Gate is the most impressive of these (Figure 13.24). This gate received its name from the tribunals that met there to try petty thieves. On the keystone of the outer horseshoe arch is carved a great open hand and on the keystone of the smaller arch within, a key is carved. While it is likely that these carvings represent Moorish law and faith, legend offers another, more colorful explanation.

According to an ancient Moorish story, the hand and the key are magical signs on which the fate of the Alhambra depended. The Moorish king who built the palace was a great magician who placed the entire structure under a magic spell. This spell protected the Alhambra over the centuries during which earthquakes and storms destroyed many other buildings. The spell would last until the hand on the outer arch reached down and grasped the key. Then the entire structure would crumble and the treasures hidden within by the Moors would be revealed.

The Court of the Lions at the heart of the Alhambra palace is impressive (Figure 13.25). It was built in the fourteenth century by Muhammad V around a massive, low-lying fountain, which gave the court its name. A delicate arcade supported by 124 marble columns is a reminder of the covered walkways found in monasteries throughout western Europe.

The fountain in the center of the court, with its crudely carved lions (Figure 13.26), seems out of place in this enchanting setting. The fountain has a poem carved in Arabic around the rim. It describes how fierce the little lions would be if they were not behaving themselves out of respect for the king.

➤ What was the Alhambra? How did this gate receive its name? Do you think an enemy would have difficulty gaining entry through this gate? Explain your answer.

Figure 13.24 Justice Gate. The Alhambra, Granada, Spain. Fourteenth century.

The columns and walls of the arcade and apartments around the Court of the Lions are filled with delicate stucco decorations. These consist of a variety of ornate designs, including bands of inscriptions from the Koran (Figure 13.27). Impressive today, they must have been especially beautiful in the fourteenth century. At that time they were brilliantly colored and gilded.

Moorish kings did not build for the future—they built for the present. Beneath the rich decorations of the Alhambra are assorted bricks and stones. As each new ruler ascended to the throne, he would tear down the structures of his predecessor to make room for his own new palace. These palaces were, however, all similar in that they grouped rooms around a central patio or court.

The End of Moorish Rule in Spain

Although they gradually lost parts of their kingdom to the advancing Christian armies, the Moors managed to maintain a presence in Spain until 1492.

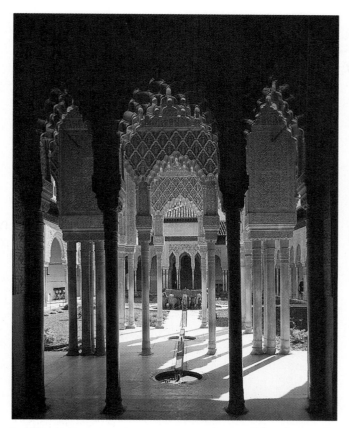

➤ What is this structure's most impressive feature? What does it tell you about the ruler who built it?

Figure 13.25 Court of the Lions. The Alhambra.

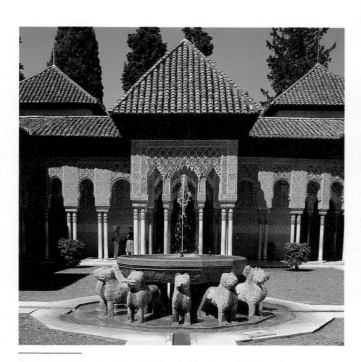

Figure 13.26 The Lion Fountain, Court of the Lions. The Alhambra.

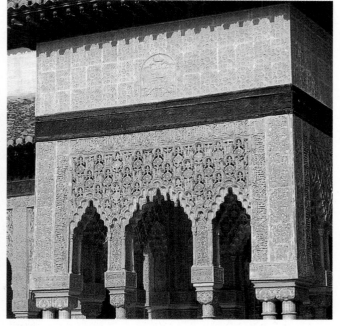

➤ Why do you think stucco decorations like these were so popular in Moorish Spain? What famous religious document provided the passages used in these decorations?

Figure 13.27 Detail of Stucco Decorations, Court of the Lions. The Alhambra.

Art · P A S T A N D P R E S E N T ·

The Brand Library

In Glendale, California, one can walk into the public library and learn about Islamic architecture. The Brand Library *is* an example of Islamic architecture, complete with minarets, domes, and horseshoe arches.

This library was once the home of Leslie Carlton Brand, who developed the city's utilities and owned the First National Bank. Called El Miradero, which means "high place with an extensive view," the building was inspired by Brand's visit to the World's Columbian Exposition in 1893. He was enchanted by the sight of the East Indian Pavilion, a magnificent structure that combined Moorish, Spanish, and Indian stylistic features. Brand immediately hired his brother-in-law, architect Nathaniel Dryden, to create a similar building on Brand's land in Glendale. Brand, committed to the project, then sent Dryden to India to learn more about the East Indian style of architecture. Completed in 1904, the mansion covers 5,000 square feet (465 square m). The grounds feature an aerodrome for Brand's small fleet of

Figure 13.28 Brand Library, Glendale, California.

planes, a clubhouse, tennis courts, a swimming pool, stables, goldfish ponds, orange groves, and a lake.

Brand deeded his home and its adjoining 488 acres (198 ha) to the city of Glendale with the provision that they be used for a park and library after the death of his wife. He died in 1925 and his wife died in 1945.

In 1969, architects Raymond Jones and Charles Walton built a 21,000-square-foot (1,951-square-m) addition to the library, which, though modern in style, integrated with the original building's Islamic-style façade.

Following a period of intrigue, the last Moorish king, Boabdil, surrendered Granada and the Alhambra to the Christian monarchs, Ferdinand and Isabella.

With the surrender of Granada, the 781 years of Moorish rule in Spain came to an end. What happened to the Moors? The American author Washington Irving, who greatly admired the Alhambra, offers one answer to that question: "Ask the shores of Barbary and its desert places. The exiled remnants of their once powerful empire disappeared among the barbarians of Africa and ceased to be a nation. They have not even left a distinct name behind them, though for nearly eight centuries they were a distinct people." However, if the Islamic religion had vanished from Spain, its contributions had not. Muslim advancements in mathematics, medicine, architecture, and classical philosophy had profoundly affected European thought and helped make possible the European Renaissance.

Islamic Book Illustration

The furnishings of palaces and mosques in Spain and other parts of the Islamic empire revealed a love for rich, decorative effects. This same love is noted in the pictures created to illustrate Islamic books. By the year A.D. 1200, the art of book illustration reached its peak, particularly in Iraq and Iran.

Book illustrators were free to depict images that could never have been represented in mosques. Without the limitations placed on decorators of mosques, artists printed manuscripts with scenes of everyday pleasure. These included banquets, hunting scenes, incidents inspired by popular romantic stories, and even scenes from mosques.

In the sixteenth century, an artist named 'Abd Allah Musawwir painted a miniature illustrating a story. It

shows different scenes inside and outside a mosque (Figure 13.29). Within this mosque a young man listens intently to the wise words of his teacher. Seven bearded men nearby sit quietly or talk earnestly among themselves. Several other men peer out the ornate windows above. Outside another teacher approaches the door to the mosque where he is met by two beggars with hands outstretched. At the far left a man drinks from a jar while a youth at the right prepares to follow the custom of washing his feet before entering a holy building. Delicate flowing lines are used to draw each of these figures. However, they certainly do not appear to be lifelike. A lack of shading makes them look flat rather than round. This same flat appearance is noted in the rugs and floor tiles that seem to be hanging vertically. The artist has clearly elected to ignore realistic appearances in favor of rich, decorative patterns and intense, clear colors. A wide range of bright, contrasting colors adds to the freshness and vitality of the scene. Small areas of rich color are skillfully blended to create a work that would challenge the dazzling effects of the most precious jewel in a caliph's treasury.

➤ Notice the bright colors in this painting. Some of the pigments for the work were made by grinding precious metals such as gold and silver.

Figure 13.29 'Abd allah Musawwir. *The Meeting of the Theologians.* c. 1540–49. Colors on paper. 28.9 x 19 cm (11⅜ x 7½"). The Nelson-Atkins Museum of Art, Kansas City, Missouri. The Nelson Fund.

Review

1. Who was Muhammad?
2. What is the Koran, and what role did Muhammad play in its creation?
3. What is a mosque?
4. What is the most important part of a mosque? Describe its appearance.
5. What is the Alhambra? Name and describe the architectural feature found at the heart of the Alhambra.
6. Describe the events leading up to the defeat of the Moors in Spain.
7. Who was the last Moorish king in Spain? To whom did he surrender the Alhambra?

Creative Activity

Studio. Persian miniature paintings are richly colored illustrations. To keep the flat effect that works well with Islamic calligraphy, these artists used several composition devices. One was to build upward in the picture plane instead of using perspective to move back into space. The figures in the back are the same size as those in the foreground but are placed higher in the picture. Another device is the combination of several planes into one — outside and inside spaces. Study Figure 13.29.

Plan a miniature-style painting of the inside and outside of your home, placing people in both spaces.

BYZANTINE-STYLE SELF-PORTRAIT

Supplies

- Pencil and sketch paper
- Small hand mirror
- Sheets of white drawing and black construction paper, 12 x 18 inches (30 x 46 cm)
- Tempera or acrylic paint
- Brushes, mixing tray, and paint cloth
- Water container
- Paper cutter or scissors (*See Safety Tip)
- White glue

CRITIQUING

- *Describe.* Is your drawing immediately recognized as a human face seen from the front? Are all the facial features shown? Which of these has been emphasized?
- *Analyze.* Are the different features of the face shown as large, simple, flat shapes? Is the face painted with intense colors? Does the use of contrasting subdued intensities for the background emphasize the face?
- *Interpret.* Does your "mosaic" self-portrait look solemn and dignified? What gives it this kind of an appearance?
- *Judge.* What is most successful about your self-portrait—its resemblance to your actual appearance, or its effectiveness in expressing a solemn, dignified feeling? Do you think your work is successful? Why or why not?

Paint a self-portrait as an attendant in a mosaic created in the Byzantine style. Show your face viewed from the front. Compose large, simple, flat shapes to represent the features. Make the expression on your face communicate the same solemn, dignified look as the Byzantine portraits. For emphasis, use intense colors to paint your portrait and colors in subdued intensities for the background. Cut your painting into 1-inch (2.5-cm) squares and assemble to simulate a mosaic.

Focusing

Examine carefully the mosaics showing Justinian and Theodora in Figures 13.14 and 13.15 on pages 295–296. What words best describe the feelings revealed by their faces? What details are expressed in those faces? Notice how the colors add to a dreamlike dignity.

Creating

Use a hand mirror and study your face. Complete several pencil sketches of your face, avoiding the use of small details. Select your best sketch and reproduce it lightly in pencil to fill the sheet of white drawing paper. Paint your self-portrait with a variety of intense colors. Select colors in contrasting values for the background to emphasize your self-portrait.

Cut your self-portrait into 1-inch (2.5-cm) (or smaller) squares. Arrange these squares on the sheet of black construction paper so that there is a 1/4-inch (6-mm) gap around each and glue them in place.

Exhibit your drawing along with those by other members of your class. Can other students pick your self-portrait out from the rest?

Figure 13.30 Student Work

Safety Tip

*Paper cutters should be used with caution. Use in a separate, uncrowded area. Hold materials to be cut with hand away from cutting blade.

CREATING A WORD DESIGN

Complete an india ink design made up entirely of words and parts of words inspired by a school or community event. Overlap the words throughout the design to produce a variety of shapes. Paint some of these shapes with india ink and leave others unpainted. Fill some with closely spaced ink lines to create gray areas and provide a simulated texture to your design.

Focusing

Examine the decorative script from a ninth-century copy of the Koran illustrated in Figure 13.16 on page 297. Why is this script visually pleasing to viewers even though they may not be able to read it? Turn to Figure 13.27, page 303, showing a stucco decoration. Why did Islamic artists use bands of inscriptions like these instead of paintings and relief carvings to decorate their buildings?

Creating

Identify a current event to serve as the source of ideas for words to use in your design. For example, a school election might suggest such words as *vote, candidate, politics, campaign,* and *ballot.* Identify at least five words.

Make several quick sketches in which you arrange your words into a visually pleasing design. Letters of the words may be in different block styles (upper and lower case), should overlap, and can even run off the page. Overlapping letters will result in a range of large and small shapes that will add variety to your design.

Use pencil to lightly draw your word design on the mat board. Paint in some of the letters and shapes produced by overlapping letters with india ink. Use a fine pen point to make closely spaced straight and curved lines in other shapes. Leave some letters and shapes white.

Figure 13.31 Student Work

Supplies
- Pencil and sketch paper
- Ruler
- Sheet of white mat board, 12 x 18 inches (30 x 46 cm)
- India ink
- Pens and penholders
- Small, pointed brushes

CRITIQUING

- *Describe.* Is your design made up entirely of words or parts of words? Is it possible to read any of these words or recognize any of the letters represented?
- *Analyze.* Did you use a variety of values in your design? Where are simulated textures evidenced? How were these textures made?
- *Interpret.* Were other students able to identify the event that inspired your design? What words or parts of words in the design helped them make this identification possible?
- *Judge.* What elements and principles contributed the most to the success of your design? Are these the same elements and principles that contributed to the success of the Islamic artworks illustrated in Figures 13.16 and 13.27?

Reviewing the Facts

SECTION ONE

1. When was the Christian religion made legal by the Roman emperor Constantine?
2. What were the catacombs?
3. Explain why early Christian paintings showed little interest in the beauty, grace, and strength of the human body.
4. Why did the Christians select the Roman basilica as a model for their churches?
5. Why were huge churches, such as Hagia Sophia, decorated with mosaics on the inside walls?

SECTION TWO

6. Discuss the historical importance of Muhammad.
7. Describe the interior appearance of the mosque at Cordoba.
8. How does the interior of an Islamic mosque differ from that of a Christian church?
9. List two elements and two principles of art used by the artisans who designed the dome before the mihrab in the mosque at Cordoba.
10. Explain the symbolism behind the great open hand and the key above the Justice Gate at the Alhambra.

Thinking Critically

1. **Synthesize.** You have read that the Christian basilicas were designed to allow large numbers of people inside to worship. Remember that the Greek Parthenon was a religious temple which people were not allowed to enter. Based on this contrast, what might you say about each religious culture?

2. **Compare and contrast.** List the similarities and differences between the Byzantine church Hagia Sophia and the Roman Pantheon. Consider the construction techniques of each building, as well as the elements and principles of art.

3. **Analyze.** Refer to Figures 13.14, page 295, *Justinian and Attendants*, and Figure 13.15, page 296, *Theodora and Attendants*. What art elements has the artist used to create harmony in these works? In what ways has the artist created variety?

Using the Time Line

Examine the time line and determine what year work began on Hagia Sophia. What great religious leader, discussed in this chapter, died one hundred years later? What important event, also mentioned in this chapter, occurred exactly one hundred years after his death? Explain why that event is considered to be so important.

| 500 | B.C. | A.D. | 500 | 1000 | 1600 |

- Meeting of the Theologians
- Leaf from *Koran*
- The Alhambra
- Palace at Madinat az-Zahra
- Pyxis
- Mezquita Mosque at Cordoba, Spain
- Hagia Sophia at Constantinople
- Catacomb Ceiling Painting

Megan Fraser, Age 16
Klein Forest High School
Houston, Texas

Megan was fascinated by the symbolism used by the early Christian artists to disguise the meanings in their paintings, and she decided to do a project that incorporated symbols. She also decided to use a group of people arranged in a flat, linear format similar to the Byzantine mosaic *Theodora and Attendants* (Figure 13.15, page 296).

As the subject, Megan selected a family reunion, using her family as members of the group. Although she had not yet worked with paints, she decided to try acrylics for this project. She began by doing a pencil sketch and then roughed in the figures with paint. "I discovered that the faces were the hardest part for me to paint, and that the figures were very complicated, even though I tried to keep them primitive and simplified."

As the painting progressed, Megan thought about the symbols she would introduce, and she decided to design a border for her painting. "The circles symbolize the unity of the family. I also included clues to what matters to each of us, using individual symbols."

Megan discovered that she liked working with paints but that there was a temptation to continue trying to polish the piece, painting to a point where the freshness was lost. In evaluating the finished work, Megan was satisfied with its overall appearance and with the idea of including a border.

In using the symbols of the early Christian paintings and the shallow space favored by the Byzantine mosaics shown in the chapter, Megan linked two historical aspects of the period described in the chapter.

➤ *Family Reunion.* Acrylics on illustration board. 46 x 86 cm (18 x 34").

The Age of Faith:
Early Medieval and Romanesque Art

Objectives

After completing this chapter, you will be able to:

➤ List the contributions of Charlemagne and the monks to learning and the arts during the Early Medieval period.

➤ Identify the symbolism of Early Medieval paintings, illuminations, and sculptural works of art.

➤ Describe the structural changes that occurred with Romanesque churches.

➤ Create a woodblock print.

Terms to Know

ambulatory
cloister
feudalism
illuminations
monasticism
pilgrimage
serfs
tapestries
transept
tympanum

Figure 14.1 *Lindau Gospels* (back cover). c. 870. Gold and semiprecious stones. 35 x 27 cm (13¾ x 10½").
© The Pierpont Morgan Library, 1992. New York, New York.

The Byzantine Empire managed to survive for about one

thousand years, while the Western Roman Empire rapidly crumbled. During

this period, the court of Constantinople with its power, wealth, and learning had no

equal in the West. Meanwhile, western Europe struggled through a period of change. It

began with the fall of Rome and ended with the beginning of modern culture

in the fifteenth century. This period from about 500 to 1500 is

known as the Middle Ages, or the Medieval period.

SECTION ONE

Centuries of Change: The Early Medieval Period

At one time the Middle Ages were known as the Dark Ages, a label suggesting that they represented many blank pages in the history of Western civilization. However, a closer look has helped to fill in those pages with an impressive list of accomplishments. During this period, many of the important features of our modern world were born: parliamentary government and common law evolved; universities were started; present-day languages were born; and national states began to take shape. In art, the period was anything but dark. It was the most splendid of all periods for bookmaking. In addition, it was a time of a great architectural revival that led to the construction of magnificent structures known as Gothic cathedrals. The "Dark Ages" also saw sculpture grow in importance until it joined with architecture as an equal partner.

The Age of Faith

Perhaps a more accurate label for this period would be the Age of *Faith*. The hearts and minds of these medieval peoples were fixed on one all-important goal—the preparation for eternal life after death. Assisting them in the quest for that goal was the Church.

The Church was the only stable institution remaining in western Europe after the collapse of the Roman Empire. Its power and influence had an impact on the lives of kings and peasants alike. Political boundaries simply did not exist where the Church was concerned. Virtually everyone was born into the faith and was expected to place loyalty to the Church above everything else. This loyalty was freely given because the priceless gift of eternal salvation was promised in return.

Because of its length, it is helpful to divide the Middle Ages into three overlapping periods. They are: the *Early Medieval*, which dates from about the last quarter of the fifth century to the middle of the eleventh; the *Romanesque*, which, in most areas, took place during the eleventh and twelfth centuries; and the *Gothic*, which overlapped the Romanesque and continued in some areas into the sixteenth century. This chapter will deal with the Early Medieval and Romanesque periods. Chapter 15 will focus attention on the Gothic period.

From Charlemagne to Feudalism

The fall of Rome is considered the start of the Early Medieval period. This was a time of great uncertainty because the strong central government that had assured law and order to all Roman subjects was gone. The period was marked by conflicts, open warfare, and mass migrations of foreigners into and across lands formerly controlled by the Romans. Under these trying conditions, the Carolingian dynasty

was founded. Although it survived less than 150 years, this dynasty managed to bring about the revival of a strong, efficient government. Furthermore, it stimulated a renewed interest in learning and the arts.

The Role of Charlemagne

One man was largely responsible for the many accomplishments of the Carolingian dynasty. His name was Charles the Great, better known as Charlemagne. Already King of the Franks, Charlemagne was crowned emperor by the pope on Christmas Day in the year 800. Thus he became the first of the Holy Roman Emperors, although he chose not to use the title.

It seemed that Charlemagne was destined to restore the political unity that had existed during the time of the Roman emperors. His domain grew until it included all of the western part of the old Roman Empire except Britain, Spain, southern Italy, and Africa. Furthermore, his subjects enjoyed an efficient government and a remarkable level of law and order.

Beyond creating a great empire, Charlemagne did everything he possibly could to encourage learning and the arts. He ordered every monastery and abbey to establish a school where students could learn arithmetic, grammar, and the psalms. His most important achievement, however, may have been the preserva-

Figure 14.2 Europe

tion of ancient manuscripts. He invited scholars from England and Ireland to his court to rewrite old texts and prepare new ones. It is to Charlemagne's credit that many of the ancient documents we have today were copies made by scholars working under his command.

The center and capital of Charlemagne's empire was Aix-la-Chapelle, now the German town of Aachen. (See map, Figure 14.2.) Here he set up his court and tried to restore the splendors of ancient Rome. Statues were brought from Italy, baths were constructed, and a chapel was built (Figure 14.3) that closely resembled the famous Roman church at Ravenna (Figure 13.13, page 294).

Unfortunately, Charlemagne's empire and the strong central government ended shortly after his death in 814. By the close of the ninth century, civilization in western Europe was in a shambles once again. Weak central government and the need for protection led to the formation of a governmental system known as feudalism.

The Rise of Feudalism

Feudalism was *a system in which weak noblemen gave up their lands and much of their freedom to more powerful lords in return for protection.* The lord allowed the former owner to remain on the land as his administrator. The administrator was the servant, or vassal, to the lord and pledged total loyalty to him.

Most of the people, however, were **serfs**, or *poor peasants who did not have land* to give in return for protection. These people worked the land and went along with it when it was handed over from one nobleman to another. Serfs lived in small villages and toiled in the open fields nearby. In payment for protection, they were required to turn over a share of their annual harvest to the lord or his vassal. The peasants were allowed to keep only enough food to feed themselves.

➤ The capital of Charlemagne's empire was Aix-la-Chapelle (now Aachen), Germany. It was here that he built his palace and tried to recapture the glories of Rome.

Figure 14.3 Palace Chapel of Charlemagne. Aachen, Germany. 792–805.

Churches and Monasteries

Like their early Christian ancestors, Medieval church builders used Roman models. The Roman civic basilica continued to be the most popular type of structure for religious services. You may recall that the basilica featured a rectangular plan, which was divided on the inside to form a nave, or central aisle, and two or more side aisles. Light from windows in the walls of the nave above the side aisles lit the interior of the building. As in the early Christian church, at one end of the nave was the main entrance, and at the opposite end was a semicircular area known as the apse. An altar was placed in the apse in plain view of the people who assembled in the nave.

During Charlemagne's time, a few changes were made in the basic basilica plan. Some churches were built with a **transept**, *another aisle that cut directly across the nave and the side aisles*. This aisle was placed between the apse and the main entrance and extended beyond the side aisles. Seen from above, the addition of this aisle gave the church the shape of a cross. Thus the transept not only increased the space inside the building but also added to its symbolic appearance. Occasionally, towers were also added to the outside of the churches. These towers were to influence church construction in western Europe for centuries (Figure 14.4).

Unfortunately, most of the churches erected during the Early Medieval period were made of timber. Warfare during the ninth and tenth centuries and accidental fires destroyed most of these. Today, only a few heavily restored buildings remain.

The Spread of Monasticism

Throughout the long Medieval period, there were people who labored in the service of learning and art. Charlemagne was the most famous of these, but there were others whose names have not come down to us. Many were monks, devoted religious men who lived under a strict set of rules in remote communities called monasteries.

Monasticism refers to *a way of life in which individuals gathered together to spend their days in prayer and self-denial*. It had its roots in the Near East as early as the third and fourth centuries A.D. At that time, some people began to feel that the Church had become too worldly. As a result, they sought lives of quiet contemplation and prayer in the wilderness or desert. Eventually, groups of men with the same spir-

itual goals banded together. They formed religious communities far removed from the rest of society. Each monk was provided with little more than an isolated, barren cell or cave where he spent his time in prayer and sacrifice.

The Monastery of San Juan de la Peña

Monks built their monasteries in remote places. Often the monasteries were carved out of deep forests or perched on the rocky slopes of mountains. Most of the earliest medieval monasteries have long since crumbled away, but in northern Spain, deep in the forests covering the foothills of the Pyrenees Mountains, you can still visit the ruins of one of these ancient monasteries. Even today it is isolated and difficult to find, but the search is well worth the effort. Positioned dramatically within a huge cave at the end of a narrow gorge, it still manages to stand proudly

➤ Of what other type of medieval building does this church remind you? In what ways were they similar?

Figure 14.4 Village Church. Ujue, Spain. Eleventh century.

after nearly nine hundred years—the Monastery of San Juan de la Peña.

Centuries of neglect have allowed the once-fertile fields and lush pastures of San Juan de la Peña to return to the wild. Here and there among the weeds, a few stones piled one on top of another are the only remnants of walls erected by the industrious monks. Silent now, the monastery was once filled with the solemn chants of monks at prayer.

Like many ancient structures, the history of San Juan de la Peña is shrouded in legend, but none is more interesting than the building itself. From the outside, the thick stone walls and small windows give it the look of a fortress. Inside it is dark and damp. Walking through it you soon find that the windows are too small and too few for light or ventilation. It is difficult to make out details in the dim light as you pass from room to room. Dark smoke stains on the

walls tell you that torches were once used to light the interior. The rooms are empty; no furniture remains, of course, but there was little to begin with. You remember that the monks took a vow of poverty, but standing in the barren, gloomy interior of San Juan de la Peña you can appreciate the full meaning of that vow.

You make your way to a flight of stairs which leads to an upper story. There an arched doorway beckons. Stepping through it, you find yourself in the sunlight once more, standing in an open court with the massive, projecting wall of the cliff overhead. This was the **cloister**, *a covered walkway surrounding an open court or garden* (Figure 14.5). It is as peaceful now as it was centuries ago when the monks, weary from their work in the fields, would come here to pray.

Much emphasis was placed on private prayer and contemplation in the monastery. Typically, this was

➤ Judging from its outside appearance, do you think the inside of this monastery was very comfortable? What kind of sites were preferred for monasteries? What contributions did monasticism make to the society of the time?

Figure 14.5 Monastery of San Juan de la Peña. Near Jaca, Spain. c. 922.

done in the cloister, where the monks spent several hours each day. Generally, the cloister was attached to one side of the church, linking it to the other important buildings of the monastery. Here, in all kinds of weather, the monks came to pray, meditate, and read from books they received from an adjoining library.

Art of the Early Medieval Period

No doubt you would be surprised by the appearance of a Medieval library. Frequently it was little more than an alcove located off the cloister and the number of books on its shelves was modest, perhaps only twenty or so.

Manuscript Illumination

Perhaps no other art form captures the spirit of the Early Medieval period better than the illuminated manuscript (Figure 14.6). Until the development of the printing press in the fifteenth century, all books had to be copied by hand. Usually this was done by monks working in the monasteries. These monks were often men of great skill who took pride in their beautifully designed letters. Often they decorated manuscript pages with delicate miniature paintings done in silver, gold, and rich colors. For nearly one thousand years, these **illuminations**, or *manuscript paintings*, were the most important paintings produced in western Europe. It is surprising then that today many people pass them by in museums with little more than a fleeting glance. Perhaps, too, they fail to realize that these manuscripts contain the precious ideas of the past. They contain ideas preserved for later ages by dedicated men who were so humble that they rarely identified themselves.

Sheltered from the rest of the world by mountains and forests, writing painstakingly in Latin, Medieval monks were skilled in the use of words. They sought to pass on the ideas of classical writers and church fathers. Often they phrased these ideas in beautiful and complex ways. The inspiration and skill that they gave to their work was no less than that offered by the painter, the sculptor, or the architect.

Throughout the Medieval period, it was customary to illustrate manuscripts of the Gospels with small paintings of the four Evangelists. A symbol was usually used to help the reader identify each of these

➤ Why are illuminated manuscripts so important to us today? How were they produced? Who produced them? Do you think this was an enjoyable task?

Figure 14.6 *St. John*, from the *Franco-Saxon Gospels*. c. 850. The Pierpont Morgan Library, New York, New York.

Gospel writers. Matthew was symbolized by an angel; Mark, by a lion; Luke, by a bull; and John, by an eagle. A painting of Matthew (Figure 14.7) from a ninth-century Gospel book created in Reims, France, shows the Evangelist seated before a small writing table. His left hand holds an ink container shaped like a horn, while a quill pen is clutched in his right. However, it is clear that the artist who painted this picture was interested in presenting more than a realistic portrait of Matthew. This is not a picture of a scholar calmly recording his thoughts and ideas. It is a painting of an inspired man frantically writing down the words of God. The entire scene is filled with a dramatic vitality that sets everything in motion. The drapery swirls around the figure, while sketchy lines behind seem to push upward. Motion and not form is the main ingredient here. You are invited to share Matthew's excitement as he works furiously at the moment of inspiration to record the sacred message. He is only human, however, and he fears that the words will be

forgotten before he can write them down. His wide-open eyes, furrowed brow, and rumpled hair are clues to his intense concentration. A huge, clumsy hand guides the pen rapidly across the pages of his book. He struggles to keep up as an angel, Matthew's symbol, reads from a scroll on which is written the sacred text. It is Matthew's responsibility to pass these words on to the world. His expression and actions show that he is painfully aware of this responsibility.

The Church was the center for art and learning as well as religion during the Medieval period. It favored art that could teach and inspire the people in their faith. This was especially important at a time when most people could not read. The written portions of manuscripts were meant for the few people who could

read, while the illustrations were intended for those who could not. The messages contained in the illustrations had to be simple and familiar so everyone could understand them. For this reason, the pictures often told the same Scripture stories that the people heard every Sunday in church sermons.

Other Religious Art

These Scripture stories were not just told on the pages of manuscripts. In the twelfth century an unknown artist carved the familiar story of Adam and Eve on several columns in the cloister of Santes Creus Monastery in Spain. The story was told in several scenes and can be read in much the same way that we read comic strips today. In one scene, God is seen

➤ What is this figure doing? Can you identify the object in his left hand? Point to the different lines found in this work. What effect is created by the use of these lines? Does this person look calm and collected, or active and excited? Do you think he regards his task as an important one? How can you tell? What seems to be more important here, the literal qualities or the expressive qualities?

Figure 14.7 Carolingian Manuscript. *St. Matthew*, from the *Gospel Book of Archbishop Ebbo of Reims*. c. 830. Approx. 25.4 x 20.3 cm (10 x 8"). Bibliothque Municipale, Epernay, France.

looking for Adam and Eve, who cover their ears and hide from him (Figure 14.8a). They have already eaten the forbidden fruit of the Tree of Life and cringe in fear and shame. In the next scene (Figure 14.8b) an angel drives Adam and Eve from the garden of paradise while they clasp their hands together and look heavenward for forgiveness and pity.

The efforts of medieval artists may seem crude and even amusing to you today. However, you should not make the mistake of judging them solely in terms of their literal qualities. Rather, they should be judged for their expressive qualities—for the feelings and ideas that they tried to pass on to the people who viewed them.

➤ Do these people look like real people? Why or why not? Describe their actions and their expressions. Could you determine who these people are and what is happening to them by simply studying the carvings?

Figure 14.8a *Adam and Eve.* Relief carving on a capital from the cloister, Santes Creus Monastery. Near Tarragona, Spain. Twelfth century.

➤ Since these people are neither realistic nor beautiful, must these works be considered unsuccessful? Can you think of a reason why they could be called successful works of art? What is your reason?

Figure 14.8b *Adam and Eve Banished from the Garden of Eden.*

SECTION ONE

Review

1. Name the contributions made by Charlemagne to learning and the arts.
2. What is meant by feudalism?
3. What is monasticism? Where and when did it originate?
4. What is a cloister? Where is it found, and what purpose does it serve?
5. Name and describe the decorations used on Early Medieval manuscript pages.
6. Give several examples of symbolism used by manuscript illustrators.
7. Describe the type of art favored by the Church during the Medieval period.

Creative Activity

Humanities. Dance combined with pantomime and dramatic hymns was a part of the Christian religious ritual from earliest times. By the Middle Ages, these dances had developed into mystery plays, performed on the *ballatoria*—dancing pavement—in front of the church. They included dances symbolizing follies such as greed, ambition, or violence.

An outgrowth of this kind of drama was the miracle play, performed by troupes of professional actors who traveled in high wagons.

Plan a mystery play, a miracle play, or a dance symbolizing follies. Plan characters to represent these follies and choreograph actions for them.

The Romanesque Period

The art of the Early Medieval period began to take on new features and abandon others until a new artistic style known as Romanesque emerged. This new style was especially apparent in architecture. Churches began to dot the countryside in greater numbers, and most of these had many features in common. Of course, it is impossible to say when the Early Medieval style left off and the new style began, but by the eleventh century the Romanesque style appears to have been accepted throughout most of western Europe. It continued to thrive until the middle of the twelfth century when another style, Gothic, appeared on the scene.

The Effects of Feudalism

The feudal system, which had originated in the ninth century, reached its peak during the Romanesque period. It contributed to the constant disputes and open conflict that continued to mar the Medieval period. Under this system, land was the only source of wealth and power, but the supply was limited. A nobleman hoping to add to his estate might do so by marriage, but this was not always possible. If he was already married or there was no suitable bride, he often turned to a second course of action — war. Nobles, lords, and kings were constantly fighting each other in order to protect or add to the land under their control.

Life in the Castles

With warfare unchecked, nobles found it wise to further fortify their dwellings. Towers of stone were built by the late eleventh century, and by the twelfth century the now-familiar stone castle had evolved (Figure 14.9). With its towers, walls, moat, and drawbridge, the castle became the symbol of authority during the Romanesque period.

Although the life of the nobles centered around the castle, it could hardly have been a comfortable place. Its main purpose was defense, and this eliminated the possibility of windows. The thick outer walls were pierced only by narrow slots through which archers could fire upon attackers. Stairs were steep and passageways dark and narrow, making movement difficult. The drafty rooms were usually sparsely furnished and lacked decoration. Occasionally **tapestries**, *textile wall hangings that were woven, painted, or embroidered with colorful scenes*, were hung to help relieve the monotony of the gray stone walls. However, these were intended to keep the dampness out rather than add a decorative touch to the gloomy interior. In cold weather, the only warmth came from

▶ Why did nobles find it necessary to fortify their dwellings? Do you think the people inside this fortress were well protected? Point to the features that made this castle so secure. Why did the builders choose not to add more windows for light and ventilation?

Figure 14.9 Castle of Peñafiel, Spain. c. Fourteenth century.

Art · P A S T A N D P R E S E N T ·

Marine Mammal Quilt

Tapestries were once hung on castle walls to help keep out the dampness. They also relieved the drabness of the stone walls with their colorful scenes. Today, wall hangings sometimes do more than that.

In 1982, The Marine Mammal Center of Sausalito, California, began to develop a marine mammal quilt for the purposes of public education and public relations. The Marine Mammal Center was founded in 1975 to help, rescue, treat, and study ill or injured marine mammals. Since its inception, The Center has brought hundreds of endangered marine mammals, such as sea lions, otters, dolphins, and seals, back to health and has returned them to their natural habitat.

The quilt, measuring 7 × 8 feet (2 × 2.4 m), was designed to depict thirty marine mammals with scientific accuracy. Dozens of artists, needlework experts, and quilters contributed to the design and production of the quilt. Artists from both coasts as well as the Midwest joined together to create this beautiful wall hanging. The artists who donated designs include some of the finest marine mammal and wildlife artists in the United States, such as Richard Ellis, George Sumner, and Larry Foster. Needlework appliqué experts worked on the project, and the East Bay Heritage Quilters donated the time and effort of several top quilters to direct the quilting. The creation of the marine mammal quilt was truly a community event.

Figure 14.10 Marine Mammal Quilt

The quilt, designed to travel to museums and oceanariums throughout the United States, is accompanied by exhibits on the natural history of marine mammals, rehabilitation processes, and the quilt-making process.

Certainly this wall hanging was created to do more than keep out the chill!

fireplaces, the largest located in the great hall where the family gathered and meals were served.

In addition to the great hall, there were a kitchen, storage rooms, and bedrooms. Again, there was little furniture beyond a large canopied bed. Heavy curtains hung from the canopy to keep out drafts at night after the fire died out. Often the bedroom was home for any number of hounds, birds, and even farm animals. It was not uncommon for noblemen to keep their favorite horse in the bedroom.

The Growth of Cities

Castles remained important as long as the feudal system flourished, but the growth of trade and industry in the thirteenth century brought about an economy based on money rather than land. Cities sprang

up, and castles became more and more obsolete. Mighty stone walls which had withstood siege and assault fell victim to time and neglect.

The still-unsettled times made it necessary to erect barricades around the towns. Wooden walls were used at first, but these were replaced during the twelfth and thirteenth centuries by more sturdy stone barricades. An early example of such a stone wall still surrounds the historic city of Avila in Spain (Figure 14.11). Often referred to as one of the most ambitious military constructions of the Middle Ages, it measures more than 1.5 miles (2.4 km) and contains eighty-eight towers and nine gates.

Town walls may have succeeded in keeping out plunderers, but they created problems as well. As more people moved into a town, space ran out and

Figure 14.11 City Walls, overlooking River Adaja. Avila, Spain. Eleventh century.

overcrowding resulted. To solve this problem, buildings were built higher, sometimes reaching heights of seven stories or more. The amount of space inside was increased by building each story so that it projected out more and more over the street. As a result, it was not unusual for people on the top floor of one building to carry on a conversation easily with those living at the same level in the building across the street. Of course, this method of construction made the narrow streets below very dark (Figure 14.12). However, that was hardly the most serious problem. People developed the annoying habit of throwing their refuse out the windows onto the street below. Pedestrians had to keep a sharp eye turned upward to avoid being showered by someone's trash. In a noble gesture to protect their ladies' clothing, gentlemen formed the habit of walking on the outside. Their ladies' clothing was in

danger not only from the refuse raining down from overhead, but also from the water splashed by passing carriages. The custom of walking on the outside was continued by gentlemen in western European countries over the centuries and was even carried to America. In many places, it is practiced to the present day.

Romanesque Churches

Every town had one thing in common — in its center stood a church (Figure 14.13). During the Romanesque period, the Church increased its influence on the daily lives of the people. It offered comfort in this life and, more important, it provided the means to salvation in the next. It is not surprising, then, that the entire community joined in when the need for a new church arose. The richly decorated stone churches of the eleventh and twelfth centuries are a testimony to the power of the Church, the faith of the people, and the skill of the builders.

➤ Why was the Church such an important institution in the Medieval period? In what ways did the Church provide work for artists?

Figure 14.13 Church of Santa Maria. Sangüesa, Spain. Twelfth to thirteenth centuries.

Figure 14.12 Narrow, dark street in Viana, Spain.

Pilgrimage Churches

The Church at this time placed great importance on piety and encouraged people to take part in pilgrimages. A **pilgrimage** is *a journey to a holy place.* These journeys were a visible sign of religious devotion. People would band together and travel under often hazardous conditions to pay homage to saints and relics in far-off churches. They believed that by praying before the sacred remains of a saint, a plentiful harvest could be assured, diseases could be cured, personal problems could be solved, and the promise of eternal salvation could be achieved.

▶ Who were the pilgrims who made the dangerous journey to visit this famous cathedral in northwest Spain? What brought them here? What did they hope to receive in return for making this journey? Why was it necessary to build churches this large?

Figure 14.14 Cathedral of Santiago de Compostela, Spain. Eleventh to thirteenth centuries.

The Holy Land and Rome were the destinations for many of the early pilgrimages. However, the long journey to the Holy Land was very dangerous and was undertaken at great risk. A pilgrimage to the shrine of St. James at the Cathedral of Santiago de Compostela (Figure 14.14) in northwest Spain became an acceptable substitute. Soon churches and shelters were being built along this pilgrimage route in southern France and northern Spain. Builders continued to use the Roman basilica plan, but the churches were made larger to hold the great number of pilgrims that visited them.

In order to increase the size of a Romanesque church, the nave and transept were extended and two more aisles were added, one on each side. Often, an **ambulatory**, *an aisle curving around behind the main altar*, was added as well. This aisle made it easier for religious processions and groups of pilgrims to move about inside the building.

Large numbers of priests also took part in pilgrimages, and they were required to say Mass every day. This meant that more altars had to be provided in the churches along the pilgrimage routes. These altars were placed in small, curved chapels built along the transept and the ambulatory. The chapels, projecting out from the building, became a familiar part of a Romanesque church (Figure 14.15).

One of the biggest problems faced by Romanesque builders was how to construct stone roofs over their huge churches. They solved the problem by again turning to methods developed by the Romans. The Romans had been able to roof large areas by creating a series of arches to make a barrel vault (Figure 9.10, page 195). Romanesque builders used this same technique. However, it meant that they had to build thick, solid walls and huge pillars to support the outward and downward pressure of the heavy stones above. The weight of the roof made it dangerous to place windows in the walls because this would weaken the walls. Even though great care was taken, Romanesque builders were not always successful. In 1255, part of the roof of Cluny Abbey in France suddenly collapsed because the walls were not strong enough to support it.

The Church of San Sernin in Toulouse

It was in France that the Romanesque style reached its peak in architecture. Perhaps no structure better illustrates this style than the Church of San Sernin in Toulouse (Figure 14.16).

Surveying this church from the outside, you would probably be impressed by its large size and solid ap-

> Chapels projecting out from churches were a familiar feature of Romanesque architecture. Why was it necessary to build these tiny chapels? These chapels were built inside the church along what two areas?

Figure 14.15 Santillana del Mar Collegiate Church, apse exterior.

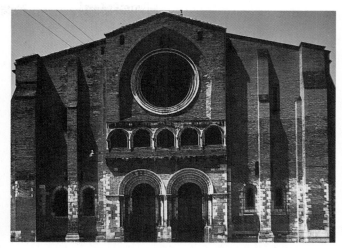

> Note the main features of this building. In what ways is this church like a castle? Do you think the inside is light and graceful, or dark and massive? On what do you base your decision?

Figure 14.16 San Sernin. Toulouse, France. c. 1080–1120.

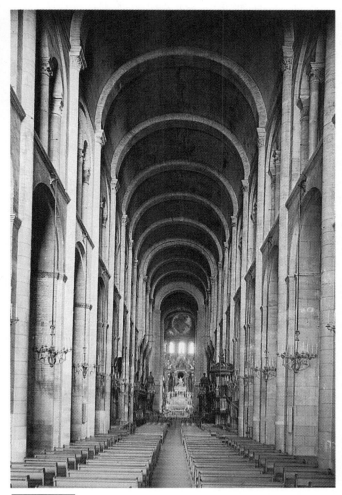

Figure 14.17 Interior of San Sernin, looking toward the apse.

pearance. A huge octagonal tower rises from the center of one end of the structure. With its small windows and lack of ornamentation, this tower gives the building a fortresslike appearance. It is no wonder that churches like this came to be known as Fortresses of God.

Inside, the church is spacious, but dark and gloomy. A few steps lead down into the wide nave; on either side are two other aisles. A series of massive, closely spaced piers lines the nave and separates it from the aisles on either side. These form a majestic arcade of arches leading from the main entrance to the altar at the far end of the church (Figure 14.17). Above, barely visible in the dim light, is the rounded ceiling of the barrel vault. There are no surprises inside such a church. The nave, side aisles, transept, apse, and ambulatory are quickly identified. After a short

stroll through it, you could easily sketch a plan of the building. Such a sketch would reveal that the church is laid out in the form of a huge cross (Figure 14.18).

Many feel that the overall impression of San Sernin is one of quiet strength and dignity. Indeed, there is little about it to suggest lightness and grace, nor could you describe it as fancy or ornate. It is simple and direct. With its massive walls, small windows, and durable tower, it has the look and feel of a stone castle.

What goings-on would you have witnessed if you had walked inside this Romanesque church on a typical Sunday morning over eight hundred years ago? No doubt you would be surprised at some of the things happening around you . . .

As you enter the cool, dim interior of the church, you are struck by the contrast with the warm, bright sunlight outside. In those first few moments while your sight adjusts to the darkness, your other senses are sharper. The first thing you become conscious of is the noise. Your ears are flooded with all kinds of sounds, such as rustling, humming, and clattering. Next you are struck by the strong scent of incense and candle wax. Finally, aided mainly by the small, high windows and rows of flickering candles, your eyes begin to take in the activities around you. People are seated in small

groups loudly exchanging bits of gossip gathered during the week. A knight struts by, stopping only long enough to threaten the snarling hounds at his heel. Beggars wend their way slowly through the congregation with outstretched hands to receive offerings. In return, they promise to say prayers for any ailment, problem, or desire. Merchants earnestly discuss the past week's business and argue over prospects for the next. Yet, in spite of the apparent disrespect, you observe that everyone's gaze constantly returns to the apse at the far end of the nave. There, before a richly decorated altar where the greatest number of candles glow, a priest solemnly celebrates the Mass. . . .

The Revival of Sculpture and Painting

The revival of the sculptor's craft was one of the important achievements of the Romanesque period. Many of the churches along the pilgrimage routes used relief sculptures as another way to teach the faith to people who were largely illiterate. Like manuscript illustrations, these stone carvings reminded people of the familiar stories from Scripture.

Two architectural features were found to be ideal places for relief carvings: the **tympanum**, the *half-round panel that fills the space between the lintel and the arch over the doorway of the church* (Figure 14.19), and the capitals of columns inside.

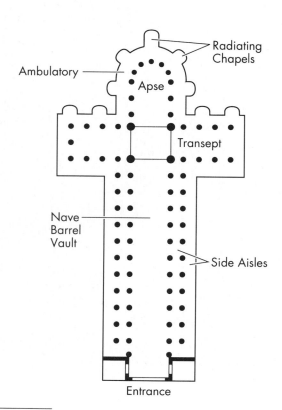

Figure 14.18 Plan of a Romanesque Church

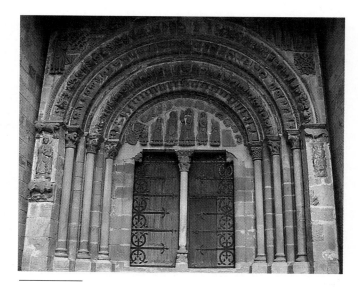

Figure 14.19 West portal and tympanum, Leyre Monastery. Province of Navarra, Spain. Twelfth century.

Tympanum Reliefs

The tympanum on the outside of the church was an area to which people naturally lifted their eyes as they entered the building (Figure 14.20). It was a perfect location for relief sculpture, and artists were quick to take advantage of it. The shape of the tympanum seemed to demand a large figure in the center, which became the focus of attention. Smaller figures were placed on either side of this central figure. It was soon found that a subject such as the Last Judgment was especially well-suited for this arrangement.

On the tympanum of the pilgrimage church of Santa Maria in Sangüesa, Spain (Figure 14.21), God the Father is placed in the center. He is surrounded by angels trumpeting the news that the Final Judgment has arrived. The row of figures below includes Mary holding the Christ Child, with the twelve apostles at either side. God is shown welcoming the chosen at his right, but with a down-pointing left arm (not visible in the illustration), he condemns sinners. In a far corner, St. Michael is seen weighing souls to determine who is worthy to enter heaven. The drama of this event

is suggested by the upright stance of the saved and the contortions of the condemned. Notice how the sinners are either falling or are being pulled backward to their doom.

Efforts were made to fit as many stories as possible into the space available on the front of Romanesque churches. This was certainly the case at Santa Maria

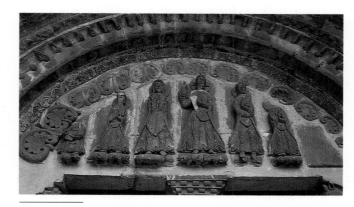

Figure 14.20 Tympanum of west portal, Leyre Monastery. Province of Navarra, Spain. Twelfth century.

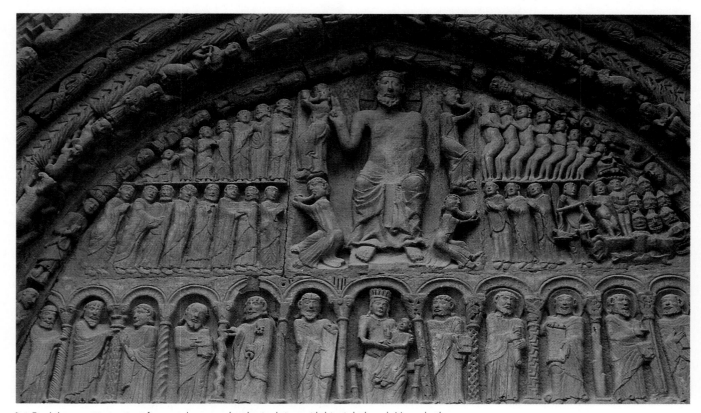

➤ Find the most important figure; observe what he is doing with his right hand. How do the figures on his right differ from those on his left? What do you think all this means?

Figure 14.21 *Last Judgment.* Tympanum, Church of Santa Maria. Sangüesa, Spain. Twelfth to thirteenth centuries.

in Sangüesa (Figure 14.22). There you will even find one of the few carvings of the hanged Judas Iscariot, as shown in Figure 14.23. Judas is the figure to the far right in the bottom row of figures, which flank the door on either side.

There is one feature of Romanesque carvings that might seem strange and out of place to you. It occurs often enough that once people are aware of it they begin to look for this feature, and they are rarely disappointed. There lurking among carvings of the Holy Family, church fathers, apostles, and saints are fantastic creatures, half man and half animal (Figure 14.24). They may be evil spirits or devils. Perhaps the artists who created them were trying to tell us that these spirits lie in wait everywhere hoping to snare the unwary. These grotesque combinations of animal and human forms may be a sign that artists were beginning to use their imaginations once more.

Capital Decoration

Inside churches and in cloisters, the capitals of columns were another excellent place for carvings.

Here, where the weight of the ceiling was met by the upward thrust of columns, the roving eyes of the faithful came to rest. Many medieval sculptors served their apprenticeships by carving these capitals with biblical scenes, human figures, birds, and animals. Once they had developed their skills, they moved on to carving larger scenes.

Romanesque capitals are often a curious mixture of skilled craftwork and quaint storytelling. For example, in a capital relief carving in the cloister of the cathedral at Tarragona, Spain (Figure 14.25), rats are seen carrying a "dead" cat to its grave. The wily cat, however, is only pretending to be dead as it is carried on the litter. In the next panel, it is shown jumping from the litter to claim its careless victims. There are several explanations for this carving. Some claim it is a rare example of medieval humor. Others say it was inspired by an old Spanish proverb that says, "The mouse is wise, but the cat is wiser." Then again it may be a reference to the Resurrection itself, indicating

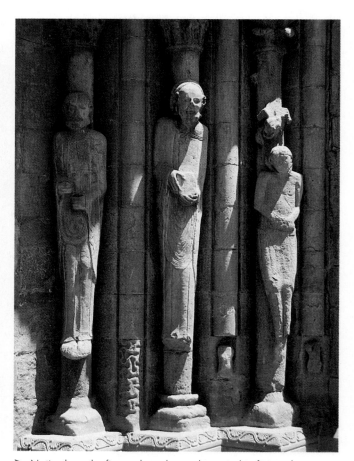

➤ Romanesque church façades like this one were known as Bibles in Stone. Can you tell why?

Figure 14.22 *Santa Maria façade. Sangüesa, Spain. Twelfth to thirteenth centuries.*

➤ Notice how the figures have been elongated to fit into the spaces between the columns. What is unusual about the figure on the right?

Figure 14.23 *Portal sculpture. Santa Maria façade. Detail, Judas. Sangüesa, Spain. Twelfth to thirteenth centuries.*

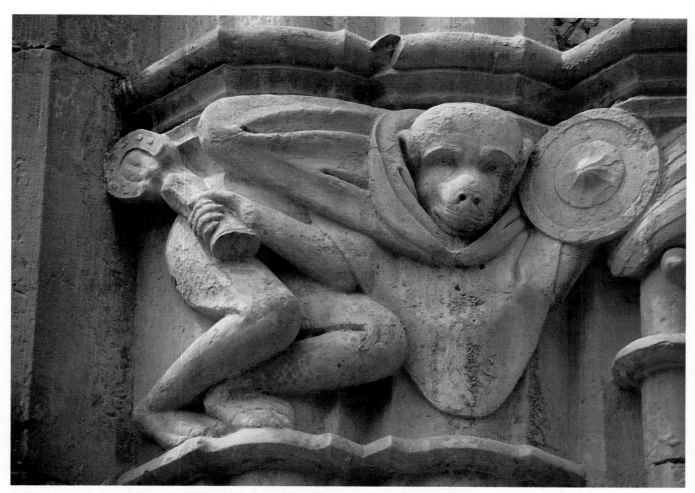

➤ Romanesque sculptors often included fantastic creatures among their carvings. What reasons could they have had for creating these unusual creatures?

Figure 14.24 Relief carving from the cloister, Santes Creus Monastery. Near Tarragona, Spain. Twelfth century.

➤ Identify the animals found in these relief carvings. There are two scenes to the story being told here. Reading from left to right, what is happening in each scene?

Figure 14.25 Left and right views of capital relief carvings from the cloister, Cathedral at Tarragona, Spain. Twelfth to thirteenth centuries.

that Christ's return from the dead will result in the destruction of his enemies. Of course, you may have your own interpretation of this scene. If so, you would join a legion of viewers who have tried for centuries to unravel the meaning behind this curious carving.

On a single capital in Pamplona, Spain, the artist presents a series of scenes in carved relief which deal with the death of Christ (Figure 14.26). The work is carefully designed to lead the viewer's eye around the capital from one scene to the next. The stories are clearly told, but not at the expense of unity. The relief is "low"—nothing projects beyond the contour of the capital. Its compactness adds to a monumental quality. This quality and a vivid narrative are trademarks of Romanesque sculpture.

Figure 14.26 Detail of capital carving, Cathedral at Pamplona.

➤ Notice how the artist used pointing fingers to lead your eye from one scene to the next. Do you think this work is noteworthy because of its precise carving or because it presents a story in an easily understood way? Is this kind of sculpture an effective design for a capital? Why or why not?

Figure 14.26 Capital carvings from the cloister, Cathedral at Pamplona, Spain. Twelfth to thirteenth centuries.

Constance Leslie

Ceramicist Constance Leslie (b. 1949) makes handcrafted, sensuously colored architectural details such as cornices, moldings, and columns. Although such elements are usually given less attention than a room's furnishings or fine art, they are the type of details that describe the personality of a space and give it a sense of completeness. Leslie says, "It's important to pay attention to the details in a room, just as it's important to pay attention to the details in life. I have a great respect for the artisans who once did this kind of work routinely."

Leslie did not always plan to specialize in ceramic columns. She earned a degree in sculpture at the Rhode Island School of Design in Providence, gradually realizing that "it was the immediacy of the clay modeling process that I liked best about sculpting," and so she chose to work as a ceramicist rather than a fine artist.

When traveling in Spain, Leslie became intrigued with the Romanesque columns that she saw, especially their figural and ornamental elements. She describes them as "a natural point of departure for sculpture. Architects have always played around with Romanesque columns in a way that they've never felt free to do with the Classical orders. In fact, I also love Corinthian capitals, and I'm now starting to play around with them, too."

Leslie works in an old horse barn that was converted into a studio complete with drawing table upstairs and a room to glaze and fire pieces below. She begins a project by making detailed watercolor renderings, sometimes consulting reference books for ideas such as how to color trout, one of her fa-

vorite three-dimensional motifs to adorn a column. With the help of an assistant, Leslie rolls out white clay with a rolling pin, cuts and shapes the clay, and then bisque-fires the piece. Later Leslie applies hand-mixed glazes and quick-fires the work by the Japanese raku method. This technique produces a finish with more depth than can be achieved using either commercial or traditional glazes.

Like many artists, Leslie creates pieces that mingle her aesthetic vision and her everyday interests. An avid trout fisher, Leslie says that she loves making trout because "the gleam on their bodies is exactly what the raku process produces. Perhaps when I'm sixty, I'll stop working in clay and go fishing."

Figure 14.27 Romanesque column. Completed 1987.

Church Wall Paintings

Large paintings decorating the inside walls of churches were also done during this period. Often artists were required to fit their paintings into a specific area. At San Clemente in Tahull, Spain, the painter took a familiar Byzantine theme and tailored it to fit within the apse of the church (Figure 14.28). Christ as Ruler of the Universe is seated on an arch representing the sphere of the universe with his feet resting on a semicircular shape. His right hand is raised in blessing, while his left holds an open book proclaiming his title as Supreme Ruler. He is surrounded by the four Evangelists. Below are several apostles and Mary holding the Holy Grail, the cup used by Christ at the Last Supper. The background is decorated with broad bands of color, a common feature of Medieval wall paintings. A bold use of line, brilliant colors, and a sensitive feeling for pattern are reminders of the manuscript illuminations produced during the same time. It is likely that many works like this one were painted by artists who also decorated the pages of Medieval manuscripts.

Miniature Painting in Religious Manuscripts

Miniature painting in religious manuscripts continued to be an important activity throughout the Romanesque period. The flattened look seen in figures carved in stone is even more obvious in these paint-

➤ How would you feel if you saw this huge figure peering down at you in a darkened church? Do you think this is a successful work? Would you support your decision by referring to the literal qualities, design qualities, or expressive qualities found here?

Figure 14.28 *Christ in Majesty.* Wall painting from San Clemente. Tahull, Spain. Twelfth century.

ings. There are no shadows and no suggestion of depth. Certainly Romanesque painters possessed the skill to reproduce more accurately what they saw, but they chose not to do so. Shadows and depth were simply not necessary. Painters were concerned mainly with the presentation of easy-to-understand religious symbols and not with the imitation of reality. This flattened quality is evident in an illumination from a gospel produced around the middle of the twelfth century in Swabia, a small territory in southwest Germany (Figure 14.29). Here an angel appears before a woman who raises her hands in surprise.

Followers of the Christian religion had no difficulty recognizing this scene as the Annunciation. The angel, with his hand raised to show that he is speaking, has just announced to Mary that she is to be the mother of the Savior. The easy-to-read message, flat, colorful shapes, and a bold use of line are common features in this and all other Romanesque paintings.

➤ How is this work similar to the carved reliefs you have been examining? Which of the two figures seems to be speaking? What makes you think so? Point to the clues that tell you that this is a religious painting.

Figure 14.29 *The Annunciation.* Leaf from a Breviary or Missal. German. Twelfth century. Colors and gold leaf on vellum. 15.2 x 12 cm (6 x 4¾"). The Metropolitan Museum of Art, New York, New York. Fletcher Fund, 1925.

SECTION TWO

Review

1. Name some familiar features of a castle.
2. What was the primary purpose of a Romanesque castle?
3. What was one of the biggest problems with medieval towns? How was this problem overcome?
4. Why was it necessary to increase the size of Romanesque churches?
5. What part of the church building is the tympanum? Where is it located?
6. Name two architectural features found to be ideal places for relief carvings.
7. Describe one kind of Romanesque sculpture that indicated artists were beginning to use their imaginations.
8. What was of greatest concern to the artists who painted the miniatures in religious manuscripts?

Creative Activity

Studio. Medieval manuscripts were done on *parchment*, or *vellum*—a material made from the underbelly skin of a calf, a kid, or a lamb. Parchment is a strong, translucent material that is still used today.

Parchment, or vellum, was an advancement over the papyrus used by Egyptians, but the Chinese had invented paper made from shredded plant and rag fibers in A.D. 105. It was not until about 1150 that papermaking spread to Spain. It reached Italy by 1275 and Germany by 1390. The Italians sized the paper by adding animal glue instead of the Chinese method of using rice paste, thus making a stronger paper.

Chinese rice paper is available in marvelously imaginative forms, with threads, flowers, even butterflies imbedded in it. Investigate paper production and make your own handmade papers.

WOODBLOCK PRINT OF AN IMAGINARY CREATURE

Supplies
- Pencil and sketch paper
- Carbon paper
- Pieces of soft pine wood, approximately 8 x 10 inches (20 x 25 cm)
- Wood carving tools (V- or U-shaped gouges with wooden handles
- Bench hook (see illustration, Figure 14.31)
- Water-soluble printer's ink
- Brayers
- Shallow pan
- Newspapers
- White drawing paper or colored construction paper, 9 x 12 inches (23 x 30 cm)

Complete a woodblock print of a fantastic imaginary creature. In the process of preparing your wood block, you must identify the positive and negative shapes in your design. The negative shapes will then be cut away, leaving the positive shapes to be inked and printed. Include a variety of rich, simulated textures in your final prints.

Focusing
Examine and discuss in class the examples of Romanesque carving noted in Figures 14.22, 14.23, and 14.24. Note in particular how medieval artists often included fantastic creatures in carvings of this kind. What purpose do you think these creatures served? Describe their features. What made them look so unusual or frightening?

Creating
Imagine that you are a medieval artist preparing to illustrate a religious manuscript. Impressed by the fantastic creatures seen on the capital carvings created by other artists, you decide to include an illustration of such a creation in your own work. Complete several sketches of fantastic creatures by concentrating on making them as unique as possible. In doing so, you might wish to combine the features of several animals with those associated with a human form. These sketches should be done on pieces of paper cut to the same size and shape as the wood block on which you will be working.

Transfer your best sketch to the wood block using pencil and carbon paper. Label the positive and negative shapes in your design and then cut away the negative shapes with the wood carving tools. Remember, these negative shapes will not show in your final print.

Figure 14.30 Bench Hook

Marty Winzel "Flower Dragon" 5/5 1992

Figure 14.31 Student Work

CRITIQUING

• *Describe.* Does your print show a creature unlike any actual animal you know of? What are the most unusual features of your creature? How did you arrive at the idea of using those features?

• *Analyze.* Did you clearly distinguish between the positive and negative shapes of your design before carving your wood block? Did you use a variety of simulated textures to add interest to your print?

• *Interpret.* What adjective best describes your fantastic creature? Is it menacing, frightening, shocking, friendly, amusing, or humorous? What words do other students in your class use to describe the feelings aroused by your creature?

• *Judge.* Evaluate your woodblock print in terms of its expressive qualities. Does your work succeed in communicating a particular idea or emotion? Do others experience the feelings you hoped to arouse in them with your creation?

Make all cuts with the wood carving tools in the direction of the wood grain. Cuts across the grain will bind the tool and may splinter the wood. Always make certain that the hand holding the wood block is kept away from the path of the carving tool.

Easily constructed wooden bench hooks are ideal for use during the cutting operations (Figure 14.31). Hooked over the edge of a desk or table, they hold the wood block in place, making carving easier and safer.

Check your design from time to time by placing a piece of newsprint over it and rubbing the surface with the side of a pencil. Once the negative shapes are carved away, details and textures can be cut into the positive shapes.

When carving is completed squeeze a small amount of printer's ink from the tube into the shallow pan. Roll the ink with a brayer until it is spread evenly over the pan.

Apply the inked brayer to the wood block, covering it completely with ink. Print the block using either of the following two methods:

1. Carefully place the inked block facedown on a sheet of white drawing paper or colored construction paper and press down firmly by hand. Several thicknesses of newspaper placed under the paper on which the printing is done will result in a better-quality print.
2. Place a sheet of white drawing paper or colored construction paper over the inked wood block and rub it firmly with the fingers or the back of a large spoon. Before removing the paper, it is advisable to pull back a corner to determine if additional rubbing is called for.

Re-ink your wood block for additional prints. Try printing on various kinds of paper for different results.

Review

Reviewing the Facts

SECTION ONE

1. What years are considered the Middle Ages or the Medieval period?
2. What event in history marks the start of the Early Medieval period?
3. Name the main features that would be identified in a plan of a Romanesque church.
4. List several ways the Christian Church taught illiterate people the stories of the Scripture.

SECTION TWO

5. During the Medieval period when land was the only source of wealth and power, how could a nobleman increase his wealth?
6. Who originated the barrel vault construction?
7. Why did sculpture regain importance during the Romanesque period? What purpose did sculpture serve?
8. What was the subject matter of the sculpture that was produced during the Medieval period?

Thinking Critically

1. **Analyze.** Look closely at each of the illustrations of paintings in Chapter 14. What can you say about Medieval period artists' interest in creating a sense of deep space in their paintings? What can you say about their interest in using areas of pattern?

2. **Apply.** With your pencil draw a long, thin rectangle, about 1 x 6 inches (2.5 x 15 cm). Create a pattern that repeats itself inside the strip. Now refer to the list of techniques that help create the illusion of depth or distance on page 39 in Chapter 2. Use these to explain why an area of pattern tends to look flat.

3. **Evaluate.** Refer to Figure 14.28 on page 330, *Christ in Majesty*. Consider the elements of color, value, line, and shape. What can you say about how the artist used the principles of balance, emphasis, harmony, and variety to arrange each of the elements mentioned?

Using the Time Line

During which century was work completed on Charlemagne's Palace Chapel at Aachen? At about this same time, Muslim architects were beginning work on a huge structure in Cordoba, Spain. Can you name that structure? What did it have in common with Charlemagne's chapel? Can you identify a work of art, illustrated in this book, that was created in China during this same century?

| 400 | 600 | 800 | 1000 | 1200 | 1400 |

EARLY MEDIEVAL PERIOD

ROMANESQUE PERIOD

Church of Santa Maria, Sangüesa, Spain

• *Christ in Majesty*
• *The Annunciation*

Adam and Eve, Santes Creus Monastery, Tarragona, Spain

Village Church at Ujue, Spain

• *Carolingian Manuscript:* St. Matthew
• *Franco-Saxon Gospels:* St. John

Palace Chapel of Charlemagne, Aachen, Germany

Elisa Lendvay, Age 17

Booker T. Washington High School for the Performing and Visual Arts Dallas, Texas

Elisa was inspired by the illuminated manuscripts created in the Medieval period. She decided to adopt the idea of telling a story by using multiple images.

To tie all the small images together, Elisa found a metal grid and arranged the individual oil paintings on her canvas so that each one would show through an opening in the grid.

Because of the format she chose, Elisa made a discovery: coming up with a creative idea is only part of the creative process. It takes a great deal of self-discipline to carry the idea through to completion. Based on her experience with this project, she said, "I found there are no limits to the types of media a person can combine to achieve the desired expression of an idea."

➤ Elisa's painting won the First Place Regional Award given by the Texas Visual Arts Association.

In the Beginning . . . Mixed Media. 77.5 x 91.4 cm (30½ x 36").

The Age of Faith Continued: Gothic Art

Objectives

After completing this chapter, you will be able to:

➤ Name the main features of Gothic architecture.

➤ Point out how the sculptures on Gothic cathedrals differed from sculptures on Romanesque churches.

➤ Discuss how stained-glass art influenced manuscript illumination during the Gothic period.

➤ Describe the features of the International style of painting.

➤ Explain the fresco technique of painting.

➤ Create a tympanum landscape.

Terms to Know

buttress
fresco
gargoyles
Gothic

Figure 15.1 The Limbourg Brothers. *May*, a page from a *Book of Hours* painted for the Duke of Berry. 1413–16. Illumination. 21.6 x 14 cm (8½ x 5½"). Museé Condé, Chantilly, France.

A revival of cities during the late stages of the Romanesque period

gradually changed the character and tempo of life in western Europe. These

new cities drew large numbers of serfs away from their rural villages with the

promise of a better life. By the beginning of the thirteenth century, thriving cities could

be found in northern Italy, southern France, and Flanders. By 1200,

the Flemish towns of Bruges, Ghent, and Lille boasted populations numbering

in the thousands. By the late thirteenth century, the population in Florence, Italy, had

reached forty-five thousand. These and other cities were the center of most of the

intellectual and artistic progress during the Late Medieval period.

Emergence of the Gothic Style

It is difficult to say whether cities contributed to the revival of trade or trade brought about the rebirth of cities. It is certain, though, that the growth of trade kept pace with the growth of cities throughout the thirteenth and fourteenth centuries. Trade routes were established between existing cities, and new cities sprang up along these routes. Trade, the growth of cities, and the increasing power of kings combined to bring an end to the feudal system in which serfs were bound to the land they tilled for the nobility.

A New Period Begins

Gothic is *the term used to identify a period which began around the middle of the twelfth century and lasted to the end of the fifteenth century and, in some places, into the sixteenth.* It was a name coined by later critics who scorned the art of the period because it did not hold to the standards of ancient Greek and Roman art. Since the Goths and other barbarian tribes had brought about the fall of Rome, the term *Gothic* was given to buildings that replaced classical forms. The name is misleading; the buildings during this time were not actually built by the Goths at all.

It would be a mistake to think that the Romanesque style died as the Gothic was born. Romanesque prepared the way for the Gothic and, in most areas, merged with it as smoothly as dawn dissolves into a new day. In fact, many buildings that were begun as Romanesque were completed as Gothic (Figure 15.2). The lessons learned in producing Romanesque churches were put

Figure 15.2 Cathedral of Tarragona, Spain. Begun in the twelfth century.

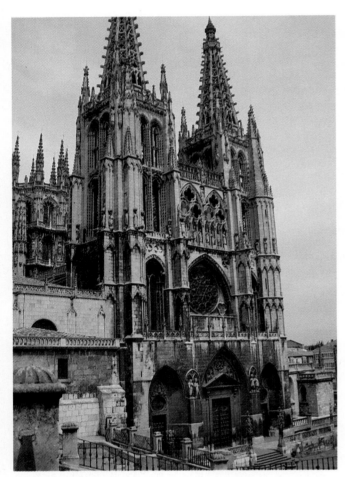

> Why do you think the Gothic cathedral is called medieval architecture's greatest triumph? How does its appearance differ from Romanesque churches?

Figure 15.3 Cathedral of Burgos, Spain. Begun in the thirteenth century.

to good use during the Gothic era. This experience enabled builders to erect the most complex and ambitious art form ever created. If the greatest of the medieval arts was architecture, then the Gothic cathedral was medieval architecture's greatest triumph (Figure 15.3).

Innovations in Cathedral Architecture

Gradually, Gothic architecture moved away from Romanesque heaviness and solidity toward lightness, grace, and even frailty. Romanesque builders never learned how to build churches with walls that could contain many windows and still be strong enough to support a heavy stone roof. As a result, their churches were low, thick-walled, and dimly lit. This was changed in France during the thirteenth century by the introduction of the pointed arch and the flying buttress. These innovations enabled builders to erect the slender, soaring Gothic cathedral.

Pointed Arches and Flying Buttresses

Gothic builders discovered that they could reduce the sideways pressure, or thrust, of a stone roof by replacing the round arch with a pointed one. Because the curve of a pointed arch is more vertical, the thrust is directed downward. This downward thrust is then

> Were slender interior columns like these enough to support the stone roof of a cathedral? If not, what else was used?

Figure 15.4 Plasencia Cathedral (interior). Plasencia, Spain. Begun in the thirteenth century.

> A support that reaches out to absorb the outward thrust of the heavy roof of a Gothic cathedral is called a flying buttress.

Figure 15.5 Avila Cathedral, Spain.

transferred to slender supporting columns, or piers, within the building (Figure 15.4). Additional support is provided by buttresses. A **buttress** is *a support or brace that counteracts the outward thrust of an arch or vault*. Because they often had to reach over the side aisles of the church, these braces came to be known as "flying buttresses" (Figure 15.5). The use of pointed arches, piers, and flying buttresses created a thrust-counterthrust system that supported the ceiling. This system eliminated the need for solid walls. As a result, the space between the supporting piers could be filled in with stained-glass windows.

To more clearly visualize this Gothic support system, picture in your mind a giant bird cage. The wires across the top of this cage represent the arches that support the roof. These arches become piers when they turn downward to form the sides of the cage. The spaces between these piers are places where stained glass could be used. The only things missing in the bird-cage illustration are the buttresses on the outside which act as a counterthrust to the outward push of the arches.

Stained-Glass Windows

The walls of glass, which builders were now free to use between the piers, let light flow into the cathedrals. It would be a mistake, though, to think that these windows did nothing more than let light in. They were an ideal way of impressing and instructing the faithful congregation. The light streaming through the windows made them richer and brighter than the dull surface of a wall painting. With stories depicting the lives of Christ, the Virgin Mary, and saints, they bring to mind the beautifully colored illuminations found in Medieval manuscripts. In cathedrals such as those at Chartres, Reims, and Paris in France and León in Spain, huge areas were devoted to stained glass (Figure 15.6).

> What innovations enabled Gothic builders to use so much stained glass in their cathedrals? What effect do you think was created inside the cathedral when light filtered through these stained-glass windows?

Figure 15.6 Notre Dame Cathedral, Paris, France.

Albinas Elskus

Albinas Elskus (b. 1926) has designed stained-glass windows for hundreds of churches as well as many nonarchitectural glass panels. His love of this medium was inspired when he spent four days observing the colors change inside Chartres Cathedral. Although Elskus describes that visit as "one of the finest things I did in my life," he is no slave to medieval stained-glass design. He states, "I'm still in awe of the windows in Chartres, but I can't do that type of work today. I'm not in their shoes. We live in a different time."

Born in Lithuania, Elskus first studied stained-glass design during the German occupation of his nation in 1942. Elskus and his fellow students had to produce all of their work on paper because glass was not available during the war. To escape the advancing Soviet soldiers, Elskus fled to Germany and enrolled in architecture school, since all of the art schools had closed. Because the finest windows in Lithuania and Germany had been removed during the war to protect them from damage, Elskus never had a chance to see them. This did not diminish his interest in studying stained-glass techniques, however, and in 1949 he settled in Chicago, where he finally received hands-on training.

He went to France in 1952, and it was there that Elskus spent the fateful four days watching the light and colors inside Chartres Cathedral. He was particularly impressed by the straightforward and simple drawing in Gothic windows. Elskus notes that American Gothic Revivalists had adopted "a more realistic approach, stressing faces that are too pretty. Body movement in Gothic windows, particularly those of the thirteenth century, shows more than the faces."

Back in the United States, Elskus worked with the glass designer John Gordon Guthrie, who helped him discover the possibilities of light colors, silver stain, and vitreous paint. Vitreous paint is a mixture of ground glass and metallic oxides that is sold in powdered form and diluted with water, gum arabic, white vinegar, turpentine, oil, or another mixing agent before it can be applied to glass. Glass painted in this manner must be fired in a kiln to permanently bond the paint to the glass surface.

Glass painting is a highly controlled and exacting art, but Elskus delights in adding seemingly arbitrary, abstract graphic elements to his designs. His favorite part of creating stained glass, however, lies in incorporating realistically drawn imagery, and it is his mastery in this area that has earned Elskus a reputation as one of the finest and most meticulous stained-glass artists working today.

Figure 15.7 Albinus Elskus. *Mary Magdalene Easter Morning.* 1985. Vitreous-painted glass. 442 x 243.8 cm (14'6" x 8'). St. Gertrude Cemetery, Colonia, New Jersey.

The making of stained glass was one of the greatest of medieval art forms. Medieval stained glass was of such high quality that it has not been matched since. For color, artisans added minerals to the glass while it was still in a molten state. In this way, the glass was stained rather than painted and was very bright. Small pieces of this stained glass were then joined together with lead strips and reinforced with iron bars. Often, the lead strips and iron bars were made a part of the design (Figure 15.8).

The Gothic Interior

Gothic interiors required no more decoration than the vertical lines of the architecture, the richly colored stained glass, and the colorful flow of light. Romanesque churches had to be lighted from within by candles and lamps. Gothic interiors, on the other hand, were bathed in tinted sunlight passing through walls of stained glass. Thus, the flickering candlelight of Romanesque churches gave way to a rainbow of color in Gothic cathedrals.

A Gothic cathedral such as the Cathedral of Chartres or the Cathedral of Reims (Figure 15.9a) is just as impressive on the inside as it is on the outside. It is so huge that it forces the viewer to become physically involved in looking. It cannot be examined from one spot because no single point offers a view of the entire structure. Instead, the viewer must move from one position to another to gain a picture of the whole. Walking through such a cathedral, you would soon find that your eye is constantly moving in all directions. A beautifully carved relief sculpture captures your attention for a moment, but then an immense expanse of stained glass draws your eyes upward. Tilting your head back as far as it will go, you see an arched stone ceiling that seems to float lightly overhead.

➤ Here pieces of colored glass were cut to shape, details were painted on, and the pieces were fired to fuse the painting with the glass.

Figure 15.8 *Mary Magdalene,* (detail). Stained-glass window in the Cathedral of Leon, Spain. Thirteenth to fourteenth centuries.

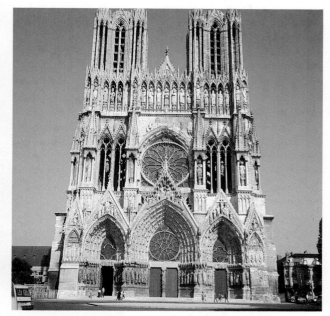

➤ What kind of balance has been used on the exterior of this cathedral?

Figure 15.9a Reims Cathedral (exterior). Reims, France. Begun c. 1225.

> Do you think you could see everything in this cathedral from a fixed position, or would you have to move from one position to another?

Figure 15.9b Reims Cathedral (interior).

While these Gothic interiors (Figure 15.9b) are always striking, they are even more so at sunset. At that time of day, when the rays of the sun strike low and filter through the many colors of the window, the effect is breathtaking. As the sun settles lower and lower, the light on the columns and walls rises slowly. It seems to penetrate even the darkness of the farthest reaches of the lofty nave. Then, suddenly, the sun dips below the horizon. At this moment, the church is filled with a deep purple twilight that accents a strange silence. Not surprisingly, it was once said that the mysterious light in Gothic cathedrals would lead the souls of the faithful to the light of God.

Gothic Church Construction

Romanesque churches were usually built in rural settings. However, Gothic cathedrals were products of the new and prosperous cities. They were meant to serve as churches for bishops, and their construction included all in the community. Not only were they an expression of religious devotion, but they were products of civic pride as well. Rival bishops and cities vied for the right to claim that their cathedral was the biggest, the tallest, or the most beautiful. After the citizens of Paris built the nave of Notre Dame Cathedral 115 feet (35 m) high, builders of the Amiens Cathedral raised their roof to almost 147 feet (45 m). Builders of the cathedral at Beauvais, not to be outdone, raised

> Earlier you learned that cloisters like this served a valuable purpose. What was that purpose?

Figure 15.10a Santes Creus Cloister (exterior). Near Tarragona, Spain. Twelfth century.

theirs to almost 157 feet (48 m), the tallest of them all. There was a limit, however. Twelve years after the last stone was laid in place, the roof at Beauvais collapsed.

The money to finance these huge structures came from a variety of sources. Countless fund-raising activities were planned and individual contributions sought. One person might pay for a pillar; another, for a door. Everything, no matter how humble, was gladly accepted. Thus, it was reported that one gentleman willed his razor and several cushions, while another left a selection of choice arrows. People who had nothing to give donated their time and effort. Artists and craftspersons offered their knowledge and skills, and the clergy promised to reward everyone who helped by praying for them.

The Spread of Gothic Architecture

The Gothic style of architecture spread from France, the land of its birth, to other western European countries. In each country, it was altered to meet different needs and tastes. The church continued to be the most characteristic large structure of the period. However, Gothic architectural features were not limited to cathedrals. These features were also incorporated into the construction of monasteries (Figures 15.10a and 15.10b), town halls, and other secular buildings.

➤ What Gothic features can be seen in the cloister of this monastery?

Figure 15.10b *Santes Creus Cloister (hall).*

<hr />

SECTION ONE

Review

1. What was responsible for changing the character and tempo of life in western Europe during the late stages of the Romanesque period?
2. Explain why the term *Gothic* was given to the art of this period.
3. Name three characteristics of a Gothic cathedral.
4. List three ways a Romanesque church differed from a Gothic cathedral.
5. What structural features enabled Gothic builders to add windows to their cathedrals?
6. What art form was used to decorate the interiors of Gothic cathedrals?
7. Where were Gothic cathedrals built?

Creative Activity

Studio. The changing life style of the Gothic era is seen in the family or guild donors for stained-glass windows. In Chartres Cathedral there are nineteen guilds represented in the bottom sections of the windows along with images of their trade—furriers, butchers, jewelers, bakers, and shoemakers.

Design a window for a contemporary trade or craft. Start with a defining shape such as a rectangle or semicircle. Then plan your design in sections of color which would represent pieces of glass in a stained-glass window. Outline the sections in black to illustrate the lead strips. Add line detailing in the color sections.

Gothic Sculpture and Illustrated Books

With the building of the cathedrals grew the arts which were used to decorate them. Gothic sculpture as well as the stained glass of the period was designed as part of one large composition—the cathedral erected to the glory of God. Gradually, sculpture was to develop along more and more realistic and individualized lines, but it always complemented the architectural setting in which it was placed.

➤ Do these figures seem lifelike, or are their proportions elongated and stretched out of shape? With your finger, trace along the repeated lines of these sculptures. In what direction do the lines lead you?

Figure 15.11 *Statues from the Royal Portal façade of Chartres Cathedral, France. Early thirteenth century.*

Sculptural Decorations

Seen from the narrow streets of medieval cities, the spires of Gothic cathedrals stretched upward to heaven. This upward tendency is noted everywhere. The pillars, pointed arches, and windows are unified in the upward surge. A statue of normal size and proportions attached to such a structure would have detracted from this soaring quality. To avoid this, sculptures were elongated, or stretched out (Figure 15.11). The long folds on their sculptured garments emphasized the vertical movement of these figures. Not even the feet were permitted to rest flat on the ground. Often, the figures stand on globes with their toes pointing downward to create the impression that they are rising upward.

Romanesque carvers made their figures appear to be firmly attached to the wall. Gothic sculptors, by contrast, made theirs project outward into space. Further, each figure was clearly identified in some way and easily recognized by anyone who was familiar with the Bible. Thus, a figure holding keys was im-

➤ Would you describe these figures as excited and active, or calm and dignified? What is there about them that gives these figures the appearance of being real?

Figure 15.12 *Statues from the west portals, Tarragona Cathedral, Tarragona, Spain. Thirteenth century.*

> Notice the design of the entrance to the cathedral. Is this an example of symmetrical or asymmetrical design?

Figure 15.13a Sarmental portal, Burgos Cathedral. Thirteenth century.

mediately identified as St. Peter, since he was entrusted with the keys of the heavenly kingdom. Another bearing stone tablets was recognized as Moses; engraved on the tablets were the Ten Commandments given to him by God on Mount Sinai (Figure 15.12).

The Growing Concern for Reality

Gothic sculptors wanted to do more than present sacred symbols of biblical figures. Increasingly, they tried to make these figures look like real people. The figures appear to move and look about, and the drapery looks as though it is covering a real three-dimensional body.

Although it still recalls the spirit of the Romanesque, the south door of the Burgos Cathedral reveals this growing concern for reality (Figure 15.13a). In the tympanum (Figure 15.13b) are the twelve apostles and above them a calm and serene Christ in Majesty. Christ is not shown as a menacing judge of doomsday,

> Can you identify the figures (accompanied by their symbols) surrounding the central figure? What are these figures doing? How many seated figures can you count along the bottom of this tympanum? Does this number provide a clue to their identity?

Figure 15.13b Sarmental portal tympanum, Burgos Cathedral.

➤ In what ways does this tympanum differ from that of the Sarmental portal at Burgos (Figure 15.13b)? Describe the behavior of the figures.

Figure 15.14 *Death of the Virgin*. Cloister tympanum, Cathedral of Pamplona, Spain. Fourteenth century.

but a majestic, thoughtful, and approachable man. He is surrounded by the four Evangelists who are bowed over their writing desks, allowing them to fit into the triangular shape of the tympanum. Their symbols take up the rest of the available space.

Like Romanesque tympana, the one at Burgos makes use of a formal balance. As the Gothic style continued to develop, an informal, more natural balance was sought. This informality is observed in a fourteenth-century tympanum in the cathedral cloister in Pamplona, Spain (Figure 15.14). Here fifteen figures surround a bed on which rests the lifeless body of the Virgin Mary. Again, the figures are carefully designed to fit within the tympanum. Christ is the largest figure and, if you look closely, you will see that he holds a small version of Mary. This is her soul, which he is preparing to carry to heaven. Small angels hover overhead holding garments with which to clothe Mary in glory. A sign of the growing concern for human emotions is noted in the sorrowful expressions on the faces of the mourners around the deathbed. These are more than mere symbols for religious figures. They are real people expressing a genuine grief at the loss of a loved one.

Veneration for the Virgin Mary

Veneration for the Virgin Mary grew steadily during the Gothic period. This was especially true in France, where great cathedrals were erected in her honor in Paris, Chartres, Rouen, and other cities.

➤ What was so special about this sculpture that made it famous? How is this pose similar to that of such Greek sculptures as the *Spear Bearer* by Polyclitus?

Figure 15.15 *Golden Virgin*. From the south portal of the Cathedral of Amiens, France. c. 1250–70.

> What is the name for these medieval sculptures? What purposes do they serve? What do they represent?

Figure 15.16 Gothic gargoyle, St. Just Cathedral, Narbonne, France. Begun 1272, completed in Gothic style.

On the south portal of Amiens Cathedral is an almost freestanding sculpture of Mary holding the Christ Child (Figure 15.15). Originally covered in gold, it came to be known as the *Golden Virgin*. People weary from long hours of work or facing problems of various sorts found comfort in her warm, welcoming smile. The figure is both elegant and noble. Its gentle human features and friendly expression made it one of the most famous sculptures in Europe.

There is one other sculptural feature of Gothic cathedrals that has not been mentioned yet. This unusual feature is the **gargoyles** (Figure 15.16), *the grotesque flying monsters that project out from the upper portions of the huge churches*. They look as if they are about to unfold their wings and fly off to some far-off land of mystery. Made of carved stone or cast metal, these gargoyles are rain spouts intended to carry rainwater from the roofs of the churches. Why were they made to look like frightening monsters? Perhaps because someone — someone with a very fertile imagination — thought it would be a good idea to make rain spouts look more interesting. They were made to look like evil spirits fleeing for their lives from the sacred building.

Illustrated Books

The new style in architecture that substituted stained glass for solid walls eliminated the need for wall paintings in churches throughout most of western Europe. Without walls to decorate, artists had to find other ways to use their talents. Some turned to designing stained-glass windows, while others preferred to create graceful and colorful illuminations for manuscripts.

A demand for illustrated books containing psalms, Gospels, and other parts of the liturgy grew steadily during the thirteenth and fourteenth centuries. These books were called "psalters" and were the prized possessions of the wealthy. Artists used tiny, pointed brushes and bright colors to illuminate these psalters with scenes from the life of Christ.

The Influence of Stained-Glass Art

During the thirteenth and fourteenth centuries, manuscript illumination showed the influence of stained-glass art. Often these illustrations were placed within a painted architectural framework which resembled the frames used for stained-glass windows. In addition, the elegant figures found in these manuscript illuminations were drawn with firm, dark outlines, suggestive of the lead strips used to join sections of stained glass. With these features, plus rich, glowing colors, the illuminations closely resembled the stained-glass windows set into Gothic cathedral walls.

The influence of stained glass can be seen in an illumination found in a thirteenth-century English book of prayers known as the Carrow Psalter (Figure 15.18, page 349). This full-page illustration shows the assassination of Thomas à Becket, archbishop of Canterbury, before the altar of his cathedral. Four knights are seen attacking the kneeling archbishop with such fury that the blade of one sword breaks. An astonished church attendant helplessly looks on as the archbishop is forced to the floor by the swords and the foot of one knight.

While the illustration from the Carrow Psalter is simple and easy to read, its style is certainly not realistic. The gold background and absence of shading on the figures deny the existence of space and make everything seem flat. The faces have similar features and lack the dramatic expressions associated with such an event. Thomas à Becket's face seems almost expressionless. It reveals none of the shock and pain

Art · PAST AND PRESENT ·

Book Illustration

Artists began illuminating manuscripts as early as the fifth century. By the thirteenth century, artwork was being used to illustrate books containing psalms and gospels. In the fifteenth century, the Limbourg brothers produced *The Book of Hours*. The calendar pages in this book are among the most famous illustrations in the history of manuscript illumination. (See *May*, Figure 15.1, page 336.)

Today, children's books provide some of the finest examples of book illustration. American artist Maxfield Parrish (1870–1966) provided art for many publishers of children's literature. Among the most famous illustrations are those he did for *The Knave of Hearts*, a play by Louise Sanders. Based on the rhyme "The Queen of Hearts," Parrish provided twenty-six paintings to decorate the pages and illustrate the text. The piece shown is titled "Entrance of Pompdebile, King of Hearts." In this illustration, the king is about to enter. Two trumpeters who have announced his arrival flank the doorway and two attendants follow. All five convey a mood of merriment.

Parrish's work is noted for its brilliant, clear color, inventive imagination, and fine detail.

Figure 15.17 Maxfield Parrish. *Entrance of King Pompdebile*, from *The Knave of Hearts*. Oil on board. 50.8 x 40.6 cm (20 x 16"). Private collection. Photo courtesy the Alma Gilbert Gallery, Burlingame, California.

he must be experiencing. Two years after his death in 1170, Thomas à Becket was made a saint and his fame quickly spread throughout England. However, in 1538 King Henry VIII ordered the destruction of all portraits of the saint. Fortunately this particular manuscript page was not destroyed. Instead, it was covered by a sheet of paper glued in place to hide it from view. Later, when the paper was removed some of the paint on the upper corner was pulled off.

The International Style

In the years that followed, painters began to exhibit a greater concern for realistic detail in their works. Even more important than this, however, was a desire to make their painted figures more graceful and colorful. They took delight in painting elegant and beautiful subjects with the same care and precision as that of a skilled goldsmith. So successful were they that their pictures glowed on the pages of manuscripts like rare and delicate jewels. This elegant art style ap-

pealed to the tastes of the wealthy throughout western Europe, and the demand for manuscripts illustrated in this manner grew. Because of its widespread popularity, this style of painting came to be known as the International style.

Among the greatest of the artists working in the International style were the Limbourg brothers. These three brothers from Flanders had settled in France, where their patron was the Duke of Berry, the brother of the French king. Early in the fifteenth century, the brothers produced a luxurious book of prayers, or *Book of Hours*, for the duke. Included in this book were a series of elaborate pictures illustrating the cycle of life through scenes from each of the twelve months. In an illustration for *May* (Figure 15.1 on page 336), lords and ladies are shown enjoying a carefree ride in the brilliant, warm sunshine. The cold, gray winter months, which meant confinement within castle walls, have finally come to an end. The lords and ladies have donned gay attire and crowned themselves with leaves and flowers to welcome spring.

➤ Notice the influence of stained-glass art in this illumination.

Figure 15.18 *The Martyrdom of Thomas à Becket.* From the *Carrow Psalter.* Mid-thirteenth century. Walters Art Gallery, Baltimore, Maryland.

Trumpeters announce the new season's arrival; lively horses prance about excitedly; and the people exchange warm and friendly words.

The precision found in paintings of this kind is fascinating. The artists must have relished the chance to demonstrate in paint their powers of observation. Beautiful women and handsome men dressed in elaborate costumes and wearing fine jewelry are perched atop steeds decked out in the finest bridles and saddles. Behind them the trees of a forest are painted with such exactness that each branch and many of the leaves stand out clearly. The same concern for minute detail is observed in the ornate castle beyond. To paint such detail, the Limbourg brothers must have held a magnifying glass in one hand and a very fine brush in the other.

You may have noticed that the desire for rich detail and gracefulness is stressed at the expense of realism here. The finely dressed ladies sit regally on their horses, unmindful of the fact that their positions are not very secure. They look as if they could slide off their mounts at any moment, but this matters little. Of greater importance is that they look graceful, sophisticated, and beautiful. At the same time, however, they look posed. Much of the movement suggested in the work is a result of the flowing lines of the drapery rather than any action on the part of the figures themselves.

SECTION TWO

Review

1. How do the sculptures attached to a Gothic cathedral differ from sculptures on a Romanesque church?
2. Gothic sculptors were not content with creating sacred symbols of biblical figures. What else did they try to do?
3. Describe two techniques used by Gothic sculptors that made their work look different from Romanesque sculptures.
4. Why were paintings no longer required on the interior walls of most churches in western Europe during the Gothic period?
5. In what ways did stained-glass art influence manuscript illumination in the thirteenth and fourteenth centuries?
6. What two adjectives best describe the figures painted in the International style?

Creative Activity

Studio. Make your own papier-mâché gargoyle. (The root word *garg* means "throat" in French. The drain spouts were the "throats" of these fantastic creatures.) Start with a 12 x 18 inch (30 x 46 cm) piece of chicken wire. Shape it to form the head and open mouth. You can make it into a wearable mask if you wish. Then add rolled pieces of newspaper to make eyes, ears, horns, and grotesque forms. Attach them with masking tape. When the dry form is detailed, begin layering strips of newspaper dipped in a preparation of cellulose wallpaper paste. At least three layers are needed to make the finished form hard. Allow to dry and then paint in colors you choose.

Italian Church Painting

Italy was one country that refused to be impressed by the new Gothic style in architecture. The extensive use of windows did not appeal to Italian builders, who continued to construct churches in a modified Romanesque style during the Gothic period. Perhaps the warmer climate of their country caused them to prefer the darker, cooler interiors of the Romanesque building. Instead of stained-glass windows, they continued to commission artists to decorate the large wall spaces in their churches with murals.

Duccio

Paintings on wooden panels were also used to decorate the interiors of Italian churches. One of the most famous of these panel paintings was created by an artist named Duccio di Buoninsegna (**doot**-cho dee **bwo**-neen-**seh**-nya) for the altar at the Cathedral of Siena. It was known as the *Maestà* (or "majesty") *Altarpiece* and was actually a combination of several panel paintings. The Virgin in Majesty was the subject of the main panel. This painting was done on a large central panel almost 11 feet (3.4 m) high and showed the Madonna enthroned as the Queen of Heaven. Below and above this panel and on the back were a series of smaller panels on which Duccio painted scenes from the lives of the Virgin Mary and Christ. When the *Maestà* was completed and the people saw it, they were so impressed that they carried it in triumph through the streets of Siena to the cathedral. It remained there until the eighteenth century when it was dismantled. Two of the panels are now in the National Gallery of Art in Washington, D.C.

One of the *Maestà* panels in the National Gallery shows Christ calling to Peter and Andrew, inviting them to join him as his apostles (Figure 15.19). The extensive use of gold in the background of this picture calls to mind the rich mosaics of Byzantine art. The intense colors, two-dimensional figures, and shallow space are further reminders of the Byzantine style. A Byzantine influence is not surprising since Italy had been a part of the Byzantine world for a long time. Byzantine art was both familiar and popular in Italy.

You may recall that the Byzantine style stressed the spiritual and ignored references to the real world. Byz-

▶ Is there any clue to suggest that these figures are communicating with each other? What is it?

Figure 15.19 Duccio di Buoninsegna. *The Calling of the Apostles Peter and Andrew.* 1308–11. Tempera on wood. 43.5 x 46 cm (17½ x 18⅛"). National Gallery of Art, Washington, D.C. Samuel H. Kress Collection.

antine artists stripped reality to its essentials and avoided suggestions of depth and volume in their works. The mosaics that these artists created in their churches were not intended to be realistic or decorative. Instead, they were to aid the people in understanding their faith. These mosaics were noteworthy for the intense religious feelings they expressed.

Unfortunately, this art style proved to be very conservative. Byzantine artists did not attempt to improve upon the efforts of earlier artists. Indeed, they felt obliged to paint religious figures in the same way as their ancestors did. By doing this, they thought they were continuing a tradition that began at the time of Christ, when artists painted the actual portraits of the Savior, saints, and martyrs.

Duccio's painting avoids the typical Byzantine stiffness and introduces a more realistic, relaxed look. The three figures seem solid, and the details in their faces and gestures give them a natural appearance. It is unlikely that Duccio followed a formula when painting these figures. Instead, they suggest that he studied real men before he attempted to paint them. Christ reaches out with one hand to the two men in the boat, while Peter, surprised, returns his gaze. The gestures are natural and not forced. The serene expression on Christ's face is contrasted by the startled look of Peter and the hesitancy of Andrew. The two fishermen,

dumbfounded by Christ's sudden summons, are pictured at the moment of decision. Should they ignore the stranger calling to them from the shore and pull in their net filled with fish, or should they leave everything to follow this man who speaks gently to them about joining him?

Giotto

While Duccio struggled to free himself from Byzantine conservatism, another artist was covering the walls of a small chapel in Padua with murals that were destined to change the future course of Italian painting. The subjects for those paintings were not unusual. They were the familiar stories from the lives of Christ and the Virgin, but they were illustrated with realistic-looking people who moved about in what seemed to be real space. The man who painted those murals was a poet, sculptor, architect, and painter by the name of Giotto di Bondone (**jot**-toe dee bahn-**doh**-nee).

A popular legend tells us that Giotto was a poor shepherd who learned to draw on flat stones in the fields. One day the famous artist Cimabue (cheem-ah-**boo**-ay) came across Giotto at work on one of his drawings. He was so amazed at the boy's skill that he took him into his studio as his pupil.

As Giotto's fame grew, stories about his great talent captured the imagination of his contemporaries. It was said that when he was still studying with Cimabue he painted a fly on the nose of one of the master's figures. The fly was so realistic that when Cimabue returned to work on the picture he tried several times to brush it off before discovering that it was a painting by his mischievous student.

The Fresco Technique

Most of Giotto's paintings were murals painted on the inside walls of churches in a form of painting called fresco. **Fresco** is *a painting created when pigment is applied to a wall spread with fresh plaster*. In order to make a fresco, Giotto first drew with charcoal directly on the wall. Then, taking only as much of the drawing as he could finish before the plaster dried, he spread a thin coat of wet plaster over the dry wall and then retraced the charcoal lines, which he could barely see underneath. Pigment, mixed with water and whites of eggs, was applied directly to this fresh plaster. The paint and wet plaster mixed together to form a permanent surface. Sometimes artists painted over this surface after it had dried, but the repainting usually flaked off in time. If a mistake was made, the whole surface had to be cleaned off and the section done again.

This fresco technique did not allow Giotto time to include many details in his pictures. The paintings had to be completed quickly while the plaster was still wet. This meant that only the most essential details could be included. As a result, Giotto's fresco paintings were simple but powerful. (See Figure 15.20.)

➤ What aspects of the fresco technique had an effect on Giotto's style? Did this technique help or hinder an artist who wanted to convey a powerful message?

Figure 15.20 Giotto. *Death of St. Francis* (detail). c. 1320. Fresco. Bardi Chapel, Santa Croce, Florence, Italy.

Realism and Expression of Emotions

One of Giotto's frescoes in Padua testifies to his monumental talent. It is entitled *Lamentation* and shows a group of mourners around the body of Christ following the Crucifixion (Figure 15.21). The figures are modeled in light and dark so that they look as solid and round as sculptures. There is a feeling that real bodies exist beneath those robes. The picture is made to look more real by the addition of a natural background of blue sky, rocky ledge, and dead tree. Gone is the flat, gold background that was a standard feature of earlier works. The purely spiritual did not interest Giotto. He vigorously pursued a more realistic course.

Giotto's concern for realism led him to study human emotions, and he tried to show those emotions in his paintings. In *Lamentation*, anguish, despair, and resignation are noted in the expressions and gestures of the figures surrounding Christ. In the foreground, framed by the two massive seated figures, you can see the dead Christ in the arms of a grieving woman. She is undoubtedly Christ's mother, Mary. To the left are several other mourners. The two women at the front of this group are especially noteworthy. One throws her hands upward and her lips part as if to release a cry of sorrow, while the other clasps her hands in anguish and suffers in silence. To the right,

the bent-over figure of a young man dominates. He throws his hands back dramatically in a violent gesture of horror and disbelief. His actions seem even more dramatic when compared with the two men at the far right who endure their sorrow without an outward trace of emotion.

Planning for Dramatic Effect

Giotto arranged his scene carefully with an eye for dramatic effect, much like a director placing the actors in a play. Even though the fresco technique did not permit him to use many details, it is unlikely that he would have done so anyway. Giotto would probably still have used only a few details or props to enhance his story. In the *Lamentation*, he offers a solitary rock ledge rather than a mountain range; he presents a single tree instead of a forest. Neither of these objects is decorative; they are there for a purpose. They direct your attention to the players acting out the great tragedy of Christ's death on a narrow stage. The ledge guides your eye to the most important part of the picture—the faces of Christ and his mother. The tree visually balances the figure of Christ in the opposite corner and also serves as a symbol for his eventual Resurrection. It appears to be dead, but, like Christ, it will rise up in the spring. In the background is the sky, as flat and solid as a wall. It forces you to focus your

➤ Do you think that this is a successful work of art? What aesthetic qualities would you use to defend your judgment?

Figure 15.21 Giotto. *Lamentation*. c. 1305. Fresco. Arena Chapel, Padua, Italy.

attention on the scene in front of it. From a position between the two seated figures, you can see the weeping mother and the dead son. You do not "read" this story as you would a Romanesque carved relief. Instead, you *experience* it as a helpless, totally involved witness.

Giotto's Fame Spreads

Giotto's fame eventually spread to Rome, where the pope was preparing to decorate St. Peter's Basilica with paintings. His curiosity aroused, the pope sent a messenger to Florence to gather more information about the artist. It was reported that the messenger found Giotto at work in his studio and told him of the pope's plans for St. Peter's. When the messenger asked Giotto for a sample of his work to take back to the pope, the artist took a pencil and, with a quick turn of his hand, produced a perfect circle on a scrap of paper. He handed this to the startled messenger, who thought Giotto was joking. "Is this what you want me to take to the pope?" he asked. Giotto nodded, saying, "It is enough and more than enough." Reluctantly, the messenger took the drawing of the circle to the pope and presented it to him along with a description of how it was made. The pope looked at the circle and immediately summoned the artist. When Giotto ar-

rived in Rome, he was received with great honor, having demonstrated with a twist of his wrist that he was one of the outstanding artists of his time.

Giotto was admired by intellectuals and adored by the common people. No doubt his ready wit contributed to his great popularity. Once the King of Naples said to him: "Giotto, if I were you on such a hot day, I would leave my painting for a while." Giotto immediately replied: "So would I, if I were you."

Giotto died in 1337. Later, one of the most powerful men in Italy, Lorenzo de Medici, had a stone statue erected in Giotto's honor in a church in Florence. The final lines of the Latin inscription are a fitting epitaph to the great artist: "I am Giotto, that is all. The name alone is a triumphal poem."

Today, Giotto's works may seem quaint and even awkward to you, but you should remember that artists ever since Giotto have continued to build upon the ideas and techniques that he originated. He painted realistic figures, actions, and emotions studied directly from life and not copied from traditional models as before. This was a revolutionary break with Byzantine art. Giotto identified new goals in art, goals that were to guide artists for generations. It is a further testimony to his greatness that not until Masaccio one hundred years later was there an artist who could match Giotto's power and skill.

SECTION THREE

Review

1. Why did Italian builders continue to build churches in a modified Romanesque style during the Gothic period?
2. What effect did the construction of Italian Gothic churches have on the art used to decorate them?
3. What artist was responsible for creating the *Maestá Altarpiece*?
4. How do Giotto's painted figures differ from those painted by earlier artists?
5. What is a fresco painting?
6. What limitations are imposed on artists like Giotto who used the fresco technique?

Creative Activity

Humanities. The city of Siena in Italy was designed around an open square called Piazza del Campo, which gently slopes down from Siena's three hills to divert rainwater. It has a wide paved border, which is the scene of the Palio, a race on horseback that dates back to 1310 and continues today. Palio refers to the prize, a silk banner.

The race itself lasts only a minute, but the ceremony begins with a splendid parade, colorful flags, and people in costume.

The Palio is the only surviving game of many that filled the calendar of medieval life. It brought people together in community as well as competition. Study the games we have today. Discuss their value as a means of forming or strengthening community.

DRAWING A LANDSCAPE TYMPANUM

CRITIQUING

- **Describe.** Can you point out and name the different objects in your landscape? What is the most unusual object in your drawing?
- **Analyze.** Which object did you choose to emphasize in your composition? How did you attempt to do this? Is your composition balanced symmetrically or asymmetrically? Do the objects in your landscape fit comfortably within the half-round or triangular shape?
- **Interpret.** Is a particular season of the year suggested by your drawing? How is this season indicated? Were other students able to identify the season?
- **Judge.** What is the most successful feature of your drawing: its realistic appearance, its use of the elements and principles of art, or its effectiveness in illustrating a particular season?

Complete a pencil drawing of a landscape in which one object is singled out and emphasized because of its larger size or its placement at or near the center of the composition. The landscape should suggest a particular season of the year. All the objects included in the drawing must be designed to fit within a half-round or triangular shape. Before beginning you must indicate in writing if your landscape is going to be balanced symmetrically or asymmetrically.

Focusing

Compare and contrast examples of Romanesque and Gothic tympana illustrated in *Art in Focus* (Figures 15.13b, page 345 and 15.14, page 346). Which of these appears to be more lifelike? How is each balanced?

Creating

On a sheet of paper list the kinds of things you are likely to see during a long walk in the country. Make several quick sketches.

On a large sheet of sketch paper outline a half-round or triangular shape measuring no less than 12 inches (30 cm) in length and 8 inches (20 cm) in height. Cut this out.

Look over your landscape sketches and identify one of the items that you would like to emphasize. Place it at or near the center of the composition.

Add the other objects to your landscape, making certain that they fit comfortably within the half-round or triangular shape.

Figure 15.22 Student Work

CARVING A TYMPANUM LANDSCAPE RELIEF

Complete a clay relief sculpture of a tympanum landscape. Use deep carving techniques to create the nearly three-dimensional forms of the landscape, resulting in a rich surface pattern of light and dark values. Use a variety of tools to create at least five different actual textures on the relief.

Focusing

Examine the tympanum from the Sarmental Portal of Burgos Cathedral (Figure 15.13b, page 345) and the *Death of the Virgin* tympanum from the Cathedral of Pamplona (Figure 15.14, page 346). Notice how the various forms in these reliefs were created.

Creating

Roll out a large slab of clay to a uniform thickness of 1 inch (2.5 cm). The clay slab must be large enough to accommodate the 12 x 18 inch (30 x 46 cm) tympanum design completed in the previous lesson.

Place your tympanum drawing directly on the clay slab. Cut out the half-round or triangular shape of the tympanum. Then trace over the lines of your landscape drawing with a sharp pencil. This will transfer the lines of your drawing to the soft clay slab.

Use clay modeling tools to carve your landscape in the clay. Do not use modeling techniques. Instead, use the subtractive carving method to create a panel in high relief. Use only the clay tools to smooth surfaces and add details.

When it is thoroughly dry, the relief should be bisque-fired and, if desired, glazed.

Supplies
- Tympanum drawings from the previous lesson
- Clay
- Two wood slats, 1 inch (2.5 cm) thick
- Rolling pin and clay modeling tools
- Canvas, muslin, or cloth about 14 x 14 inches (36 x 36 cm) to cover table or desktops

CRITIQUING

• *Describe.* Is the subject of your relief easily identified as a landscape? When questioned, can other students name the different objects in your landscape?

• *Analyze.* Did you clearly emphasize one object in your landscape? Did your way of doing this differ from the way you emphasized this object in the drawing? Can you point to five different examples of actual texture in your relief?

• *Interpret.* What season of the year is represented in your relief? What are the most important clues to this season?

• *Judge.* Assume that you are an art critic inclined to judge works of art in terms of design qualities. Would you consider this relief to be a successful work of art? How would you defend your judgment?

Figure 15.23 Student Work

Reviewing the Facts

SECTION ONE

1. What contributed to bringing an end to the feudal system in Europe?
2. Name two architectural innovations that enabled architects to construct the huge, soaring Gothic cathedrals.
3. Describe the feeling evoked by the interior of a Gothic cathedral.

SECTION TWO

4. How were sculpted figures altered to fit into the "upward surge" feeling of the Gothic architecture?
5. Compared to Medieval sculptures, were Gothic sculptures more or less realistic? Why?
6. What is a gargoyle?

SECTION THREE

7. Which country continued to build churches with solid walls, unlike the new Gothic architecture?
8. Why did Giotto have to work quickly when he was painting a fresco?
9. What new goals did Giotto identify in painting?

Thinking Critically

1. *Compare and contrast.* Refer to Figure 15.13 on page 345 (Sarmental portal, Burgos Cathedral) in this chapter and to Figure 14.21 on page 325. Make a list of similarities and differences between the relief sculpture on the Romanesque church and that on the Gothic church. Be sure to consider each element and principle of art.

2. *Analyze.* Look closely at the colors used in Figure 15.1 on page 336. Make a list of the colors you see that are intense, or very bright. Then make another list of the colors that the artist used that are dull or low in intensity. Remember that in some cases the same color will be in both columns. How do you think the artist mixed the blue-gray color of the horse?

3. *Evaluate.* You have read that the Gothic cathedrals were not only an expression of religious devotion, but also often products of civic pride. Think about your own city. What buildings, constructions, or sights are considered a source of civic pride? Are these the same sights that tourists visit?

Using the Time Line

What two Italian artists were active at the beginning of the fourteenth century? Is the name Marco Polo familiar to you? For what is he famous? Did you know that he was a contemporary of these two artists? Find the point on the time line that designates the year 1347. That was the year of the Black Death in western Europe. Conduct a library search to determine the impact this plague had upon the people living at that time.

1100	1200	1300	1400	1500

MEDIEVAL / **GOTHIC PERIOD**

- Limbourg Brothers. *The Book of Hours. May*
- Cathedral of Burgos, Spain

- Giotto. *Lamentation*
- Duccio. *The Calling of the Apostles Peter and Andrew*

Gargoyles

- Carrow Psalter. *The Martyrdom of Thomas à Becket*
- The Golden Virgin

Cathedral of Reims, France

Statues from Royal Portal Chartres Cathedral, France

Kenneth Woodruff, Age 17
*Glencliff Comprehensive High School
Nashville, Tennessee*

Kenneth enjoys Gothic architecture, and when he read this chapter he was inspired by the towers on the Cathedral of Reims. He decided to produce a column with figures in niches and a gargoyle.

Finding a self-hardening clay too brittle to carve, he experimented with several other materials before settling on plaster. He used wood-carving tools to sculpt the column itself and a pliable sculpting product to form the figures. During the middle stages, Kenneth realized that the project was far more ambitious than he had anticipated. In addition, the carving process required not only skill but also patience.

When he had completed the carving and had attached the figures, Kenneth gave the column a coat of paint. He was pleased with the overall appearance. "Although the column appears delicate, I had hoped to be able to carve even more detail and make the column more elaborate. Time ran out, however, and I had to eliminate some of the proposed details." Kenneth's advice to other students is: "Set realistic goals and keep an even temperment, or you can accidently damage your art."

➤ Gothic Column. Plaster, paint. 41.6 x 10 x 10 cm (16⅜ x 4 x 4").

Art of an Emerging Modern Europe

Moses (detail) Page 360
1513–15

The Burial of Count Orgaz (detail) Page 416
1586

1400	1450	1500	1550	1600

RENAISSANCE ART IN ITALY

FIFTEENTH-CENTURY ART IN NORTHERN EUROPE

ART OF THE SIXTEENTH CENTURY IN EUROPE

Descent from the Cross
c. 1435

Page 394

Self-Portrait
1635

Page 447

Still Life with Rib of Beef
1739

Page 463

| 1650 | 1700 | 1750 | 1800 | 1850 |

BAROQUE ART

ROCOCO ART

A Time of Titans:
Renaissance Art in Italy

Objectives

After completing this chapter, you will be able to:

➤ Explain the impact of the printing press on the middle class.

➤ Identify artists of the Italian Renaissance and describe their contributions.

➤ Analyze how linear perspective and aerial perspective are used to create depth and space.

➤ Discuss the reasons why there were few artworks by women artists before the Renaissance.

➤ Use gradation of value and linear perspective to create works of art.

Terms to Know

aerial perspective
linear perspective
Pietà
Renaissance

Figure 16.1 Michelangelo. Moses (detail). c. 1513–15. Marble. Approx. 244 cm (8') high. San Pietro in Vincoli, Rome, Italy.

During the Middle Ages, people in western Europe thought

of the Church as the center of their existence, guiding them over the rough

road of life to salvation. By the beginning of the fifteenth century, however, people

began to rediscover the world around them and realize that they were an important part

of that world. They had believed that life in this world was little more than a preparation

for heaven, and this gave way to an interest in the world of here and now. This change

*of view and the period in which it took place is referred to as the **Renaissance**, a*

period of great awakening. The word renaissance *means "rebirth."*

The Emergence of Italian Renaissance

The fifteenth century was a time of great growth and discovery. Commerce spread, wealth increased, knowledge multiplied, and the arts flourished. In Italy, a number of cities grew to become important trading and industrial centers. Among these was Florence, which rose to become the capital of the cloth trade and boasted of having the richest banking house in Europe. (See map, Figure 16.2.) The Medici family, who controlled this banking empire, became generous patrons of the fine arts. They also built libraries, spending an estimated twenty million dollars in thirty years for manuscripts and books to encourage the development of rational, humanistic scholarship.

During this period, artists and scholars developed an interest in the art and literature of ancient Greece and Rome. Artists greatly admired the lifelike appearance of classical works and longed to capture the same quality in their own works. They turned to a study of nature and the surviving classical sculptures in an effort to make their artworks look more realistic.

In the middle of the fifteenth century, a German printer named Johannes Gutenberg perfected the printing press, an invention that ranks as one of the most important contributions of the Renaissance. Within years, thousands of presses were in operation in Germany, France, England, and Italy, and hundreds of books were printed from these presses. This mass-production capability made available to great num-bers of readers the works of ancient Greek and Roman writers, religious books, and volumes of poetry and prose. While the clergy and nobility bought their share of these books, the biggest market was the growing middle class in the cities. Wealthy from trade, finance, and industry, the middle-class people were eager to improve themselves. Education was seen as the surest way to do this.

Figure 16.2 Renaissance Italy

Masaccio and His Contributions

In Florence, the wealthy and better-educated citizens grew in number and began to show a lively interest in the arts. Beginning in the fourteenth century and continuing through the fifteenth century, they made their city the artistic capital of Italy. It was in Florence that a carefree young painter known as Masaccio (ma-**saht**-chee-oh) brought about a revolution in art equal to that of Giotto.

Masaccio is regarded as the first important artist of the Italian Renaissance, although he certainly did not look the part. Completely devoted to his art, he paid little attention to his appearance or to the events going on around him. It was said that he was so carefree that he never bothered to collect the money orders owed him unless he was in great need. People laughingly called him "Masaccio," or "Clumsy Thomas," instead of his real name, Tommaso, but he was unruffled. No matter what they called him, no one denied his genius with a brush, and that was all that mattered to him. He took the innovations of Giotto and developed them further to produce a style that became the trademark of the Italian Renaissance. It was a style that owed a great deal to the fresco technique that continued to be popular throughout Italy.

You will recall that the Gothic architectural style, which was flourishing in other countries, never was widely popular in Italy. The walls of glass common to this style did not appeal to the Italians. Instead, they liked the solid walls and cool, dark interiors of the Romanesque style. The walls of their churches were covered with bright mosaics and large frescoes. At this time, northern artists were making intricate stained-glass windows and small manuscript illustrations. Italian artists, on the other hand, were doing huge wall paintings on the insides of their churches.

The Holy Trinity

Masaccio worked in fresco when he created one of his greatest works in the Florentine church of Santa Maria Novella. The painting was *The Holy Trinity* (Figure 16.3), and Masaccio was twenty-one years old when he painted it. Like Giotto before him, he ignored unnecessary detail and focused his attention on mass and depth. He wanted his figures to look solid and real, so he modeled them in light and shadow. To show that some of these figures were at different distances from the viewer, he overlapped them. To in-

crease the lifelike appearance of his painting even more, Masaccio created the illusion of a small chapel. In it he placed the Holy Trinity, St. John, and the Virgin Mary. On either side of this chapel, he added two figures, members of the wealthy family that had commissioned him to paint the fresco. These two figures are life-size. However, the figures inside the painted chapel are smaller to show that they are farther back in space.

Shortly before Masaccio painted *The Holy Trinity*, an architect and friend named Filippo Brunelleschi (fee-**leep**-poh brew-nell-**less**-key) made a discovery known as **linear perspective**, *a graphic system that showed artists how to create the illusion of depth and volume on a flat surface*. Based on geometric principles, this system enabled an artist to paint figures and objects so that they seem to move deeper *into* a work

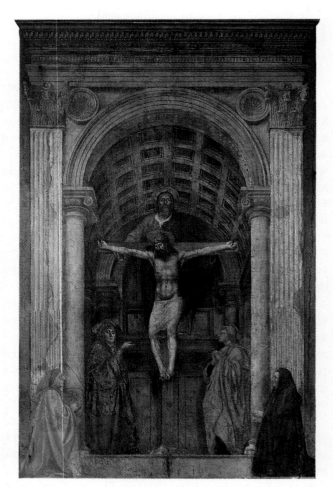

➤ This painting was done on a flat wall, and yet it seems as if you are looking into another room. How has line been used to create this illusion of depth?

Figure 16.3 Masaccio. *The Holy Trinity*. c. 1428. Fresco. Santa Maria Novella, Florence, Italy.

Art · P A S T A N D P R E S E N T ·

Perspective Then and Now

With the invention of linear perspective in the early Renaissance, artists were suddenly able to give the illusion of distance in their paintings. The discovery, generally attributed to Brunelleschi, provided a set of rules that enabled artists to show figures and objects in space. The rules of perspective made the placement of objects, and the depiction of their mass, measurable and exact. This gave an exciting visual reality to works of art.

Today, perspective is used by many kinds of artists. Videogame designers use perspective to provide three-dimensional effects for auto-racing games. Graphic artists design logos for television that zoom into the foreground and rotate in space. Computer games have been designed that provide the experience of piloting and landing a plane; the perspective changes as the plane changes altitude.

Figure 16.4 Video game showing perspective.

Linear perspective was discovered more than five hundred years ago. Imagine how Renaissance artists would react to the ways perspective is used today.

rather than across it. Slanting the horizontal lines of buildings and other objects in the picture makes them appear to extend back into space (Figure 16.5). If these lines are lengthened, they will eventually meet at a point along an imaginary horizontal line representing the eye level. The point at which these lines meet is called a *vanishing point*. Some scholars speculate that Brunelleschi used a mirror to discover and perfect his method of linear perspective. A mirror reveals features of perspective that are not observed by the naked eye—features such as the horizontal lines of a building which appear to come together in the distance when viewed in the mirror. Indeed, with a mirror the three-dimensional relationships are automatically represented on a two-dimensional surface just as they are in a drawing using linear perspective.

Masaccio made brilliant use of Brunelleschi's discovery when he painted *The Holy Trinity*. He placed all his figures several feet above the floor of the church and slanted the lines of the ceiling and capitals of the columns downward and inward so they would meet at a vanishing point below the foot of the cross. As a result, you are made to believe that you are looking into a real chapel with real people in it, when actually the entire scene is painted on a flat wall.

If you find Masaccio's painting lifelike, imagine how it must have appeared to the people of his time. Never

having seen realism of this kind in art before, they were stunned by the work. It was even reported that some fled from the church in fright. They thought they had gazed upon the real thing.

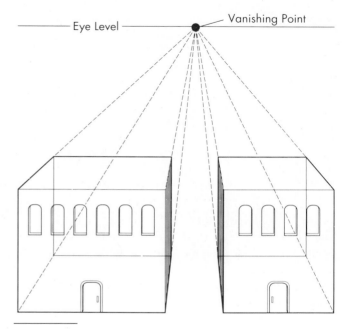

Figure 16.5 An example of linear perspective

The Tribute Money

Not too long after finishing *The Holy Trinity*, Masaccio began working on a number of large frescoes in another Florentine church. *The Tribute Money* (Figure 16.6) is one of these frescoes. In it he grouped three scenes to tell a story from the life of St. Peter. In the center, Christ tells St. Peter that he will find a coin in the mouth of a fish with which to pay a tax collector. The tax collector is shown at Christ's left with his back to you. At the left side of the picture, you see St. Peter again, kneeling to remove the coin from the mouth of the fish. Finally, at the right, St. Peter firmly places the coin in the tax collector's hand.

As in his earlier painting of *The Holy Trinity*, Masaccio wanted to create a picture that would look true to life. Depth is suggested by overlapping the figures. With linear perspective, he slanted the lines of the building to lead the viewer's eye deep into the picture. He also made distant objects look bluer, lighter, and duller, heightening the illusion of deep space. This method, known as atmospheric or **aerial perspective**, *uses hue, value, and intensity to show distance in a painting*. In *The Holy Trinity*, aerial perspective was not used because the space was limited to a chapel interior. In *The Tribute Money*, an outdoor setting offered Masaccio the opportunity of using aerial perspective to create the impression of endless space.

You probably noticed in *The Tribute Money* that Masaccio again modeled his figures so that they seem to be as solid as statues. To achieve this effect, he used a strong light that strikes and lights up some parts of his figures while leaving other parts in deep shadow. Then he placed these figures before a faint background. This not only makes them seem even more solid but also much closer to you. Added to this is the fact that the figures are quite large in relation to the rest of the picture and are shown standing at the front of the scene rather than farther away. Because these figures are so large and so near, you can see clearly what Masaccio was trying to do. He was concerned with showing how the body is put together and how it moves, but he does not stop here in his quest for reality. Notice the natural and lifelike gestures and poses of the apostles around Christ. Now look at the face of St. Peter at the left. In his effort to bend over and take the money from the fish's mouth, his face has turned red. Finally, at the right, observe how St. Peter hands over the coin with a firm gesture while the tax collector receives it with a satisfied expression on his face. The actions and expressions here are what you might expect from real people.

There is no way of knowing what further advances Masaccio might have made to art had he lived a long life. Unfortunately this young genius died at the age of twenty-seven.

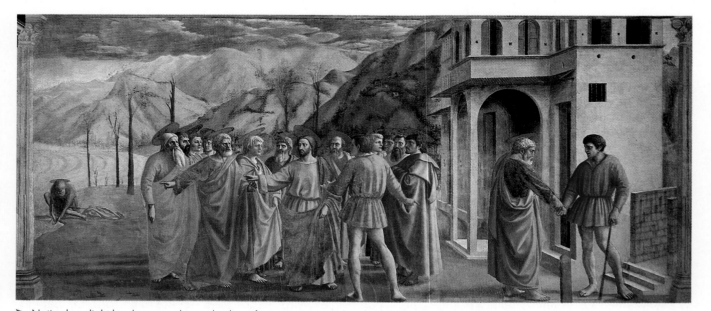

➤ Notice how light has been used to make these figures seem round and solid. Point to the perspective lines that lead your eye *into* this painting. How have hue, value, and intensity been used to heighten the illusion of deep space?

Figure 16.6 Masaccio. *The Tribute Money.* c. 1427. Fresco. Brancacci Chapel, Santa Maria del Carmine, Florence, Italy.

Blending Renaissance and Gothic Ideas

Not all Italian artists accepted the innovations made by Masaccio. Many chose to use some of his ideas and ignore others. Italian art at this time was a blend of the progressive ideas of the Early Renaissance and the conservative ideas of the Gothic period. Two artists who worked in this way were the painter Fra (or "brother") Angelico and the sculptor Lorenzo Ghiberti.

Fra Angelico

Fra Angelico (frah ahn-**jay**-lee-koh) was described by the people who knew him as an excellent painter and a monk of the highest character. A simple, holy man, he never started a painting without first saying a prayer and never painted a crucifixion without crying. He also made it a practice not to retouch or try to improve a painting once it was finished. He felt that to do so would be tampering with the will of God.

A few years after Masaccio's death, Fra Angelico painted a picture in which the angel Gabriel announces to Mary that she is to be the mother of the Savior (Figure 16.7). This painting shows that he was familiar with Masaccio's ideas and did not hesitate using some of them in his own work. Fra Angelico's earlier paintings had been done in the Gothic style and were filled with figures and bright colors. In this painting there is a simplicity that calls to mind the works by Masaccio. Rather than filling his picture with figures and a colorful background, Fra Angelico uses just two figures, placing them in a modest, yet realistic, architectural setting.

While he makes some use of perspective, it is clear that Fra Angelico was not greatly interested in creating an illusion of deep space in his picture. The figures of Mary and the angel do not overlap as do the figures in Masaccio's paintings. Instead, they are separated and placed within a limited area marked off by arches. A full arch in the background surrounds Mary's head like a second halo. A half-arch above Gabriel's head serves the same purpose. Fra Angelico chose not to use Masaccio's modeling techniques to make his figures look round and solid. There is little to suggest that real people exist beneath the garments he paints.

There are no surprises or sudden movements depicted in Fra Angelico's paintings. The gestures and facial expressions are easy to read. Like Gothic artists before him, Fra Angelico painted the religious story

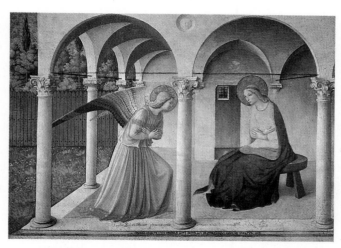

▶ Are these figures as lifelike as the figures painted by Masaccio (Figure 16.6)? Does this artist show the same concern for deep space as Masaccio does? What seems to be the most important concern here—realistic subject matter, or a clear, easily understood story?

Figure 16.7 Fra Angelico. *The Annunciation.* c. 1440–45. Fresco. San Marco, Florence, Italy.

so that it could be understood by those who saw it. This religious story was more important to Fra Angelico than making his picture seem true to life.

How do you think the people of his time reacted to Fra Angelico's paintings? Giorgio Vasari, a sixteenth-century biographer, claimed that Fra Angelico's paintings of the Madonna were so devout, charming, and well made that they were like the products of heaven and not man.

Lorenzo Ghiberti

Like Fra Angelico, Lorenzo Ghiberti (loh-**ren**-zoh gee-**bair**-tee) combined elements of the new Renaissance style with the earlier Gothic style. A sculptor, Ghiberti is best known for the works he made for the Baptistry of the Florence Cathedral.

In 1401, the Florence City Council decided to sponsor a contest. The purpose was to find an artist to decorate the north doors of the Baptistry of the cathedral. This Baptistry, built in the twelfth century and dedicated to St. John the Baptist, was one of the most important buildings in the city. It was here that every child was baptized and officially brought into the Church. In 1330, an artist named Andrea Pisano had been selected to decorate the south doors of the Baptistry with scenes from the life of St. John the Baptist. Pisano had done so by creating a series of bronze reliefs in the Gothic style of that period. Now the city determined to decorate the north doors as well and offered a challenge to the leading artists of the day.

Sculptors were asked to design a sample relief panel in bronze. The subject for the relief was to be the Sacrifice of Isaac. This subject was chosen because it seemed like a good test for an artist. It was a religious scene of great dramatic interest, and it would have to include several figures in motion. Entries were turned in by hopeful artists and were carefully examined. Finally Ghiberti was declared the winner. He spent the next twenty-one years of his life completing the twenty-eight panels used on the doors. His reliefs are a great feat of artistic skill. This is especially evident when one considers that he was in his early twenties when he began.

When you compare Ghiberti's winning relief panel with one produced by his chief rival in the competition, Filippo Brunelleschi, some interesting similarities and differences are apparent. Ghiberti's panel (Figure 16.8) and Brunelleschi's panel (Figure 16.9) both are marked by the Gothic influence. However, Ghiberti's shows that he was aware of the new trends in art as well.

A requirement of the competition was that all the panels had to employ the same Gothic frame used by Pisano on the south doors of the Baptistry. At first glance, this frame makes the panels created by Brunelleschi and Ghiberti both look like pictures from a medieval manuscript. A close inspection, however, reveals that only one panel retains the Gothic style.

Brunelleschi formed each of his figures separately without concerning himself too much with how these figures related to each other. His panel also shows a Gothic flatness, which you can see in the way the figures have been arranged *across* the front plane. In fact, Brunelleschi's panel can be divided horizontally into three layers, which are placed one on top of the other. Ghiberti, on the other hand, tried to pull the different parts of his work together to form a more unified whole. The figures and objects in his work overlap each other in a more natural way. Moreover, his figures turn and move freely across and *into* the work. They seem to be communicating with each other by glances or gestures. There is indeed movement in Ghiberti's panel. However, much of this movement is suggested by the flow of the draperies rather than by the figures themselves. By this you can see that Ghiberti did not choose to abandon completely the flowing lines and graceful gestures that were the trademarks of earlier Gothic figures.

➤ Compare this panel with the one created by Brunelleschi and decide which has figures that turn and move across and *into* the work most effectively.

Figure 16.8 Lorenzo Ghiberti. *The Sacrifice of Isaac.* 1401–02. Gilt bronze. 53.3 x 43.2 cm (21 x 17″). Museo Nazionale del Bargello, Florence, Italy.

➤ Compare this panel with the one by Ghiberti. Decide which has figures and objects that overlap each other in the most effective way. Which panel has the most unified look?

Figure 16.9 Filippo Brunelleschi. *The Sacrifice of Isaac.* 1401–02. Gilt bronze. 53.3 x cm (21 x 17″). Museo Nazionale del Bargello, Florence, Italy.

The Gates of Paradise. Ghiberti drew more heavily upon new Renaissance ideas later in his career when he worked on a second set of doors for the Baptistry. Since everyone had been so pleased with his first doors, there was no competition for this second set. These doors showed scenes from the Old Testament. For them, Ghiberti abandoned the Gothic frame used in earlier panels and made the individual reliefs square. He also introduced a greater feeling of space by using linear perspective. This made the buildings and other objects appear to extend back into the work. Finally, he modeled his figures so that they stand out from the surface of the panel and seem almost fully rounded (Figure 16.10). The effect was so impressive that when Michelangelo gazed upon these doors, he said they were worthy of being used as the gates to heaven. There seems to have been no argument then, nor is there now — Ghiberti's doors are still referred to as "The Gates of Paradise."

➤ There was no competition for these second doors to the Baptistry. Notice how the artist used linear perspective to give depth to the panels. Which famous artist referred to these doors as "The Gates of Paradise"?

Figure 16.10 Lorenzo Ghiberti. *Door of Paradise.* 1425–52. Gilt bronze. Approx. 43.2 cm (17") high. Baptistry of Florence, Italy.

SECTION ONE

Review

1. During the Renaissance, what changes took place in the way people viewed life and the world around them?
2. What contribution did Gutenberg's printing press make to the intellectual rebirth of the Renaissance?
3. How did Masaccio give his figures mass and achieve the feeling of depth in *The Holy Trinity* (Figure 16.3 on page 362)?
4. What is linear perspective, and who is given credit for its discovery?
5. Describe how a mirror can help an artist see linear perspective relationships.
6. What result did Masaccio achieve by using linear perspective to paint *The Holy Trinity*?
7. What was Fra Angelico's main goal in his paintings, and how did he achieve it?

Creative Activities

Humanities. The rebirth of literature in Italy during the Renaissance centers around three Florentine writers — Dante Alighieri (c. 1265–1321), Petrarch (c. 1304–1374), and Boccaccio (c. 1313–1375).

All three of these writers wrote in the *vernacular* — the spoken Italian language — rather than in Latin, making their works readable by the ordinary person. Research their contributions to world literature and report to the class.

Studio. Egg tempera was an important medium of Medieval and Early Renaissance painting. Done on a wood panel, it used egg as the binder of the paint. The panel was prepared with a coat of *gesso* (a mixture of glue and plaster). Egg tempera paintings have brilliant color and fine detail. Try making your own egg tempera paint.

The Acceptance of Renaissance Ideas

A number of changes had taken place during the early 1400s that influenced artists and thinkers. Patrons of the arts such as the Medici family knew who the talented artists were and provided them with generous funding. The Medicis also encouraged reading, spending money to acquire manuscripts and books for their libraries. Scholarship was encouraged and intellectual curiosity spread in both the humanities and the arts. The medieval search for salvation gradually diminished and changed to a focus on a new, rational order.

As a result of this intellectual rebirth, artists acquired additional areas of interest from which to draw ideas for their works and developed techniques that brought an exciting new vitality to their paintings and sculptures.

The Development of Renaissance Style

While Fra Angelico and Ghiberti were finding it difficult to break completely with the old Gothic style, other artists were eagerly accepting new Renaissance ideas. However, some of these artists were unable to grasp the full meaning of the bold new style. Instead, they concentrated on certain innovations and ignored the rest.

Paolo Uccello

Paolo Uccello (**pah**-oh-loh oo-**chell**-oh) was one of these. He became so enthusiastic about perspective that he devoted all his time and energy to it. It excited him so much that he would work far into the night arranging the perspective lines in his paintings. When his wife begged him to stop working and come to bed, he would only reply, "Oh what a delightful thing is this perspective!"

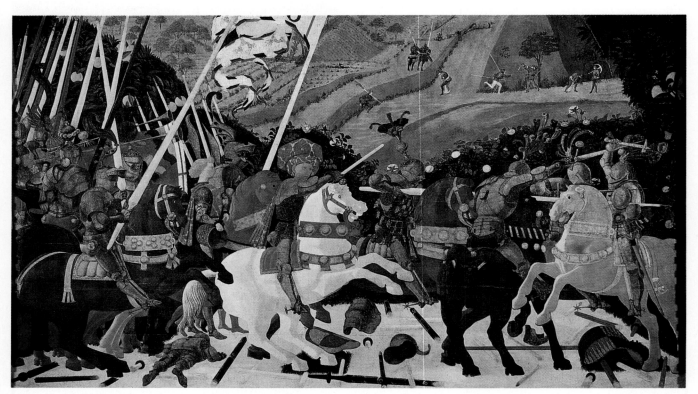

➤ Find places where contour and axis lines have been used to lead your eye into this work. Why does this picture fail to look realistic? Is there a great deal of movement and action here, or do the figures seem stiff and frozen?

Figure 16.11 Paolo Uccello. *The Battle of San Romano.* 1445. Tempera on wood. 182 x 323 cm (6' x 10'5"). National Gallery, London, England.

Uccello's concern for perspective is evident when you analyze his painting of *The Battle of San Romano* (Figure 16.11). Bodies and broken spears are placed in such a way that they lead your eye into the picture. Horses and men are posed at daring angles as Uccello uses every opportunity to show space and distance. Yet, even with all its depth, you would never say that this work looks realistic. It is more like a group of puppets arranged in a mock battle scene. By concentrating on perspective, Uccello failed to include movement and zest in his painting. The world that he painted is not a real world at all, but a strange, fairy-tale world.

Piero della Francesca

Fra Angelico and Ghiberti could not turn their backs entirely on the Gothic style. Uccello's interest in the Renaissance style was solely in perspective. It was up to a fourth artist, Piero della Francesca (pee-**air**-oh **dell**-ah fran-**chess**-kah), to break with tradition and fully embrace the new style. By doing so, he carried on the ideas that started with Giotto and were continued by Masaccio.

The *Baptism of Christ* (Figure 16.12) shows how Piero painted figures that have the same three-dimensional aspect found in figures painted by Giotto and Masaccio. Christ is a solid form placed in the center of the picture. The hand of St. John the Baptist and a dove representing the Holy Spirit are placed directly over his head. The figures show little movement or expression. They are serious, calm, and still. The tree and the figures in the foreground provide a strong vertical emphasis. The effect of this vertical emphasis is softened by the artist's use of contrasting horizontals and curves. The horizontals are found in the clouds and the dove. The curves are seen in the branches, stream, and horizon line.

Did you observe how Piero used two gently curving arches to frame and draw your attention to Christ's face? One of these arches curves over Christ's head. It is formed by a tree branch and the hand and arm of John the Baptist. A second arch, representing the horizon line, dips down below Christ's head.

Piero is well known for the way he used light and color in his paintings. His use of light and color gave solidity to his figures and added a new realism to the space around them. He captured the look of fresh, clear morning air, which brightens the wide landscape and flows around the people in his pictures. Piero went further than any artist of his time by studying and reproducing in paint the effects of sunlight on his landscape and figures.

➤ Observe what has been done to make these figures look solid and three-dimensional. How is the main figure emphasized and made to look more important than the others? Two gently curving arches frame the face of the main figure—can you find them? What words best describe the mood of this picture: excited or peaceful? serious or lighthearted? loud or quiet?

Figure 16.12 Piero della Francesca. *The Baptism of Christ.* 1445. Tempera on panel. 167.6 x 116.2 cm (66 x 45¾"). National Gallery, London.

Innovations in Sculpture, Architecture, and Painting

A new emphasis on realism inspired by surviving models from classical Greece and Rome revealed itself in various ways in the visual arts of the Italian Renaissance. In painting, more and more artists turned their attention to creating depth and form to replace the flat, two-dimensional surfaces that characterized medieval pictures. Perspective and modeling in light and shade were used to achieve astonishing, realistic appearances. This same concern for realism was manifested in the sculpture created at

the same time, particularly in the lifelike figures of Donatello and Michelangelo that seemed to move freely and naturally in space. Renaissance architects, following the lead of Filippo Brunelleschi, abandoned the Gothic style in favor of a new architectural style that traced its origins back in time to the carefully proportioned, balanced, and elegant buildings of classical times.

Donatello

One of the assistants who worked for Ghiberti on the first set of doors for the Baptistry of Florence would go on to become the greatest sculptor of the Early Renaissance. A good friend of Brunelleschi, he also shared Masaccio's interest in realistic appearances and perspective. His name was Donatello (doh-nah-**tell**-loh).

You might think it strange to talk about perspective in sculpture, but Donatello used it when carving figures that were to be placed in churches above eye level. In such figures, he made the upper part of the bodies longer so that when viewed from below they would seem more naturalistic (Figure 16.13). This kept his sculptures from looking short and awkward.

Donatello's sculptures became famous for their lifelike qualities. Even he was delighted by their realism. Vasari tells of one incident in which Donatello, while working on one of his sculptures, commanded it again and again to speak to him. You can see this remarkable realism for yourself in Donatello's sculpture of *St. George* (Figure 16.14). The young knight seems to lean forward in anticipation as he stares intently ahead. Perhaps he is watching the advance of an enemy and is preparing for his first move. He certainly looks ready to do battle.

➤ Notice that the sculptor stretched the upper part of the body here. What happens when you look up at this sculpture from below? Which artists contributed to Donatello's interest in perspective?

Figure 16.13 Donatello. *St. Mark.* 1411–13. Marble. Approx. 236 cm (7′9″) high. Or San Michele, Florence, Italy.

➤ In what ways is this figure similar to classical Greek sculptures? Was this similarity accidental, or did this artist study the works of ancient sculptors? Describe the expression on the knight's face.

Figure 16.14 Donatello. *St. George.* 1415–17. Marble. Approx. 210 cm (6′10″) high. Museo Nazionale del Bargello, Florence, Italy.

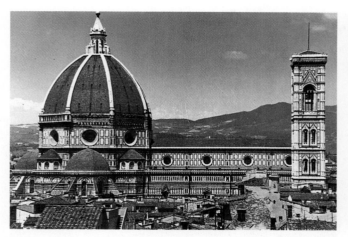

➤ The plan for constructing this dome was based on building techniques developed by Gothic architects.

Figure 16.15a Filippo Brunelleschi. Dome of Florence Cathedral. 1420–36.

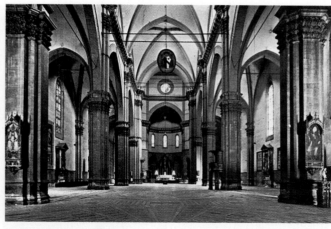

➤ The interior of the cathedral was illuminated by the light coming into the windows in the drum.

Figure 16.15b Filippo Brunelleschi. Florence Cathedral, interior.

In many ways, the sculpture of St. George is similar to classical Greek sculptures. Its slightly twisting, contrapposto pose may remind you of the *Spear Bearer* by Polyclitus (Figure 8.23, page 180). Even though Donatello's figure is clothed, there is no mistaking the presence of a human body beneath the garments. With works like this, Donatello reveals that he admired, studied, and mastered the techniques of the great Greek and Roman sculptors.

Donatello lived a long, productive life and created works of art in several Italian cities. Everywhere he went, people were so amazed by his talent that they did everything possible to persuade him to stay. Finally, back in his native Florence and eighty years old, it was obvious to all that the famous sculptor was nearing death. Some of his relatives visited him and told him it was his duty to leave them a small estate that he owned. Donatello's reply to them tells a great deal about the character of this famous artist. He listened patiently to his relatives. Then he told them he was going to leave the property to the peasant who had cared for it faithfully over the years. After all, he explained, the relatives had done nothing to the property but desire it. For this they were not entitled to it.

Filippo Brunelleschi

You may be wondering what became of Filippo Brunelleschi. He was, you recall, the artist credited with discovering linear perspective. You may also recall that he was Ghiberti's major rival for the right to design the doors for the Baptistry in Florence. When he lost the contest to Ghiberti, Brunelleschi was very disappointed. In fact, it caused him to abandon sculpture for a career in architecture. He could not accept the idea that Ghiberti was a more gifted artist than he was. Once, when asked to name the best thing Ghiberti ever did, he answered, "Selling his farm." He was referring to a worthless piece of property for which Ghiberti had paid too much. Ghiberti finally sold it in disgust when it failed to produce anything.

Sixteen years later, however, the two rivals faced each other again in another competition. This time they were asked to submit their designs for a huge dome for the Cathedral of Florence. Work on the cathedral had been under way for generations. Everything had been completed except a dome, which would span the huge opening above the altar, but no one was able to design a dome to cover such a large opening. Many claimed that it could not be done. Brunelleschi was one of those who claimed that it could. He submitted a plan based on Gothic building techniques and was awarded the opportunity to try.

Brunelleschi's plan called for the use of eight Gothic ribs which met at the top of the dome and were joined by horizontal sections around the outside of the dome at its base. The surface between the ribs was then filled in with bricks. In Figure 16.15a four major ribs can be seen on the outside of the dome. For extra height, the entire dome was placed on a drum. Circular windows in this drum allowed light to flow into the building (Figure 16.15b).

It took sixteen years to build the dome, but when it was finished Brunelleschi's reputation as an architect and engineer was made. The towering dome dominated Florence and soon became a symbol of the city's power and strength. It was so spectacular that later,

➤ Notice the resemblance in style to ancient Roman buildings.

Figure 16.16a Filippo Brunelleschi. Pazzi Chapel. Santa Croce, Florence, Italy. Begun c. 1440.

➤ How does this church interior differ from Gothic interiors?

Figure 16.16b Filippo Brunelleschi. Pazzi Chapel, interior.

when designing the great dome for St. Peter's in Rome, Michelangelo borrowed ideas from it.

Before he began work on the dome, Brunelleschi agreed to design a chapel for the Pazzi family. They were one of the wealthiest and most powerful families in Florence. In this chapel, he rejected the Gothic style. Instead, he chose a new architectural style based upon his studies of ancient Roman buildings (Figure 16.16a). Inside the Pazzi Chapel (Figure 16.16b), you will not see soaring pointed arches or a long, high nave leading to an altar. The vertical movement was not stressed. Rather, Brunelleschi wanted to achieve a comfortable balance between vertical and horizontal movements. He preferred a gently rounded curve rather than a tall, pointed arch. Dark moldings, pilasters, and columns were used to divide and organize the flat, white wall surfaces. The overall effect is not dramatic or mysterious as in a Gothic cathedral, but simple, calm, and dignified. Its beauty is due to the carefully balanced relationship of all its parts.

Sandro Botticelli

Unfortunately, Brunelleschi never saw the completed Pazzi Chapel. He died in 1446, and the chapel was finished much later in the 1460s. His life overlapped by just two years that of a remarkable painter by the name of Sandro Botticelli (**sand**-roh **bought**-tee-**chel**-lee). Botticelli was born in 1444 and died quietly in Florence some sixty-six years later. Not many took note of his passing, and his name was even misspelled in the official register. Forgotten for centuries, the artist's paintings are now ranked among the most admired of the Renaissance period.

When he was a boy, Botticelli angered his father by ignoring his schoolwork. Art seemed to be the only thing that interested the boy, and so his father finally placed him, as an apprentice, in the studio of a goldsmith. Later, Botticelli studied in the workshop of a well-known painter. Then, like so many painters, sculptors, and architects of that time, he worked for the powerful Medici family of bankers and wool merchants. Apparently the Medici family thought of him as a decorator, for they had him paint a number of ornamental pictures for bed fronts and chests. Work of this kind had an effect on the development of his unique, decorative style of painting.

When you describe and analyze a painting by Botticelli, you find yourself drawn into a unique world of flowing lines and graceful forms. In his *Adoration of the Magi* (Figure 16.17), an aisle bordered by kneeling figures leads you to the Holy Family. They are surrounded by the Magi and their attendants, all dressed in garments worn during Botticelli's time. The Magi are presenting their gifts to the Christ Child seated on Mary's lap. The figures are drawn with crisp, sharp contour lines, and their garments have folds that twist and turn in a lively, decorative pattern. Clearly Botticelli was less interested in the literal qualities than in the qualities that enabled him to create a decorative design. For example, you may find that the figure of Mary seems stretched out of shape, but this was a feature of Botticelli's graceful style. He thought that by elongating the form and tilting the head he would make Mary look more elegant.

Botticelli relied on the element of line to organize and add interest to his painting. Notice what happens

when you draw a line around the principal figures. It forms a large triangle with the Madonna and Child at the apex, or top. When you include the Magi's attendants who fan outward on both sides, a large *W* is formed. Above, the diagonal lines of the ruined classical building guide your eye to the central figures. Thus, Botticelli tied all the parts of his picture together into a unified whole and directed your attention to the most important parts.

Before leaving Botticelli's painting, one last question seems to beg for an answer. Where is the famous star that guided the Magi on their long journey? The star itself is not included in the painting, but the artist provides a clue indicating that it is present somewhere overhead. Did you notice this clue? You would be correct if you pointed to the young man at the far right. He looks upward in awe as though struck by the brilliance of the star hovering over the scene.

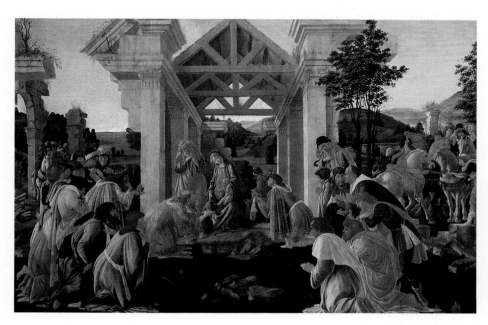

➤ Determine which of the art elements is stressed here. How would you describe the contour lines — crisp and sharp, or soft and vague? What has been done to guide you into the picture to the main figures? Who do you think these people are, and what are they doing?

Figure 16.17 Sandro Botticelli. *The Adoration of the Magi.* c. 1481. Tempera on wood. Approx. 70 × 104 cm (27⅝ x 41″). National Gallery of Art, Washington, D.C. Andrew W. Mellon Collection.

SECTION TWO

Review

1. What technique did Piero della Francesca use more than any other artist of his time to give solidity to his figures and realism to the space around them?
2. What interests did the sculptor Donatello share with the painter Masaccio?
3. Describe how Donatello used perspective in his sculptural figures.
4. Which Renaissance artist abandoned his career as a sculptor to become an architect? Name one of the projects he designed.
5. Who was the Medici family, and how did they influence the work of Botticelli?
6. What element of art did Botticelli use to tie together all the parts of his painting *The Adoration of the Magi*?

Creative Activity

Humanities. Renaissance theater tapped all the resources of that rich period — scientific, musical, artistic — to produce spectacular programs. Scenery painted in perspective imitated marble and other fine materials. Even Leonardo da Vinci designed costumes and ornaments for theatricals. These plays, often based on Greek mythology, were staged with remarkable feats. For example, Neptune, god of the sea, drawn in a carriage by two sea horses and accompanied by eight sea monsters, performs a sword dance while the carriage is ablaze with fire. Even the interludes between the acts were exciting with fireworks, torches, and acrobats.

Compare this to present-day parades and celebrations. Discuss the slapstick we view in sitcoms in comparison to Renaissance plays.

SECTION THREE
New Levels of Excellence

One of the most remarkable things about the Renaissance was its great wealth of artistic talent. During this period lived the artistic giants Leonardo da Vinci, Michelangelo Buonarroti, and Raphael Sanzio. Each of these artists alone would have set any period apart as something special, but all three lived in Italy during the Renaissance. Never before had such a concentrated surge of creative energy occurred simultaneously on three fronts. Like all artists before them, these great masters dreamed of achieving new levels of excellence. Unlike most other artists, each succeeded in his own way.

➤ Leonardo's sketchbooks reveal his remarkable curiosity. Can you name some of the subjects that interested him? Were all of his experiments successful? Name one that was not.

Figure 16.18 Leonardo da Vinci. *Anatomical Studies.* Date unknown. Windsor Castle, Royal Library. © 1992, Her Majesty Queen Elizabeth II.

Leonardo da Vinci

Even when he was a child, people saw that Leonardo da Vinci (lay-oh-**nar**-doh da **vin**-chee) was blessed with remarkable powers. He had gracious manners, a fine sense of humor, and great physical strength. Leonardo also had a curiosity that drove him to explore everything. As he grew older, he studied architecture, mathematics, sculpture, painting, anatomy, poetry, literature, music, geology, botany, and hydraulics. It is estimated that he completed 120 notebooks filled with drawings surrounded by explanations (Figure 16.18). They reveal a driven man moving abruptly from one area of study to another. The subjects range from anatomy to storm clouds to rock formations to military fortifications. He dissected cadavers at a time when the practice was outlawed and subject to severe punishment. This enabled Leonardo to learn how arms and legs bend and how muscles shift as the body moves. He was especially interested in the head, particularly how the eye sees and how the mind reasons. He searched for that part of the brain where the senses meet, believing that this was where the soul would be found.

The Last Supper

Leonardo's artworks are limited in number. He left many projects unfinished because the results did not please him or because he was eager to move on to some new task. In addition to this, he was always experimenting, and many of these experiments ended in failure. Perhaps his greatest "failure" is his version of *The Last Supper* (Figure 16.19). This was a magnificent painting that began to flake off the wall shortly after he applied his final brushstroke.

The Last Supper had been painted many times before, and so Leonardo probably welcomed the challenge of creating his own version. He had an entire wall to work on. It was a wall in a dining hall used by monks in the Monastery of Santa Maria delle Grazie in Milan. Using linear perspective, Leonardo designed his scene so that it would look like a continuation of the dining hall. Christ is the center of the composition. All the lines of the architecture lead to him silhouetted in the window. He has just announced that one of the apostles would betray him, and this news has unleashed a flurry of activity around the table. Only Christ remains calm and silent, and this effectively separates him from the others. The apostles are grouped in threes, all expressing disbelief in his statement except Judas. The third figure on Christ's left,

➤ Describe the setting, the figures, and the event portrayed in this painting. With your finger, trace along the straight lines of the walls and ceiling — where do they lead you? Can you find a curved line among the lines of the architecture? Why is this line important? Did you notice anything unusual about the way the figures are seated at the table? Why do you think they are painted this way?

Figure 16.19 Leonardo da Vinci. *The Last Supper*. c. 1495–98. Fresco. Grazie, Milan, Italy.

Judas, leans on the table and stares at Christ, his expression a mixture of anger and defiance. He is further set off from the others by the fact that his face is the only one in shadow. The other apostles, stunned, shrink back and express their denials and questions in different ways.

As you examine Leonardo's painting, you may be struck by an unusual feature. All the apostles are crowded together on the far side of the table. Certainly they could not have been comfortable that way, and yet none had moved to the near side where there is ample room. Leonardo chose not to spread his figures out because that would have reduced the impact of the scene. Instead, he jammed them together to accent the action and the drama.

Leonardo broke with tradition by including Judas with the other apostles. Earlier works usually showed him standing or sitting at one end of the table, apart from the others. Instead, Leonardo placed him among the apostles but made him easy to identify with a dark profile, suggestive of guilt. This was to show that Judas was separated from the other apostles in a spiritual way rather than in a physical way.

Vasari says that the prior of the monastery became impatient with Leonardo while he was painting *The*

Last Supper. He thought the artist was taking much too long to finish the painting. He became especially upset when he noticed that Leonardo spent long periods of time staring at the picture rather than working on it. Angry, the prior went to the Duke of Milan to complain. Leonardo was then summoned to appear before the Duke. After hearing the complaints made against him, Leonardo said that men of genius sometimes produce the most when they do not seem to be working at all. The Duke found no reason to argue with that. Therefore, Leonardo continued by saying that two heads in the composition were providing him with some difficulty — Christ's and Judas's. He would search for a model for Judas, he said, but it was not hopeful that he could ever find anyone so wicked and depraved as the man who betrayed Christ. However, he hastened to add, he could always paint in the head of the troublesome prior!

It is fortunate indeed that Leonardo's painting of *The Last Supper* still exists. It has suffered a great deal of abuse and neglect in the centuries since it was completed. After Leonardo's death, other artists tried to repair it but used the wrong colors. Years passed and the painting grew more and more faint. At one point, a monk in the monastery ordered a door placed

in the wall. The mark from that door can still be seen at the bottom of the picture. Later, Napoleon's army swept into Italy, and the dining hall was turned into a temporary barracks. The bored soldiers amused themselves by throwing their boots at the figure of Judas. Then, during World War II, the monastery was bombed, and the dining hall suffered a direct hit. Only one wall, protected by sandbags and a steel frame, was left standing—the one with Leonardo's masterpiece. Still safe, but badly scarred, the painting was covered by a canvas. Moisture gathered under the canvas, and when it was removed the entire wall was found to be covered with a white fungus. After the war, it took two years of work to save the painting. Work at preserving this great painting continues today.

Portrait of Ginevra de' Benci

The only painting by Leonardo in the United States may be a portrait of Ginevra de' Benci, the daughter of a rich Florentine banker (Figure 16.20). In his famous picture entitled the *Mona Lisa*, Leonardo created a mysterious, haunting smile. However, in this portrait of Ginevra de' Benci the eyes command atten-

tion. At first they seem to focus on you, but in the next instant they appear to stare at something behind you. He may have done this to draw your gaze to the pupils, which have been painted with layer upon layer of transparent paint until they appear to glow. It is not known why he placed so much importance on the eyes in this picture. However, it may have had something to do with his curiosity about the mind and how it worked. Leonardo may have come to regard the eyes as windows to that mind.

An "Unfinished" Masterpiece

Leonardo was a genius who showed great skill in everything he tried. This was his blessing and his curse, for he jumped from one undertaking to the next. His constant experimenting often kept him from remaining with a project until it was completed. A perfectionist, he was never entirely satisfied with his efforts. When he died, he still had in his possession the *Mona Lisa* portrait. He had been working on it for sixteen years and yet claimed that it was still unfinished. That painting, which he regarded as unfinished, is now one of the most famous works of art ever created.

➤ What is the most interesting feature on this face?

Figure 16.20 Leonardo da Vinci. *Ginevra de' Benci*. c. 1474. Wood. 38.8 x 36.7 cm (15¼ x 14½"). National Gallery of Art, Washington, D.C. Ailsa Mellon Bruce Fund.

Michelangelo

Ranked alongside Leonardo as one of the greatest artists of the Renaissance was Michelangelo Buonarroti (**my**-kel-**an**-jay-loh bwon-nar-**roh**-tee). Like Leonardo, Michelangelo was gifted in many fields, including sculpture, painting, and poetry.

Pietà

A measure of Michelangelo's early genius is provided by his *Pietà* (Figure 16.21), carved when he was still in his early twenties. A **Pietà** is *a work showing Mary mourning over the body of Christ*. In this over-life-size work, the Virgin Mary is presented as a beautiful young woman seated at the foot of the cross. She holds in her lap the lifeless form of the crucified Christ. Gently, she supports her son with her right arm. With her left, she expresses her deep sorrow with a simple gesture. The Virgin's face is expressionless. It is a beautiful face, but small when compared to her huge body. In fact, you may have noticed that Mary's body is much larger than that of Christ. Why would Michelangelo make the woman so much larger than the man? Probably because a huge and powerful Mary was necessary to support with ease the heavy

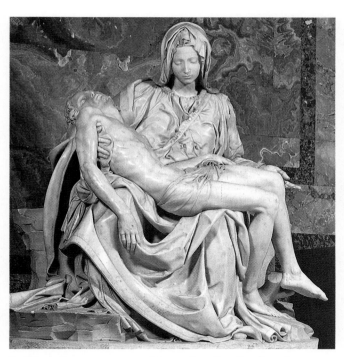

➤ Why is the woman so much larger than the other figure?

Figure 16.21 Michelangelo. *Pietà*. c. 1500. Marble. St. Peter's, Rome, Italy.

about 40 feet (12 m) wide and about 133 feet (40.5 m) long and had a rounded ceiling. It looked impossible to paint, and Michelangelo protested. It was not just the difficulty of the task. No doubt his pride was hurt as well. Ceiling paintings were considered less important than wall paintings, but the walls of the Sistine Chapel had already been painted by Botticelli and other well-known artists. Furthermore, what could he paint on such an immense ceiling so high above the heads of viewers? Michelangelo's anger was intensified by the fact that he thought of himself as a sculptor and not a painter. In the end, all his protests were in vain. The proud, defiant artist gave in to the pope.

Before he could begin work on the ceiling, Michelangelo had to build a high scaffold stretching the length of the chapel. Then, refusing the aid of assistants, he bent over backward and lay on his back to paint on the wet plaster applied to the ceiling. He divided the ceiling into nine main sections and in these painted the story of humanity from the Creation to the Flood.

body of her son. Michelangelo wanted you to focus your attention on the religious meaning of the figures and the event, not on Mary's struggle to support the weight of Christ's body.

Soon after the *Pietà* was placed in St. Peter's Basilica in Rome, Michelangelo overheard some visitors discussing it. He became dismayed when it became clear that they did not know who had created it. Later, he returned with his carving tools, and, on the band across Mary's chest, he carved "Michelangelo Buonarroti of Florence made this." As word of his talent spread, it became obvious to all that only Michelangelo could have carved such a masterpiece.

The Ceiling of the Sistine Chapel

Everything that Michelangelo set out to do was on a grand scale. For this reason, many projects were never completed. Asked by Pope Julius II to design a tomb for him, Michelangelo created a design calling for forty figures. However, only a statue of Moses and some figures of slaves were ever finished. While Michelangelo was still preparing for this project, the pope changed his mind and decided not to spend any more money for it. Instead, he assigned the artist the task of painting the immense ceiling of the Sistine Chapel in the Vatican (Figure 16.22). This chapel was

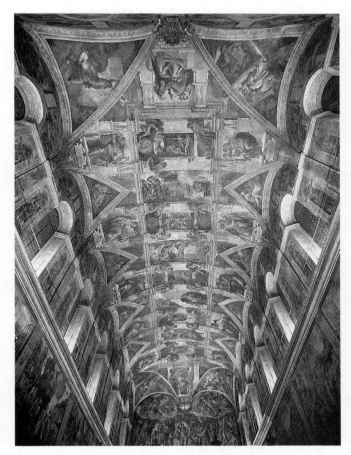

➤ Michelangelo painted these works lying on his back.

Figure 16.22 Michelangelo. Ceiling of the Sistine Chapel. 1508–12. Fresco. The Vatican, Rome, Italy.

Looking up at this huge painting you can see that Michelangelo the Sculptor left his mark for all to see. It looks more like a carving than a painting. The figures are highly modeled in light and shade to look solid and three-dimensional. They are shown in violent action, twisting and turning until they seem about to break out of their niches and leap down from their frames (Figure 16.23).

For over four years, Michelangelo toiled on the huge painting over 68 feet (20.7 m) above the floor of the chapel. Food was sent up to him, and he only climbed down from the scaffold to sleep. He became so involved with this task that he did not take off his clothes or boots for weeks at a time. When he finally removed his boots, the dead, outermost skin of his feet peeled off with them. Perhaps his greatest difficulty was being forced to see and work while bending backward in a cramped position. He grew so accustomed to this that when he received a letter he had to hold it overhead and bend over backward to read it. He claimed that after working on the Sistine ceiling he was never able to walk in an upright position again. When he was finished, he had painted 145 pictures with over three hundred figures, many of which were 10 feet (3 m) high. Only a man of superhuman strength and determination—only a Michelangelo—could have produced such a work.

Moses

As soon as the Sistine Chapel was finished, Michelangelo returned to work on the pope's tomb. Attacking the stone blocks with mallet and chisel, he said that he was "freeing" the figures trapped inside. In about two years, he carved the life-size figures of two slaves and a seated *Moses* (Figure 16.24).

Michelangelo's *Moses* shows the prophet as a wise leader, but capable of great fury. Indeed, here Moses seems to be about to rise up in anger. It is a powerful and commanding portrait, so striking that once you see it, it is difficult to picture Moses looking any other way.

Michelangelo's Energy and Spirit

Popes and princes admired Michelangelo, and everyone stood in awe before his works. His talents were so great that people said that he could not be human, that he must be a descendant from some super race of beings, but he had some very human characteristics as well. A violent temper made it difficult for him to work with assistants, and a suspicious nature caused him to suspect everyone of cheating him. He placed his art above everything else. Only death, at age eighty-nine, could silence the energy, the spirit of the man regarded by many as the greatest artist in a time of great artists.

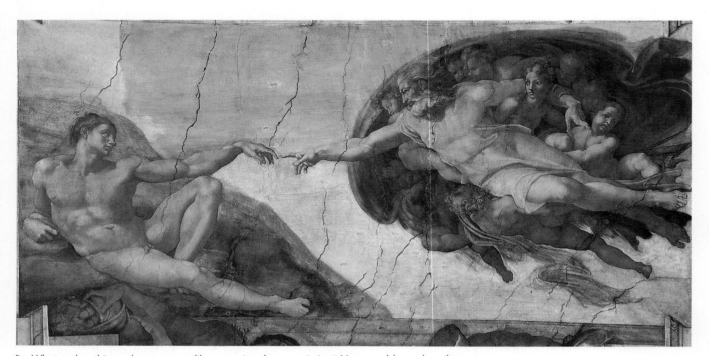

➤ What makes this work seem more like a carving than a painting? How would you describe the actions and gestures of these figures?

Figure 16.23 *The Creation of Adam*, detail from the Sistine Chapel ceiling.

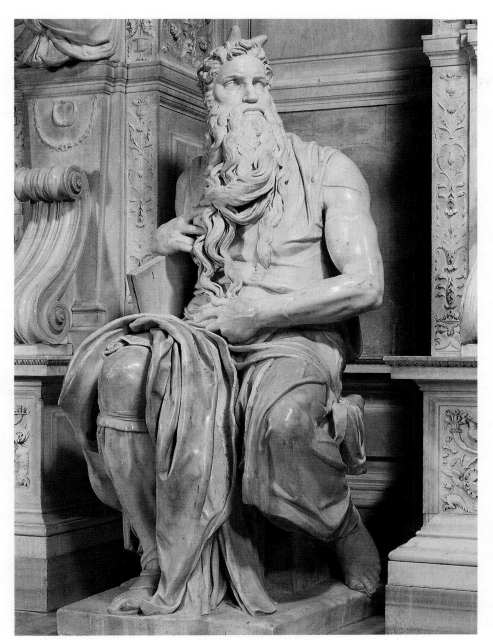

➤ Observe the statue of Moses. Does he seem relaxed and peaceful? If not, how would you describe him? What do you feel is the most impressive feature of this sculpture? Why do you find that feature so impressive?

Figure 16.24 Michelangelo. *Moses.* c. 1513–15. Marble. Approx. 244 cm (8') high. San Pietro in Vincoli, Rome, Italy.

Raphael

Michelangelo was a lonely, tragic figure, but the opposite was true of Raphael Sanzio (**rah**-fah-yell **sahn**-zee-oh). Raphael was successful, wealthy, and admired throughout his brief but brilliant career. Born in a small town in central Italy, he probably had his first art lesson from his father, who was a painter at the court of the Duke of Urbino. While still a child, he was apprenticed to an artist named Perugino. This man taught him to use soft colors, simple circular forms, and gentle landscapes in his paintings.

Having learned all he could from Perugino, the young, ambitious Raphael traveled to Florence to study the works of the leading artists of the day. He was an excellent student and learned a great deal by studying the works of others, especially Leonardo and Michelangelo. From Leonardo he learned how to use shading to create the illusion of three-dimensional form. From Michelangelo he learned how to add vitality and energy to his figures. As an inventor and original thinker, Raphael could not equal either of those masters. By blending the ideas of those artists in his own works, however, he arrived at a style that made him the most typical artist of the Renaissance.

César Martínez

César Martínez (b. 1944) has focused his career as an artist almost exclusively on Chicano issues. He states, "From the time of its birth, mestizo culture has been very dynamic, inventing and reinventing itself to cope with the times. This cultural dynamism continues and has come, perhaps, to a pivotal point. . . . I like to think that the work produced by those of us on the artistic front has played an important role in all this."

Martínez's parents experienced the hardship of the Mexican Revolution and later came to Texas. Martínez, born in Laredo, maintained close ties with relatives across the Texas border.

Although Martínez often spent time drawing and painting, "I also knew that artists didn't make any money. I thought taking business courses would be more practical, but I didn't do well. I just wasn't interested." Still concerned about making a practical choice, he eventually switched his college major from business to art education.

While serving in the United States armed forces in Asia, Martínez purchased inexpensive photographic equipment, and after his 1971 discharge Martínez chose to make photography his principal artistic medium.

During the 1970s Martínez became involved in a variety of Chicano projects. He produced a set of slides that illustrated the history of Chicano art, cofounded the Chicano periodical *Caracol*, and joined one of the first Chicano organizations for artists, Con Safos. Martínez describes this era as "an important time in my development as an artist" because it helped him unify and express his cultural, political, and aesthetic ideas.

Martínez reflects a great deal on his Chicano heritage and the interaction of Spanish, Native American, and European-American cultures: "I'm not sure I would have liked being Aztec or Spanish during that historical period five hundred years ago. Both had enough negatives to make me glad I wasn't there as either. But the native Mexicans and the Spaniards were also similar. Both had a fondness for adventure and conquest. Both ruled harshly. Both were achievers in the arts and architecture."

Given Martínez's sensitivity to the interplay of cultures, it is perhaps not surprising that he should create the painting *Mona Lupe*, which pictures Leonardo da Vinci's Italian Renaissance lady as the Virgin of Guadalupe. This image of Mary is based on the sixteenth-century Indian Juan Diego's vision in the mountains near Tepeyac.

Figure 16.25 César Martínez. *Mona Lupe: The Epitome of Chicano Art.* 1991. Acrylic on canvas. 71.4 x 51.4 cm (28⅛ x 20¼").

The Alba Madonna

In 1508, when Raphael was twenty-five years old, Pope Julius summoned the artist to Rome to paint frescoes for the papal palace in the Vatican. It was while he was working on these frescoes that Raphael probably painted the well-known *Alba Madonna* (Figure 16.26). This is an excellent example of the kind of pictures that were painted in Italy at the peak of the Renaissance. For this reason, it is well worth discussing at some length.

The painting shows three figures, a woman and two children, placed in the foreground with a peaceful and calm landscape stretching back into the distance. You will find no other figures in the painting. In fact, the only other signs of people are the steep-roofed farm houses in the distance. The figures seem round, solid, and lifelike, a result of Raphael's subtle shading technique. The unclothed child in the center turns in the woman's lap and reaches out for a cross held by the second child, dressed in animal skins. The woman is seated on the ground leaning against the trunk of a tree. In her left hand she holds a book, which she must have been reading. A finger holds her place in the book as she glances away. The facial expressions are serious as all eyes focus on the cross. There is no sign of joy or happiness on these faces.

There is a balanced use of hue in the painting. Raphael has used the three primary colors—red, yellow, and blue—which represent a balance of the color spectrum. Blue dominates; it is used throughout the work and, in the background, adds to the illusion of deep space. This illusion is heightened further by the use of duller hues in the background.

A gradual change from light to dark values adds a feeling of roundness and mass to the shapes. The shapes that make up the three figures combine to form a single large trapezoid which is placed slightly off center in the circular composition. You can identify this trapezoid by drawing an imaginary line around the contour of the three figures. The repeated horizontal lines in the background help to balance and hold this large trapezoid in place.

The halos and cross immediately suggest a religious theme. The woman and unclothed child are identified as the Madonna and the Christ Child. The second child is probably St. John the Baptist. The

➤ How have these figures been made to look lifelike? What three hues are used in this painting? What do we call these hues—primary colors, secondary colors, or complementary colors? How are hue, value, and intensity used to create the look of deep space? In your opinion, is this a good work of art? Why or why not?

Figure 16.26 Raphael. *The Alba Madonna.* c. 1510. Oil on wood transferred to canvas. Diameter, 94.5 cm (37¼"). National Gallery of Art, Washington, D.C. Andrew W. Mellon Collection.

camel's hair garment that he wears fits the description of the garment he wore later while preaching in the desert. St. John holds a small cross, the symbol of salvation made possible by Christ's death. The Christ Child freely accepts the cross and appears to be turning and moving on his mother's lap. He twists around in a way that suggests that he wants St. John, representing all people, to follow him.

At first you may think that this painting is little more than a gentle picture of Christ, his mother, and St. John the Baptist enjoying a pleasant outing in the sunshine. However, there is an undercurrent of tension in the work that becomes obvious the more you study it. This tension is best noted in the faces. Everything else is calm and peaceful, but the faces fail to show signs of happiness or contentment. A sadness veils Mary's face as she lifts her eyes from her book. Perhaps something she has read causes her to turn her attention to the cross in her child's hand. All three figures stare intently at this cross, and their thoughts drift to the future. Do they recognize the meaning of the cross, or are they only concerned with the unexpected uneasiness it stirs up within them?

Once you have described, analyzed, and interpreted Raphael's painting, you may find that your own judgment echoes that of Vasari, who wrote the following: "Other masters painted pictures, but Raphael paints life itself."

In the spring of 1520, Raphael fell ill with a violent fever. Friends told him that it was nothing serious, but Raphael knew he was dying and calmly went about putting his affairs in order. He died on his thirty-seventh birthday and was buried with full honors in the Pantheon in Rome. His epitaph, in Latin, says simply, "He who is here is Raphael." No other words were necessary; the name alone was enough to testify to his greatness.

Renaissance Women Artists

You may have noticed that in the coverage of art periods up to this point there has been no mention of women artists. The reason for this is that few works by women artists completed before the Renaissance have come to light. Furthermore, it was not until the Renaissance had passed its peak that women artists were able to make names for themselves as serious artists. Even in that enlightened period, it was not easy for women to succeed as artists because of the obstacles that had to be overcome.

During the Medieval period, women were expected to tend to duties within the household. Their first responsibilities were those of wife and mother. If that failed to occupy all their time, they were required to join their husbands in the backbreaking chores awaiting in the fields. There seemed to be no reason for women to seek an education or learn a trade because there were few opportunities for them to work outside the home. They were, in general, excluded from the arts because, as women, most of them were prevented from gaining the knowledge and skills needed to become artists. Their involvement in art was limited, for the most part, to making embroideries and tapestries and occasionally producing illustrated manuscripts.

During the Renaissance, artists came into their own as valued and respected members of society. However, the new importance attached to artists made it even more difficult for women to pursue a career in art. Artists at that time were required to spend longer periods in apprenticeship. During this time, they studied mathematics, the laws of perspective, and anatomy. Serious artists were also expected to journey to major art centers. There they could study the works of famous living artists as well as the art of the past. This kind of education was out of the question for most women in the fifteenth and sixteenth centuries. Only a handful were determined enough to overcome all these barriers and succeed as serious artists. One of these was Sofonisba Anguissola (soh-foh-**niss**-bah ahn-gue-**iss**-sol-ah).

Sofonisba Anguissola

Anguissola was the first Italian woman to gain a worldwide reputation as an artist. She was the oldest in the family of six daughters and one son born to a nobleman in Cremona about twelve years after Raphael's death. At that time, art was flourishing in Cremona. Sofonisba's father was no doubt pleased to find that all his children showed an interest in art or music. He encouraged them all, especially his oldest daughter. Sofonisba was allowed to study with local artists, and her skills were quickly recognized. Her proud father even wrote to the great Michelangelo about her. The response was words of encouragement and a drawing that Sofonisba could study and copy as part of her training.

Many of Sofonisba's early works were portraits of herself and members of her family. However, she is known to have done a few religious paintings as well. Her father was always eager to spread the word about his talented daughter. He sent several of her self-portraits to various courts, including that of Pope

Julius III. Publicity of this kind contributed to her growing reputation. In 1559, while she was still in her twenties, Sofonisba accepted an invitation from the King of Spain, Philip II. He asked her to join his court in Madrid as a lady-in-waiting. For ten years, she painted portraits of the royal family. After this time, she met and married a nobleman from Sicily and returned to Italy with him. She took with her a fine assortment of gifts presented to her by the appreciative Spanish king.

Many of Sofonisba's portraits deserve to be included among the best produced during the Late Renaissance. The reason will be clear when you examine her portrait of the son and daughter of a wealthy Florentine family (Figure 16.27). You can then appreciate Vasari's claim that her pictures were "so lifelike that they lacked only speech." Speech is hardly necessary in this straightforward painting of a boy gazing up thoughtfully from an open book he has been reading. As he does so, his sister places her arm around him. The artist seems to be telling us that the boy not only knows how to read, but is intelligent enough, even at this young age, to think seriously about what he has read. His sister's gesture and expression are signs of her affection and her pride.

➤ What sets this artist apart from those you have learned about up to this point? This artist's international reputation was based upon an ability to paint which of the following: still lifes, landscapes, portraits, or religious subjects?

Figure 16.27 Sofonisba Anguissola. *Double Portrait of a Boy and Girl of the Attavanti Family.* Date unknown. Oil on panel. Diameter, 40 cm (15¾"). Allen Memorial Art Museum, Oberlin College, Oberlin, Ohio.

SECTION THREE

Review

1. Name five of the many different subjects Leonardo studied.
2. Why did Leonardo da Vinci complete so few artworks?
3. Why did Michelangelo distort the proportion of the two figures in his *Pietà*?
4. Why was Michelangelo not asked to paint the walls of the Sistine Chapel?
5. What subject did Michelangelo paint on the ceiling of the Sistine Chapel?
6. Why is Raphael regarded as the most typical of the Renaissance artists?
7. How did Raphael create the feeling of deep space in his painting *The Alba Madonna*?
8. Why were women excluded from the arts until the Renaissance?

Creative Activities

Humanities. It was a tremendous responsibility that four Vatican restorers took on when they began the cleaning of the Sistine Chapel ceiling in the early 1980s. Almost five hundred years of grime had darkened this master work, even obliterating parts of its wonderful detail. The risk of removing too much and damaging the paintings made the task formidable. After experimenting on smaller Michelangelo frescoes, the restorers devised a solution with an apple-butter consistency that was spread on the surface and left for three minutes. Then it was removed and the section was washed with distilled water. After twenty-four hours, the process was repeated.

Find out more about the restoration process of this magnificent work of art.

PAINTING A CITYSCAPE

Supplies
- Pencil and sketch paper
- White drawing paper, 9 x 12 inches (23 x 30 cm)
- Tempera or acrylic paint (one hue plus white and black)
- Brushes, mixing tray, and paint cloth
- Water container

Complete a painting of a cityscape in which buildings and other objects are shown as flat, overlapping shapes. Paint these shapes with a variety of values obtained by mixing white and black with a single hue. To create an illusion of deep space, apply the darkest values to shapes in the foreground. Values applied to buildings and objects in the distance will be gradually lighter.

Focusing

Examine paintings by Masaccio (Figures 16.3, page 362 and 16.6, page 364), Botticelli (Figure 16.17, page 373), and Raphael (Figure 16.26, page 381). What methods did these artists use to create an illusion of deep space in their pictures? What is the name given to this method of showing space? How do changes of value contribute to this effort to suggest space on a two-dimensional surface?

Figure 16.28 Student Work

Creating

Complete several sketches of city buildings. Then simplify these sketches by transforming the buildings into flat, overlapping shapes. However, make certain that each of the buildings maintains some of its own unique features.

Reproduce the best of your sketches on the sheet of drawing paper. Make all the lines of this drawing as precise as possible.

Choose a single hue to paint your cityscape. Mix white and black with this hue to create a range of values. Apply the darkest value to the building or object in the immediate foreground. As you paint each object farther back in the picture, use a lighter value. The lightest value should be reserved for the building or object farthest back in the composition.

Figure 16.29 Student Work

Reviewing the Facts

SECTION ONE

1. Were Renaissance artists and scholars more interested in studying the artistic accomplishments of the Medieval period or those of the Greeks and Romans?
2. What invention was most responsible for helping to educate the middle classes during the Renaissance?
3. Who is regarded as the first important artist of the Italian Renaissance?

SECTION TWO

4. Refer to Piero della Francesca's *Baptism of Christ* (Figure 16.12 on page 369). How is the main figure made to look most important?
5. Who was the greatest sculptor of the Early Renaissance? What quality did his sculptures exhibit?
6. Name the architect who designed the dome for the Cathedral of Florence.

SECTION THREE

7. Who painted the *Mona Lisa* and how long did he work on it?
8. What does the word *Pietà* mean?
9. Name several barriers that made it difficult for women to become known artists.

Thinking Critically

1. ***Analyze.*** Look at Masaccio's *The Holy Trinity* (Figure 16.3 on page 362). Then refer to the list of techniques that create the illusion of depth on page 39 in Chapter 2. Identify the techniques that Masaccio has used.
2. ***Extend.*** You read that the Italians continued to build in the Romanesque style of architecture, instead of the Gothic style, because the solid walls kept the insides of their buildings cool. Since this feature of their buildings gave them the opportunity to continue developing their paintings, it seems only natural that it would be an Italian (Masaccio) to make the first advances in painting. How significant do you think external factors such as weather, location, or available materials are in the success of major breakthroughs in any field?

Using the Time Line

While Michelangelo was working on the Sistine ceiling in 1509, a new king was crowned in England, a king who was to become famous for his many wives. Who was he? What work of art was created by Raphael in the following year? What does his painting tell you about the political climate of that period?

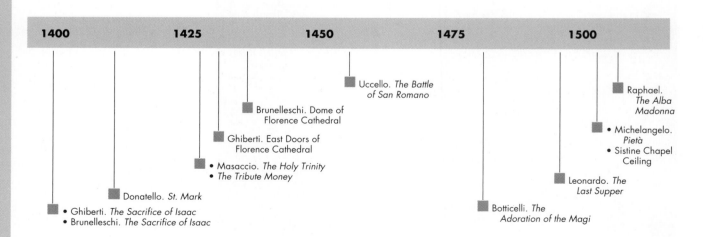

1400	1425	1450	1475	1500

Uccello. *The Battle of San Romano*

Raphael. *The Alba Madonna*

Brunelleschi. Dome of Florence Cathedral

• Michelangelo. *Pietà*
• Sistine Chapel Ceiling

Ghiberti. East Doors of Florence Cathedral

• Masaccio. *The Holy Trinity*
• *The Tribute Money*

Leonardo. *The Last Supper*

Donatello. *St. Mark*

Botticelli. *The Adoration of the Magi*

• Ghiberti. *The Sacrifice of Isaac*
• Brunelleschi. *The Sacrifice of Isaac*

Jonathan Edward Allen, Age 17
Roswell High School
Roswell, Georgia

hallway to give an illusion of distance and to provide a marked value contrast between the background and the foreground.

"Finally, the Renaissance spurred mankind on to consider more thoughtfully its past, surroundings, and intentions. This is why the skeleton turns its head in anticipation—forever considering another alternative, another way, another path.

"I would advise my fellow artists to consider the deeper implications of their artwork and their role as artists; to truly try and see how much their art, and the ideas, intentions, and vision represented by their art, really matter."

"Leonardo's sketchbooks inspired me to choose a skeleton as the primary subject of this artwork. I was also intrigued by Filippo Brunelleschi's discovery of linear perspective and decided to incorporate it in my composition. The chapter's discussion of Renaissance architecture as well as the value contrasts in Masaccio's *The Tribute Money* provided further inspiration.

"I wanted to capture the sense of rebirth that the Renaissance created. This rebirth was so powerful and influential that it did, in a sense, bring skeletons to life. I also wanted to create a visual portrayal of man's path through space and time; the hallway served this purpose. I lengthened the

➤ *Bones 'n Hall.* Pencil. 40.6 x 50.8 cm (16 x 20").

With Sight and Feeling: Fifteenth-Century Art in Northern Europe

Objectives

After completing this chapter, you will be able to:

➤ Explain why the change from a medieval art style to a more modern style occurred more slowly in northern Europe than in Italy.

➤ Discuss the use of symbolism in fifteenth-century art in northern Europe.

➤ Describe the differences in paintings done by Jan van Eyck and Rogier van der Weyden.

➤ Design a visual symbol.

Terms to Know

gesso
oil paints
tempera

Figure 17.1 Robert Campin (Master of Flémalle). *Joseph in His Workshop*, right panel from *The Mérode Altarpiece*. c. 1425–28. Oil on wood. 64.5 x 27.3 cm (25⅜ x 10¾"). The Metropolitan Museum of Art, New York, New York. Cloisters Collection.

The fifteenth century saw commerce and industry thrive

in northern Europe just as in Italy. This contributed to the growth of cities and a vigorous

middle class. The people of this new middle class did not exhibit the same interest

in the spiritual life as had their medieval ancestors. Their thoughts were fixed on

the here and now rather than on an eternal life after death. They placed their faith in a

future on earth and preferred to enjoy the pleasures and material possessions of

this world instead of preparing for spiritual rewards in the next.

SECTION ONE

Renaissance Painting in Northern Europe

Throughout the century, most artists in northern Europe (see map, Figure 17.2) remained true to the traditions of the Late Medieval period. This was especially true in architecture. The construction of churches and government buildings in the Gothic style lasted into the next century. However, the progress of painting in the North during this time was more complicated.

Figure 17.2 Renaissance Northern Europe

Continuation of the International Style

The change from a medieval art style to a more modern art style began later and progressed more slowly in northern Europe than it did in Italy. Northern painters showed little interest in the classical art of ancient Greece and Rome. While Italian artists were busy studying ancient art, northern artists carried on and developed further the International style. For this reason, their paintings continued to show a great concern for accurate and precise details. Artists spent countless hours painting the delicate design on a garment, the leaves on a tree, or the wrinkles on a face. At the same time, symbolism, which was so important in Gothic art, grew even more important. Many of the details placed in a picture had special meanings. For example, a single burning candle meant the presence of God; a dog was a symbol of loyalty; and fruit signified the innocence of humanity before the Fall in the Garden of Eden.

Development of the Oil-Painting Technique

Up to this time, European artists were accustomed to using **tempera**, *a paint made of dry pigments, or colors, which are mixed with a binding material.* A binder is a liquid that holds together the grains of pigment in paint. Typically, this binder was egg yolk, although gum and casein were also used. Tempera paint was applied to a surface, often a wooden panel,

which had been prepared with a smooth coating of **gesso**, *a mixture of glue and a white pigment such as plaster, chalk, or white clay*. This painting method produced a hard, brilliant surface, which was used for many medieval altarpieces.

In the fifteenth and sixteenth centuries, the northern artist's concern for precision and detail was aided by the development in Flanders of a new oil-painting technique. **Oil paints** *consist of a mixture of dry pigments with oils, turpentine, and sometimes varnish.* With such a mixture, artists could produce either a transparent, smooth glaze, or a thick, richly textured surface.

The change from tempera paint to oil was not a sudden one. At first, oil paints were used as transparent glazes placed over tempera underpaintings. The solid forms of figures and objects were modeled with light and dark values of tempera. Then oil glazes were applied over them, adding a transparent, glossy, and permanent surface. Later, artists abandoned the use of an underpainting and applied the oil paint directly to the canvas, often building up a thick, textured surface in the process.

One of the more important advantages of the oil-painting technique was that it slowed down the drying time. This gave artists the chance to work more leisurely. With the new technique, there was no need to hurry as the Italian artists had while working in fresco. Thus, artists had time to include more details in their pictures. Also, the layers of transparent glazes added a new brilliance to the colors so that finished paintings looked as if they were lit from within. The artist usually given credit for developing this new painting technique was the Flemish master Jan van Eyck (yahn van **ike**).

The Flemish Influence: Jan van Eyck

The art of Jan van Eyck and his successors made Flanders the art center of northern Europe. Throughout the fifteenth century, the art produced by Flemish artists was a great influence on other artists in Europe, from Germany to Spain. Nowhere, however, did it reach the lofty heights achieved by van Eyck and two other Flemish artists, Rogier van der Weyden and Hugo van der Goes.

Jan van Eyck was mostly a product of the late Middle Ages, although he went beyond the older traditions of the exceedingly detailed International style to introduce a new painting tradition. Like other northern artists, he did not turn his back on the International style as did many Italian artists at this time. Instead, he used it as a starting point. As a result, his break with the past was not as sudden as that of Italian artists such as Masaccio.

Giovanni Arnolfini and His Bride

One of van Eyck's best-known works is a painting of two people standing side by side in a neat, comfortably furnished room (Figure 17.3). The room is modest in size and illuminated by a subdued light entering through an open window at the left. But who are these people and what are they doing? The man is Giovanni Arnolfini and the woman at his side is his bride. You are witnessing in this extraordinary painting their marriage ceremony.

Giovanni Arnolfini was a rich Italian merchant who lived in Flanders. Since he was from the city of Lucca, it is probable that he became wealthy by selling the beautiful silk brocade for which that town was famous. Like many other Italians in Flanders, he no doubt sold other luxury goods as well and may have worked as a banker. When Giovanni Arnolfini decided to marry Jeanne de Chenay in 1434, he looked for the best artist available to paint a picture of their wedding. He found that artist in Jan van Eyck, who made him, his bride, and their wedding immortal.

The wedding couple solemnly faces the witnesses to the ceremony. Giovanni raises his right hand as if he is saying an oath, while his bride places her right hand in his left. Her frail body seems lost in the full, green, fur-lined dress. Her curving posture may look odd, but at that time it was considered quite fashionable to stand that way. Both figures look real but frozen in their poses. The face of the bride is white and smooth as a china doll's. However, Giovanni's is much more natural. Given the opportunity to examine the actual painting, you would be able to see the stubble on his chin.

Van Eyck's picture is rich in detail; every part of it is painted with a precision rarely equaled in art. Did you notice the mirror on the far wall of the room? In this mirror are shown the reflection of the room, the backs of Giovanni and his bride, and two other people standing in the doorway. These two people face the bride and groom and are probably the witnesses to the exchange of vows. Above the mirror is a Latin inscription that reads, "Jan van Eyck was here." Could van Eyck be one of those witnesses seen in the mirror? What do you think?

Numerous symbols can be found in Jan van Eyck's painting of the wedding ceremony. The couple have removed their shoes as a sign that they are standing on holy ground. It is holy because of the blessed event taking place there. The burning candle in the chandelier tells you that God is present at the solemn ceremony, while the little dog between them represents the loyalty that the husband and wife pledge to each other. Innocence is suggested by the fruit on the table and windowsill. From the finial of the bed's headboard hangs a whisk broom, symbolizing care of the home.

Adoration of the Lamb

Van Eyck's painting of the *Adoration of the Lamb* (Figure 17.5, page 393) is the central lower panel of a large (14.5 x 11 feet [4.4 x 3.4 m]) altarpiece containing twelve panels. It shows angels, saints, and earthly worshipers coming from all directions through a green valley toward a sacrificial altar. A lamb, one of the symbols of Christ, stands on this altar. Blood from the lamb flows into a chalice. In the foreground is a fountain from which flows the pure water of

➤ Look closely at the details shown in this picture. Are these people well-to-do, or poor? In what ways is this picture lifelike? Symbolism is an important feature of this painting; can you find any examples of symbolism?

Figure 17.3 Jan van Eyck. *Giovanni Arnolfini and His Bride.* 1434. Oil on panel, 83.8 x 57.2 cm (33 x 22.5"). National Gallery, London, England.

Art · PAST AND PRESENT ·

Mythical Symbols

Much of the art produced in northern Europe during the fifteenth century included visual symbols. Artist Roger Brown recently used symbolism in a mosaic mural he created for a building at 120 North LaSalle Street in Chicago.

In Greek mythology, architect and inventor Daedalus builds a labyrinth in which the Minotaur, a fearsome half-bull, half-man, is to be kept. Daedalus rescues a man from the Minotaur and, as punishment, is confined to the labyrinth with his son Icarus. There Daedalus builds wings from wax and feathers in order to escape. He instructs his son to fly the middle course, neither too high nor too low. However, Icarus chooses to fly too close to the sun. The sun melts the wax in his wings and he plummets to his death in the sea below.

Figure 17.4 Roger Brown. *The Flight of Daedalus and Icarus.*

Like other artists whose work is highly symbolic, Brown's mosaic does more than illustrate a story. He uses the ancient myth to symbolize the idea of taking chances, the importance of creativity, the willingness to experiment, and the experiences of modern humanity with science and technology.

eternal life. Most likely this painting was inspired by a passage from the Bible that refers to Christ as the Paschal, or sacrificial, Lamb. The symbolism in the picture conveys the belief that eternal salvation is possible for all because of Christ's willingness to sacrifice his life on the cross, and that his death made possible the water of salvation received by the faithful at baptism.

The scene is carefully organized so that the lamb is the obvious center of interest. The placement of the angels kneeling at the altar and the prophets and other worshipers around the fountain serves to lead your eye to this center of interest. Other groups of saints and worshipers move toward it from each of the four corners of the painting. The two groups in the foreground form wedges that point to the center of interest.

Like Masaccio, van Eyck controls the flow of light and uses atmospheric perspective to create the illusion of deep space in his work. However, unlike that in Masaccio's work, the light in van Eyck's painting is crystal clear. It allows you to see perfectly the color, texture, and shape of every object. Van Eyck was less interested in telling the viewer how he felt about things. Instead, he took pride in demonstrating his ability to see very clearly and pass on to others with his paint and brushes the wonders he discovered in the world around him.

The details in van Eyck's picture are painted with extraordinary care. The soft texture of hair, the glitter and luster of precious jewels, and the richness of brocade are all painted with the same concern for precision. Every object, no matter how small or insignificant, is given equal importance. This attention to detail enabled van Eyck to create a special kind of realism — a realism in which the color, shape, and texture of every object were painted only after long study.

Even with all the advantages of modern science, it is still not known how van Eyck was able to achieve many of his effects. Somehow, by combining a study of nature with a sensitive use of light and color, he was able to produce paintings that others admired but could not duplicate. No painter has ever been able to match van Eyck's marvelous precision and glowing color.

➤ Notice how the figures have been arranged in this work. Does this direct your attention to a particular spot? How has hue been used to create the illusion of deep space? When judging this work, did you refer more to its literal qualities or its expressive qualities?

Figure 17.5 Jan van Eyck. *Adoration of the Lamb,* central panel from *The Ghent Altarpiece.* 1432. Tempera and oil on wood. St. Bavo, Ghent, Belgium.

SECTION ONE

Review

1. What effect did the growth of cities and a vigorous middle class have on the spiritual interests of the people?
2. In what way did the interests of Italian artists differ from those of northern European artists during the fifteenth century?
3. Name two characteristics of the International style used widely by northern European artists.
4. What is a binder?
5. List two advantages of oil paints over tempera.
6. Describe two details included in Jan van Eyck's *Giovanni Arnolfini and His Bride* (Figure 17.3, page 391) and tell what they symbolize.

Creative Activities

Humanities. The invention of oil-based paint as a medium revolutionized the world of art in many ways. Fresco painting was done directly on a wall. Egg tempera was painted on wood panels. Oil paint, however, could be applied to a piece of canvas, which could be rolled up and shipped anywhere. This gave the artist a new role in society, because individuals could commission or purchase paintings for their homes.

Find a mortar and pestle (a bowl and a ball-end tool for grinding) and discover for yourself what was involved in the proper preparation of pigments.

Northern Art Combines Emotionalism and Realism

Gradually, northern fifteenth-century art developed into a style that combined the realism of Jan van Eyck with the emotionalism and attention to design found in works done during the late Gothic period. This style is best seen in the works of another northern artist.

Rogier van der Weyden

Jan van Eyck had been concerned with painting every detail with careful precision. Rogier van der Weyden (roh-**jair** van der **vy**-den) continued in this tradition, but also added some new ideas of his own.

Descent from the Cross

In Rogier's painting of the *Descent from the Cross* (Figure 17.6), you will see more emotion and a greater concern for organization than you will find in van Eyck's pictures. In this instance, organization is

➤ Observe the emotions conveyed by the figures in this work. Do the facial expressions and gestures differ, or are they all alike? How are the figures made to look lifelike? Can you find any repeated, curved axis lines? Why are these lines important to this composition? How does the background force you to keep looking at the figures?

Figure 17.6 Rogier van der Weyden. *Descent from the Cross.* c. 1435. Tempera and oil on wood. Approx. 2.2 x 2.6 m (7' 2⅝" x 8' 7⅛"). The Prado, Madrid, Spain.

achieved through use of repeating curved axis lines. Observe how the two figures at each side of the picture bend inward and direct your attention to Christ and his mother. In the center of the picture, Christ's lifeless body forms an S curve, which is repeated in the curve of his fainting mother. Unlike van Eyck, Rogier made no attempt to create a deep space. Space is restricted as if to compress the action across the surface of the painting. Rogier managed to group ten figures in this shallow space without making them seem crowded. By placing these figures on a narrow stage and eliminating a landscape behind, he forces you to focus your attention on the drama of Christ's removal from the cross. The figures and the action are brought very close to you, forcing you to take in every detail. This enables you to see that the faces clearly differ from one another just as the faces of real people do. Every hair, every variation of skin color and texture, and every fold of drapery is painted in with care.

Rogier does not stop there. Equal attention is given to the emotions exhibited by the different facial expressions and gestures. No two people react in the same way. In fact, the entire work is a carefully designed and forceful grouping of these different emotional reactions to Christ's death. Yet, one of the most touching features is also one of the easiest to miss. The space between the two hands—Christ's right and Mary's left—suggests the void between the living and the dead. It may seem like a minor point, but once you notice those hands, so close and yet so far apart, you are not likely to forget them or their meaning.

➤ This picture contains sharp and subtle contour lines. Can you find examples of each? What has been done to make this face stand out?

Figure 17.7 Rogier van der Weyden. *Portrait of a Lady.* c. 1460. Oil on oak. Approx. 34 x 25 cm (13⅜ x 10⅝"). National Gallery of Art, Washington, D.C. Andrew W. Mellon Collection.

Portrait of a Lady

Rogier van der Weyden was a very popular artist, and many people wanted their portraits painted by him. One of those people was a young woman, unknown to us today, whose portrait (Figure 17.7) Rogier painted some twenty years after the *Descent from the Cross*. The woman's face, framed by a white, starched headdress, stands out boldly against a dark background. Light flows evenly over it, revealing a pleasant, but not beautiful, woman. The headdress is thin and transparent, allowing you to see the line of her shoulder.

You might not think so at first, but this is a remarkable portrait. Look at it closely. Now, what does this painting tell you about the personality of the woman? Do you think she was loud and outgoing, or was she quiet, shy, and devout? Does she appear to be bold and active, or frail and reserved? Rogier provided you with clues to answer questions like these. The lowered eyes, tightly locked fingers, and frail build all suggest

a quiet dignity. The young woman is lost in thought, her clasped hands seemingly resting on the frame. She must have been wealthy but does not flaunt her good fortune. A gold belt buckle and rings are the only signs of luxury. Even though it is not known who the woman was, Rogier has left us with a vivid impression of the kind of person she must have been.

Rogier's Influence

Rogier van der Weyden performed a valuable service by preserving the Gothic concerns for good design and vivid emotion. Those concerns could have been lost in the rush to use van Eyck's new oil-painting technique to produce highly detailed pictures, but Rogier's paintings set an example for other artists. When he died in 1464 after being the most famous painter in Flanders for thirty years, his influence was second to none outside Italy.

Robert Longo

Robert Longo (b. 1953) is regarded by many as the most important North American artist of his generation, a reputation that may surprise those who knew him during his youth in Brooklyn. Longo had difficulty in school because of his restless and rebellious temperament. He suffered from dyslexia, a problem that makes reading very frustrating, and was not diagnosed until his final year of high school.

After high school, Longo tried to study music in college. This and two other attempts to earn a degree failed. He turned to studying art conservation, but after a trip to Florence, Italy, Longo realized that he wanted to make art himself, not repair art made by others. He also discovered that the artists he most admired were well versed in the history of art.

This realization inspired him to overcome his reading problem and earn a degree in art history.

By the early 1980s, Longo had developed his own highly charged art that focused on the psychological violence of urban life, a violence that he wanted his audience to notice. His aggressive, energetic, and socially critical art, which included multimedia performances, film, drawing, and sculpture, reflected his personal need for constant stimulation.

Working in New York City, Longo frequently visited the trading floor of the New York Stock Exchange. The mayhem that he witnessed there inspired his monumental relief panel *Corporate Wars: Walls of Influence.* "Everyone [at the stock exchange] seemed to be mad, everyone was fighting with everyone else. I felt like this really small guy surrounded by the strange, creepy monumentality of finance and buildings, and it reminded me of how insecure I am, how insecure we probably all are." To underline the drama and suffering of this scenario, Longo incorporated references to Rogier van der Weyden's *Descent from the Cross* (Figure 17.6, page 394) and other historical religious paintings.

Skyrocketing to fame after an exhibit of his larger-than-life charcoal drawings of urbanites twisting and writhing in a mysterious fashion (his *Men in the Cities* series), Longo became an overnight celebrity. The hectic art scene of the 1980s, however, eventually ceased to hold glamour for Longo. Reflecting on the hazards of success, Longo stated, "You start getting upset you're not in a magazine that week. Or somebody is selling more art than you are. . . . You can drive yourself crazy."

Figure 17.8 *Corporate Wars: Walls of Influence.* 1982. Mixed media. 274 x 792 x 122 cm (9 x 26 x 4').

Hugo van der Goes

One of the artists who continued in the direction taken by Rogier was Hugo van der Goes (**hoo**-go van der **goose**). Hugo combined the emotionalism of Rogier with the realistic detail of Jan van Eyck. In addition, he made his own unique contribution: He was not afraid to alter or distort nature or the proportion of people or objects if it would add to the emotional impact of his picture.

Hugo van der Goes rose to fame as an artist in Bruges, one of the wealthiest cities in Flanders. At the peak of his popularity and while he was still a young man, he entered a monastery near Brussels where he remained the rest of his life. Hugo however, did not retire to a strict life of prayer and meditation when he entered the monastery as did other men who chose the monastic life. Apparently, he was regarded as something of a celebrity because of his talent as a painter and enjoyed special favors. He continued to work as a painter and enjoyed a great many luxuries not available to other monks, but he suffered from fits of depression and thought that he was destined to everlasting punishment in the next world because of his sinful ways. Hugo van der Goes, the unhappy genius, died in 1482 only seven years after entering the monastery.

The Portinari Altarpiece

Hugo's most ambitious work was an altarpiece completed in 1476 for the Italian representative of the Medici bank in Bruges. This huge work is known as the *Portinari Altarpiece* after the name of this banker. It is especially important because it was sent to Florence soon after it was completed. There it was a great influence on late-fifteenth-century Italian artists who were deeply impressed by Hugo's ability to portray human character and feeling.

Unlike van Eyck, Hugo decided not to organize the space in his picture so that it would look real. Instead, he took liberties with space to increase the emotional appeal of his picture. In the central panel of his altarpiece showing *The Adoration of the Shepherds* (Figure 17.9), he tipped the floor of the stable upward. This not only gives you a better view but makes you feel as though you are an on-the-spot witness to the event. However, a clear view of Hugo's version of the Nativity leads to some strange discoveries. Where is the joy and gladness usually associated with the birth of Christ? Joseph and Mary both seem strangely withdrawn, even sad. This was odd behavior for such a joyous event. Could it be that they are thinking ahead to the suffering in store for their son? Of course you cannot know for sure what Joseph and Mary are thinking, but one thing is certain: Hugo's picture succeeds in arousing your curiosity. He makes it difficult for

➤ The artist organized space in this picture so that it would not look real. Point to things in the picture that make it seem as if you are seeing it as a dream or a vision. Identify some symbols in this work and explain their meaning.

Figure 17.9 Hugo van der Goes. *The Adoration of the Shepherds,* central panel of *The Portinari Altarpiece.* c. 1476. Approx. 2.5 x 3 m (8'3" x 10'). Galleria degli Uffizi, Florence, Italy.

you not to think ahead in time to the tragic events awaiting the Christ Child.

More strange discoveries await you in Hugo's painting. Did you notice the unusual differences in the sizes of the figures? The angels closest to you, for example, should be much larger than the figures farther back in space. Instead they look much smaller. Also, the three shepherds at the right are about the same size as Mary even though they are farther away. It is unlikely that these differences in size are due to this artist's lack of skill. There must be some other explanation. Could Hugo have been trying to paint this scene as if he were seeing it in a dream or a vision? This is a possibility, since the figures in a dream would not have to follow the rules of logic. Large and small figures could be placed next to each other or could even float about in space.

One of the most fascinating things about Hugo's painting is his portrayal of the three shepherds (Figure 17.10). More than anything else, their behavior and expressions set this painting apart from countless other Nativity scenes produced since the early Christian period. It was Hugo's painting of these shepherds that later caused so much excitement among the Italian artists who saw this picture. They had never seen

➤ The artist's treatment of these three shepherds caused much excitement among the Italian artists who saw this painting. Describe the appearance, expressions, and actions of these figures.

Figure 17.10 Hugo van der Goes. *The Adoration of the Shepherds* (detail).

figures painted like this before. Hugo's shepherds are not saints, or angels, or elegant noblemen. They are ragged, coarse peasants from the lowest level of society. They represent the great masses of common people in the world who are as interested in salvation as anyone else. Their crudeness, curiosity, and blind faith contrast with the quiet dignity and grace of the adoring angels. One of the kneeling shepherds clasps his hands reverently, while another spreads his in wonder. Meanwhile, the standing shepherd presses forward to peer over their heads, his mouth open in amazement. In different ways, each of these shepherds shows his surprise at finding himself witnessing a grand and glorious event. It is an event, however, that they cannot fully understand. With these poor, rough shepherds, Hugo presents a new kind of piety. It is a piety expressed by the ordinary uneducated people of the world, a piety based on blind faith rather than on knowledge and understanding.

In the manner of Jan van Eyck, the *Portinari Altarpiece* is enriched by the addition of symbols. A sheaf of wheat in the foreground symbolizes the bread of the Eucharist. The bouquets of iris and columbine are traditional symbols for the sorrows of Mary. The shoe at the left, you will recall, is the same symbol in van Eyck's *Giovanni Arnolfini and His Bride*. It is a reminder of God's words to Moses from a burning bush on Mount Sinai: ". . . put off your shoes from your feet, for the place on which you are standing is holy ground."

The donkey and the ox standing behind the manger also had a symbolic meaning in this painting. In medieval times these two animals were often used to illustrate the different ways in which people reacted to Christ. The donkey was used to symbolize those who failed to recognize Christ as the Savior, while the ox represented those who did. In earlier works (Figure 17.11), the unconcerned donkey was sometimes shown eating or, at other times, even tugging on the swaddling clothes of the Christ Child. This symbolism was used to show that it was either too ignorant or too stupid to understand the meaning of Christ's birth. In contrast, the enlightened ox was frequently shown kneeling in adoration before the Child. In this painting, the donkey is idly eating the straw in the manger, while the ox is solemnly surveying the miracle of Christ's birth.

The art of Hugo van der Goes marks the end of a period. The innovations of Jan van Eyck and Rogier van der Weyden began to lose ground by the end of the fifteenth century. They were replaced by new ideas spreading northward from Renaissance Italy.

➤ Symbolism was used in this medieval relief carving. Can you identify the animals in the relief? How do their actions reflect the different ways people reacted to this important religious event?

Figure 17.11 *Nativity.* Relief carving. The Village Church, Ujue, Spain. Eleventh century.

SECTION TWO

Review

1. How do Rogier van der Weyden's paintings differ from those of Jan van Eyck?
2. In his painting *Descent from the Cross* (Figure 17.6, page 394), what does Rogier achieve by placing the figures on a narrow stage without a landscape behind them?
3. Which artist combined the emotionalism of van der Weyden with the realistic detail of van Eyck? For which work is this artist best known?
4. Describe one way Hugo van der Goes altered or distorted nature to add to the emotional impact in his painting *The Adoration of the Shepherds* (Figure 17.9, page 397).
5. What feature in Hugo's *Adoration of the Shepherds* caused great excitement among the Italian artists who saw it?
6. What caused the innovations of Jan van Eyck and Rogier van der Weyden to lose ground by the end of the fifteenth century?

Creative Activity

Humanities. A survey of portraits through history can also be a study of fashion through the ages. For Flemish women in the fifteenth century, a high hairline was considered fashionable. Women had their foreheads and eyebrows shaved to achieve this look. (See Figure 17.7, page 395.)

It was at this time that the first active religious orders for women were founded. The fashionable starched headdresses and the elaborate starched collars were adopted as features of the *habits* in religious orders. For the following centuries, long after the fashion changed, these headdresses, collars, and long dresses identified individual communities of nuns.

Compare hairstyles for women — and men — as they have changed through the last fifty years. Popular in the 1940s, the electric clipper again finds its place in fashion in the 1990s.

EXPANDING DETAIL DRAWING

Supplies
- Pencil
- White drawing paper, 9 x 12 inches (23 x 30 cm) or larger

Complete a highly detailed and precise pencil drawing by starting with a small detail found on an interesting and intricate object. Your drawing will expand in all directions from this starting point until it runs off the paper at all sides. A complex assortment of values, shapes, lines, and textures will illustrate every detail as accurately as possible.

Focusing

Study closely the paintings by van Eyck and van der Weyden illustrated in this chapter. Are you inclined to like pictures like these? What have both of these artists done to make their pictures look so lifelike?

Creating

Bring to class an interesting and complicated object to draw. Among the things you might consider are: a kitchen appliance; an old, laced boot; a kerosene lantern; a piece of complex machinery.

Beginning at or near the center of your paper, draw some part of the object as accurately as possible. Precision is maintained as you add each new detail to the drawing, allowing it to "grow" in all directions until it reaches all four edges of the paper.

The shapes, lines, and textures used in your drawing should be complex. Abrupt and gradual changes of value should be used to suggest three-dimensional forms and show shadows.

Draw slowly and carefully, creating on paper what your eye observes.

CRITIQUING

- **Describe.** Is your drawing accurate and precise in every detail? Does it look like the object you selected to draw? Can you point to the detail on this object that you used as your starting point?
- **Analyze.** Did you use a complex assortment of values, shapes, lines, and textures in your drawing? Did the use of these elements contribute to the realistic appearance you were seeking?
- **Interpret.** What adjective would you use to describe your drawing? What adjectives do others use when describing your drawing?
- **Judge.** Limiting yourself to a consideration of the literal qualities only, is your drawing successful? What was the most important thing you learned from this studio experience?

Figure 17.12 Student Work

DESIGNING A VISUAL SYMBOL

Design and construct with mat board a three-dimensional container for a familiar household product. This container not only holds the product, but it also serves as a visual symbol for that product. Along with the name, it will help others quickly identify the product. Make use of simplified colors, forms, and shapes. Use bold contrasts of hue, value, and intensity to help draw attention to your package.

Focusing

Examine the works by van Eyck and van der Goes in this chapter. The works of both of these artists include a great many symbols. Are you aware of the different uses of symbols today? Are there certain symbols that you automatically associate with specific products? What are these symbols?

Creating

Bring to class a small-sized package containing a familiar product found in the home such as matches, toothpicks, or dry cereal.

Make several pencil sketches of a new container for your product. This container must act as a visual symbol for the product inside, so consider carefully its overall shape and the images placed on this shape. The name of the product must be prominently displayed on the container.

When you have a satisfactory design, construct the container. Cut sections of mat board to the desired shapes and glue these together to make the three-dimensional container. Remember to include a lid of some kind so that it can be opened easily and closed securely.

When your container has been assembled, use tempera or acrylic to paint it. Do not become overly concerned with small details that cannot be seen at a distance. Use simplified colors and shapes.

Place your product in the container. It should fit with no room to spare.

Figure 17.13 Student Work

Supplies

- Pencil and sketch paper
- Mat board
- Scissors and/or paper cutting knife
- White glue
- Tempera or acrylic paint
- Brushes, mixing trays, and paint cloth
- A familiar household product to be repackaged
- Water container

CRITIQUING

- **Describe.** Did you design and construct a three-dimensional container for a familiar household product? Does the product you brought to class fit within this container?
- **Analyze.** Does your design include simplified colors, forms, and shapes? Are bold contrasts of hue, value, and intensity used? Do these help draw attention to your container?
- **Interpret.** Do you think your package is an effective symbol for the product within? Can others readily identify this product by looking at the package, or must they rely on the name to identify it?
- **Judge.** Do you think your container can be regarded as a successful symbol for a particular product? What could you have done to make it more effective? What is the most pleasing feature of your design, its overall shape or the images and words placed on this shape?

Review

Reviewing the Facts

SECTION ONE

1. What was the meaning of a single burning candle to fifteenth-century northern Europe painters?
2. Until the fifteenth century, what type of paints were European artists using?
3. Why would an artist using oil paint be more inclined to include small details than an artist painting a fresco?
4. Was Jan van Eyck more interested in painting people's emotions or the details that surrounded the people?

SECTION TWO

5. Does Rogier van der Weyden's painting, *Descent from the Cross*, give the illusion of deep space or shallow space? What does this treatment of space add to the work?
6. What was unusual about the three shepherds that Hugo van der Goes included in his painting, *The Adoration of the Shepherds*?
7. What gives Hugo's painting, *The Adoration of the Shepherds*, a dreamlike quality?
8. What is the symbolic meaning of the donkey and the ox in paintings of this period?

Thinking Critically

1. ***Analyze.*** Discuss the color scheme of Jan van Eyck's painting, *Giovanni Arnolfini and His Bride* (Figure 17.3, page 391). Consider the following in your discussion: complementary colors, intensity of the colors, and value contrasts.
2. ***Analyze.*** Refer to Rogier van der Weyden's *Portrait of a Lady* (Figure 17.7, page 395). Identify areas of the painting where the value contrast is strong and areas where there is little value contrast.
3. ***Evaluate.*** Look again at *The Adoration of the Shepherds* by Hugo van der Goes (Figure 17.9, page 397). Explain the success, or lack of success, of the painting from the perspective of each of the art theories: imitationalism, formalism, and emotionalism.

Using the Time Line

Examine the time line and determine the year that Rogier van der Weyden completed his painting *Descent from the Cross*. At this same time, in Florence, Italy, a major architectural project was nearing completion. What was this project, who was responsible for its design, and why was it so significant?

| 1400 | 1425 | 1450 | 1475 | 1500 |

• van Eyck. *Giovanni Arnolfini and His Bride*
• van der Weyden. *Descent from the Cross*

• van der Goes. *The Adoration of the Shepherds*

van Eyck. *Adoration of the Lamb*

van der Weyden. *Portrait of a Lady*

Chris Murray, Age 18
Klein Forest High School
Houston, Texas

Chris responded to Jan van Eyck's detailed paintings and especially to the way the artist captured reflections in mirrors and metallic surfaces. He decided to do a still life that included metal objects and other items that reflect light.

Rearranging the still life until he felt the objects related well to one another, Chris started by making a loose sketch on his canvas. He chose oil paint as his medium because of its gemlike quality. He began his painting by laying down some broad areas of color to balance the composition.

During the middle stage, one of the biggest challenges occurs: "Painting metallic surfaces is difficult because they are not a particular color in themselves—they reflect the colors of the objects around them. I've also discovered that the hardest part of creating an artwork of this kind is to use perspective, making the closer objects richer in detail and color than the ones in the background."

In evaluating his finished work, Chris felt he could have used a broader range of colors. He was satisfied with the composition in that it provided several paths for the eye to travel and seemed to have good depth.

➤ *Still Life.* Oil on canvas. 61 x 46 cm (24 x 18").

403

Crisis and Transition: Art of the Sixteenth Century in Europe

Objectives

After completing this chapter, you will be able to:

➤ Explain how the painters of Rome and Venice drew upon different sources of inspiration for their work.

➤ Discuss how Giorgione's use of landscapes in his paintings differed from that of earlier artists.

➤ Define Mannerism and name some artists who practiced it.

➤ Explain why the works of Mannerist artists were welcomed by the Church.

➤ Explain how the paintings of Hieronymus Bosch reflected the time and place in which they were done.

Terms to Know

Mannerism
parable
Protestant Reformation

Figure 18.1 Albrecht Dürer. *Stag Beetle*. 1505. Watercolor and gouache. 14.2 x 11.4 cm (5⁹⁄₁₆ x 4½"). Collection of the J. Paul Getty Museum, Malibu, California.

Artists in Florence and Rome looked to the classical

monuments of Greece and Rome, which they still saw around them, for much

of their inspiration. Venetian artists, lacking these monuments close by, turned

to other sources of inspiration. One of the most important of these

sources was their beautiful and unique island city.

SECTION ONE

The Art of Venice

During the sixteenth century, as now, Venice could be described as a city of constantly changing lights and reflections. On clear days, brilliant sunlight poured down on colorful buildings, which were mirrored in the rippling waters of its famous canals. These reflections softened contours, lessened the contrast between lights and darks, and broke up shapes into patches of shimmering color. On overcast days, colors and shapes were dimmer, less distinct, and seemed to melt into a silvery mist in the distance. Artists had only to look around them as they made their way down the streets and canals of Venice to discover new ways of making their painted forms glow with color.

Centuries of close contact with the East had also left their mark upon the appearance of Venice. The dazzling mosaics that decorated Venetian churches; the different-colored buildings; and the Venetians' pervading love of color, light, and texture can be traced to the Byzantine art style of the East. The Byzantine influence on Venetian art was far different from that of classical Greece and Rome on the Renaissance cities of Florence and Rome. Unlike their classical counterparts, Byzantine artists were not primarily interested in portraying a world of solid bodies and objects existing in space. Instead, they sought to present a world of carefully designed surfaces and brilliant colors. Byzantine art did not try to mirror what was happening in the present world. It wanted to offer a glimpse of the next.

Venetian artists skillfully adapted the Byzantine use of color, light, and texture to their own painting. At the same time, they were not blind to the new Renaissance concern for reality that characterized the art of Florence and Rome. This concern for reality, originat-

ing in Florence, had spread throughout Italy. It eventually reached Venice near the end of the fifteenth century. When it did, it touched off a revolution in painting. Venetian artists successfully combined the best of the Byzantine with the best of the Renaissance. This produced the greatest school of color and pure painting that Europe has seen.

Giorgione

One of the first great Venetian masters was Giorgione da Castelfranco (jor-**joh**-nay da **cah**-stell-**frahn**-koh), who died of the plague while he was still in his early thirties. Unfortunately, very little is known about him. Art historians can point to no more than a handful of pictures that were definitely painted by him. These reveal that he was among the first artists in Europe to place importance on the landscape. Before, artists had used the landscape primarily to fill in the spaces around their figures. Giorgione used it as a stage-setting device and to create a mood or feeling in his paintings.

Giorgione also used oil paint to add a new richness to his colors. This medium was more suited to the Venetian taste than the cold, pale frescoes of Florence and Rome. For one thing, it was more vivid and allowed the artist to create delicate changes in hue, intensity, and value. Further, the artist could linger over his painting to produce a glowing effect with colors that stayed wet and workable for days. Giorgione, inspired by his radiant Venetian surroundings, eagerly used this new medium to make his pictures glow. He avoided hard edges and lines and bathed his subjects in a soft, golden light.

The Concert

One of Giorgione's most beautiful and haunting paintings is *The Concert*. No matter how long you

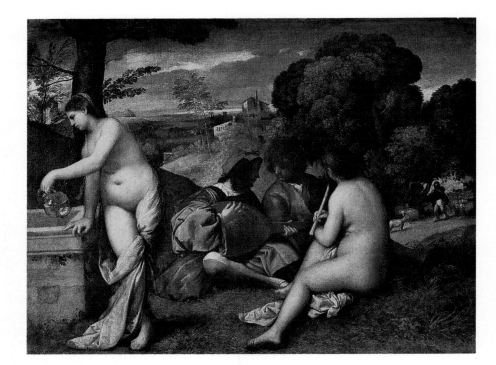

➤ Notice how Giorgione has used landscape to provide a mood in this painting. Are the hues intense or dull? Are the contour lines sharp or blurred? How is color used to draw your attention to the center of the composition? Point to places where value gradation is found. What mood or feeling does this picture communicate to you?

Figure 18.2 Giorgione. *The Concert.* c. 1508. Oil on canvas. Approx. 100 x 140 cm (43 x 54″). The Louvre, Paris, France.

study it, you will still find it difficult to determine exactly what is going on in this picture (Figure 18.2). This adds to its charm and mystery and keeps luring you back for another look, another guess about its meaning. As you search for a meaning, you will find yourself falling under the spell of the work's mood, or feeling. It is this mood, rather than the uncertain meaning, that you will remember most about this work. It is a calm, gentle mood, although there is a touch of sadness here as well . . .

On a peaceful summer day, two weary travelers meet and pass some time together in the lengthening shadows alongside the road. They may be strangers coming from different backgrounds and going in different directions. One is dressed simply and is barefoot. He listens intently as the second, dressed in rich garments, plays a lute. As for the two women, they are a mystery. Perhaps they are not flesh and blood at all, but exist only in the minds of the two young men. Their imaginary images may have been suggested by the tune being strummed on the lute. Perhaps in a few moments the song will end, and they will vanish. Then the two men will rise, bid each other a reluctant good-bye, and go their separate ways. It will signal the end of an enchanted moment that can never be repeated.

Giorgione's scene appears to glow in the warm rays of a setting sun. The edges of his figures are blurred as though a light mist is settling around them. This mist surrounds and blends together the green and blue shadows and softens the red accents of a cloak and a hat. It also dulls the other colors found farther back in space. Giorgione's treatment of the landscape and his use of color enabled him to create a picture that is as haunting as the strains of an unforgettable melody. It may be just such a melody that the young traveler plays on his lute.

Titian

Giorgione's approach to painting was carried on after his untimely death by another Venetian artist, Titian (**tish**-un). Titian's career reportedly started when, as a child, he painted a Madonna on the wall of his father's house with the juice of flowers or fruit. Unlike Giorgione, Titian lived a long life. He was almost one hundred years old when he died, not of old age as you might expect, but of the plague. A nobleman's artist, Titian's patrons included Lucrezia Borgia, the Duchess of Farrara; Pope Paul III; and the Emperor Charles V, who made Titian a knight and a count. According to Vasari, there was hardly a noble of high rank, scarcely a prince or lady of great name, whose portrait was not painted by Titian. See Figure 18.3 for a portrait of the young son and heir of Charles V, Philip II.

The Entombment

From Giorgione, Titian learned how to use landscape to set a mood. He also learned to use oil paints to make works that were rich in color and texture. However, while Giorgione's figures always seem to be inactive—sleeping, dreaming, or waiting—Titian's are wide awake, alert, and active. Observe how the figures in his painting of *The Entombment* (Figure 18.4) are more powerfully built and more expressive than those of Giorgione. When Titian combined Giorgione's lighting and color with these sturdy figures, he created a highly emotional scene. The mourners carrying the crucified Christ to his tomb turn their eyes to him and lean forward under the weight of the lifeless body. This helps to direct your gaze to Christ between them. The rapidly fading light of day bathes the scene in a mellow glow. It heralds the approach of night and accents the despair of the figures in this tragic scene.

Curiously, Titian placed the head and face of Christ in deep shadow. Why do you suppose he would do this with the most important person in the painting? Before trying to answer this question, you might ask yourself if you have seen this done before. Look again at Giorgione's painting of *The Concert* (Figure 18.2, page 406), and you will find that the faces of the two young travelers also are placed in shadow. Both artists used this technique to arouse your curiosity and get you involved with their paintings. They challenge you to use your imagination to complete the most important part of their pictures—the faces of the main characters.

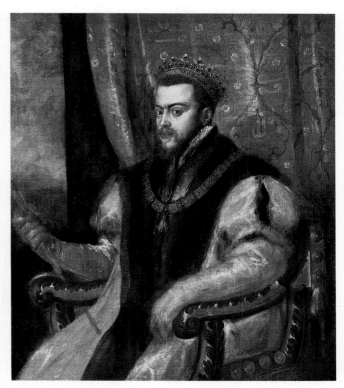

➤ Titian painted this full-scale oil sketch to serve as a model from which official portraits of the Spanish king could be made.

Figure 18.3 Titian. *Philip II*. c. 1549–51. Oil on canvas. 106.4 x 91.1 cm (42 x 35⅞"). Cincinnati Art Museum, Cincinnati, Ohio. Bequest of Mary M. Emery.

➤ Although Titian painted religious subjects like this, he is best known for another kind of painting. What is it? Why do you think Titian is regarded as one of the greatest painters in history? Do you agree with that assessment? Why or why not?

Figure 18.4 Titian. *The Entombment*. 1525. Oil on canvas. 149.2 x 215.3 cm (58¾ x 84¾"). The Louvre, Paris, France.

Art · **PAST AND PRESENT** ·

Byzantine Influences

Venice in the sixteenth century showed the influence of centuries of close contact with the East. The glowing colors of the mosaics on the churches; the different-colored buildings; and the Venetian love of color, light, and texture all stem from the Byzantine art style. Byzantine art presented a world of carefully designed surfaces and brilliant colors. The Venetian artists of the sixteenth century adapted this use of color, art and texture.

Today, one artist is still adapting the Byzantine and Venetian use of color, light and texture. John August Swanson, a Los Angeles artist, interprets old stories and seeks to share their relevance with contemporary audiences. For instance, he considers his series of paintings entitled, "The Story of Ruth," to be relevant today, since it is the story of a refugee. For this series, he used forty-eight different colors.

A number of different art styles and artists influence his work. Swanson visited the Cathedral of Chartres and was impressed by the richness of the

Figure 18.5 *Psalm 85.* 1990. Acrylic on canvas. 76.2 x 91.4 cm (30 x 36").

stained-glass windows and the stories they told. Medieval and Islamic miniatures fascinated him. So, too, did Byzantine art and Russian icons.

His works can be found in private collections as well as in the Smithsonian Institution, the Victoria and Albert Museum, the Tate Gallery, the Vatican Museums, and other major museums.

Doge Andrea Gritti

Titian's greatest fame was as a painter of portraits. One of his most forceful was of Andrea Gritti, the doge, or ruler, of Venice (Figure 18.6). Gritti ruled during troubled times when Venice was involved in a series of wars and conflicts. During this period, Venetian sea power was the only barrier between threatening Muslim invaders and Christian Europe.

In spite of his advanced age (he was over eighty years old when Titian painted his portrait), Gritti took an active role in the fighting. It was this fierce determination and power that Titian captured in his portrait. The doge is shown as if he is about to burst from the frame. A curving row of buttons curls up the robe

leading to the stern, defiant face. Titian leaves no doubt that this was a fierce, iron-willed leader.

If the face somehow fails to communicate that impression to you, look at the powerful right hand. It was modeled after the hand on Michelangelo's heroic statue of *Moses* (Figure 16.1(detail), page 360; Figure 16.24, page 379). Titian knew of this hand even though he did not visit Rome until about five years after completing his picture of the doge. A cast had been made of it and brought to Venice by a sculptor named Jacopo Sansovino. Titian realized that such a hand could communicate as well as any facial expression. For this reason, he enlarged it and showed it clutching the heavy robe. It is neither delicate nor relaxed, but as strong and tense as the man.

Titian's Enduring Fame

All the important people of his day were eager to have their portraits painted by Titian. As a result, he lived like a prince, traveling far and wide to complete his commissions, accompanied by numerous servants, admirers, and students. It was said that after Titian had finished his third portrait of Charles V, the emperor exclaimed, "This is the third time I have triumphed over death!" Titian's many great paintings assured his own victory over death. In his lifetime he became nearly as famous as the legendary Michelangelo, and his fame has not lessened over the centuries. In the nineteenth century, the great French painter Delacroix said of him, "If one were to live for 120 years, one would prefer Titian to everything." His talents are no less admired today. Artists, historians, and critics without exception list Titian among the greatest painters of all time.

➤ Did Titian portray this man as gentle and content, or powerful and stern? On what do you base your opinion?

Figure 18.6 Titian. *Doge Andrea Gritti.* c. 1546–48. Oil on canvas. 133.6 x 103.2 cm (51½ x 40⅝"). National Gallery of Art, Washington, D.C. Samuel H. Kress Collection.

SECTION ONE

Review

1. Venice, Italy, an island city with constantly changing light, had what effect on artists working there?
2. Venetian artists used Byzantine color, light, and texture in their work. What did they incorporate from Renaissance art?
3. Which artist carried on Giorgione's approach to painting after his untimely death?
4. When did Titian first exhibit artistic skills?
5. How did Titian's portrait subjects differ from Giorgione's?
6. What characterizes the figures in Titian's *Entombment* (Figure 18.4, page 407)?
7. Why did Titian and Giorgione place the faces of some of their figures in shadow?
8. List three ways Titian conveyed the power of Doge Andrea Gritti in his portrait of the eighty-year-old ruler.

Creative Activity

Humanities. Venice was a world of the arts in the sixteenth century. Giorgione and Titian played musical instruments and painted them into their works. Musical terms such as *orchestrale* and *concertare* are still used to describe paintings of this period.

Giovanni Gabrieli, the chief organist at St. Mark's cathedral in Venice from 1585 until his death, brought in many acoustical innovations, such as distancing sections of the choir from each other, thus creating an exciting interplay of sounds. The word *concertare* means to compete. His compositions played soloists against full choirs, and instruments against voices.

Polyphonic music—meaning many sounds—found its way into individual homes with madrigals and instrumental accompaniment. Listen to polyphonic music to hear the harmony achieved not by singing together in harmony, but by several voices singing different melodies.

A Break from Renaissance Harmony

Artists like Giorgione and Titian made Venice a great art center that rivaled and then surpassed Florence and Rome. In Rome, art suffered a decline. Its artists struggled to find new avenues of expression in the vacuum left by the passing of Leonardo, Michelangelo, and Raphael. The period in which this struggle took place is referred to as the Mannerist period.

Mannerism

Today, **Mannerism** is thought of as *a deliberate revolt by artists against the goals of the Renaissance*. Why would Mannerist artists turn against the art of the Renaissance? To answer this question you must compare the Italy in which the Renaissance masters lived with the Italy in which Mannerist artists lived.

When Raphael painted the *Alba Madonna* around 1510, Italy was at peace and the Church continued to be the unchallenged seat of authority. Most people were still absorbed in seeking eternal salvation and were certain that the Church would help them toward this goal. It was a period of confidence and hope, and this was reflected in the artworks that were created. Artists like Raphael produced works that were carefully thought out, balanced, and soothing. Then a series of events took place that shook the confidence and replaced the hope with uncertainty. Within the span of a few decades, the religious unity of Western Christendom was shattered. In 1517, *a group of Christians led by Martin Luther left the Church in revolt to form their own religion in a movement called the* **Protestant Reformation**. This movement, along with the French invasion of Italy in 1524 and the sack of Rome in 1527, brought about an era of tension and disorder. It was in this setting that Mannerist art was born and matured.

Mannerism was an effort by artists to show through their art what was going on in their minds during this period of crisis. An art of balance and harmony could hardly be used to express the instability and tension around them. Thus, where the art of the Renaissance tried to achieve balance, Mannerism preferred imbalance. The calm order found in works like the *Alba Madonna* (see Figure 16.26, page 381) was replaced by a restlessness. Mannerism was a nervous art, created in and mirroring a world filled with confusion. Its artists painted the human figure in strange new ways, twisting it into impossible poses and stretching it to unreal proportions. Gone was the three-dimensional fullness sought by Masaccio, Michelangelo, and other Renaissance artists. Mannerist artists preferred figures that were slender, elegant, and graceful. Gradually, these figures began to look less natural and more supernatural.

Parmigianino

This new style is evident in the work of Francesco Mazzola, called Parmigianino (par-mih-jah-**nee**-noh), who was among the first generation of Mannerists in Rome. Born in Parma, Parmigianino went to Rome four years after Raphael's death. There he found artists working in a number of different styles. His own very personal art style developed as he took and combined features found in the work of other artists.

The Madonna with the Long Neck

After the sack of Rome in 1527, Parmigianino fled to Bologna, but in several years returned to his native Parma. It was there that he painted his best-known work, *The Madonna with the Long Neck* (Figure 18.7). You will not get too far into a description of this painting before a number of disturbing questions arise. For one thing, is this an interior or an exterior setting? It is difficult to say for certain because the drapery at the left and the columns at the right suggest a background that is both interior and exterior. What purpose do the columns serve? It seems as if some confused builder went to a great deal of trouble to construct this row of tall, slender columns and then forgot why and abandoned the whole project. Now look at the unusual figures of the Madonna and Christ Child. The Madonna is seen from a low vantage point and seems to be sitting, although no throne or chair is indicated. She is enormous and towers over the other figures in the picture even though she is seated and they are standing. If this were not enough, she also has a small head, long neck, wide hips, and long legs that taper down to small, delicate feet. It looks as if she is about to stand, and this places the child on her lap in real danger. Notice how the baby already seems to be slipping from the mother's lap. Curiously, the mother shows no concern. Her eyes remain half-closed and she continues to look content and quite pleased with herself.

➤ Look closely at the figures in this work. Do you find anything surprising about these people? If so, what?

Figure 18.7 Parmigianino. *The Madonna with the Long Neck.* c. 1535. Oil on panel. 220 x 130 cm (85 x 52"). Galleria degli Uffizi, Florence, Italy.

It is unlikely that you would describe the Christ Child as robust and full of life. Actually, he looks lifeless; his flesh is pale and rubbery, and his proportions are unnatural. The Madonna's left hand conceals the child's neck, and this, coupled with the position of the head, makes it look as if the head is not attached to the body. Crowding in tightly at the left side of the picture are a number of figures who have come to admire and worship the Christ Child. However, they pay little attention. Instead, they look about in all directions—one even stares out of the picture directly at you.

Before leaving this crowded group of figures, look at the leg in the left corner. To whom does this leg belong? You might be inclined to say that it belongs

to the figure with the unusual urn who looks up toward the Madonna. If this is his leg, however, he is indeed unfortunate because he would have almost no waist at all and his leg would be attached to his body at a most unusual place.

The foreground space occupied by the Madonna and other figures is crowded; everyone seems jammed together here. Furthermore, when your gaze moves to the right side of the picture, you plunge into a deep background where you encounter the strange row of columns and the small figure of a man reading from a scroll. The size of this man indicates that he is far back in space, but there is no way of determining the distance between him and the foreground figures. Who is this man and what is he doing? It is impossible to be certain since the artist gives no clues to his identity. Nor do you know to whom he is directing his reading—the frame of the painting cuts his audience off from view.

The questions do not stop after you have described and analyzed Parmigianino's painting. They continue as you move on into interpretation. Is it just an accident that the Christ Child looks lifeless, or that his arms are outstretched in the same position he would take later on the cross? Could the mother be a symbol of the Church? After all, it was common to refer to the Church as the spiritual mother to all, but why does she seem so unconcerned even though her child seems to be slipping from her grasp? Then, why are all those people crowding in at the left—at first you might think that they are only interested in catching a glimpse of the child, but only one is looking at him. The painting dares you to make sense out of all this. What is Parmigianino trying to say? Could he be criticizing the Church and the people for their growing worldliness? Was he trying to say that they were becoming so concerned with their own well-being that they had forgotten the sacrifices made for them by Christ? Of course, you can never know for certain what Parmigianino meant by this picture. Only one thing is clear: He has left you with pieces of an unforgettable puzzle. You can put these pieces together to arrive at many different solutions, but you will never know if any one of them is right. Parmigianino's painting raises a great many questions and offers very few answers. No doubt, that is exactly what it was intended to do.

In many ways, Parmigianino's life was as unusual as his painting. According to Vasari, toward the end of his short life (he died when he was thirty-seven years old), Parmigianino changed. He let his hair and beard grow, turned his back on the world, and became an almost savage wild man.

Tintoretto

Mannerism established itself later in Venice than in other parts of Italy. The best-known Venetian artist to work in this style was Tintoretto (tin-toh-**reh**-toh). He was able to combine the goals of Mannerism with a Venetian love of color.

Tintoretto's real name was Jacopo Robusti, but he was the son of a dyer and he became known as "Tintoretto," the Italian word for "little dyer." He was born, lived, and worked all his life in Venice. He taught himself to paint by copying the works of other artists. Eventually he developed a style that featured quick, short brushstrokes and a dramatic use of light.

Presentation of the Virgin

When you look at Tintoretto's painting of the *Presentation of the Virgin* (Figure 18.8), you will see some of the qualities that make it a Mannerist work. Among these are the elongated figures with their dramatic gestures, the odd perspective, and the strange, uneven light that touches some parts of the picture and leaves other parts in deep shadow. Almost everyone in the picture is watching the young Mary as she climbs solemnly up the stairs to the temple. The woman in the foreground points to the small figure of Mary silhouetted against a blue sky. This woman's gesture is important because without it you might not notice Mary at all. Mary may be the most important person in the picture, but Tintoretto placed her in the background and made her look small and unimportant. He may have done this because he wanted you to become actively involved in finding her and helped to lead the eye to her with visual clues.

Tintoretto is interested in doing more than merely describing another event in the life of the Virgin. He tries to capture the excitement of the event and make you a part of it. He wants you to feel as though you are actually there, to put yourself on the stairs to the temple.

El Greco

Highly emotional religious pictures by Mannerists like Tintoretto were welcomed by the Church during this troubled period. The Church was placing a renewed emphasis on the spiritual in order to counter the Reformation.

➤ Can you find the main character in this picture? What clues did you use to find this figure? How would you interpret the gesture of the woman at the bottom center — casual, excited, or tragic? How do her actions differ from those of the seated woman at the right?

Figure 18.8 Tintoretto. *Presentation of the Virgin.* c. 1550. Oil on canvas. 4.3 x 4.8 m (14′1″ x 15′9″). Church of Santa Maria dell' Orto, Venice, Italy.

➤ Huge and simple, you would have to walk about 10 miles (16 km) to visit every room in this palace built for King Philip II of Spain. What part did this king and this palace play in luring El Greco to Spain?

Figure 18.9 The Escorial, east façade. Near Madrid, Spain. 1563–84.

Art could aid this effort by working on the emotions of the people, reminding them that heaven awaited those who followed the Church's teachings. Nowhere was this more evident than in Spain. It is there that you will find the last and most remarkable of the Mannerist artists, El Greco (el **greh**-koh).

El Greco's story ends in Spain, but it begins in Crete, the Greek island where he was born and christened Domeniko Theotocopoulos. Around the middle of the sixteenth century, he left Crete to continue his art studies in Venice. There he came under the influence of Titian and Tintoretto. From Titian the young artist learned how to use contrasts of light and dark to heighten the drama in his works. Tintoretto taught him to add an active movement to his compositions. El Greco's curious elongated treatment of the human figure may have also been inspired by Tintoretto.

After spending several years in Venice, El Greco moved to Rome, where he became familiar with the work of Michelangelo. However, the work of that great genius failed to overwhelm El Greco. He claimed that if Michelangelo's *Last Judgment* were to vanish from the Sistine Chapel he could do it over again just as well. According to El Greco, Michelangelo was a good man, but he did not know how to paint. No doubt, statements like these did not make El Greco a popular figure in Roman art circles where Michelangelo's talents were legendary. In any event, he left Italy for Spain in 1577, probably hoping to find work in the court of Philip II (see Figure 18.3, page 407). At that time, the Spanish king was looking for artists to decorate the Escorial, his huge new palace (Figure 18.9).

The Martyrdom of St. Maurice and the Theban Legion

Unfortunately, El Greco's dream of working for Philip did not last long. In 1580 he was commissioned to paint two pictures for the king. One of these, *The Martyrdom of St. Maurice and the Theban Legion* (Figure 18.10, page 414), so displeased the king that he refused to have it hung in the Escorial. El Greco never again received a royal commission. What of his painting of St. Maurice? Today it is regarded as one of his greatest works.

In order to understand this painting, you should know something about Maurice, his soldiers, and their fate. Maurice and his troops were Christian and loyal subjects of the pagan Roman emperor. A serious problem arose when the emperor ordered everyone in the army to worship the Roman gods or face execution. Maurice and his soldiers could not do this and remain Christian, but they did not want to be disloyal to the emperor. Their solution was to accept death.

El Greco's picture blends the three parts of this story into a single scene. In the foreground, Maurice is seen explaining the situation to his officers. Farther back, he and one of his officers are shown watching their men being beheaded. They calmly offer their encouragement, knowing that shortly they will face the same end. At the top of the picture, the heavens open up and a group of angels prepares to greet the heroes with the laurels of martyrdom.

At first, Philip seemed to like El Greco's picture and ignored complaints that the artist was spending too

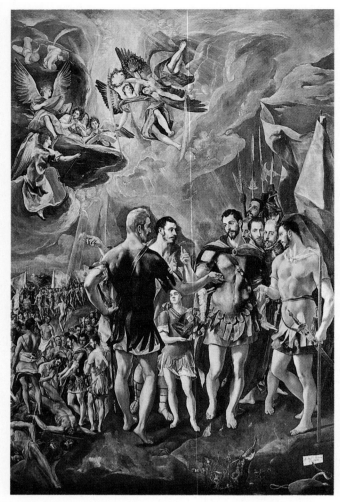

> Philip II rejected this painting by El Greco. How is this painting regarded today?

Figure 18.10 El Greco. *The Martyrdom of St. Maurice and the Theban Legion.* 1580. Oil on canvas. 4.4 x 3 m (14'6" x 9'10"). The Escorial, near Madrid, Spain.

much money on materials for it. Later he came to dislike it, however, and finally judged it a failure. It was hidden away as a disgrace until found by another great Spanish artist, Velázquez, who finally had it hung in the Escorial.

The Burial of Count Orgaz

Disappointed after his experience with Philip, El Greco went to Toledo, where he spent the rest of his life. He was well on the way to becoming a successful and popular artist when the Church of St. Tomé hired him to paint a most unusual picture. El Greco was asked to paint the burial of a man who had died two hundred years before. The huge painting, entitled *The Burial of Count Orgaz* (Figure 18.11), took him two

years to paint — and another two years to collect his fee, but El Greco called it his greatest work.

Just who was the Count of Orgaz and why would anyone want a picture of his burial? The count had been a deeply religious man who had commanded his subjects to contribute money, cattle, wine, firewood, and chickens to St. Tomé each year. When the count died, so it was said, St. Stephen and St. Augustine came down from heaven and placed the count in his tomb with their own hands. The villagers of Orgaz continued to pay their annual tribute to St. Tomé for generations, but then, feeling that they had done enough, stopped. Officials at St. Tomé protested and a church trial was held. After all the testimony was heard, it was decided that the villagers should continue making their payments. El Greco's painting of the count's funeral was meant to be a reminder of their eternal debt to St. Tomé. In his contract, El Greco was instructed to show witnesses to the miracle, a priest saying Mass, and heaven opened in glory.

Analyzing *The Burial of Count Orgaz*

You will discover a great deal when you study a complicated painting like this. As a starting point, observe the boy in black at the lower left who seems to be introducing you to the scene. This boy's pointed finger directs your attention to the richly dressed figures of the two saints, a young St. Stephen and a much older St. Augustine. The saints bend over and support the body of the count dressed in armor. His lifeless pose and pale color show that he is dead; the two saints are lowering him into his grave. A monk in a gray habit at the left and a priest reading from an open book at the right frame this tragic scene. Between them, a row of black-robed figures silently witness the event. Their faces, set off by white ruffles at the neck, separate the quiet funeral scene from the swirling action overhead. The gaze of a priest at the right leads your eye to a winged angel who carries something in his hands. Upon closer examination, you will see that he is carrying a small, cloudlike figure — the soul of the dead count. The clouds part, giving the angel a clear path to the figure of Christ seated in judgment at the top of the painting. Saints and angels have gathered before Christ to ask that the count's soul be allowed to join them in heaven.

El Greco has done a masterful job of tying all the parts of this complex picture together. He divides the painting into two parts, heaven and earth, by using a horizontal axis line made up of the heads of the witnesses. Then he unites the two parts with another axis line that begins at the right shoulder of St. Stephen.

Tracing this line you will find that it passes down the arm of the saint and through the arched body of the count. It continues to curve upward through the body of St. Augustine to the wing of the angel and on to the soul of the dead count. The contour lines of the clouds at either side of the angel guide your eye even higher to the figure of Christ. Thus, with the aid of axis and contour lines, El Greco takes you on a journey from the bottom of the painting to the top. He also makes sure that along the way you meet the most important figures: the two saints, the dead count, the angel, the count's soul, and Christ.

Details about El Greco's life are sketchy. Some people think that the woman who occasionally appears in his paintings—here shown as the Virgin—may have been his wife. That is uncertain, although it is quite likely that the boy in this picture is his son. On a paper sticking out of the boy's pocket, El Greco has painted his son's birthdate. El Greco may have included his own self-portrait in this picture as well. Many feel that he is the thin man a bit left of the center just above the finger of an upturned hand (Figure 18.12, page 416). This man and the boy stand out in the painting because they are the only figures looking out at the viewer.

An interesting story about El Greco makes an appropriate postscript to this brief examination of his famous painting of Count Orgaz's burial. It seems that one beautiful sunny day a friend found El Greco in his house working in a room with the curtains drawn. He chided the artist for being in the dark and invited him for a stroll in the sun. El Greco refused, however, say-

▶ With your finger, trace along the axis and contour lines that lead your eye to the top of the painting. Describe how the actions, dress, and expressions of the figures in the top half differ from those in the bottom half. Do you think this is a successful painting? What aesthetic qualities did you use when making a judgment about this work?

Figure 18.11 El Greco. *The Burial of Count Orgaz.* 1586. Oil on canvas. 4.9 x 3.7m (16 x 12′). Santo Tomé, Toledo, Spain.

ing the sunlight would destroy the light shining within him. He need not have worried; his light continues to shine from paintings that startle, mystify, and amaze those who gaze upon them.

El Greco carried Mannerist ideas as far as they could go. His intense emotionalism and strong sense of movement could not be imitated or developed further. Thus, the final chapter in the development of the Mannerist style was written in Spain. In Italy, the new Baroque style was already beginning to appear. However, an examination of that new style must wait. It is time to look north.

➤ Many people think that El Greco included his own portrait in *The Burial of Count Orgaz*. What would cause you to believe that the face in the center of the painting is the artist's?

Figure 18.12 El Greco. *The Burial of Count Orgaz* (detail).

SECTION TWO

Review

1. What was Mannerism?
2. What qualities did Mannerist artists seek in their work—balance and harmony, or imbalance and restlessness? Why?
3. Why did the Church welcome the highly emotional religious pictures created by Mannerist artists like Tintoretto?
4. Name three Mannerist painters discussed in this chapter. Which of these painters practiced his art in Spain?
5. Referring to the pictures painted in the Mannerist style, select one and describe how a figure in that picture has been distorted.
6. List three other ways Mannerist artists distorted reality in their works of art.
7. Mannerist artists often depicted many things happening at the same time in their paintings. Select one of the Mannerist paintings by Parmigianino, Tintoretto, or El Greco, and list at least four events shown happening simultaneously.

Creative Activities

Humanities. Mannerist architects also reached out for new forms. They layered arches and columns, giving depth and sculptural feeling to their designs.

Architect Andrea Palladio's Olympic Theater at Vicenza gave new depth to interior space with seating arranged in a semicircle like ancient amphitheaters.

Theater design today uses many of the same devices to bring the audience closer to the action. Compare the floor plans of several theater designs and discuss your own experiences in various theater spaces.

Studio. Draw from a posed model in a Mannerist style. Elongate the neck, body, arms, and legs. Pose your model in a sinuous position to emphasize the elongation. Think about background shapes that would work with this pose— drapery, architectural details such as arches, and landscape to show distance.

Northern Art: A Conflict of Styles

During the fifteenth century, most of the artists north of the Alps remained indifferent to the advances made by the Italian Renaissance. Since the time of Jan van Eyck, they had looked to Flanders and not to Italy for leadership. However, this changed at the start of the next century. Artists began to make independent journeys to Italy and other countries and became aware of what was happening there. Eventually, the lure of Italian art became so strong that a trip to Italy to study the great Renaissance masters was seen as essential for artists in training.

➤ What do you find most impressive about this work — its realism or its expression of intense agony and sorrow? Color has been used to heighten the drama here. How would a light blue sky have changed the effect of this picture?

Figure 18.13 Matthias Grünewald. *The Small Crucifixion*. c. 1511–20. Oil on wood. 61.6 x 46 cm (24¼ x 18⅛"). National Gallery of Art, Washington, D.C. Samuel H. Kress Collection.

The Spread of the Renaissance Style

The spread of the Renaissance style across western Europe was further aided by powerful monarchs with a thirst for art. These monarchs were eager to attract well-known artists to their courts to work for them. Some Italian artists were invited to visit other countries. They helped to spread the Italian influence wherever they went. Artists from other countries were also asked to visit Italy. When they left Italy to return home or to go to other lands, these artists carried with them what they had learned of Italian Renaissance ideas. In response to such an invitation, Leonardo da Vinci left Italy and journeyed to France. Albrecht Dürer, the famous German artist, visited Italy. Hans Holbein, another German artist who visited Italy, also visited and then settled in England.

However, not all northern artists were willing to accept the new Italian Renaissance style. Early in the sixteenth century, a conflict of styles developed between those remaining faithful to the style of the Late Gothic period and those in favor of adopting Italian Renaissance ideas as quickly as possible. This conflict continued until the Renaissance point of view triumphed later in the century.

Matthias Grünewald

By comparing the work of two great northern painters of that time, Matthias Grünewald (muh-**tee**-uhs **groon**-eh-vahlt) and Albrecht Dürer (**ahl**-brekt **dur**-er), this conflict of styles can be brought more clearly into focus. Both these German artists felt the influence of the Italian Renaissance. They understood the rules of perspective and could paint figures that looked solid and real. One, however, continued to show a preference for the dreams and visions favored by Gothic art. He used Renaissance ideas only to make his pictures of these dreams and visions appear more vivid and powerful to the viewer. This artist was Matthias Grünewald.

The Small Crucifixion

In his small painting of *The Small Crucifixion* (Figure 18.13), Grünewald used an active imagination to create a powerful version of the familiar Christian subject. His aim was the same as that of generations

of earlier Medieval artists, that is, to provide a visual sermon.

How differently a Renaissance artist like Raphael would have painted this same scene. Raphael would have used a balanced composition. His story would have been told with a calm dignity rather than with frenzied action. He would have tried to present the event as a reminder of Christ's sacrifice. However, it would have been a gentle reminder, told in a whisper. Grünewald's message, on the other hand, is neither calm nor gentle. It is a booming sermon forcefully describing Christ's agony and death. It spares none of the brutal details that Italian artists preferred to avoid. The pale yellow of Christ's body is the color of a corpse. The vivid red in the garments is the color of blood. The cold, black sky behind the figures is a dark curtain against which the tragic scene is played, emphasizing the people in the foreground by its contrasting value and hue.

Much of the impact of Grünewald's painting comes from the way in which it was painted. Look at the figure of Christ. The ragged edge of his cloth garment repeats and emphasizes the savage marks of the wounds covering his body. Now, focus your attention on the hands. Notice how the fingers twist and turn in the final agony of death. Like everything else in the work—color, design, brushwork—this contributes to an expression of intense pain and sorrow. The calm balance of the Renaissance has been ignored. Instead you see a forceful representation of the Crucifixion that seeks to seize and hold your emotions.

Albrecht Dürer

Almost every German artist at this time followed the same course as Grünewald. Only Albrecht Dürer turned away from the Gothic style to embrace the Renaissance. Dürer was born in Nuremberg, Germany, in 1471, the second son in a family of eighteen children. Since he was the son of a goldsmith, it was assumed that he would follow in his father's profession. However, Dürer showed such skill in drawing that he was apprenticed to a local painter at the age of fifteen.

A trip to Italy when he was in his early twenties introduced Dürer to Renaissance painting and the Renaissance ideal of the artist as an intellectual. He returned to Nuremberg with a fresh view of the world and the artist's place in it. Dürer made up his mind to make the new Renaissance style his own and set about educating himself in all fields of learning that went with this new approach to art. He studied perspective and the theory of proportions in order to capture the beauty and balance found in Italian painting. Then he applied the techniques he had learned to his own art.

Knight, Death, and the Devil

This does not mean, though, that Dürer did nothing more than imitate the Italian Renaissance style. His studies enabled him to pick out the most interesting and impressive features of that style and combine them with his own ideas. For example, in his engraving entitled *Knight, Death, and the Devil* (Figure 18.14), the horse and rider exhibit the calmness and the solid, round form of Italian painting. The figures representing death and the devil, however, are reminders of the strange creatures found in northern Gothic paintings. The brave Christian soldier is shown riding along the road of faith toward the heavenly Jerusalem seen at the top of the work. The knight's dog, the symbol of loyalty, gallantly follows its master. This is no easy journey—the knight is plagued by a hideous horseman representing death, who threatens to cut him off before his journey is complete. Behind lurks the devil, hoping the knight will lose his courage and decide to turn back. However the knight knows full well where he wants to go and what he must do to get there. His journey through life on the road to heaven may be lined with danger, but he rides bravely forward, never turning from the Christian path, no matter how frightening the dangers along the way.

At this time, Dürer found himself in the center of the conflict between Martin Luther and the Roman Church. He accepted Luther's principles and became a strong supporter of the Reformation. He took his place, so he said, alongside those who were looked down upon as heretics. His engraving of *Knight, Death, and the Devil* may have been his way of showing the tremendous tensions he and everybody else were experiencing during that turbulent period of history.

A Curiosity Like Leonardo's

Throughout his life, Dürer exhibited a curiosity much like that of Leonardo. This curiosity led him to collect and study all kinds of strange and rare objects. Hearing of a whale stranded on a beach in the northwest part of the Netherlands, he set off to see it for himself. He died on the return journey. As for the whale, Dürer never saw it. It decomposed before he got there.

➤ Point to features in this work that show Dürer was influenced by the Italian Renaissance. What trait did Dürer have in common with Leonardo da Vinci? In what ways does this picture reveal some of the conflicts experienced by the artist who created it? Do you think that this work can be considered important in the historical development of art? Why or why not?

Figure 18.14 Albrecht Dürer. *Knight, Death, and the Devil.* 1513. Engraving. 24.6 x 19 cm (9⅝ x 7½"). Museum of Fine Arts, Boston, Massachusetts. Gift of Mrs. Horatio Greenough Curtis in memory of her husband, Horatio Greenough Curtis.

Hieronymus Bosch

One of the most interesting artists of the late fifteenth and early sixteenth centuries was the Flemish painter Hieronymus Bosch (heer-**ahn**-nih-mus bosh). He picked up and carried on the emotional quality noted in the works of Rogier van der Weyden and Hugo van der Goes. Bosch's paintings, like those of the Italian Mannerists, mirrored the growing fears and tensions of the people during that uneasy period. Many people felt that the increasing religious conflicts were a sign that the evil in the world had reached new heights. It was only a matter of time, they felt, before an angry God would punish them all. This religious and moral climate gave artists subject matter for their works of art.

Bosch's pictures were meant to be viewed in two ways—as stories and as symbolic messages. His stories clearly focused on the subject of good and evil. His symbolic messages are more difficult to understand, however, because the meanings for many of his symbols have been forgotten over the years. Many of these symbols probably came from magical beliefs, astrology, and the different religious cults that were popular in his day. Even though his paintings are often frightening or difficult to understand, they are not without traces of humor. Bosch often pictured the devil as a fool or a clown rather than as the sinister Prince of Darkness.

Death and the Miser

Bosch's skills as a storyteller as well as his sense of humor are evident in his painting of *Death and the Miser* (Figure 18.15). He uses the picture to tell you that no matter how evil a man has been during his lifetime, he can still be saved if he asks for forgiveness before dying. An old miser is shown on his sickbed as a figure representing death enters the room and prepares to strike. Even at this final moment, the miser is torn between good and evil. An angel points to a crucifix in the window and urges the miser to place his trust in the Lord. At the same time, a devil tempts him with a bag of money. Who will the miser listen to? It is difficult to say; he seems about to look up at the crucifix, although his hand reaches out for the money at the same time. He cannot make up his mind. At the bottom of the picture is a scene from an earlier period in the miser's life. Here too Bosch shows that the miser cannot make a decision between good and evil. The man fingers a rosary in one hand, but adds to his hoard of money with the other.

Pieter Bruegel

Bosch's unique art style did not pass away with his death in 1516. Forty years later, another Flemish artist turned away from the landscapes he had been painting to create pictures that owe a great deal to Bosch's influence. The artist's name was Pieter Bruegel (**pee**-ter **broi**-gul).

The Parable of the Blind

Bruegel's pictures are often based on the unsettled conditions in the Netherlands during the sixteenth century, but what could he have had in mind when he painted *The Parable of the Blind* (Figure 18.16)? Five blind beggars are seen walking in a line; the sixth—their leader—has stumbled and is falling over the bank of a ditch, and the others are destined to share his misfortune. Like Bosch's work, Bruegel's painting can be seen as a **parable**, *a story that contains a symbolic message*. It illustrates the proverb that reads "And if the blind lead the blind, both shall fall into a ditch."

➤ This picture tells a story but does not give it an ending—the man in the bed has to make an important decision. What is the decision he must make?

Figure 18.15 Hieronymus Bosch. *Death and the Miser.* c. 1485–90. Oil on oak. 93 x 31 cm (36⅝ x 12³⁄₁₆″). National Gallery of Art, Washington, D.C. Samuel H. Kress Collection.

The picture could be interpreted as a warning to those who blindly follow the lead of others. Such people should be prepared to suffer the same fate. Bruegel's beggars follow a road leading to eternal suffering rather than the one leading to salvation. In their blindness they stumble past the distant church cleverly framed by trees and the outstretched staff of one of the beggars. The ditch they are about to tumble into could represent hell. It would represent the only possible end for those who allow themselves to be led down the path of wickedness. Bruegel warns that anyone can be misled; even the blind man wearing a showy cross as proof of his piety is being led astray.

Bruegel demonstrates a keen sense for detail—no less than five different eye diseases were once identified by a French physician after studying the faces in this picture. Also, observe the variety of expressions the figures show. They range from the confusion of the man at the far left to the fear of the figures at the right.

This concern for detail ties Bruegel more firmly to Jan van Eyck and other Flemish painters than to any Italian Renaissance artist. At a time when many Flemish artists were freely adopting the Renaissance style,

Bruegel followed his own path. The Renaissance Italians ignored what they thought to be excessive details. Bruegel, by contrast, emphasized them. The Italians also placed little importance on symbolism. Bruegel, on the other hand, used it in much the same way as the medieval artist did in illustrating stories from the Bible. His blind men are symbols painted with accurate details to give them a more lifelike appearance.

Hans Holbein

Several years after the death of Grünewald and Dürer, another German artist named Hans Holbein (hans **hole**-bine) left his native country to settle in England. Carrying a letter of recommendation from the great scholar Erasmus, Holbein hoped to escape from the strife of the Reformation. Known for his lifelike portraits, he became the court painter for King Henry VIII. He was the king's favorite painter and eventually painted portraits of Henry and three of his

➤ This painting stands as a warning to those who blindly follow the lead of others. Do you feel Bruegel was successful in getting his message across? Is this, in your opinion, a good illustration of a parable? Why or why not?

Figure 18.16 Pieter Bruegel. *The Parable of the Blind*. 1568. Tempera on canvas. 86 x 152 cm (34 x 60"). Museo Nazionale, Naples, Italy.

Mitch Ryerson

Massachusetts furniture artist Mitch Ryerson (b. 1955) became involved in furniture design only after extensive training and experience in traditional wooden-boat building. Born in Boston and raised in a family that valued the arts, Ryerson notes that boat building and furniture making require similar skills and both emphasize a functional aesthetic.

In the furniture field, however, Ryerson found a greater freedom to design pieces according to his own taste. Although trained in woodworking at a time when natural finishes and streamlined, subtly curvilinear forms were emphasized, Ryerson evolved a style that is colorful and playful. He is now one of the nation's premier designers of furniture art, meticulously crafted one-of-a-kind furniture that is sold in galleries and is as much an art object as it is functional.

Ryerson's work is often inspired by artifacts from the past, items that reflect the personality of the owners as well as the temperament of the person who made it. "I like to look at old stuff, things that have been worn, used, and abused." Ryerson is keenly aware of the "personality" of furniture and tries to make pieces that have a personable, approachable character. He notes, "I use color, playful arrangement, historical references, and anything else I can think of to make furniture that I hope is irresistibly inviting and reasonably functional." Even though much of Ryerson's furniture incorporates historical design elements, he has never been inter-

ested in making exact reproductions of antiques. He prefers to devise loose, highly expressive, and often ingenious interpretations that are completely contemporary in design and spirit.

Ryerson shares a cooperative woodshop with several other woodworkers, an arrangement that relieves the isolation of working as an independent artist and allows the members to share ideas, encouragement, machinery, and tools. His favorite part of being a studio furniture maker is starting a new project and working on it while it is still fresh. Although Ryerson enjoys the process of making things, he admits to sometimes tiring of the length of time it can take to complete a major project and the necessity of promoting his work to potential dealers and clients.

The *Elizabethan Cabinet*, which took two months to make, is the result of Ryerson's experiments with Renaissance themes and woodworking methods based on low-relief medieval stone carving. The technique of carving allowed him to include many different textures and to see how carving and painting could be combined in the same place.

Figure 18.17 Mitch Ryerson. *Elizabethan Cabinet.* 1988. Maple, plywood, basswood, mahogany, and wrought iron.

wives. The king was so impressed by Holbein's talent that he once remarked that he could make seven lords from seven peasants, but he could not make a single Holbein, not even from seven lords.

Edward VI as a Child

As a New Year's gift in 1539, Holbein presented Henry with a portrait of his fourteen-month-old son, Edward (Figure 18.18). The birth of this son had been widely acclaimed in England, because it meant that the king finally had a male heir to the throne. It was partly due to Henry's desire for a son to succeed him as king that he had divorced his first wife, Catherine of Aragon. This act had thrown the whole country into confusion. The pope condemned the action, and Henry broke with the Church, taking his country with him. Unfortunately, Henry did not father a son while married to his second wife either. The future King Edward was born while he was married to his third wife, Jane Seymour.

Holbein painted the young Edward in royal garments and placed a gold rattle in his hand. Even though the face and hands are childlike, Edward hardly looks like a child not yet two years of age. The artist probably wanted to impress Henry by showing the child's royal dignity rather than his infant charms.

The Latin verse below Edward's portrait asks him to follow the path of virtue and to be a good ruler.

➤ How did this artist help spread the Renaissance style across western Europe? For what famous king did he work? Study the portrait of Edward VI. Does the child in this picture look and act childlike? Why did the artist choose to show him acting more like an adult than a child?

Figure 18.18 Hans Holbein. *Edward VI as a Child.* c. 1538. Oil on wood. 56.8 x 44.1 cm (22⅜ x 17⅜"). National Gallery of Art, Washington, D.C. Andrew W. Mellon Collection.

Unhappily, the young king had little opportunity to do either. He was never strong and died of tuberculosis at the age of sixteen.

Anne of Cleves

The year after completing his painting of young Edward VI, Holbein was asked by Henry VIII to complete another portrait—a most unusual portrait. At that time, Henry was looking for a new bride, having divorced Catherine of Aragon, beheaded Anne Boleyn, and seen Jane Seymour die in childbirth. Hearing that Anne, the young daughter of the Duke of Cleves in Germany, was available, he decided to send a delegation to look her over. Included in this delegation was

Holbein, who was sent along to paint a portrait of Anne. Taking the artist aside, Henry confided, "I put more trust in your brush than in all the reports of my advisors."

Hearing this, Sir Thomas Cromwell, one of the king's most powerful ministers, summoned Holbein. Cromwell was anxious to see a marriage between Anne and Henry since it would certainly make Anne's father an ally against England's enemies on the Continent. Meeting with Holbein, Cromwell told the artist that he must, without fail, bring back a most beautiful portrait of Lady Anne.

Holbein met Anne in her castle in Germany on a hot August afternoon—and found her to be no vision of loveliness. She was good-natured, patient, and hon-

➤ Describe this woman's appearance, expression, and clothing. Point out and describe the different textures noted in this painting. Do you think this is an important person? How do you know? From the clues provided in this portrait, how do you think this woman might act at a party?

Figure 18.19 Hans Holbein. *Anne of Cleves.* 1539. Tempera and oil on parchment. 65 x 48 cm (25⅝ x 18⅞"). The Louvre, Paris, France.

est but, unfortunately she was also dull, lifeless, and plain.

This presented a problem for the artist. If he painted Anne to look beautiful, he would please Cromwell but risk the anger of the king. On the other hand, if he painted her plain, he would offend both Cromwell and the woman who might become queen.

Apparently Holbein decided to let his brush make the decision for him and completed the portrait in less than one week. Returning to England he showed the painting (Figure 18.19) to Henry, who took one look at it and signed the marriage contract. Arrangements were soon under way for a marriage ceremony that would dazzle all of Europe.

Anne crossed the English Channel and arrived at Rochester the day before New Year's Eve, 1539. As planned, Henry was waiting for her in Greenwich where the wedding was to take place. Staring at Holbein's portrait, he became increasingly impatient and eager to meet his bride-to-be. Finally, unable to stand the suspense any longer, he sprang to his feet, called for his horse, and dashed to Rochester.

Henry burst in on Anne and froze. He was so stunned by her appearance that he forgot to give the girl the presents he had brought for her. He returned to Greenwich in a rage but was forced to go ahead with the wedding because he was afraid that if he did not, the girl's father would join his enemies.

The marriage took place on January 6, 1540, and, on July 7, it was legally dissolved. The king gave Anne two residences, a generous yearly income, and the most unusual title of "Adopted Sister." Anne was apparently overjoyed and was seen wearing a new dress every day—along with a wide smile.

Thomas Cromwell was not as fortunate. He was arrested for treason and executed in the Tower of London.

Surprisingly, Holbein suffered no ill effects for his part in the affair, although Henry chose his next two wives after close personal inspection. Only one of them was to be beheaded. Holbein remained in Henry's good graces and was painting a portrait of the king when he fell victim to the plague. He died in London in the fall of 1543.

SECTION THREE

Review

1. Which German artist showed a preference for the dreams and visions favored by Gothic art?
2. Which German artist turned away from the Gothic style to embrace the ideals of the Italian Renaissance?
3. Tell how the paintings of Hieronymus Bosch are similar to those of the Italian Mannerists.
4. How were the paintings of Hieronymus Bosch meant to be viewed?
5. Why are the symbolic meanings in Bosch's works difficult to understand today?
6. Explain the parable illustrated in Bosch's *Death and the Miser* or Bruegel's *The Parable of the Blind*.
7. Select a painting illustrated in this section and tell why an art critic holding the emotionalist view of aesthetics would consider it successful.

Creative Activity

Humanities. Through the Middle Ages and into the Renaissance, the accepted subjects for the arts were religion, courtly love, the nobility, and the mythology of ancient Greece and Rome. Geoffrey Chaucer (1340–1400) broke new ground with his *Canterbury Tales*, representing the entire spectrum of social levels and people, all on a pilgrimage to Canterbury Cathedral. This use of ordinary people and events in art is called *genre*.

Some artists of northern Europe began painting genre subjects in the 1500s. Hieronymus Bosch (1450–1516) depicted the ugliness of an evil world and its punishments in a fantasy form that parallels a twentieth-century painting style known as surrealism. His *Punishments of Hell* in the famous triptych *The Garden of Earthly Delights* shows a man crucified on his harp and others trapped in a huge stomach.

Compare the shapes, the colors, and the movement of Bosch's work to that of the twentieth-century surrealists in Chapter 24.

PAINTING OF A BIZARRE CREATURE

Supplies

- A length of colored yarn, about 10 inches (25 cm) long
- White glue
- Pencil
- White drawing paper, 9 x 12 inches (23 x 30 cm)
- Tempera or acrylic paint
- Brushes, mixing tray, and paint cloth
- Water container

CRITIQUING

- **Describe.** Does your painting feature a bizarre, highly imaginative creature? Are you able to point out and name the most unusual features of this creature?
- **Analyze.** Is the yarn line used to start your picture clearly visible? Does your painting include a variety of hues, intensities, and values?
- **Interpret.** What makes the creature you created seem so unusual? What feelings does it arouse in students viewing your picture for the first time? Were these the feelings you hoped to arouse when you were creating your creature?
- **Judge.** Evaluate your picture in terms of its design qualities. Is it successful? Do the same with regard to its expressive qualities. What was the most difficult part of this studio experience?

Complete a highly imaginative tempera painting of a bizarre creature. The starting point for this painting will be a line arrived at by manipulating a length of colored yarn on a sheet of paper. The finished painting will contain a variety of hues, intensities, and values obtained by mixing the three primary colors and white and black.

Focusing

Did you notice the strange creatures lurking in the works of Dürer and Bosch (Figures 18.14 and 18.15)? Which of these creatures did you find especially bizarre? Can you find earlier works illustrated in this book that may have influenced the two artists in creating these unusual creatures?

Creating

Begin by experimenting with a length of yarn, dropping and manipulating it on a sheet of paper. Use your imagination to see this yarn line as the starting point for a drawing of a bizarre creature. This creature can have human or animal characteristics, or could combine characteristics of both.

When you are satisfied that you have a starting point for your drawing, glue the yarn in place on the paper. Use a pencil to continue this line at both ends to create your creature.

Paint your picture. Limit yourself to using only the three primary colors. However, do not use any of these colors directly from the jar or tube. Instead mix them to obtain a variety of hues and intensities. Add white and black to secure a range of values.

Do not paint over the yarn line. Allow it to stand out clearly as the starting point in your picture.

Figure 18.20 Student Work

HUMOROUS FACE FROM EXPANDED SHAPES

Using a variety of large and small shapes cut from a single, free-form shape, create a face that is humorous in both appearance and expression.

Focusing

Examine Bruegel's painting, *The Parable of the Blind* (Figure 18.16, page 421). Observe the different expressions on the faces of the blind men. Do the faces suggest that these men are clever or foolish? How is this indicated? Do you find yourself feeling sorry for these characters, or are you more inclined to smile at their predicament? Do you think humor is acceptable in art?

Creating

Cut a simple, free-form, solid shape from the white paper. Then cut this into three shapes of approximately the same size. Cut each of the three into five shapes, producing a total of fifteen.

Arrange all fifteen pieces on the sheet of colored paper. In doing this, make certain that each touches the shape from which it was cut at some point. At this time, expand the shapes slightly, producing a small gap between each piece.

Glue all shapes in place and study your design carefully. Use your imagination to "see" the beginnings of a humorous face. When such a face is discovered, add hair, eyes, ears, nose, mouth, and other details cut from colored paper. Try to make your face as humorous as possible.

Supplies
- Sheet of white construction paper, 6 x 9 inches (15 x 23 cm)
- Sheet of colored construction paper, 12 x 18 inches (30 x 46 cm)
- Scissors and white glue
- Scrap pieces of colored construction paper

CRITIQUING

- **Describe.** Can viewers easily identify the subject of your picture as a face? Are the eyes, nose, mouth, and other features clearly indicated? Is your face realistic?
- **Analyze.** Is your picture composed of a variety of large and small shapes? Were all these cut from a single, free-form shape?
- **Interpret.** Is the face you have created humorous? What makes it so? Do you think others will find it humorous?
- **Judge.** Do you think that your picture is successful? Did you find that making a work of art that is humorous is just as challenging as making one that is more "serious"?

Figure 18.21 Student Work

Review

Reviewing Art Facts

SECTION ONE

1. How did Giorgione use the landscape in his paintings?
2. How does Giorgione call attention to one of the main figures in his painting, *The Concert* (Figure 18.2, page 406)?
3. For what subject matter was Titian most famous?

SECTION TWO

4. List five unsettling or ambiguous aspects of Parmigianino's painting, *The Madonna with the Long Neck* (Figure 18.7, page 411).
5. What did El Greco learn from Titian that helped him add drama to his works?

SECTION THREE

6. What was Matthias Grünewald's goal in creating *The Small Crucifixion*?
7. What does the dog in Dürer's engraving *Knight, Death, and the Devil* (Figure 18.14, page 419) symbolize?
8. In what two ways were Hieronymus Bosch's and Pieter Bruegel's paintings meant to be viewed?

Thinking Critically

1. ***Analyze.*** Identify two works in this chapter where the artists understate the main subjects in the works. Explain, in each case, how understating the subject seems to have the effect of drawing attention to it.

2. ***Compare and contrast.*** Refer to Figure 18.14, page 419 (Albrecht Dürer's *Knight, Death, and the Devil*) and Figure 16.22, page 377 and Figure 16.23, page 378 (Michelangelo, ceiling of the Sistine Chapel, with detail of *The Creation of Adam*). Describe the similarities and differences between the works. Be sure to include how each artist creates the solid round forms of the figures.

3. ***Extend.*** You read that Mannerism was an effort by artists to show through their art what was going on in their minds during a crisis period. Consider some of today's more radical popular songs and discuss whether you think this is an indication that we are living in a crisis period. If so, what kind of crisis?

Using the Time Line

In what year did Giorgione complete work on *The Concert*? Can you recall, from your examination of the time line for Chapter Sixteen (page 386), what Michelangelo was doing at this time? The same year that Dürer completed *Knight, Death, and the Devil*, Portuguese explorers crossed what is now the area of the Panama Canal to make a great discovery. What was that discovery?

1500	1525	1550	1575	1600

Tintoretto. *Presentation of the Virgin*

Titian. *Doge Andrea Gritti*

• Grünewald. *The Small Crucifixion*
• Dürer. *Knight, Death, and the Devil*

Holbein. *Anne of Cleves*

Giorgione. *The Concert*

Parmegianino. *The Madonna with the Long Neck*

El Greco. *The Burial of Count Orgaz*

Jill C. Stidham, Age 17
Roswell High School
Roswell, Georgia

In reading the chapter on art produced during the sixteenth century, Jill responded to Dürer's work. She did some further research on this artist and decided to do a drawing of draped fabric based on some of Dürer's drapery studies.

Jill chose a pencil and a charcoal pencil as her media. She began by making a sketch of the draped fabric, first concentrating only on drawing the large folds. After she drew them in with light pencil lines, she went back and blocked in some of the shaded areas with the charcoal pencil. Alternating between adding fold lines and shaded areas, she worked her way through the various parts of the drapery.

During the middle stage of the project, Jill found that it was difficult to make the folds look rounded and that it required concentration to achieve the desired result. The biggest challenge was translating the highlights and shadows created by the folds in the fabric to the two-dimensional surface of her paper.

When she had finished blocking in all the major light and dark areas, she began to darken some of the deeper parts of the folds with her charcoal pencil. Shading helped to develop the contrasting values. To provide more contrast, she used white chalk to heighten the highlights.

In evaluating the finished work, Jill said that it did not look as realistic as she had hoped but that she was pleased with the different values in shading that she had been able to attain.

➤ *Drapery. Pencil and charcoal pencil. 46 x 30 cm (18 x 12").*

A World of Light and Shadow:
Baroque Art

Objectives

After completing this chapter, you will be able to:

➤ Explain what is meant by the Counter-Reformation.

➤ Describe the qualities Baroque sculptors sought in their work.

➤ Identify the woman artist who is regarded as having made the greatest impact upon the art of her time.

➤ Name several important Dutch painters and describe the kinds of subject matter for which they are best known.

➤ Identify the painter known as the greatest of the Spanish Baroque artists and explain why he is thought of in this way.

Terms to Know

Baroque art
chiaroscuro
Counter-Reformation
façade
genre

Figure 19.1 Frans Hals. *Yonker Ramp and His Sweetheart.* 1623. Oil on canvas. 105.4 x 79.4 cm (41½ x 31¼"). The Metropolitan Museum of Art, New York, New York. Bequest of Benjamin Altman, 1913.

Late in the sixteenth century and early in the seventeenth century,

a more relaxed and confident attitude replaced the tension and doubts of

the Mannerist period. By the start of the seventeenth century, the Catholic Church had

gained back much of its power in Italy. It was now answering the challenge of

the Protestant Reformation with a reform movement of its own.

Architecture and Sculpture in the Counter-Reformation

This movement, known as the **Counter-Reformation**, was *an effort by the Church to lure people back and to regain its former power*. Art played a major role in this Counter-Reformation. It was seen as an important weapon in the struggle to stamp out heresy and encourage people to return to the Church. For this reason, artists and architects were called to Rome to create works that would restore religious spirit and make the city the most beautiful in the Christian world. A style emerged that had dramatic flair and dynamic movement. It was called **Baroque art** and *is a style characterized by movement, vivid contrast, and emotional intensity*. Once again, Rome became the center of the art world, just as it had been during the height of the Renaissance a century before.

A New Style in Church Architecture

In architecture, the Counter-Reformation brought about a revival of church building and remodeling. One of these new Roman churches, Il Gesù (Figure 19.2), was among the first to use features that signaled the birth of the new art style. While many of its features are familiar, one certainly is not. The huge, sculptured scrolls at each side are something you have not seen before. They are used here to unite the side sections of the wide **façade**, or *front of the build-*

➤ Point to a feature on this building that you have not seen before. Do you think the purpose of this feature was decorative or structural? What effect does it have on the proportion of the building's façade?

Figure 19.2 Il Gesù. Rome, Italy. c. 1575.

ing, to the central portion. This sculptural quality on buildings like Il Gesù was an important feature of the Baroque architectural style. This style rose quickly to brilliant heights, and over the next one hundred years it spread across a large part of Europe.

Francesco Borromini

An excellent example of the mature Baroque style in architecture is a tiny Roman church designed by an emotionally unstable architect named Francesco Borromini (fran-**chess**-coh bore-oh-**mee**-nee), who

> ➤ This building is said to produce an effect of movement. How is this effect achieved? In what ways is the surface of the façade like sculpture?

Figure 19.3 Francesco Borromini. *San Carlo alle Quattro Fontane.* 1665–76.

died by suicide in 1667. The church that made Borromini famous worldwide was San Carlo alle Quattro Fontane (Figure 19.3). The façade of this church is a continuous flow of concave and convex surfaces. This makes the building seem elastic and pulled out of shape. It also adds a sense of movement to the façade. The push and pull that results creates a startling pattern of light and shadow across the building. The façade is three-dimensional, almost sculptural. The moldings, sculptures, and niches with small framing columns add three-dimensional richness and value contrast. Borromini boldly designed this façade to produce an effect of movement, contrast, and variety.

Emphasis on Mood and Drama in Sculpture

Throughout the Baroque period, sculptors showed the same interest in movement, contrast, and variety as did architects. They placed great importance on the mood or feeling expressed by their work and tried to capture the moment of highest drama and excitement. Less interest was shown in portraying realistic beauty. Drapery, for example, no longer suggested the body beneath. Instead, it offered artists a chance to show off their skills of complex modeling and reproducing different textures. Deep undercutting was used to create shadows and sharp contrasts of light and dark values. This added to the dramatic impact of the work. Colored marble replaced white marble or somber bronze as the preferred sculptural medium.

Frequently, however, several materials were used together in a single work.

During this time, sculptures were made that seemed to break out of and flow from their architectural frames. They projected out in different directions. This created an effect that was like that found in murals and ceiling paintings done at the same time (Figure 19.4). The results overwhelm and even confuse the viewer. Sometimes the viewer has trouble seeing where the painting or sculpture ends and reality takes over.

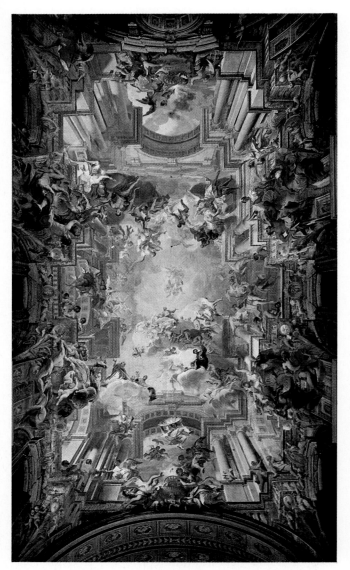

> ➤ The artist who painted this ceiling placed a small mark on the floor beneath it. When people stood on this mark and looked up, they had the best view of this amazing painting. Can you tell where the building ends and the painting begins? What makes this a "Baroque" painting?

Figure 19.4 Fra Andrea Pozzo. *The Entrance of St. Ignatius into Paradise.* 1691–94. Ceiling fresco. Sant' Ignazio, Rome, Italy.

Gianlorenzo Bernini

A fine example of this feature of Baroque sculpture is seen in Gianlorenzo Bernini's (jee-ahn-loh-**ren**-zoh bair-**nee**-nee) altar containing the famous *Ecstasy of St. Theresa* (Figure 19.5). This altar shows Bernini's skill in combining sculpture and architecture. It was dedicated to St. Theresa, a sixteenth-century Spanish nun who was one of the great saints of the Counter-Reformation.

In one of her books, St. Theresa described a vision in which an angel pierced her heart with a fire-tipped golden arrow symbolizing God's love. This vision served as the inspiration for Bernini's sculpture. The angel and saint are carved in white marble and placed against a background of golden rays radiating from above. This scene is lit from overhead by a concealed yellow glass window that makes the figures appear to float in space within a niche of colored marble. The figures do more than just occupy space, however. They appear to move about freely within that space. This new relationship with space sets Baroque sculpture apart from the sculpture of the previous two hundred years.

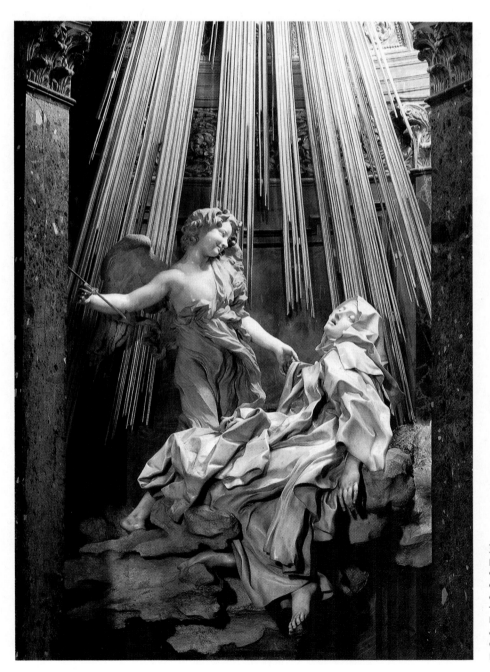

➤ Which of the elements and principles of art did Bernini employ when creating this sculpture? Point to as many examples as you can to support your opinion.

Figure 19.5 Gianlorenzo Bernini. *The Ecstasy of St. Theresa*. 1645–52. Marble. Life-size. Cornaro Chapel, Santa Maria della Vittoria, Rome, Italy.

This new relationship of active figures with space is observed in Bernini's sculpture of *David* (Figure 19.6). If you compare this work with a Renaissance sculpture such as Donatello's *St. George* (Figure 16.14, page 370), you will quickly recognize the Baroque sculptor's love of movement within space. Donatello's St. George remains still and calm as he plans his first move, but Bernini's David has already decided what he must do and is doing it. The theme in Bernini's work is movement. David's body is twisting in space as he prepares to hurl the stone at the mighty giant, Goliath. The coiled stance, flexed muscles, and determined expression are clues to his mood and purpose; but where is David's enemy, Goliath? Although he is not shown, his presence is suggested by the action and the concentration of David. It is clear that he is watching his enemy approach and is about to release the shot that must be on target or he is doomed. The space in front of David, which would be occupied by Goliath, thus becomes an important part of the work. The dramatic action of the figure forces you to use your imagination to place Goliath in that space.

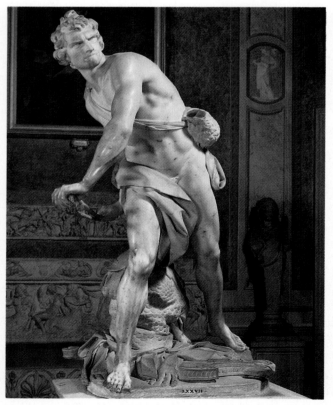

➤ How was this work designed to encourage a viewer to move around it rather than view it from one spot?

Figure 19.6 Gianlorenzo Bernini. *David.* 1623. Marble. Life-size. Galleria Borghese, Rome, Italy.

Painting Expresses Emphasis on Motion

The forms and figures of Baroque art twist, turn, and spiral in space. As a result, everything seems to be in motion. Architects, sculptors, and painters of this period all used more action in their works than had their predecessors and this increased the excitement of their creations. Furthermore, they used dramatic lighting effects to make vivid contrasts of light and dark. This magnified the action and heightened the excitement.

Michelangelo da Caravaggio

More than any other artist, Michelangelo da Caravaggio (mee-kel-**ahn**-jay-loh da car-ah-**vah**-jyoh) gave Baroque art its unique look and feeling. The paintings he produced during a brief and stormy career were an important influence on artists throughout Europe.

Rather than drawing his inspiration from the Renaissance artists who preceded him, Caravaggio chose to study and paint the world around him. He made light an important part of his painting, using it to illuminate his figures and expose their imperfections. By showing their flaws, he made his figures seem more real and more human. There is little about his figures to remind you of the supernatural beings found in Mannerist pictures.

The Conversion of St. Paul

Caravaggio's *The Conversion of St. Paul* (Figure 19.7) is a fine example of his painting style. Only St. Paul, his horse, and a single attendant are shown. The saint has been thrown from his horse and lies on his back with his arms outstretched. His companion grips the bridle of the uneasy horse and looks on in surprise. The entire scene is pushed forward on the canvas so that you are presented with a close look. There is no detailed landscape in the background to distract your attention from this scene. In fact, you can see nothing but darkness behind the figures. Instead of stretching back into the picture, space seems to project outward from the picture plane to include you as an eyewitness to the event.

At first the religious meaning of this picture may be overlooked. It looks as if the artist is only interested

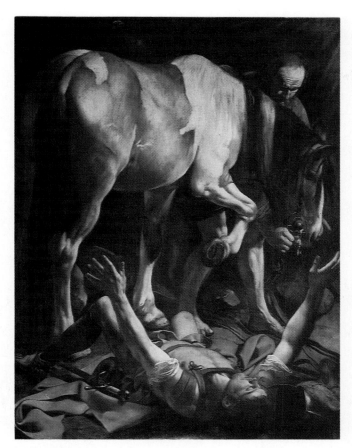

➤ Describe the light in the picture — is it natural, artificial, or mysterious? Where does it come from? What mood or feeling is created by the use of this light? Point to areas where gradations of value are found. What effect does this gradation have upon the shapes in the painting? How did you judge this painting?

Figure 19.7 Caravaggio. *The Conversion of St. Paul.* c. 1601. Oil on canvas. Approx. 228.6 x 175.3 cm (90 x 69"). Santa Maria del Popolo, Rome, Italy.

exact moment that he hears God's voice. This voice cuts through the darkness like the light. It demands to know, "Saul, why do you persecute me?"

Controversial Portrayal of Religious Subjects

Caravaggio's desire to use ordinary people in his portrayal of religious subjects met with mixed reactions. Some of his paintings were refused by the Church officials who had commissioned them. They disliked the fact that Christ and the saints were shown in untraditional ways. In one of these paintings, Caravaggio showed St. Matthew with his legs crossed and the dirty sole of his bare foot turned outward toward the viewer. Often the figures looked like peasants and common beggars. The people of Caravaggio's time were used to seeing religious figures pictured as majestic and supernatural beings. Since he refused to do this, the church officials turned to lesser artists whose works were more in keeping with their tastes.

Caravaggio's reckless life was as shocking to the public as many of his pictures. During the last decade of his life, he was in constant trouble with the law because of his brawls, sword fights, and violent temper. Finally he was forced to flee Rome after killing a rival during a quarrel over a point in tennis. Through all this, he continued to paint, and, surprisingly, the pictures from this period are among the most gentle he ever created.

Caravaggio died of malaria in 1610 when he was just thirty-seven years old, but his dynamic style of art and dramatic use of chiaroscuro helped to change the course of European painting during the seventeenth century. Spreading north into Flanders and Holland, these techniques and new approaches to religious subject matter provided inspiration for Rubens, Rembrandt, and a host of other artists who were to follow.

Artemisia Gentileschi

Among Caravaggio's many Italian followers were Orazio Gentileschi and his daughter, Artemisia (ar-tay-**mee**-zee-ah jen-ti-**less**-key). Artemisia was an artist of such skill that her fame, in time, surpassed that of her father. Her skill was such that she became the first woman in the history of Western art to have a significant impact upon the art of her time. During her career, she went to Florence, Venice, Naples, and Rome. The paintings she did on these travels helped spread

in providing an accurate account of a traveling accident. There is nothing to tell you that the figure on the ground is St. Paul who, as Saul, was once feared as a persecutor of Christians. Yet, there is something unreal and mysterious about this scene. A powerful light illuminates the figures and makes them stand out boldly against the dark background. This could hardly be described as a natural light. More like a spotlight, it originates outside the picture, making it something of a mystery. Its purpose goes beyond making it easy for you to see what is going on. Caravaggio uses it to add drama to the scene. This *arrangement of dramatic light and shadow* is called **chiaroscuro**. In Italian *chiaro* means "bright," and *oscuro* means "dark." Caravaggio uses light in the same way a technician skillfully turns on and directs a spotlight on a darkened stage. The brilliant flash of light reveals St. Paul at the

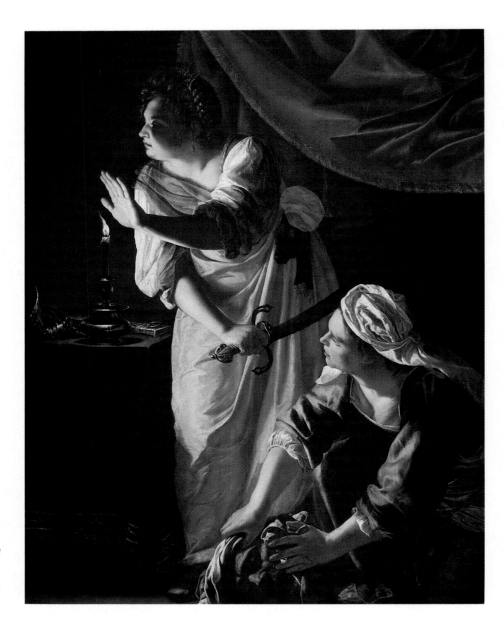

➤ Why is this artist so important in the history of art? Which artist greatly influenced her painting style? In what way is that influence evident in this picture?

Figure 19.8 Artemisia Gentileschi. *Judith and Maidservant with the Head of Holofernes.* c. 1625. Approx. 183 x 142.2 cm (72 x 56"). Detroit Institute of Arts, Detroit, Michigan. Gift of Mr. Leslie H. Green.

Caravaggio's style throughout Italy. Her debt to him can be seen in her works. A good example is *Judith and Maidservant with the Head of Holofernes* (Figure 19.8), painted when she was at the peak of her career.

The biblical story of Judith is one of great heroism. She used her charms to capture the fancy of Holofernes, the enemy of the Jewish people and general of King Nebuchadnezzar. Waiting in his tent until Holofernes was asleep, Judith struck suddenly, cutting off his head. Artemisia captures the tense scene just after this act. Judith stands with the knife still in her hand as her servant places the severed head in a sack. A mysterious noise has just interrupted them. Judith raises a hand in warning and both wait quietly, hardly daring to breathe, staring intently into the darkness.

The dark, cramped quarters of the tent are an effective backdrop for the two figures illuminated by the light from a single candle. Judith's raised hand partially blocks the light from this candle and casts a dark shadow on her face. Her brightly lit profile is thus accented, and this adds force to her anxious expression. Have they been discovered? Are soldiers gathering outside the tent to block their escape, or was the noise nothing more than the wind tugging at the flaps of the tent? Artemisia's lifelike treatment of the subject matter, her use of light and dark contrasts for dramatic effect, and her skill as a forceful storyteller are all evident in this painting. As did Caravaggio, Artemisia captured the moment of highest drama and excitement and intensified it for the viewer with chiaroscuro.

Peter Paul Rubens

Of all the European artists of the seventeenth century, Peter Paul Rubens most completely captured the exciting spirit and rich effects of the Baroque style. While still a young man, he spent eight years in Italy. There he observed Italian sixteenth-century painting and the works of Caravaggio. When he went back to his native Antwerp, he set up his own studio. This studio soon became the busiest in Europe. Assisted by many helpers, he turned out portraits, religious pictures, and scenes from myths.

The Raising of the Cross

Rubens liked powerful and exciting subjects, and this is evident in his preliminary painting for *The Raising of the Cross* (Figure 19.9). This was to be the first major altarpiece he painted after his return to Flanders from Italy and even this study shows how much he learned from the Italians. He was inspired by the rich color of Titian and the dramatic composition of Tintoretto. Both are evident in this work. In addition, he created powerful, twisting figures that were inspired by Michelangelo's paintings on the Sistine Chapel ceiling. From Caravaggio he learned to use light to illuminate the most important parts of his

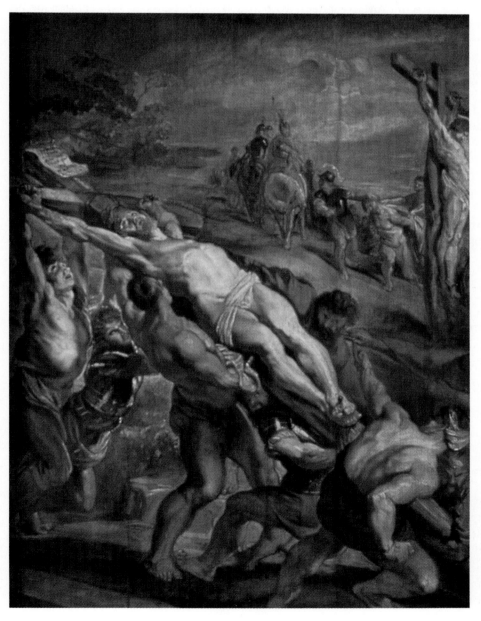

➤ This is a preliminary oil sketch for the painting called *The Elevation of the Cross*, which is in the Antwerp Cathedral. In what way does this painting remind you of works by the following artists: Jan van Eyck, Michelangelo, Titian, and Caravaggio? Make a list of the most obvious Baroque features found in this work.

Figure 19.9 Peter Paul Rubens. *The Raising of the Cross* (sketch). 1609–10. Oil on board. 68 x 52 cm (26⅘ x 20½"). The Louvre, Paris, France.

work. However, Rubens did not ignore his Flemish roots. He shows a concern for realistic detail, which had been a feature of Flemish painting since van Eyck. He blends these realistic details with a swirling mixture of colors and shapes to produce a picture of great dramatic force.

Rubens carefully arranged his figures to form a solid pyramid of twisting, straining bodies. However, this is no stable, balanced pyramid. It tips dangerously to the left, and the powerful figures seem to push, pull, and strain in an effort to restore balance. Like many other Baroque artists, Rubens makes use of a strong diagonal axis line in this picture. It follows the vertical section of the cross through the center of the pyramid. Notice how it runs from the lower right foreground to the upper left background. In this way the axis line not only organizes the direction of movement in the painting but also adds to the feeling of space. It serves to draw your eye deep into the work. The figures arranged on either side of this axis line form the unbalanced pyramid, which sweeps across the canvas like an overflowing stream at springtime.

The action in this painting is so intense that it embraces the viewer—you are made to feel as though you are part of it. This attempt to draw the viewer into the work is a trademark of the Baroque style. You will see it demonstrated over and over again in architecture and sculptures as well as in painting.

Perhaps more than any other artist, Rubens was able to give his pictures a feeling of energy and life. He did this by avoiding stiff, geometric forms; you will rarely find straight contour lines or right angles in a painting by Rubens. Instead, he used curving lines that join with one another to create a feeling of flowing movement. Then he softened the edges of his forms and placed them against a swirling background of color. The effect is one of violent and continuous motion.

Compare Baroque and Renaissance Styles

A comparison of Rubens's *The Raising of the Cross* with Raphael's *Alba Madonna* (Figure 16.26, page 381) should aid your understanding of both the Baroque and Renaissance styles. This comparison brings out the restraint and dignity of the *Alba Madonna* in contrast to the action and drama of *The Raising of the Cross*. Rubens replaces the calm, peaceful balance of the Renaissance with motion, power, and tension. Raphael, with much care, plans the placement of his figures to gain balance and stability. Rubens, on the other hand, uses a lively diagonal composition to entice the viewer into the scene. Then he blurs contours, makes the colors more intense, and spotlights powerful figures. This all adds to the excitement. Raphael's work invites you to leisurely view and think about its subject. Rubens's work gives you no time for this. It immediately reaches out and pulls you into the work, where you become emotionally involved. You *look* at the Raphael and *experience* the Rubens.

In order to meet all the demands for his art, Rubens had to rely on many assistants. This was especially true when he worked on the large pictures he preferred to paint. One of these assignments was to paint

➤ Point to the light source in this painting. How is the figure of the man made to stand out? What is he doing? What clues tell you that he was not the first to be placed in this situation? Do you think this man will suffer the same fate as his predecessors?

Figure 19.10 Peter Paul Rubens. *Daniel in the Lions' Den.* c. 1615. Oil on linen. 224.3 x 330.4 cm (88¼ x 130⅛"). National Gallery of Art, Washington, D.C. Ailsa Mellon Bruce Fund.

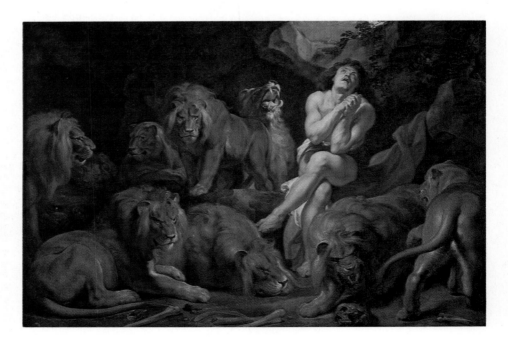

twenty-one huge paintings showing events from the life of the French queen, Marie de Médicis. Some of these pictures were as large as 12 x 20 feet (3.6 x 6 m). While assistants worked with him on this project, Rubens painted some of these pictures by himself and applied the finishing touches to all of them. In a letter he once wrote to a representative of the king of England, Rubens said of himself: "My talent is such that no undertaking, no matter how large or complex, has taxed my courage." From most artists, this would be dismissed as vain and boastful. From Rubens, it was a simple statement of fact.

Daniel in the Lions' Den

A painting that Rubens did without the aid of assistants illustrates the biblical story of *Daniel in the Lions' Den* (Figure 19.10). The prophet, illuminated by the light coming in from a hole overhead, stands out against the dark interior of the lions' den. He raises his head and clenches his hands in an emotional prayer. God's answer is indicated by the behavior of the lions—they pay no attention at all to Daniel. As in all of Rubens's works, there is a great deal of emotion here, but not at the expense of realism. The lions are accurately painted and arranged in natural poses. Rubens painted them after making a number of drawings of lions at a nearby zoo (Figure 19.11).

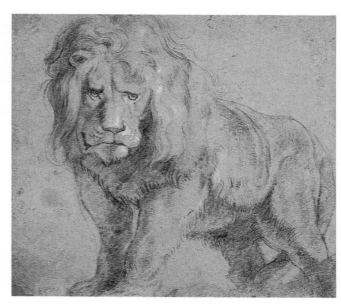

➤ This study was one of a number Rubens made in preparation for the painting *Daniel in the Lions' Den*. Notice how the artist used the chalk to capture details of the lion's bone and muscle structure. Can you identify this lion in the finished artwork?

Figure 19.11 Peter Paul Rubens. *Lion.* c. 1614. Black, yellow, and white chalk. 25.2 x 28.3 cm (9¹⁵⁄₁₆ x 11⅛"). National Gallery of Art, Washington, D.C. Ailsa Mellon Bruce Fund.

SECTION ONE

Review

1. In what way was art viewed in the Counter-Reformation movement?
2. What was the name given to the new art style exemplified by Il Gesù and San Carlo alle Quattro Fontane?
3. What qualities did Baroque sculptors like Bernini feel were most important in their work?
4. Which Italian artist's revolutionary style of painting helped change the course of European painting during the seventeenth century?
5. What was unusual about the work of the artist Artemisia Gentileschi?
6. How did Rubens give his works energy?

Creative Activity

Humanities. The importance of theater in the Baroque period is evident in the setting of Bernini's *The Ecstasy of St. Theresa*. Located in a recessed chapel of the church of Santa Maria della Vittoria in Rome, it is flanked on each side of the recess with sculptured theater *loges*, or boxes. In each box are the sculptured portrait figures of members of the Cornaro family, the donors of the piece. The family members are portrayed leaning forward as if watching a dramatic performance.

Patronage played an important role in Western art from the cathedral guild windows on. Trace its many forms, especially in Flemish Renaissance art. What is the role of patronage today? Consider the dominance of advertising in our society.

SECTION TWO

Dutch Art Takes New Directions

In 1648, a treaty with Spain (known as the Peace of Westphalia) divided the Low Countries into two parts. Flanders in the south remained Catholic and a territory of Spain. Holland in the north, which was largely Protestant, finally gained its independence from Spain. In Holland, the Baroque style had little impact. Although some features of this dramatic style appear in Dutch art, the Baroque was limited mainly to Catholic countries, where it was the style of the Counter-Reformation.

➤ Frans Hals specialized in painting portraits. Was it unusual for artists at this time and in this country to specialize in certain subjects for their paintings? Hals demonstrated the ability to capture a robust laugh, a shy smile, or a sly snicker. List the things in this painting that make it seem so lifelike. What does this painting have in common with a photograph? Describe the details Hals has shown in the clothing worn by the officer.

Figure 19.12 Frans Hals. *Portrait of an Officer.* c. 1640. Oil on linen canvas. 86 x 69 cm (33¾ x 27"). National Gallery of Art, Washington, D.C. Andrew W. Mellon Collection.

Dutch Genre Paintings

Dutch Protestants did not want religious sculptures or paintings in their churches, and this presented a problem for artists. If you think back about the kind of art that had been produced in western Europe before this time, the problem becomes obvious. Artists had focused primarily on religious subjects since early Christian times. Now there was no market for such paintings. What then was left for the Dutch artist to paint? Trade and colonization had brought wealth to the country, and so people could certainly afford art; but if religious art no longer interested patrons, what did? The search for an answer to this dilemma eventually leads to an examination of the Dutch people themselves.

Typical Dutch citizens enjoyed their comfortable homes and profitable businesses. In art, they favored works that reminded them of these as well as their loyal, hard-working wives; polite, obedient children; and good-natured friends. They wanted to surround themselves with paintings of the things they loved most. Realizing this, artists began to paint people and places, city squares and streets, the countryside and the sea. Many of these works were *scenes from everyday life*, or **genre** paintings. The market for portraiture, landscape, still life, and genre paintings grew to such an extent that artists began to specialize. For instance, some painted only pictures of the sea, while others did views of the city or interior scenes of carefree groups in taverns and inns.

Frans Hals

One artist, Frans Hals (frahns hahls), preferred to paint portraits of people: laughing soldiers, brawling fish vendors, and happy merrymakers (Figure 19.1, page 430). He used quick, dashing brushstrokes to give his works a fresh, just-finished look. His portraits are so successful in capturing a fleeting expression that they look like candid photographs. In one of Hals's portraits (Figure 19.12), an officer looks as if he has just turned to glance over at the painter. Perhaps he has been posing for some time and is tired. Abandoning pretense for a moment, he is shown behaving in a completely natural way. Placing one hand impatiently on his hip and flashing a sly grin, he appears to be saying, "Really, Mr. Hals, aren't you finished yet?"

➤ Light is an important factor in this picture. Why is it so important? Does this light come from the right or the left? Point to the main characters in this crowded scene. What are they doing? Describe the actions of the other figures. If sound could be added to this picture, what would you hear? Is this a successful work? Would it be as effective if you could see every detail clearly?

Figure 19.13 Rembrandt. *The Company of Captain Frans Banning Cocq (The Night Watch)*. 1642. Oil on canvas. 3.7 x 4.4 m (12'2" x 14'7"). Rijksmuseum, Amsterdam, Holland.

While Hals's portraits may look as though they were done in a matter of minutes, they actually took a great deal of time. His genius lies in the illusion that he creates. You are led to believe that Hals, in an instant, has caught a characteristic expression of the subject and recorded it in paint.

For many years, Frans Hals was among the busiest and most prosperous portrait painters in Holland. As he grew older, however, the public turned to other, more fashionable painters. His carefree life, huge family, and constant lawsuits for past debts finally drove him to accept a meager assistance from the pauper's fund in Haarlem, where he lived. The last payment from this fund, in 1666, was "four florins to the gravedigger to open a tomb in the Groote Kerk for a Meester Frans Hals."

Rembrandt van Rijn

No discussion of Dutch seventeenth-century art could be complete without mention of Rembrandt van Rijn (**rem**-brant van **ryne**), often referred to as the greatest Dutch painter of his era. His works alone make Dutch painting outstanding in the history of Western art.

The Night Watch

Like other artists of his time, Rembrandt painted portraits, everyday events, historical subjects, and landscapes. But, unlike most, he refused to specialize and was skilled enough to succeed in all. If he specialized at all, it was in the study of light, shadow, and atmosphere. The results of this study can be observed in one of Rembrandt's best-known paintings, *The Night Watch* (originally titled *The Company of Captain Frans Banning Cocq*) (Figure 19.13). Light can be seen throughout this picture, although it is brightest at the center. There an officer in charge gives instructions to his aide. The shadow of the officer's hand falls across the aide's uniform, telling you that the light comes from the left. The light falls unevenly on the other figures in the picture. Several, including a young woman and a drummer, are brightly illuminated, while others are barely visible in the shadows. Rembrandt's skill in handling light for dramatic effect, so obvious in this painting, was one of his most remarkable accomplishments.

Study this painting and use your imagination to add movement and sound. When you do, you will find that you become a spectator at a grand pictorial symphony. Light flashes across the stage, a banner is unfurled, a musket is loaded, lances clatter, and boots thud softly on hard pavement. At the same time, a

dog barks at a drummer and instructions are heard over the murmur of a dozen conversations. Rather than paint a picture showing continuous movement, Rembrandt has frozen time, allowing you to study different actions and details. The visual symphony before you is not as loud and emotional as that of a Rubens. This melody is quieter and more soothing. *The Night Watch* holds your attention with highlights and challenges your imagination with hints of half-hidden forms.

The Mill

Few artists have been as successful as Rembrandt in arousing the viewer's curiosity and rewarding it with a warm and comfortable feeling. Nowhere is this more evident than in his painting of *The Mill* (Figure 5.11, page 107). This is his largest and probably most famous landscape. *The Mill* is an example of the highly personal work that Rembrandt did after the death of his wife, Saskia, in 1642. Deeply saddened, the artist took long walks in the country. The peace and quiet he found in nature may have helped him overcome his grief. He shares this peace and quiet with you through his painting of the mill.

Artist in His Studio

Early in his career, Rembrandt painted a small picture of an artist in his studio (Figure 19.14). It may be a self-portrait—after all, he painted over ninety in his lifetime—or it could be a picture of one of his first students. In either case, it seems to be more than a faithful record of a young painter before his easel. Could it be that Rembrandt uses this painting to tell the viewer something about his ideas on art? In the picture, the artist is not actually working on his painting, nor is the painting visible to you. Instead, he stands some distance away and seems to be studying it. This could be Rembrandt's way of saying that art is a deliberate, thoughtful process requiring much more than skill with a brush. Rembrandt once advised visitors to his studio to stand back from his pictures because the smell of the fresh paint might offend them. Was he hoping that if they stood back they might share some thoughts that passed through his mind as he studied his paintings? If so, how remarkably similar this is to the ideas expressed by Leonardo da Vinci almost 150 years earlier when he said that men of genius sometimes produce the most when they do not seem to be working at all.

Jan Steen

During the same period in which Hals and Rembrandt were working, a group of artists doing only genre paintings supplied the Dutch with pictures for their fashionable homes. These artists are now called the "Little Dutch Masters." However, this label should not in any way suggest that these artists were lacking in skill or sensitivity. Indeed, one of the greatest painters of this period, Jan Vermeer, is often associated with this group of artists. Before discussing Vermeer, some time should be spent examining a painting by one of these Little Dutch Masters, an artist by the name of Jan Steen (yahn styn). It will be time that is well rewarded.

Steen's painting *Eve of St. Nicholas* (Figure 19.15) demonstrates again how a painting can be used to tell a story. Here the story is not religious or historical. It is a simple story involving common people and familiar events. When you inventory the literal qualities in this picture, the story becomes clear. It is the Christmas season, and St. Nicholas has just visited the children in this Dutch family. At the right, a young man holding a baby points up to something outside the picture. The child beside him looks upward, his mouth open in wonder. You can almost hear the man saying, "Look, out the window! Isn't that St. Nicholas?" (See Figure 19.16.)

➤ Describe the room illustrated in this picture. Why do you suppose Rembrandt placed the easel in the foreground? What idea or message do you receive from this work?

Figure 19.14 Rembrandt. *Artist in His Studio.* c. 1627. Oil on panel. 24.8 x 31.7 cm (9¾ x 12½"). Museum of Fine Arts, Boston, Massachusetts. The Zoe Oliver Sherman Collection. Given in memory of Lillie Oliver Poor.

➤ This painting tells a story. What seems to be happening? Point to all the diagonal lines you can find on the right side of this picture. Where do these lines lead? Find the one figure that looks directly at you. Where is this figure pointing? Why is the boy at the left crying? What clues reveal that this is a family gathering to celebrate some holiday? What do you think the man at the right is pointing to? Do you think Jan Steen has told the story well?

Figure 19.15 Jan Steen. *Eve of St. Nicholas.* c. 1660–65. Oil on canvas. 82 x 70 cm (32¼ x 27¾"). Rijksmuseum, Amsterdam, Holland.

However, this is not a joyous occasion for everyone in Steen's picture. The boy at the far left has just discovered that his shoe is not filled with gifts at all. Instead of candy or fruit, his shoe contains a switch. This can only mean that he did not behave himself during the year and now must suffer the consequences. A child in the center of the picture smiles at you and points to the shoe's disappointing contents. This child makes you feel like a welcomed guest, enjoying the holiday along with this family.

Because he was such an excellent storyteller, you could easily overlook the care that Steen took in organizing this painting. He used diagonal lines to lead you into and around his picture. The long cake at the lower left guides you into the work where the diagonal lines of the table, chair, and canopy direct your attention to the crying boy at the left. Jan Steen not only recognized a good story—he knew how to tell it.

Figure 19.16 Jan Steen. *Eve of St. Nicholas* (detail).

Art · PAST AND PRESENT ·

Chiaroscuro Provides Drama

Chiaroscuro, a popular technique used by Baroque artists such as Caravaggio and Gentileschi, is still used by artists today. Many kinds of artists, but especially photographers, use the contrast between light and dark to set a mood. Powerful light — light that is not natural — can add a sense of mystery and drama to a piece of art. The dramatic effect of a strong source of illumination on an object is often used, for example, by advertisers in food photography to make the food seem more appealing. Strong value contrast is also used in movies to give a powerful, dramatic effect to a scene.

Figure 19.17 Imogen Cunningham. *Martha Graham, Dancer.* 1931. Photograph. Imogen Cunningham Trust.

The contrast of light and dark is used, in particular, for portrait photography. Strong light can accent strong bones or highlight unusual features. It is sometimes used to highlight imperfections, thus adding to the "realism" of a portrait. The stark drama of black-and-white chiaroscuro can add beauty to a portrait that is not otherwise conventionally attractive. Just as Baroque artists used the contrast of light and dark to set or heighten a mood, so do modern photographers use this technique.

Jan Vermeer

With Jan Vermeer (yahn vair-**meer**), Dutch genre painting reached its peak. Unfortunately even though he is regarded today as one of the greatest artists of all time, little is known about him. For over two hundred years, Vermeer was all but forgotten, until his genius was recognized during the second half of the nineteenth century. It is known that he lived and died in Delft and that he was the father of eleven children. He most probably had difficulty providing food and shelter for all those children because he was such a slow worker. Less than forty pictures are known to have been painted by Vermeer. Of these forty, most illustrate events taking place in the same room. Because so many of his paintings show inside scenes, Vermeer is often thought of as a painter of interiors. Even though there are people in his paintings, they seem to be less important than the organization of the composition and the effect of light on colors and textures.

The Love Letter (Figure 19.18) demonstrates Vermeer's mastery as an artist. He has taken an ordinary event and transformed it into a timeless masterpiece of perfect poise and serenity. Everything seems frozen for just a moment as if cast under some magic spell. You are soon made to feel as if you are actually in the painting, standing in a darkened room that looks very much like a closet. A curtain has been pulled aside and a door opened, allowing you to peer into another room where a cool, silvery light filters in from the left. The black-and-white floor tiles lead your eye into this room, where you see two women. The clothes of the standing woman suggests that she is a servant. A basket of laundry rests on the floor beside her. She has

just handed a letter to the seated woman. This second woman is richly dressed and, until this moment, has been amusing herself by playing the lute. The facial expression and exchange of glances tell you that this is no ordinary letter. The young woman holds the letter carefully but avoids looking at it. Instead, she glances shyly up to the face of the servant girl. No words are uttered, and none are needed. A reassuring smile from the servant girl is enough to tell the young woman that it is indeed a very special letter — no doubt from a very special young man.

On the wall behind the two women are two pictures; both serve a purpose. The landscape in the upper picture curves to repeat the diagonal sweep of the curtain above the door. In this way, it connects the foreground and the background. The second picture is a marine painting showing ships at sea. Perhaps Vermeer is using this picture to tell you that the letter is from someone at sea or someone who has been transported afar by sea. This is quite possible. Dutch artists were fond of painting pictures of people reading letters, and a remarkable number of those paintings include pictures of ships.

The two figures in Vermeer's painting seem to be surrounded by light and air. This contributes to a feeling of space that is increased by placing the viewer in the darkened closet. Moreover, the doorway of this closet acts as a frame for the scene in the next room. Thus, the foreground is an introduction to the story unfolding deeper in the work.

Vermeer died in 1675 at the age of forty-three. He left behind no romantic legends, no hint of mysterious intrigues, no stories of brawling or tragic love affairs. He left behind much more, a precious few paintings that rank among the greatest works of art ever produced.

➤ Compare the two rooms shown in this painting. In which room are you, the viewer? Describe the dress, expressions, and actions of the two women. Which is the servant and which is the mistress of the house? How can you tell? Describe their behavior toward one another. Does this behavior have anything to do with the letter held by the seated woman? There is a clue in this picture to suggest that this letter came from far away. Can you find it? Who do you think could have sent the letter?

Figure 19.18 Jan Vermeer. *The Love Letter.* 1666. Oil on canvas. 44 x 38.5 cm (17⅜ x 15⅛"). Rijksmuseum, Amsterdam, Holland.

Judith Leyster

You may think it unusual, but turning the pages of history ahead to the year 1893 helps to introduce another noteworthy Dutch painter. In that year, officials at the great Louvre museum in Paris decided to clean a painting in the museum collection long thought to have been painted by Frans Hals (Figure 19.19). Imagine their shock when they discovered that the name on the painting was not that of Hals at all. Adding to their amazement was the fact that the signature was that of a woman—Judith Leyster (**lie**-stir).

Who was this artist whose work looked so much like that of the great and famous Frans Hals? Surprisingly, it was found that there was little written information available on Judith Leyster. At first, some

➤ Compare this painting with the works by Frans Hals (Figure 19.1, page 430 and Figure 19.12, page 440). Can you see how people may have thought that this painting was created by Hals rather than Leyster? What similarities do you see in the work of these two artists? Do you think that people were so willing to accept this work as Hals's because they could not accept the idea that a woman could paint so well?

Figure 19.19 Judith Leyster. *The Jolly Companions.* 1630. The Louvre, Paris, France.

historians considered her little more than an imitator of Hals. However, in the years since, it has been determined that Leyster was a great deal more than that. She is now recognized as a unique and talented artist whose work had its own impact on Dutch art of the seventeenth century.

Judith Leyster was born in 1609 to a brewer in Haarlem. By the time she was seventeen years old, she was already gaining a reputation as a painter of considerable promise. She stood alone in her choice of subject matter of different types. Women artists at the time were expected to paint delicate still lifes. Leyster also painted still lifes, but chose in addition to do genre subjects and portraits. A serious student of art, Leyster studied the works of others and skillfully applied what she learned to her own painting. From artists who had visited Italy she learned about Caravaggio's dramatic use of light and dark. This sparked her own interest in the effects of light on her subjects under varying conditions. It was an interest that remained with her for years to come.

Leyster also learned from the pictures painted by her fellow Dutch artists. She was not only familiar with Hals's work but was a friend of his as well. Records show that she attended the baptism of one of his many children. However, their friendship was strained several years later when Hals coaxed one of Leyster's students to leave her studio and study with him. She brought a lawsuit against him and won, and Hals was required to pay her the money she would have received from the student.

Leyster and Hals had their differences, but this did not interfere with Leyster's appreciation of Hals's technique. She, in fact, imitated it in several instances. It is clear that she saw much to be learned from Hals's remarkable brushwork. However, the influence of Hals on Leyster's style was not far-reaching. The majority of her works give less an impression of the fleeting moment and more the feeling that care and time have been taken to achieve an overall elegant effect. While the subjects in Leyster's portraits often smile and gesture toward the viewer as they do in Hals's pictures, they do so more quietly and with greater dignity. Nowhere is this more evident than in a self-portrait she did at about the time she was involved in her lawsuit with Hals (Figure 19.20). Here you are made to feel as if you have been looking over her shoulder as she worked on a painting of a laughing fiddler. She has just turned to see how you like it. The smile on her attractive face is friendly, and she seems to be completely at ease. Her manner convinces you at once that you are in the company of a good friend. It was just

this kind of psychological interaction between subject and viewer that Leyster sought in her paintings of people, and in this self-portrait, she succeeded in achieving it.

Not long after this painting was completed, Leyster married a fellow artist named Meinse Molenaer. Unfortunately, she painted less and less after her marriage. Although she may have worked with her husband on his paintings, it is probable that their three children kept her too busy to return to her easel. Judith Leyster, the artist who shocked the art world with a painting mistaken for a Frans Hals, died in 1660 when she was only fifty years old.

➤ In what ways is this painting similar to the portrait done by Frans Hals? How is it different? What connection did Leyster have with Hals? Does the woman in this picture seem startled, annoyed, or relaxed? Would you describe her as warm and friendly, or cold and aloof? Identify qualities shown in the picture that support your conclusion.

Figure 19.20 Judith Leyster. *Self-Portrait.* c. 1635. Oil on canvas. 72.3 x 65.3 cm (29⅜ x 25⅝"). National Gallery of Art, Washington, D.C. Gift of Mr. and Mrs. Robert Woods Bliss.

SECTION TWO

Review

1. Why did the highly religious Baroque style have little impact in Holland?
2. What kind of subjects did Dutch seventeenth-century artists paint, and why?
3. What is genre painting?
4. What type of picture did Frans Hals prefer to paint?
5. How did Rembrandt succeed in arousing the viewer's curiosity?
6. What were the "Little Dutch Masters" doing during the Baroque period?
7. With which Dutch painter did genre painting reach its peak?
8. How was the Baroque painter Judith Leyster "discovered" in 1893?
9. Name the artist who most influenced Judith Leyster and list at least two ways in which her artworks show this influence.

Creative Activity

Humanities. England in the late 1500s saw some of the first plays by William Shakespeare. For many today his name *means* theater. His plays have been performed in innumerable languages all over the world.

Shakespeare is a master of both tragedy and comedy. The rhythm of Shakespearean dialogue carries the viewer/listener into the action of the plot. Read these lines from *As You Like It*, a story about the escapades and loves of English nobility.

"Sweet are the uses of adversity,
Which, like the toad, ugly and venomous,
Wears yet a precious jewel in his head;
And this our life, exempt from public haunt,
Finds tongues in trees, books in the running
 brooks,
Sermons in stones, and good in every thing."
 As You Like It, II, i, 12

Read more of this play. It includes Shakespeare's famous story of life, which begins with "All the world's a stage. . ."

Spanish Art Continues with Religious Subjects

Dutch artists at this time, then, were busy painting portraits, landscapes, and genre subjects. At the same time, however, Spanish artists continued to paint saints, crucifixions, and martyrdoms. Religious subjects always interested Spanish artists more than other subjects. This had certainly been true in the sixteenth century. At that time, El Greco's art led the mind of the viewer to a mysterious, spiritual world. The seventeenth century was to see a slight change, however. Artists at this time often used the same religious subjects as El Greco, but their works brought the viewer back to earth. Their paintings had a more realistic look. One of the first to show greater realism in his works was Jusepe de Ribera (zhoo-**say**-pay day ree-**bay**-rah).

Jusepe de Ribera

Ribera was born near Valencia, Spain, but moved to Italy while he was still a young man. Because of his short stature, he came to be known to the Italians as Lo Spagnoletto, or "The Little Spaniard." He lived and studied art in Rome for several years and then moved to Naples, where he remained for the rest of his life. Caravaggio had died only a few years before Ribera arrived in Rome, and the latter's paintings show that he was strongly influenced by that Italian Baroque artist.

The Blind Old Beggar

In his painting of *The Blind Old Beggar* (Figure 19.21), Ribera used Caravaggio's dramatic lighting and realism to paint an old man and a young boy standing together in the shadows. Their faces stand out clearly against a dark background. A light originating outside the painting illuminates these faces and allows you to see every detail. The wrinkles, creases, and rough beard of the old man's face contrast with the smooth freshness of the boy's. The old man's unseeing eyes are tightly closed, but the lively eyes of the boy stare openly at you.

Who are these people that Ribera introduces to you? Some have suggested that they are the main characters from an autobiography published about

➤ How did Caravaggio influence this painter's style?

Figure 19.21 Jusepe de Ribera. *The Blind Old Beggar.* c. 1638. Oil on canvas. 124.5 x 101.7 cm (49 x 40⅟₁₆"). Allen Memorial Art Museum, Oberlin College, Oberlin, Ohio. R.T. Miller, Jr. Fund, 1955

eighty years before Ribera painted this picture. This book describes the life of a penniless wanderer named Lazarillo de Tormes, or "Little Lazarus of Tormes." It starts with an account of how Lazarillo's mother, unable to feed her many children, gave him to a blind man to act as his guide. In return for his help, Lazarillo was to be cared for by the old man. Forced by a brutal world to depend on each other for survival, they went through many adventures together; but the relationship between the crafty, often cruel old man and the innocent boy was unhappy from the beginning. Gradually the boy became just as shrewd and hardened as his master. Nothing could shock, or surprise, or frighten Lazarillo, and the same can be said for the boy who stares boldly at you from the shadows of Ribera's painting.

A Simple, Calm Style

Baroque painters like Rubens liked to paint large complicated pictures with masses of active people. Ribera's paintings, however, were much simpler. He

preferred to paint a single tree rather than a forest, one or two figures instead of a crowd. He also avoided excitement and action in favor of calmness in most of his works. While Rubens's pictures were like a rousing symphony played by a grand orchestra, Ribera's were more like a sonata softly played by a small string quartet.

Works Popular in His Native Spain

Although he chose to live in Italy, Ribera's fame was not limited to that country. He was also well known in his native Spain and was even visited by the court painter to the Spanish king, who came to Italy to purchase works for the royal collection. This court painter's name was Diego Velázquez (dee-**ay**-goh vay-**lahs**-kess), destined to be honored as the greatest of Spanish Baroque artists.

Diego Velázquez

Velázquez was born in Seville to a noble family. This presented some problems for him since it was considered improper at that time for a nobleman to earn his living as a common artist. He could follow a career as a painter only if he found a position at the royal court.

With this in mind, the young artist went to Madrid with a letter of introduction to one of the king's attendants. His talent was soon recognized, and he was asked to paint a portrait of the king, Philip IV. When it was finished, Philip was so pleased that he said no one but Velázquez would ever again paint his picture. He was a man of his word. In all, Velázquez painted Philip thirty-four times. No artist ever painted a king so often.

Surrender of Breda

When he was thirty-five years old, Velázquez completed his largest painting. This work celebrated the Spanish victory over the Dutch city of Breda nine years earlier (Figure 19.22). The picture shows the moment when the commander of the Spanish army receives the key to the conquered city. Clearly, the two commanders are the main characters in this scene. However, the two figures at either side of the picture are also important. It is they who direct your attention to these main characters. Both side figures stare directly at you. Their gaze, coming from different places in the picture, pinpoints your position in front of the painting. From this position, you can observe the meeting of the two rival commanders (Figure 19.23, page 450). So you will know exactly what is happening, the key to the city being passed from one

➤ The two men in the center are the main characters in this scene — what has been done to make them stand out? What are they doing? What is the one at the left offering the other? How do these figures act toward one another? The soldiers at the right hold their lances erect; how does this differ from the behavior of the soldiers at the left? Does this offer a clue as to which army is the victor and which is the defeated? Does this picture emphasize the horror and brutality of war, or its glory and gallantry?

Figure 19.22 Diego Velázquez. *Surrender of Breda*. 1634–35. Oil on canvas. 3.07 x 3.65 m (10'1" x 12'). The Prado, Madrid, Spain.

Main
Characters

Figure
One

Figure
Two

Viewer

Figure 19.23 Diagram of the viewer's position before *Surrender of Breda*.

trait of the king and queen? Perhaps the girl at her right is trying to persuade the princess to go with her to another room so that the painter can go on with his work. On the other hand, the artist may be trying to paint the princess while the king and queen watch; but the princess, tired of posing, turns her back to him. Generations of curious viewers have tried to discover what is happening in this picture; but is it really so important? If one sees the painting as nothing more than a picture of everyday life at the palace, it is still interesting. The scene is peaceful, quiet, and natural. There are no surprises or sudden movements. Even the playful boy at the right seems gentle and unhurried as he arouses a sleeping dog with his foot. The dog, only half-awake, seems unconcerned. As soon as he is left alone, he will go back to sleep.

One of the most striking things about Velázquez's painting is the way he creates the illusion of space. You can see the scene stretched out before you as well as a continuation of it behind you reflected in the mirror. Velázquez goes even further, however, by

commander to the other is silhouetted against a light background. At the right, the position of a horse helps to lead your eye deeper into the painting where you see the lances and the flag of the Spanish army. The soldiers of this army proudly hold their lances erect. After all, they are the victors. How different are their actions when compared to the careless manner in which the defeated Dutch soldiers at the left hold their lances! Repeating the diagonal movement of the Spanish flag is the smoke rising from the captured city in the background. In this way, Velázquez unites the triumphant army with the city they conquered.

Las Meninas

Later in his career, Velázquez painted one of his best-known works, *Las Meninas* (or *The Maids of Honor*) (Figure 19.24). In it he placed the young daughter of the king surrounded by ladies-in-waiting, attendants, and a dog. The artist also shows himself standing at his easel. Farther back in the picture, reflected in a mirror, are the faces of the king and queen. Velázquez's use of a mirror in this way may remind you of Jan van Eyck's picture of Giovanni Arnolfini and his bride (Figure 17.3, page 391). It is quite possible that Velázquez was influenced by van Eyck's painting since it was a part of the Spanish royal collection at that time.

What is happening in this picture? Has the princess just entered a room where the artist is painting a por-

▶ Is the open door at the back of the room the only place where light enters? If not, from which direction does additional light come? How is the illusion of space created in this painting? How is space beyond the room suggested? Do you think this is an important event, or just a common occurrence for these people? What do you find most appealing about this picture?

Figure 19.24 Diego Velázquez. *Las Meninas (The Maids of Honor)*. 1656. Oil on canvas. 3.18 x 1.08 m (10'5" x 9'). The Prado, Madrid, Spain.

Audrey Flack

Painter and sculptor Audrey Flack (b. 1931) has always felt an affinity for the passionate, emotionally charged work of both southern and northern Baroque artists. As a child growing up in New York City, Flack enjoyed visiting the Metropolitan Museum of Art and the Hispanic Society, where she was fascinated by the polychromed sculptures by Baroque Spanish artists. Flack has stated, "I am deeply involved with seventeenth- and eighteenth-century Spanish passion art. . . . I feel these artists have not received the recognition they deserve probably because they displayed openly their passion and feeling." Flack was also inspired to create art in the manner of still lifes painted by Dutch Baroque artists such as Maria van Oosterwyck.

Although raised in a Jewish family, Flack's art reflects her appreciation of many different religious traditions. She is concerned with mortality, healing, moral strength, and the transcendence of suffering and uses imagery from a wide range of religious cultures to express these themes. Her art is as likely to include a Buddha as it is to portray the Virgin Mary, a Greek goddess, or a shaman. *Marilyn* is a contemporary version of Protestant northern Baroque *vanitas* paintings, which used material objects to subtly symbolize the shortness of life and the relative unimportance of earthly treasures in the face of death. A calendar, a candle that will eventually burn out, a tiny hourglass, a clock, ripening fruit, and other items all point to the fragility and brevity of life, even for so glamorous a person as Marilyn Monroe. Flack's work emerges from intensely personal conviction—in this instance, she has included a photo of herself and her brother amidst the other objects as a reference to her own mortality.

Flack feels that much of the art in the United States is too reserved and devoid of feeling, especially realist art. One of her favorite ways to introduce a sense of passion in her art is to paint with highly saturated colors and to use the airbrush technique. This allows Flack to achieve an intensity and quality of color not possible when paint is applied with a brush. She explains, "Spraying produces small beads of color and the density of application affects the intensity of color—the air-brushed paint appears foamy, lighter, smoother, and alive. . . . Light reflects differently being bounced off thousands of tiny particles than it would off a brush-painted surface." Flack's skilled experimentation with various techniques during her lengthy career is enough to win her recognition, but her true acclaim as an artist is grounded in her moral conviction, her use of historical themes and styles, and her dedication to the creation of art that appeals to both the art-world elite and ordinary people.

Figure 19.25 Audrey Flack. *Marilyn*. 1977. Oil over acrylic on canvas. 2.4 x 2.4 m (8 x 8'). Collection of The University of Arizona Museum of Art, Tucson, Arizona. Museum purchase with funds provided by the Edward J. Gallagher, Jr. Memorial Fund.

suggesting the world beyond the room, which he allows you to glimpse through an open door. Light from a window illuminates the foreground, while the background is veiled in soft shadows. You not only see space here — you can almost feel it. If you could enter that room, you would first pass through the bright, warm sunlight in the foreground and, with each step, move deeper and deeper into the shadowy coolness of the interior. If you wished, you could walk through the open door, up the steps, and out of the room.

Bartolomé Esteban Murillo

While Velázquez was working at the royal court in Madrid, another artist named Bartolomé Esteban Murillo (bar-toh-loh-**may ess**-tay-bahn moo-**ree**-yoh) was building a reputation for himself in Seville. Like Velázquez, Murillo was born in Seville, but not to a noble family. Orphaned at ten, he was raised by an uncle who realized that the boy had talent and placed him

➤ Compare the clothing worn by the two men in the center. What does this tell you about them? Would you say that your eye is drawn into this picture, or does it sweep across it?

Figure 19.26 Bartolomé Esteban Murillo. *The Return of the Prodigal Son.* 1667–70. Oil on canvas. 236.3 x 261.0 cm (93 x 102¾"). National Gallery of Art, Washington, D.C. Gift of the Avalon Foundation.

with a local artist with whom he could study art. Later, Murillo was forced to earn a living by painting and selling pictures in the marketplace. At first, people stopped to look at his work out of curiosity and were surprised to find that they liked what they saw. They bought his works, and Murillo's reputation began to grow, until he was recognized as the leading artist.

The Return of the Prodigal Son

Many of Murillo's paintings were done for monasteries and convents. One of these tells the familiar tale of *The Return of the Prodigal Son* (Figure 19.26). You see the father welcoming his wayward son; the calf to be prepared for the celebration feast; and servants bringing a ring, shoes, and new garments. Notice the contrast between excited and calm feelings in the picture. On the one hand, you see a little dog barking excitedly and servants conversing in an earnest manner. On the other hand, you see that the tone of the reunion between father and son is tender and quiet. Murillo avoided sharp lines and color contrasts in order to keep his composition simple and harmonious. In this way, the viewer would not be distracted from observing the joy associated with the son's return.

Church Division Has Lasting Effect on Art

It seems fitting for a discussion of the seventeenth century to close with a painting of *The Return of the Prodigal Son*. This subject accurately reflects the Catholic Church's attitude during this period of the Counter-Reformation. Like the forgiving father, it welcomed back those who had followed Martin Luther and other Protestant reformers. Many did return, but many others did not. The religious map of Europe was now complete, and it has stayed about the same ever since. For artists, this meant that they could no longer seek out or depend upon a universal Church for commissions. At the same time, they experienced a new freedom. Rather than producing works solely for the Church, they were able to paint, carve, and build for a variety of patrons. Their freedom also extended to subject matter, for most of these patrons did not ask for religious works. In fact, most of them taxed the artists' ingenuity with demands for art that was not inspired by religion.

SECTION THREE

Review

1. How did the subject matter of Spanish Baroque painters differ from that of Dutch Baroque artists?
2. Tell how Caravaggio's style influenced Jusepe de Ribera.
3. Look at *Surrender of Breda* (Figure 19.22, page 449) and tell how Velázquez used line to express the pride of the victors.
4. List at least three ways Velázquez uses space to intrigue the viewer in *Las Meninas* (Figure 19.24, page 450).
5. How did Murillo keep a calm tone in his painting *The Return of the Prodigal Son* (Figure 19.26, page 452)?
6. Select either *The Blind Old Beggar* (Figure 19.21, page 448) or *The Return of the Prodigal Son* (Figure 19.26, page 452) and tell whether you think the artist was successful in conveying an *expressive* quality, and why or why not.

Creative Activity

Humanities. In 1605, Miguel de Cervantes published the first part of his masterpiece *Don Quixote*. In this great work of fiction, Cervantes satirized the extremism of Spanish society through the eccentric idealism of Don Quixote and the earthiness of Sancho Panza. Cervantes himself had led a fictionlike life, being permanently wounded in his left arm while in the army, captured by Barbary pirates and sold into slavery to a viceroy in Algiers, and ransomed five years later at the cost of his family's financial ruin.

Don Quixote had a profound effect on the emerging structure of the novel, bringing together bitter satire, humor, pathos, and the transforming power of illusion. The addled idealism of its hero, jousting at windmills and pursuing his chivalric adventures, is still today a commonly used metaphor for futile effort. Read *Don Quixote* or see *Man of La Mancha*.

PAINTING A SHAPE MOVING IN SPACE

Supplies
- Pencil
- White drawing paper, 9 x 12 inches (23 x 30 cm)
- Small piece of cardboard or mat board
- Scissors, ruler
- Tempera or acrylic paint
- Brushes, mixing tray, and paint cloth
- Water container

CRITIQUING

- **Describe.** Is the object in your painting easily identified? Is it clear that this object is moving through space? Did you show that it has bounced on the floor at least twice? Did you use two complementary colors to paint your object?
- **Analyze.** Can you trace the movement of your shape along an axis line? Do repeated, overlapping shapes and gradual changes of intensity add to the illusion of a falling object, turning and bouncing through space?
- **Interpret.** What adjective best describes the movements of the object pictured in your painting? Is the idea of a falling, bouncing object clearly suggested by your picture?
- **Judge.** Which theory of art, formalism or emotionalism, would you use to determine the success or lack of success of your painting? Using that theory, is your painting successful?

Complete a painting that records, in repeated overlapping shapes and gradual changes in intensity, the movement of a falling, bouncing object as it turns and twists along an axis line through space. Select two complementary hues to obtain a range of color intensities.

Focusing
Study Peter Paul Rubens's *The Raising of the Cross* (Figure 19.9, page 437). Can you trace your finger along the axis line in this picture? Explain how this line helps organize the placement of shapes and contributes to the illusion of movement.

Creating
On the piece of cardboard draw the outline of a small, simple object such as a key, large coin, or eraser. Cut out this shape with scissors.

With a ruler and pencil make a straight, horizontal line about one-half inch (1 cm) from the bottom of a sheet of white paper positioned lengthwise. Think of this line as representing a tabletop or the floor.

Position your cardboard shape at the upper left corner of your paper and trace around it with a pencil. Draw the same shape at the lower right corner on the paper so that it appears to rest on the horizontal line.

Imagine that the objects you have drawn are made of rubber. The two drawings represent the first and last positions of the same object. It has been dropped, strikes the floor, and bounces through space. To indicate this movement, lightly draw an axis line from the object at the top of the paper to the one at the bottom.

Using your cardboard shape as a model, complete a series of drawings showing your object as it twists, turns, and bounces through space along the axis line. Your drawings of the object should overlap slightly.

Select two complementary colors and paint the shapes you have created. Use gradation of intensity to show that your object is bouncing.

Figure 19.27 Student Work

CHARCOAL FIGURE DRAWING

Complete a series of charcoal drawings of figures in action. Each of the figures drawn will fill a large sheet of drawing paper and will be seen spotlighted so that contrasts of light and dark values are clearly indicated. These light and dark values will add drama to your drawings.

Focusing

Examine the Baroque paintings by Caravaggio, Gentileschi, Rembrandt, Rubens, Ribera, and Velázquez illustrated in this chapter. What do these works have in common? How has each artist used light and dark value contrasts to increase the dramatic effect of his or her picture?

Creating

Volunteer to take turns acting as models for this series of drawings. In the first of these, the model should stand on a raised platform or table and assume an active pose (throwing, chopping, pulling, pushing). Complete a large drawing of the model lightly in pencil, concentrating on contours and the action noted in the model's pose.

Darken the room and direct a spotlight on the model, who continues in the same action pose. Use charcoal to shade in the dark areas.

Vary the pressure on the charcoal to obtain a range of dark and light values. Use the tip of the charcoal stick to indicate the most important contour lines of the figure.

Complete several other drawings of figures in action poses. When you gain skill and confidence, eliminate the preliminary pencil drawing and use charcoal exclusively. Select your best drawing for critiquing.

Figure 19.28 Student Work

Supplies
- Pencil
- Several sheets of white drawing paper, 18 x 24 inches (46 x 61 cm)
- Charcoal

CRITIQUING

- *Describe.* Is your drawing easily identified as a human figure? Does this figure completely fill the paper on which it is drawn?
- *Analyze.* Did you use charcoal to create areas of dark value? Did these contrast with other areas of light value? Does the use of these value contrasts show that the figure was illuminated by a spotlight?
- *Interpret.* Does your drawing succeed in showing a figure in action? Is this action easily identified? Do the contrasts of value in your drawing add to its dramatic impact?
- *Judge.* Do you think that your drawing is successful? Is its success based mainly on its literal qualities, design qualities, or expressive qualities? Compare the first drawing you did with the last. In what ways have your figure-drawing skills improved?

Review

Reviewing the Facts

SECTION ONE

1. What was the Counter-Reformation?
2. Do Baroque artworks suggest a sense of movement or stillness? How?
3. How did Caravaggio paint his figures to remind the viewer that they were not supernatural beings?
4. Which painting, Rubens's *The Raising of the Cross* or Raphael's *Alba Madonna*, forces the viewer to experience the scene? Why?

SECTION TWO

5. While artists in the Catholic countries were painting religious subjects, what were the Dutch Protestants painting?
6. Who painted *The Night Watch*?
7. What kind of subject matter did Vermeer generally paint?
8. Where has Vermeer placed the viewer in his painting *The Love Letter*?
9. How does Judith Leyster involve the viewer in her *Self-Portrait*?

SECTION THREE

10. For what purpose did Velázquez paint the two side figures who stare out at the viewer in his painting *Surrender of Breda*?
11. What freedoms were artists experiencing by the end of the seventeenth century?

Thinking Critically

1. **Compare and contrast.** Look at Bernini's sculpture of *David* (Figure 19.6, page 434). Then refer to Myron's copy of the Greek sculpture *The Discus Thrower* (Figure 8.18, page 176). What can you say about the similarities and differences between these two sculptures? Be sure to closely examine details such as the hair or facial expressions.

2. **Analyze.** Look closely at the lighting in Rembrandt's *The Night Watch* (Figure 19.13, page 441). Turn your book upside down and squint at the painting so everything except the light areas are blocked out. Trace along the light areas with your finger. Now turn the book right side up and, on a sheet of paper, draw a rectangle the same size as the illustration in the book. Then diagram where the light areas of the painting are located.

Using the Time Line

Find the year 1616 on the time line. Can you name two famous writers, one Spanish and the other English, who died in that year? Judith Leyster was eleven years old and Peter Paul Rubens was forty-three when the Pilgrims left Plymouth, England aboard the Mayflower. What was the year?

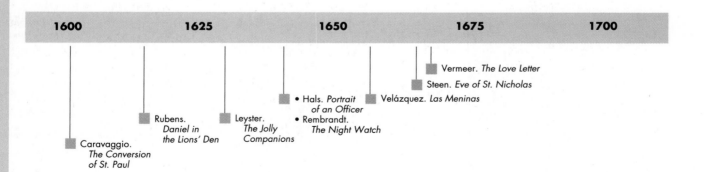

1600	1625	1650	1675	1700

Vermeer. *The Love Letter*

Steen. *Eve of St. Nicholas*

Velázquez. *Las Meninas*

• Hals. *Portrait of an Officer*

• Rembrandt. *The Night Watch*

Rubens. *Daniel in the Lions' Den*

Leyster. *The Jolly Companions*

Caravaggio. *The Conversion of St. Paul*

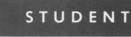

Camine White, Age 17
Buena High School
Sierra Vista, Arizona

Las Meninas by Diego Velázquez is the painting that inspired Camine's project. She decided to create a fantasy scene with some of the same qualities that draw the viewer into Velázquez's cavernous room. Her major goal was to create a feeling of depth and space. In addition, she wanted to present this scene from an angle.

Camine began by sketching the interior of a large room containing a platform. The steps on the sides of the raised area were angled to provide perspective. She included other architectural details to increase the depth of the room.

Camine chose to use colored pencils, which blend easily and give a broad range of color choices. She used markers to provide intensity. By using both, she achieved color that was easily controlled but alive and bold. In evaluating her work, Camine said she was happy with the quality of the color. She was less satisfied with the level of realism she achieved, feeling the details had a somewhat stylized look. Because her composition was complex and detailed, Camine said that it took patience and intense concentration to complete the work. Her advice to other students attempting a similar project is: "Take your time, but maintain your focus."

➤ Fantasy Scene. Colored pencils and markers. 40.6 x 55.9 cm (16 x 22").

457

In Search of Pleasure: Rococo Art

Objectives

After completing this chapter, you will be able to:

➤ Identify the differences between Baroque and Rococo art.

➤ Name the greatest Rococo painter and describe some of the features that characterize his work.

➤ Explain how the pictures of Jean-Baptiste Siméon Chardin differed from those of other French eighteenth-century painters.

➤ Identify the kind of paintings preferred in England and offer reasons to explain their popularity.

➤ Identify and describe the best-known work of Sir Christopher Wren.

Terms to Know

aristocracy
Rococo art
satire

Figure 20.1 Jean-Baptiste Siméon Chardin. *The Attentive Nurse* (detail). c. 1738. Oil on canvas. 46.2 x 37 cm (18⅛ x 14½"). National Gallery of Art, Washington, D.C. The Samuel H. Kress Collection.

The end of the seventeenth century witnessed the decline of

Dutch and Spanish naval power and political influence. This was matched

by a similar decline in the quality of the art produced in both countries. At

the same time, a new art style emerged to replace the Baroque. The drama and

movement that characterized the Baroque gave way to artworks marked by a new concern

for elegance and gaiety. This new style first appeared in France and was responsible

for elevating that country to a position of leadership in the art world. It was

destined to maintain that position for the next three centuries.

Courtly Beginnings and the French Aristocracy

On a pleasant evening in 1661, the young king of France, Louis XIV, attended a celebration in his honor at a great chateau owned by his minister of finance. The king viewed the fine home of his minister and grew jealous and suspicious. He decided, correctly, that the minister must be stealing from him in order to live in such luxury. Angered, he sent his minister to prison for life. Then he hired the minister's architects, artists, decorators, and gardeners to work for him on the greatest building project of the age.

➤ Louis XIV, known as the Sun King, gilded the ornamentation on the palace at Versailles to catch the sun's rays.

Figure 20.2 Louis Le Vau and Jules Hardouin-Mansart. Palace of Versailles, Versailles, France. 1669–85.

The Palace at Versailles

At Versailles, a short distance from Paris, the king's father had built a hunting lodge, and this became the site for the largest, most elegant palace in the world (Figure 20.2). It was to be the king's home as well as the capital of France. The royal family moved into it in 1682, but the palace continued to undergo changes. Louis and his followers were always making improvements and adding new decorations. Walls were torn down and new ones built; windows, balconies, and staircases were added; and paintings and sculptures were purchased. No cost was too great and no improvement or change was too small. The palace at Versailles would outshine all other palaces.

Within the palace, Louis was treated as if he were a god. He chose the sun as his emblem and was known as the Sun King. Fences, balconies, and even the roof of the palace were gilded to reflect the golden rays of the sun. In this luxurious setting, court life was a continuous pageant with the **aristocracy**, or *persons of high rank and privilege*, in constant attendance and the king always in the spotlight. To make sure that there was an audience for this display of power and wealth, people were free to enter and wander about the palace as long as they were properly dressed.

➤ The elaborate decorations, gilded and painted ceiling, and architectural detail in the Hall of Mirrors is typical of the palace interior.

Figure 20.3 Hall of Mirrors in the Palace at Versailles.

There they could stare at the artworks, the tapestries, and the mirrors (Figure 20.3). They could even watch the king and queen eat their spectacular meals. Every action of the king was made into a royal ceremony with strict rules. Thus, only high-ranking noblemen were allowed to dry the king after his bath or hand him his shirt during the dressing ceremony.

Versailles was considered to be an example of the Baroque style in France. However, in this elegant, aristocratic setting were also the seeds of a new style that was to see fruition at the beginning of the eighteenth century. This new style had its origins in the luxurious court of Louis XIV, but more truly reflected the character of the court of Louis XV, great-grandson of the Sun King. The style was marked by a free, graceful movement, a playful use of line, and bright colors. Sometimes referred to as Late Baroque, it differed enough from the Baroque that it deserved its own label. It received one when artists at the beginning of the next century irreverently called it *Rococo*.

Rococo art *placed emphasis on the carefree life of the aristocracy rather than on grand heroes or pious martyrs*. Love and romance were thought to be more fitting subjects for art than history and religion. At a time when poets were creating flowery phrases of love, painters were using delicate, pastel colors to express the same sentiment. Both showed a zest for describing a lighthearted world filled with people looking for pleasure and happiness.

Rococo comes from the French *rocaille*, meaning "pebble" or "rockwork" of the kind used to decorate artificial grottoes. The reason for the selection of this word to describe the ornamental, decorative art style of the eighteenth century is unknown. However, it is certain that when the word was first used toward the end of the century, it was meant to indicate disrespect for this style of art.

New Directions in French Painting

In painting, the dramatic action of the seventeenth century gave way to this new, carefree Rococo style. The constant movement of the Baroque lost its force in Rococo art, which favored greater control and elegance. Paintings made greater use of rich colors and curved, graceful patterns. This made them look more lighthearted and decorative. When seen in the palaces and chateaus for which they were intended, these paintings added a final touch of gaiety and elegance.

Antoine Watteau

The greatest of the Rococo painters was a Frenchman named Antoine Watteau (an-**twahn** wah-**toh**). Watteau began his career as an interior decorator and rose to become the court painter to King Louis XV. Although he painted religious works and portraits, Watteau is best known for pictures of characters or scenes from the theater as well as paintings showing the French aristocracy at play.

In *Embarkation for Cythera* (Figure 20.4), he combines both these themes in a work that demonstrates the elegance of the Rococo style. The subject of this painting comes from a play and shows a happy group of young aristocrats about to set sail from Cythera, the legendary island of romance. (For two hundred years this famous painting has been known by the wrong name! It has always been called "Embarkation for Cythera" but recent interpretations point out that it shows a departure *from* the mythical island of romance.)

The soft, dreamlike atmosphere, luxurious costumes, dainty figures, and silvery colors give the picture its unique feeling, or mood. Nothing is still, but nothing seems strained either. The figures move with graceful ease. Arranged like a garland, they curl over a small hill and down into a valley bordering the sea. A similar garland made of cupids playfully twists around the mast of the ship. In many ways, Watteau's figures look like fashion dolls—although the fashion may look odd to you. No doubt, you would look twice if you saw men wearing high-heeled shoes and carrying walking sticks today, but in the eighteenth century accessories of that kind were considered to be the height of fashion.

Embarkation for Cythera appears to be a happy scene, but it is tempered by a touch of sadness. One figure in particular seems to sum up this feeling. It is the woman in the center who casts one final backward glance as she reluctantly prepares to join her companions in boarding the boat. Along with her friends, she has spent a carefree day on the island paying homage to Venus, the goddess of love (whose flower-covered statue is seen at the far right of the picture). The day is now coming to a close. It is time to leave this world of make-believe and return to reality. The woman lingers for just a moment hoping to capture the scene in her memory, but her companion reminds her to hurry—the dream is ending.

Many of Watteau's works hint at the fleeting nature of happiness. Perhaps the sadness in his pictures reflects the sadness in his own life. Watteau was always in poor health, and four years after this painting was completed, he died. He was only thirty-seven years old.

➤ Describe the dress and manners of these people. Do you think they are poor, middle-class, or wealthy? Can you find many dark, heavy outlines, or do the colors and shapes seem to blend together? Does this look like a real or an imaginary setting? It is said that this was a happy occasion. Can you detect another mood in any of the members of the party? If you had to use a single word to describe the mood of this picture, what would it be?

Figure 20.4 Antoine Watteau. *Embarkation for Cythera.* 1717–19. 1.3 x 1.9 m (4'3" x 6' 4½"). The Louvre, Paris, France.

Art · PAST AND PRESENT ·

Rococo Art

An antique is a work of art, piece of furniture, or decorative object made during an earlier period. According to various U.S. customs laws, an object must be at least one hundred years old to be considered an antique. Such antiques are available through dealers, galleries, and even specialized antiques malls. Antiques dealers obtain their supplies from various sources including estate sales, auctions, private collectors, and other dealers.

The curved forms and elaborate ornamentation that characterize the rococo decorative accessories found at Versailles still appeal to people today. Buyers collect furnishings created during this period.

Pictured is a lighting fixture created during the 1700s. It is ormolu, a copper and zinc alloy. Part is patinated with gold; the angels have a patina of a darker material.

People collect antiques from almost every period in history. Antiques grow more and more popular with each year, which makes finding genuine antiques more and more difficult. Because supplies of genuine antiques are limited, some craftspeople create reproductions so that more people can own and enjoy period furniture and accessories. These objects may not be exact duplicates of genuine antiques; often, they are simply characteristic of the styles of earlier periods.

Figure 20.5 A Rococo Lamp

Jean-Honoré Fragonard

Ignoring the growing signs of unrest that led to the French Revolution, the upper class continued to devote their lives to pleasure. They liked to frolic in parklike gardens, gaze dreamily through telescopes, pamper their pets, play on elegant swings, or engage in idle gossip. All of these trivial pastimes are found in a painting by Jean-Honoré Fragonard (zjahn oh-no-**ray** frah-goh-**nahr**).

Fragonard, like Watteau, was a court painter. Until the revolution, he was also one of the most popular artists in France. He painted pictures about love and romance using glowing, pastel colors applied in a sure, brisk manner. These pictures also reveal that Fragonard was a master designer as well. In *The Swing* (Figure 20.6) he used axis lines and contour lines to tie the parts of his composition together. The arrangement of the figures, the ropes of the swing, the water from the lion fountains, even the position of the telescope form a series of parallel diagonal lines in the lower part of the picture. He tied the sky and the landscape together with repeated, rounded contours; the clouds at the right repeat the curved contours of the trees at the left.

The French Revolution brought a swift end to Fragonard's popularity despite the admiration and support of such painters as David. Near the end of his life he stopped painting entirely. At the time of his death in 1806 (he died of a stroke while eating ice cream), he was all but forgotten, and he died in poverty. Today his works are reminders of a bygone era and an outdated way of life. To the sensitive viewer, however, they still whisper softly of pleasant outings in the park, idle talk, and romance.

As soon as it was hung, the sign began to attract great crowds of people who marveled at the skill of the young artist.

As his work matured, it revealed that Chardin saw in the arrangement of simple objects the symbols of the common man. He painted still lifes (Figure 20.7) of humble, everyday items. Earthenware containers, copper kettles, vegetables, and meat were his subjects. Chardin took delight in showing slight changes of color, light, and texture. The way he painted these everyday objects made them seem important and worthy of close examination.

Toward the middle of his career, Chardin began to paint simple genre scenes. One such scene is *The Attentive Nurse* (Figure 20.8, page 464). There is a gentle, homespun quality in this work that is unforced and natural. His brush illuminates beauty hidden in the commonplace. Chardin shows you a quiet, orderly, and wholesome way of life. You are welcomed into a

> ➤ Identify the different activities found in this painting. What sort of people would have the opportunity to spend their days in this way? Note the rounded contours of the clouds — can you find the same rounded contours repeated elsewhere in this picture? Why do you think this was done? What adjectives would be appropriate to describe the colors here — bold, bright, dull, muted? How has Fragonard arranged the people and other objects in this painting to show distance? Do you think this is a successful work of art?

Figure 20.6 Jean-Honoré Fragonard. *The Swing.* c. 1765. Oil on canvas. 215.9 x 185.4 cm (85 x 73"). National Gallery of Art, Washington, D.C. The Samuel H. Kress Collection.

Jean-Baptiste Siméon Chardin

Not all artists in eighteenth-century France accepted the elegant court style of Watteau and Fragonard. Jean-Baptiste Siméon Chardin (zjahn-bahp-**teest** see-may-**ohn** shahr-**dahn**) disliked the delicately painted subjects of the court artists. He preferred subjects that were more in keeping with those painted by the Little Dutch Masters. His works showed peasants and the middle class going about their simple daily chores. He chose to show this rather than aristocrats engaged in frivolous pastimes.

Chardin's career as a painter began in an unusual way. Asked by a surgeon to paint a sign for his shop, Chardin decided not to paint the customary symbols for the profession—a shaving dish and a surgical knife. Instead, he painted a scene showing a wounded dualist being cared for by a surgeon on his doorstep.

> ➤ How did Chardin's work differ from the works of court artists such as Watteau and Fragonard? What was his purpose in painting these unimportant, common objects? Which aesthetician would consider this a successful work of art?

Figure 20.7 Jean-Baptiste Siméon Chardin. *Still Life with Rib of Beef.* 1739. Oil on canvas. 40.6 x 33.2 cm (16 x 13¹/₁₆"). Allen Memorial Art Museum, Oberlin College, Oberlin, Ohio. R. T. Miller, Jr. Fund, 1945.

comfortable household where a hardworking nurse is carefully preparing a meal. Light filters in softly to touch the figure and the table in the foreground. The rest of the room is partly hidden in the shadows. The light reveals the rich textures and creates the changes of value on cloth, bread, and kitchen utensils. The colors are silvery browns and warm golds, which add to the calmness, the poetry of this common domestic scene.

In his old age, Chardin gave up oil painting in favor of pastels because of his failing eyesight. Other reasons have been suggested for Chardin's decision to work in pastels. Some historians have indicated that he used pastels because they allowed him to work more quickly than did oil paints. Because pastels require less time and effort for preparation, Chardin may have found them more relaxing to work with. The best of these pastels included portraits of his wife. Weakened by illness, he died in 1779.

➤ Do you think this woman enjoys what she is doing? How can you tell? How do the dark and light values help to emphasize the main parts of this painting? Point to places where there is a contrast of value; a gradation of value.

Figure 20.8 Jean-Baptiste Siméon Chardin. *The Attentive Nurse.* c. 1738. Oil on canvas. 46.2 x 37 (18⅛ x 14½"). National Gallery of Art, Washington, D.C. Samuel H. Kress Collection.

SECTION ONE

Review

1. How did Louis XIV, known as the Sun King, make artworks available for the people of France to view and enjoy?
2. What subject did French Rococo artists consider most suitable for their paintings?
3. How did the style of Rococo art differ from that of Baroque art?
4. Who was considered the greatest of the French Rococo painters?
5. What two types of subject is Antoine Watteau best known for — portraits, religious scenes, characters and scenes from the theater, or pictures of the French aristocracy at play?
6. Not all eighteenth-century artists accepted the elegant court style of Watteau. Name one who did not.
7. Name the two subjects that most interested the painter Chardin.

Creative Activity

Humanities. King Louis XIV surrounded himself with splendor, commissioning architects to build long flights of stairs with cloud-filled ceilings for him to descend and employing many teams of musicians whose only responsibility was composing fanfares—short, pompous works to accompany every move he made. He rose to music, ate to music, hunted, danced, and worshiped to music. The king had twenty-four violinists in constant attendance.

One fanfare, "Rondeau" by J. J. Mouret, has taken on new significance today since it is the theme of PBS "Masterpiece Theatre." Listen to this theme and imagine the Sun King making his entrance.

Art in England and Spain

Artists in England and Spain responded in different ways to the elegant and decorative Rococo style that emerged in France. Most rejected the artificial subjects preferred by Watteau and Fragonard but adopted their delicate, light-washed painting techniques. In England, artists made use of this technique to paint portraits, scenes and events from daily life, and still lifes. As the century progressed, these paintings became more and more realistic. The century came to a close with a Spanish artist, Francisco Goya, who turned away completely from the Rococo style to paint pictures that drew their inspiration from a new source—his own personal thoughts and feelings.

The Art Movement in England

Up until this time, England could boast of only a few outstanding painters and sculptors. No doubt, the Protestant Reformation was partly to blame for this. Reformers were against religious images, and this had a crushing effect on art. However, with the return of the fun-loving Stuarts to the English throne, the visual arts gained in importance. Portrait painting in particular grew in popularity. Instead of making use of English artists, however, the wealthy invited foreign portrait painters such as Hans Holbein to England. This practice continued until around the middle of the eighteenth century. By then the talents of native English painters were finally being appreciated.

Sir Joshua Reynolds

Sir Joshua Reynolds (**ren**-uhldz) was one of a number of English artists who painted the fashionable portraits that the English nobility desired. Highly respected as an artist and a scholar, he was also a kindly man who was genuinely fond of children. No doubt this interest in children enabled him to capture on canvas their sensitive and fleeting expressions. This skill also helped make him one of the most popular artists of his time. His appealing portrait of the five-year-old daughter of the Duke of Hamilton (Figure 20.9) shows that he could make his young subjects seem completely natural and at ease.

➤ Point to the warm and cool colors used in this painting. Are the warm colors used in the foreground or in the background? Where are the cool colors used? When judging this picture, to which aesthetic qualities—literal, design, or expressive—did you refer most often?

Figure 20.9 Sir Joshua Reynolds. *Lady Elizabeth Hamilton.* 1758. Oil on canvas. 116.8 x 83.8 cm (46 x 33"). National Gallery of Art, Washington, D.C. Widener Collection.

Thomas Gainsborough

Reynolds's great rival was Thomas Gainsborough (**gainz**-burr-oh), who began his career by painting landscapes. Ultimately he became the favorite portrait painter of English high society. Gainsborough was admired for his delicate brushwork and rich, glistening pastel colors. His works showed the shining silks and buckles, fragile lace, and starched ruffles of fashionable clothing.

A professional rivalry with Reynolds resulted in one of Gainsborough's best-known paintings, *The Blue Boy.* In a lecture to the Royal Academy of Art, Reynolds had stated that blue, a cool color, should always be used in the background. He said it should never be used in the main part of a portrait. When Gainsborough heard this,

➤ How does the use of warm and cool colors here differ from the use of warm and cool colors in Reynolds's picture of Lady Elizabeth Hamilton?

Figure 20.10 Thomas Gainsborough. *The Blue Boy.* c. 1770. 177.8 x 121.9 cm (70 x 48"). The Huntington Library, San Marino, California.

he accepted it as a challenge and began planning a blue portrait. According to one account, he had a blue satin costume prepared and then set about finding someone to model it for the painting. The "someone" turned out to be a delivery boy whom Gainsborough met in his own kitchen. He quickly arranged to have the surprised youth pose for him and completed the painting (Figure 20.10). The finished portrait showed a princely looking boy dressed in a shimmering blue satin suit standing in front of a warm brown background. The work was an immediate success in the eyes of most viewers — although Reynolds never publicly admitted that Gainsborough had proved him wrong.

This story does not end here, however. Later, when Gainsborough was dying, Reynolds paid him a visit. What they said to one another is unknown. We do know that when Gainsborough died, Reynolds, with tears in his eyes, delivered another lecture to the Royal Academy, this time praising the rival who had challenged him.

William Hogarth

Other artists in England at this time refused to cater to the tastes of the aristocracy in the manner of Reynolds and Gainsborough. William Hogarth (**hoh-gahrth**) was one of these. Hogarth began his career as a commercial artist in London, a city that he must have enjoyed. In all his sixty-seven years, he left it only twice. He was more interested in painting the common people he found on London streets and in taverns than in painting portraits for wealthy patrons. Nothing gave him more pleasure than exposing the immoral conditions and foolish customs of his time. He used his art to tell a story, scene by scene, picture by picture, with great wit and attention to detail. His pictures were like stages decorated with lavish sets and filled with colorful performers from every level of society: lords, ladies, lawyers, merchants, beggars, thieves, and lunatics.

In a series of six paintings entitled *Marriage à la Mode*, Hogarth criticized the practice of arranged marriages. In the first of this series, *The Marriage Contract* (Figure 20.11), he introduces the main characters in his story. At the right, a nobleman with gout points proudly to the family tree to prove that his son is a worthy groom. He is speaking to a wealthy merchant seated across from him who is eager to have his daughter marry into a noble family. The merchant peers through his thick spectacles, studying the marriage agreement as if it were nothing more than a business contract. Meanwhile, the future bride and groom, their backs to each other, seem uninvolved and uninterested. A lawyer flirts with the young woman, while her bored fiancé prepares to take a pinch of snuff.

The other five pictures in this series show the progress of the marriage from this unfortunate start. It moves from boredom to unfaithfulness to death. Each scene is painted with the same brilliant, biting **satire**, *the use of sarcasm or ridicule to expose and denounce vice or folly*. The paintings demonstrate Hogarth's uncanny ability to remember and use what he saw in the world around him. The gestures and expressions that he uses were learned during long observations of the way real people behave in different situations. Interestingly, Hogarth was too impatient to carry a notebook or sketchpad, although he sometimes used his thumbnail as a tiny surface on which to sketch. In Hogarth's case, nothing else was necessary.

Hogarth was a small man, slightly over five feet (1.5 m) tall, although this did not prevent him from being stylish. As soon as he could afford one, he bought a sword and wore it at all times. He was proud and cocky and never hesitated to voice his opinion on any subject. The quality of his art and his great wit, however, won him the admiration of many intellectuals and the affection of the English public.

While it took English painters a long time to gain acceptance in their native country, this was not the case with architects. In fact, many of the most impressive buildings in London are due to the efforts of a single English architect: Sir Christopher Wren.

Sir Christopher Wren

At 1:00 A.M. on September 2, 1666, a fire broke out in a baker's shop on Pudding Lane in the sprawling city of London. The blaze spread quickly from building to building and raged for four days. Before it could be brought under control, it had destroyed eighty-nine churches, the city gates, a large number of public buildings, and some fourteen thousand houses. For years after this fire, Sir Christopher Wren was responsible for designing churches and other buildings to replace those that had been destroyed. St. Paul's Cathedral and fifty-one parish churches were built according to his designs. As if this were not enough, he also played an active role in supervising the construction of each. He routinely walked from one building

site to the next, jotting down notes as he went along. Because Wren assumed the entire responsibility for each construction, he felt free to make changes, and make changes he did. Workers would rarely know what to expect from one day to the next. Each day he would present them with rough plans that were often sketched on the spot. If he did not like the results, even if they were done according to his plans, he would order the work torn down and rebuilt according to a new design.

It was not easy to design churches to fit comfortably within specified areas. Many of these areas were small and awkward, yet Wren was able to design churches that were ideally suited for their settings. Often, he used a tall, slender steeple to crown these churches. Soaring proudly above surrounding buildings that threatened to hide the church, this steeple became an inspiration for later architects in England and America.

The best known of Wren's work is St. Paul's Cathedral. Before the fire, he had been hired to restore the old cathedral, which had been built late in the eleventh century. The fire, however, destroyed the building, and Wren was asked to design a new cathedral instead. Like most of his other buildings, St. Paul's was constantly changed as it was being built.

The facade of St. Paul's is marked by a pattern of light and dark values. This pattern is created by the use of deep porches at two levels. Each porch is

➤ From your reading, can you identify the main characters in this drama? What clues can you find to suggest that the marriage being planned will not be a happy one?

Figure 20.11 William Hogarth. *Scene I from Marriage à la Mode, The Marriage Contract.* 1744. Oil on canvas. The National Gallery, London, England.

➤ What characteristics does this cathedral have in common with classical structures?

Figure 20.12 Sir Christopher Wren. St. Paul's Cathedral, London, England. 1675–1710.

supported by huge columns arranged in pairs. The top porch is narrower than the one below and draws your eye upward to the tympanum and the great dome above. Two towers flank the façade and frame the dome (Figure 20.12).

One of the most impressive features of St. Paul's is its overall unity. All of the parts are joined together to form a symmetrically balanced whole that is a striking reminder of classical structures like the Parthenon (Figure 8.3, page 164). Much of this unity is no doubt due to the fact that this building is the only major cathedral in Europe to be erected under the watchful eye of a single architect. Other cathedrals required a century or more to build and incorporated the varied ideas of a succession of architects. However, when the final stone was laid in place on St. Paul's, its only architect, Sir Christopher Wren, was on hand to make certain that it was done according to his design.

The London skyline is Wren's legacy — and his monument. The Latin inscription on his tomb calls attention to this skyline with a simple but appropriate statement that reads in part: "If ye seek my monument, look around." Only when you do can you fully appreciate this great architect's remarkable imagination, skill, and energy.

Spanish Rococo Art

This discussion of eighteenth-century art ends in Spain with the work of Francisco Goya (frahn-**seese**-koh **goh**-yah), an artist who eventually rejected the past and looked to the future.

Francisco Goya

Early in his career, Goya adopted the Rococo style to gain considerable fame and fortune. Eventually appointed court painter to King Charles IV, he was kept busy painting portraits of the royal family and the aristocracy using the same soft, pastel colors favored by Watteau and Fragonard. However, this happy and successful period in his life was destined to be short-lived. In 1792 he became seriously ill, and two years later he suffered a grave accident. (What this accident was has never been fully explained.) Goya's hearing was affected, and within a short time he was totally and permanently deaf.

The Duchess of Alba

Not long after these physical setbacks, Goya met and was completely captivated by the most celebrated woman of the day, the thirteenth Duchess of Alba. While under her spell, Goya painted a portrait of the duchess pointing confidently to the artist's name scrawled in the sand at her feet (Figure 20.13). Indeed Goya was, for a short time, at the feet of this remarkable, haughty, and independent noblewoman. In addition to being one of the wealthiest people in Spain, she was also one of the most controversial. Married at age eleven to the fabulously wealthy Marquis of Villafranca, she had thirty names to her full title, thirty-one separate palaces, mansions, and estates, insulted the Queen of Spain repeatedly, and was involved in so many scandals that she was the subject of gossip throughout Europe.

At the time Goya painted her, the duchess was in exile from Madrid for having once again embarrassed her queen, Maria Luisa. She had announced a great ball in honor of the queen and then sent spies to Paris to learn what kind of gown the queen was planning to wear. When the queen arrived at the Alba palace, prepared to make a grand entrance, she was greeted by a score of servant girls — each wearing the same gown as the queen!

In Goya's portrait, the duchess gazes directly at the viewer with large eyes under black eyebrows. She wears two rings on the fingers of her right hand. These

bear the names Goya and Alba and, like the inscription in the sand, are meant to illustrate the union of artist and model. However, the fickle duchess soon turned her attention elsewhere, and the bitter artist painted over the word *solo,* or *only*, placed before his name in the sand. However, the disillusioned Goya was never able to forget the duchess. Before he died in 1828, he turned over all his belongings to his son. Out of the hundreds of pictures he painted, he kept only two. His portrait of the Duchess of Alba was one of these.

Perhaps you are wondering what became of the duchess after she and Goya separated. Following her return to Madrid, and after continued insults directed at the queen, she fell ill and died. Her death was so sudden that many thought she may have been poisoned. In her will, the duchess left her fortune to her servants. However, the queen managed to have her declared insane and the will was declared illegal. The properties and possessions of the duchess were confiscated and, in time, the queen was seen proudly wearing the Alba jewels.

➤ What does this portrait tell you about the duchess? Describe the expression on her face. Do you think you would find it interesting to know this woman? Why or why not?

Figure 20.13 Francisco Goya. *The Duchess of Alba.* 1797. Oil on canvas. 210.2 x 149.2 cm (82¾ X 58¾"). Courtesy of The Hispanic Society of America, New York, New York.

Goya, the Rebel

Goya was satisfied to be a fashionable society painter until he reached middle age. Then, following his illness and after witnessing the brutality and suffering caused by war, his art changed and he became Goya the Rebel.

He was in Madrid when the French invaded Spain. One of his most memorable paintings commemorates an uprising of the people of Madrid after the French had occupied the city (Figure 20.14). On May 2, 1808, people had gathered in anger before the royal palace. They had heard that the children of the king were to be taken to France. A fight broke out, and Spanish civilians and French soldiers were killed. That night and the next morning, French troops executed the Spanish patriots they had taken prisoner. It was a tragic scene that Goya may have witnessed personally from his balcony.

Goya's view of this grim event shows the patriots, including a clergyman, lined up and about to be shot. The morning sky is almost black, and a lantern placed on the ground lights the scene. In the glare of this lantern, you see the wild gestures of the helpless victims, in contrast to the cool efficiency of the French troops. The soldiers lean forward, pointing their rifles like lances, their faces hidden from view, but their

➤ Notice how the figures are arranged in this picture. Which is the most important figure in this composition? How has that figure been made to stand out? Repeated shapes and axis lines have been used to create a sense of movement. What is the direction of that movement? What feeling or emotions do you receive from this picture?

Figure 20.14 Francisco Goya. *The Third of May, 1808.* 1814. Oil on canvas. Approx. 2.64 x 3.43 m (8'8" x 11'3"). The Prado, Madrid, Spain.

Sue Coe

Artist Sue Coe (b. 1951) is perhaps the only prominent social-protest artist to have taken animals as her main subject. Her dark drawings and paintings expose the grim side of the industrialized meat-processing industry and the numbed human sensibility that is both its cause and its consequence.

In adopting this difficult subject matter, Coe is often said to be a direct descendant of Goya, who also exposed brutality that was otherwise ignored. Just as Goya's paintings and prints forced viewers to see war stripped of chivalry and glory, Coe's art shows that animals raised and slaughtered for human consumption do not lead a storybook farmyard existence.

Coe was born into a working-class family in Tamworth, England. Her family did not encourage her to become an artist. She worked on an assembly line packing candy bars when she was fifteen and expected to become a typist and marry. Although she loved to draw, Coe didn't see how art could be her future until she learned she could go to art school on a scholarship. By the time she graduated, Coe had developed a strong sense of the moral dimensions of art and was committed to producing art that would help to promote a more humane world. When asked about the role of art in political and moral issues, Coe quotes the medieval poet Dante:

"The hottest places in hell are reserved for those who, in times of great moral crisis, maintain their neutrality."

Coe's paintings of the meat industry require careful and sometimes difficult research. She has visited some fifteen slaughterhouses in order to document the procedures used by the meat-processing industry. Coe, who has worked in New York since 1972, states that her first impulse is to rescue the animals she sees. She also grieves for the workers, many of whom have told her that they feel sorry for the animals they have to kill.

It is Coe's hope that her art will awaken viewers to the plight of animals. She does not, however, feel that shock tactics are the best way to convey her message: "I want the work to be intimate and humble. . . . I don't use gallons of blood in this work and don't want it to scream — it's more a weeping. I want the work to be rooted in grief rather than rage."

Despite the unpleasant nature of Coe's research, she remains upbeat and describes herself as an optimist. She states, "If I wasn't an optimist, I'd deny [animal suffering] existed, because I wouldn't think it could be changed. But I think it will change — it is changing."

In the past two decades, a number of improvements have taken place in methods used by the meat-processing industry. Perhaps these changes have been due, in part, to the concerned efforts of artists and others such as Sue Coe.

Figure 20.15 *Last Bit of Daylight. Porkopolis #6.* 1988. Graphite on paper. 37.5 x 45 cm (14¾ x 17¾"). Courtesy of Galerie St. Etienne, New York, New York.

faces are unimportant here. They are like robots—cold, unfeeling, unthinking. The wedge of light from the lantern reveals the different reactions of the men facing death. The central target is a figure in white with his arms raised. His pose suggests an earlier sacrifice—Christ on the cross. To his right, a monk seeks refuge in prayer. Others exhibit less courage. One stares blindly upward, avoiding as best he can the rifle barrels pointed at him. Another holds his ears so he will not hear the crack of the rifles. A third buries his face in his hands.

Goya's painting does not echo the traditional view of war. Unlike his countryman Velázquez (Figure 19.22, page 449), he placed no importance on chivalry and honor or bravery and glory. To him, war meant only death and destruction, and he used his art to pass his feelings on to others.

Goya — His Later Years

As he grew older, Goya became even more bitter and disillusioned. Increasingly he turned away from the subject matter found in the real world because it could not be used to communicate his thoughts and feelings. Instead, he began to rely on his dreams and visions for subject matter. The drawings, paintings, and etchings he produced were unlike anything that

➤ On what is this figure sitting? What does this tell you about his size? Point to places where there are contrasts in value; gradations in value. Do you find anything frightening about this figure? Whom or what do you think he represents?

Figure 20.16 Francisco Goya. *The Giant.* c. 1810–18. Aquatint, first state. 28.5 x 21 cm (11¼ x 8¼"). The Metropolitan Museum of Art, New York, New York. Harris Brisbane Dick Fund, 1935.

had been created before. For the first time, an artist reached deep into his own mind for inspiration. By doing this, Goya made it difficult for others to understand exactly what he was trying to say. He also challenged them, however, to use their imaginations to arrive at their own interpretations of his work.

One of Goya's most unforgettable prints shows a giant sitting on the edge of the world (Figure 20.16). A small landscape in the foreground is dwarfed by the towering presence of this giant. Who is he and what is he looking up at? Could this be Goya's vision of war—a giant who could, with one swipe of his mighty hand, cause widespread destruction and suffering? He glances up as if something has just disturbed him. If so, what does this hold in store for the unsuspecting world resting peacefully in the moonlight?

Breaking with Tradition

The eighteenth century began with artists creating works that stressed the lighthearted and fanciful. Artists like Watteau and Fragonard painted the beauty, wealth, and gaiety of court life. A more middle-class view of life was provided by the works of Chardin and Hogarth. Goya's works ranged from the courtly Rococo style to the more realistic and finally to the realm of his imagination. By using his own visions and dreams as the inspiration for his art, Goya opened the door for others to follow. From that point on, artists no longer felt bound by tradition. Like Goya, they could rely on their own personal visions to move in any direction they wished. For this reason, Goya is regarded as the bridge between the art of the past and the art of the present.

SECTION TWO

Review

1. What kind of painting grew in popularity in eighteenth-century England? What contributed to its popularity?
2. Which artist ultimately became the favorite portrait painter of English high society? Why?
3. Why did Sir Joshua Reynolds say blue should never be used in the main part of a portrait?
4. How did Thomas Gainsborough prove Sir Joshua Reynolds wrong with regard to the use of blue in portraiture?
5. Name an English artist who was not interested in catering to the tastes of the aristocrats. Tell what he preferred to paint and how he got his message to the viewer.
6. For which type of work is Sir Christopher Wren best known? Name the best-known example of his work.
7. Does Francisco Goya's painting *The Third of May, 1808* echo the traditional view of war? If not, how does it reflect the artist's personal view of war?

Creative Activity

Humanities. The novel had its beginnings in England at this time. Henry Fielding's *Tom Jones*, published in 1740, might be considered the first full-length novel. Its hero, Tom, is a foundling whose escapades have him in and out of trouble. Fielding gave new direction to writing by moving away from epic themes and medieval romances to stories about ordinary people.

Ann Radcliffe (1764–1823) wrote what we now call *gothic* novels—stories that arouse terror and curiosity with seemingly supernatural events that are later found to have natural explanations. Novels became enormously popular in England in the mid-1700s with the invention of the public library. Women, who could not go about alone, were allowed to go to libraries. They became voracious readers.

Read some of these early literary works. Look for similarities and differences between attitudes of the eighteenth century and of today.

STILL-LIFE CHALK DRAWING

Supplies
- Poster board, cardboard, or heavy paper, about 6 x 6 inches (15 x 15 cm)
- Neutral-tone construction paper, 18 x 24 inches (46 x 61 cm)
- Scissors, ruler
- White chalk, colored chalk (pastels)

CRITIQUING

- **Describe.** Are the still-life objects in your drawing easily recognized even if they are not shown completely?
- **Analyze.** Did you use gradations of value to emphasize the three-dimensional forms of still-life objects? Does your drawing show at least three different examples of simulated texture?
- **Interpret.** Do you feel that your picture provides an interesting close-up view of the still life?
- **Judge.** Would an art critic favoring the theory of imitationalism be pleased with your drawing? What feature of your drawing do you think such a critic would appreciate most?

Using colored chalk, complete a drawing showing a close-up view of a selected portion of a still-life composition. This drawing should include gradations of value to emphasize three-dimensional forms. It should also contain at least three different examples of simulated texture.

Focusing

Compare the Rococo painting style of Watteau (Figure 20.4, page 461) with the style of Chardin (Figure 20.7, page 463). How do these styles differ? Which artist's works do you think would be most appreciated by an art critic favoring the theory of imitationalism? What has that artist done to make his works look so lifelike?

Creating

Working with other members of your class, set up a still-life arrangement. Include a variety of common, everyday objects brought to class for this purpose.

Make a simple "viewfinder" by cutting a piece of poster board, cardboard, or paper into two L shapes, as shown.

By manipulating the viewfinder, you will be able to alter the views of the still-life arrangement. You may find that a close-up view of a small portion of the still life is more appealing than a view that includes all of the objects.

Using a large sheet of neutral-tone construction paper and white chalk, draw the view that you find most pleasing when looking through the viewfinder.

Complete your drawing using colored chalk. First apply base colors; then change the values by blending in white and dark chalk where needed. Add textures and the darkest shading last. Exhibit your drawing in class along with those made by other students.

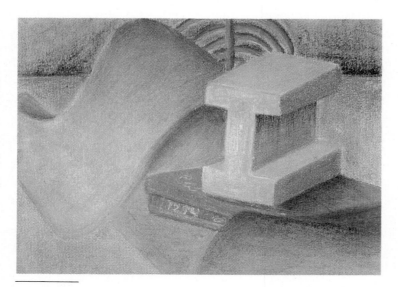

Figure 20.17 Student Work

EXPRESSIVE SELF-PORTRAIT COLLAGE

Create a self-portrait that expresses characteristics of your own unique personality rather than one that offers an accurate picture of what you look like. Cut pictures, phrases, and words that say something about you from magazines and newspapers. Assemble these as a collage, illustrating your "real inner self."

Focusing

Examine Goya's etching of *The Giant* in Figure 20.16, page 472. How does a picture like this differ from other pictures of people, such as those created by Reynolds (Figure 20.9, page 465) or Gainsborough (Figure 20.10, page 466)?

Creating

Look through magazines and newspapers for pictures, phrases, and words that say something about yourself—your hopes, aspirations, and feelings. Tear these out and set them aside.

Make several sketches showing the general outline of your face viewed from the front or in profile. Redraw the best of these lightly on the construction paper or mat board.

Cut the magazine and newspaper items into various shapes and assemble these within and around your face drawing. If you prefer, you can draw certain parts of your portrait. However, do not draw the entire face. Exhibit your self-portrait along with those created by other students. Can you determine which student created which portrait? Were other students able to correctly identify your self-portrait?

Figure 20.18 Student Work

Supplies
- Pencil and sketch paper
- Magazines and newspapers
- Colored construction paper or mat board, 12 x 18 inches (30 x 46 cm)
- Scissors and white glue

CRITIQUING

- **Describe.** Do you think that viewers can readily identify your collage as a portrait? Are the different features of this portrait clearly evident?
- **Analyze.** Would you describe the arrangement of colors, lines, shapes, and textures in your portrait harmonious or varied? Did you do this intentionally? If so, why?
- **Interpret.** Does your self-portrait present an accurate picture of what you are like inside? Do you think others can read the clues you have provided to learn more about your thoughts and feelings?
- **Judge.** A critic known to favor the expressive qualities is asked to judge your self-portrait. How do you think this critic will respond to your work? Do you think a critic favoring the theory of imitationalism would be impressed with your effort? Why or why not?

Review

Reviewing the Facts

SECTION ONE

1. Explain why Louis XIV was called the Sun King.
2. Did Rococo art place a greater emphasis on religious subjects or scenes from the life of the aristocracy? Why?
3. Describe how Watteau's *Embarkation for Cythera* typifies Rococo art.
4. What subject matter did Fragonard paint? Give one example.
5. Tell how Chardin's career began.

SECTION TWO

6. What artist was known to paint scenes that exposed the foolish customs of the time?
7. What event occurred that gave the English architect, Sir Christopher Wren, the opportunity to design over fifty churches in London?
8. What features cause the light and dark pattern on the façade of St. Paul's Cathedral?
9. How does Goya identify the main character in his painting *The Third of May, 1808*?
10. Why is Goya regarded as the bridge between the art of the past and the art of the present?

Thinking Critically

1. **Extend.** Imagine a film that includes Watteau's *Embarkation for Cythera* (Figure 20.4, page 461) as an important scene in the narrative. On a piece of paper, outline an appropriate plot for this film. Indicate when Watteau's scene would occur and explain why it is such an important scene. Also, identify what you feel would be suitable background music for this particular scene. Finally, give your film a title. Share your ideas with other members of the class.

2. **Analyze.** Refer to Chardin's painting *The Attentive Nurse* (Figure 20.8, page 464). Describe how the art elements, color, value, line, texture, shape, form, and space are used in the painting. Which elements are emphasized? Which are less important to the artist?

3. **Evaluate.** Refer to Goya's print *The Giant* (Figure 20.16, page 472). Evaluate the work from the perspective of each of the theories of art: imitationalism, formalism, and emotionalism. Then do the same for Goya's earlier work, *The Duchess of Alba* (Figure 20.13, page 469). What aesthetic qualities did Goya become more interested in later in his life?

Using the Time Line

Refer to the time line and determine the year that Sir Joshua Reynolds painted his portrait of Lady Elizabeth Hamilton. Six years earlier, a demonstration took place in the American colonies proving that lightning was electricity. Can you describe this demonstration and the man who conducted it?

1700	1725	1750	1775	1800

Chardin. *The Attentive Nurse*

Watteau. *Embarkation for Cythera*

Gainsborough. *The Blue Boy*

Fragonard. *The Swing*

Reynolds. *Lady Elizabeth Hamilton*

Jason Jones, Age 18
Northwestern Senior High School
Miami, Florida

Jason was impressed by Francisco Goya's shift from society painter to Goya the Rebel—a man deeply concerned about human suffering. He selected a topic that is affecting a large segment of retired Americans: how to live on Social Security income. He wanted to convey the frustration felt by older people who have to survive on a fixed income and to live with the fear that it might diminish or cease altogether.

Jason used his sketchbook to collect images and ideas for his painting. His next step was to rough in an old man frustrated with his financial standing. He used acrylics, layering his painting until he was satisfied that he had reached a point where the color was balanced. His primary concern, however, was to convey the message and to evoke feelings in those who see his art.

➤ *Social Security.* Acrylics. 71 x 52 cm (28 x 20½").

Art of a Changing Era

Newspaper Boy Page 510
1869

The Horse Fair Page 495
1853–55

1750	1800	1850

NEW STYLES IN NINETEENTH-CENTURY ART

ART OF THE LATER

Backyards, Greenwich Village
Page 548
1914

Solomon R. Guggenheim Museum (interior)
Page 576
1943–59

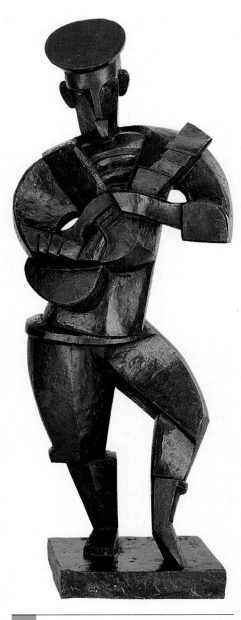

Sailor with Guitar
Page 572
1914

1900
1950
2000

NINETEENTH CENTURY

ART OF THE EARLY TWENTIETH CENTURY

ART TO THE PRESENT

Era of Change:
New Styles in Nineteenth-Century Art

Objectives

After completing this chapter, you will be able to:

➤ Explain how the growth of academies in France and England changed the way artists were taught.

➤ Describe the Neoclassic style and name two artists who practiced it.

➤ Define Realism and identify some artists associated with this style of painting.

➤ Identify the objectives of the Impressionists and describe the painting technique they developed to achieve those objectives.

➤ Name two famous women artists associated with the Impressionist movement.

Terms to Know

academies
candid
Impressionism
Neoclassicism
propaganda
Realism
Romanticism
Salons

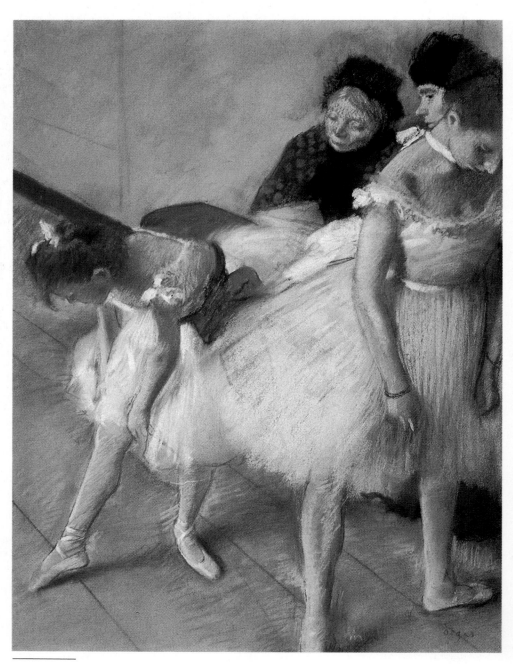

Figure 21.1 Edgar Degas. *The Dance Examination*. c. 1880. Pastel on paper. 63.4 x 48.2 cm (25 x 19"). Denver Art Museum, Denver, Colorado.

The growth of academies, or art schools, in France and England

during the seventeenth and eighteenth centuries changed the way artists were taught. No

longer were they apprenticed to established masters to learn their craft. Instead, art was taught

in schools the same way as other school subjects were taught.

Neoclassicism: Looking to the Past

The *art schools*, called **academies**, urged their students to study the famous works of the past as the best way of developing their own skills. The emphasis on the greatness of the past was not limited to the academies. The people who bought paintings also showed a preference for artworks produced by the great masters. Thus, when a wealthy French merchant decided to buy a painting for his new country home, he preferred a work by one of the old masters rather than one done by a living artist. Of course, this presented a problem for contemporary artists seeking buyers for their works.

In an effort to correct this problem, the Royal Academies in Paris and London began to hold yearly exhibitions. These *exhibitions of art created by Academy members were called* **Salons**. They became important social events and aroused great interest and even controversy. Reputations were made and destroyed during these annual events. For this reason, artists worked long and hard on the works they submitted. However, the artists who won honors at these exhibitions were not always the most gifted. Those who best reflected the tastes of the academies were acclaimed while others were ignored or ridiculed.

Neoclassic Artists

In France, the Academy endorsed a new style of art based on the art of Greece and Rome. This style had been born late in the eighteenth century. When the buried ruins of Pompeii and Herculaneum were found in the 1730s and 1740s, the world gained renewed interest in the Classical period and art forms. This

interest was true of artists as well. They studied and copied classical sculptures. Their aim was to learn to draw and, in time, equal what legendary ancient artists had done. These French artists rejected the earlier Baroque and Rococo styles. Instead, they used classical forms to express their ideas on courage, sacrifice, and love of country. Their new art style, known as **Neoclassicism**, *sought to revive the ideals of ancient Greek and Roman art, and was characterized by balanced compositions, flowing contour lines, and noble gestures and expressions.* One of the first artists to work in this style was the painter Jacques Louis David (zjahk loo-**ee** dah-**veed**).

Jacques Louis David

David's involvement in politics, his love of ancient art, and his skill as a painter are all apparent in his picture of *The Death of Marat* (Figure 21.2, page 482).

The Death of Marat. David admired the noble simplicity and calm beauty of Greek art and tried to achieve the same qualities in this tribute to Jean Paul Marat, one of the major figures of the French Revolution. Marat suffered from a skin ailment that required him to spend time each day in a medicinal bath. Not a man to waste time, he placed a board across the tub and covered it with a cloth to serve as a desk. David had a fresh image to draw upon when he painted this picture, because he had seen Marat in his bath the day before his death.

On the day of Marat's assassination, a young woman was allowed into the room with a petition. While Marat was reading it, she stabbed him. David shows Marat still holding his pen in one hand and the petition in the other.

This painting often produces an emotional shock in the viewer seeing it for the first time. You see the dead figure of the political leader slumped over the side of his bathtub. The murder weapon still lies on the floor where it was dropped by the assassin. The clear, cool lighting illuminates a room that is almost bare. A simple wooden box and a plain green cloth are placed before a rough, greenish brown wall. The textured

wall contrasts with the smooth skin of the dead politician. Marat, wearing a white turban, leans back against a white cloth that lines the tub. His color is cool except for the red around the small wound. As you can see, color has been used sparingly.

David's study of Greek and Roman sculptures taught him how to paint a figure so that it looks realistic and noble. He learned how to avoid details that could interfere with a simple, direct statement. Like the *Dying Gaul* (Figure 8.24, page 181), David's picture was meant to stir your emotions. He wants you to become involved in the drama, to share the pain and anger he felt at the "martyrdom" of Marat.

But David's work gives you only one side of the story. It fails to tell you that Marat's fanatical support of violence and terror during the Revolution led to his own violent end. You may have seen a picture or photo that was designed to influence your opinion about something. *Information or ideas purposely spread to promote or injure a cause* is called **propaganda**. David's painting is a fine work of art, but it is also a form of propaganda because he was trying to influence public opinion about Marat.

Napoleon in His Study. Later under Napoleon, David became the court painter. The emperor and the artist were well suited to each other because Napoleon recognized the value of propaganda, and David had already proved that he knew how to produce it. In a portrait of Napoleon (Figure 21.3), David presents the emperor standing by a desk covered with impor-

➤ What do you see in this work? Would you describe it as complex and exciting, or simple and calm? Point to an area of smooth texture. Now find an area with a contrasting rough texture. What has happened to this man? What does the knife on the floor suggest? Does this picture look lifelike? If so, how has this been achieved? What idea or mood does it communicate to you?

Figure 21.2 Jacques Louis David. *The Death of Marat.* 1793. Oil on canvas. Approx. 1.6 x 1.24 m (5'3" x 4'1"). Musées Royaux des Beaux-Arts de Belgique, Brussels.

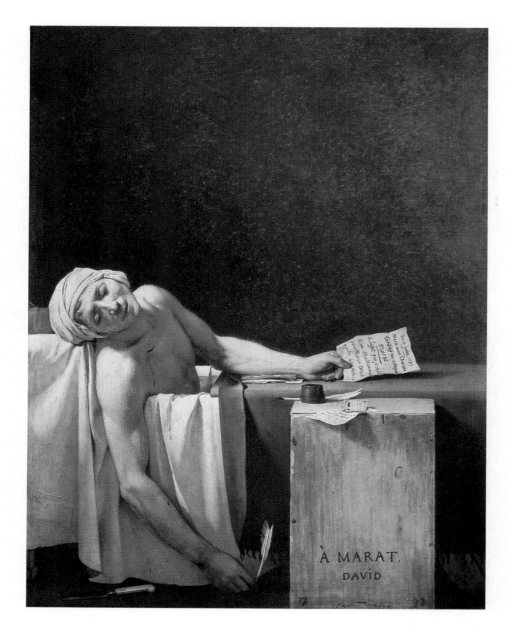

tant papers of state. The clock tells you that it is after four o'clock, and the candle tells you that it is nighttime rather than afternoon. The message here is clear. While his subjects sleep peacefully, the emperor toils far into the night for their well-being.

Élisabeth Vigée-Lebrun

David chose to stay in France and take an active part in the Revolution. However, another artist, Élisabeth Vigée-Lebrun (ay-**lee**-zah-bet vee-**zhay** luh-**bruhn**), left France and did not come back until peace was restored. Vigée-Lebrun is one of history's most

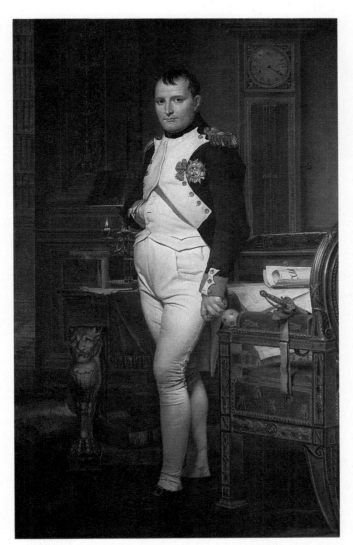

➤ Describe everything you see in this room. What time of day is it? How do you know it is nighttime rather than daytime? What makes this man look important? Using the clues presented, what do you think he has been doing?

Figure 21.3 Jacques Louis David. *Napoleon in His Study.* 1812. Oil on canvas. 203.9 x 125.1 cm (80¼ x 49¼"). National Gallery of Art, Washington, D.C. The Samuel H. Kress Collection.

celebrated women artists. Her life story would, in fact, have made a fine film. Before she was twenty, she had studied in a convent and had received private art lessons. She had also painted portraits of important members of the French aristocracy. By the age of twenty-five, she was employed by Queen Marie-Antoinette. Vigée-Lebrun's wit, beauty, and talent made her a favorite of the queen, whose portrait she painted some twenty times.

On the night the king and queen were arrested, Vigée-Lebrun escaped from Paris. While the Revolution interrupted her career in France, it did not keep her from working. She was able to continue painting with equal success in other capitals of Europe. Everywhere she was warmly received and flooded with requests. Many of the leading social figures asked that she paint their portraits. By the age of thirty-five, Vigée-Lebrun estimated that she had earned over a million francs from her painting. This was a huge sum for any artist. Unfortunately, she needed every bit of it to pay her husband's debts. Jean-Baptiste Lebrun liked nothing better than to visit houses of chance, and he usually emerged a loser.

Vigée-Lebrun's portraits frequently were extremely flattering to the sitter. Especially in her self-portraits (see Figure 5.13, page 109), Vigée-Lebrun tended to be quite generous. To all of her sitters, the artist gave large, expressive eyes and played down realistic—and unique—details of the face.

Madame de la Châtre. Madame de la Châtre was just twenty-seven years old when she had her portrait painted by Vigée-Lebrun (Figure 21.4, page 484). As in most of her portraits, the artist selected a pose that was simple and direct. Madame de la Châtre glances up from an open book and turns slightly to face in your direction. However, she takes little notice of you. Instead, there is a faraway look in her eyes, and it seems as though her thoughts still linger on the words she has been reading. Notice how the artist has made use of repeating contour lines to achieve harmony in this picture. The sweeping contour of the woman's hat is repeated by the curve of the sofa back, and the angle of the forearm is duplicated by the edge of the pillow. The diagonal of the upper arm is found again in the deep crease of the skirt. The color scheme is subdued by the extensive use of dark gray for the background and of a dull white for the dress. Needed contrast is provided by the green velvet sofa, the blue gray sash and hat ribbon, and the gold trim on the pillow.

Vigée-Lebrun outlived her husband and children by twenty-two years. When she died, her will specified

➤ The France of Vigée-Lebrun's time differed from the France of Watteau's time. How did Vigée-Lebrun's actions concerning the revolution in France differ from those of David? Who was Vigée-Lebrun's most famous patron? What happened to that patron?

Figure 21.4 Élisabeth Vigée-Lebrun. *Madame de la Châtre.* 1789. Oil on canvas. 114.3 x 87.6 cm (45 x 34½"). The Metropolitan Museum of Art, New York, New York. Gift of Jessie Woolworth Donahue, 1954.

that a relief sculpture of a palette and brush be carved on her gravestone. It is certainly a fitting reminder of a painter who left behind eight hundred paintings.

Jean-Auguste-Dominique Ingres

By the start of the nineteenth century, the art of Europe was influenced by France, and the art of France was influenced by the Academy. The Academy itself was influenced by Neoclassic artists who followed David. The Neoclassic style was carried to its highest point by Jean-Auguste-Dominique Ingres (zjahn oh-**gust** doh-min-**eek ahn**-gr). He was the best known of David's students. In 1801, Ingres won the coveted *Prix de Rome* (Rome Prize). It was a prize given by the Academy and allowed him to study in Rome for three years. However, he stayed in Italy for eighteen years. When he finally returned to Paris, the Neoclassic movement was without a leader.

David was by then an old man living out his final years in Brussels. Ingres brought with him a large religious painting he had been commissioned to paint for a cathedral in southern France. He was not sure how this work would be received since the Academy had criticized many of his earlier works. He need not have worried; the painting, which borrowed heavily from Raphael's pictures of the Madonna and Child, was a great success. In fact, it was so successful that it made Ingres the leader of the Neoclassic movement in France.

Carlo Maria Mariani

The Italian artist Carlo Maria Mariani (b. 1931) has always felt drawn to the last decade of the eighteenth century and the early years of the nineteenth. Although he is fascinated by the history and politics of that era, it is Neoclassical art and the Golden Age of Greece that most attracts Mariani. Canova and Ingres are among the artists whose work has inspired him.

Many viewers are puzzled by Mariani's affection for the Neoclassical period. The artist explains that "it was a time more than any other when certain qualities, certain virtues — aesthetic sense, beauty, humility, nobility — were exalted, and to me it was a very positive time, a period of great enlightenment. I don't think it is unusual for artists to turn back to a period which they find fascinating and which they take as a model. For example, look at Delacroix's great love for Rubens."

One critic has suggested that Italians, living as they do amidst architectural ruins of the ancient world, are particularly sensitive to connections between past centuries and the present day. Mariani is also inspired by music from Europe's past. As he works in either of the studios that he maintains in New York City and in Rome, Mariani plays the music of such composers as Palestrina and Bach. When outside his studio, however, he prefers to listen to Pink Floyd and Jimi Hendrix.

In *It is Forbidden to Awaken the Gods*, two laurel-wreathed artists are asleep with paint brushes in their hands. A veiled stone head and a gigantic stone hand are nearby. Mariani hopes that his paintings of perfect youths with serene Olympian faces will be seen as more than pretty pictures. He believes that they can help viewers realize that something is not quite right in the modern world (represented by the sleeping figures), that it needs a sense of mystery and the sublime. Mariani's paintings are as much a critique of industrial, technocratic society as they are a means of honoring a bygone era and longing for a time of beauty, harmony, and a peaceful universe.

Figure 21.5 *It Is Forbidden to Awaken the Gods.* 1984. Oil on canvas. 200 x 250 cm (78¾ x 98½"). Courtesy of the artist.

Madame Moitessier. Ingres preferred to paint large historical paintings and said that he disliked painting portraits, but today his portraits are ranked among his most impressive works. He took years to complete a portrait of Madame Moitessier (Figure 21.6) and probably grumbled the entire time.

Madame Moitessier looks as though she is about to leave for an evening at the opera. In her left hand, she holds a small fan with which to cool herself if the theater becomes too warm. She stands before a dark violet wallpaper. The dress she is wearing is elegant and black. The light source is behind the viewer to eliminate the shadows on the figure. Thus, Ingres could show more clearly the smooth, graceful contour line of the shoulders, arms, and face. This free-flowing line is repeated in the pearl necklace.

Ingres believed that line was the most important element in painting and that color was secondary. In fact, he placed so little importance on color that he once said that an artist could learn all there is to know about it in an afternoon.

➤ Judging by her manner, dress, and surroundings, what sort of woman is this?

Figure 21.6 Jean-Auguste-Dominique Ingres. *Madame Moitessier*. 1851. Oil on canvas. 146.7 x 100.3 cm (57¾ x 39½"). National Gallery of Art, Washington, D.C. The Samuel H. Kress Collection.

SECTION ONE

Review

1. How did the academies of France and England change the way artists were taught?
2. What were the Salons, and on what basis were the artworks judged?
3. Why were the Salons of such importance to artists?
4. What events created renewed interest in the Classical period and its art forms?
5. What characterized the Neoclassic style?
6. Name two artists who practiced the Neoclassic style.
7. Define propaganda.
8. Describe how propaganda was used by Jacques Louis David in either *The Death of Marat* (Figure 21.2, page 482) or *Napoleon in His Study* (Figure 21.3, page 483).

Creative Activity

Humanities. Art produced in the Neoclassic style was characterized by balanced compositions, flowing contour lines, figures modeled in light and dark, and noble gestures and expressions. The term *classical*, when used in references to music, is exemplified in the work of Wolfgang Amadeus Mozart (1756–91). Clarity, perfect proportion, balance, fluidity, and grace all characterize the work of Mozart. Conflicts seem to be resolved, and a glowing serenity pervades his music.

Listen to a work by Mozart and compare the sound qualities you hear with the visual qualities of a Neoclassic artist whose work appears in this chapter. Share your observations with the class.

Romanticism and Realism

Even though the Neoclassic style of David and Ingres became the official style of the Academy, it did not go unchallenged. Not all artists shared these painters' enthusiasm for classical art forms, noble subject matter, balanced compositions, and flowing contour lines. Some artists chose to focus on dramatic events; others preferred to represent everyday scenes and events. The two new styles were Romanticism and Realism.

The Romantics

In 1819, a young French artist named Théodore Géricault (tay-oh-**door** jay-ree-**koh**) exhibited a painting called *Raft of the Medusa* (Figure 21.7). It signaled the birth of a new art style in France. Known as **Romanticism**, this style *portrayed dramatic and exotic subjects perceived with strong feelings*.

Théodore Géricault

Géricault was an artist with great natural ability. Many have wondered what heights he might have reached if he had lived a longer life. Unfortunately, he died at the age of thirty-three of a fall from a horse.

Géricault's *Raft of the Medusa* shows a dramatic, contemporary event as it actually happened, rather than something from the classical past. In July of 1816, the French ship *Medusa* was wrecked in a storm off the west coast of Africa. When it was certain that the ship was sinking, 149 passengers and crew members were placed on a large raft made from parts of the ship. The raft was then towed by officers aboard a lifeboat. Later, it was claimed that the officers, concerned with their own survival, cut the raft adrift. By the time they were rescued, only fifteen men on the raft remained alive.

As you study Géricault's picture, you may be reminded of the diagonal compositions of Rubens. Or perhaps you will think of the sculpturesque painted figures of Michelangelo. Géricault arranged his figures in a design based on two opposite diagonals. The major diagonal runs from lower left to upper right. It carries you into the work and leads you over a series of twisting figures. These figures express a range of emotions from complete despair to hope. A second diagonal begins with the corpse at the lower right. It moves upward to the mast of the crude raft at the upper left. This serves to balance the composition. The diagonal design, twisting figures, strong emotion, and dramatic use of light are important characteristics of the Romantic style. They marked Géricault's break with the Neoclassic style, which stressed calmness and balance.

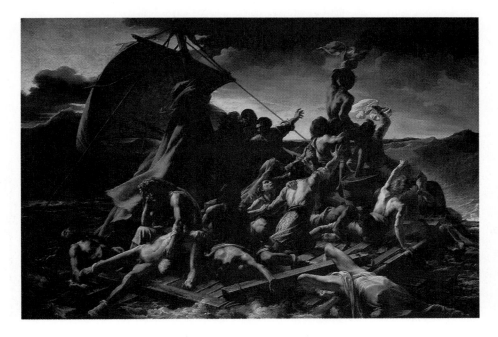

➤ In what ways does this painting remind you of works created by Michelangelo and Rubens? In what ways does it differ from works created by Neoclassic artists? How have opposing diagonal axis lines been used to organize and balance this composition?

Figure 21.7 Théodore Géricault. *Raft of the Medusa.* 1819. Oil on canvas. 4.9 x 7m (16 x 23'). The Louvre, Paris, France.

This work was displayed in the Academy show of 1819. Its title was *Shipwreck*. All knew the history of the subject though, and the work drew much attention. The final version may lack some of the excitement of Géricault's early sketches, but it still ranks among the most powerful paintings ever done. It also had a strong influence on another young French artist. That artist was Eugène Delacroix (oo-**zhen** del-lah-**kwah**).

Eugène Delacroix

When Géricault suddenly died, his position of leadership in the Romantic movement fell to Delacroix. Glowing colors and swirling action are marks of Delacroix's style. However, Ingres and his followers disliked such work. They found it violent, crude, and unfinished. This resulted in a long rivalry between Delacroix and Ingres. The former spoke for Romanticism, while the latter was the champion of the Neoclassical cause. These two artists disliked each other's art, and they disliked each other as well. Delacroix once described Ingres's art as "the complete expression of an incomplete intelligence."

Delacroix's love of dramatic action and exotic settings is evident in his painting of *The Lion Hunt* (Figure 21.8). He took a six-month trip through Morocco, Tangiers, and Algiers in 1832, and the trip fired his enthusiasm for the Near East. The sketches he did during that trip gave him the inspiration and subject matter for paintings done long after his return to France. *The Lion Hunt* was among these.

The theme of *The Lion Hunt* is action. The excited movement of hunters, horses, and lions is arranged in a circular pattern placed within an oval of light. The violent action is made more convincing by the use of blurred edges, rapidly applied brushstrokes, and spots of bold color. Again, there are reminders of Rubens. You find them in the swirling action, the dramatic use of color, and the bold contrasts of light and dark. The scene looks as though it has been caught up in a tornado. Everything has been swept up into the swirling spiral, making colors and forms blur as they whirl.

Color was the most important element in painting for Delacroix. "A painting," he said, "should be a feast for the eye." Unlike Ingres, he did not begin his paintings with lines. When painting a figure, for example, he did not draw the outline first and then fill it in with color. Instead, he began painting at the center of the figure. He then worked outward to the edges.

Delacroix learned a great deal from studying the work of the English landscape painter John Constable, who used patches of color placed side by side instead of blending them smoothly together. When Delacroix did this, however, he was criticized for the rough finish of his works.

At first, the honors and awards in the battle between Neoclassicism and Romanticism went to

➤ Describe the way the artist has organized this composition. Are the edges blurred or distinct? What seems to dominate here—color or line? Are the colors and shapes varied or harmonious? Which of the following adjectives would you use when interpreting this work: rigid, calm, ordinary, swirling, exciting, dramatic? Which aesthetic qualities would you use when judging this work?

Figure 21.8 Eugène Delacroix. *The Lion Hunt.* 1861. Oil on canvas. 76.5 x 98.5 cm (30 x 38¾"). Collection of The Art Institute of Chicago. Mr. and Mrs. Potter Palmer Collection, 1922.

Art • PAST AND PRESENT •

Art Schools Today

The growth of the academies — art schools — in England and France changed the way artists were trained. By the nineteenth century, artists were no longer apprenticed to established masters, but instead were taught in art schools. These art schools taught art the way any other subject was taught.

Today, many artists are still trained in academies. The methods of training have not changed dramatically since the nineteenth century. Students are still instructed in the subject of art the way they are instructed in other subjects. They are expected to study and understand the works of the old masters. Of course, students also spend much of their time creating art works. Competitions and exhibits are sponsored by these art schools, just as salons were sponsored by academies in the past.

Art schools offer instruction in all areas of art, including drawing, painting, photography, printmaking, textile design, ceramics, sculpture, and jewelry. Some schools even offer special training in art history.

Students can attend academies at both the high school and the college level. One such high-school-level academy is the Booker T. Washington High School for the Performing and Visual Arts in Dallas, Texas. Some college-level art schools include The School of the Art Institute of Chicago, Parsons

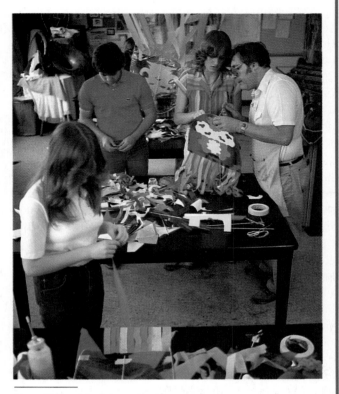

Figure 21.9 Art Students and Instructor

School of Design in New York, Pratt Institute, and the Art Center College of Design in Pasadena, California.

Ingres. Six times in a row the French Academy refused to admit Delacroix as a member. When he was finally admitted, it was too late to mean very much to him. Romanticism had been generally accepted by then, and other, younger artists were already beginning to paint pictures in a new style known as Realism. However, before looking at the work of the Realists in France, the paintings of two extraordinary English artists should be examined.

English Landscape Painters

By 1800, qualities that were to characterize English painting throughout the nineteenth century could be found in the works of John Constable and Joseph M. W. Turner. Both artists were primarily landscape painters.

However, they went in different directions in the way they painted their landscapes.

John Constable

John Constable formed his own personal way of looking at things among the trees and meadows of the English countryside. His approach to painting was like that of the seventeenth-century Dutch masters. Like them, he wanted to paint the sky, meadows, hills, and streams as the eye actually sees them. He delighted in trying to capture the light and warmth of sunlight, the coolness of shadows, and the motion of clouds and rain. He painted wide-open landscapes with great detail, re-creating the exact look and feel of the scene.

During long walks through the fields, Constable would carry a small sketchbook. The pages of this sketchbook measured little more than 3 x 4 inches (8 x 10 cm). On these tiny pages he drew the landscape from

different angles. He was especially interested in the way changes in sunlight altered the look of things. Later, when working on his large paintings, he referred over and over again to these sketches.

Constable's *The Dell in Helmingham Park* (Figure 21.10), with its sparkling color and dewy freshness, is a scene of quiet charm. It reveals a gently flowing stream in a small, secluded, wooded valley. A wooden footbridge spans the valley, and a solitary cow is seen at the lower left. Perhaps it has wandered here alone in search of shelter from the afternoon sun. The full, rich trees cast deep shadows that are as cool and inviting for the viewer as for the animal.

When you examine Constable's painting closely, you will find that its freshness and vitality are due to the artist's use of tiny dabs of pure color, stippled with white and applied with a brush or palette knife. This technique creates a sparkling shimmer of hue and light across the work that effectively captures the fleeting effects of nature.

What happens when you use your imagination to "listen" to the sounds hinted at by this painting? Do you hear the murmur of the stream, the sound of the cow making its way slowly through the water, the rustle of leaves as a soft summer breeze stirs the trees? When you take into account what you see *and* what you hear, what feelings and moods are suggested by this work?

In *Wivenhoe Park, Essex* (Figure 21.11), Constable offers his view of an estate belonging to a friend of his father. The landowner, a retired army general, commissioned the painting and asked that certain things be included in it. In fact, when Constable finished the picture, the general objected because he thought the artist had not shown enough of the estate. Constable then had to sew pieces of canvas to both sides of his painting to widen the scene. He added interest by including a pony cart, swans, cattle, and birds.

The painting conveys the look and feel of the scene as Constable saw it. He caught the light airiness of the atmosphere and the sweeping movement of the clouds. The sparkle of light across the dark green leaves of the trees and the lighter green of the rolling hills are shown. In addition, the artist captured the stately look of the red brick house. The entire scene has a feeling of the momentary—as though you have been given a quick glimpse of nature as it exists at a particular moment in time.

Joseph M. W. Turner

Joseph M. W. Turner began his career as a watercolor painter and later turned his attention to painting landscapes in oils. A talented artist, he first exhibited in the Royal Academy when he was only sixteen years old. As his career progressed, he became less and less

➤ List the things you see in this painting. What makes this picture look so real? Is the overall feeling of texture rough or smooth? What sounds are suggested by this picture? What mood does it communicate to you? Do you consider this a successful work? Why or why not?

Figure 21.10 John Constable. *The Dell in Helmingham Park.* 1830. Oil on canvas. 113.4 x 130.8 cm (44⅝ x 51½"). Nelson-Atkins Museum of Art, Kansas City, Missouri. Nelson Fund.

➤ Constable was interested in showing how sunlight affected the subject matter in his pictures. In this respect, he was a great influence on a style of art developed by Claude Monet, Pierre Auguste Renoir, and others. What was that art style called?

Figure 21.11 John Constable. *Wivenhoe Park, Essex.* 1816. Oil on canvas. 56.1 x 101.2 cm (22⅛ x 39⅞"). National Gallery of Art, Washington, D.C. Widener Collection.

interested in showing nature in realistic detail. Instead, he turned his attention to the effects that light and atmosphere have upon subject matter. In time, light and atmosphere became the most important part of his works. They added a kind of magic to his pictures of the most ordinary scenes. When painting a landscape with a castle, for example, Turner would not make the castle the center of interest as you might expect. Instead, he would paint a glowing atmosphere as a way of arousing your curiosity and luring you closer for a longer look; and what would you find? The blurred forms and intense colors would be changed by way of your imagination. In the indistinct forms you would see a blazing sunset, violet mountains, and the silhouette of a medieval castle. No wonder that Constable, when talking about Turner's pictures, said, "Turner has golden visions, glorious and beautiful. . . . One could live and die with such pictures."

Turner's painting entitled *Snow Storm: Steam-Boat off a Harbor's Mouth* (Figure 21.12) is his view of nature at its most violent. He captures this violence with a bold use of sweeping light and color rather than detail. However, when this painting was exhibited at

➤ Turner's picture differs from traditional pictures of ships at sea. What is the most important thing in this picture—the steamship or the storm? Turner's mature works reveal his interest in which of the following: (a) precise detail, (b) genre scenes, (c) light and atmosphere, (d) symbolism? Describe the mood that is created by the swirling colors. What feelings do you experience when viewing this work?

Figure 21.12 Joseph M.W. Turner. *Snow Storm: Steam-Boat off a Harbor's Mouth.* 1842. Oil on canvas. 92 x 122 cm (36 x 48"). The Tate Gallery, London, England. The Clore Collection.

the Royal Academy in London, critics were shocked and angered. They were used to traditional pictures of ships at sea and failed to find any value in this painting of blurred and violent impressions. Why, it was impossible to find the ship in the picture, they claimed. It was all but lost in the swirling action of light and color.

What the critics failed to understand was that Turner was painting things that have no shape or form — things like speed, wind, and atmosphere. To learn how to do this, he boarded a small steamship during a snowstorm and, as the storm grew, asked crew members to tie him to the mast. For four hours he remained bound to the mast, at times certain that he would not survive. However, he was determined to witness the full fury of the storm and then paint it exactly as he saw it. His picture shows the steamship in the middle of the swirling composition, but it is almost lost in the mist, smoke, and windblown snow. The ship is not the most important thing in the work. Of most importance is the violent mood of the storm raging about the ship. The powerful but majestic violence of nature is painted without the distraction of unnecessary details.

Space and Light. Turner's later paintings of space and light became even more abstract. They were so formless that he had to attach rings to the frames so galleries would know which way to hang them.

An insight into this artist's views about his work is provided by a conversation between Turner and a gentleman viewing one of his landscapes. After studying the painting for a few minutes, the gentleman turned to the artist and complained that he had never seen skies as Turner painted them. The artist only nodded and replied, "Possibly — but don't you wish you could?"

Turner died on December 19, 1851, a death listed simply as "natural decay." His last words were, "The sun is God."

The Realists

Meanwhile, in France, many young artists were looking for subject matter that did not glorify the past or present romantic views of current events. They rejected both Neoclassicism and Romanticism.

To understand the reaction against both Neoclassicism and Romanticism, you must look at conditions in France at that time in history, roughly the mid-1800s. More and more factories were using new machines to increase production. This drew great num-bers of people from rural areas to the cities. Artisans who took pride in their handmade products were replaced by factory workers who mass-produced the same products more cheaply and in greater quantities. These factory workers were usually unskilled and poorly paid. They lived in crowded conditions in drab, unhealthy slums. In a short time, this "industrial revolution" pushed aside old beliefs, habits, and institutions.

These changes had an effect on artists who were sensitive to what was going on around them. They realized that classical models and romantic subject matter were out of place in their world. A peasant, they felt, was as good a subject for their brush as a Greek goddess, and the life of a factory worker offered as much inspiration as a lion hunt in some far-off land. They also knew, however, that they could not paint the world around them by using old techniques. They would have to invent new ones. So they discarded the formulas of Neoclassicism and the theatrical drama of Romanticism to paint familiar scenes and trivial events *as they really looked*.

Gustave Courbet

Gustave Courbet (**goo**-stahv koor-**bay**) was in the forefront of this group of artists. He and his followers became known as *Realists*. Their art style, known as **Realism**, *represented everyday scenes and events as they actually looked*.

In *Burial at Ornans* (Figure 21.13), Courbet painted the funeral of an ordinary villager. It is a common scene, certainly not what you would call an important event. Unlike El Greco's *Burial of Count Orgaz* (Figure 18.11, page 415), you will find no saints assisting at this burial. Nor will you see an angel bearing the soul of the departed upward to be welcomed by Christ and a host of heavenly inhabitants. Courbet shows nothing more than a large group of almost-full-size figures standing beside an open grave in front of a somber landscape. There is no mystery or miracle here to marvel over; the painting communicates little in the way of grief or piety. Indeed, not one person looks at the cross or at the grave. Why are they there? The people attending this funeral do so out of a sense of duty. The priest routinely reads the service. After all, he has done this many times before, and there is nothing about this funeral to set it apart from all the rest. The kneeling gravedigger looks bored and impatient to get on with his work. The women at the right go through the motions of mourning, but they are not very convincing.

Courbet's friends had posed for the painting, and, in most cases, they could be identified. He used them

➤ The critics found fault with this painting. What argument did Courbet use to defend his picture?

Figure 21.13 Gustave Courbet. *Burial at Ornans.* 1849. Approx. 3 x 6.7 m (10 x 22'). The Louvre, Paris, France.

because they were important to him and were a part of his life. However, when he exhibited his painting in Paris, he was criticized for using his friends as models. His work was considered insulting because he had dared to use plain, ordinary people painted on a scale that was by tradition reserved for important people or great events.

Courbet felt that an artist should draw upon his or her own experiences and paint only what could be seen and understood. He once said that it was impossible for him to paint an angel because he had never seen one. He *did* experience this funeral, and he painted it just as he saw it. It is an actual scene painted honestly. The work shows real people behaving the way real people behave.

Édouard Manet

Among the artists who took part in the Realist movement was Édouard Manet (ay-doo-**ahr** mah-**nay**). He exhibited with Courbet and was often attacked by critics for the same reasons. However, unlike Courbet, Manet was more concerned with *how* to paint than with *what* to paint.

In *Gare Saint-Lazare* (Figure 21.14, page 494), Manet uses his technical knowledge and skill to paint a simple, everyday scene. A woman is sitting with a sleeping puppy nestled in her lap. She has just looked up from a book she has been reading. You are made to feel as though you have come upon her by chance and she looks up to see who it is. You exchange casual glances, and, at the same time, your eye takes in the vertical black fence posts of a railway station.

A little girl stands with her back to you, peering through this fence at the steam and smoke left by a passing locomotive. The girl's left arm unites her with the figure of the woman while also breaking up the strong vertical pattern of the fence. At the same time, the curving shapes of the figures contrast with the repeated verticals of the railings. In this way, Manet adds variety and interest to his composition.

Manet did not pose the figures in his pictures. He painted them as he found them—and as he saw them. Details were avoided because he wanted his picture to show what the eye could take in with a quick glance. His concern with technique is seen in the way he placed his colors on the canvas. In some places, the paint is stroked on carefully. In others, it is dabbed on or pulled across the canvas. The result is a richly textured surface that adds even more to the variety and interest of the picture.

Rosa Bonheur

An artist who effectively combined the flair of Romanticism with the accuracy of Realism was Rosa Bonheur (**roh**-zah bah-**nur**). Few artists were as successful or as admired in their lifetime as this woman.

➤ Describe the lines in this picture. How have these lines been used to tie the composition together? To what aesthetic qualities would you refer when judging this picture? Having applied those qualities, do you judge it to be successful or unsuccessful?

Figure 21.14 Édouard Manet. *Gare Saint-Lazare.* 1873. Oil on fabric. 93.3 x 111.5 cm (36¾ x 43⅞"). National Gallery of Art, Washington D.C. Gift of Horace Havemeyer in memory of his mother, Louisine W. Havemeyer.

Rosa Bonheur received her first painting lessons from her father, who was a painter and art teacher. When her mother died, the young Rosa was forced to leave school and help her father raise her two brothers and a sister. This did not prevent her from continuing to paint, however. The family had moved to Paris when she was seven years old, and Bonheur often copied the works of the masters found in the many galleries there. She soon showed a preference for sketching live animals rather than copying paintings. During her teens and early twenties, she journeyed regularly to country fields and to the stockyards outside Paris to draw the animals. (See Figure 3.14, page 63.)

Bonheur also found subjects for her works at cattle markets and fairs where horses were being sold. To facilitate her work, she substituted comfortable men's clothing for the restrictive women's clothing of the day. (However, this was done only after permission had been obtained from the authorities.) Men's clothing was much more suitable for walking and sketching among the animals, and it helped her avoid the jeers of the workers and spectators.

When she was just nineteen, two of Bonheur's paintings were chosen for exhibition at the Salon. Four years later, she was given a medal. This was the first of many honors and awards she earned during her long career. Eventually, she was made an officer of the Legion of Honor, the first woman to be so recognized.

Bonheur's accurate anatomical studies of animals enabled her to successfully undertake such large, sweeping works as *The Horse Fair* (Figure 21.15). In it, she combines her knowledge and admiration of horses with an understanding of the emotion and vigor found in paintings by Géricault and Delacroix. She shows horses being led by their handlers around the exhibition area of a fair. The scene is crackling with tension and excitement. High-strung horses rear up suddenly and wildly flail the air with their hooves. Others trot and prance about, barely held in check. The result is a thrilling blend of movement, drama, and reality that echoes the accomplishments of both the Romantic and Realist artists. Her animals are painted boldly with a heavy, rich application of paint. She possessed the skill and the confidence to paint pictures of great size. *The Horse Fair*, for example, is over 16 feet (4.9 m) wide. In another work entitled *Horses Thrashing Corn*, she painted ten life-size horses. At the time, it was the largest animal picture ever done.

Bonheur's animal paintings made her one of the most popular painters in Europe. It is a mark of her talent that her popularity has not lessened over the years.

➤ In what ways does this painting remind you of the works of Géricault and Delacroix? How is it similar to Realist paintings by Courbet and Manet? If you could invent a name for this artist's style, what would it be?

Figure 21.15 Rosa Bonheur. *The Horse Fair.* 1853–55. Oil on canvas. 244.5 x 506.8 cm (96¼ x 199½"). The Metropolitan Museum of Art, New York, New York. Gift of Cornelius Vanderbilt.

SECTION TWO

Review

1. Define Romanticism and tell how the subject matter of artworks in this style differed from that of the Neoclassicists.
2. Name three characteristics of the Romantic style used by Théodore Géricault in his painting *Raft of the Medusa* (Figure 21.7, page 487).
3. Identify two characteristics of Eugène Delacroix's style.
4. Describe how Delacroix painted an object.
5. What aspect did Joseph M.W. Turner consider most important in his landscapes and seascapes?
6. Tell how Realism differed from Neoclassicism.
7. Refer to *The Horse Fair* by Rosa Bonheur (Figure 21.15) and list three ways in which she combined the flair of Romanticism with the accuracy of Realism.

Creative Activity

Humanities. Romanticism gave inspiration to women writers to pursue their writing despite society's pressures to limit them. Aurore Dupin (1804–76) took the pen name George Sand in order to be free to publish. Her novels and plays express a romantic love of nature and an extravagant moral idealism. Her later works demanded social reform, particularly demanding for women the same freedoms given to men.

Mary Anne Evans (1819–80) also took a masculine pen name. She is known as George Eliot, the author of *Silas Marner*, *Mill on the Floss*, and *Middlemarch*. Her novels show a remarkable sensitivity to the humor and pathos of human nature.

Read the works of these two women whose nineteenth-century voices called for equality of the sexes.

SECTION THREE

Impressionism: A New Quest for Realism

The generation of artists that followed Courbet and were associated with Manet carried even further the quest for realism. They took their easels, paints, and brushes outdoors to paint rather than work from sketches in their studios.

A New Style Emerges

These artists contributed to a new style of painting that stressed the effects of atmosphere and sunlight on subject matter. They tried to capture this effect by using quick, short brushstrokes. This approach resulted in paintings made up entirely of small dabs, or spots, of color. When viewed from a distance, these dabs of color were blended together in the eye of the viewer to create the desired effect.

Because these artists were concerned with momentary effect, they avoided posed or staged compositions. Instead, they preferred an informal, casual arrangement in their paintings. In many ways, their pictures have the same natural look as quickly snapped photographs. This "snapshot" approach to composition added a lively, more realistic appearance to their paintings.

Claude Monet

In 1874, a group of artists using this new style of painting held an exhibition of their works in Paris. One of these artists was Claude Monet (kload moh-**nay**), who exhibited a picture entitled *Impression: Sunrise*. Outraged critics took the word *Impression* from Monet's title and used it as a label when referring, unkindly, to all the works in this exhibition. The movement, called **Impressionism**, described *an art style that tried to capture an impression of what the eye sees at a given moment and the effect of sunlight on the subject*.

Monet's painting of the west façade of Rouen Cathedral (Figure 21.16) shows the famous building bathed in bright, shimmering sunlight. It is one of twenty-six paintings of this same church produced by this artist. Why twenty-six paintings of the same object? When you find the answer to this question, you will have a

better understanding of what the Impressionists tried to accomplish with their paintings.

Haystack at Sunset Near Giverny. It may seem odd, but a good place to begin a search for an answer is a farm near Paris on a sunny afternoon in 1891. There, in a field of haystacks, a middle-aged man in a wide-brimmed hat stands before an easel. On the easel is a half-finished painting of a haystack (Figure 21.17). The man takes his brush and continues to work on the picture by adding dashes and dots of brightly colored paint. His eyes dart quickly from the haystack in the field to the canvas and back again. His hand moves as quickly from his palette to the canvas.

➤ Why did Monet frequently paint the same subject over and over again? What technique did he use to apply his paint to the canvas? Can you find any clear, precise lines in this picture? Name the hues found in the work. What was Monet trying to show in his pictures? How did the critics react to his work? What effect did this have on the artist?

Figure 21.16 Claude Monet. *Rouen Cathedral, West Façade.* 1894. Oil on canvas. 100 x 66 cm (39½ x 26"). National Gallery of Art, Washington, D.C. Chester Dale Collection.

➤ What is the subject matter in this painting? Describe the edges of the shapes — are they firm or blurred? What effect does this create? Point to areas where the most intense colors are used. Does the surface of this picture look smooth or rough? Do you think it would be accurate to call this a "super-realistic" work? Why or why not?

Figure 21.17 Claude Monet. *Grainstack (Thaw, Sunset)*. 1891. Oil on canvas. 64.9 x 92.3 cm (25½ x 36⅓"). The Art Institute of Chicago, Chicago, Illinois. Gift of Mr. and Mrs. Daniel C. Searle, 1983.

Suddenly the sunlight changes, and the artist glances upward to see that a cloud has passed in front of the sun. He notices the way the sunlight filters through the clouds and the effect this has on the haystack he is painting. Removing the unfinished painting, he places it carefully on the ground and picks up a new canvas from a stack beside him. He sets this new canvas on the easel and smiles. "Of course," he says softly to himself, "when the sunlight changes, the colors change." The artist is Claude Monet.

Several times during the day, Monet changes his canvas, until by sunset he has started more than a dozen paintings of the same haystacks. Each of these captures a different moment of light. Each has its own character, and each conveys a different impression than the one before because of the changing light.

For months, Monet worked in the field painting the same haystacks. Often he worked on several pictures at once, rushing from one to another as the light changed. He painted the haystacks at all hours of the day, always trying to record in paint the exact colors he saw reflected from them. Sometimes the sun was so brilliant that the outlines of the haystacks became blurred and seemed to vibrate. Monet tried to capture these optical effects in his pictures, painting exactly what his eye saw rather than what he knew was actually there.

However, when Monet exhibited his haystack paintings later in Paris, most critics responded in anger. It was not so much the bright colors or the common subject matter that they objected to; it was the way the paintings were done. They looked crude and hastily completed, as if they were no more than sketches, or preliminary studies that had to be developed further to be considered finished works. The critics thought it was an insult to put a frame around a quick oil sketch and then call it art. After all, they said, it was no more than could be expected from an artist like Monet, who had a reputation for being stubborn and defiant.

Monet refused to be discouraged. Instead, he began work on another series of paintings showing a row of poplar trees along a river. This time he was interested in painting not only the colors reflected from the subject, but how these colors looked in the rippling water of the stream as well. He anchored a small boat in the river and painted this new "slice of life" in every kind of light. The area he wanted to show in his pictures was not large, but he wanted to show all of it. He tried to show it as if it had been experienced all at once in a single glance at a particular moment in time.

Later, when they were shown in Paris, Monet's poplar trees were more warmly received than his haystacks had been. Monet, however, was not impressed. "What do the critics know?" he asked.

Rouen Cathedral. That winter, exhausted, Monet visited his brother, who lived in the cathedral city of Rouen. Late one afternoon he stopped to make a purchase in a little upstairs shop. Through a window, he spied the towers and the doorway of the great church looming in the twilight. He sent home for his canvases and soon set up his easel in the window of the little shop. Day after day during three winters, Monet painted the doorway and towers of the cathedral. At the end of the second winter, he wrote, "What I have undertaken is very difficult. I have not the strength to pick up my canvases. The more I continue, the more I fail."

One of Monet's paintings of Rouen Cathedral (Figure 21.16) uses complementary colors—blues and oranges. These colors were applied in separate brushstrokes, which look like an uneven mixture of colored dabs and dashes when seen up close. Viewed from a distance, however, they blend together. As a result, what the viewer sees is not solid form, but a rich visual impression.

When the critics saw Monet's pictures of Rouen Cathedral, they marveled at last. The highest tribute to Monet's genius, however, may have come from another great artist. Paul Cézanne said, "Monet is only an eye, but what an eye!"

Main Features of Impressionism

Now that you have learned something about Impressionism, do you think you could pick out the Impressionist painting among several works of art representing different styles (Figures 21.18, 21.19, and 21.20)? Try it; you will find that it is not difficult if you keep in mind some of the main features of Impressionism. Perhaps the most obvious one is the use of dabs and dashes of bright colors that seem to blend together as you look at them. There are other features as well; some of them are listed here:

- Blues and violets are used in place of grays, browns, and blacks, even in the areas where there are shadows.

- Smooth, slick surfaces are replaced by richly textured surfaces made up of many short brush-strokes.
- Because they are composed of strokes and patches of color, solid forms lose some of their solidity.
- Hard, precise outlines are replaced by blurred edges.
- Often there is *no* emphasis or center of interest to which your eye is guided by perspective lines.
- Details are missing because the artist includes only those things that can be taken in with a single glance. This gives the picture a casual, almost accidental look.
- The subject matter used comes from the contemporary world, which may seem unimportant when compared to the grand subjects painted by earlier artists.

➤ This was the official style of the French Academy throughout the century, but particularly during the first half. This style made use of ancient Greek and Roman sculptures as models. It stressed the importance of balanced compositions, flowing contour lines, figures modeled in light and dark, subdued colors, and noble gestures and expressions.

Figure 21.18 Jacques Louis David. *Death of Socrates.* 1787. Oil on canvas. 129.5 x 196.2 cm (51 x 77¼"). The Metropolitan Museum of Art, New York, New York. Wolfe Fund, 1931. Catharine Lorillard Wolfe Collection.

▶ These artists used short brushstrokes to reproduce the flickering quality of sunlight. Their pictures show that they were less interested in the solid look of forms. They concentrated instead on the changing effects of light and atmosphere.

Figure 21.19 Pierre Auguste Renoir. *Landscape at Cagnes.* c. 1914. Oil on canvas. 29.2 x 44.2 cm (11½ x 17⅜"). Allen Memorial Art Museum, Oberlin College, Oberlin, Ohio. A.A. Healy Fund.

Pierre Auguste Renoir

Have you decided which is the Impressionist painting? You would be correct if you selected Figure 21.19. It is a landscape by Pierre Auguste Renoir (pee-**air** oh-**gust** ren-**wahr**), whom you may remember from the discussion in Chapter 5 (pages 99–101). Like many Impressionist paintings, the work is quite small, only 11½ x 17¾ inches (29 x 45 cm). Why so small? Because the Impressionists painted outdoors, and the canvases on which they painted had to be easy to carry.

Renoir's paintings are happy paintings. He delighted in showing the happiest side of nature. You will never find anything evil or ugly in his pictures. He even avoided painting night or winter scenes and could not understand how Monet and the other Impressionists could. "For me," he declared, "a picture must be an amiable thing. Joyous and pretty—yes, pretty! There are enough troublesome things in life without inventing others."

Renoir loved to paint and did so up to the day he died. Even though he was crippled by rheumatism during his final years, he continued to paint by having his brush tied to his wrist. Shortly before his death, he was honored in an unusual way—he was invited to visit the great Louvre museum in Paris. What was unusual about this visit was that he was to be its only guest that day. Seated in a wheelchair, he was pushed from one gallery to the next. What pride he must have felt when he viewed his own works exhibited alongside those of the great artists of the past.

▶ This style developed and flourished during the first half of the century. It favored the use of rich, dramatic color and a sense of movement rather than balance. Paintings done in this style did not begin with contour lines, but with patterns of color that were used to create shapes and figures.

Figure 21.20 Eugéne Delacroix. *Arabs Skirmishing in the Mountains.* 1863. Canvas/oil on linen. 92.5 x 74.6 cm (36⅜ x 29⅜"). National Gallery of Art, Washington, D.C. Chester Dale Fund.

Major Influences

Monet, Renoir, and the other Impressionists sought inspiration everywhere. Certainly, one source of inspiration was the Japanese print.

A century before, the Japanese had perfected an inexpensive way of printing pictures in several colors. In fact, it was such an inexpensive process that it became possible to produce huge quantities of prints that could be sold at modest costs to large numbers of people. Those prints were made by using several wood blocks. Each block was covered with a different-colored ink and applied to one piece of paper.

The prints produced in this way were usually landscapes or genre scenes (Figure 21.21). They were done with an elegant pattern of lines and delicate, flat colors. No attempt was made to create an illusion of depth by using perspective or shading. Further, Japanese printmakers revealed new and unusual ways of looking at and representing the world. For one thing, they did not hesitate to show only part of a figure. Sometimes a curtain or even the edge of the print was used to "cut off" a figure so that part of it could not be seen. This was something that European artists had never done.

The Japanese did not place much value on these inexpensive, mass-produced prints. As a result, when trade was begun with Europe in the nineteenth century, they were often used as packing material, just as old newspapers are today. In time, the Impressionists discovered the prints. Then, awed by their beauty, they began to collect them. Before long, some of the features found in the Japanese prints began to appear in their paintings.

In addition to Japanese prints, the Impressionists were influenced by the new art of photography. The camera opened their eyes to the possibilities of **candid**, or *unposed*, views of people. They were startled and then excited by the way snapshots showed familiar subjects from new and unusual points of view.

The influence of both Japanese prints and the art of photography on the Impressionists is readily apparent in a painting by Gustave Caillebotte (**goo**-stahv **kigh**-bott) (Figure 21.22). Three men are seen walking, or lingering, on a bridge spanning the same railroad tracks indicated in Manet's picture of *Gare Saint-Lazare* (Figure 21.14, page 494). The setting and the people, as in Japanese prints, reflect everyday life. The bridge pictured was newly erected and connected four busy avenues in the center of Paris. Notice how each of the figures is shown. Their unposed actions at a particular moment in time are frozen within the parameters of the picture plane. One leans casually over the rail to view the scene below. Another pauses briefly to glance in the direction of the railroad station. A third, apparently no longer fascinated by the novelty of the new bridge, strolls by so rapidly that he is about to pass completely beyond the edge of the picture. A cut-off figure like this would have been unheard of before the appearance of Japanese prints and the development of modern photography.

Edgar Degas

Another artist who found inspiration in these new discoveries was Edgar Degas (ed-**gahr** day-**gah**). His pictures reveal that he learned a great deal from studying Japanese prints and photographs. The same cut-off figures, unusual points of view, and candid

➤ How is space handled in this print?

Figure 21.21 Suzuki Harunobu. *Girl with Lantern on a Balcony at Night.* c. 1768. Woodcut. 32.4 x 21 cm (12¾ x 8¼"). The Metropolitan Museum of Art, New York, New York. Fletcher Fund, 1929.

➤ How did photography and the techniques used by Japanese printmakers influence the layout of this work?

Figure 21.22 Gustave Caillebotte. *On the Europe Bridge.* 1876–80. Oil on canvas. 105.3 x 129.9 cm (41½ x 51⅛"). Kimbell Art Museum, Fort Worth, Texas.

to delay your journey into his painting. Carefully painted, detailed objects at the "starting point" of that journey might have caused such a delay.

Drawing. Degas's great interest in drawing also set him apart from the other Impressionists. This interest may have come from his admiration for Ingres. Degas's drawings, and the paintings that he developed from those drawings, show that he was concerned with the line, form, and movement of the human body. This explains why so many of his pictures show scenes from the ballet. (See Figure 21.1, page 480.) They offered him the chance to capture the split-second movement of a dancing ballerina. Along with scenes of the racetrack, these views of ballerinas became his favorite subject.

Sculpture. An interest in the figure carried over into Degas's work in sculpture. He may have turned to sculpture because his eyesight was beginning to fail and he was trying to compensate for this by drawing upon his sense of touch. The subjects for his sculptures were the same ones he used for his

poses noted in Caillebotte's picture can be found in many of Degas's paintings. Some of these features are evident in his painting *The Glass of Absinthe* (Figure 21.23).

Beginning with the slightly out-of-focus items on the nearest table, you are led indirectly to the two figures at the upper right. A folded newspaper acts as a bridge enabling you to cross from one table to the next and from there across to the woman and man. Degas wanted nothing to interfere with this journey into and across his painting. He decided not to paint legs on the tables because they might lead your eye away from the route he wanted you to travel. His carefully planned tour is well rewarded. At journey's end you meet a woman you will not soon forget. Lonely, sad, lost in her own thoughts, she is seated next to a man who looks at something outside the picture. The woman is empty of feeling and past caring. Looking at her you know she leads a dull, dreary life and that the man with her is incapable of feeling any genuine sympathy or affection for her.

Although he was in sympathy with many of their objectives, Degas did not consider himself to be an Impressionist. He always painted in his studio using sketches made from life. *The Glass of Absinthe* may well have originated as a sketch made while Degas was seated in a Paris café. Perhaps those out-of-focus items on the nearest table are some of his drawing instruments. They may have been intentionally painted out of focus because Degas wanted nothing

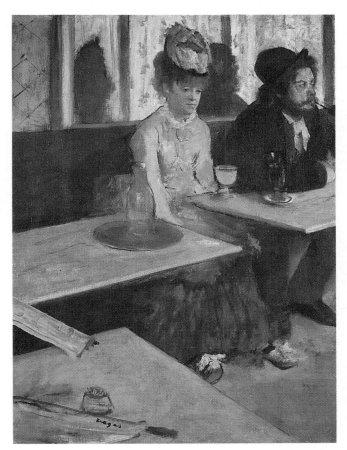

➤ How does the artist guide your eye to the figures?

Figure 21.23 Edgar Degas. *The Glass of Absinthe.* 1876. Oil on canvas. Approx. 92 x 68 cm (36 x 27"). The Louvre, Paris, France.

paintings—ballerinas and horses (Figure 21.24). Because he wanted to capture the illusion of swift movement, he avoided the use of details. After all, he reasoned, it is impossible to observe all the details of a horse as it dashes by.

Mary Cassatt

Degas played an important role in the development of one of America's finest painters, Mary Cassatt (cuh-**sat**). The daughter of a wealthy Pittsburgh banker, Cassatt spent several years in Paris as a child. During the Civil War, she studied art in Philadelphia even though her father disapproved. He said he would almost rather see her dead than become an artist. Cassatt, however, was also strong-willed. At the age of twenty-three, she returned to Paris to continue her studies. She soon found that as a woman she had to work twice as hard to gain recognition in the competitive nineteenth-century Paris art world.

One day, a work by Degas in a shop window caught her eye. It was Cassatt's introduction to Impressionism, and it had an immediate and lasting effect on her. "I used to go and flatten my nose against the window," she said later. "It changed my life."

Cassatt's admiration for Degas's work was not one-sided. Her own paintings soon attracted his attention, and they became good friends. Degas introduced her to the Impressionists, and they liked her paintings so much that she was invited to show her work at their exhibitions.

Cassatt painted *Girl Arranging Her Hair* (Figure 21.25) in answer to a challenge made by Degas. He may have been expressing his doubts that a woman could ever become a serious artist, or perhaps he wanted to spur his friend into putting forth her best effort. In any event, Degas urged Cassatt to produce a painting of real merit—if she could. She responded by painting a subject Degas had used often in his own work. Her finished painting demonstrated that she was a first-class painter, and Degas was so impressed that he bought it. "Now here is someone who sees as I do," he exclaimed.

Like many of Degas's subjects, the girl in Cassatt's picture is not pretty. She was a young Irish kitchen maid with big teeth. Cassatt dressed her in a baggy nightgown and had her pose in an awkward position in front of a cheap washstand. Concentrating on the design of her picture, Cassatt tried to make certain that the viewer's eye would be attracted to the model's face. How did she do this? You can answer this question for yourself by examining the direction of the various contour and axis lines found in the work. Cassatt led your eye exactly where she wanted to.

➤ What explanation can you give for the lack of detail on this sculpture?

Figure 21.24 Edgar Degas. *Galloping Horse.* 1865–81. Bronze. 31.1 x 46.3 cm (12¼ x 18¼"). The Saint Louis Art Museum, St. Louis, Missouri. Purchase.

➤ What do you think the artist wanted to say with this work? Do you consider it a successful painting?

Figure 21.25 Mary Cassatt. *Girl Arranging Her Hair.* 1886. Oil on canvas. 75 x 62.3 cm (29½ x 24½"). National Gallery of Art, Washington, D.C. Chester Dale Collection.

➤ How are the two figures in the picture similar? Would you describe their pose as relaxed and natural, or stiff and artificial? Explain how the two fans serve to unite the figures.

Figure 21.26 Berthe Morisot. *The Sisters.* 1869. Oil on canvas. 52.1 x 81.3 (20½ x 32"). National Gallery of Art, Washington, D.C. Gift of Mrs. Charles S. Carstairs.

With your finger, trace the contour lines along the model's back upward and around her right shoulder. Do the same thing with the axis line formed by the right arm and the top of the nightgown. Finally, run your finger upward along the front of the nightgown. All these lines lead to the girl's face. The more you look at this face, the more interesting and appealing it becomes—just as Cassatt knew it would. She proved that any subject, even one that is not very attractive, can be made to look beautiful by a skilled artist.

When Cassatt reached her mid-sixties, she began to go blind—just as Degas did. This made it impossible to continue her painting. As a result, she turned her attention to a new task. Acting as an adviser for her wealthy American friends, she persuaded them to buy artworks by old and new masters—especially the Impressionists. When she died at the age of eighty-two, Mary Cassatt had succeeded in enriching the world with her art, and she had enriched America with some of the world's greatest masterpieces.

Berthe Morisot

Mary Cassatt was not the only woman artist included in the Impressionist group. Berthe Morisot (bairt maw-ree-**zoh**) had a long and important career and took part in all the Impressionist exhibitions but one. That one she missed only because she was awaiting the birth of a child.

Morisot's entire life was entwined with art. A great-granddaughter of Jean-Honoré Fragonard, she was born into a family with a rich artistic tradition. From the time she was a child, she was certain that she would become a painter. At fifteen, following the ad-vice of her teacher, she began to study painting by copying pictures in the Louvre. At that time, it was common practice to learn from the masters of the past by copying their works. In the Louvre, Morisot often saw Édouard Manet. They met and became good friends. Several years later, she married Manet's brother Eugène.

Throughout her lifetime, Morisot was uncertain about her talent. She always valued the opinions and suggestions about her work from those she respected, especially Manet. When she was twenty-nine years old, she finished a portrait of her mother and sister and asked Manet to give his opinion of it. He was pleased with it, but suggested a few changes. Carried away with his critique, he suddenly picked up a brush and spent several hours retouching parts of the portrait. While he was still working, a carriage arrived to take the picture to the Salon where it was to be considered for the annual exhibition. Of course Morisot was furious with Manet because he had worked on her painting, but there was nothing else to do but send the picture as it was. Her anger did not last long though, because the painting was much acclaimed by the judges.

Like Manet, Morisot concentrated on portraits and interior scenes. However, she added a fresh, delicate vision that was entirely her own. In *The Sisters* (Figure 21.26), two young women dressed in identical ruffled gowns sit quietly on a sofa. They are almost exactly alike in appearance and manner. They are attractive and properly reserved. Neither would be so bold as to stare directly at you. Instead, they shyly lower their gaze and hold their pose patiently. It is unlikely that

they had to do so for very long. Morisot usually posed her models for short periods of time and then painted them largely from memory. In that way she was able to capture the more natural but fleeting expressions of her sitters. She avoided the stiff, artificial expressions displayed when poses were held over long periods.

Did you attach any importance to the two fans in this picture? They are not only decorative, but also act as a way of bridging the space between the sisters. The framed fan over the sofa and another held casually by the girl at the right link the two figures seated at either end of the sofa.

As with so many fine women artists throughout history, Morisot's achievements as a painter were largely overlooked in her day. Critics during her lifetime ignored her or refused to regard her as a serious, talented artist. Often this was just because she was a woman. Her fellow Impressionists, however, considered her work equal to theirs. It was not until after her death at age fifty-four that Morisot's work finally received the widespread acclaim it deserved.

Auguste Rodin

One man dominated the world of sculpture at the end of the nineteenth century and beginning of the twentieth. He was the Frenchman Auguste Rodin (oh-**gust** roh-**dan**). Like the Impressionists, he was able to capture in his work the most fleeting moments of life. His technique in sculpture was similar to that of the Impressionists in painting. As he modeled in wax or clay he added pieces bit by bit to construct his forms, just as the painters added dots and dashes of paint to create their pictures.

The uneven surfaces of Impressionist paintings are also found on Rodin's sculptures, such as *The Prodigal Son* (Figure 21.27). The way light and shadow play over the uneven surface of this figure gives it life and vitality. Rodin was more than just an Impressionist sculptor, however. The prodigal son with head and arms reaching upward is a powerful image. His wealth and self-esteem gone, at the edge of despair, he pleads for forgiveness. Rodin said he wanted to express joy and sorrow and pain as he saw them. His vision of pain and desperation is so effective here that, like the father to whom the son pleads, you are moved to show mercy.

Rodin's sculpture of *The Burghers of Calais* (Figure 21.28) was designed for public display in that French city. The work commemorates an event that took place in the city's medieval past. In 1341, six citizens presented themselves before the conquering King of Eng-

land, Edward III, dressed in sackcloth with nooses around their necks. They offered their own lives in order that their city and its inhabitants might be spared from destruction. Rodin depicts the men as they might have appeared as they approached the English king, not as a compact group of stalwart heroes, but as ordinary people reacting in different ways to impending doom. Some stride defiantly forward, others appear desperate, while still others seem to hesitate in fear. Their facial expressions and gestures, captured at a particular moment in time, echo these different emotions.

Rodin's sculpture was meant to be viewed at street level, enabling the viewer to walk up to and around it, thus making the encounter direct and immediate. The emotional impact of this encounter is powerful and enduring. The work is an unforgettable reminder of humankind's boundless capacity for love and self-sacrifice.

➤ What feeling or mood is communicated to you by this work?

Figure 21.27 Auguste Rodin. *The Prodigal Son.* c. 1907–17. Bronze. 137.8 cm (54¼"). Allen Memorial Art Museum, Oberlin College, Oberlin, Ohio. R.T. Miller Fund, 1955.

➤ In his sculptures, Rodin tried to capture the fleeting moment, as did the Impressionists. He used small pieces of clay or wax to form his works. This technique was like that of the impressionists, who used small dabs of paint to create their pictures. The uneven surface of his works also looks like the rough-textured surfaces of their paintings.

Figure 21.28 Auguste Rodin. *The Burghers of Calais.* 1884–89, cast c. 1931–47. Bronze. 2 x 2 x 1.9 m (79⅜ x 80⅞ x 77⅛"). Hirshhorn Museum and Sculpture Garden. Smithsonian Institution, Washington, D.C. Gift of Joseph Hirshhorn, 1966.

SECTION THREE

Review

1. What was stressed by the Impressionist style of art?
2. What painting technique did the Impressionists use to achieve their objective?
3. How was this Impressionist painting technique perceived by the eye of the viewer?
4. List at least three characteristics of Impressionist artworks.
5. How did the new art of photography influence the Impressionists?
6. What two famous women artists were associated with the Impressionists? Which of these artists was an American?
7. In what way are Rodin's sculptures similar to Impressionist paintings?

Creative Activity

Studio. Edgar Degas drew most of his ballet dancer artworks with pastels. In fact, he carried the secret of his intense colors to the grave with him. Pastel work should be done on a surface with *tooth* — a roughness that can pick up good quantities of the chalk. Try working on sandpaper of different grades, or try preparing a surface for your pastel drawing with gesso or acrylic medium mixed with sand.

Choose a subject with rich colors and try to capture the brilliance with colored pastels.

WATERCOLOR STILL LIFE IN THE PAINTERLY STYLE

Supplies
- Several sheets of white drawing paper or water-color paper
- Watercolors
- Brushes, mixing trays, and paint cloth
- India ink
- Pens and penholders
- Water container

Paint a still life in which the shape of each object is shown as an area of color. These areas of color are created by using a painterly technique in which still-life objects are painted quickly without the aid of preliminary outlines. Instead, you will paint each object by beginning at the center and working outward to the edges. A variety of contrasting thick and thin contour lines will be added only after all painting has been completed.

Focusing

Examine the paintings by Ingres and Delacroix illustrated in Figure 21.6 (page 486) and Figure 21.8 (page 488). How do these works differ? Which appears to place more emphasis on line? Which on color? Does one of these paintings seem more concerned with showing movement? If so, what has been done to suggest that movement?

Creating

Set up a still-life arrangement consisting of three or more objects. A variety of sizes, shapes, and colors should be represented.

Paint the still-life arrangement with watercolors, beginning with the object closest to you. As you paint each object, start in the center and work outward to the edges. Work with lighter values first and then paint in the darker values. Paint rapidly, with your eye moving continuously from the still life to your paper and back again. Fill the entire sheet of paper with paint.

When the paint has dried, outline the various shapes of the still-life objects with ink. These ink lines should be as accurate as possible in defining the objects. They are not meant to merely encircle areas of different colors. Some colors will extend beyond these outlines while others will fail to reach the contour lines. This should be expected. It is a feature of this more

Figure 21.29 Student Work

spontaneous painterly style. This style emphasizes quick application of color without the aid of preliminary, precise outlines. Additional ink lines should be added to show various details noted in the still-life objects.

Complete several of these paintings from different vantage points around the still-life arrangement. Select your best painting to critique.

CRITIQUING

• **Describe.** Are the still-life objects in your painting easily identified? Which of these is especially successful in terms of the literal qualities?

• **Analyze.** Where is the principle of variety evidenced in your painting? How did your use of line in this painting differ from your use of line in earlier paintings? Which approach do you favor?

• **Interpret.** Does your painting give the impression that it was done rapidly? Does this give it a more relaxed, informal appearance?

• **Judge.** Are you pleased with the results of this painting style? When comparing your work with that of Ingres and Delacroix, which artist's work more closely resembles your own? What theory or theories of art seems most appropriate to use when judging your painting?

Figure 21.30 Student Work

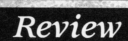

Review

Reviewing the Facts

SECTION ONE

1. What characterized the Neoclassic style?
2. Refer to Vigée-Lebrun's painting of *Madame de la Châtre* (Figure 21.4, page 484). The angle of the subject's arm is repeated somewhere else in the picture. Where?
3. What element of art did Ingres believe was the most important in a painting?

SECTION TWO

4. What element of art did Delacroix believe was the most important in a painting?
5. What were Realist artists such as Courbet attempting to do that is reminiscent of Hugo van der Goes's break with the tradition of his time?
6. Name the artist who painted *The Horse Fair* and tell what was unusual about this particular artist's choice of subject matter.

SECTION THREE

7. Why did the Impressionists paint on small canvases?
8. At the end of the nineteenth century, who was the most important sculptor? What did his technique have in common with Impressionist painters?

Thinking Critically

1. **Compare and contrast.** Refer to Jacques Louis David's *The Death of Marat* (Figure 21.2, page 482) and to the Roman copy of the *Dying Gaul* (Figure 8.24, page 181). Discuss the aesthetic qualities that seem most important to each artist. Then identify similarities and differences between the two works.

2. **Extend.** Imagine that you are a well-known television reporter noted for your probing interviews of famous people. Select an artist discussed in this chapter and prepare a list of questions that you might ask him or her during a television interview. Ask another student to play the role of the artist and, in class, conduct your "interview."

Using the Time Line

Note the year 1850 on the time line. Did you know that in that year Charles Dickens published his novel *David Copperfield*? What controversial painting was completed a year earlier? Rodin was beginning work on his sculpture of *The Burghers of Calais* as a well-known American author was putting the finishing touches on his novel about a boy's adventures on the Mississippi River. Can you identify the year, the author, and the novel?

1800	1825	1850	1875	1900

Bonheur. *The Horse Fair*

Courbet. *Burial at Ornans*

Constable. *The Dell in Helmingham Park*

Géricault. *Raft of the Medusa*

David. *Napoleon in His Study*

Monet. *Grainstack*

• Cassatt. *Girl Arranging Her Hair*
• Rodin. *The Burghers of Calais*

Degas. *The Dance Examination*

Malena Rivas, Age 17
Milton High School
Alpharetta, Georgia

Malena, an exchange student from Germany, responded to the style of the Impressionists, especially that of Monet. She decided to set up a still life and to include a mirror to provide reflected light. Her goal was to paint the fruit realistically and to capture the effect of changing light on their bright colors. Using broken brushstrokes, she started by painting the fruit. As the painting progressed, she discovered that the colors and their reflections looked different each day, depending on the quality of the light. In order to avoid the temptation to go back and repaint, she concentrated on completing one specific area each day. Her last step was to add highlights. Malena was pleased with the lively quality she attained by using short brushstrokes.

▶ *Still Life with Fruit.* Tempera. 25.4 x 35.5 cm (10 x 14″).

A Time for Rebels:
Art of the Later Nineteenth Century

Objectives

After completing this chapter, you will be able to:

➤ Identify the Post-Impressionist artists and explain their objectives.

➤ Describe the painting style of Paul Cézanne.

➤ Explain how Cézanne, van Gogh, and Gauguin influenced artists who followed them.

➤ Explain where Winslow Homer turned most often for ideas for his paintings.

➤ Discuss the contributions to the growth of American art made by African-American artists.

Terms to Know

plane
Post-Impressionism

Figure 22.1 Edward Mitchell Bannister. *Newspaper Boy.* 1869. Oil on canvas. 76.6 x 63.7 cm (30⅛ x 25"). National Museum of American Art, Smithsonian Institution, Washington, D.C. Gift of Frederick Weingeroff.

During the last two decades of the nineteenth century,

some artists who had been connected with Impressionism began to

find fault with it. They felt that this style sacrificed too much by trying to capture

the momentary effects of sunlight on forms and colors.

SECTION ONE

Europe in the Late Nineteenth Century

Artists painting during the 1880s and 1890s wanted to continue painting the contemporary world but hoped to overcome some of the problems they saw in the Impressionist style. They felt that art should present a more personal, expressive view of life rather than focusing solely on the changing effects of light on objects. While their work continued to exhibit an Impressionistic regard for light and its effect on color, it also included a new concern for more intense color and a return to stronger contours and more solid forms.

Post-Impressionism

The most important of the artists who were searching for solutions to the limits of Impressionism are Paul Cézanne, Vincent van Gogh, and Paul Gauguin. Each of these artists wanted to discover what was wrong or missing in Impressionism. Their search for an answer led them in different directions and had an important effect on the course of art history. They belong to a group of artists who are now called *Post-Impressionists*. **Post-Impressionism** was *the French Art movement that immediately followed Impressionism*. The artists who were a part of this movement showed a greater concern for structure and form than did the Impressionist artists.

Paul Cézanne

Early in his career, Paul Cézanne (pawl say-**zahn**) was associated with the Impressionists and even took part in their first exhibition in 1874. However, he never lost his strong affection for the art of the old masters.

His studies of the great artists in the Louvre led him to believe that Impressionist paintings lacked form, solidity, and structure. He spent the rest of his life trying to restore those qualities to his paintings, although he did not turn his back entirely on Impressionism. Indeed, he wanted to make Impressionism "something solid like the art of museums."

The style that Cézanne worked so hard to perfect was not realistic. He was not concerned with reproducing exactly the shapes, colors, lines, and textures found in nature. It is true that nature was his starting point, but he did not feel bound to it. He felt free to discard anything that he thought was unnecessary. Further, he carefully placed the objects in his works rather than paint them as he found them. Thus, Cézanne reversed a trend in art that had its origin with the great Italian artist Giotto. Giotto had abandoned the flat, decorative style of medieval art and turned to nature as his teacher and his model. For six hundred years, artists followed his example and did the same, trying to reproduce nature as faithfully as possible in their pictures.

Cézanne's effort to change this representational style began with experiments in still-life painting followed by pictures with figures and landscapes. Often he painted the same object over and over again until he was completely satisfied. If a picture did not please him, he would throw it out the window, or leave it in the field where it had been painted, or give it to his son to cut up for a jigsaw puzzle. In time, his patience paid off; he arrived at a technique in which he applied his colors in small, flat patches. These patches of color were placed side by side so that each one represented a separate **plane**, or *surface*. When he painted a round object such as an apple, these planes were joined together to follow the curved form of the object. Each of these planes had a slightly different color as well, because Cézanne knew that colors change as they come forward or go back in space. So he used cool colors that seemed to go back in space and warm colors that seemed to advance in space to make his painted objects look more three-dimensional.

➤ Look at the objects in this painting. Can you find some things that do not look accurate? Find as many straight lines as you can — then find lines that curve and contrast with these straight lines. Which hue dominates? Point out shapes that are painted with a color that is a complement to this dominant hue. Do the shapes look solid and heavy, or thin and fragile? When judging this work, would you refer most often to the literal qualities or the formal qualities?

Figure 22.2 Paul Cézanne. *Still Life with Peppermint Bottle.* c. 1894. Oil on canvas. 65.9 x 82.1 cm (26 x 32⅜"). National Gallery of Art, Washington, D.C. Chester Dale Collection.

It might be easier for you to understand Cézanne's technique if you imagine that someone gave you a pile of bricks and asked you to build a high, curved wall. You would have to arrange each brick so that it turned slightly in order to make the wall round. Now, try to imagine painting that same wall by using patches or planes of color to make it look round. Each plane of color would be placed next to another at a slightly different angle just as the bricks had been placed next to one another. To show that the planes were coming forward or going back into space, you would have to change the color of each plane slightly. With this technique, Cézanne was able to create the solid-looking forms that he felt were missing in Impressionist pictures.

Cézanne developed this painting technique with still-life pictures. You can learn more about it by studying one of those paintings (Figure 22.2). Earlier artists like Chardin (Figure 20.7, page 463) painted still lifes because this type of subject matter allowed them to choose objects for their unique shapes, colors, lines, and textures. Cézanne was interested in still-life objects because they did not move and he could study them closely. In portrait painting, the subject often moved. Still-life painting, on the other hand, gave him the chance to study and paint objects over long periods of time. Sometimes he even used artificial fruit and flowers, because they would not spoil or

wilt over the long hours in which he studied and painted them.

Up close, everything in Cézanne's still life seems flat, because your eye is too near to see the relationships between the colored planes. When viewed from a distance, however, these relationships become clear, and the forms take on a solid, three-dimensional appearance.

Notice how every object in Cézanne's still life has been carefully positioned. There are no "happy accidents" here. Like a master builder, he has placed objects so they balance and complement each other. All the pieces in his picture fit neatly together to form a unified design. The dark vertical and horizontal bands on the wall not only hold the picture together but also direct your eye to the most important objects arranged in the center of the composition. To balance the strong horizontal lines at the right, Cézanne has strengthened the contour of the white napkin at the left by placing a shadow behind it. Because the firm line on the wall to the right of the glass jug might compete with the jug, he blends it out. Then he adds a dark blue line to strengthen the right side of the jug. To add interest and variety, Cézanne contrasts the straight lines with the curved lines of the drapery, fruit, and bottles.

The blue-green hue used throughout this painting helps to pull the parts together into an organized

whole. Also, Cézanne showed a preference for blue tones whenever he wanted to show depth. Observe how the pieces of fruit placed throughout the middle of the still life seem to float forward toward you and away from the blue-green cloth and wall. This illusion is due to the warm reds and yellows used to paint the fruit. These hues are complements to the cool blue-green. When placed before a blue-green background, they appear to come forward.

Cézanne's still life does not look very realistic; the drapery fails to fall naturally over the edge of the table, and the opening at the top of the jug is too large. However, he was willing to sacrifice realism in order to achieve another goal. He wanted the apples to look solid and heavy and the napkin and tablecloth to appear as massive and monumental as mountains.

This same solid, massive quality is found in Cézanne's landscapes. Notice how the rock in the foreground of his *Pines and Rocks* (Figure 22.3) looks heavy and solid. Small brushstrokes have been used to suggest the form of this rock, giving it the weight and volume of a mountain. The foliage of the trees is painted as a heavy mass of greens and blue-greens. Like everything else in the work, the foliage is created with cubes of color. The work has the appearance of a three-dimensional mosaic. Some cubes seem to tilt away from you, while others turn in a variety of other directions. They lead your eye in, out, and around the solid forms that make up the picture. In some places outlines are firm and strong, and in others they fade out, allowing forms to blend together to unify the composition.

Cézanne did his best to ignore the critics who scorned or laughed at his work. Even the people in the little town where he lived thought that he was strange. They wondered about a man who spent his days alone painting in the fields, creating works that no one bought. What sort of an artist would stand for long periods of time staring at a little mountain? Further, when he finally put his brush to canvas, he would make no more than a single stroke before returning to his study. Cézanne painted more than sixty versions of the little mountain known as Sainte-Victoire (Figure 22.4 and Figure 1.2, page 6). In each, he used planes of color to build a solid form that is both monumental and durable.

One day while he was painting in the fields, it began to rain; but Cézanne refused to stop working and seek shelter. Finally, he collapsed. He was picked up by a man in a passing laundry cart and taken home. A few days later he died of pneumonia.

➤ How did Cézanne show form and solidity in this work?

Figure 22.3 Paul Cézanne. *Pines and Rocks (Fontainebleau?)*. 1896–99. Oil on canvas. 81.3 x 65.4 cm (32 x 25¾"). The Museum of Modern Art, New York, New York. Lillie P. Bliss Collection.

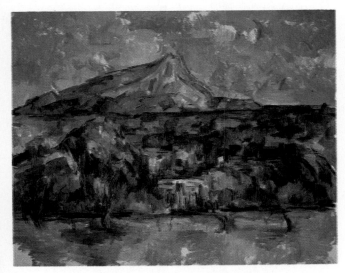

➤ Cézanne, like Claude Monet, often painted the same subject over and over again. Were the objectives of these two artists the same? How did they differ?

Figure 22.4 Paul Cézanne. *Mont Sainte-Victoire*. 1902–06. Oil on canvas. 63.8 x 81.5 cm (25⅛ x 32⅛"). Nelson-Atkins Museum of Art, Kansas City, Missouri. Nelson Fund.

Vincent van Gogh

There are few people today who are not familiar with the tragic story of Vincent van Gogh (**vin**-sent van **goh**). It has been told and retold in scores of books, motion pictures, and even in popular songs. This is unfortunate, because the story of this unhappy artist's life has probably lured attention away from his art.

As a young man, van Gogh worked as a lay missionary in a poor Belgian mining village, but he was a failure at this vocation. More and more he withdrew into himself and turned to his art. He loved art; wherever he went he visited museums and would draw and paint at every opportunity. His early pictures were painted in browns and other drab colors and showed peasants going about their daily routines. One of these early paintings was *The Potato Eaters* (Figure 22.5). In this picture, a peasant family has gathered around a table to eat their humble meal of potatoes. In most families, this would be a happy time, a time

to share experiences and talk over the events of the day. However, there is no happy chatter here. This day is no different from any other day. It has meant the same backbreaking work in the dark mines for the men and the usual dull routine in and around the drab cottage for the women.

The interior of the cottage is dark and cool. Steam rises from the potatoes and from the tea, and everyone wears heavy clothing. There is little color; the walls, clothing, and even the faces of the people have an earthen hue. It looks as if the entire scene is taking place underground. Look at the faces a moment; what do they resemble? Surprisingly, they look like the potatoes that grow in the ground and provide this poor family with its only nourishment.

You have seen paintings before that draw you into them and make you feel like a participant in the event. Jan Steen's *Eve of St. Nicholas* (Figure 19.15, page 443) is an excellent example of such a painting. In *The Potato Eaters*, van Gogh *prevents* you from join-

➤ Give your interpretation of this painting; be sure to mention why you think the people do not seem to be enjoying themselves.

Figure 22.5 Vincent van Gogh. *The Potato Eaters*. 1885. Oil on canvas. 82 x 114 cm (32¼ x 44⅞"). National Museum Vincent van Gogh, Amsterdam, Holland.

➤ Large, flat areas of bright color and a strange perspective are noted in this painting of Van Gogh's narrow room. What two influences contributed to the development of this artist's painting style?

Figure 22.6 Vincent van Gogh. *The Bedroom at Arles.* 1888. Oil on canvas. 73.6 x 92.3 cm (29 x 36"). The Art Institute of Chicago, Chicago, Illinois. Helen Birch Bartlett Memorial Collection.

ing the family around the dinner table. His figures form a tight circle, and the young girl even turns her back to you. Why do you think the artist has done this? Possibly he is trying to tell you that you can never join this family circle without first experiencing the poverty and the hardship they have experienced. You are allowed to be no more than a silent witness to their actions. You can never share their hopelessness without being hopeless yourself.

In 1886, van Gogh moved to Paris to be with his brother Theo, an art dealer. Recognizing his brother's abilities as an artist, Theo gave van Gogh an allowance so that he could continue painting. While he was in Paris, van Gogh was influenced by the art of the Impressionists. As a result, he started to use brighter colors and more spirited brushstrokes. At about this same time, he saw his first Japanese woodcut prints. These also had an effect on his painting style. He began to use large, flat areas of color and to tilt his subject matter to present a strange new kind of perspective (Figure 22.6).

In 1888, when he was thirty-five years old, van Gogh traveled to the city of Arles in the south of France. He hoped to find there the brilliant colors he saw in Japanese prints, but because the Impressionist technique of using short brushstrokes to apply dabs and dashes of paint did not suit his restless and excitable personality, he began to turn away from Impressionism to develop his own painting style. This style was marked

by a use of bright colors, twisting lines, bold brushstrokes, and a thick application of paint. The bright sunshine of southern France offered him a landscape of vivid colors. He began to paint fields bathed in sunlight and trees and flowers that twisted and turned as if they were alive. In his eagerness to capture these colors and forms in his pictures, he would squeeze yellows, reds, and blues from the paint tubes directly onto his canvas. Then he used his brush and even his fingers to spread the paint with swirling, curving strokes.

During this period, the last two years of his life, van Gogh painted his best works—portraits, landscapes, interiors, and night scenes. In one of his night scenes, *The Starry Night* (Figure 22.7, page 516), you can see how quick slashes of paint were used to create the dark cypress trees that twist upward like the flame from a candle. Overhead the sky is alive with bursting stars that seem to be hurtled about by violent gusts of wind sweeping across the sky. Short, choppy brushstrokes are combined with sweeping, swirling strokes, which give a rich texture to the painting's surface. Unlike Cézanne, van Gogh did not try to think his way through the painting process. He painted what he *felt*, not what he thought. Here he felt and responded to the violent energy and creative force of nature. In order to capture that energy and force, he had to develop a painting style that was energetic and forceful.

➤ Describe the texture of this painting. Is this an example of actual texture, or simulated texture? Do you think this picture represents what the artist saw, or what he felt? Explain your answer. Which of the following terms would you use when interpreting this work: calm, peaceful, dull, exciting, forceful? What does this picture tell you about nature?

Figure 22.7 Vincent van Gogh. *The Starry Night.* 1889. Oil on canvas. 73.7 x 92.1 cm (29 x 36¼"). Collection, The Museum of Modern Art, New York, New York. Acquired through the Lillie P. Bliss Bequest.

Van Gogh's personality was unstable, and he suffered from epileptic seizures during the last two years of his life. Informed that there was no cure for his ailment, he grew more and more depressed. He lived in fear that his seizures would become more frequent and more severe. If this were not enough, he worried about the burden he placed upon his brother Theo, who had been providing him with money for years. Theo was married and had a son, and van Gogh felt that he was a greater burden to his brother than ever. Finally, on a July evening in 1890, in a wheat field where he had been painting, van Gogh shot himself. The wound was not immediately fatal, however, and he was able to return to his room where Theo rushed to his side. He died two days later. Like Raphael and Watteau before him, van Gogh died at the age of thirty-seven.

As for Theo, the faithful brother, he was so heartbroken that he died six months later. He is buried in Auvers, beside the artist brother he unselfishly encouraged, supported, and loved.

Vincent van Gogh received only one favorable review and sold only one painting during his lifetime. His art, however, served as an inspiration for many artists who followed. Today the works of this lonely, troubled man are among the most popular and most acclaimed in the history of painting.

Paul Gauguin

Like Cézanne and van Gogh, Paul Gauguin (pawl goh-**gan**) passed through an Impressionistic period before moving in another direction. He was a successful broker who began painting as a hobby. Under the influence of some of the Impressionists, he exhibited with them in the early and mid-1880s. Then, at the age of thirty-five, he left his well-paying job and turned to painting as a career. This was not a popular decision with Gauguin's wife and family. They could not understand how a successful businessman could give up everything for art. To make matters worse, his paintings did not sell, and he and his family were reduced to poverty. Still, Gauguin never lost heart. He felt that he was destined to be a great artist.

Throughout his career, Gauguin moved from one location to another in search of an earthly paradise with exotic settings that he could paint. His quest took him from Paris to Brittany to Provence to the South Seas, where he lived with the natives and shared their way of life. In Tahiti, he painted a strange and haunting picture entitled *Spirit of the Dead Watching* (Figure 22.9, page 518). In a letter to his wife, Gauguin tried to describe and explain this work. First, he painted a young girl lying on a bed. She has been frightened by the spirit of a dead woman appearing behind her. Gauguin explained that this girl was a

Melissa Miller

Melissa Miller (b. 1951) never intended to become an animal painter, but she is now famous for her portraits of domestic and wild animals in landscapes. The paintings of zebras, hyenas, polar bears, salmon, and other animals have a strong affinity with the brightly colored palette and expressionistic brushstrokes pioneered by Vincent van Gogh. Miller's work also recalls the animal pictures created by nineteenth-century painter Rosa Bonheur (Figure 21.15, page 495). Unlike many contemporary artists whose works have expressionistic roots, Miller combines the emotionally charged quality associated with strong color and loose handling of paint with concern for technical skill and realistic detail.

Miller was born and raised in Houston, and her interest in animals can be traced to the time she spent at the Texas ranches of her relatives and at her grandparents' cabin in New Mexico. Miller notes, "We didn't have TV during those visits, so we invented things and spent our time outdoors. Now when I look at what I paint, I see a real connection to the experiences of my childhood; the wild animals, the livestock, the pets, and all that time spent in a rural environment."

As a teenager, Miller was not particularly interested in the visual arts. Nevertheless, on the first day of freshman orientation at the University of Texas in Austin, she spontaneously decided to major in art. After she graduated from college with a degree in art, Miller worked with a teacher who emphasized the traditional skills of drawing in perspective and rendering three-dimensional space. She loved this approach and began to paint from nature.

Miller returned to Texas and spent most of her time taking care of the family ranch. Her first paintings of animals depicted the chickens, cows, dogs, and cats that were nearby: "I really enjoyed that moment of recognition, of seeing some animal I knew evolve on the canvas. I began to realize that the animals in all of my paintings were more important than the people."

Eventually Miller branched out and painted exotic and wild animals that required a great deal of research to depict. Sometimes she works in series. For example, she painted a "nighteaters" series inspired when she returned home after a trip abroad and discovered that her garden had been devoured by "nighteaters" such as deer, racoons, and rabbits. Other paintings by Miller take a more fanciful approach, such as her picture of tigers and leopards watching one of their group transform into an ethereal creature. Such subjects allow her to explore a wide range of emotional relationships and themes, such as the conflict between life and natural forces. She says, "My paintings combine many, many different sources and ideas; they don't come from just one place. Often I simply delight in the images my mind comes up with and there *is* no 'message.'"

Figure 22.8 Melissa Miller. *Zebras and Hyenas.* 1985. Oil on linen. 183.6 x 213 cm (72⁵⁄₁₆ x 83⁷⁄₈"). Archer M. Huntington Art Gallery, The University of Texas at Austin, Austin, Texas. Michener Collection Acquisition Fund, 1985.

Maori and that these people had a great fear of ghosts and spirits. He made the ghost in the painting look like a little woman because the girl believed that ghosts looked like the people they were in life.

Gauguin was more interested in creating a decorative pattern than a picture that looked real. Flat areas of bright colors are combined with forms that look round and solid. Notice how the shapes that surround the girl are arranged in a relatively flat pattern, while the body of the girl looks three-dimensional. Gauguin felt that the artist should be free to use light and shadow when and where he wanted, but that he should never feel bound to do so.

Gauguin's pictures started with the exotic subject matter he searched for in his travels. As he painted, however, he allowed his imagination to take over. "I shut my eyes in order to see," he said. What he saw were crimson rocks, gold trees, and violet hills. He used color in unusual ways to make his pictures more visually exciting. "How does that tree look to you?" he asked. "Green? All right, then use green, the greenest on your palette. And that shadow—a little blue? Don't be afraid. Paint it as blue as you can."

Gauguin's novel ideas about color are demonstrated in another picture he did in Tahiti entitled *Fatata te Miti* (Figure 22.10). This means "By the Sea" in the Maori language, which Gauguin learned. Beyond a huge, twisted tree root, two native girls wade out into the blue-green sea for a swim. In the distance, a fisherman with spear in hand stalks his quarry. Flat areas

➤ Do you think the girl knows the little woman is there? Why doesn't the girl turn around and face her?

Figure 22.9 Paul Gauguin. *Spirit of the Dead Watching*. 1892. Oil on burlap mounted on canvas. 72.4 x 92.4 cm (28½ x 36⅜"). Albright-Knox Art Gallery, Buffalo, New York. A. Conger Goodyear Collection, 1965.

of bright colors, especially in the foreground, give the picture the look of a medieval stained-glass window. Except for the figures, the forms are flattened into planes of color that overlap to lead you into the work. Gauguin is not really interested in creating the illusion of real space here. He is more concerned with combining flat, colorful shapes and curving contour lines to produce a rich, decorative pattern.

➤ What do you see in this picture? What has been done to create the illusion of depth? Identify the most intense color. Are there many straight lines in this work? Describe the contour lines. Would you judge this work mainly in terms of its literal, formal, or expressive qualities? Do you think it is successful?

Figure 22.10 Paul Gauguin. *Fatata te Miti* (*By the Sea*). 1892. Oil on canvas. 67.9 x 91.5 cm (26¾ x 36"). National Gallery of Art, Washington, D.C. Chester Dale Collection.

Although he returned to Paris for a short time, Gauguin's last years were spent in the Pacific Islands. Unfortunately, he had little money, was in poor health, and was always arguing with local officials. In 1903, he was sentenced to three months in prison for an insulting letter sent to a government official. Before he could serve his sentence, he died, alone and helpless in his hut.

Gauguin always believed he would be a great artist, and he was right. His contribution to the history of art is unquestioned. He succeeded in freeing artists from the idea of copying nature. After Gauguin, artists no longer hesitated in using a bright red color to paint a tree that was only touched with red or an intense blue to paint a shadow with a bluish cast. Later artists felt free to change the curve of a branch or a shoulder to the point of exaggeration. They felt at liberty to paint any way they wished.

The Influence of These Artists

Cézanne, van Gogh, and Gauguin saw the world in different ways and developed their own methods to show others what they saw. Cézanne sought weight and solidity in his carefully composed still lifes, landscapes, and portraits. He used planes of warm and cool colors that advance and recede to model his forms, creating a solid, enduring world with his brush. Van Gogh used vibrating colors, distortion, and vigorous brushstrokes to show a world throbbing with movement and energy. Gauguin took the shapes, colors, and lines he found in nature and changed them into flat, simplified shapes, broad areas of bright colors, and graceful lines. Then he arranged these elements to make a decorative pattern on his canvas.

Each of these artists experienced loneliness, frustration, and even ridicule; but their work had a tremendous influence on the artists of the twentieth century. Cézanne inspired Cubism. Van Gogh influenced the Fauves and the Expressionists. Gauguin showed the way to different groups of primitive artists and American Abstract Expressionists.

SECTION ONE

Review

1. During what time period did French artists begin to become dissatisfied with the Impressionist style?
2. What was the name of the French art movement that immediately followed Impressionism?
3. What did Cézanne believe was lacking in Impressionistic paintings?
4. How did Vincent van Gogh convey the hopelessness of the family portrayed in *The Potato Eaters*?
5. Describe van Gogh's later painting style and tell how it differed from the style of his earlier paintings, such as *The Potato Eaters*.
6. What was Paul Gauguin searching for by moving from one location to another? Where did he paint *Spirit of the Dead Watching*?
7. Describe how Gauguin used color to make his paintings more decorative.

Creative Activity

Humanities. The world of the late nineteenth century was taking a new look at many things. Musicians, such as Arnold Schoenberg, began rethinking the scale and triadic harmony, on which all Western music had been written for centuries. They began inserting semitones between the notes of the major and minor scales. This device, called *chromaticism*, resulted in a twelve-tone scale. The construction of brass instruments was modified by fitting them with valves that could play the new semitones.

This twelve-tone method is sometimes called *atonalism*—a musical language based on the equality of all twelve chromatic notes. Listen to works by Schoenberg, and compare his structured approach to sound with Cézanne's structured forms in painting.

America in the Late Nineteenth Century

The United States came of age in the nineteenth century and began to be aware of itself as a nation. It was a time of great change and growth. There was growth westward, growth in trade and industry, growth in population, and growth in wealth. Although the Civil War stopped the rate of progress for a time, it continued with a new vigor after the war ended.

American scientists, inventors, and businessmen provided new products to make life easier for people. These were products such as the typewriter, sewing machine, and electric lamp. Meanwhile, immigrants from all over Europe brought their knowledge and skills to the new world. Great fortunes were made. Wealthy industrialists and businessmen like Carnegie, Rockefeller, and Morgan funneled some of their riches into schools, colleges, and museums. Interest in education grew due to the efforts of Horace Mann, Henry Barnard, Emma Willard, and others. The first state university was founded in 1855 in Michigan, and others quickly followed. By 1900, the United States had become a world leader.

Changes in American Art

Change and growth were also noted in American art. Works were produced by self-taught artists traveling from village to village. Other works were created by more sophisticated artists who journeyed to the art centers of Europe to study. Some chose to remain there, where they became part of European art movements. Others returned to the United States to develop art styles that were American in subject matter and technique. One of these artists was Winslow Homer.

Winslow Homer

Homer was born in 1836 in Boston, Massachusetts. When he was six, his family moved to Cambridge, and it was there, growing up with his two brothers in the country, that Homer learned to love the outdoors. This was a love of a lifetime that he expressed through his paintings.

Homer's interest in art began while he was quite young. He was about ten years old when his talent for drawing became obvious to those around him. His mother was an amateur painter, and she as well as other members of his family approved of the boy's enthusiasm for art. When he was nineteen, Homer was accepted as an apprentice at a large printing firm in Boston, even though he had little formal art training. However, he soon tired of designing covers for song sheets and prints for framing and decided to become a magazine illustrator.

For seventeen years, Homer earned his living as an illustrator, chiefly for *Harper's Weekly* in New York. During the Civil War, *Harper's* sent him to the front lines, where he drew and painted scenes of army life. His first public recognition came in 1866 for a painting entitled *Prisoners at the Front*.

After the war, Homer decided to strike out on his own as a painter. He traveled a great deal, drawing and painting the things he saw. The income from the sale of his works financed two trips to Europe. In between these trips, he painted the American scene: pictures of schoolrooms, croquet games, and husking bees—pictures that were popular with everyone but the critics. They felt his works were too sketchy and looked unfinished.

From 1883 until his death, Homer lived in Prout's Neck, Maine, where the ocean crashing against majestic cliffs inspired many of his great seascapes. His paintings followed hours in which he studied the ocean in all its moods, as well as the sun and clouds, rain and fog. Long regarded as one of the most skillful and powerful painters of the sea, Homer is seen at his best in works such as *The Fog Warning* (Figure 22.11).

In this painting, a lone fisherman in oilskins rests the oars of his small dory and takes advantage of his position on the crest of a wave to get his bearings. He turns his head in the direction of a schooner on the horizon, although his eyes are locked on the fog bank beyond. Apparently the fisherman is returning to the schooner after a successful day of fishing, for there are two or three large fish amid the items in the dory. The sea is very rough. Whitecaps are clearly visible, and the bow of the light dory is lifted high in the air, while the stern settles deep into a trough of waves. Overhead the sky is still clear but touched with the fading colors of late afternoon and marred by the fog bank lying low on the horizon. All the signs evident in the sea and the sky point to an approaching storm.

Different values separate the sea, sky, and fog. The horizontal contour lines of the oars, boat seats, horizon, and fog bank contrast with the diagonal axis lines of the dory and portions of the windblown fog. Notice in particular how effectively Homer directs your attention to the right side of the picture. A diagonal line

➤ How has this scene been made to look lifelike? What is the man in the boat doing? What do you see on the horizon? Describe the action of the sea — is it calm or rough? Do you think the fisherman is in danger? If so, what do you think he will do next?

Figure 22.11 Winslow Homer. *The Fog Warning.* 1885. Oil on canvas. 76.2 x 121.9 cm (30 x 48"). Courtesy of Museum of Fine Arts, Boston, Massachusetts. Otis Norcross Fund.

representing the crest of the wave on which the dory rests leads your eye in this direction. Furthermore, the curving axis line of the fish in the dory guides you to the same destination. There you discover the schooner and the advancing fog bank. Why was Homer so interested in making certain that you did not overlook these two items? Because they make it clear that this is not just a pleasant, very realistic picture of a man in a fishing boat. The concerned gaze of the fisherman, the choppy sea, and the fog bank suggest a great deal more. Homer has caught the exact moment that the fisherman recognizes the danger he is in. He stops rowing for just a few seconds. Even the dory seems frozen at the top of a wave as he calculates whether or not he will be able to reach the schooner before it is hidden by the windswept fog. For a moment, he cannot catch his breath. His pulse quickens. You know that the next instant he will begin rowing as he has never rowed before in a desperate race to beat the fog to the schooner. His survival depends on whether or not he can win that race. If he loses, he will be lost, alone, and at the mercy of the storm.

Homer's unique imagination and organizational skills are further shown in a painting finished a year before his death, *Right and Left* (Figure 22.12). The horizontal and diagonal lines of the waves and clouds provide a backdrop for two ducks. One is plunging into the sea, while the other rises upward and is about

➤ From what point of view are you witnessing this scene? Explain how the background is organized; be sure to discuss how lines, shapes, and values are used. What do you think are the most successful features of this work?

Figure 22.12 Winslow Homer. *Right and Left.* 1909. Oil on canvas. 71.8 x 122.9 cm (28¼ x 48⅜"). National Gallery of Art, Washington, D.C. Gift of the Avalon Foundation.

to fly out of the picture. You may be so engrossed with the startling realism of the ducks that it comes as a surprise when you realize that your vantage point is in the sky, near the two ducks. You are looking back at a hunter in a boat who has already shot the duck at the right and is, at this moment, firing at the second duck. Homer has placed you at the same height as the ducks, so you can look down at the stormy sea and the hunter.

Not long after painting *Right and Left*, Homer completed a picture entitled *Driftwood*. It shows a small, solitary human figure observing the sea in a storm. It was Homer's final tribute and farewell to the sea he loved. When it was finished, he set aside his easel and his brushes, never to paint again. A short time later, after a full and active life, Winslow Homer died.

Thomas Eakins

Winslow Homer and Thomas Eakins (**ay**-kins) are considered to be among the first Realists in American painting. Both were firmly rooted to their time and place and drew upon these roots for their work. The subjects they chose differed, however. Homer, as you know, chose to portray the drama of nature, especially the sea. Eakins, by contrast, was mainly interested in painting the people and scenes of his own Philadelphia setting.

Early in his career, Eakins studied in the Paris studios of a Neoclassic artist and was certainly influenced by the realism of Courbet. However, he learned the most from the seventeenth-century masters Velázquez, Hals, and the painter he called "the big artist," Rembrandt. From Rembrandt, Eakins learned to use light and dark values to make his figures look solid, round, and lifelike.

When he returned to the United States, Eakins found that Americans did not appreciate his highly realistic style. They preferred sentimental scenes and romantic views of the American landscape. Many felt his portraits were too honest, too lifelike. Eakins painted only what he saw. He would not flatter his subjects. Even though it reduced his popular appeal, Eakins never varied his realistic style during a career that spanned forty years.

One of Eakins's best works and one of the great paintings of the era was *The Gross Clinic* (Figure 22.13). The famous surgeon, Dr. Gross, has paused for a moment during an operation to explain a certain procedure. Eakins draws attention to the head of the doctor by placing it at the tip of a pyramid formed by the foreground figures. Behind, barely visible in the darkness of the medical arena, the doctor's students watch and listen attentively.

➤ What did Eakins do to make his figures look so authentic? Why did many Americans object to his portraits?

Figure 22.13 Thomas Eakins. *The Gross Clinic*. 1875. Oil on canvas. 244 x 198 cm (96 x 78″). The Jefferson Medical College of Thomas Jefferson University, Philadelphia, Pennsylvania.

The artist's attention to detail and his portrayal of figures in space give this painting its startling realism. For some viewers, it was too real. They objected to the blood on the scalpel and hand of the surgeon. It would have been impossible, however, for Eakins not to show everything he saw exactly as he saw it. You may wonder why the doctors and attendants around the patient are shown in street clothes. This was the custom before science discovered that a sterile environment was needed to protect the patient from infection. You may be relieved to learn that the cringing figure at the left is not a doctor but a relative of the patient. The law at that time required that a relative be present as a witness during surgery.

Throughout his life, Eakins was fascinated by the study of the human body. He was a knowledgeable, enthusiastic student of anatomy by dissection and required his own students to dissect corpses to learn how to make their figures look more authentic. His knowledge of the human body was so vast, in fact, that he once gave a paper on this topic to a scientific group. It was this knowledge that enabled Eakins to

paint figures that looked as if every bone and muscle had been taken into account.

Albert Pinkham Ryder

Eakins and Homer painted realistic scenes from everyday American life. The works of Albert Pinkham Ryder, on the other hand, were inspired by the Bible, Chaucer, Shakespeare, and nineteenth-century romantic writers. Ryder went to Europe several times, although he exhibited little interest in the works of other artists he saw there. He lived as a hermit, apart from the rest of the world, and looked within himself for inspiration.

Ryder was born in New Bedford, Massachusetts, when it was still a thriving fishing port. When he was a young man, his family moved to New York City, where an older brother helped pay his expenses to art school. At first Ryder lived in Greenwich Village, but later he moved to a humble rooming house on the city's West Side. There he slept beneath piles of old overcoats on a floor littered with stacks of yellowing newspapers, empty cans, and other trash. Troubled with poor eyesight, he remained indoors during the day and roamed the streets of the city alone at night. Passersby must have wondered about the big bearded man dressed in tattered clothing, especially when they observed him staring for long periods of time at the moon. Perhaps, during those walks alone down dark city streets, ideas were formed that Ryder eventually expressed in his paintings.

In *Jonah* (Figure 22.14), Ryder shows the Old Testament figure flailing about helplessly in a sea made turbulent by a raging storm. Jonah has been tossed from the frail boat by a crew who are filled with fright and who hold him responsible for their misfortune. The whale, in whose stomach Jonah is to spend three days, is fast approaching at the right. It is almost lost in the violent action of the water. Ryder's version of the whale may look strange to you. He had never seen the real thing, so he had to rely on his imagination when painting it. At the top of the picture, barely visible in a golden glow, God, Master of the Universe, looks on.

Color and texture were as important to Ryder as the objects or events he painted. His small pictures were built up carefully over months and even years until the forms were nearly three-dimensional. At one time these simple, massive forms had the rich color of precious stones. Now the colors have faded, because his paints were of poor quality or were applied improperly. However, there is more to Ryder's pictures than texture, form, and color. If you have seen the fury of a storm at sea or have been in a boat during such a storm, you will be aroused by his pictures. Even if you have never seen or experienced the sea in this way, Ryder's paintings act as a springboard for your imagination. This would please Ryder, who withdrew from

➤ Find the following principal characters in this drama: (a) a man in the sea, (b) a whale, (c) a boat manned by a frightened crew, (d) God. Which elements of art dominate in this picture? What is your interpretation of this scene? Is this a successful work of art? What aesthetic qualities would you use to defend your decision?

Figure 22.14 Albert Pinkham Ryder. *Jonah.* c. 1885. Oil on canvas. 69.2 x 87.3 cm (27¼ x 34⅜"). National Museum of American Art, Smithsonian Institution, Washington D.C. Gift of John Gellatly.

Art · PAST AND PRESENT ·

Photography Then and Now

The technology of photography has changed dramatically since the 1850s, when some of the first photographs were taken. In the early days, the photographer had to use a huge box camera that he or she looked through in order to see and shoot. A cloth was draped over the photographer's head to keep the light out. The subjects of the photograph had to sit still for their shapes to be captured clearly.

Now, however, the technology of photography is so advanced that a camera can catch an athlete in the act of running, and the photograph that results can be as clear and focused as if the subject had been standing completely still. Cameras have lenses that are capable of catching scenes both up close and very far away. Modern cameras have automatic focus; the photographer merely needs to aim and shoot. Video cameras are another exciting advance in the technology of photography; one can record events as they occur and then show the film on a video cassette recorder/player. There are even disposable cameras that come equipped with film.

Figure 22.15 Capturing Wildflowers on Film

When the photographer sends the film to be developed, he or she sends the whole camera, which is broken open and disposed of.

Other advances in the technology of photography are less obvious. Cameras now have better focusing mechanisms and produce clearer pictures; they are easier to use; and while one can spend thousands of dollars on photography equipment, inexpensive, good-quality cameras are also available.

➤ Where did Ryder often turn to find ideas for his paintings? In what ways does this picture seem more like a scene from a dream than from real life?

Figure 22.16 Albert Pinkham Ryder. *Flying Dutchman*. c. 1887. Oil on canvas. 36.1 x 43.8 cm (14¼ x 17¼"). National Museum of American Art, Smithsonian Institution, Washington, D.C.

the world around him and relied upon his own imagination for inspiration. In this way, he discovered a dream world where dark boats sail soundlessly on moonlit seas (Figure 22.16), mysterious forests are bathed in an unearthly light, and death rides a pale horse around a deserted racetrack.

African-American Artists

African-American artists have contributed a great deal to the growth of art in the United States. In colonial times, many artists were black. They gained much success traveling from one town to the next and practicing their craft. One such artist, Joshua Johnston of Baltimore, was in demand among wealthy Maryland families who sought him out to paint their portraits. However, after his death, other artists were often given credit for pictures that were actually painted by Johnston. Such mistakes are now being corrected, and Johnston's place in history is being confirmed.

Two years after the Civil War, a black artist was angered by an article in a New York newspaper. The artist was Edward Mitchell Bannister from Providence, Rhode Island. The writer claimed that blacks were especially talented in several arts, but not in painting or sculpture. Bannister later shattered that claim by becoming the first American black painter to win a major award at an important national exhibition. His landscape *Under the Oaks* received first prize at the Philadelphia Centennial Exhibition. It is of interest to note that when the judges learned that he was black, they considered withdrawing the award. The other artists in the show, however, insisted that Bannister receive the award he had won.

Although he preferred to create romantic interpretations of nature in pictures of the land and sea, Bannister also painted portraits and other subjects as well. One of these, painted in 1869, shows a well-dressed newsboy clutching a bundle of newspapers (Figure 22.1, page 510). The boy stares intently ahead while reaching into his pocket with his left hand. He may have just sold a newspaper and is pocketing the coins received. However, the expression on his face is not what one would expect of a boy who has just made a sale. The expression and his actions suggest that he may be checking his pocket to determine how much money is there. Perhaps the search has revealed only a few coins to reward him for his day's labor. Bannister captured the serious expression of a young man concerned with earning his way.

➤ How would you answer someone who claimed that this picture was too sentimental?

Figure 22.17 Henry Tanner. *The Banjo Lesson.* 1893. Oil on canvas. 124.5 x 90.2 cm (49 x 35½"). Hampton University Museum, Hampton, Virginia.

Henry Tanner

The most famous African-American artist of the late nineteenth and early twentieth centuries was Henry Tanner. Tanner was born and raised in Philadelphia. His father was a Methodist minister who later became a bishop. Tanner's interest in art began by chance when he was just twelve. One day he and his father were on an outing in a city park when they happened to see a landscape painter at work. The boy was fascinated, and this fascination grew with the years. Finally, against his father's wishes, he enrolled at the Pennsylvania Academy of the Fine Arts. There he studied with Thomas Eakins. They became friends, and Eakins influenced Tanner to turn from landscapes to genre scenes. Eakins also convinced his student to stay in the United States rather than go to Europe. Eakins saw little need to go abroad when there was so much of interest to paint in the United States. Tanner took his advice and went south to North Carolina and

➤ How does this picture differ from a painting of the same subject by Rubens (Figure 19.10, page 438)? Describe the different ways each artist chose to portray Daniel. Which of these two works do you favor? Why?

Figure 22.18 Henry Tanner. *Daniel in the Lion's Den.* 1922. Oil on paper mounted on canvas. 104.5 x 126.7 cm (41⅛ x 49⅞"). Los Angeles County Museum of Art, Los Angeles, California. Mr. and Mrs. William Preston Harrison Collection.

Georgia when he had finished his studies at the Academy.

Tanner's painting of *The Banjo Lesson* (Figure 22.17, page 525) grew out of his experience among the blacks of western North Carolina. Here, under the watchful eye of an old man, a boy strums a tune on a worn banjo. Man and boy are lost in concentration, forgetting for a precious few moments their humble surroundings. This music lesson represents more than just a pleasant way to pass the time for them. For the old man, music is his legacy to the boy, one of the few things of value he has to pass on to him. For the boy, music may represent the one source of pleasure he can always rely on in a world often marked by uncertainty and difficulty. Tanner tells this story simply and without sentimentality, and because he does, it is not likely to be forgotten.

In time, Tanner decided to ignore Eakins's advice to remain in the United States. He was not enjoying financial success—a one-man show in Cincinnati failed to sell a single work. Furthermore, his strong religious upbringing made him eager to paint biblical subjects. It was time for a new start. So following the route of many leading artists of his day, Tanner journeyed to Paris when he was thirty-two years old. Five years later his painting of *Daniel in the Lion's Den* (Figure 22.18) was hanging in a place of honor in the Paris Salon. The next year, another religious painting was awarded

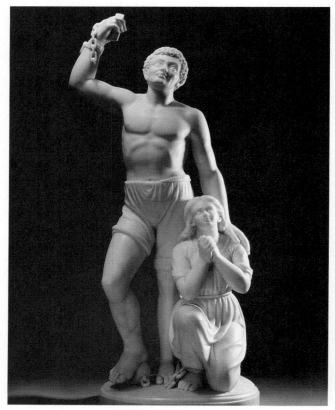

➤ What freedom does this sculpture symbolize?

Figure 22.19 Edmonia Lewis. *Forever Free.* 1867. Marble. The Howard University Gallery of Art, Permanent collection. Howard University, Washington, D.C.

a medal and purchased by the French government. The recognition Tanner failed to receive in his homeland was finally his.

Edmonia Lewis

Tanner's European success as a painter surpassed that achieved earlier by the American sculptor Edmonia Lewis, an artist whose life and death were marked by mystery. Half American Indian, half African-American, Lewis was born in Greenhigh, Ohio, and was raised by her mother's tribe, the Chippewa Indians. In 1856 she received a scholarship to Oberlin College, and for three uneventful years studied such traditional subjects as Greek and zoology. Although she would have preferred taking courses in sculpture, none were offered by the college. Then, in her fourth year, Lewis found herself at the center of controversy. Two of her best friends were poisoned, and Lewis was charged with their murder. Her celebrated trial ended in a not-guilty verdict, and Lewis was carried triumphantly from the courtroom by friends and fellow students.

After the trial, Lewis turned her attention to marble carving. In 1867, with money she received for a bust of Colonel Robert Gould Shaw, she purchased a boat ticket to Europe and settled in Rome. Shortly after her arrival, she completed *Forever Free* (Figure 22.19). The work was done in celebration of the Thirteenth Amendment to the United States Constitution, which ended slavery forever. For a time her works sold for large sums and her studio became a favorite place for tourists to visit. One visitor, deeply impressed by the young artist and her work, described Lewis as one of the most fascinating representatives of America in Europe.

Unfortunately, Lewis's fame and prosperity were fleeting. A taste for bronze sculpture developed, and the demand for her marble pieces declined. Edmonia Lewis dropped out of sight, and the remainder of her life remains a mystery.

SECTION TWO

Review

1. Where did Winslow Homer find ideas for his paintings?
2. Which two painters are considered to be among the first Realists in American art?
3. Why did some viewers object to Eakins's painting of *The Gross Clinic*?
4. Where did Albert Pinkham Ryder find inspiration for his art?
5. How did Ryder's style differ from Eakins's style with regard to their use of media?
6. What accomplishment by Edward Mitchell Bannister helped destroy the myth that black artists could not produce works of merit in painting and sculpture?
7. Tell how Henry Tanner's roots influenced his choice of subject matter.
8. Describe the change in taste for sculpture media that brought the career of Edmonia Lewis to an end.

Creative Activity

Humanities. Two American women, both in the late nineteenth century, transformed the world of twentieth-century dance. As a child, Isadora Duncan rebelled against ballet lessons, seeing nature as her teacher. She studied "the movements of flowers and the flight of bees" and wanted her dance to be "in harmony with the movements of the earth." At a time when ballet was emphasizing gravity-defying toe dancing and leaps, Duncan said, "All movement on earth is governed by the law of gravitation, by attraction and repulsion, resistance and yielding; it is that which makes the rhythms of dance."

Loie Fuller was born in Illinois in 1862. She went to Paris in 1892, where her dance performances with flowing silks and gauzes and magical stage lighting brought her fame. In her "Flame Dance" she moved on a pane of glass with light streaming through it.

Find films about these two dancers and enjoy the grace and natural beauty of their movements.

PAINTING EMPHASIZING AESTHETIC QUALITIES

Supplies

- Pencil and sketch paper
- White mat board about 12 x 18 inches (30 x 46 cm)
- Tempera or acrylic paint
- Brushes, mixing tray, and paint cloth
- Water container

CRITIQUING

Exhibit your painting in class along with those created by other students. Use the same kinds of questions applied to van Gogh's painting to conduct a class critique.

- **Describe.** Ask and answer questions that focus attention on the literal qualities.
- **Analyze.** Ask and answer questions that focus attention on the design qualities.
- **Interpret.** Ask and answer questions that focus attention on the expressive qualities.
- **Judge.** Discuss the success of the works on display in terms of the literal, design, and expressive qualities.

Complete a painting guided by your answers to questions about van Gogh's painting *The Potato Eaters* (Figure 22.5, page 514).

Focusing

Examine Vincent van Gogh's painting of *The Potato Eaters* with other members of your class. Answer the following questions dealing with the different aesthetic qualities noted in this painting.

Literal Qualities: How many people are in this picture? What are these people doing? What kind of clothing are they wearing? How would you describe the room and the economic condition of this family?

Design Qualities: What kinds of colors, values, textures, and space dominate? What has the artist done to direct the viewer's eyes to the main parts of the painting?

Expressive Qualities: Do you think the room in this painting is warm and cozy, or cold and uncomfortable? What word best describes the peoples' expressions? How do you think the people in this picture feel? What feelings or moods does this work arouse in viewers?

Creating

Examine the questions about van Gogh's painting once again. Select two or more questions in each of the three categories and answer them as if you were talking about a painting of your own—a painting you are about to do. For example:

- Literal Qualities: How many people will I include in *my* picture?
- Design Qualities: What color or colors will dominate *my* painting?
- Expressive Qualities: What will the mood in *my* painting be?

Use your answers to the questions you chose as a guide and complete several sketches. Transfer your best sketch to the mat board and paint it with tempera or acrylic. Remember to take into account the answers you made to the design-qualities questions as you work.

Figure 22.20 Student Work

TEMPERA BATIK IN THE STYLE OF GAUGUIN

Complete a tempera batik in which you present your view of life in contemporary America to enlighten viewers who are unfamiliar with modern society.

Focusing

Examine Gauguin's painting of *Fatata te Miti* (Figure 22.10, page 518). How are the shapes used to suggest space? Are the colors bright or dull? Would you describe this as a realistic-looking picture? What does this painting tell you about life on a South Pacific island?

Creating

Complete several sketches in which you present your version of life in twentieth-century America. However, your view of contemporary life must be directed to people living on a remote South Sea island.

Reproduce your best sketch to fill the sheet of colored construction paper. Overlap the shapes in your drawing to suggest shallow space.

Go over the main lines in your picture with white chalk, making some lines thick and others thin.

Paint your picture with a *heavy* application of tempera paint. Choose bright, rather than dull, colors. Paint up to, but not over the chalk lines. A thick coating of tempera is needed because some of the paint will wash off later. Overlapping paint layers should be avoided, since the top layer will be lost during the final operation. Tempera paint details should never be applied to a previously painted surface. They must be painted directly onto the construction paper and other colors applied around them.

As soon as the tempera paint is dry, cover your picture completely with a brushed-on coat of india ink.

When the ink is completely dry, gently wash the ink from the surface of your picture. However, do not remove all the ink from the painted surfaces. If this is done, you will lose much of the batiklike look you are trying to achieve. If some retouching is called for, it should be done while the picture is still damp. Small amounts of paint can be applied with a sponge or a crushed paper towel.

CRITIQUING

- **Describe.** Does your batik present viewers with your ideas about life in contemporary America? What typically American people, objects, or events did you include?
- **Analyze.** Did you use large, flat shapes? Were these shapes painted with bright, intense colors? How is space suggested in your picture? Is it a deep or shallow space? Did you use a variety of thick and thin lines?
- **Interpret.** Do you think you gave viewers enough visual clues for them to form an accurate opinion about life in contemporary America? What single idea does your picture communicate?
- **Judge.** What type of critic or critics would be most pleased with your picture: those favoring the theory of imitationalism, formalism, or emotionalism? Explain your answer.

Figure 22.21 Student Work

Review

Reviewing the Facts

SECTION ONE

1. What did Cézanne feel was missing in Impressionist paintings?
2. What principle of art does Cézanne use when he combines straight lines and curved lines within a painting?
3. What is the most intense color in van Gogh's painting *The Bedroom at Arles* (Figure 22.6, page 515)?

SECTION TWO

4. Refer to Winslow Homer's painting *The Fog Warning* (Figure 22.11, page 521). How does the artist direct the viewer's eyes to the schooner on the horizon?
5. How would you describe the colors in Homer's painting *Right and Left* (Figure 22.12, page 521)?
6. Thomas Eakins learned to use light and dark values to make his figures look solid by studying the work of what artist?
7. Why are the doctors in Eakins's painting *The Gross Clinic* wearing street clothes instead of surgical gowns?

Thinking Critically

1. ***Analyze.*** Look again at Vincent van Gogh's painting *The Starry Night* (Figure 22.7, page 516). Discuss the elements of color, line, texture, and shape. Tell how they have been used according to the principle of movement. What elements of art do you think were most important to van Gogh?

2. ***Extend.*** You read that after black artist Joshua Johnston died, others were often given credit for pictures that were actually painted by him. This was not an uncommon thing to happen to women artists also. You might recall reading about the incident where Frans Hals was given credit for a painting by Judith Leyster. Discuss the reasons why this might have happened to black and women artists.

Using the Time Line

Examine the time line and determine when Edward Mitchell Bannister painted *Newspaper Boy*. The boy in this painting could be holding newspapers describing a famous engineering feat completed in the same year as Bannister's painting. Do you know what it was? A year after Eakins painted *The Gross Clinic*, a teacher of a system of speech for the hearing impaired, named Bell, patented an invention most of us would call indispensable. What is it?

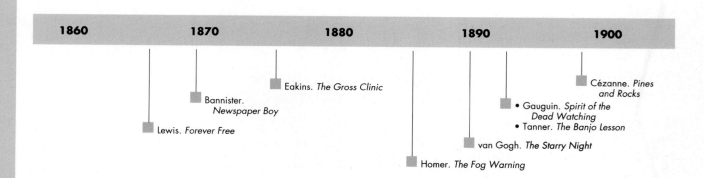

1860	1870	1880	1890	1900

Eakins. *The Gross Clinic*

Bannister. *Newspaper Boy*

Lewis. *Forever Free*

Cézanne. *Pines and Rocks*

• Gauguin. *Spirit of the Dead Watching*
• Tanner. *The Banjo Lesson*

van Gogh. *The Starry Night*

Homer. *The Fog Warning*

Kenneth R. Washington, Age 18
Klein Forest High School
Houston, Texas

The work of Henry Tanner inspired Kenneth to try a self-portrait. He set up a mirror next to his easel and began to sketch himself against the background of the classroom, which was also reflected in the mirror. Using charcoal for the preliminary study, Kenneth did several sketches of himself and the room in preparation for his watercolor painting.

Kenneth's goal for the finished artwork was to create his own watercolor style and to maintain that style throughout the composition. As he began to actually paint, Kenneth found that it was difficult to attain intensity of color with the watercolors he was using. He also discovered that the surface, or "tooth," of the paper plays a major role in controlling the painting process. He was pleased, however, with the likeness he captured in the portrait and with the consistently loose, free style he maintained throughout the painting.

➤ *Self-Portrait.* Watercolor. 56 x 71 cm (10 x 14").

A New Vision: Art of the Early Twentieth Century

Objectives

After completing this chapter, you will be able to:

➤ Discuss the objectives of the Expressionists and name some of the artists associated with this art movement.

➤ Name the Mexican muralists and tell what they chose as subject matter for their art.

➤ Identify and describe the American art movement responsible for challenging traditional painting techniques and subject matter.

➤ Discuss the reasons for the eclectic style of architecture practiced in the United States by architects such as Julia Morgan.

➤ Explain how American architect Louis Sullivan broke with the past to create a new architectural style.

Terms to Know

Armory
 Show
Ashcan
 School
collage
Cubism
eclectic style
Expressionism
Fauves
nonobjective art

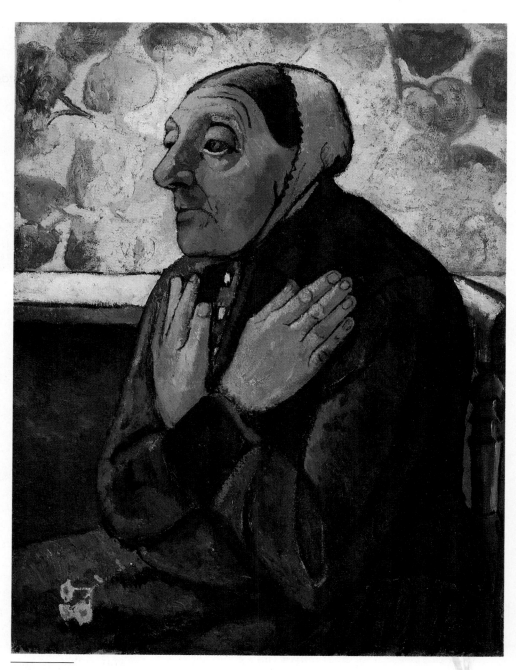

Figure 23.1 Paula Modersohn-Becker. *Old Peasant Woman.* c. 1905. Oil on canvas. 75 x 57 cm (29½ x 22½"). Detroit Institute of Arts, Detroit, Michigan. Gift of Robert H. Tannahill.

Looking back in time from our vantage point today, the beginning

of the twentieth century is recognized as a period of revolution and change in art.

Artists introduced a variety of new art styles that not only broke with the artistic traditions of

the past but also pointed the way for future innovations. At first, Europe was the birthplace for

these new art styles — styles that greatly influenced the art created later in America. However,

this changed as the century wore on and American art began to exhibit a bold, new character

of its own. Ultimately, the artworks created by American artists became the models to

which artists in Europe and other parts of the world turned for inspiration.

SECTION ONE

Many Movements in European Art

The turn of the century saw the end of the Academy's influence and the beginning of a new series of art movements in Europe. The first of these movements came to public attention in 1905. A group of younger French painters under the leadership of Henri Matisse exhibited their works in Paris. Their paintings were so simple in design, so brightly colored, and so loose in brushwork that an enraged critic called the artists **Fauves**, or *Wild Beasts*.

The Fauves

The Fauves carried on the ideas of Vincent van Gogh and Paul Gauguin. They took the colors, movement, and concern for design stressed by those artists and built an art style that was unrealistic, free, and wild. Their works looked hectic when compared to those of van Gogh and Gauguin because they tried to extend and intensify the ideas first expressed by those Post-Impressionists. They were more daring than van Gogh in their use of color, and bolder than Gauguin in their use of flat shapes and lively line patterns.

Henry Matisse

Henri Matisse (ahn-**ree** mah-**tees**), the leader of the Fauves, was the son of a middle-class couple from northern France. When he was a twenty-year-old law student, he suffered an appendicitis attack. His mother, who was interested in art, gave him some paints to help him pass the time while recovering, and he began his first painting. Later Matisse said, "I felt transported into a paradise in which I felt gloriously free." Eventually Matisse convinced his father to allow him to study art rather than law. He spent a brief period as a student of an academic painter, but found this experience almost as frustrating as studying law. Then he studied with another artist, Gustave Moreau (**goo**-stahv maw-**roh**), who was not as rigid and strict. Moreau encouraged Matisse to exercise greater freedom in his use of color. While studying with Moreau, Matisse met Georges Rouault and some of the other artists who became associated with him in the Fauve movement.

By 1905, Matisse had developed a style that made use of broad areas of color that were not meant to look like the shapes or colors found in nature. This style is shown in his painting entitled *The Red Studio* (Figure 23.2, page 534). Many artists including Velázquez (Figure 19.24, page 450) and Rembrandt (Figure 19.14, page 442) used their studios as subjects for their paintings. Matisse also used his studio as a subject, but unlike the others, he did not include himself in the picture. He does show a number of his paintings, however, which hang from or lean against the walls in a haphazard way. He welcomes you into his studio by using linear perspective. A table at the left and a chair at the right direct you into the room and invite you to look around. Of course, Matisse's studio could hardly have looked like this. In the painting, the room has been flattened out into a solid red rectangle. The walls do not have corners; round objects look flat;

and there are no shadows. Red is found everywhere—it covers the walls, floor, and furnishings. It is a strong, pure red selected for its visual impact and not because it was the actual color of the objects depicted.

Matisse was mainly interested in organizing the design qualities in this picture rather than providing you with a lifelike view of his studio. He used the studio as a starting point. It suggested the colors, shapes, lines, and textures that he could use in new and exciting ways to create a colorful decorative pattern. The objects in his work seem to be suspended by the intense red hue. This illusion allows you to glance casually about the room where surprising contrasts of greens, pinks, black, and white serve to attract and hold your interest. Unnecessary details are stripped away. The result is a balanced design in which tables, dresser, and chairs exist as colors, lines, and shapes. With paintings like this, Matisse was able to realize his goal of "an art of purity and serenity without depressing subject matter."

Today it is difficult to understand why Matisse's paintings were so shocking to people when they were first exhibited. Perhaps critics were upset by the simplicity of his pictures, but Matisse used simplicity because he wanted a more direct form of personal expression. In a way, he is like a writer who chooses to use a few sentences and simple, easy-to-understand words to make his or her message as precise and direct as possible. Nowhere is this more obvious than in his version of a circus knife thrower (Figure

> What technique and materials were used to create this work? How have the figures been made to stand out?

Figure 23.3 Henri Matisse. *The Knife Thrower*, from *Jazz*. 1947. Stencil. 40.3 x 64.7 cm (15⅞ x 25½"). Philadelphia Museum of Art, Philadelphia, Pennsylvania. John D. McIlhenny Fund.

23.3). With simple shapes and a few colors, Matisse playfully contrasts the furious actions of a knife thrower with the inactive pose of his female assistant.

During the last years of his life, Matisse devoted most of his efforts to making paper cutouts. He cut these shapes from papers that he had painted earlier. Sometimes he cut these shapes at random, sometimes with a certain idea in mind. After cutting out the shapes, he would spend days and even weeks arranging and rearranging them until he was satisfied with the results.

Matisse had no complicated theories to explain his paintings or cutouts. He relied on his own instincts when composing his works. What purpose were they intended to serve? Throughout his career, Matisse claimed that they had only one purpose: to give pleasure. He felt that painting should have a calming influence on the mind. "Art," he once said, "is something like a good armchair that provides relaxation from physical fatigue."

Georges Rouault

This point of view was not shared by Georges Rouault (zjorzj roo-**oh**), another artist associated with the Fauves. Instead of trying to show happiness and pleasure in his art, Rouault chose to illustrate the more sorrowful side of life.

Matisse thought that art could solve problems—he would prop his colorful pictures around the beds of sick friends to cheer them up and speed their recovery. Rouault used his art in a different way—to point out the problems he saw in the world. His works were

> How does Matisse welcome you into his studio?

Figure 23.2 Henri Matisse. *The Red Studio*. 1911. Oil on canvas. 181 x 219.1 cm (71¼ x 86¼"). Collection, The Museum of Modern Art, New York, New York. Mrs. Simon Guggenheim Fund.

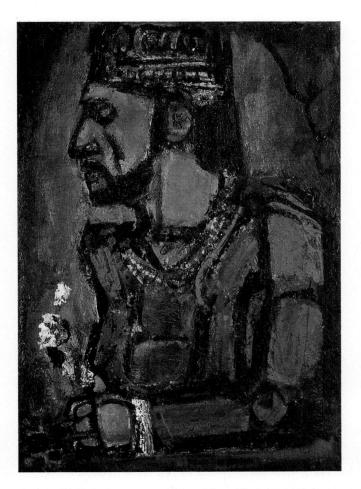

➤ Describe the expression on the king's face. How does this picture make you feel?

Figure 23.4 Georges Rouault. *The Old King.* 1916–36. Oil on canvas. 76.8 x 54 cm (30¼ x 21¼"). Museum of Art, Carnegie Institute, Pittsburgh, Pennsylvania. Patrons Art Fund.

bold visual sermons condemning the world's injustices and suffering.

When he was a boy, Rouault was apprenticed to a stained-glass maker. Later he used heavy, dark lines to surround areas of thick, glowing colors, creating paintings that looked like medieval church windows. In this manner he painted clowns, landscapes, and biblical figures. He claimed that he did not belong to the age in which he lived. "My life," he said, "is back in the age of the cathedrals."

Rouault's heavy lines do more than make his painting of *The Old King* (Figure 23.4) look like stained glass. They also tie his picture together while stressing the sorrowful expression of the figure. Rouault may have been trying to arouse your curiosity with this picture. Who is this king, and why is he so sad? Certainly this is no proud, joyful ruler. Is Rouault trying to tell you that even a king, with all his power and wealth, cannot find comfort in a world of suffering, or is he suggesting that no king is powerful enough to offer his subjects the happiness needed to guarantee his own happiness?

Rouault hated to part with his pictures, because he was never completely satisfied with them. He always felt that with a little more time, he could have made them much more effective. Sometimes he kept them for as long as twenty-five years, during which he would endlessly study and change them, hoping to achieve perfection. One night, late in his life, he arose suddenly from his bed and padded into his studio in bare feet. Picking up one of his pictures, he tossed it into the fireplace and then, relieved, returned to bed. Like Cézanne before him, Rouault did not hesitate to destroy a painting if it failed to please him. It did not bother him in the least that the picture he casually threw away could have been sold for thousands of dollars.

German Expressionism

Rouault and Matisse felt that art was a form of personal expression. It was a way for them to present their own thoughts and feelings about the world. In Germany, this view was eagerly accepted by several groups of artists. *The art movement, in which artworks conveyed strong emotional feelings, was called* **Expressionism**. These artists, who were interested in communicating their deep emotional feelings through their artworks, were called *Expressionists*.

Paula Modersohn-Becker

In Germany, Paula Modersohn-Becker has long been recognized as an extraordinary artist. Over a brief career she created some four hundred paintings and more than one thousand drawings and graphic works. However, she regarded most of these as the efforts of a student. She only expressed satisfaction with her work in 1902, five years before her death, after having completed a portrait of her stepdaughter. For the first time she felt confident enough to exclaim, "I am going to amount to something!" She went on to justify that claim with paintings that demonstrate the depth of her feelings and her ability to communicate those feelings in a highly personal, expressive style.

In the only example of Modersohn-Becker's work in the United States (Figure 23.1, page 532), the viewer is presented with a haunting image of a peasant woman. Seated, with her arms crossed and clutched to her chest, the old woman stares ahead intently, suggesting

that she might be at prayer. Her lined face, rough hands, and coarse clothing speak of the hardships she has endured, although these hardships have failed to shake her faith or temper her dignity.

Modersohn-Becker died just when she was beginning to realize her artistic goals and to receive favorable reviews of her work. On November 21, 1907, nineteen days after giving birth to a daughter, she got up from her bed for the first time and suffered a fatal heart attack.

Ernst Ludwig Kirchner

Street, Berlin (Figure 23.5) is a painting by Ernst Ludwig Kirchner (airnst **lood**-vig **keerk**-ner), who used clashing angular shapes to express one of his favorite themes — the tension and artificial elegance of the city. The people here are jammed together on a street, part of a never-ending parade. They look strangely alike, as if cut from the same piece of cardboard with the slash of a razor-sharp knife. They are uninterested and uninteresting people who appear to

be concerned only with themselves and going their own way. Or are they? Their faces are more like masks. Behind those masks are their *real* faces, but they are hidden because they might betray the people's true feelings. This picture was painted in Berlin just before the outbreak of World War I. It may be the artist's attempt to suggest the tension lurking just beneath the phony elegance of the German capital on the brink of war.

Kirchner's colorful, decorative, and highly expressive style is readily apparent in the haunting portrait of a young woman seen in Figure 23.6. Actually, the model was a street urchin known only as Franzi. The girl appeared one day at the artist's studio and remained to serve as a model and do odd jobs in return for food and lodging. When this painting was done, Franzi was about twelve years old. She stares calmly out of the picture, directly at the viewer, with large, sad eyes. Blue shadows below the eyes contrast with the yellow face, attesting to the hardships that marked her past and hinting at those that lie ahead. While the history of this portrait is well known — Kirchner would never part with it — the history of the young model is incomplete. Franzi disappeared during World War II and was never heard from again. The only clue to her existence is Kirchner's painting.

Kirchner was a troubled artist; a persistent nervous condition kept him out of the war and sent him to Switzerland seeking relief. Even there, trouble fol-

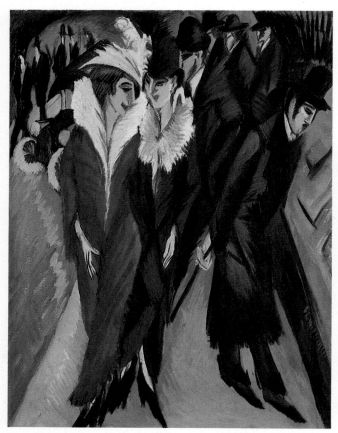

➤ What makes these people look so much alike?

Figure 23.5 Ernst Ludwig Kirchner. *Street, Berlin.* 1913. Oil on canvas. 120.6 x 91.1 cm (47½ x 35⅞"). Collection, The Museum of Modern Art, New York, New York. Purchase.

➤ What is the most unusual feature about this woman?

Figure 23.6 Ernst Ludwig Kirchner. *Seated Woman.* 1907. Oil on canvas. 80.6 x 91.1 cm (31¾ x 35⅞"). The Minneapolis Institute of Arts, Minneapolis, Minnesota. The John R. Van Derlip Fund.

➤ Describe the appearance and actions of the woman and children in this picture. Why is it appropriate to make use of the expressive qualities when judging this work?

Figure 23.7 Käthe Kollwitz. *Woman Greeting Death*. 1934. Lithograph.

lowed him. In 1938, his works were condemned by Hitler. Kirchner, ill and upset about the conditions in Germany, was unable to face up to this insult and took his own life.

Käthe Kollwitz

Käthe Kollwitz (**kah**-teh **kohl**-vits) was another of Germany's great Expressionists. She used her art to protest against the tragic plight of the poor before and after World War I. Hoping to reach the greatest number of viewers, she chose to express her ideas with etchings, woodcuts, and lithographs. Her lithograph *Woman Greeting Death* (Figure 23.7) is an example of this work. It shows a woman—frail, weak, and defeated—extending her hand to Death. Having exhausted her determination and her strength in a desperate struggle for survival, she now acknowledges defeat and quietly surrenders herself and her children to the inevitable. Too weak even to show fear, she reaches out with one hand while gently pushing her children forward with the other. One child, terrified, turns away, but the other stares directly at Death. Perhaps he is too young to recognize the stranger who takes his mother's hand and will soon reach out for his.

Kollwitz and many of the other German Expressionists were greatly influenced by Vincent van Gogh, the Fauves, and a Norwegian painter named Edvard Munch.

The Influence of Edvard Munch

The childhood of Edvard Munch (**ed**-vard moonk) was marked by tragedy. His mother died when he was five, and one of his sisters died when he was fourteen. His father was a doctor in a poor district, and Munch's own health was never strong. The fear, suffering, and death of loved ones that he experienced in his own life became the subject matter for his art.

How much his own suffering contributed to his work can be seen in a picture entitled *The Sick Child* (Figure 23.8). He returned to this subject several times in paintings and prints and was no doubt inspired by the death of his older sister. In the painting, Munch captures the pale complexion, colorless lips, and hopeless stare of a child weakened and finally conquered by illness. Beyond caring, she looks past her grieving mother to a certain, tragic future.

Pictures like this shocked viewers when the paintings were first seen. Munch's figures seemed crude and grotesque when compared to the colorful and lighthearted visions of the Impressionists, who were enjoying great popularity at the time. Munch's works, however, were in keeping with the period in which he lived, a period when writers and artists were turning their attention inward. Like Munch, they were interested in exploring feelings and emotions rather than describing outward appearances.

➤ How did this artist's own life influence his art?

Figure 23.8 Edvard Munch. *The Sick Child*. 1907. Oil on canvas. 118.7 x 121 cm (46¾ x 47⅔"). The Tate Gallery, London, England.

Have you ever heard someone say that they were so upset that they could not see clearly? Munch tried to show the world as seen through the eyes of such a person. Before, artists showed people in anguish, just as they would appear to a rational, objective viewer. With Munch and the other Expressionists, this changed. They showed the world as viewed through the eyes of people in anguish. When seen that way, the colors and shapes of familiar objects change. Trees, hills, houses, and people are pulled out of shape and take on new, unexpected colors.

The painting style based on this view of the world is illustrated in Munch's painting of *The Scream* (Figure 23.9). In it you can see that he used curved shapes and colors that are expressive rather than realistic. Everything is distorted to make you feel a certain way, and thus share with the artist a particular emotion. How does this picture make you feel?

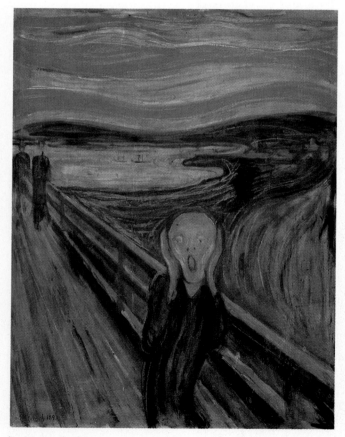

➤ Notice the figures in this work. What emotion do you associate with the nearest figure—joy, anger, or fear? List the things in the picture that will support your decision. Would you say that the shapes and colors here are natural and familiar, or new and surprising?

Figure 23.9 Edvard Munch. *The Scream.* 1893. Casein on paper. 91 x 73.5 cm (36 x 29"). Nasjonalgalleriet, Oslo, Norway.

Happy? Of course not. Sad? Possibly, but this reaction does not seem strong enough. Afraid? Yes, that is more like it; the subject of this picture is fear. Although impossible to determine why, there is no mistaking the fact that the person in this painting is terrified. The body bends and twists as a scream builds and erupts from deep within. It is a scream so piercing that the figure clasps its hands tightly over its ears. The entire scene vibrates with the intensity of this scream—it echoes across the landscape like ripples across still water.

Nonobjective Art

Until the nineteenth century, artists made use of recognizable images in their works. This approach changed when artists began to alter the appearance of the objects they painted. Cézanne painted jugs with openings that were too large, Gauguin created crimson trees and rocks, and Matisse stripped unnecessary details from the figures and objects in his pictures. By the beginning of the twentieth century, more and more artists were veering away from literal interpretations of subject matter to focus attention on the formal qualities in their art. Eventually, some of these artists came to feel that the presence of recognizable figures and objects in their works weakened their designs. The solution? Remove the figures and any other objects that might interfere with the artist's desire for a unified and visually appealing design. The first of these artists is said to have been Wassily Kandinsky.

Wassily Kandinsky

About two years after Munch painted his haunting picture of *The Scream*, a twenty-nine-year-old Russian lawyer strolled into an exhibit of French Impressionist paintings in Moscow. His name was Wassily Kandinsky (vah-**see**-lee kahn-**deen**-skee). He was overwhelmed by the paintings, particularly one by Claude Monet. After several hours, he left the exhibit with reluctance. In the weeks and months that followed, his thoughts kept returning to the works he had seen. Finally, he left his legal career and went to Munich, Germany, to study painting. In 1900, five years after his visit to the Impressionist exhibit, he received his diploma from the Royal Academy in Munich.

For several years, Kandinsky tried different styles: Impressionism, Post-Impressionism, Fauvism, and Expressionism. However, his works did not seem greatly original. Then, around 1909, he turned away

from these outside influences and listened to his own instincts. A year later he finished a watercolor painting that changed the course of art history. It was brightly colored and may have been based on some earlier landscape studies. Most important, no subject matter could be seen in the work. With this painting, Kandinsky's place in history as the inventor of a new art style was assured. The result was called nonobjective art. **Nonobjective art** *is a style that employs color, line, texture, and unrecognizable shapes and forms. These works contain no apparent references to reality.* Kandinsky is generally regarded as the founder of the movement, although this is by no means certain.

After that, Kandinsky went on to do more paintings that lacked subject matter, even as a starting point (Figure 23.10). His main goal was to convey moods and feelings. This effect could be achieved, he felt, by arranging the elements of art in certain ways. Colors, values, lines, shapes, and textures were selected and carefully arranged on the canvas for a certain effect. Kandinsky felt that art elements, like musical sounds, could be arranged to communicate emotions and feelings. In fact, Kandinsky believed that a painting should be the "exact duplicate of some inner emotion." He did not believe that art should be an illustration of objects as they appear in nature. Thus, Kandinsky was able to free painters completely from relying on nature for all of their ideas and images as they had in the past.

▶ In what way did works like this change the course of art history? What are works without recognizable subject matter called? If this artist was not interested in subject matter, what was he interested in? Which aesthetic qualities would you use when judging and supporting your judgment of this painting?

Figure 23.10 Wassily Kandinsky. *Improvisation 28 (Second Version)*. 1912. Oil on canvas. 111.4 x 162.1 cm (43⅞ x 63⅞"). The Solomon R. Guggenheim Museum, New York, New York. Gift, Solomon R. Guggenheim, 1937. The Solomon R. Guggenheim Foundation.

▶ Explain how this painting is similar to those created by Fauve artists. Münter succeeds in conveying a mood in this painting. How does she accomplish this?

Figure 23.11 Gabriele Münter. *Schnee und Sonne (Snow and Sun)*. 1911. Oil on cardboard. 50.8 x 69.8 cm (20 x 27½"). The University of Iowa Museum of Art, Iowa City, Iowa. Gift of Owen and Leone Elliott.

Gabriele Münter

In 1911, Kandinsky and several other painters banded together in Munich to form a group known as the *Blaue Reiter* (Blue Rider), a name taken from a painting by Kandinsky. One of the founding members of this group was a former student of Kandinsky's named Gabriele Münter. Münter's early works were in the Impressionist style, but as she matured as an artist, she began to use the intense colors, heavy outlines, and simplified shapes associated with the Fauves. This mature style is seen in her *Schnee und Sonne (Snow and Sun)* (Figure 23.11), painted in the same year that the Blue Rider was founded. It shows a figure walking along the snow-covered street of a small village. Despite the bright colors, bitter cold is suggested by the leaden sky and the heavily clothed figure. However, the most impressive feature of this work is its timeless quality. The scene looks as though it could have been painted today or two hundred years ago. It illustrates the simple, slow-paced life of a small village far removed from the complex, constantly changing life-style in large cities. In this respect, Münter's painting echoes those of other twentieth-century painters who believed that modern culture had become too complicated, too mechanized, and too detached from real feelings or a true understanding of the important things in life.

The Blue Rider disbanded in 1914, and three years later Münter pulled away from Kandinsky's influence. Following a period in which she traveled a great deal, Münter chose to spend the rest of her life in seclusion.

Cubism

Earlier you learned that German Expressionism, with its concern for expressing moods and feelings, can be traced back to the works of van Gogh and Gauguin. Another twentieth-century art movement can be linked in much the same way to the work of Paul Cézanne in the nineteenth century.

Artists such as Pablo Picasso (**pah**-blow pee-**cah**-so) and Georges Braque (zjorzj brahk) started with Cézanne's idea that all shapes in nature are based on the sphere, the cone, and the cylinder. They carried this idea further by trying to paint three-dimensional objects as if they were seen from many different angles at the same time. *This style of painting, in which artists tried to show all sides of three-dimensional objects on a flat canvas, was called* **Cubism**.

Perhaps the Cubist approach to painting can be illustrated with the simple sketches provided here (Figure 23.12). In the first sketch, an ordinary coffee cup has been drawn from several different points of view. After these first sketches have been done, the artist studies them to find the parts of the cup that are most interesting and most characteristic of coffee cups. These parts are then arranged in a composition. Thus, parts from the top, sides, and bottom of the cup are blended together to complete the picture. Of course, this illustration is very simple, but it may help you to understand the process a Cubist artist used when painting a picture like *Glass of Absinthe* (Figure 23.13).

Do not be surprised if you fail to recognize any of the objects in this Cubist painting. Recognition is hampered by the breaking up of shapes and the reassembling of these shapes in the composition. This produces a complex arrangement of new shapes that is often very confusing to the viewer. You can never be

➤ What did Cubist artists want to show in their paintings?

Figure 23.13 Pablo Picasso. *Glass of Absinthe.* 1911. Oil on canvas. 38.4 x 46.4 cm (15⅛ x 18¼"). Allen Memorial Art Museum, Oberlin College, Oberlin, Ohio. Mrs. F. F. Prentiss Fund, 1947.

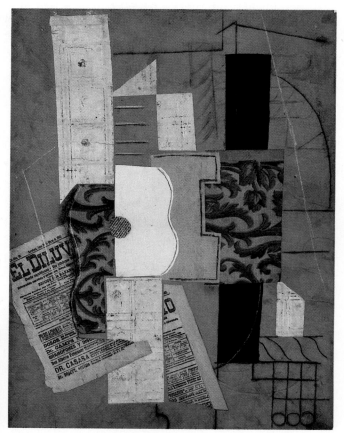

➤ Can you identify the materials used in this collage?

Figure 23.14 Pablo Picasso. *Guitar.* 1913. Cut and pasted paper, ink, charcoal, and white chalk on blue paper, mounted on board. 66.4 x 49.6 cm (26⅛ x 19½"). Collection, The Museum of Modern Art, New York, New York. Nelson A. Rockefeller Bequest.

Figure 23.12 A student's drawing in the style of Cubism.

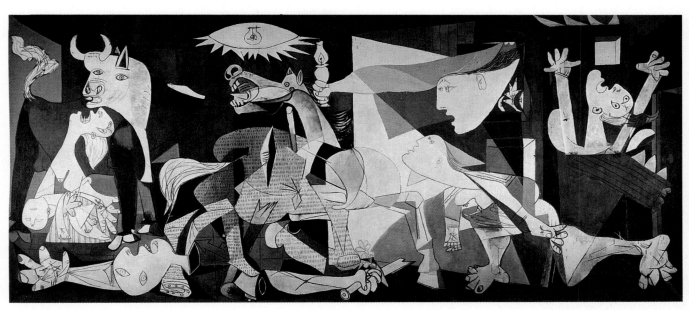

➤ What message do you receive from this painting?

Figure 23.15 Pablo Picasso. *Guernica.* 1937. Oil on canvas. Approx. 3.5 x 7.8 m (11'6" x 25'8"). Museo del Prado, Madrid, Spain.

sure when one shape is ahead of another, because part of it seems to be in front and part behind. This confusion is heightened by the use of lines that end suddenly when you expect them to continue, or continue when you expect them to end. Colors associated with the objects were not used. Instead, the artist chose grays, browns, and other drab colors, which painters before this time had avoided.

Cubists were also interested in making the surfaces of their paintings richer and more exciting by adding a variety of actual textures. Around 1911, Picasso, Braque, and others began to add materials such as newspaper clippings, pieces of wallpaper, and labels to the picture surface. *The technique of pasting other materials to the surface was known as* **collage**. It further blurred the recognizable connection between the painting and any represented object. The materials arranged in shapes on the surface of the painting seemed to take on a reality of their own (Figure 23.14).

Now that you know what a Cubist work looks like and how it was done, you might be wondering why artists painted this way. Cubism was an *intellectual* approach to art, rather than a descriptive or emotional one. Cubist artists thought their way through their paintings, trying to show what they knew was there, not what they saw or felt. Picasso may have summed up the intent of Cubism best when he said, "We have kept our eyes open to our surroundings, but also our brains." It was the product of their brains, not their eyes or hearts, that they wanted to share with viewers.

Pablo Picasso

Pablo Picasso led a long and productive life. As an artist, he passed through many different stages. For some time he worked in the Cubist style, then returned to paintings of the human figure. At this time he began to use a greater range of colors. Then, in 1937, he painted his famous anti-war picture, *Guernica* (Figure 23.15).

Guernica was a large mural (11'6" x 25'9" feet [3.5 x 7.1 m]) made for the Pavilion of the Spanish Republic at the Paris International Exposition. The work was inspired by the bombing of the ancient Spanish city of Guernica by German planes during the Spanish Civil War. Guernica was not an important military target. Its destruction apparently served no other purpose than to test the effectiveness of large-scale bombing. As a result of the "tests," the city and most of its inhabitants were destroyed.

The large triangle in the center of Picasso's painting may remind you of the way earlier artists organized their work. This technique was used in the Renaissance by artists like Botticelli and Raphael. Here it effectively links a series of tragic images. At the far right, a woman crashes through the floor of a burning building. In front of her, another woman dashes forward blindly in panic. A horse with a spear in its back screams in terror. A severed head with staring eyes rests on an outstretched arm, its hand reaching for nothing. Another hand tightly clutches a broken sword. A woman holds a dead child and raises her

head skyward to scream out her horror at the planes overhead.

In this work, Picasso combines Expressionism and Cubism. Like the Expressionists, he exaggerates and distorts forms. At the same time, he overlaps flat shapes in an abstract design as did the Cubists. Picasso uses bold blacks, whites, and grays instead of color to give the impression of newsprint or newspaper photographs. Adding to the look of newsprint is the stippled effect on the horse. The painting's powerful images, however, convey the full impact of the event far more effectively than could the words in a newspaper account, or even photographs.

Just who was this artist who was not only the most famous artist of his time, but may be the most famous artist of all time? People who have never heard of Giotto, or Rubens, or Matisse know of Picasso. They may not understand or like his work, but they know that he was a major figure in the modern art movement. Pablo Picasso was born in Malaga, Spain, in 1881. As a boy, he never stopped drawing. In fact, his mother claimed that he could draw before he could talk. When he finally did talk, she went on to report, his first word was "piz," baby talk for *lapiz*, or *pencil*.

One day his father, a painter and teacher, arrived home to find that his young son had finished a portrait. After comparing it with his own work, he gave all his art materials to Pablo and vowed never to paint again. His son, he said later, had surpassed him and he could work no longer.

Later Picasso's father took a position with the Barcelona School of Fine Arts. Pablo wished to enroll in the school but was required to take the entrance exam. This exam was so difficult that it often took a month to complete. Picasso, however, took it in one day and was admitted to advanced classes the next.

Picasso lived a long and full life; he was ninety-one years old when he died in 1973. He left behind a tremendous number of paintings, prints, and sculptures — and a profound influence on twentieth-century art and artists.

Georges Braque

Unlike Picasso, Georges Braque did not go through a series of style changes during his career. He always maintained that a painting is a flat surface and should remain a flat surface. He remained involved throughout his life with ways to make that surface more interesting with the use of colors, lines, shapes, and textures.

From 1907 to 1914, Braque and Picasso worked closely together to develop Cubism. When World War I

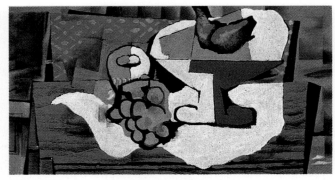

> What style of art is represented by this work?

Figure 23.16 Georges Braque. *Still Life with Fruit.* 1920–23. Oil with sand on canvas. 34.9 x 64.8 cm (13¾ x 25½"). The University of Iowa Museum of Art, Iowa City, Iowa. Gift of Owen and Leone Elliott, 1968.

broke out, Braque was called into the army and, in 1915, was seriously wounded. In 1917, following long months in recovery, he returned to his painting. His work from that point on shows a growing respect for subject matter, more playful curves, and brighter colors. Always interested in texture, he applied his paint, often mixed with sand, in layers to build a rich, heavy surface. In this way, he said, his pictures were more "touchable." He painted still lifes (Figure 23.16), but instead of concentrating only on foods or flowers, he used more permanent man-made objects, such as tables, bottles, mandolins, and books. These were objects people used when they were relaxing and enjoying pleasant thoughts. These quiet, elegant still lifes did exactly what Braque intended them to do — they put viewers in a gentle, comfortable mood.

Balance and Simplicity

The same kind of gentle, comfortable feeling is experienced when you stand before the sculptures of Aristide Maillol (ah-ree-**steed** my-**yohl**). Unlike Rodin, Maillol was not interested in dramatic gestures and expressions, or with a sculptured surface made up of bumps and hollows. He did not seek to shock or surprise the viewer. He admired the balance, simplicity, and peacefulness of ancient Greek sculptures and tried to capture these same qualities in his own work.

Aristide Maillol

Maillol began his career as a painter, but, since he did not enjoy great success in that medium, he later turned to tapestry making. In his workshop, he designed the tapestries and dyed the materials himself.

Then, when he was forty years old, an eye ailment prevented him from weaving. Although he must have been discouraged, he refused to abandon his career in art. Instead, he became a sculptor. To his amazement, he discovered that sculpture was his true medium. Almost immediately he mastered a style that he used for the rest of his life.

Maillol had been a sculptor for only a few months when he created a seated woman entitled *The Mediterranean* (Figure 23.17). This work contained all of the main features of his style. A sturdy woman is posed in a quiet, restful position without a hint of movement. There is no sign of nervousness or tension, or any sign that she is even aware of what might be going on around her. From the side, the figure forms a large triangular shape, which gives it a balanced, stable look. Smaller triangles are created by the raised leg and the arm supporting the head. The repetition of these triangular shapes is important here because it helps to unify the work in the same way that a certain color used over and over again can unify a painting. There is nothing about this woman to suggest that she is a specific individual. Maillol was not attempting a portrait. He was using the woman's figure to represent a particular mood or feeling. In this case, that mood was thoughtful, gentle, and calm.

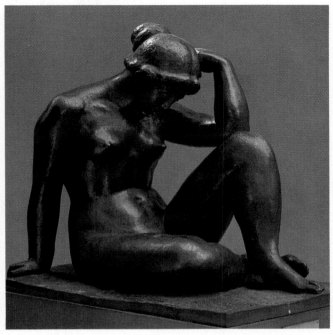

➤ Notice the triangular shapes in this work. What purpose do these triangular shapes serve? Would you describe this figure as slim and graceful, or solid and sturdy? Does she seem nervous and tense, or quiet and restful?

Figure 23.17 Aristide Maillol. *The Mediterranean.* 1902–05. Cast c. 1951–53. Bronze. 104.1 x 114.3 x 75.6 cm (41 x 45 x 29¾"). Collection, The Museum of Modern Art, New York, New York. Gift of Stephen C. Clark.

SECTION ONE

Review

1. What does the word *Fauves* mean? To whom was the name given and why?
2. Who was the leader of the *Fauves* and what did he feel was the purpose of his art?
3. What did the German Expressionists wish to represent in their works? Name a famous woman artist who was associated with the German Expressionists.
4. What is meant by nonobjective art? Who is often regarded as its founder?
5. What impact did the discovery of nonobjective art have upon future artists?
6. What were the Cubist artists hoping to show in their art? Name two of these Cubist artists.
7. What objects did Georges Braque select to include in his still lifes and why did he choose them?

Creative Activity

Humanities. The influence of Africa on the early twentieth century can be seen and heard. Picasso's Cubism found inspiration in the geometric tribal masks that he began to collect. The music of Africa influenced music in America.

Trace the beginnings of jazz in Scott Joplin's rags and the vibrato sounds of Louis Armstrong. Listen to the *improvisation* that gave jazz the endless variety that still characterizes it today.

Jazz influence can also be heard in the works of classical composers—Igor Stravinsky, Sergey Prokofiev, Aaron Copland, Leonard Bernstein, and many others. George Gershwin wrote a jazz opera, *Porgy and Bess*.

Research the art and music of other cultures that have influenced the art and music of America. Discuss your findings with the class.

SECTION TWO

Contributions from Mexico and the United States

Much of the early twentieth-century art in Mexico and the United States came into existence as a reaction to a bewildering assortment of events and circumstances. In Mexico, political and social turmoil proved to be a force so strong that it motivated many artists to create bold and powerful images expressing their reactions. At the same time, changes in all aspects of life were taking place in the United States at a pace more rapid than in any earlier period. These changes shook artists out of a conservative slumber at the beginning of the century and helped push them in new directions.

The early twentieth century in Mexico was a time when the poor, landless peons tried to make a better life for themselves. They increased their efforts to be free of corrupt landlords who treated them no better than feudal serfs. In 1911 this struggle reached a bloody climax with the fall of the dictator, Porfirio Diaz, and the start of the Mexican Revolution. The revolt ended in 1921.

The Muralists in Mexico

The years following the conflict saw the emergence and rise of Mexican mural painting. A group of Mexican muralists became known worldwide. As their subject matter, they chose the political and social problems of the Mexican people and adorned both the inside and outside walls of buildings with their murals. Buildings in the United States as well benefited from their art.

Can you think of other times when art was done on building walls? You may recall the mosaics in Byzantine churches, such as those in Italy's San Vitale. The mosaics were meant to teach the Christian message. Later Giotto, Masaccio, and others used a fresco technique to illustrate stories from the Bible on the interior walls of Italian churches. Several Mexican artists revived that ancient practice, but they intended to tell different kinds of stories. They told of revolutions, native traditions, festivals, and legends. Painting their pictures on the walls of public buildings allowed these artists to take their work directly to the people. They did not want their paintings placed in museums, galleries, or private homes where only a few people would see and respond to them. Instead, their works were intended to be public property, not the private property of the wealthy and powerful.

Diego Rivera

One of the first and most famous of these Mexican mural painters was Diego Rivera (dee-**ay**-goh ree-**vay**-rah). He created the first modern mural painting in Mexico. As a young man, Rivera studied the art of the great Italian fresco artists. This study helped him to achieve his own artistic goal — to record in art the gallant struggle of the Mexican peasant.

In the *Liberation of the Peon* (Figure 23.18), Rivera draws equally upon his skills as a painter and as a master storyteller to create one of his finest works. It shows a group of somber revolutionary soldiers cutting the ropes that bind a dead peon. A blanket is held ready to cover the peon's naked, whip-scarred body. In the distance, a hacienda burns. This image tells you that the landowner responsible for the peon's death had already been punished by the soldiers. Now, silently and sorrowfully, they do what they can for their dead comrade. Rivera's story is not difficult to read or to understand — the peon has been "liberated" from a life of oppression and suffering. Like scores of other poor peasants, his liberation has come in the form of death.

Can you point to any similarities between Rivera's painting and Giotto's *Lamentation* (Figure 15.21, page 352)? Like Giotto's figures, Rivera's have bulk and weight and seem to move in space. They also act out their story with easily understood gestures and expressions. Both works succeed in stirring in the viewer a feeling of helplessness, sorrow, and anger.

José Clemente Orozco

Another of the Mexican muralists, José Clemente Orozco (hoh-**say** cleh-**men**-tay oh-**ross**-coh), developed a style of painting that earned him the title of the Mexican Goya. It is a style stripped of everything but emotions. Orozco used it to paint pictures that expressed his anger for all forms of tyranny. Even in pictures that at first seem calm and quiet there is an undeniable undercurrent of power and fury. *Zapatistas* (Figure 1.3, page 7) is such a painting. In it, the followers of the revolutionary leader Emiliano Zapata are shown going to war. The determined plodding of the grim peons, and the rhythm created by their forward-pressing bodies, gives the impression of a steady, marching movement across the work. Like an avalanche that grows in strength as it rumbles down

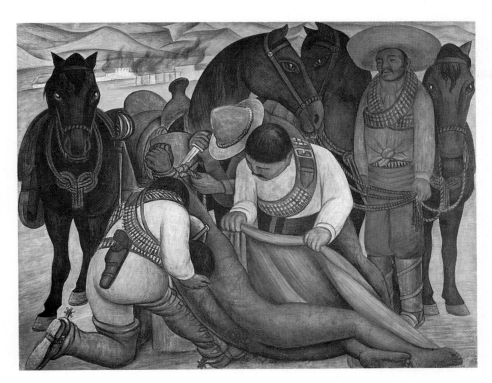

▶ Do you think the soldiers shown here are responsible for the man's death? How did he die? Can you find clues to indicate that the man's death has been avenged?

Figure 23.18 Diego Rivera. *Liberation of the Peon.* 1931. Fresco. 188 x 241 cm (74 x 95"). Philadelphia Museum of Art, Philadelphia, Pennsylvania. Given by Mr. and Mrs. Herbert Cameron Morris.

a mountain, more and more people will join this march. Nothing will stop it until the enemy is crushed, justice restored, and freedom achieved.

David Alfaro Siqueiros

Orozco painted his first mural for the National Preparatory School of Mexico City in 1922. Working next to him was another, younger painter, who was also doing his first mural. That painter's name was David Alfaro Siqueiros (dah-**veed** al-**far**-oh see-**kay**-rohs). Along with Rivera and Orozco, he was to be known as a founder of Mexican mural painting.

Siqueiros was just as involved in politics as he was in art. Several times he was sentenced to prison or exiled for his political beliefs. *Echo of a Scream* (Figure 23.19) is his nightmarish protest against war. It was done in the year that Picasso finished his masterpiece on the same theme—*Guernica*. If you compare these two works, you will see how two artists expressed the same anti-war theme in completely different ways. In his painting, Picasso used overlapping flat shapes, a variety of contrasting light and dark values, and an abstract design. Siqueiros, on the other hand, used gradations of value to model three-dimensional forms that look as if they are flowing forward and backward in space. This three-dimensional quality makes his work more vivid, like a horrible dream brought into sharp focus. Siqueiros also centers his attention on one of the most innocent and helpless victims of a

Figure 23.19 David Alfaro Siqueiros. *Echo of a Scream.* 1937. Enamel on wood. 121.9 x 91.4 cm (48 x 36"). Collection, The Museum of Modern Art, New York, New York. Gift of Edward M. M. Warburg.

war—a baby. The infant is shown sitting amid the rubble of a shattered city. What purpose is served by the addition of a second, larger head? It may be a symbol for all children killed, crippled, orphaned, or made homeless by war. Its magnified scream of terror pierces an unnatural stillness, but this scream is destined to fade without having reached a single ear. The child alone survives but, fragile and alone, it cannot survive much longer.

The Impact of These Artists

Clearly, the art of Rivera, Orozco, and Siqueiros reveals a strong preoccupation with suffering and war. The reason for this is obvious. These artists, with their strong social and political views, were products of their time. Much of the mural art was concerned with telling the story of the peons' bitter struggle to overthrow the corrupt landowners who had used and abused them for generations. The artists told this story in bold murals that brought about a revolution in painting. The changes in painting were just as intense as the political upheaval that altered the course of events in their country.

At various times, all three of these Mexican artists visited and painted murals in the United States where they had a great impact on many young artists. Some of these American artists even went on to show the same concern for social and political problems in their own works. In the late forties and fifties, the idea of huge wall paintings was so appealing to a number of artists that they abandoned their easels and small canvases to paint on a monumental scale. In fact, many of their works were so large that they came to resemble walls. One of the most notable of these American artists was Jackson Pollock, whom you will meet later.

A Mexican Expressive Painter

While some Mexican artists became involved in political struggle, creating art that protested against social injustices, others chose to use their art to express their own personal feelings. One of these was Frida Kahlo (**free**-dah **kah**-loh), Diego Rivera's wife.

Born in Mexico City in 1907, Kahlo rose to prominence as a painter at a time when few women artists were taken seriously. Polio as a child and a bus accident when she was eighteen sentenced her to a life-

long struggle with pain. While recovering from her accident, Kahlo turned to painting even though she was only able to work lying down. Her injuries were so severe that she was unable to sit up. From the beginning, her paintings offered her the opportunity to express her feelings about herself. Sometimes she showed herself as beautiful and content, but at other times she revealed the physical anguish with which she began and ended each day.

In 1931, Kahlo painted a wedding portrait in which she and her husband stand stiffly, hand in hand, looking out at the viewer rather than at each other (Figure 23.20). The joy that one expects to find in a wedding portrait is lacking here, and the artist's solemn expression may hint at her uncertainty about a future with her new husband. While often rewarding, their marriage was marked by bitter quarrels. Twelve years after painting this picture, Kahlo wrote, "I suffered two grave accidents in my life. One involved a bus . . . the other accident is Diego."

➤ What clues can you point to that identify this as a wedding portrait? How is the man's profession indicated? Compare this wedding portrait with the one created by Jan van Eyck (Figure 17.3, page 391). Which of these two works do you favor? Why?

Figure 23.20 Frida Kahlo. *Frida and Diego.* 1931. Oil on canvas. 100 x 78.7 cm (39⅜ x 31"). San Francisco Museum of Modern Art, San Francisco, California. Albert M. Bender Collection. Gift of Albert M. Bender.

Art · PAST AND PRESENT ·

Museum Reproductions

Exciting art reproductions are available from many large museums. These institutions sell to the public through catalogs and shops. Some museums have permanent space set aside for their shops inside the museums themselves. Others set up temporary shops in malls, especially during the holiday season.

Most of the objects sold are developed by museum designers and are adapted from the museum's collections. A small sample of the items available include: greeting cards illustrated with major works of art;

Figure 23.21 Fun with Hieroglyphs. © 1990 by The Metropolitan Museum of Art. All rights reserved.

fine art reproductions; silk scarves printed with designs adapted from fabrics in the museum's collection; needlepoint kits with patterns taken from ancient tapestries or rugs; jewelry adapted from Egyptian and Byzantine art; and reproductions of Paul Revere's metalwork. There are even more exotic objects available, such as a reproduction of a Roman portrait sculpture from the second century A.D.; books of gospels and psalms with reproductions of illustrated manuscripts from the Middle Ages; lac-

quer boxes and trays adapted from Japanese lacquerware; and a cat-shaped doorstop inspired by a design from the Ica Valley in Peru.

Some of the museums, which help raise money and gain new members through their shops and catalog sales, include the Detroit Institute of Arts, the Art Institute of Chicago, the Boston Museum of Fine Arts, and The Metropolitan Museum of Art in New York City. Use your museum not only for viewing art but also for obtaining unique art reproductions.

American Art

The start of the twentieth century was a time of Henry Ford, George Bernard Shaw, J. P. Morgan, Harry Houdini, the Wright brothers, and Teddy Roosevelt. The United States was a growing industrial nation. It was a land of assembly lines, locomotives, airships, steam shovels, telephones, and buildings that rose ten or more stories high. Large city sidewalks overflowed with shoppers. The elevated train rumbled past the windows of shabby tenement buildings; as it passed, windows, furniture, and occupants shook. Laundry hung limply from fire escapes. In the coal fields of

Pennsylvania, miners lived in small company houses and bought their food and clothes at company stores. After digging 3 tons (2.7 t) of coal a day, they were paid $1.60. In the South, workers stripped tobacco leaves for 6 cents an hour.

American art at the start of the twentieth century was conservative. Though artists like Homer, Eakins, and Ryder were still working, art as a whole did not show much progress or excitement. Many American artists still felt that success required study in Europe. However, once there, they met with stale academic approaches. They learned to accept traditional painting techniques and subject matter rather than look for new approaches and images.

The Ashcan School in the United States

This conservative trend was challenged early in the century by a group of young realistic painters who lived in New York. These artists rebelled against the idealism of the academic approach. Instead, they chose to paint the life around them. Most of these painters had been newspaper cartoonists or magazine illustrators, and that work had opened their eyes to the contemporary world. In a way, they had much in common with the Dutch artists of the seventeenth century. The Americans had the same feeling for the sprawling, bustling city of the twentieth century as the Dutch had for the countryside of their time. For subject matter, the Americans turned to the city's nightlife, cafés, streets, alleys, and theaters. Their goal was to record all of the city's color, excitement, and glamour. However, when this group held its first show in New York in 1908, they were laughingly called the **Ashcan School**, *a popular name identifying the group of artists who made realistic pictures of the most ordinary features of the contemporary scene.*

John Sloan

An example of the kind of painting produced by members of this group is John Sloan's *Backyards,* *Greenwich Village* (Figure 23.22). If you examine this picture carefully, you will be impressed with Sloan's skill as he guides you from one item to the next.

As your eye sweeps over this picture, it eventually comes to rest on the cat at the bottom center. This cat sits contentedly on the fence facing you. From there, your gaze moves to the second cat gingerly picking its way through the snow toward the two children who are putting the finishing touches on their snowman. One child uses a small shovel to pat the snowman into shape. The diagonal formed by his arm and the shovel directs your attention to the fence at the right. This fence leads you across the painting to the face of a smiling girl peering out of a tenement-building window. This child is placed at the very edge of the picture, and it would have been easy for you to miss her if Sloan had not carefully organized his picture to lead you to this spot. Then, to prevent your eye from roaming off the right side of the picture, he used the lines of the window, shutter, and bricks to take you further back into the work. Here you discover more buildings, fences, and clothes hanging out to dry on lines strung high overhead.

You may have expected to feel some sadness when looking at Sloan's picture. After all, it is a painting of a working-class residential area in a large city. The dingy tenement buildings are crowded tightly together, giving the children little space in which to play.

➤ Describe the way in which Sloan guides the viewer's eye through this picture. What was the name given to the group of artists with whom Sloan was associated? Why was this name given to these artists?

Figure 23.22 John Sloan. *Backyards, Greenwich Village.* 1914. Oil on canvas. 66 x 81.3 cm (26 x 32"). Collection of Whitney Museum of American Art, New York, New York. Purchase.

➤ Notice what techniques have been used to make the two boxers stand out in this painting. How do the blurred contours add to the feeling of violent action? Do you think this picture is more successful in capturing the appearance or the excitement of a prizefight?

Figure 23.23 George Bellows. *Stag at Sharkey's.* 1909. Oil on canvas. 92 x 122.5 cm (36¼ x 48¼"). The Cleveland Museum of Art, Cleveland, Ohio. Hinman B. Hurlbut Collection.

However, the picture is not sad at all. It does not dwell on the unhappy aspects of tenement living. Instead, it is a happy scene painted with sensitivity and affection. It illustrates the gift that children everywhere seem to have—the gift to find joy and pleasure in almost any kind of situation. It is the memory of that joy and pleasure that you will carry away with you.

George Bellows

George Bellows, while not a member of the Ashcan School, created paintings that were similar in many ways to those of Sloan and his companions. Realizing that anything could be used as subject matter for art, Bellows concentrated on the subject he loved most—sports. An outstanding athlete throughout his school years in Ohio, he may have been the only artist who

ever had a choice between being an artist or a major-league baseball player. His background in sports led to a desire to capture in his pictures the strength and grace of athletes in action.

Bellows left his native Ohio while he was still a young man and spent the rest of his short life in New York. He had a studio across the street from an athletic club where he could see the boxing matches he loved to paint. Applying his paint to the canvas with slashing brushstrokes, he was able to reproduce the violent action of the ring in works like *Stag at Sharkey's* (Figure 23.23). There you share the wild excitement of the fight crowd as they cheer the favorite and boo his opponent. Illuminated by the lights overhead and silhouetted against the dark background, the two boxers abandon all caution to flail away at each other. Both are willing to accept brutal punishment rather than

give ground. Bellows captures this powerful determination and swift action with strong diagonal lines and blurred contours.

In addition to his oil paintings, Bellows produced lithographs, and in the last five years of his life, he began to paint portraits. There is no telling how he may have developed as an artist had he lived a long life. Ignoring stomach pains that would have sent most men hurrying to a doctor, Bellows died of a ruptured appendix when he was just forty-three years old.

The Armory Show of 1913

The Ashcan School played a major role in American art from about 1908 until about 1913. This marked the opening of the famous **Armory Show**, *the first large exhibition of modern art in America*. This exhibit was organized by a group of artists who knew of the exciting new art being done in Europe. They wanted to introduce the American public to the works of such artists as Cézanne, van Gogh, Gauguin, Matisse, Munch, and Picasso. In the show were some thirteen hundred works by three hundred artists. Most were Americans, but about one hundred were Europeans. It was the European work that caused the greatest controversy. Well over a quarter of a million people saw the exhibition. For most, it was their first contact with modern European and American art, and they did not know what to make of it. Unlike the French public who had seen modern art evolve slowly, step by step, the American public were caught by surprise. Some tried to understand the new works; others tried to explain them; most either laughed or were enraged. The room where the Cubist paintings were hung was called the "Chamber of Horrors." Furthermore, it was said of Matisse, "It is a long step from Ingres to Matisse, but it is only a short one from Matisse to anger."

The Armory Show marked the end of one era and the start of another. Both younger and more mature American artists saw the new styles of the Fauves, Expressionists, and Cubists. As a result, many turned away from traditional academic art to carry on their own daring experiments. Thus, the Armory Show set the stage for the development of modern art in America. In the years that followed, New York replaced Paris as the art capital of the world.

SECTION TWO

Review

1. What event in Mexican history occurred in 1911 that had an effect on the subject of artworks produced shortly thereafter?
2. Describe the story told in Diego Rivera's *Liberation of the Peon*.
3. Who were the Mexican muralists? What did these artists choose as the subject matter for their art?
4. What was unusual about the wedding portrait painted by Frida Kahlo?
5. What early twentieth-century American art movement challenged traditional painting techniques and subject matter? Where did the members of this movement find the subject matter for their art?
6. Name three ordinary features of the contemporary scene included by John Sloan in his *Backyards, Greenwich Village*.
7. What did George Bellows select as subject matter for many of his paintings and what in his background provided him with knowledge about this subject?

Creative Activity

Humanities. As the visual artists focused on the streets of the city and the social problems of the time, the new medium of motion pictures was looking to the future. George Melies had already made over two hundred two-minute films in the streets of Paris by 1900. In 1902 he made his first feature film, *A Trip to the Moon* — a five-minute film that sowed the seeds for *Star Wars*.

American filmmaker Edwin S. Porter, who worked for Thomas Edison, followed with *The Great Train Robbery*, which included in its fifteen minutes the first chase scene. By 1915, D. W. Griffith had produced *The Birth of a Nation*, still listed among the greatest films ever made. This patriotic epic about the Civil War focused on two families, one from the North and the other from the South.

Find some of these early films and enjoy the first examples of this medium.

SECTION THREE

European and American Architecture

During the nineteenth century, architects were content to use ideas from the past. This practice became widespread, and buildings in Europe and America showed a variety of styles: Greek, Roman, Romanesque, Gothic, and Renaissance. However, some architects in the late nineteenth and early twentieth centuries saw the exciting potentials for use of the new industrial methods and materials. They broke the ground for others who followed in the years to come.

The Beginnings of Change: Alexandre Gustave Eiffel

Late in the nineteenth century, a French builder and engineer named Alexandre Gustave Eiffel (ahl-ex-**ahn**-der **goo**-stahv **eye**-fel) saw the value of iron and steel, which he used to build bridges and industrial plants. However, he is best known for the 984-foot (300-m) tower that he built for the Paris Industrial Exposition of 1889 (Figure 23.24).

The Eiffel Tower is a spire boldly made of exposed ironwork. To build it, Eiffel used open beams made of small angle irons and flat irons. The entire structure was prefabricated. It was riveted together without accident by only 150 men in just seventeen months, an amazing feat at that time. It was made even more amazing by Eiffel's confident claim that his tower was strong enough to stand forever. At first it appeared unlikely that it would stand until the end of the Exposition because it produced such howls of protest from artists, architects, and leading citizens. They felt that it was a disgrace to their beautiful city and should be removed. However, it was not taken down, and within two decades it became one of the most popular landmarks in Europe. Although it had been planned as a temporary monument for the Exposition, it still stands — and Eiffel's boast that it could stand forever no longer seems quite so absurd.

Eiffel's tower was one of a series of engineering feats that demonstrated how new materials and construction techniques could be used in major building projects. The use of cast iron and steel made it possible to erect buildings more quickly and more economically. These building materials also seemed to offer added protection against fire. However, a series of disastrous fires in the United States near the end of the century showed that this was not the case. These experiences led to the practice of adding an outer shell of masonry to iron and steel buildings, making them both strong and fire-resistant.

➤ How did Eiffel's background prepare him to design this famous tower? What new materials and techniques were used? What have other builders learned from this structure?

Figure 23.24 Alexandre Gustave Eiffel. Eiffel Tower. Paris, France. 1887–89.

New Inspirations: Antonio Gaudi

The work of the Spanish architect Antonio Gaudi (ahn-**toh**-nee-oh **gow**-dee) reflected his belief that an entirely new kind of architecture was possible. Gaudi turned away from current practices. He was inspired instead by nature and his own vivid imagination. Gaudi felt that if one listened very closely to nature, its secrets could be learned. He believed these secrets could be used by the sensitive artist in architectural designs. Thus, the roof of a building could resemble

a mountain with its ridges and slopes (Figure 23.25). Ceilings could look like the wind- and water-worn walls of caves, and columns could suggest the stout, sturdy legs of elephants.

In 1900, a rich textile manufacturer named Güell asked Gaudi to design a city that would show the latter's ideas on town planning. It was to be a garden city of sixty dwellings. The proposed site was a hill that overlooked the sprawling city of Barcelona, Spain. Sadly, Gaudi's busy schedule kept him from completing the project. Construction was limited to the main entrance with two gatehouses, fountains, play area, gardens, roads, and footpaths. Later, the 38-acre (15.3-ha) site was given to the city to be used as a public park.

If you were to visit Güell Park today, you would pass through the main gate with its two fairy-tale gatehouses on either side (Figure 23.26). Your eye would be dazzled by the pieces of brightly colored ceramic tiles on the walls and roofs. However, this is nothing compared to what you would see inside. There you would find yourself in an enchanted garden with a double staircase curling around bubbling fountains. A huge, colorful dragon would greet you as you climbed the stairs. At the top, you would find a great Doric colonnade supporting a children's game terrace. A snakelike bench, covered by mosaics made from pieces of glazed pottery, completely surrounds this terrace. It is an enchanted world that Gaudi created here, a world with no direct link with the past, a world that owes its existence to a truly unique imagination.

➤ Today, Gaudi's works are being rediscovered and showered with praise. To what do you attribute this new interest? Notice the photograph in Figure 23.27, which was inspired by this building of Gaudi's.

Figure 23.25 Antonio Gaudi. Casa Mila. Barcelona, Spain.

As he grew older, Gaudi showed little interest in anything except his art. On June 7, 1926, while crossing a busy street, he was hit by a streetcar. He was so poorly dressed that witnesses thought he was a street beggar. Taxi drivers refused to drive him to the hospital, and so several passersby finally carried him to a local clinic for treatment. Later, he was moved from the clinic to the hospital and placed in a charity ward. Several hours passed before friends found the famous architect in a pauper's bed. Gaudi never regained consciousness and, three days later, he died.

Drawing on the Past: Julia Morgan

In the United States a widespread fondness for the architectural styles of the past continued from the late nineteenth into the early twentieth centuries. Many architects planned structures with the public's fondness for the past in mind. Both architects and patrons considered certain styles to be right for certain types of buildings. For instance, Gothic was thought right for churches, Roman for banks, and Classical for museums and libraries. Tudor was the style in which many houses were built. Eighteenth-century French was the style for mansions. A fine example of an **eclectic style**, or *one composed of elements drawn from various sources*, is the estate designed for William Randolph Hearst by Julia Morgan. It is located at San Simeon, California (Figure 23.28, page 554).

➤ What makes Gaudi's work so unique?

Figure 23.26 Antonio Gaudi. Gatehouse, Güell Park. Barcelona, Spain. 1900–06.

Eikoh Hosoe

Japanese photographer Eikoh Hosoe (b. 1933) believes that "a true photographer in the greatest sense should be able to portray that which is invisible." This philosophy grew out of a career that began during the American occupation of Japan after World War II and culminated in the development of a highly personal photographic style that captures essential elements in a unique way.

The son of a Shinto priest, Hosoe was in his second year of high school when he had his first success as a photographer. He states that "my photographs at that time were mostly out of focus or blurred, underexposed or overexposed," but a particularly excellent picture won a prize. Hosoe recalls, "My success caused me to think, naively, that photography could make me a millionaire, and thereafter I became too obsessed with taking photos to study my school work. Instead, my entire attention was directed to reading photographic books or magazines."

By the time Hosoe enrolled in the Tokyo College of Photography in 1951, he had begun to appreciate the aesthetic value of photography as well as its financial rewards. During the 1950s he was one of several photographers working in a new expressive manner quite unlike the realistic documentary style then in favor in postwar Japan.

Extensive international travel has been a hallmark of Hosoe's photographic career. On a 1964 trip to Barcelona, Spain, Hosoe became fascinated with Gaudí's architecture. "I was so taken by his creations, in fact, that I forgot I was a photographer and just kept gazing at his strange buildings without taking a single picture. I found myself strongly attracted to something I was unable to define." Thirteen years later, Hosoe began to photograph Gaudí's creations in a way that brought out their organic qualities. He eventually published an entire book on Gaudí, who he feels explored a Zen Buddhist philosophy through architecture. Hosoe says, "As I gazed on those stones, and again at the front entrance to Casa Mila, with its H-shaped pillar, I felt I was suddenly transferred bodily to Ryoanji, the famous Zen temple in Kyoto renowned for its mysterious sand-and-stone garden."

Hosoe continues to experiment with new techniques, exhibit and publish photographs, and conduct workshops around the world. Despite the years he has spent as a photographer, Hosoe insists that photography is a still-changing art form: "Like the Möbius band, photography can be viewed as a continuous surface formed from a rectangular strip with one end rotated 180 degrees and attached to the other end. My humble wish is that my photography will remain similarly as free."

Figure 23.27 Eikoh Hosoe. *The Cosmos of Gaudi. Casa Mila.* Barcelona, Spain. 1979.

Morgan was the first woman to graduate as an architect from the famous École des Beaux Arts in Paris. She ranks as one of America's top architects. Between 1902 and 1952 Morgan designed over seven hundred structures. Yet, she is barely known today. She chose not to publicize her work but preferred, instead, to have it speak for her. For this reason, Morgan would not have her name placed at construction sites. When she retired in 1952, she destroyed all of her records.

In 1919, this shy, retiring woman was already successful. In that year she was chosen to plan the estate of the flamboyant journalist and congressman William Randolph Hearst. Its location in San Simeon was about two hundred miles south of San Francisco. The main structure on this huge estate is the house of one hundred rooms, which was started three years later. The critics had a name for its free use of many styles. They called it the "Spanish, Moorish, Romanesque, Gothic, Renaissance, Hang-the-Expense" style of architecture. It is easy to see why. The façade includes two towers that rise 137 feet (41.8 m) high. They are replicas of a tower found on a sixteenth-century Moorish cathedral in Ronda, Spain. Each tower is topped by a prominent weather vane. These vanes were brought from Venice and date from the seventeenth century. The two towers are joined by a teakwood gable roof that came from a Peruvian palace. The main doors were taken from a Spanish convent of the sixteenth century. They are flanked by Spanish Gothic relief sculptures.

Morgan was known for doing her best to satisfy the needs and desires of her clients. This is certainly evident at San Simeon. Surely though, her patience must have been put to test in the face of Hearst's tendency to change his mind and redo things. For example, Hearst approved Morgan's plans for the towers, but once they were up they did not please him. At great expense, he had them torn down and replaced by the more decorative versions that now stand. When he wanted to move a large French Renaissance fireplace in one of the guest houses, it was moved. Later, when he decided that he liked it better in its original position, it was moved back again.

Julia Morgan died in 1957, six years after Hearst. She had built a reputation as an architect with a strict concern for detail and a stubborn appreciation for high-quality work. Her many projects, especially the grand design for San Simeon, speak eloquently for this woman who refused to speak up for herself.

A New Style: Louis Sullivan

America's pioneering architect of the late nineteenth and early twentieth centuries was Louis Sullivan. Other architects at this time were inspired by the past. Unlike them, Sullivan was busy exploring new approaches. Early in the 1890s, he designed the Wainwright Building in St. Louis (Figure 23.29), a structure that owes little, if anything, to earlier styles. For its basic support, Sullivan used a large frame, or cage, made of steel beams. This frame was then covered with vertical strips of brick. Windows and decorative panels filled the spaces in between. The cagelike frame can be seen clearly from the outside of the

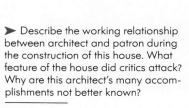

➤ Describe the working relationship between architect and patron during the construction of this house. What feature of the house did critics attack? Why are this architect's many accomplishments not better known?

Figure 23.28 Julia Morgan. San Simeon. Between Los Angeles and San Francisco, California. Begun 1919.

➤ Vertical steel beams support the walls of this building.

Figure 23.29 Louis Sullivan. Wainwright Building. St. Louis, Missouri. 1890–91.

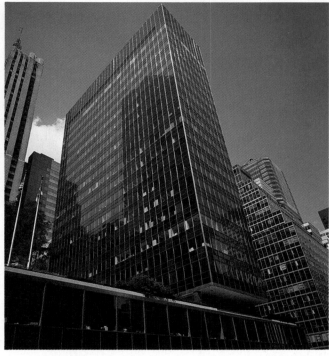

➤ List the main features of structures like this that were built according to the International Style of architecture. Compare these features with Louis Sullivan's Wainwright Building (Figure 23.29). Do you see examples of each kind in your city?

Figure 23.30 Skidmore, Owings, and Merrill. Lever House. New York, New York. 1952.

structure. It is evident that this steel frame, and not the brick walls, supports the building.

The simplicity and logic of buildings like Sullivan's were not lost to architects who followed. During the twentieth century, buildings made with steel frames covered with glass and concrete were built everywhere, resulting in an International Style of architecture. The Lever House in New York City (Figure 23.30) is an excellent example of this style.

SECTION THREE

Review

1. For what work is Alexandre Gustave Eiffel best known?
2. Why is Eiffel's creation regarded as an important engineering feat?
3. What two sources provided Spanish architect Antonio Gaudi with the inspiration for his architecture?
4. How did Gaudi's Güell Park structures differ from traditional park buildings — in materials and design?
5. Why is Julia Morgan's work on San Simeon described as *eclectic*?
6. What set Louis Sullivan apart from other architects of the same period?
7. Describe the features of Sullivan's Wainwright Building that were considered new and pioneering.

Creative Activity

Humanities. Louis Sullivan's skeleton-steel structures changed the look of architecture. No longer did buildings have to be heavy masonry. Trace the modern form of architecture from the 1930 glass-and-steel simplicity of Mies van der Rohe (whose first such buildings were designed as low-cost housing for German workers) to the International Style that they inspired. This stark form dominated world architecture until the 1970s. Architects broke from the plain line and began the Postmodern movement, a return to many elements of past form — arches, columns, domes, atria (as in ancient Roman homes), and many other wildly imaginative variations — all reinterpreted in the materials and technology of today. Look in architecture magazines and photograph buildings in your area. Gather many examples of Postmodern into a bulletin board display.

ABSTRACT CUT-PAPER FIGURES

Supplies

- Pencil and sketch paper
- Sheet of white drawing paper, 18 x 24 inches (46 x 61 cm)
- Large and small pieces of fadeless art paper or colored construction paper
- Scissors, glue

CRITIQUING

- *Describe.* Are the two figures in your work easily identified? Can others distinguish between the active figure and the motionless figure even though both are highly abstracted?
- *Analyze.* Are repetitious, decorative shapes used to add harmony to your composition? Is variety realized by making these shapes in different sizes? Does your composition avoid the suggestion of depth?
- *Interpret.* Are other students able to correctly identify the relationship between the two figures? Can they determine what each is doing?
- *Judge.* What aesthetic quality, or qualities, would you use when judging your work? Using these, is your work successful? If you were to do it again, what would you do differently?

Complete a paper cutout featuring two large, abstract figures, one in action and the other motionless. These will be large silhouettes cut from brightly colored fadeless art paper or construction paper. Glue the figures to a white background so that they appear to relate to one another in some way. Cut out other abstract shapes in various sizes and glue them in place to increase the decorative effect and add harmony to your composition. Make no effort to suggest space or depth.

Focusing

Look again at Henri Matisse's colorful cutout of *The Knife Thrower* (Figure 23.3, page 534). Can you locate the two figures? Which one is the knife thrower? How do you know? What is the other figure doing? How do the smaller shapes add harmony to this work? Do you think space is an important element in this composition?

Creating

Make several pencil sketches in which two large, abstract figures dominate. One of these figures must be engaged in some kind of spirited activity. The other should appear quiet and motionless. There should be a clear relationship between these two figures, just as the knife thrower and his assistant are related in Matisse's cutout artwork.

Enlarge and redraw your figures lightly on the pieces of brightly colored paper. Cut these out as two abstract silhouettes by concentrating on the outlines and eliminating all unnecessary details.

Design and cut out several smaller, decorative shapes in a variety of sizes. These should be similar in appearance since they will be used to add harmony to your composition.

Arrange your figures and shapes on a large sheet of white paper and, when you are satisfied with the design, glue them in place.

Figure 23.31 Student Work

CUBIST-STYLE PAINTING

Create a painting in the Cubist style based on a series of realistic drawings of a cup and saucer. This painting will show all sides of the two three-dimensional objects on a two-dimensional surface. To do this, make certain to include different parts of the cup and saucer as seen from the top, sides, and bottom. Do not show a complete cup or saucer anywhere. Use a variety of light and dark values mixed from a single hue to paint your composition. Use no less than six different values.

Focusing

Look at the Cubist painting in Figure 23.13, page 540. Can you identify any of the objects in this painting? How many hues are used? Are the objects in Picasso's collage (Figure 23.14, page 540) or Braque's painting (Figure 23.16, page 542) easier to identify? Can you find any complete objects in these works? Which of these works do you find most appealing? Why?

Creating

Complete several realistic pencil drawings of a cup and saucer. Draw these objects together and separately from different points of view. Examine your finished drawing carefully and identify the most interesting parts.

On the sheet of white paper, create a composition that combines these parts into a visually interesting whole. Make certain to use parts selected from each of your drawings so that the top, sides, and bottom of the cup and saucer are represented.

Paint your composition using no less than six values of a single hue. Mix these values by adding white or black to the hue that you have selected. Shapes can be painted as flat areas of color, or gradation of value can be used to suggest three-dimensional forms. The contours of your shapes or forms should be crisp and smooth.

Figure 23.32 Student Work

Supplies
- Pencil and sketch paper
- Sheet of white drawing paper, 12 x 18 inches (30 x 46 cm)
- Tempera or acrylic paint
- Brushes, mixing tray, and paint cloth
- Water container

CRITIQUING

- **Describe.** Does your painting include sections of a cup and saucer seen from different points of view? Can you point out and name these sections? Did you show a complete cup or saucer anywhere in your composition?
- **Analyze.** Did you use six or more light and dark values mixed from a single hue when painting your picture?
- **Interpret.** Can other students identify the cup and saucer elements in your picture? Do they recognize that your painting is an attempt to show all sides of these three-dimensional objects on a two-dimensional surface?
- **Judge.** What aesthetic quality would you want others to rely on when judging your painting? Using that aesthetic quality, do you think your painting is successful? Which of the Cubist works in this chapter most closely resembles your own efforts in this style?

Review

Reviewing the Facts

SECTION ONE

1. Was Matisse more interested in literal qualities or design qualities in his paintings?
2. Name the artist associated with the Fauves whose works were a condemnation of the world's suffering.
3. The artists of what German movement were interested in representing deep emotional feelings in their work?

SECTION TWO

4. What kinds of stories did the Mexican artists tell with their murals?
5. What subjects did the artists from the Ashcan School paint?
6. What event in what year introduced the American public to the works of the modern European artists?

SECTION THREE

7. Name the famous American female architect who designed the main structure of the Hearst estate at San Simeon in California.
8. Describe the construction of the buildings by American architect Louis Sullivan and tell what style of architecture it inspired.

Thinking Critically

1. **Analyze.** Look again at Georges Rouault's painting *The Old King* (Figure 23.4, page 535). Write a description of the quality of the lines in the painting. Then look through the book and identify an artist whose lines are very different from Rouault's lines. Write a description of the quality of that artist's lines also.

2. **Compare and contrast.** Refer to Maillol's sculpture *The Mediterranean* (Figure 23.17, page 543) and the Greek sculpture *Seated Boxer* (Figure 8.26, page 182). What comparisons can you make between the two sculptures? In what ways do you see that they are different or similar? Consider the literal, design, and expressive qualities of both sculptures.

Using the Time Line

Note the year 1913 on the time line. What work is shown to have been created in that year? What important artistic event took place in the United States in 1913? What event of international significance took place the following year? When did Käthe Kollwitz create *Woman Greeting Death*? In that same year, a political leader assumed complete control in Germany. Who was he and what was his impact upon the world?

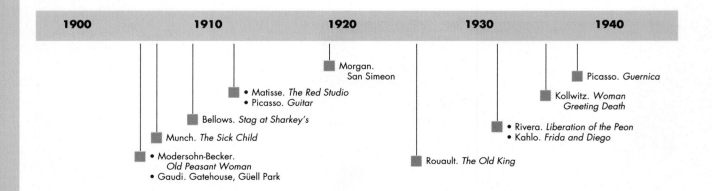

1900	1910	1920	1930	1940

Morgan. San Simeon

• Matisse. *The Red Studio*
• Picasso. *Guitar*

Picasso. *Guernica*

Bellows. *Stag at Sharkey's*

Kollwitz. *Woman Greeting Death*

Munch. *The Sick Child*

• Rivera. *Liberation of the Peon*
• Kahlo. *Frida and Diego*

• Modersohn-Becker. *Old Peasant Woman*
• Gaudi. Gatehouse, Güell Park

Rouault. *The Old King*

Dusty Kaylor, Age 16
Milton High School
Alpharetta, Georgia

Dusty wanted to try Rouault's style of combining intense, bold colors with black. She chose a sunflower as her subject and began by using watercolor washes for background colors. Next she switched to colored pencils to depict the details, such as petals and seeds.

In evaluating the finished work, Dusty felt that the media combined well to provide the bold colors and shapes she sought. She enjoyed the effect she attained by using a loose, uncontrolled style for the first stage and a very detailed, controlled style to finish the work. She felt that by using the colored pencils over a watercolor undercoat, she achieved an added richness and depth that would not have been possible by using only one medium.

➤ *Sunflowers.* Watercolor and colored pencils. 25.4 x 20.3 cm (10 x 8″).

New Directions:
Art to the Present

Objectives

After completing this chapter, you will be able to:

➤ Explain what is meant by Dada and Surrealism in art.

➤ Define Regionalism and point out the features that made it a completely American art style.

➤ Define Abstract Expressionism and explain how it differs from representational art.

➤ Describe the innovations in architecture made by Le Corbusier and Frank Lloyd Wright.

➤ Explain what is meant by Op art and name some artists who employed this style in their work.

Terms to Know

Abstract
 Expressionism
assemblage
Dada
Hard-edge
 art
mobile
Op art
Photo-
 Realism
Pop art
Regionalism
Surrealism

Figure 24.1 Alfred Leslie. 7 A.M. News. 1976–78. Oil on canvas. 2.1 x 1.5 m (7 x 5'). Frumkin/Adams Gallery, New York, New York.

During the early 1900s, artists in Europe and America continued to

show much interest in new materials and techniques. Painters seemed more anxious

than ever before to work with design and expressive qualities. Sculptors used traditional and

modern materials in new ways; through new kinds of processes, they found unique

ways to combine forms. Architects working with iron, steel, reinforced

concrete, and glass were also discovering new techniques.

SECTION ONE

Revolutions in European and American Art

The years following World War I in Europe were marked by revolution and inflation, anxiety and unrest. To many it was apparent that the "war to end all wars" was not going to bring about prolonged peace and prosperity. It was a time of disillusionment, and this was apparent in much of the art that was produced.

Painting in Europe: Dada, Surrealism, and Fantasy

One group of artists expressed their disillusionment in their art. Known as **Dada**, *the movement ridiculed contemporary culture and traditional art forms.* The movement is said to have received its name when one of its members stuck a pin into the word *dada* on a page of a dictionary opened at random. The word, which sounded like baby talk, made no sense at all. However, since the members of the movement believed that European culture had lost all meaning and purpose, this word seemed appropriate.

Dada artists like Marcel Duchamp (mahr-**sell** dyu-**shahn**) exhibited the most ordinary and absurd objects as works of art. These objects included an electric iron with tacks glued to it and a fur-covered cup, saucer, and spoon. Perhaps no work sums up the Dada point of view as well as Duchamp's photograph of the *Mona Lisa* — with a carefully drawn mustache. With works like this, the Dada artists sought to ridicule the art of the past.

The Dada movement ended in 1922. However, it set the stage for later artists who were attracted to the idea of creating art that was whimsical, humorous, and fantastic.

Joan Miró

Joan Miró was a forgetful, modest little man who looked as if he should be working in a bank rather than in a painting studio. He lived on the island of Majorca off the eastern coast of Spain and painted in a room so small that he had difficulty moving around in it. Because he never lost his childhood curiosity, his house was filled with toys, which he collected and studied with enthusiasm and amusement.

When he was a student in his native Spain, a teacher made him draw objects by feeling them and thinking about them rather than by looking at the objects. Nothing could have been better for him; he was always more fascinated by the world within than by the world around him.

In 1925, Miró startled the Paris art world with a painting called *Carnival of Harlequin* (Figure 24.2, page 562). This work served notice that the shy little Spanish artist was a major figure in twentieth-century art. The painting was among the first in a new style of art called **Surrealism**, *in which dreams, fantasy, and the subconscious served as inspiration for artists.*

The *Surrealists* were a group of artists who rejected control, composition, and logic. They preferred instead to paint the world of dreams and the subconscious. The world of dreams had been explored before by Bosch, Goya, and others. However, in even the most fantastic of their works, the subjects could be recognized. This is not true of Miró's paintings.

Miró saw many hardships, and these led to the visions that inspired paintings like *Carnival of Harlequin*. When he arrived in Paris in 1919, he forced himself to live on one meal a week, chewing gum to

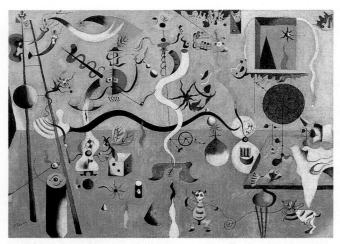

➤ This was among the first works to be called Surrealist. What were the Surrealists interested in showing in their paintings?

Figure 24.2 Joan Miró. *Carnival of Harlequin.* 1924–25. Oil on canvas. Approx. 66 x 92.7 cm (26 x 36⅝"). Albright-Knox Art Gallery, Buffalo, New York. Room of Contemporary Art Fund, 1940.

deaden his appetite and eating dried figs for energy. Then, when he began painting, forms came to him as if seen in a vision. Sometimes an accidental brushmark suggested the beginnings of a picture. This period of unconscious experiment would only last for so long. He would then work on each detail. The result of this effort was a carefully controlled design.

After seeing *Carnival of Harlequin*, a writer said that Miró's pictures were for children. The statement was meant to belittle Miró's paintings, but it contains a certain amount of truth. Miró's playful paintings, you see, appeal to the child in everyone.

➤ To which aesthetic qualities would you refer when making a judgment about this painting?

Figure 24.3 Salvador Dali. *The Persistence of Memory.* 1931. Oil on canvas. Approx. 24 x 33 cm (9½ x 13"). Collection of the Museum of Modern Art, New York, New York. Given anonymously.

Salvador Dali

Miró's countryman Salvador Dali (**dah**-lee) joined the Surrealist movement late and used his skills as a master showman to become its most famous member. In *The Persistence of Memory* (Figure 24.3), he created an eerie world in which death and decay are symbolized by a dead tree and a strange sea monster decomposing on a deserted beach. Ants swarm over a watch in an unsuccessful attempt to eat it. The meaning of this unusual picture seems clear; in time, everything will die and decay except time itself. Time alone is indestructible. The limp watches indicate that someone has the power to twist time as he or she sees fit. That person is the artist who painted them this way. Thus, Dali tells you that the artist alone, through his or her works, is able to conquer time and achieve immortality.

The meanings in Dali's other works are not always as clear. In some, the symbolism is lost to everyone but the artist. Furthermore, his images are frequently so bizarre and grotesque that some people have called them the products of a madman. Dali, enjoying the controversy caused by his works and his unusual behavior, responded by saying, "The difference between a madman and myself is that I am not mad."

Paul Klee

Although the Swiss painter Paul Klee (clay) was never a Surrealist, fantasy was an important part of his painting. On scraps of burlap, paper, glass, and linen, he produced pictures based on his own imagination and wit. Often he worked on several paintings at the same time, sitting before his easels for hours, puffing on his pipe. He was fascinated by a world which he said was filled with wonders, and spent hours studying shells, coral, butterfly wings, stained glass, and mosaics. His reactions to the world resulted in pictures that can free you from accustomed ways of looking at things or cause you to smile with delight and amusement.

In 1902, while in Italy, Klee visited the aquarium in Naples. For hours he stood with his nose almost pressed against the glass, watching the fish in the huge tanks dart, turn, and glide gracefully by. He was bewitched by the colorful fish, the flora that swayed gently in the current, and the bubbles that drifted lazily upward. Later, Klee recalled that marvelous dream world he saw in the aquarium. Inspired, he took his brush and slowly began to make lines and shapes on a canvas. He had no definite idea in mind, but as he worked, forms slowly began to take shape. He painted many pictures this way, each showing a

marvelous dream world suggested by the things he had seen in the aquarium. One of those pictures was named *Fish Magic* (Figure 24.4).

Klee created almost nine thousand paintings and drawings. In 1933, after years spent painting, teaching, and writing in Germany, he returned to his native Switzerland, where he died seven years later. On his tombstone is an inscription that is a testament to his immortal imagination: "I cannot be understood in purely earthly terms. For I can live as happily with the dead as with the unborn."

Painting in America: Surrealism, Regionalism, and the American Scene

American art, from the time of the Armory Show in 1913 until the start of World War II in 1939, owed much to the modern art movements that sprang up in Europe at the start of the century. Some artists were influenced by the bright, decorative style of the Fauves or explored their own personal approaches to Cubism. Others took the path of the Expressionists or the Surrealists.

Kay Sage

Kay Sage, for example, shared an interest in Surrealism with her husband, the French-born painter Yves Tanguy. In *No Passing* (Figure 24.5), Sage shows you a fantastic world of beautifully built but meaningless structures. Complex and illogical, these architectural forms are repeated over and over again until they disappear into infinity. To experience the full impact of this mysterious painting, place yourself in the picture. Almost immediately you sense the loneliness, the nightmarish quality of the work. You seem to be standing on some strange, deserted planet. Nothing moves; no sounds are heard. You look up to see huge forms towering over you. They look like the painted scenery left over from a stage play produced in the distant past by a race of giants. Their colors are dull and earthy as if time had dimmed their brilliance. Who built them and why have they been abandoned?

How has Sage created this vision that disturbs and attracts you at the same time? It is composed of repeated angular forms placed in what appears to be a limitless space. A strange light from an unknown source illuminates these forms. Each form is painted in a slightly lighter value and on a slightly smaller

➤ Did Klee have a clear idea in mind when he started working on a painting? What procedure did he follow?

Figure 24.4 Paul Klee. *Fish Magic*. 1925. Oil on canvas mounted on board. Approx. 77.5 x 97.8 cm (30⅜ x 38½"). Philadelphia Museum of Art, Philadelphia, Pennsylvania. The Louise and Walter Arensberg Collection.

➤ Has the artist succeeded in creating the illusion of deep space? If so, how has this been done?

Figure 24.5 Kay Sage. *No Passing*. 1954. Oil on canvas. 130.2 x 96.5 cm (51¼ x 38"). Collection of the Whitney Museum of American Art. New York, New York. Purchase.

scale, until they fade away into a gray mist. The brushwork is almost invisible and the image difficult to describe exactly. There is no denying the impression that, no matter how far you walk into this picture, you will always face that row of absurd forms stretching to the horizon and beyond.

Unlike Sage, other American artists chose not to follow the art movements of Europe, because they felt those doctrines were too complicated. They wanted to paint the American scene in a clear, simple way so that it could be understood and enjoyed by all. During the 1930s, **Regionalism** became a popular art style in which *artists painted the scenes and events that were typical of their sections of America.* Thomas Hart Benton painted his native Missouri; John Steuart Curry, Kansas; and Grant Wood, Iowa.

Grant Wood

Like the other Regionalists Benton and Curry, Grant Wood studied in Europe. In Paris, he was exposed to the modern art styles, but the art he saw on a trip to Munich, Germany, in 1928 impressed him more deeply. The fifteenth- and sixteenth-century Flemish

➤ With what group of artists was Wood associated? Why were these artists given this name?

Figure 24.6 Grant Wood. *American Gothic*. 1930. Oil on beaver board. Approx. 76 x 63 cm (29⅞ x 24⅞"). Courtesy of The Art Institute of Chicago, Chicago, Illinois. Friends of American Art Collection, 1930.

and German paintings he saw there were to affect much of his later work. When Wood returned to his native Iowa, he painted rural scenes using a style of realism modeled after that of the Flemish and German works. His well-known painting *American Gothic* (Figure 24.6) captures some of the simple faith and determination of the European Gothic period.

Because it is such a familiar picture, you may think that there is little still to be learned from it. However, when you go beyond *description* to conduct a thorough *analysis*, you will be impressed by the way the artist has organized this painting. A curved contour line is repeated over and over again throughout the work as a way of adding harmony. You can find these contour lines for yourself, beginning with the curve representing the top of the woman's apron. Trace this line with your finger, and then see how many similar curves you can find in the rest of the picture. As you do this, you might notice that the pattern of the pitchfork is repeated in the seam of the man's overalls. Also, did you see how the heads of the figures are linked by the horizontal lines of the porch roof and the diagonals forming the peak of the house?

Edward Hopper

Edward Hopper was not a Regionalist in the true sense of the word, although he did paint the American scene in a realistic manner. As a student of Robert Henri, Hopper had early ties with the Ashcan School. However, unlike the Ashcan artists who used the city as a setting for their pictures, Hopper concentrated on the look and feel of the city itself. Ignoring the glitter and excitement of the city life, he set out to capture the emptiness and loneliness that were also a part of the urban scene. Many of his pictures did not include people—they were not needed. He was able to communicate a feeling of loneliness, isolation, and monotony with pictures of deserted streets and vacant buildings. When he did show people, they were often seen through the windows of all-night diners, huge, empty houses, and drab apartments. At other times, they were glimpsed as if seen from a fast-moving car. His pictures re-create the mystery and the loneliness which, for many people, are as much a part of a great city as its towering skyscrapers and endless traffic.

Typical of Hopper's paintings of loneliness and isolation is *Drug Store* (Figure 24.7). He shows the shop at night—its warm lights threatened by the darkness, the emptiness, and the silence on all sides. With pictures like these, Hopper was able to re-create the same feeling you have when you find yourself all alone in strange surroundings with nothing to do.

➤ What kind of mood is expressed by this painting? If you could use only one aesthetic theory when judging this work, which would it be: imitationalism, formalism, or emotionalism?

Figure 24.7 Edward Hopper. *Drug Store.* 1927. Oil on canvas. 71 x 103 cm (28 x 40½"). Museum of Fine Arts, Boston, Massachusetts. Bequest of John T. Spaulding.

American Artists Take a New Direction

Painters like Grant Wood and Edward Hopper remained convinced that art should make use of subject matter. Other artists, however, did not share this same commitment to subject matter. Included among these was Stuart Davis.

Stuart Davis

Although Stuart Davis's early works were influenced by the Ashcan School, the Armory Show introduced him to new models. Almost at once, he set out to find a new visual language with which to express himself. At first, he did colorful landscapes that looked like the work of the Fauves. Then in 1927 he nailed an electric fan, a pair of rubber gloves, and an egg beater to a table, and for an entire year painted nothing else. It was a turning point for the young artist, because it drew him away from a reliance on subject matter and opened his eyes to the possibilities of abstraction.

Davis's best works reveal his affection for urban America. Sometimes, as in *Swing Landscape* (Figure 24.8), he used parts of recognizable objects in his works. At other times, he used only the colors, shapes, and textures suggested by the world around him. He painted the American scene as he saw it, felt it, and heard it.

➤ Does this work exhibit a great deal of movement and excitement, or does it seem calm and still? What has been done to make some shapes seem closer than others? In what way is this painting like the musical rhythms played by a jazz band?

Figure 24.8 Stuart Davis. *Swing Landscape.* 1938. Oil on canvas. 2.2 x 4.4 m (7' 2¾" x 14' 5⅛"). Indiana University Art Museum. Bloomington, Indiana.

Art · PAST AND PRESENT ·

American Art on Videodisk

Reproducing art has been of concern to patrons of the arts throughout history. In modern times, photography, film, and television have all been used to make reproductions of art available to the general public, who might not otherwise have been able to view important works of art.

In an attempt to make art more readily available to the public, the National Gallery of Art in Washington, D.C., is using computers to capture about 2,500 works of American art on videodisk. This project will make masterpieces of American art available for viewing at home or at school.

The videodisks are the equivalent of a slide library, with details of and information on each piece of art. In fact, the disks will contain over 10,000 images. Videodisk was chosen as the medium because of the quality of the reproduction and for ease of use. Images on a disk can stand still for any period of time, and a specific frame can be found in a moment.

The project was undertaken to make works of art more easily available to students of art. These videodisks will allow greater access to American art than ever before and are available to teachers who would like to use them through a free loan program.

Figure 24.9 Art on Videodisk

Other galleries and museums, such as the Louvre in Paris and the Art Institute of Chicago, are exploring ways in which the computer can be used — for instance, by developing interactive programs and three-dimensional pictures — to convey images of art in new, inviting, and instructional ways.

Georgia O'Keeffe

Stuart Davis drew his inspiration from urban America, but Georgia O'Keeffe was more at ease when she based her art on the things of nature. O'Keeffe studied art in Chicago, New York, and Virginia before taking a position as a high school art teacher in Amarillo, Texas. She was immediately fascinated by the beauty of the dry, open western landscape. While in Texas, she began to paint watercolors based upon her response to the flat, stark landscape where, she said, one could see the weather coming for a week.

Without her knowledge, a friend took a group of O'Keeffe's paintings to the gallery of Alfred Stieglitz in New York. Stieglitz was a talented and well-known photographer. He was impressed with O'Keeffe's paintings at once, exhibited them, and became her most enthusiastic supporter and, eventually, her husband.

During her long career, O'Keeffe painted pictures of New York skyscrapers; the clean white bones, des-

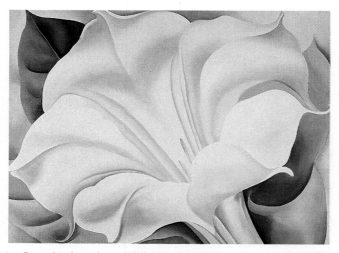

➤ Describe the colors and shapes used in this painting. Point to the places where contrast and gradation of value are found.

Figure 24.10 Georgia O'Keeffe. *White Trumpet Flower.* 1932. Oil on canvas. 75.9 x 101.3 cm (29¾ x 39¾"). San Diego Museum of Art, San Diego, California. Gift of Mrs. Inez Grant Parker in memory of Earle W. Grant.

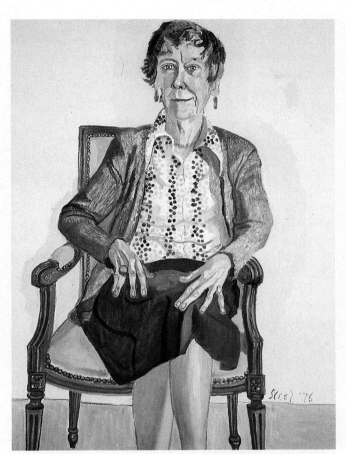

➤ What subject matter did this artist prefer to paint? Where did she find this subject matter?

Figure 24.11 Alice Neel. *Portrait of Ellen Johnson.* 1976. Oil on canvas. 111.8 x 81.3 cm (44 x 32"). Allen Memorial Art Museum, Oberlin College, Oberlin, Ohio. R.T. Miller, Jr. Fund and gift of the artist in honor of Ellen Johnson on the occasion of her retirement, 1977.

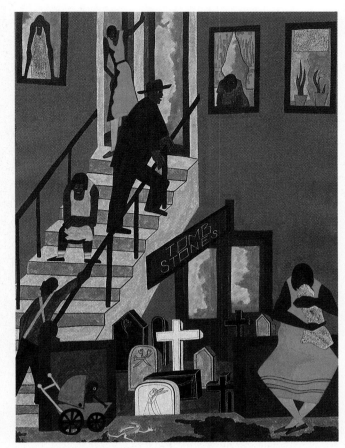

➤ What is the mood of these people? Do they communicate with one another? To what aesthetic qualities would you refer when judging this work? What is your judgment?

Figure 24.12 Jacob Lawrence. *Tombstones.* 1942. Gouache on paper. 73 x 52 cm (28¾ x 20½"). Collection of the Whitney Museum of American Art, New York, New York. Purchase.

ert shadows, and mountains of her beloved Southwest; and flowers (Figure 24.10). Because a flower is so small, so easy to overlook, she determined to paint it in such a way that it could not be ignored. The result was a startling close-up view, painted in sharp focus.

Alice Neel

Alice Neel found the inspiration for her art in people's faces. Her portraits are not realistic, but somehow they still manage to exhibit a lively quality. She painted teachers (Figure 24.11), businesspeople, salespersons, artists, authors, and children. Neel collected people and preserved them on canvas. Like an avid collector always looking for new specimens, she found them everywhere. She often stopped strangers on the street and asked them to pose, and she painted portraits of salespersons who came to her door. Her portraits are all unique — some smile, others frown, still others seem as though they are about to speak.

Some of her portraits are done with great care and precision. Others appear to be casually painted, reflecting perhaps the look and attitude of the sitters.

Take a few minutes to study Neel's portrait of Ellen Johnson. How would you describe the expression on this face? What mood do you think this person is in? Notice that Neel has managed to create the impression that her sitter's mood is a fleeting thing. It might change at any moment, and with it, her expression and her appearance. Studying Neel's portraits will cause you to look more closely at the faces of people you come into contact with, people you meet in school, at parties, or in the street. Like Neel's portraits, you will find all those faces unique and memorable.

Jacob Lawrence

Jacob Lawrence came out of a tradition of social protest. The flat, brightly colored shapes that marked his mature style can be traced back to the work with

poster paints and cut paper Lawrence did as a boy in a New York settlement house. In *Tombstones* (Figure 24.12, page 567), he simplified these flat, colorful shapes to tell a story of hopelessness. Notice how the postures and gestures of the figures in this painting provide clues to their despair. None of these people seem inclined to go anywhere or do anything. They even ignore the crying infant in the baby carriage who has dropped her doll. At first, it seems as if the people in this picture are just waiting, but what are they waiting for? In the basement apartment of the building in which they live is a tombstone dealer. Every day they pass the tombstones on display or peer down on them from their apartment windows. This sight is a constant reminder that the only change in their dreary lives will come when their own names are carved on one of those tombstones.

Abstract Expressionism

After World War II, a new art movement sprang up and took hold in America. Probably no other movement ever gained such instant recognition or caused so much confusion and anger. The roots of this new movement can be traced back to the works of Kandinsky, Picasso, and especially the Surrealists.

The movement was called **Abstract Expressionism**, because *artists applied paint freely to their huge canvases in an effort to show feelings and emotions rather than realistic subject matter*. They did not try to create the illusion of space filled with figures, buildings, or landscapes. They thought of the picture surface as if it were a flat wall and emphasized the physical action it took to paint it. Instead of carefully planned brushstrokes, artists dribbled, spilled, spattered, and splashed paints onto their pictures. As they applied colors this way, they looked for and emphasized areas of interest as they began to emerge. These areas of interest added structure to their work. Several artists were identified with the development of this new style. Included among these artists were Willem de Kooning, Jackson Pollock, Helen Frankenthaler, and Robert Motherwell.

Willem de Kooning

Willem de Kooning (**vill**-em duh **koe**-ning) was born in Holland but moved to the United States in 1926. Among his most powerful and shocking paintings are those showing the female figure, which he began to paint in the late 1940s. Of course, many artists had painted women before, and some, including Raphael, Botticelli, Titian, and Rubens, were famous for their pictures of female subjects. What was so unusual about de Kooning's pictures? Even a quick glance at one of his women (Figure 24.13) should provide an answer to that question. It was not his choice of women as subject matter, but his way of showing them, that aroused so much controversy. People said that his women were grotesque, insulting, and ugly. In fact, they reveal de Kooning's feeling that a woman is a great deal more than just a pretty face. She is revealed as a complex human being with unique interests, skills, and responsibilities. Her emotions range from hate to pity, anger to love, and sorrow to joy. De Kooning knew that it would be impossible to show all this by painting a traditional picture of a woman limited to outward appearances. As he painted, de Kooning stripped away the façade to show the person *within*.

De Kooning's new vision of women grew out of the creative act of painting. Using sweeping, violent strokes, he applied an assortment of rich colors to

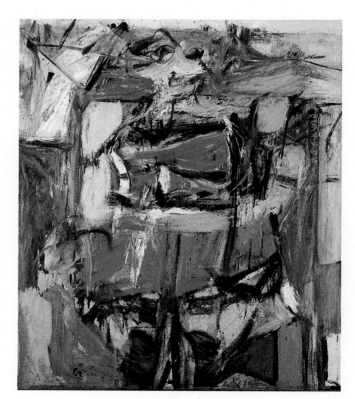

➤ What do you feel is the main concern here — is it outward appearances, or has the exterior been stripped away to allow the viewer to see within the subject?

Figure 24.13 Willem de Kooning. *Woman VI*. 1953. Oil on canvas. 1.74 x 1.49 m (68½ x 58½"). Museum of Art, Carnegie Institute, Pittsburgh, Pennsylvania. Gift of G. David Thompson, 1955.

➤ Jackson Pollock expressed his feelings physically as he painted.

Figure 24.14 Jackson Pollock. *Cathedral.* 1947. Enamel and aluminum paint on canvas. 181.6 x 89.1 cm (71½ x 35¹⁄₁₆"). Dallas Museum of Art, Dallas, Texas. Gift of Mr. and Mrs. Bernard J. Reis.

his canvas. Giving full reign to impulse and accident, he worked until the image slowly came into focus. He never allowed the images to come completely into focus, however; a great deal is left to your imagination.

Jackson Pollock

De Kooning's style was unique, yet his method of painting was more traditional than that of Jackson Pollock. De Kooning worked from a position in front of his paintings with brush in hand. Pollock, by contrast, placed his huge canvases on the floor while he worked. He walked onto and around them, using brushes, sticks, and knives to drip and spatter his paints on the canvas. This technique enabled him to become physically involved with the creative act.

Pollock abandoned the idea that the artist should know beforehand how the painting will look when it is finished. He began each new work by randomly dripping paint over the entire canvas (Figure 24.14).

The purpose of Pollock's art was to *express* his feelings and not just to illustrate them. Other artists chose to picture feelings by painting figures crying, laugh-

ing, or suffering. Pollock's pictures were created while *he* was experiencing those feelings, and they influenced his choice of colors and how he applied them.

Helen Frankenthaler

Helen Frankenthaler (frank-en-**tahl**-er) developed her own unique painting technique as an extension of Pollock's method of applying swirls and drips of paint onto a canvas spread out upon the floor. She moved away from a heavy application of paint, however, to use paint thinned with turpentine. This thinned paint is then poured onto an unprimed, or uncoated, canvas so that it will sink into the canvas and stain it. The paints, poured onto a flat canvas in this manner, produce flowing, graceful, freeform shapes of intense color. These shapes, some with soft edges, others with hard edges, overlap, contrast, or blend with other shapes. Frankenthaler's concern centers upon the way these shapes work in relation to each other.

By concentrating on shapes and colors, Frankenthaler permits a fantasy to take shape on the canvas (Figure 24.15). Like all of her works, this one is nonobjective. Its meaning is for you to discover for yourself.

➤ Point to shapes with soft edges; hard edges. Do you feel a sense of energy here? If so, point to the areas of energy and to the shapes that seem to hold that energy in check.

Figure 24.15 Helen Frankenthaler. *Interior Landscape.* 1964. Acrylic on canvas. 2.66 x 2.35 m (8' 8⅞" x 7' 8⅝"). San Francisco Museum of Modern Art, San Francisco, California. Gift of the Women's Board.

Robert Motherwell

Another leader in the Abstract Expressionist movement was Robert Motherwell. Beginning in 1948, Motherwell created a series of large paintings reflecting the horror and destruction of the Civil War in Spain. Like Picasso before him (*Guernica*, Figure 23.15, page 541), he reveals the war's impact upon the defenseless in paintings like *Elegy to the Spanish Republic 108* (Figure 24.16). Huge, ominous black shapes form before a background of delicate, warm hues, suggesting an overpowering sense of doom. Intent upon communicating the helplessness and anguish of an entire nation on the brink of an inevitable war, Motherwell chose to use a completely nonobjective style. Earlier, Picasso elected to use an abstract style to communicate the same feelings experienced by the suffering inhabitants of a single village who also suffered the ravages of war.

➤ An elegy is a speech or song of sorrow. How is sorrow expressed in this work?

Figure 24.16 Robert Motherwell. *Elegy to the Spanish Republic 108.* 1966. Oil and acrylic on canvas. 213.4 x 373.4 cm (84 x 147"). Dallas Museum of Art, Dallas, Texas. The Art Museum League Fund.

SECTION ONE

Review

1. Name the art movement that came out of a sense of disillusionment and a belief that European culture made no sense at all.
2. What did the Surrealists use as a source of subject matter for their art?
3. What subject matter was used by the Regionalists?
4. Describe the particular artwork that is considered a turning point in Stuart Davis's career.
5. What made Georgia O'Keeffe's painting of flowers so unique?
6. Where did Alice Neel find inspiration for her paintings?
7. What was the subject of Jacob Lawrence's painting of *Tombstones*?
8. Define Abstract Expressionism.

Creative Activity

Studio. The Regionalists painted their own locales—the Midwest, the plains of Kansas. The artists of the Ashcan School before them painted the back alleys and the ordinary scenes of New York with its immigrant population. Look around your own neighborhood and draw the scenes that most represent your region. List all the images you see that capture the character of your place and time. Do many sketches and then combine them into a composite. Complete your regionalist work in tempera, acrylic, or mixed media. Consider what kind of a statement you want to make about your area: a proud celebration, a social statement, an environmental statement.

Art: The Never-ending Quest for New Visual Experiences

The twentieth-century search for new forms was not limited to painters. Many sculptors in Europe and America were engaged in the same quest. Sculptors also felt that they had to break away from their dependence on subject matter to invent new forms. In addition to this, they thought that it was necessary to learn as much as possible about their materials in order to make the best use of them. The material, they argued, could guide the sensitive sculptor in the search for new forms. The work of the English sculptor Henry Moore could certainly be used as evidence in support of their argument.

Sculpture and the Search for New Forms

Like painters, sculptors no longer were just concerned with subject matter and realism. Their works also became more and more abstract and nonobjective. The focus on their work was now on the formal elements and principles of art. Sculptors such as Henry Moore, Barbara Hepworth, and Jacques Lipchitz were among the leaders of the new style.

Henry Moore

Henry Moore sought to create sculptures that would be completely unique and original—images in stone, wood, and bronze that had never been seen before. Because he had no desire to make copies of things, he avoided the use of a model and kept an open mind each time he started a new work. If he chose to do a sculpture in stone, he first studied the block carefully from every angle, hoping that it would suggest something to him. Then, prompted by something he saw or felt, he would take his hammer and chisel and begin to cut into the stone.

His search for new and unusual forms led Moore to cut holes, or openings, into his sculptures. This was something that had never been dared before. In his *Reclining Figure* (Figure 24.17), rounded abstract forms and openings suggest a human image that has been eroded and worn smooth by the forces of nature. The work is Moore's tribute to nature.

Barbara Hepworth

Barbara Hepworth was also a student of nature and applied what she learned to her work in sculpture. As a girl, she often painted the funnellike caves cut into the cliffs along the Yorkshire coast of England. Having had the same teacher as Moore—nature—it is not surprising that many of her works have much in common with his. Beginning in the 1930s, they followed a similar path, opening up their sculptural forms by piercing them with holes and hollowing them out. (See Figure 4.15, page 87.)

Hepworth shared with Moore an affection for and knowledge of natural materials. Meanwhile, other sculptors were looking in different directions.

➤ Do you think you could learn more about this work by studying it from a fixed position or by walking around it? What aesthetic qualities would you use when making a judgment about this sculpture?

Figure 24.17 Henry Moore. *Reclining Figure.* 1939. Elmwood, 94 x 200 x 76.2 cm (37 x 79 x 30"). Courtesy of The Detroit Institute of Arts, Detroit, Michigan.

father on their Oklahoma farm. However, Houser managed to find time to continue with his favorite pastime — art.

In 1948, having found only slight success with his paintings, Houser was thinking of becoming a housepainter. Fortunately, one of his designs was chosen for a war memorial statue at the Haskell Institute in Lawrence, Kansas. Since then he has had little time to think about any other career but sculpture.

Waiting for Dancing Partners (Figure 24.19) is a pink Tennessee marble carving of two Indian women standing side by side at a dance. Their smooth, polished faces contrast with the strands of long hair that encircle them. Over their shoulders they wear heavily textured shawls with fringes. These shawls add further textural contrast to the faces and long, smooth skirts. The textural similarities of the two women tie them together as effectively as do their positions next to each other. A carving like this is meant to be explored slowly with the eyes in order to appreciate the rich surface effects.

➤ What style of painting influenced Lipchitz when he created works like this?

Figure 24.18 Jacques Lipchitz. *Sailor with Guitar.* 1914. Bronze. 78.7 x 21.6 cm (31 x 8½"). Philadelphia Museum of Art, Philadelphia, Pennsylvania. Given by Mrs. Morris Wenger in memory of her husband.

Jacques Lipchitz

Some sculptors, including Jacques Lipchitz (zjahk **lip**-sheets), were influenced by the new movements in painting. Lipchitz arrived in Paris from his native Lithuania in 1909. Soon after, he was attracted to the ideas of Cubism. His *Sailor with Guitar* (Figure 24.18) was done in the Cubist style. It is a three-dimensional form with the same kinds of geometric shapes found in paintings by Picasso and Braque. Flat surfaces of different shapes were placed at various angles to one another. The result suggested a jaunty sailor strumming his guitar.

Allan Houser

Many contemporary sculptors choose to work with abstract or nonobjective forms. Some, on the other hand, prefer more realism. One of these is Allan Houser.

Houser's father was the grandson of the Apache chief, Mangus Colorado, and a relative of Geronimo. The oldest child in a family of two girls and three boys, he had to leave high school in order to help his

➤ Describe these figures in as much detail as possible. From their facial features and clothing, what do you know about these people? Is texture an important art element here? How has it been used? Describe the mood of these figures.

Figure 24.19 Allan Houser. *Waiting for Dancing Partners.* 1979. Tennessee marble. 76.2 x 53.3 cm (30 x 21"). Museum of the Southwest, Midland, Texas.

Innovations in Sculptural Design

While some sculptors looked to Cubism and others to their own cultural backgrounds for inspiration, another sculptor, Alexander Calder, was attracted to abstract and nonobjective art.

Alexander Calder

You do not have to walk around Calder's works to see them completely. They can be viewed from a single vantage point. His sculptures move, and this allows you to stand still and see all their parts as they change position.

Marcel Duchamp invented a term to describe these sculptures that move. He called them mobiles (**moh-beels**). A **mobile** is *a construction made of shapes that are balanced and arranged on wire arms and suspended from the ceiling so as to move freely in the air currents.* This moving arrangement of sheet-metal shapes treats the viewer to constantly changing patterns of colors and shapes. Unlike traditional sculpture, the appeal of these works is almost entirely visual. The works are most effective when the wire arms and attached shapes begin to quiver, swing, and rotate in space (Figure 24.20). Calder's concern centered on the changing relationships of nonobjective shapes.

Louise Nevelson

An interesting contrast to the works of Calder is offered by the sculptures of Louise Nevelson. Hers is a sculptural style of **assemblage**, *a kind of three-dimensional collage.* The massive wooden walls of black, white, and gold that she began to construct during the 1950s firmly established her international reputation.

While she was still in school, a teacher praised her artwork, and that helped her decide to become an artist. Early in her career, she was primarily a painter. However, she did produce some sculptures in bronze, terra cotta, marble, and wood. Some carpenters' scraps from a remodeling project and the chance find of a discarded wooden box proved to be the inspiration for a series of nonobjective sculptures.

In *Sky Cathedral* (Figure 24.21), you can see how she carefully assembled found objects and wood scraps in boxes. These were then stacked together to make a large composition. The result was a rich variety of contrasting angles and curves that Nevelson then unified visually by painting the whole structure

➤ In what ways do Calder's works resemble the paintings of Joan Miró and Paul Klee?

Figure 24.20 Alexander Calder. *Pomegranate.* 1949. Painted sheet aluminum, steel rods and wire. 1.8 x 1.7 m (72 x 68"). Collection of the Whitney Museum of American Art, New York, New York. Purchase.

➤ How was this work put together? What was used to make it? What has the artist done to unify this composition?

Figure 24.21 Louise Nevelson. *Sky Cathedral.* 1958. Wood painted black. 3.4 x 3 x .4 m (135½ x 120¼ x 18"). Collection, The Museum of Modern Art, New York, New York. Gift of Mr. and Mrs. Ben Mildwoff.

➤ What makes this figure look so real? What emotions or feelings do you associate with this work? How would you answer someone who criticized it as looking "too realistic"?

Figure 24.22 Duane Hanson. *Football Player*. Date unknown. Oil on polyvinyl. Life-size. Collection, Lowe Art Museum, University of Miami, Coral Gables, Florida. Museum purchase through funds from Friends of Art and public subscription.

with one color. What you see is a blend of the familiar and the unfamiliar precisely fitted together to form new and novel sculptural forms. In some ways they may remind you of medieval sculptures placed within their assigned niches on the façade of a Romanesque church (Figure 14.21, page 325). Unlike the medieval works, Nevelson's forms are nonobjective.

Duane Hanson

Duane Hanson's lifelike portraits of people, from camera-laden tourists to weary janitors (Figure 4.1, page 78), have sometimes surprised viewers, who have mistaken them for actual people. He uses fiberglass, vinyl, hair, and clothes to re-create the people we pass daily in the shopping mall, at a fast-food restaurant, or on the sidelines of a football game (Figure 24.22). We might even smile at their bizarre costumes or their peculiar behavior—until we realize that other people might be similarly amused at the way *we* dress and act.

Exciting New Concepts in Architecture

As the twentieth century wore on, the International Style in architecture was seen less and less. This decline was due to uninspired and endless repeating of the style in Europe and America. Gradually, architects began to search for new forms and new approaches.

Le Corbusier

One of the most exciting of the new forms was a building in southeastern France (Figure 24.23). The Chapel of Notre Dame du Haut was built in the early 1950s by a Swiss-born architect called Le Corbusier (luh core-**boo**-see-**aye**). (His real name was Charles-Edouard Jeanneret.) The boxlike forms of the old International style are absent here. Instead, one finds massive walls that bend and curve like slabs of soft clay and a rounded, billowing roof. The windows look as if they have been cut through the thick walls with great difficulty. It is a sculptured building that combines features found in the abstract figures of Henry Moore and the curving architectural forms of Antonio Gaudi. At the same time, it suggests the same strength and solidity as a medieval fortress.

➤ In what ways does this structure resemble a sculpture?

Figure 24.23 Le Corbusier. *Chapel of Notre Dame du Haut*. Ronchamp, France. 1950–55.

Judy Kensley McKie

Making furniture is the way Judy Kensley McKie (b. 1944) utilizes both her artistic vision and her practical nature. Although she has a degree in painting and takes great pleasure in viewing art, McKie states, "I was really meant to be making things to use. . . . I guess I'm just pragmatic; I get great satisfaction from being able to sit down and eat at the table after it's been made."

McKie has enjoyed building things since she was a child and helped her father with household building projects. Entirely self-taught in woodworking, McKie first created what she calls "very normal furniture" for herself and her friends. Eventually she grew tired of these simple designs and experimented with carving low-relief animals on the surface of her pieces. This technique produced the lively, humorous, and highly individual, personable furniture style for which she has earned a national reputation.

Although the fantastic creatures carved into the furniture are entirely her own invention, McKie takes inspiration from the art and artifacts of Africa, whose warmth and directness she utilizes in her own designs. She explains that she was "always fascinated with primitive, stylized animal shapes, and after a while it became an obsession." Some of her designs also remind you of pre-Columbian and Native American art.

All of McKie's furniture ideas evolve through a lengthy series of sketches that begin with loose variations of animal and plant designs. It is during this stage that the colors, shapes, and proportions are worked out. She prefers to place the emphasis on the animal imagery, and so she selects the simplest construction techniques to adapt the sketches to a furniture form. Often McKie chooses relatively bland woods, such as poplar or limewood, that will emphasize the animal imagery and the sculptural carving. If she wants to use a light-colored wood, she sometimes bleaches a naturally dark wood such as mahogany.

When McKie is ready to build a piece, she uses power or hand tools depending on the project. Since most of her designs are made in multiples, she sends a prototype to a shop for duplication. Finishing work is done by hand.

Whether she is creating low-relief carvings, sculpture in the round, marquetry panels, or works that will ultimately be translated into bronze, McKie's final criterion for judging her work is to ask herself, "Is this a piece I could live with, have around my house and use, for the rest of my life?"

Figure 24.24 *Proud Dogs Table*. 1985. Carved cherry, ebonized; glass. 43 x 152 x 46 cm (17 x 60 x 18").

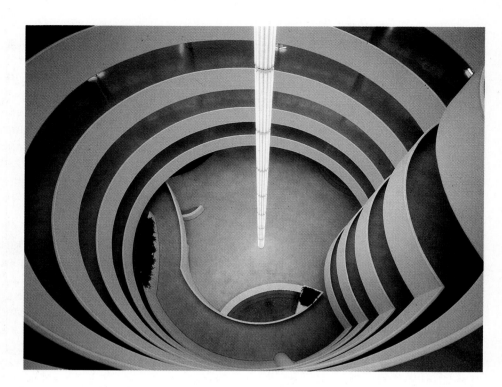

➤ How does this museum differ from more traditional museums? What would you list as its most unusual feature?

Figure 24.25 Frank Lloyd Wright. Solomon R. Guggenheim Museum, interior. New York, New York. 1943–59.

Frank Lloyd Wright

The American Frank Lloyd Wright was destined to become an architect. Before he was born, his mother hung pictures of the great cathedrals in her room to inspire the unborn child. Years later, Wright withdrew from the University of Wisconsin, where he had been studying engineering, to join the architectural firm of Louis Sullivan in Chicago. He left the firm to strike out on his own five years later but never forgot his debt to the head of that firm. Wright called Sullivan his "well-beloved master."

Wright designed over six hundred buildings during his long career. Among them were private homes, apartment buildings, office buildings, factories, churches, and hotels. The Imperial Hotel he built in Tokyo met a special test; it stood through the great earthquake of 1923. That triumph helped to make his reputation as one of the greatest architects of the century.

Wright's most controversial building is the Guggenheim Museum in New York City, a gallery for modern art. Critics said that the building was Wright's revenge on a city that he hated. Some said the outside looked like a giant corkscrew or a cupcake. When you look at the building, it is not too difficult to see how such a charge could have been made. Wright wanted to create a museum in which a single continuous ramp spiraled upward (Figure 24.25). He did not care for the

mazelike collections of rooms found in traditional museums. His plan was a departure from the usual series of connecting squares. He designed a single, round, windowless room almost 100 feet (30.5 m) in diameter. Around this room he placed a continuous ramp. Visitors could either walk up the slight grade or take an elevator to the top and stroll down to the ground level. In either case, the gently curving ramp allowed visitors to walk leisurely past the artworks that hung on the walls.

The controversy surrounding Wright's unusual design for the Guggenheim Museum began before it was finished and has continued to the present. Had he lived, Wright would have paid little attention to the praise or the disapproval heaped upon his creation. He would have been too deeply involved with new projects. Unfortunately, he died six months before his unusual museum opened its doors to the public.

I. M. Pei

Wright avoided the tradition of square-roomed galleries by using one long, circular ramp. I. M. Pei's (pay) problem in designing the addition to the National Gallery of Art in Washington, D.C., was of a different kind. The site was shaped like a trapezoid, formed by the meeting of two streets. To make the best use of this site, Pei used two triangular-shaped buildings. These two structures are linked by a great

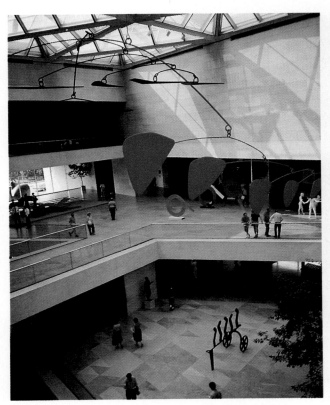

➤ What do you feel are the most appealing features of this building? In what ways is it similar to and different from Frank Lloyd Wright's plan for the Solomon R. Guggenheim Museum (Figure 24.25)?

Figure 24.26 I.M. Pei. East Wing, National Gallery of Art, interior. Washington, D.C. 1968.

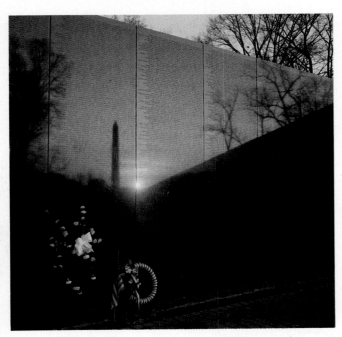

➤ The mirrorlike surface of the black granite reflects trees, lawns, and other monuments.

Figure 24.27 Maya Lin. Vietnam Veterans Memorial, Washington, D.C. 1982.

indoor courtyard (Figure 24.26). A vast skylight high above the courtyard allows natural light to filter down on trees, sculptures, and visitors. In the upper reaches of this courtyard, a huge red, black, and blue Calder mobile floats majestically. Stairways, escalators, and bridges lead from the courtyard to research facilities and numerous galleries of various sizes and shapes.

Pei's design is no less impressive from the outside. A stroll around the building is similar to walking around a huge sculpture. Shapes, forms, angles, and surfaces seem to change, and a new view is presented with each step. The result is satisfying and appropriate. After all, what could be more fitting than a work of art to house the artworks of a nation?

Maya Lin

In 1980, Congress authorized a two-acre site for a memorial that would honor the memory of Americans who had died in the Vietnam War. A national competition for a design was announced, and word eventually reached a young architecture student at Yale University named Maya Lin. Fascinated with the proj-

ect, Lin decided to visit the site in Washington, D.C. There she found a beautiful park near the Washington Monument. Later she said that, as she gazed over the site, she had an urge to cut open the earth as a way of suggesting the violence of war.

Maya Lin finally submitted her design for the monument and, along with some fourteen hundred other entries, it was considered by a jury of international artists and designers. Her design was selected, and on November 13, 1982, the Memorial was dedicated.

Maya Lin's design is a V-shaped black granite wall (Figure 24.27). The tapering segments of this wall point to the Washington Monument in one direction and the Lincoln Memorial in the other.

The wall consists of 1,560 highly polished panels, each of which is 3 inches (7.6 cm) thick and 40 inches (1 m) wide. The panels vary in height. The names of nearly sixty thousand dead or missing American servicemen and servicewomen are listed on these panels. They are listed chronologically in the order of their deaths. In order to read the names, visitors must descend gradually into the earth and then, just as gradually, work their way upward.

The monument neither preaches nor assigns blame. Instead, through its extraordinary understatement, it succeeds in touching the emotions of the more than ten thousand people who visit it each day.

The Search for New Visual Excitement

In recent years, each new generation of artists has included some who were unwilling to continue in the direction laid out by their predecessors. Abstract Expressionist artists were not immune to such challenges. Since 1960, their ideas have been challenged by a series of new art movements worldwide. The loose painting technique and the emphasis placed on personal expression, as seen in the work of de Kooning, Pollock, Motherwell, and other Abstract Expressionists, were replaced by new styles. These new art movements included Pop art, Op art, Hard-edge painting, and Photo-Realism.

Pop Art

A new art form emerged in the 1950s in England. There a group of young artists broke new ground with their collages made of pictures clipped from popular magazines. Collages, of course, were not new. Cubist, Dada, and other artists had used this technique earlier, but for different reasons. These British artists combined pictures of familiar household objects, such as television sets, vacuum cleaners, and canned hams, to state their message. They suggested that people were letting the mass media shape their lives. The art was called **Pop art**, because it *portrayed images from the popular culture*. These artists wanted people to see how meaningless their own lives were becoming, and they wanted people to change.

Pop art made its way to the United States during the 1960s. American Pop artists examined the contemporary scene and reported what they found without satire or criticism. However, they did present their images of Coke bottles and Campbell's soup cans in new ways or greatly enlarged their sizes. In this way they hoped to shake viewers out of accustomed ways of looking at the most trivial trappings of modern life.

Pop artists like Claes Oldenburg treated ordinary objects found in the manufactured environment, such as a three-way electrical plug, in much the same way that Georgia O'Keeffe treated objects found in nature. Both enlarged their subjects to increase the impact on viewers. O'Keeffe did this to call attention to the beauty in nature, which is too often taken for granted (Figure 24.10, page 566). Oldenburg wanted viewers to stop and think about the products of the industrial and commercial culture in which they lived. He felt that people had come to rely too readily on these prod-

➤ Describe the images in this painting. Which of these images dominates? Explain how color adds a sense of rhythm to this work.

Figure 24.28 Richard Lindner. *Rock-Rock.* 1966. Oil on canvas. 179 x 152 cm (70 x 60"). Dallas Museum of Art, Dallas, Texas. Gift of Mr. and Mrs. James H. Clarke.

ucts and hoped to make viewers more conscious of that fact.

Another Pop artist, Richard Lindner, used his art to illustrate the impact of contemporary culture on people. In *Rock-Rock* (Figure 24.28), a rock musician appears to lose his identity by blending with the electric guitar that dominates his life and influences the lives of countless listeners. It is difficult to determine for certain which parts of the painted image belong to the performer and which belong to the guitar. The repetitious bands of contrasting color suggest the same blaring, pulsating beat of the rock music that poured at high volume from radios across the country.

Op Art

Another nonobjective art movement developed in the United States after 1960. At about the same time, similar movements were evident in several European countries, including Germany and Italy. **Op art** was *a style that tried to create an impression of movement on the picture surface by means of optical illusion.* In traditional paintings, the aim was to draw the viewer into the work. In contrast, Op pictures seem to vibrate

and reach out to the spectator. Victor Vasarely, generally regarded as the founding father of this movement, used dazzling colors and precise geometric shapes to create surfaces that appear to move and vibrate. They seem to project forward in some places and recede backward in others.

Bridget Riley (Figure 2.5, page 30) used gradual changes of color and waving lines to add a similar sense of movement to her paintings. The effect is a surface that seems to swell out in one place and fade back in another. Israeli-born artist Yaacov Gipstein, known as Agam (ah-**gahm**), went even further, creating multiple images within the same work. This effect was created with rows of thin, fixed strips which project from the surface of his painting in vertical rows (Figure 24.29). He painted the sides of the strips differently from their tops and from the spaces in between. In this way the artist succeeded in combining several designs in a single work. The one you see depends on your position when viewing the work. When you change your position, the design will change.

Hard-edge Painters

Another group of artists to gain recent prominence are known as **Hard-edge** painters, because they *placed importance on the crisp, precise edges of the shapes in their paintings*. Their works contain smooth surfaces, hard edges, pure colors, and simple geometric shapes, and are done with great precision. Typical of Hard-edge painters is Frank Stella.

▶ What kind of effects did Op artists seek to achieve with their works? Was this artist successful in creating these effects? How did he accomplish this?

Figure 24.29 Agam (Yaacov Gipstein). *Double Metamorphosis II.* 1964. Oil on corrugated aluminum, in eleven parts. 2.69 x 4.02 m (8' 10" x 13' 2¼"). Collection of The Museum of Modern Art, New York, New York. Gift of Mr. and Mrs. George M. Jaffin.

Taking the new Hard-edge style a step further, Frank Stella began to use different canvas shapes for his works (Figure 24.30). Many of his paintings were not rectangular. Working on a huge scale, Stella painted designs that would complement the unique shapes of his canvases. He used a wide range of intense colors to create a vivid visual movement. Thin white lines, actually the unpainted white of the canvas, help define shapes and set off the colors. These white lines, along with large repeated protractorlike shapes, act as unifying elements. They hold the brightly colored work together in a unified whole.

Photo-Realism

One of the leading art styles of the 1970s was **Photo-Realism**, *a style so realistic it looked photographic*. Its instant success may have been due to the exaggerated homage it paid to the literal qualities. It was these qualities that abstract and nonobjective artists had objected to earlier.

Photo-Realists like Alfred Leslie turned away from abstract art and looked to the past for models. One of Leslie's models was Caravaggio. He used that artist's technique to paint huge genre works with a modern flavor. In *7 A.M. News* (Figure 24.1, page 560), Leslie shows a woman alone reading a newspaper. On a table next to her, a television set flickers. The woman's face is illuminated by the harsh, artificial light of the television, a reminder of the divine light found in

▶ How have repetition and contrast been used to unify this painting? What is unusual about the overall shape of this painting?

Figure 24.30 Frank Stella. *Abgatana III.* 1968. Flourescent acrylic on canvas. 3.05 x 4.57 m (10 x 15'). Allen Memorial Art Museum, Oberlin College, Oberlin, Ohio. Ruth C. Roush Fund for Contemporary Art and National Foundation for the Arts and Humanities Grant, 1968.

Andrew Wyeth was born in Chadds Ford, Pennsylvania, a small country town in which he still lives. Since he was not a healthy child, he had to stay home for long periods of time and had few friends his own age. His father became his closest friend and constant companion. Before Andrew was sixteen, he began studying art with his father, and from that point on they drew and painted together every day.

In 1945, Andrew Wyeth's father was killed in an automobile-train accident. Perhaps Andrew's grief was increased by the realization that he had never painted a picture of his father. No doubt he thought of his father constantly in the months following his death, particularly when hiking across the Pennsylvania countryside they once roamed together. His paintings of that countryside seem to reflect his grief and loss.

➤ What seems to dominate in this picture, the boy or the hill? Describe the colors used. Do these colors suggest warmth or coldness? What mood or feeling do you associate with this picture?

Figure 24.31 Andrew Wyeth. *Winter, 1946.* 1946. Tempera on board. 80 x 122 cm (31⅜ x 48"). North Carolina Museum of Art, Raleigh, North Carolina. Purchased with funds from the State of North Carolina.

Caravaggio's painting of *The Conversion of St. Paul* (Figure 19.7, page 435). News comes to this woman from the television and the newspaper. However, the woman looks as if she senses something is missing in the message she is getting from the mass media. (Notice that there are no words on the newspaper.)

Audrey Flack's complex, highly detailed still-life paintings reach the same level of reality found in photographs. In her painting *Marilyn* (Figure 19.25, page 451), Flack presents the viewer with a richly complex still-life arrangement that testifies to the fleeting nature of fame and glamour. Included in the array of objects that clutter the top of a dressing table are a calendar, a watch, an egg timer, and a burning candle—all of which serve to remind us that time runs out for everyone. Beauty, both natural (the rose) and artificial (the make-up), is no match for the persistent assault of time.

Although he is not regarded as a Photo-Realist, Andrew Wyeth (**wye**-uth) is noted for paintings in which careful attention is directed to the literal qualities. It would be a mistake, however, to think of his works as merely photographic. They are much more than this. In his paintings, Wyeth tries to go beyond showing what people or places look like. Instead, he tries to capture their essence.

Like his father, the well-known illustrator N. C. Wyeth, he feels that an artist can paint well only those things that the artist knows thoroughly. To acquire this knowledge the artist must live with a subject, study it, and become a part of it.

➤ What is the subject of this painting? Is this subject treated in a realistic manner? How are variety and harmony realized?

Figure 24.32 Emily Carr. *Forest, British Columbia.* c. 1931–32. Oil on canvas. 129.5 x 86.4 cm (51 x 34"). Collection of Vancouver Art Gallery, Vancouver, Canada.

Typical of those works is his *Winter, 1946* (Figure 24.31), painted a year after his father's death. In this painting a solitary boy runs down a hill. This particular hill appears in many of Wyeth's best-known works. The place where his father died is on the other side of this hill, in the direction from which the boy in the painting is running.

Painting in Canada: A Passion for Nature

Modern Canadian art, which barely existed before the twentieth century, can trace its origins to 1920 and a small group of landscape painters working in Toronto. These painters eventually came to be known as the *Group of Seven*.

The paintings of this group did much to direct public attention away from a cautious acceptance of European styles by exposing viewers to a unique Canadian art style.

The work of the Group of Seven played an important role in the career of Emily Carr, who was to become Canada's best-known early modern artist. Carr first studied in San Francisco before traveling abroad to perfect her painting skills in London and Paris. She saw the works of Matisse and the other Fauves while she was in Paris in 1910 and 1911. Like the painters in the Group of Seven, she was greatly impressed by the expressive qualities of those works and adapted those qualities to her own painting style. However, in works like *Forest, British Columbia* (Figure 24.32) one senses something more. The trees in this forest join together to create a place of great spirituality. Like stout pillars in a medieval church, they define and protect a quiet sanctuary awaiting anyone in need of security and consolation. Painted with spiraling forms and intense colors, the work presents a personal and powerful vision of nature.

The paintings created by Emily Carr heralded a period of artistic activity in Canada that continues to grow in diversity and quality. Today her paintings rank among the most admired in Canadian art.

SECTION TWO

Review

1. Why did Henry Moore avoid using models for his sculptures? What did he do that had never been done before?
2. What form of sculpture did Alexander Calder invent? On what shapes are most of his sculptures based?
3. Describe the sculptural technique of Louise Nevelson. How does her art style compare to that of Calder?
4. Who designed the Guggenheim Museum in New York? Why was the building so controversial?
5. What is Pop art? What did Pop artists hope to achieve with their style of art?
6. What aesthetic qualities are emphasized by the works of Alfred Leslie and Audrey Flack? What is the name given to the art style practiced by these artists?
7. What quality does Andrew Wyeth attempt to capture in his realistically painted artworks?

Creative Activity

Humanities. Artists, whether they are makers of sculpture, painting, poetry, dance, architecture, photography, story, music, drama, or any of the increasing forms that art takes, are often the most perceptive observers of their world. Their art expresses in powerful form not only the beauty of their world but also its struggles and tensions. Look for examples in all art forms of the artist's response to the problems of our country, of our world. Find out about the massive canvases of contemporary German painter Anselm Kieffer. Read the works of John Steinbeck and Sinclair Lewis, whose novels about the early decades of the twentieth century have stood the test of time and touch the same kinds of struggles faced today. Read the works of Anne Morrow Lindbergh and Rachel Carson, whose concern for ecology is expressed in the vision of the artist. Find many others — and think about your own message in an art form.

THREE-DIMENSIONAL RELIEF PORTRAIT

Supplies

- Pencil and sketch paper
- One sheet of white illustration or mat board, 12 x 18 inches (30 x 46 cm)
- One sheet of white illustration or mat board, 18 x 24 inches (46 x 61 cm)
- Black felt marker with medium tip
- Crayons, india ink, brush
- Nail or some other pointed instrument for etching
- Small pieces of cardboard
- White glue, scissors, paper cutter

Complete a full-face portrait in which features and expressions are exaggerated and distorted to illustrate a particular emotion. This portrait will be cut into six or more shapes and assembled to make a three-dimensional relief. Each shape will have a different simulated texture obtained with a crayon-etching technique. Select colors and color combinations that will emphasize the emotion you are trying to show.

Focusing

Look at the face in Willem de Kooning's painting of *Woman VI* (Figure 24.13, page 568). Does it look lifelike? Can you identify the expression on this face? What feelings or emotions do you associate with that expression? Can you find any other portraits in this book that also express emotions? What emotions do they express? How are those emotions shown?

Creating

Select a feeling or emotion to use as a theme for your portrait. Examples are *lonely*, *angry*, *excited*, and *joyful*.

Working with another student, take turns acting as artist and model. One will model an emotion by frowning, snarling, or smiling while the other draws. In this drawing use one continuous pencil line and show the face from the front. Exaggerate and distort the features and expression to em-

Figure 24.33 Student Work

Figure 24.34 Student Work

phasize the feeling or emotion. Several practice sketches may be necessary before you are able to draw the portrait in one continuous line. Doing it this way enables you to break the portrait up into a number of different shapes that will provide you with more flexibility later, when adding color. When a satisfactory drawing has been completed, reverse the roles of artist and model with your partner.

Reproduce your portrait on the smaller sheet of illustration board. Use the same continuous-line technique as before. The face should fill the board and may even go off the edges at the top, sides, and bottom.

Use a heavy application of crayon to color the shapes in your portrait. Select colors and combinations of colors that you associate with the emotion you are trying to show. Avoid dark hues and cover the entire sheet of illustration board with crayon.

Divide the illustration board into six shapes by drawing lines on the back with a pencil and ruler. Cut out these shapes with scissors or with a paper cutter.

Cover the crayoned surface of each shape with india ink. Several coats may be necessary to cover the crayon completely. Be sure to ink the sides of each shape as well.

While the ink is drying, use pencil and sketch paper to design six different textural patterns made up of closely spaced lines.

Use a nail or other pointed tool to etch your patterns into the inked shapes. By carefully scratching through the ink, you will bring out the crayon color beneath.

Assemble the six shapes of your portrait on the larger sheet of illustration board. Use small pieces of cardboard stacked to different heights to position the shapes at different levels. Glue the shapes in place to create your relief portrait.

CRITIQUING

• **Describe.** Does your relief show a face viewed from the front? Can you point out the different features on this face? Are these features exaggerated and distorted?

• **Analyze.** Is your relief made up of six different shapes? Does each shape have a different simulated texture? Are the shapes assembled to make a three-dimensional relief?

• **Interpret.** What feeling or emotion does your portrait express? How does your choice of colors and combinations of colors help show this emotion? What other colors could you have used to express the same emotion? What else did you do to emphasize the feeling or emotion? Were other students able to recognize this feeling or emotion?

• **Judge.** Using the expressive qualities as your basis for judgment, do you think your relief portrait is a success? What is its most successful feature?

Figure 24.35 Student Work

Figure 24.36 Student Work

Review

Reviewing the Facts

SECTION ONE

1. What social, political, and economic conditions prevailed in the years following World War I?
2. How does Paul Klee incorporate fantasy in his paintings?
3. How does Abstract Expressionism differ from representational art? Name four artists identified with the development of this movement.
4. Describe Jackson Pollock's technique of painting.

SECTION TWO

5. What building combines the features found in the abstract figures of Henry Moore and the curving architectural forms of Antonio Gaudi? Who was the architect for this building?
6. Maya Lin is famous for her design of what war memorial? Describe the symbolism of the design.
7. What characteristics are typical of the works of Hard-edge painters?
8. What group of Canadian artists created art that expressed their national pride?

Thinking Critically

1. *Analyze.* Look again at Kay Sage's painting *No Passing* (Figure 24.5, page 563). Which techniques does this artist use to create the illusion of depth?
2. *Analyze.* Analyze the color scheme of Edward Hopper's painting *Drug Store* (Figure 24.7, page 565). What colors are used? How do they relate to each other on the color wheel?
3. *Compare and contrast.* Refer to Henry Moore's sculpture *Reclining Figure* (Figure 24.17, page 571) and to Alexander Calder's sculpture *Pomegranate* (Figure 24.20, page 573). Compare and contrast how each artist uses natural shapes to achieve harmony.

Using the Time Line

German troops marched into Poland in the same year that Henry Moore created his *Reclining Figure*. What was that year and why was that event so important? Joseph Stalin died in 1953; examine the time line and identify a work of art completed at that time. What style of art does it represent? Can you name two other artists who practiced this style?

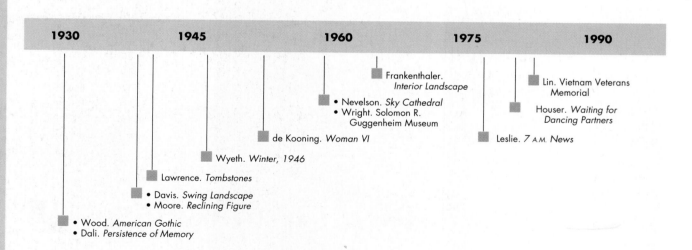

1930 1945 1960 1975 1990

Frankenthaler. *Interior Landscape*

Lin. Vietnam Veterans Memorial

• Nevelson. *Sky Cathedral*
• Wright. Solomon R. Guggenheim Museum

Houser. *Waiting for Dancing Partners*

de Kooning. *Woman VI*

Leslie. *7 A.M. News*

Wyeth. *Winter, 1946*

Lawrence. *Tombstones*

• Davis. *Swing Landscape*
• Moore. *Reclining Figure*

• Wood. *American Gothic*
• Dali. *Persistence of Memory*

Keith Williams, Age 16
Lake Highlands High School
Dallas, Texas

Keith was intrigued with Dali's surrealistic paintings and the almost magical quality that makes the unreal seem real. He began by drawing a lamp and a man inside a bottle looking up for inspiration. He then decided to convert that realistic drawing to a surrealistic abstraction, using a room to replace the bottle, a mask to represent the man, and a candle to stand for the lamp. He also added a second man, who is sneaking around and thinking he is unnoticed. The mask has changed, however, to being aware of what is happening.

Keith enjoyed using oil paints, finding that they provided rich color and enabled him to take the time to paint in a detailed manner. One of the things he enjoyed most about this project was communicating an abstract idea visually.

▶ *Conflict of Good and Evil.* Oil on canvas. 101.6 x 76.2 cm (40 x 30").

Glossary

Note Chapter and section locations appear in parentheses following definitions.

Abstract Expressionism A twentieth-century painting style in which artists applied paint freely to their huge canvases in an effort to show feelings and emotions. (24-1)

Academies Art schools. (21-1)

Acropolis The sacred hill of Athens. (8-1)

Adobe Sun-dried clay. (11-1)

Adz An axlike tool with an arched blade at right angles to the handle. (12-2)

Aerial perspective Aerial, or atmospheric, perspective is achieved by using bluer, lighter, and duller hues for distant objects. (16-1)

Aesthetic qualities Those qualities that contribute to the nature of beauty in art. Cues within a work of art, such as literal, design, and expressive qualities, that are studied during the art-criticism process. (5-2)

Aesthetician A scholar who specializes in the study of the nature of beauty and art. (1-1)

Alcazar A fortified Moorish palace. (13-2)

Altamira A cave in northern Spain where a large number of prehistoric paintings of animals were discovered. (6-1)

Ambulatory A semi-circular aisle curving around the apse of a church behind the main altar. (14-2)

Analogous colors Colors that are next to each other on the color wheel and are closely related, such as blue, blue-green, and green. (2-1)

Apse The semicircular area at the end of the church opposite the main entry. It was here that the altar was placed. (9-2)

Aqueduct A channel system that carried water from mountain streams into cities by using gravitational flow. (9-1)

Aristocracy Persons of high rank and privilege. (20-1)

Armature A framework used by a sculptor to support a figure being modeled. (4-2)

Armory Show A 1913 exhibit organized to introduce the American public to the works of such European artists as Cézanne, van Gogh, Gauguin, Matisse, Munch, and Picasso. This was the first large exhibition of modern art in America. (23-2)

Art patron An individual who sponsors and supports the arts. (1-1)

Ashcan School A group of early twentieth-century American artists who rebelled against the idealism of the academic approach and painted pictures of city life. (23-2)

Assemblage A three-dimensional collage. (24-2)

Assembly A process in which the artist joins together a variety of materials to construct a three-dimensional work of art. (4-2)

Axis line An imaginary line that indicates movement and the direction of movement. (2-2)

Balance A principle of art, it refers to the way the art elements are arranged to create a feeling of equilibrium or stability in a work. Balance can be symmetrical (formal), or it can be asymmetrical (informal). (2-3)

Baroque art The art style of the Counter-Reformation in the seventeenth century in which artists sought movement, contrast, emotional intensity, and variety in their works. (19-1)

Barrel vault A half-round stone ceiling made by placing a series of arches from front to back. Also known as a tunnel vault. (9-1)

Bas relief Sculpture in which the forms project only slightly from the background. (4-1)

Basilica A type of public building erected in ancient Rome to hold large numbers of people. Basilicas had a rectangular plan with two or four rows of columns placed along the longer axis to support the roof. This plan was later adopted by Christian church builders. (9-2)

Baths Large enclosed Roman structures that contained libraries, lecture rooms, gymnasiums, pools, shops, and restaurants. (9-2)

Benin A people and former kingdom of western Africa. Benin artists of the sixteenth and seventeenth centuries realized a high level of quality in their copper-alloy castings. (12-1)

Binder A liquid that holds together the pigment in paint. (3-1)

Book of Hours A book for private devotions containing prayers for different hours of the day, often richly illustrated. (15-2)

Brayer A roller used to ink a surface by hand. (14-SL)

Burin A steel engraving tool. (3-2)

Buttress A support, or brace, that counteracts the outward thrust of an arch or vault. A flying buttress is an arch that reaches over a side aisle to support the heavy stone roof of a cathedral. (15-1)

Byzantine art The art of the Eastern Roman Empire. Byzantine paintings and mosaics are characterized by a rich use of color and figures that seem flat and stiff. Intended as religious lessons, they were presented simply in order to be easily learned. (13-1)

Caliph A tenth-century Moorish ruler. (13-2)

Campanile A bell tower near, or attached to, a church. (13-1)

Candid photos Unposed views of people. (21-3)

Capital The top element of a pillar or column. There are three basic types of capitals: Doric, Ionic, and Corinthian. (8-1)

Caricature A humorous drawing of a person in which a familiar characteristic has been exaggerated. (1-2)

Carving The process of cutting or chipping a form from a given mass of material to create a sculpture. (4-2)

Catacombs Underground tunnels in which the Early Christians in Rome and other communities met and buried their dead. (13-1)

Ceramics The art of pottery making.

Chiaroscuro The arrangement of dramatic light and shadow. (19-1)

Cloister A covered walkway surrounding an open court or garden. It was a common feature of medieval monasteries. (14-1)

Coffer An indented panel. (9-2)

Collage A picture or design created with such elements as paper, photographs, cloth, and string, for example. (23-1)

Colonnade A line of columns supporting lintels or arches. (8-1)

Color An element of art with three properties: (1) hue, the color name, e.g., red, yellow, blue; (2) intensity, the brightness and purity of a color, e.g., bright red or dull red; and (3) value, the lightness or darkness of a color. (2-1)

Column An upright post used to bear weight. (8-1) (9-1)

Complementary colors Colors that are directly opposite each other on the color wheel, such as red and green. (2-1)

Concave Inwardly curved. (12-2)

Contour line A line or lines that surround and define the edges of an object or figures. (2-1)

Contrapposto A way of sculpting a human figure in a natural pose with the weight of one leg, the shoulder, and hips counterbalancing each other. (8-2)

Contrast Closely related to emphasis, a principle of art, this term refers to a way of combining art elements to stress the differences between those elements.

Convex Outwardly rounded. (12-2)

Cool colors Blue, green, and violet. (2-1)

Corinthian order The capital of the column is elongated and decorated with leaves. (8-1)

Cornice A horizontal member, included in the entablature, which is positioned across the top of the frieze. (8-1)

Counter-Reformation An effort by the Catholic Church to lure people back and to regain its former power. (19-1)

Criteria Standards for judgment; rules used for evaluation. (1-1)

Cubism A twentieth-century art movement developed by Picasso and Braque in which the subject matter is broken up, analyzed, and reassembled. A style of painting in which artists tried to show all sides of three-dimensional objects on a flat canvas. (23-1)

Curator The museum employee responsible for securing and exhibiting artworks for the general public and scholars to view. (1-2)

Dada An early twentieth-century art movement that ridiculed contemporary culture and traditional art forms. It was born as a conse-

quence of the collapse of social and moral values during World War I. (24-1)

Design The organization, plan, or composition of a work of art. An effective design is one in which the elements and principles have been combined to achieve an overall sense of unity. (2-3)

Design quality The careful organization of the elements and principles of design in a work of art. This aesthetic quality is favored by formalism. (5-2)

Dome A hemispheric vault or ceiling over a circular opening. (9-1)

Doric order The principal feature is a simple, heavy column without a base, topped by a broad, plain capital. (8-1)

Drum The cylindrical wall supporting a dome. (16-1)

Dry media Those media that are applied dry and include pencil, charcoal, crayon, and chalk or pastel. (3-1)

Dynasty A period during which a single family provided a succession of rulers. (7-1)

Early Medieval A period dating from c. A.D. 476 to c. 1050. (14-1)

Eclectic style A style composed of elements drawn from various sources. (23-3)

Elements of art The basic components, or building blocks, used by the artist when producing works of art. The elements consist of color, value, line, shape, form, texture, and space. (2-1)

Emotionalism A theory of art that places emphasis on the expressive qualities. According to this theory, the most important thing about a work of art is the vivid communication of moods, feelings, and ideas. (1-1)

Emphasis A principle of art, it refers to a way of combining elements to stress the differences between those elements and to create one or more centers of interest in a work. (2-3)

Engraving A method of cutting or incising a design into a material, usually metal, with a sharp tool. A print can be made by inking such an engraved surface. (3-2)

Entablature The upper portion of a classical building that rests on the columns and consists of the architrave, frieze, and cornice. (8-1)

Etching To engrave a metal plate with acid. A print can be made by inking such an etched surface. (3-2)

Expressionism A twentieth-century art movement in which artists tried to communicate their strong emotional feelings through artworks. (23-1)

Expressive qualities Those qualities having to do with the feelings, moods, and ideas communicated to the viewer through a work of art. This aesthetic quality is favored by the emotionalists. (5-2)

Façade The front of a building. (19-1)

Fauvism An early twentieth-century style of painting in France. The name *Fauves* was given to artists adhering to this style because it was felt that they used brilliant colors in a violent way. (23-1)

Feudalism A system in which weak noblemen gave up their lands and much of their freedom to more powerful lords in return for protection. (14-1)

Form An element of art, it describes an object that is three-dimensional and encloses volume. Cubes, spheres, pyramids, and cylinders are examples. (2-2)

Formalism A theory of art that places emphasis on the design qualities. According to this theory, the most important thing about a work of art is the effective organization of the elements of art through the use of the principles. (1-1)

Fresco A method of painting in which pigments are applied to a thin layer of wet plaster so that they will be absorbed and the painting becomes part of the wall. (15-3)

Frieze A decorative horizontal band usually placed along the upper end of a wall. (8-1)

Funerary Pertaining to a funeral. (12-2)

Gargoyle A rainspout carved or formed to resemble a grotesque monster. It is a common feature of Gothic cathedrals. (15-2)

Genre The representation of people, subjects, and scenes from everyday life. Genre painting achieved its greatest popularity in seventeenth-century Holland. (19-2)

Gesso A mixture of glue and a white pigment such as plaster, chalk, or white clay for use as a surface for painting. (17-1)

Gothic The name given to the style of architecture, painting, and sculpture that flourished in western Europe, mainly France and England, between the twelfth and sixteenth centuries. The cathedral is the most impressive example of the Gothic style. (14-1, 15-1)

Gradation A principle of art, it refers to a way of combining art elements by using a series of gradual changes in those elements. (2-3)

Groin vault A vault formed when two barrel vaults meet at right angles. (9-1)

Group of Seven A group of seven Canadian landscape painters who were instrumental in developing a uniquely Canadian art style in the early twentieth century. (24-2)

Hagia Sophia A church in Istanbul (formerly Constantinople) considered to be the masterpiece of Byzantine architecture. It was commissioned by the Emperor Justinian and built in A.D. 532–537. (13-1)

Hard-edge A twentieth-century movement in painting in which the edges of shapes are crisp and precise rather than blurred. (24-2)

Harmony A principle of art, it refers to a way of combining elements to accent their similarities and bind the picture parts into a whole. It is often achieved through the use of repetition. (2-3)

Hellenistic A period of Mediterranean culture influenced by the Greek world following the conquests of Alexander the Great. The expression of inner emotions was more important than beauty to the artists of this period. (8-2)

Hieroglyphics The characters and picture-writing used by the ancient Egyptians. (7-2)

High relief Sculptured forms extend boldly out into space from the flat surface of the relief sculpture. (4-1)

Hue A color's name. *See* Color. (2-1)

Illuminated manuscript A manuscript with small paintings. (14-1)

Illuminations A term applied to manuscript paintings, particularly those done during the Medieval period. (14-1)

Imitationalism A theory of art that places emphasis on the literal qualities. According to this theory, the most important thing about a work of art is the realistic representation of subject matter. A work is considered successful if it looks like and reminds the viewer of what is seen in the real world. (1-1)

Impressionism A style of painting that started in France during the 1860s. Impressionist artists tried to paint candid glimpses of their subjects and emphasized the momentary effects of sunlight. (21-3)

Intaglio A process in which ink is forced to fill lines cut into a metal surface. (3-2)

Intensity The quality of brightness and purity of a color. (2-1)

Intermediate (or tertiary) colors Colors produced by mixing unequal amounts of two primary colors or a primary color with a secondary color. (2-1)

Inuit The Eskimos inhabiting the area from Greenland to western arctic Canada. (11-1)

Investment A fireproof mold into which molten metal is poured in the casting process. (4-2)

Ionic order Columns with an elaborate base and a capital carved into double scrolls that look like the horns of a ram. (8-1)

Ka The soul, which the Egyptians believed came into the body at birth, left the body at death, and then would rejoin the body again for the journey to the next world and immortality. (7-1)

Keystone The central and highest stone in an arch. It cannot fall out of place because it is wedge-shaped, with the widest part of the wedge at the top. It is the last stone to be set in place during the construction of an arch. By pressing equally on either side, it holds the other pieces in place. (9-1)

Kiln An oven in which clay objects are fired, or baked.

Kinetic art A sculptural form that actually moves in space. (4-2)

Kiva Circular underground structures that serve as spiritual and social centers in Pueblo cultures. (11-1)

Koran The holy scripture of Islam. (13-2)

Kore A Greek statue of a clothed maiden. (8-2)

Kouros A Greek statue of a male youth who may have been a god or an athlete. (8-2)

Landscape A painting, photograph, or other work of art that shows natural scenery such as mountains, valleys, trees, and lakes. (21-2)

Line An element of art that refers to the continuous mark made on some surface by a moving point. It may be two-dimensional (pencil on paper), three-dimensional (wire), or implied (the edge of a shape or form). Often, it is an outline, contour, or silhouette. (2-2)

Linear A painting technique in which importance is placed on contours or outlines. (2-2)

Linear perspective A graphic system that showed artists how to create the illusion of depth and volume on a flat surface. The lines of buildings and other objects in a picture are slanted, making them appear to extend back into space. (16-1)

Lintel A horizontal beam spanning an opening between two walls or posts. (8-1)

Literal The word *literal* means true to fact. It refers, here, to the realistic presentation of subject matter. (5-2)

Literal quality The realistic presentation of subject matter in a work of art. This aesthetic quality is favored by imitationalism. (5-2)

Lithography A printmaking method developed in the late eighteenth century in which the image to be printed is drawn on a limestone, zinc, or aluminum surface with a special greasy crayon. The drawing is then washed with water. When ink is applied, it sticks to the greasy drawing but runs off the wet surface, allowing a print to be made of the drawing. (3-2)

Logo A graphic symbol of a company name or trademark. (1-2)

Low relief The sculptured forms project only slightly from the surface of the background. Also called bas relief. (4-1)

Mannerism A European art style that developed between 1520 and 1600. It was a style that rejected the calm balance of the High Renaissance in favor of emotion and distortion. (18-2)

Mass The outside size and bulk of a form such as a building or a sculpture. (2-2)

Mastaba A low, rectangular Egyptian tomb made of mud brick with sloping sides and a flat top, covering a burial chamber. (7-1)

Meditation The act of focusing thoughts on a single object or idea. An important element in the Buddhist religion. (10-1)

Medium A material used by an artist to produce a work of art. (3-1)

Megalith A large monument created from huge stone slabs. (6-2)

Mihrab A niche in the wall of a mosque, which indicates the direction of Mecca and is large enough to accommodate a single standing figure. (13-2)

Minaret A spiral tower. (13-2)

Mobile A construction made of shapes that are balanced and arranged on wire arms and suspended from the ceiling so as to move freely in the air currents. (24-2)

Modeling A sculpture technique in which a three-dimensional form is shaped in a soft material such as clay. (4-2)

Modeling tools Tools for working with, or modeling, clay. (4-2)

Monastery The dwelling place of persons under religious vows. (14-1)

Monasticism Refers to a way of life in which individuals voluntarily joined together in isolated communities called monasteries, where they spent their days in prayer, manual labor, and self-denial. (14-1)

Monochromatic Consisting of only a single color.

Mosaics A work of art made of small cubes of colored marble or glass set in cement. (13-1)

Mosque Muslim place of worship. (13-2)

Movement A principle of art, it is a way of combining elements to produce the look of action or to cause the viewer's eye to sweep over the work in a certain manner. (2-3)

Mural A large design or picture, generally created on the wall of a public building. (9-1)

Nave A long, wide, center aisle. (9-2)

Neoclassicism A nineteenth-century French art style that originated as a reaction against the Baroque style. It sought to revive the ideals of ancient Greek and Roman art. (21-1)

Niche A recess in a wall. (9-2)

Nonobjective Nonobjective art is a style that employs color, line, texture, and unrecognizable shapes and forms. These works contain no apparent reference to reality. (23-1)

Oba An African ruler, or king. (12-1)

Obelisk A tall, four-sided shaft of stone, usually tapering, that rises to a pyramidal point. (7-1)

Oil paint Slow drying paint made when pigments are mixed with an oil base. The oil dries with a hard film and the brilliance of the colors is protected. Oil paints are usually opaque and traditionally used on canvas. (17-1)

Old Stone Age The historical period believed to have lasted from 30,000 B.C. until about 10,000 B.C. Also known as the Paleolithic period. (6-2)

Op art A twentieth-century art style in which artists sought to create an impression of movement on the picture surface by means of optical illusion. (24-2)

Pagoda A tower several stories high with roofs slightly curved upward at the edges. (10-3)

Painterly A painting technique in which forms are created with patches of color rather than with hard, precise edges. (2-2)

Parable A story that contains a symbolic message. (18-3)

Pastel Pigments mixed with gum and pressed into a stick form for use as chalky crayons. Works of art done with such pigments are referred to as pastels. (3-1)

Patina A surface film, produced naturally by oxidation, on bronze or copper. It can also be produced artificially by the application of acid or paint to a surface. (4-SL)

Pediment A triangular section of the top of a building framed by a cornice, along with a sloping member called a raking cornice. (8-1)

Pendentives Triangular wedge-shaped portions of the arches that are joined to support a dome. (13-1)

Perspective A method for representing three-dimensional objects on a two-dimensional surface. (16-1)

Pharaoh An Egyptian king, also considered to be a god in the eyes of the people. (7-1)

Photo-Realism An art movement of the late twentieth century in which the style is so realistic it looks photographic. (24-2)

Photography A technique of capturing optical images on light-sensitive surfaces. (3-2)

Pier A massive vertical pillar that is used to support an arch, vault, or other kind of roof. (13-1)

Pietà A sculpture or painting of the Virgin Mary mourning over the body of Christ. The term comes from the Italian word for pity. (16-3)

Pigment Finely ground powder that gives every paint its color. (3-1)

Pilasters Flat, rectangular columns attached to a wall. They may be decorative or be used to buttress the wall. (9-2)

Pilgrimage A journey to a holy place. (14-2)

Plane A surface. (22-1)

Pop art An art style that had its origins in England in the 1950s and made its way to the United States during the 1960s featuring images of the popular culture such as comic strips, magazine ads, and supermarket products. (24-2)

Porcelain A fine-grained, high-quality form of china made primarily from a white clay known as kaolin. (10-2)

Portal A door or gate, usually of importance or large in size. In most Gothic cathedrals there were three portals in the main façade. (15-2)

Portrait The image of a person, especially of the face. It can be made of any sculptural material or any two-dimensional medium.

Post and lintel The simplest and oldest way of constructing an opening. Two vertical posts were used to support a horizontal beam, or lintel, creating a covered space. Massive posts supporting crossbeams, or lintels, is called post-and-lintel construction. (6-2)

Post-Impressionism A French art movement that immediately followed Impressionism. The artists involved showed a greater concern for structure and form than did the Impressionist artists. (22-1)

Potlatch An elaborate event that enabled members of one Kwakiutl clan to honor those of another while adding to their own prestige. (11-1)

Pre-Columbian The term that is used when referring to the various cultures and civilizations found throughout North and South America before the arrival of Christopher Columbus in 1492. (11-2)

Primary colors The basic colors of red, yellow, and blue, from which it is possible to mix all the other colors of the spectrum. (2-1)

Principles of art Refers to the different ways that the elements of art can be used in a work of art. The principles of art consist of balance, emphasis, harmony, variety, gradation, movement, rhythm, and proportion. (2-1)

Propaganda Information or ideas purposely spread to promote or injure a cause. (21-1)

Proportion The principle of art concerned with the relationship of certain elements to the whole and to each other. Proportion may also refer to size relationships. (2-3)

Protestant Reformation In 1517, a group of Christians led by Martin Luther left the Church in revolt to form their own religion in a movement called the Protestant Reformation. (18-2)

Raffia A fiber made from the leaves of an African palm tree. (12-2)

Realism A mid-nineteenth-century style of art in which artists discarded the formulas of Neoclassicism and the drama of Romanticism to paint familiar scenes as they actually looked. (21-2)

Regionalism A style of art that was popular in the United States during the 1930s. The artists who worked in this style wanted to paint the American scene in a clear, simple way. (24-1)

Relief A type of sculpture in which forms project from a background. (4-1)

Relief printing The image to be printed is raised from the background. (3-2)

Renaissance A revival or rebirth of cultural awareness and learning that took place during the fourteenth and fifteenth centuries, particularly in Italy. (16-1)

Repetition A principle of art, this term refers to a way of combining art elements so that the same elements are used over and over. (2-3)

Rhythm A principle of art, it refers to a way of combining art elements to produce the look and feel of movement. (2-3)

Rococo art An eighteenth-century art style that placed emphasis on portraying the carefree life of the aristocracy. The style was characterized by a free, graceful movement; a playful use of line; and delicate colors. (20-1)

Romanesque An artistic style that, in most areas, took place during the eleventh and twelfth centuries. The style was most apparent in architecture and was characterized by a large size and solid appearance. (14-2)

Romanticism A style of art that flourished in the early nineteenth century, it portrayed dramatic and exotic subjects perceived with strong feelings. (21-2)

Salon An annual exhibition of art held by the academies in Paris and London to exhibit art created by their members. (21-1)

Sarcophagus A coffin, usually of stone, although sometimes made of wood, metal, or clay. (7-1)

Satire The use of sarcasm or ridicule to expose and denounce vice or folly. (20-2)

Scarification Ornamental scars. (12-2)

Screen printing Paint is forced through a screen onto paper or fabric. (3-2)

Scroll A long roll of illustrated parchment or silk. (10-2)

Sculpture A three-dimensional work of art. Such a work may be carved, modeled, constructed, or cast. (4-1)

Sculpture in the round Freestanding sculpture surrounded on all sides by space. (4-1)

Secondary colors The colors obtained by mixing equal amounts of two primary colors. The secondary colors are orange, green, and violet. (2-1)

Secular Nonsacred, or pertaining to worldly things. (12-1)

Serfs Poor peasants who did not have land. (14-1)

Serigraph Screen print that has been handmade by an artist. (3-2)

Shaman A medicine man. (11-1)

Shape An element of art, it is an area clearly set off by one or more of the other elements such as color, value, line, and texture. (2-2)

Sipapu A hole in the floor of a kiva that symbolized the place through which the Pueblo people originally emerged into this world from the one below. (11-1)

Sketch A quick drawing that captures the appearance or action of a place or situation. (3-1)

Solvent The material used to thin the binder in paint. (3-1)

Space An element of art that refers to the distance or area between, around, above, below, or within things. It can be described as either three-dimensional or two-dimensional. (2-2)

Stained glass The art of cutting colored glass into different shapes and joining them together with lead strips to create a pictorial window design. (15-1)

Still life A drawing or painting of such things as food, plants, pots, pans, and other inanimate objects. (3-1)

Stupa A small, round burial shrine erected over a grave site to hold relics of the Buddha. (10-1)

Style The artist's personal way of using the elements and principles of art to express feelings and ideas. (5-1)

Surrealism A twentieth-century art style in which dreams, fantasy, and the subconscious served as the inspiration for artists. (24-1)

Symbol A form, image, or subject representing a meaning other than the one with which it is usually associated. (10-1, 13-1, 17-1)

Tactile Of or relating to the sense of touch.

Tapestries Textile wall hangings that are woven, painted, or embroidered with decorative designs or colorful scenes. (14-2)

Technique The manner in which an artist uses the technical skills of a particular art form.

Tempera A paint made of dry pigments, or colors, which are mixed with a binding material. In a painting method which was popular before the invention of oil painting, the pigments were mixed with an emulsion of egg yolk or egg white rather than oil. (17-1)

Texture The element of art that refers to the way things feel, or look as if they might feel if touched. (2-2)

Transept An aisle that cuts directly across the nave and the side aisles in a basilica and forms a cross-shaped floor plan. (14-1)

Triumphal arch A heavily decorated arch often consisting of a large central opening and two smaller openings, one on each side. (9-2)

Trompe l'oeil A painting technique designed to fool the viewer's eye by creating a very realistic illusion of three-dimensional qualities on a flat surface. (9-1)

Tympanum The half-round panel that fills the space between the lintel and the arch over a Romanesque or Gothic doorway. (14-2)

Ukiyo-e A Japanese painting style, which means *pictures of the passing world.* (10-3)

Unity The quality of wholeness or oneness that is achieved through the effective use of the elements and principles of art. (2-3)

Value An element of art that describes the lightness or darkness of a color. *See Color.* Often, value is found to be an important element in works of art even though color is absent. This is true with drawings, prints, photographs, most sculpture, and architecture. (2-1)

Vanishing point In perspective drawing, a vanishing point is the point at which receding parallel lines seem to converge. (16-1)

Variety A principle of art that refers to a way of combining art elements in involved ways to achieve complex relationships. (2-3)

Vault An arch made of brick, stone, or concrete. (9-1)

Vihāras Monasteries in India. (10-1)

Volume Refers to the space within a form. Thus, in architecture, volume refers to the space within a building. (2-2)

Warm colors Colors suggesting warmth. These are colors that contain red and yellow. (2-1)

Watercolor Transparent pigments mixed with water. Paintings done with this medium are known as watercolors. (3-1)

Wet media Media that are applied to the surface in a liquid form, such as ink and paints. (3-1)

Woodblock printing This process involves cutting pictures into wood blocks, inking the raised surface of these blocks, and printing. (3-2, 10-2)

Woodcut A print made by cutting a design in a block of wood. The ink is transferred from the raised surfaces to the paper. (10-2)

Yamato-e Painting in the Japanese manner. (10-3)

Zen A Chinese and Japanese school of Buddhism that believes that enlightenment can be attained through meditation, self-contemplation, and intuition. (10-3)

Index

A

Artists and
Their Works

Bibliography

UNIT 1: CREATING AND UNDERSTANDING ART

Berger, Arthur Asa. *Seeing is Believing: An Introduction to Visual Communication.* Mountain View, CA: Mayfield Publishing Co., 1989. A readable text prepared to help readers gain an understanding of how we find meaning in visual phenomena and how our minds process images. One of the distinctive features of this book is that it focuses on the mass media.

Cheatham, Frank, and Jane Hart Cheatham. *Design Concepts and Application.* Baltimore, MD: University Park Press, 1983. Intended to meet the educational needs of students who are beginning to study and apply the design elements and principles in the visual arts — either two or three dimensionally.

Feldman, Edmund Burk. *Varieties of Visual Experience.* 4th ed. Englewood Cliffs, NJ: Prentice-Hall, 1992. An excellent resource that explains how art "works" — what it does, how it speaks, and how it asks viewers to respond. Feldman wants people to feel comfortable with art and the ways it gets them to see, know, and act. A recommended reference in art criticism and art history.

Horowitz, Frederick A. *More Than You See: A Guide to Art.* 2d ed. NY: Harcourt Brace Jovanovich, 1992. Based on the assumption that there are no wrong responses to art and no bad reasons for liking it. Seeks to link the reader to the accessible, enjoyable, and endlessly fascinating world of art.

Lauer, David A. *Design Basics.* 2d ed. NY: Holt, Rinehart and Winston, 1985. An introductory text for studio classes in two-dimensional design presenting the fundamental elements and principles of design as they relate to drawing, painting, and the graphic arts. Would serve well as a review of the visual vocabulary.

Malraux, Andre. *The Voices of Silence.* Translated by Stuart Gilbert. Princeton, NJ: Princeton University Press, 1978. A daring and thought-provoking inquiry into the meaning of art. Often referred to as one of the great books of our time.

Ocvirk, Otto G., Robert E. Stinson, Philip R. Wigg, and Robert O. Bone. *Art Fundamentals: Theory and Practice.* 6th ed. Dubuque, IA: Wm. C. Brown, 1990. A widely used text which holds that art relationships are best understood through dissecting and analyzing the constituent parts as assembled by the artist. Designed as a college text, it is also used effectively in high school art classes. Earlier editions offer studio activities focusing on the elements and principles of art.

Taylor, Joshua C. *Learning to Look: A Handbook for the Visual Arts.* 2d ed. Chicago: University of Chicago Press, 1981. Designed to help students develop a comprehensive view of art, this small, highly recommended volume moves from an analytical study of specific works to a consideration of broad principles and technical matters. Excellent source of material for class discussions on how to "look" at art.

UNIT 2: ART OF EARLY CIVILIZATIONS

Aldred, Cyril. *Egyptian Art in the Days of the Pharaohs 3100–320 B.C.* NY: Oxford University Press, 1980. A fine resource providing an in-depth, scholarly examination of Ancient Egyptian art. Tells the story of a great civilization in very human terms.

Gimbutas, Marija. *The Goddesses and Gods of Old Europe, 7000–3500 B.C.: Myths, Legends and Cult Images.* Berkeley, CA: University of California Press, 1982. A fascinating look at the religious beliefs, superstitions, myths, and legends that impacted daily life in old Europe. A topic that most students find irresistible. Excellent resource for student research and class discussion.

Graziosi, Paolo. *Paleolithic Art.* NY: McGraw-Hill Book Co., 1960. A comprehensive examination of the art produced during the cultural period beginning with the earliest chipped-stone tools, about 750,000 years ago.

Hoving, Thomas. *Tutankhamen: The Untold Story.* NY: Simon and Schuster, 1978. A fascinating account of the events associated with the discovery of Tutankhamen's tomb in 1922. A resource students will find informative and exciting to read. An excellent source of material for a class report or class discussion.

Leroi-Gourhan, André. *Treasures of Prehistoric Art.* NY: Harry N. Abrams, 1967. An extensive examination of the major examples of art created in prehistoric times. A highly recommended resource on a topic that never fails to generate student interest.

Macaulay, David. *Pyramid.* Boston, MA: Houghton Mifflin Co., 1975. The author presents eighty pages of simple text and elaborate, highly detailed black-and-white illustrations that show how the Ancient Egyptians erected one of the world's most awesome structures — the pyramid. Recommended for viewing in class when studying Egyptian art.

Michalowski, Kazimierz. *The Art of Ancient Egypt.* Reprint 1985. NY: Harry N. Abrams, 1969. Beautifully illustrated, well written text focusing on a period that students always find intriguing.

National Geographic Society. *Ancient Egypt: Discovering Its Splendors.* Washington, DC: National Geographic Society, 1978. A large format, beautifully illustrated resource that tells the story of a great civilization in a clear, stimulating manner. Outstanding scholars have contributed to the text of this excellent volume. Large format provides easy viewing of beautiful illustrations in the classroom.

Woldering, Irmgard. *Gods, Men, and Pharaohs: The Glory of Egyptian Art.* NY: Harry N. Abrams, 1967. An engrossing account of the culture and society of Ancient Egypt that influenced the development of the visual arts. A fine source of information for student reports.

UNIT 3: ART OF RISING CIVILIZATIONS

Andreae, Bernard. *The Art of Rome.* NY: Harry N. Abrams, 1977. An authoritative text and excellent illustrations result in a valuable reference book on Roman art.

Boardman, John. *Greek Art.* London: Thames and Hudson, 1985. In this survey, the author presents Greek art as a lively subject to be enjoyed for its full, and sometimes unexpected, variety as well as for its better-known masterpieces.

Hale, William Harlan. *The Horizon Book of Ancient Greece.* NY: American Heritage Publishing Co., 1965. A richly illustrated, clear examination of Ancient Greek culture and art. Easy and interesting to read.

Kleiner, Diana E. E. *Roman Sculpture.* New Haven, CT: Yale University Press, 1992. Demonstrates that the social, ethnic, and geographical diversity of Roman patronage led to an art that was eclectic and marked by different styles, often tied to the social status of the patron.

Pollitt, J.J. *The Art of Greece, 1400–31 B.C.* Englewood Cliffs, NJ: Prentice-Hall, 1965. A long-established text focusing on the major artworks dating from the earliest period of Greek history. An excellent overview tracing the development of Greek art.

Quennell, Peter. *The Colosseum.* Wonders of Man Series. NY: Newsweek Book Division, 1972. An in-depth examination of the Colosseum. Readable, interesting, and well illustrated, it is especially appealing to students. An excellent source of information for student reports.

Richter, Gisela M. A. *The Sculpture and Sculptors of the Greeks.* 4th ed., rev. New Haven, CT: Yale University Press, 1970. Lucid, well organized, profusely illustrated study of ancient Greek sculptors and their works. A rich resource for students seeking to learn more about Greek sculpture.

Strong, Donald. *Roman Art.* Pelican History of Art. NY: Penguin Books, 1976. A one-volume history of Roman art written for readers with little background in classical art. Readable account of the culture, society, and politics that helped fashion Roman Art.

UNIT 4: ART OF REGIONAL CIVILIZATIONS

Cahill, James. *Chinese Painting.* Treasures of Asia. NY: Rizzoli International Publications, 1985. A comprehensive examination of nearly twenty centuries of Chinese painting. Modern techniques of color reproduction are used to capture the fine shades and subtle nuances that characterize Chinese art.

Dwyer, Jane Powell, and Edward B. Dwyer. *Traditional Art of Africa, Oceania, and the Americas.* San Francisco, CA: Fine Arts Museum of San Francisco, 1973. A far-ranging resource that enables students to compare and contrast art forms from different cultures.

Emmerich, André. *Art Before Columbus.* NY: Simon and Schuster, 1963. Comprehensive examination of pre-Columbian art. Its clear, narrative style and excellent illustrations make it a valuable reference.

Gillon, Werner. *A Short History of African Art.* NY: Penguin Books, 1987. An authoritative explanation of the full range of African visual art styles and media. Illustrated with over 250 black-and-white illustrations and fourteen detailed maps. A recommended introduction to African art.

Lee, Sherman. *A History of Far Eastern Art.* 4th ed. NY: Harry H. Abrams, 1982. A comprehensive, scholarly, introductory survey of the scope of Oriental art authored by the recognized authority in this field. Should be especially interesting to students with a knack for research.

Leonard, Jonathan Norton. *Ancient America.* Great Ages of Man Series. Alexandria, VA: Time-Life Books, 1967. As with all books in this series, an informative and interesting narrative is enlivened with excellent illustrations. An excellent resource for students seeking to learn more about ancient America.

Leuzinger, Elsy. *Africa: The Art of the Negro Peoples.* NY: McGraw-Hill Book Co., 1960. Provides in a clear and accessible manner the entire range of African art. An excellent resource to which students might turn when preparing reports on African art.

Terukazu, Akiyama. *Japanese Painting.* Treasures of Asia. NY: Rizzoli International Publications, 1977. Japanese painting is examined by a recognized authority who has made a special study of the artistic interchanges between East and West. A well illustrated and clearly written resource that students will find helpful in their efforts to understand Japanese art.

UNIT 5: ART IN QUEST OF SALVATION

American Heritage Publishing Co. *The Horizon Book of Great Cathedrals.* Edited by Jay Jacobs and the editors of Horizon Magazine. NY: American Heritage Publishing Co., 1984. A splendid resource focusing attention on the greatest cathedrals in France, England, Germany, Spain, and Italy. Tries to convey a sense of what cathedrals were like when they were first constructed. An excellent resource for students preparing reports on the Gothic period.

Brown, R. Allen. *Castles: A History and Guide.* NY: Greenwich House, Distributed by Crown Publishers, 1982. Traces the history of castles from their early beginnings in ninth century France, through the crowning achievements of the Crusades, to their final decline in the fifteenth century. Illustrated with over 200 photographs and many detailed cutaway diagrams and drawings.

Duby, Georges. *History of Medieval Art 980–1440.* NY: Rizzoli International Publications, Inc., 1986. A comprehensive, beautifully illustrated history of medieval art divided into sections focusing on imperial art, feudalism, monasticism and religious art.

Ryvan Beest Hoile, Carel J. du. *Art of Islam.* NY: Harry N. Abrams, 1970. Profusely illustrated in color and black-and-white, this book seeks to demonstrate how Islamic art and faith are inseparably bound together.

Etthighausen, Richard, and Oleg Grabar. *The Art and Architecture of Islam: 650–1250.* New Haven, CT: Yale University Press, 1992. The vast scope of Islamic art is discussed and placed within its historical context.

Fremantle, Anne. *Age of Faith.* Great Ages of Man Series. Alexandria, VA: Time-Life Books, 1965. Provides a rich account of life in medieval Europe. Well illustrated and written in a lively, stimulating style. A good source of discussion topics centering on the Medieval period.

Frisch, T.G. *Gothic Art 1140-ca. 1450.* Toronto, Canada: University of Toronto Press, 1987. A comprehensive study of Gothic art in western Europe from the middle of the twelfth century to the middle of the fifteenth century. Explains how the visual arts grew out of Romanesque forms but were directed by aesthetic decisions rather than by religious formulas.

Grabar, André. *Byzantine Painting.* NY: Rizzoli International Publications, 1979. A sensitive and original examination of Byzantine painting by a widely recognized expert in the field.

Grant, Michael. *Dawn of the Middle Ages.* NY: McGraw-Hill Book Co., 1981. This impressively illustrated volume puts the Middle Ages in a new perspective—demonstrating that it was a remarkably rich period in both the East and West, a time of innovation and development that shaped our modern world. A recommended resource for students preparing reports on the Middle Ages.

Macaulay, David. *Cathedral: The Story of Its Construction.* Boston, MA: Houghton Mifflin Co., 1973. Beautifully detailed with delicate line drawings, cross sections, and diagrams. Illustrates how a Gothic cathedral was built in thirteenth-century France. Recommended for viewing in class when studying Gothic art.

Timmers, J.J.M. *A Handbook of Romanesque Art.* NY: Harper and Row, 1976. A concise yet comprehensive survey of the Romanesque style in Europe from its first manifestations around 950 through the thirteenth century. Illustrated with maps, diagrams, and 226 photographs.

UNIT 6: ART OF AN EMERGING MODERN EUROPE

Brown, Jonathan. *Diego de Velázquez, Painter and Courtier.* New Haven, CT: Yale University Press, 1986. An in-depth examination of the seventeenth-century Spanish artist and his works. A fascinating account of one of history's outstanding painters. Makes a case for Velázquez not only as a painter but as architect, art patron, decorator, and entrepreneur. Good source of information for a student report.

Chambers, D. S. *Patrons and Artists in the Italian Renaissance.* Columbia, SC: University of South Carolina Press, 1971. An enlightening discussion of Renaissance artists and the wealthy patrons who financed their creative efforts. Examines this important period from a different vantage point. A recommended reference for a research paper.

Freedberg, Sydney J. *Painting in Italy, 1500–1600.* Pelican History of Art. NY: Penguin, 1975. An excellent overview of sixteenth-century Italian painting with attention directed to the most important artists of this period.

Gaunt, William. *The Great Century of British Painting: Hogarth to Turner.* London: Phaidon, 1971. A thorough study of the major English artists and the paintings they produced from the middle of the eighteenth century to the middle of the nineteenth.

Haak, Bob. *The Golden Age: Dutch Painters of the Seventeenth Century.* NY: Harry N. Abrams, 1984. Abundant illustrations featuring the key works of the period enliven this discussion of the major Dutch painters of the seventeenth century. A recommended source of topics for class discussions.

Hartt, Frederick. *History of Italian Renaissance Art.* 3d ed. NY: Harry N. Abrams, 1987. The standard survey text with good bibliographies of individual artists. Well illustrated in color and black-and-white.

Levey, Michael. *Rococo to Revolution: Major Trends in Eighteenth-Century Painting.* NY: Oxford University Press, 1977. A survey of eighteenth-century painting, readable, and well illustrated in black-and-white. Watteau, David, Tiepolo, and Goya are the dominant artists examined, but many lesser figures provide variety and interest.

Pope-Hennessy, John. *Italian Renaissance Sculpture.* NY: Phaidon, 1971. A survey of Renaissance sculpture. Includes excellent illustrations. The comprehensive bibliography is especially valuable to students engaged in research on the Renaissance.

Rosand, David. *Painting in Cinquecento Venice: Titian, Veronese and Tintoretto.* New Haven, CT: Yale University Press, 1986. A succinct and intelligent assessment of the historical and social events in Venice against which the arts evolved during the sixteenth century.

Snyder, James. *Northern Renaissance Art.* NY: Harry N. Abrams, 1985. An authoritative survey of Northern Renaissance art with abundant illustrations. Incorporates important research in a comprehensive account.

Vasari, Giorgio. *Lives of the Artists.* Translated by Betty Burroughs. NY: Simon and Schuster, 1946. This illustrated one-volume edition of Vasari's classic source book contains the best of the lives of the Italian Renaissance artists. Well worth discussing in class.

UNIT 7: ART OF A CHANGING ERA

Arnason, H. H. *History of Modern Art: Painting, Sculpture, Architecture, Photography.* 3d ed. NY: Harry N. Abrams, 1986. A standard survey of modern art. Profusely illustrated and readable even though intended for college-level students.

Boime, Albert. *The Academy and French Painting in the Nineteenth Century.* NY: Phaidon, 1970. An examination of the impact of the French Academy on painters of the nineteenth century. Interesting, informative, and highly readable. Good source of material for student reports and class discussion.

Britt, David. *Modern Art: Impressionism to Post-Modernism.* Boston, MA: Little, Brown and Company, 1989. With more than 400 color illustrations, this concise and authoritative introduction covers every major development in the visual arts in the last one hundred years. An excellent reference for students interested in contemporary artists and art styles.

Chadwick, Whitney. *Women, Art, and Society.* The World of Art Series. London: Thames and Hudson, 1989. Succinct summary of the achievements of women in the history of western art. Describes the issues relating to the conditions under which women have worked as artists. Fine source of material for student reports and class discussion.

Davidson, Abraham A. *The Story of American Painting.* NY: Harry N. Abrams, 1974. Traces the development of American painting from the mid-seventeenth century to the 1970s. Every painting discussed—some famous while others are less well known—is illustrated in color and black-and-white.

Driskell, David C. *Two Centuries of Black American Art.* NY: Los Angeles County Museum of Art, and Random House, 1976. Provides a comprehensive survey of African-American art in America during the past two hundred years. An excellent source of information for student reports and class discussion.

Hammacher, A.M. *Modern Sculpture: Tradition and Innovation.* NY: Harry N. Abrams, 1970. Past influences and contemporary innovation in media and techniques are taken into account in this effort to explain modern sculptural forms. Well illustrated.

Honour, Hugh. *Romanticism.* Icon Edition. NY: Harper and Row, 1979. An entertaining discussion of the Romantic movement with a varied selection of illustrations. An excellent resource.

Kelder, Diane. *The French Impressionists and Their Century.* NY: Praeger, 1970. A thorough examination of the Impressionist movement showing how it was fully integrated into the social and cultural life of the times. A rich source of information for student reports and class discussion.

Rewald, John. *Post-Impressionism: From Van Gogh to Gauguin.* 2d ed. NY: The Museum of Modern Art, 1962. An authoritative and informative guide to the origins and chief developments of Post-Impressionism. Excellent source of information for student reports and class discussions.

Wilmerding, John. *American Masterpieces from the National Gallery of Art.* NY: Hudson Hills Press, 1980. A fine general introduction to American art with detailed commentaries accompanying the many colorplates. Supplemented by over 100 black-and-white illustrations of other paintings, drawings, watercolors, prints, photographs, and sculptures.